1993

THE PELICAN HISTORY OF ART

EDITED BY NIKOLAUS PEVSNER

Z26

SCULPTURE IN ITALY: 1400–1500

CHARLES SEYMOUR JR

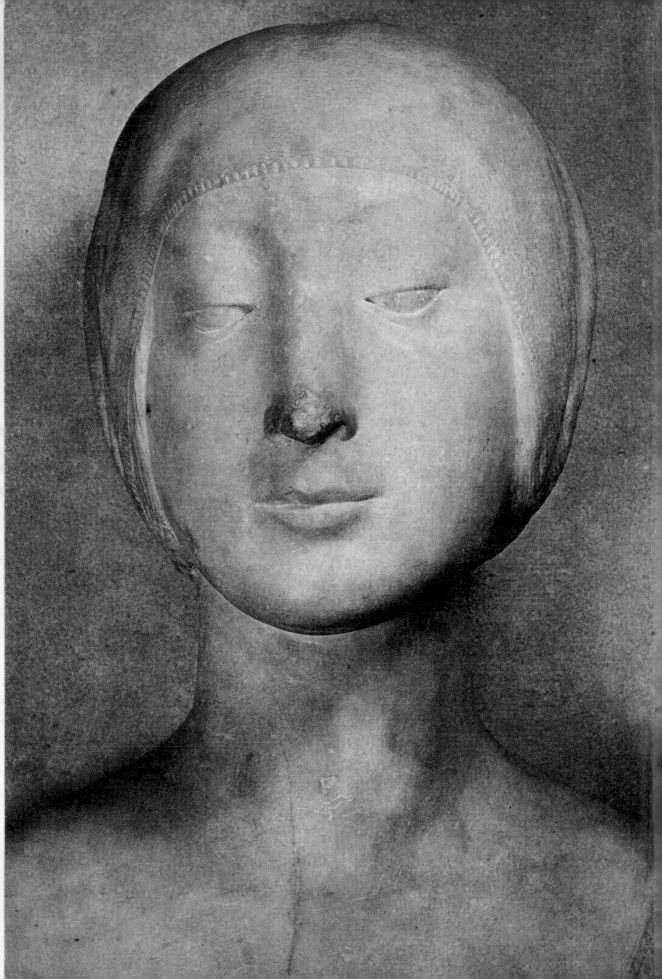

CHARLES SEYMOUR JR

SCULPTURE IN ITALY

1400 TO 1500

PUBLISHED BY PENGUIN BOOKS

Penguin Books Ltd, Harmondsworth, Middlesex
Penguin Books Inc., Baltimore, Maryland, U.S.A.
Penguin Books Pty Ltd, Ringwood, Victoria, Australia

★

Text printed by Richard Clay (The Chaucer Press), Ltd, Bungay, Suffolk
Plates printed by Balding & Mansell Ltd, London
Made and printed in Great Britain

★

TO MY WIFE
CHARLOTTE BALL SEYMOUR

CONTENTS

Part One

Part Two

CONTENTS

CONTENTS

CONTENTS

LIST OF FIGURES

xi

LIST OF PLATES

xiii

B xvii

the Sacrament (detail). Marble. *c.* 1461 (installed). *Florence, S. Lorenzo* (Courtesy of Professor C. Kennedy)

90 Desiderio da Settignano (with assistance): Central portion of tabernacle. Marble. *c.* 1461 (installed). *Florence, S. Lorenzo* (Courtesy of Professor C. Kennedy)

91 Mino da Fiesole (with assistance): Monument of Count Hugo von Andersburg. Marble. 1469 (commission)–1481 (assembly). *Florence, Badia* (Anderson)

92 (A) Mino da Fiesole: Miracle of the Snow, relief from the d'Estouteville Ciborium. Marble. *c.* 1461 (recorded inscription). *Rome, S. Maria Maggiore* (Anderson)

(B) Roman Master, probably Paolo Romano: Reception of the Relic of St Andrew, central relief, tomb of Pius II. *c.* 1464 (death date). *Rome, S. Andrea della Valle* (Anderson)

93 Paolo Romano: St Paul, originally designed for summit of stairs to Old St Peter's (hands and attributes restored). Marble. 1464. *Rome, Ponte S. Angelo* (Anderson)

94 (A) Andrea Bregno: Putto, monument of Cardinal Bartolommeo Roverella (detail). Marble. *c.* 1476–80. *Rome, S. Clemente* (Felbermeyer–Seymour, American Academy, Rome)

(B) Giovanni Dalmata: Angel, monument of Cardinal Bartolommeo Roverella (detail). *Rome, S. Clemente* (Felbermeyer–Seymour, American Academy, Rome)

95 Andrea Bregno and workshop of Mino da Fiesole: Monument of Pietro Riario (detail). Marble. *c.* 1475. *Rome, SS. Apostoli* (Anderson)

96 Giovanni Dalmata: God the Father in Glory, from the tomb of Pope Paul II originally in Old St Peter's. Marble. 1471(?)–7. *Rome, Grotte Vaticane* (Anderson)

97 Roman sculptor close to the styles of Giovanni Dalmata and Paolo Romano: The Martyrdom of St Peter (detail), relief from the ciborium of Sixtus IV for Old St Peter's. *c.* 1475–80. *Rome, Grotte Vaticane* (Anderson)

98 (A) Roman sculptor: Detail of Plate 97. *Rome, Grotte Vaticane* (Gabinetto Fotografico Nazionale)

(B) 'Maestro Andrea': Madonna and Child. Marble. *c.* 1470. *Rome, Ospedale di S. Spirito, Sale della Direzione* (Anderson)

99 Silvestro dell'Aquila (with assistance): Monument of Maria Pereira Camponeschi (detail).

Marble. *c.* 1490–1500. *Aquila, S. Bernardino* (Archivio Fotografico Gall. Mus. Vaticani)

100 (A) Silvestro dell'Aquila: St Sebastian. Painted wood. 1478. *Aquila, Museo* (Igino Carli, Aquila, Museo)

(B) Abruzzi Master: Virgin and Child from a Nativity Group. Painted terracotta. *c.* 1490. *Aquila, Museo* (Igino Carli, Aquila, Museo)

101 Francesco da Laurana: Portrait believed to be of Isabella of Aragon, wife of Gian Galeazzo Sforza, duke of Milan. Marble. *c.* 1490. *Palermo, Museo Nazionale* (Courtesy of Professor C. Kennedy)

102 (A) Francesco da Laurana: Portrait of Battista Sforza, wife of Federigo da Montefeltro, duke of Urbino. Marble. *c.* 1475. *Florence, Bargello* (Alinari)

(B) Death-mask, presumably of Battista Sforza. Terracotta. Fifteenth century. *Paris, Louvre* (Louvre)

103 Domenico Rosselli: Madonna and Saints, altar. Stone, gilt and painted. 1480. *Fossombrone, Duomo* (Gabinetto Fotografico Nazionale)

104 Matteo Civitale: Faith (unfinished). Marble. *c.* 1475. *Florence, Bargello* (Brogi)

105 Andrea della Robbia and workshop: The Adoration of the Child. Coloured glazed terracotta. *c.* 1480. *La Verna, Chiesa Maggiore* (Sop.)

106 Benedetto da Majano: Martyrdom of the Franciscan Missionaries, panel of pulpit. Marble, in part gilt. 1472 (commission)–1476. *Florence, S. Croce* (I.D.E.A., Brogi–Planiscig)

107 Benedetto da Majano: Mastrogiudici Altar. Coloured marbles and originally in part painted. 1489 (delivery). *Naples, S. Anna dei Lombardi (Monte Oliveto)* (Anderson)

108 (A) Emilian sculptor (Tommaso Fiamberti?): St Joseph, Nativity (detail), Numai Monument. Stone. *c.* 1480. *Forlì, S. Pellegrino* (Croci)

(B) Emilian sculptor: Scene from the Legend of S. Terenzio, Shrine of S. Terenzio. Marble. *c.* 1485. *Faenza, Duomo* (Alinari)

109 (A) West Coast sculptor: Crucifix. Marble. *c.* 1490(?). *Sarzana, S. Francesco* (Alinari)

(B) Donato Benti: Pulpit. Marble. *c.* 1500–4 (inscription). *Pietrasanta, Duomo* (Alinari)

110 (A) Follower of Matteo Civitale: Virgin Annunciate. Painted wood. *c.* 1485–90. *Mugnano, S. Michele* (Sop.)

FOREWORD

IT *was a great relief to me, when in the initial stages of thinking about this book and what shape it should take, that the editor agreed that the basic unit of study should be the* programme *rather than the artistic biography. By programme I have meant all along not merely subject-matter, which the word is often used to indicate alone today, but the historical complex of (1) function (social, intellectual, and visual), (2) commission, and (3) execution of a given monument or smaller work of art.*

The advantages of this approach are evident. The programme brings together artist and patron in the first instance. Documentation for Quattrocento sculpture is centred on the programme in almost every instance where it has survived. The sculptors themselves worked for the most part within a programme of some sort (often collaborative). By following the succession of programmes over the course of the century one can best sense the historical reality of the character and interplay of corporate and individual styles. *We hoped at first that the course of development in style might be traced decade by decade: although in the final version the time-spans given each chapter turned out to be more irregular because of the material, the principle of presenting to the reader cross-sections of stylistic progression has been nevertheless preserved.*

The disadvantages of this approach are also in all candour noteworthy. One, quite obviously, is that individual sculptors of the period covered, if they worked over several decades, must meet the fate of being dismembered into various sections of one or even several chapters. Fortunately, there is available in print a good number of monographic studies of the most important men; some of these studies are relatively recent and of outstanding quality, and the reader will be directed to them on many occasions. As further insurance, brief biographies of more than a hundred of the more prominent sculptors of the Italian Quattrocento are printed here at the head of the sections devoted to each in the critical and selective Bibliography. The intention has been never to lose sight of the individual; but the emphasis has been less on individual artists than on larger movements and trends. Vasari has not been used as a guide but, quite literally, as the first sentence of the Introduction reveals, as a point of departure. Not the traditional predominance of Florentine and Tuscan art has been the central theme, but the extraordinary variety, inventiveness, and quality of the artistic centres of the peninsula as a whole.

In preparing this book I have been helped by so many individuals and institutions that I cannot possibly list them all here; most will find, I trust, an all-too-brief record of my indebtedness from time to time in the notes. I would like, however, to single out some exceptions for special mention. I am particularly indebted for expert advice and friendly discussion of many basic problems in Quattrocento sculpture to Dr Ulrich Middeldorf, Director of the Kunsthistorisches Institut in Florence. The libraries of that institution and of I Tatti in Italy, the Yale University Library, the Frick Art Reference Library in New York and at the University of Pittsburgh were helpful from the point of view of books and photographs. To the Guggenheim Foundation in New York and to Yale University and the American Council of Learned Societies go my thanks for generous financial aid in making possible three study-trips of varying length to Italy, France, Germany, Austria, and England. For courtesies abroad I thank particularly Miss

Elizabeth Mariano and the late Bernard Berenson at I Tatti; Dr Filippo Rossi and Dr Ugo Procacci in Florence; Dr Enzo Carli in Siena; Dr Cesare Gnudi in Bologna; Dr Redig de Campos in the Vatican; Mlle Michèle Beaulieu, Professor Jurgis Baltrušaitis, and Professor André Chastel in Paris; Dr Ursula Schlegel in Berlin and Florence; Mr John Pope-Hennessy in London. In the United States I am especially indebted to Professor Philippe Verdier, to Mr John Walker and Mr Perry Cott, Director and Chief Curator of the National Gallery of Art, Washington, to Professor Richard Offner of New York University, Professor John R. Spencer of Oberlin, Professors H. W. Janson and Richard Krautheimer, both of New York University, to Professors Clarence Kennedy and Ruth W. Kennedy of Smith, Professor John Coolidge of Harvard, Professor Frederick Hartt of Pennsylvania, and Professor James Beck of Columbia. From colleagues at Yale University I have had support, and assistance, from Professor William Crelly, Professor Sumner Crosby, Professor George Heard Hamilton, Professor George Kubler, Professor Vincent Scully, Professor Hellmut Wohl, and Professor George Hersey. To former students in the Renaissance Seminar at Yale I am most grateful for scholarly contributions: especially Dr M. Margaret Collier, Dr Mary Davison, Mrs Wendy Stedman, Dr Peter Bohan, the late Paul Etter, Dr John Hoag, Dr Allan Ludwig, Dr Sheldon Nodelman, Mr John Pancoast, Mr John Paoletti, and Mr Stephen Scher. For bibliographical assistance at Yale I thank Miss Helen Chillman, Mrs Julia Evans, Miss Caroline Rollins, and, not least, Miss Lydia Wentworth. On the technical side of photography I shall always be thankful for the talents of Signori Malenotti in Florence and De Cusati at Yale. For the preparation of the manuscript in various phases I wish to thank Mrs Patricia Beach, Mrs Lila Calhoun, Miss Maria Cozzolino, and Mrs Nancy Siano. The map service of the Yale University Library under the direction of Mr Alexander O. Vietor furnished material for all but one of the maps. Drawings were prepared primarily by Miss Mildred Schmertz and Mr Henry Hawthorne in America and Mr Donald Bell-Scott in London. My warmest appreciation goes to Mrs Judy Nairn, who undertook the responsibility for seeing the volume through the press and for compiling the index.

Permission to reprint the perspective analysis of Ghiberti's Isaac Story panel from Professor Krautheimer's book on Lorenzo Ghiberti has been granted generously by the author and The Princeton University Press. Credits for the photographs reproduced in the Plates are given in the List of Plates. Dimensions of the statues and reliefs reproduced are not given. When they are parts of monuments reproduced as text figures their size may be gauged by the appended scales. Normally in Quattrocento sculpture the scale of statuary and of portrait-busts is that precisely of life. The reader may assume therefore life-measurements or quasi life-measurements except in the case of a few statuettes and a few colossal figures which are so characterized in the text or notes.

MAP OF ITALY
PRINCIPAL SITES OF INTEREST TO
QUATTROCENTO SCULPTURE

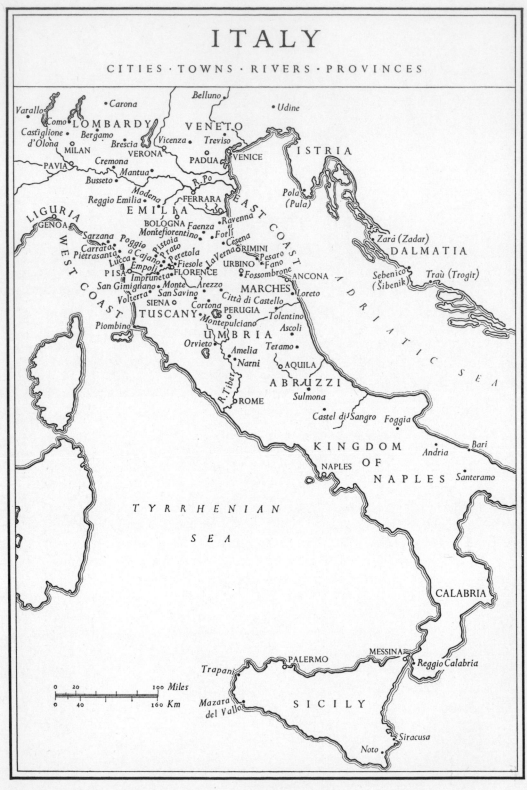

ITALY

CITIES · TOWNS · RIVERS · PROVINCES

PART ONE

INTRODUCTION: BACKGROUND AND CONDITIONS FOR FIFTEENTH-CENTURY SCULPTURE IN ITALY

WHEN towards 1545 Giorgio Vasari looked back over several centuries of what were then known as the arts of design in Italy, he discerned a turning point at the bridge from the fourteenth century to the fifteenth. At the head of his account of those artists who belonged to the second phase of the 'modern' epoch, as he called it, he placed his biography of Jacopo della Quercia (c. 1375–1438) – not a painter but a sculptor; and perhaps surprisingly, in view of Vasari's well-known sympathies, not a Florentine but a Sienese.

Upon what was this choice based? For Vasari, on many counts still in touch through tradition with previous thinking, the reason was primarily because this earlier sculptor was the first of his generation '. . . to show that a close approach might be made to Nature herself, and it was from him that other artists took courage to hope that it was possible in a certain measure to equal her works'.[1]

'Nature' and 'her works' had been referred to over a century earlier by Leone Battista Alberti in precisely the same general context of ideas. The dedication of the 1436 version of Alberti's treatise on painting was written in Quercia's lifetime. In this short dedicatory essay, written in the Italian *volgare* (his own 'natural' as well as 'civic' tongue), Alberti praised Quercia's generation of Florentine artists for their efforts to correct deficiencies of Nature, the 'Mistress of Things'. 'Grown old', Nature had seemingly begun to fail to produce either great men as artists or great artistic ideas for execution. Now, in the early fifteenth century, a new cycle seemed to be opening.

Alberti singled out as leaders, in what he saw as a dramatically vigorous movement of artistic revival, five artists. The first was Filippo Brunelleschi, to whom he dedicated his treatise in the Italian version. One only was a painter (Masaccio). One had begun as a painter and goldsmith but decades before 1436 had turned to sculpture (Ghiberti). Two others had been trained from their youth as sculptors (Donatello and Luca della Robbia). Brunelleschi, Alberti's early ideal of the intellectual artist, had been trained as a silversmith. Until fairly late in his career as an architect Brunelleschi apparently remained a sculptor on occasion. Before writing his treatise on painting, Alberti, who was possibly himself a practising sculptor, had composed a treatise on problems of sculpture entitled *De Statua*, to which we shall have occasion to refer several times in the pages which follow.

From the content as well as the implications of such theoretical writing, plastic form and sculptural shape as much as perspective appear as keys to a 'new art'. Moreover,

there was no real differentiation in importance between the so-called 'minor arts' of goldsmith work or silversmith work and what later periods were to call the 'major arts'. Nor at this date were architecture, sculpture, and painting lodged in sharply separated categories. There was a certain osmosis between the media in the definition of the new style.

Nevertheless, the marked accent towards 1435 on sculptors, and by inference on sculpture, is striking. The leadership of sculpture in early-fifteenth-century Tuscany was partly a matter of theory concerning art in general. Primarily in Florence, or by Florentines, there was expressed in writing just as much as by example, a positive connexion between the ideas of man's relation to nature and nature's relation to art, particularly to the art of sculpture. This was to have profound effects upon historical views of the development of Renaissance sculpture in Italy as a whole. It was to place an overweighted emphasis on Florence, which is difficult to redress even today. But in compensation there can gladly be acknowledged in favour of Florence the initial projection, in the early fifteenth century, of a concept of sculpture which was rapidly to begin to spread over Europe and ultimately to reach the most distant quarters of the globe.

Nature and Sculpture

On the Lucretian and Epicurean idea of the 'Mistress of Things' the Later Middle Ages and the Renaissance placed their own interpretations. To the early years of the Renaissance, *Natura* was both an impersonal force and a personification, in the Antique mode, of the constantly fertile source of all visible forms. She was the source also of man's ability to deal, as a part of the natural order, with his environment. The outward appearances, inward structure, and special capacity for metamorphosis in all parts of the human environment were believed to be *Natura*'s handiwork, following the models provided by the First Creator. In dealing with matter her hand was recognized as unsurpassed in cunning. More important, she was thought to know perfectly the system of proportionate measure that gave to each of her separate creations its just shape, both proper to itself and in proper quantitative relationships to its fellows and to the harmonious whole. *Natura* could, in fact, be looked on as an artist, and indeed a sculptor, in her own right.[2]

In the Early Renaissance view, because he belonged to the overarching natural order, man owed to *Natura*, or to mythologically presented aspects of her power, the inspiration of all his arts and sciences. It was to his great advantage to know her laws and to live by them. He alone of all created beings was to a certain extent independent through his own capacity for invention (*ingegno*) and a unique and human potential for achievement (*virtù*). Given this endowment, it was but a short step to a paradoxically 'natural' desire to compete with *Natura* herself.

In this competition the literary humanists had their part in fortifying the mind and soul by bringing back and using the writings of Greco-Roman Antiquity, in order to recreate in the mind at least the golden age of classical ἀρήτε and *virtus*. To the visual artists, including the sculptors, was flung the challenge of a direct emulation of *Natura*

as an artist. To this end they had to know her methods. Here arose a real requirement for broad as well as sharpened education, and in addition to mastery of a craft there was to grow a need also for a working association with humanist learning.

Towards 1445 the sculptor Lorenzo Ghiberti listed no less than ten 'liberal arts' of his own classification which should be controlled by a sculptor or painter alike.[3] Of these, mathematics assumed major importance. Only two belonged completely on the verbal side of the traditional medieval curriculum. They were grammar and philosophy, with rhetoric perhaps implied as referring to visual as well as to verbal forms. From this theoretical basis, as a start, one can proceed further to deduce a set of general principles, or guiding attitudes towards Italian Quattrocento sculpture. They may be summarized under three headings:

(a) *Ability to see clearly and from a 'correct' point of vantage both the productions of nature and the productions of art made in emulation of nature.* The human eye was both an instrument of analysis and a court of judgement. It followed that it was of the first necessity to understand the process of human vision. Hence a view of sculpture as an art which instinctively combined the visual with the tactile. To the importance of optics in relation to sculpture the extent alone of Ghiberti's *Third Commentary* is an eloquent witness.[4]

(b) *Discovery of the secrets of proportion underlying all natural phenomena.* The system of the universe was assumed to be homogeneous and mathematically ordered. With the tools of exact comparison and proportion (arithmetic and geometry), the artist was felt to be able to construct new forms in analogy to nature. Hence a view of sculpture which favoured as a part of outer measurement first of all a suggestion of inner structure, and secondly clarity of expression in dealing with the subject. A correspondence between inner values and outer effects was an early requirement. About 1425 the humanist Leonardo Bruni, called in to establish the subjects of the last of the Florentine baptistery doors, declared that two objectives were essential: the designs of sculpture should be 'illustri' ('that the eye might be satisfied') and 'significanti' ('that they have an import worthy of memory'). Gold and colour were not to be excluded. The notion of white-cold statuary or bare bronze was not that of the Early Renaissance in general.

(c) *Reluctance to accept* en bloc *the artistic tradition of the immediate local past which was felt to have deviated from nature's methods.* While there continued to exist an admiration for a master of the preceding generation (Ghiberti's revered 'Master Gusmin' from Cologne), a growing interest in masters of the deep past soon became more evident. By jumping far backwards in time, one rejoined in spirit the artistic ranks of long-past civilizations (the Greco-Roman or Etruscan), not simply because they were historically venerable but because they had penetrated to the core of the problem of adapting the data and methods of *Natura* to art. A new relationship of personal parallelism between 'ancients' and 'moderns' became more overt as the century advanced. This gave rise to a far greater variety of highly individual and more fervent interpretations of Antique themes and forms than can be found in earlier medieval 'renascences', or indeed in the later and more knowledgeable academic circles.[5] By the end of the century, imitation mingled with rivalry had created a taste for 'inventions' passed off as *bona*

fide antiques, as for example Michelangelo's Eros (see p. 215). In Rome and the north of Italy sculptors were taking the names of ancient sculptors as *noms-de-guerre*; for example, 'Lysippus Junior' or 'Pyrgoteles'. By this point in time, towards 1500, naturalism and humanism had joined hands. Whether one looks at Venice, Florence, or Rome at the end of the century, nature was being seen by sculptors only through the Antique.

These three headings combine to set up quite a different situation from that which we would invoke to describe the inner conditions and the underlying drives for making sculpture in Italy, until we approach the Quattrocento. It differs from the situation that might be invoked for the succeeding century on many counts also. Allowing leeway in the timetable of the emergence of these factors in the various parts of the peninsula, and even then leaving room for regional variations and the counterweight of local traditions, we may consider them as a guide rather than as a rule. They help to elucidate the apparently valid commonplace, held by both Alberti and Vasari and probably many others besides them, of a new and exciting phase in the three-point relationship of Nature–Man–Art, already in view as a strong tendency by 1400 and gathering momentum as a movement immediately thereafter.

Statua Virile

The naturalist, and gradually humanist, movement in sculpture had as a central target a convincing definition of the image of man. This it never lost sight of, and as an aim it must have been as much a commonplace as the relationship of art to nature. The primacy of sculpture in early-fifteenth-century Italy was no accident. Sculpture can work in the round. It occupies a position in the actual space of nature. Its capabilities for imagery are immediate and direct, even to the 'naturalism' of taking moulds after nature. Finally and importantly, it could be placed as public art in the open. Thus, before both architecture and painting, sculpture for a moment seized the field for experiment and evident achievement along the new lines of direction in style and expression.

At the cross-roads of the Early Renaissance complex of Nature–Man–Art is the concept of statuary (*statua, arte statuaria*). It is necessary today to make a special effort to recover the Renaissance meaning of the term. To the fifteenth-century Italians, *statua* was no colourless theoretical category. It implied, it would seem clear, more than a well-wrought image standing as a metaphor for a doctrinal tenet (one meaning of *figura*), more than a faithful image (*simulacrum* or *effigies*), and more than an image of symbolic importance (*signum*).

Figura, simulacrum, and *signum* all may be found in Late Trecento and Quattrocento documents and sources to mean statuary. The term *statua* in the Quattrocento is more literary in its usage, though in the non-literary and non-humanist documents it appears first interestingly enough as an apparent misunderstanding, referring to the block of stone from which the figure was to be carved, rather than the finished figure. The term *statua* had to compete at first with the medieval terms *figura* and *imago*, which in turn were virtually interchangeable between sculpture and painting; indeed, for a short

period towards 1410 the documents of the Florentine cathedral archives refer to marble figures in the full round as *picturae*, a usage perhaps encouraged by the practice of using painters to design, draw, and colour designs for statues and then, after the sculptors had carved the figures, to gild or to colour them.[6]

What the Early Renaissance Italians might actually have conjured up in their minds as *statua* may be gathered by re-reading after them Pliny's description of sculpture in ancient Rome, in his encyclopedia known as the 'Natural History'. There the term *statua* abounds and is given ample illustration in named examples.[7] The central idea to be applied to the Renaissance reading of Pliny seems to have been as follows. Statuary has a uniquely important function in the historical life of a great urban civilization. Unlike the medieval *figura*, which 'figures' the timeless and eternal, *statua* applies to time actually lived, and serves both as a memorial and a guide for human achievement at grips with history. It implies the notion of dedication to humanly defined ideals; it functions as a constituent part of a noble and impressive environment fit for noble and impressive human beings. The two are complementary.

In Early Renaissance texts we find references to several materials suitable for *statua*. These were marble as well as bronze, but also terracotta, with overtones of a still dimly felt tradition from Rome and Etruria. Grand elevated monuments (triumphal arch, tower, or tall votive column) appear in written theory as favoured supporting structures. *Colossi* are mentioned by Ghiberti with admiration and figure importantly in both Alberti's and Filarete's theoretical writing. Man, as a concept, was to be grasped not only 'in the life', through written history, but in his image heroically presented in high places in enduring materials. A view of ancient Rome as possessing two populations, one of remarkable human beings of flesh and blood and the other of marble and bronze, appears for a time at least to have gripped Early Renaissance imaginations.

Somewhere along this line of thought the two 'kinds' of man may have seemed almost to merge. According to the humanist Poggio Bracciolini, the fragmentary remains of Antique statuary he found in Rome about 1430 lacked only breath and the power of speech (*anima, spiritus*) to seem completely 'alive', that is, to be 'animated', to be truly a reincarnation of ancient Roman *virtus* earlier produced by *Natura*.[8] This attitude implies more than a parroting of ancient clichés or a naïve view of Antique sculpture as simply a remarkably 'lifelike' imitation or transcription of outward appearances. It was developed in the investigations of Ciriaco d'Ancona.[9] And before 1415 it was given an unforgettable expression in marble by Nanni di Banco.

The *statua virile* as a fifteenth-century idea contains the notions of *vir* and *virtus* and is not at all the same concept as the old medieval *imago hominis*, although we might translate both as 'image of man'. Ghiberti presents the new term in its Italian guise, *statua virile*, several times in his *Commentarii*, as a positive way of getting at a basic value for sculpture which his own age felt it was engaged in recovering. The problem which in practice Ghiberti had difficulty in solving himself – with the signal exceptions of the St Matthew of Or San Michele (Plate 24) and considerable parts of the 'Gates of Paradise' for the Florentine Baptistery (Plates 48–50) – was how to adapt the concept of *statua* to the conditions and programmes of fifteenth-century Italy.

Opposing the Italian humanist concept of *statua* in its pure state of the historical imagination was the late medieval European tradition of a decorative '*ymaige*', yielding gracefully to the weight of complicated draperies and resplendent in surface patterns of bright gold, ultramarine, and vermilion, so closely related to the or, azure, and gules of heraldic art. Also to a certain extent against it was the late medieval realism of literal 'repetition' (*ritrarre*) both of individuals and of groups, treated in veristic colouring and shapes, mostly on frankly sentimental or religious themes such as the Madonna and Child, the Pietà, the Mourning and Entombment of Christ. To this tradition may be linked the remarkable 'art-form' of votive effigies in coloured wax and real clothes which thronged first the shrine of Or San Michele and then that of SS. Annunziata in Florence and are recorded also in the Emilia.[10] The enormous quantity of sculpture produced in fifteenth-century Italy in direct continuity from medieval devotional traditions hardly needs recall here. One must think of fifteenth-century sculpture in Italy as at least a double stream, to be sure with cross-currents. Of these the humanist trend was only gradually to become the stronger.

Opportunities for public placement of the *statua virile* as a monument *all'antica* were, on sober count, rare. The Renaissance of the fifteenth century created very few piazze, and it excavated or recreated no Roman fora. Sculpture placed on a high column *all'antica* was a method of presentation which had an undeniable vogue as an ideal solution. In Roman times the use of the columnar monument had increased, especially for commemorative purposes. The column, frequently without a surmounting figure, symbolized individual or collective victories or permanent civic values, and was placed very prominently in public places. The Middle Ages continued to use these forms for much the same purposes. The fifteenth century did not, and probably could not, attempt a systematic revival of Antique practice, but adapted the medieval heritage from Antiquity to its own needs.

The re-use or revival of the free-standing column *all'antica* had been fairly frequent all through medieval Italy, and in the north was particularly prevalent. Sometimes a lion was represented on the summit of the column as symbol of the victories of the city. The monument was usually situated in the central piazza or market place, in Venice near S. Marco, in Mantua in front of S. Andrea, in Milan in front of S. Babila. Equally frequent and widespread until the end of the fifteenth century was the image of the patron saint of the city, in Venice St Theodore, in Ravenna St Apollinaris, with other examples in Vicenza, Udine, Rovigo, Treviso, Verona, and Brescia. In Siena the Roman Lupa (in Turini's fifteenth-century bronze) may still be seen today on a column close to the Palazzo Pubblico. In 1420 occurred the Florentine *renovatio* which placed on what was believed to have been the site of an Antique statue of Abundantia a column-figure by Donatello bearing emblems of prosperity.

Paintings and drawings show what place these monuments might hold in the ideal city plan or its embodiment in a 'cityscape' through their symbolic and visual properties. The finest survivor of this class of representations, a panel in the Walters Art Gallery in Baltimore, shows four statues on tall columns around the central fountain of a city square. Three of the figures are clearly intended to represent the cardinal virtues of

Fortitude, Justice, and Temperance, but Prudence is replaced by Wealth or Abundantia, doubtless a reflection of the iconography of the Florentine market place already cited.

The free-standing column bearing a figure remained a frequent image in fifteenth-century painting to express the taste for archaeological vestigia of the Antique, for example in Mantegna's urban view in the Camera degli Sposi in Mantua and over and over again in the sketch books attributed to Jacopo Bellini. It remained as well a widely used symbol of pagan idolatry, for example in Filippino Lippi's Martyrdom of St John the Evangelist in S. Maria Novella, in Botticelli's Death of Lucrezia in the Isabella Stewart Gardner Museum, Boston, in Antonio Vivarini's St Catherine casting down a Pagan Idol in the Kress Collection, National Gallery of Art, Washington. This frequency of use of the motif is impressive, but the fact remains that it was far easier to represent this type of sculptural programme in the illusion of painting than in the full-scale reality of sculpture in an urban setting. This was equally true of the other great Antique form of monument, the equestrian statue.

Only three monumental free-standing equestrian monuments in the open squares of cities may be counted fairly as begun between 1400 and 1485 on the antique models of the Marcus Aurelius of Rome, the 'Regisole' of Pavia, or the Justinian known to travellers to Constantinople. These are the Gattamelata in Padua and the Colleoni in Venice (Plates 62 and 117), and the less well known and no longer extant monument to Niccolò III d'Este, in Ferrara.[11] Much Early Renaissance statuary found its way either into pre-determined places on earlier medieval buildings or to emplacements in existing buildings. A semi-private courtyard, or even a fireplace in a palace (Plate 154A), a funerary monument in a great church (Plate 72), a monumental entrance to a city or building (Plate 68, A and B) – these were the new programmes which were most frequently available to sculpture which might qualify as *statua virile*.

Such emplacements were hardly all of the type that Pliny had written of. As the century advanced and revealed the true fact of the dearth of opportunity to recreate, on a heroic scale, a romantic vision of Antique statuary, one outlet occurred, as we have seen, in paintings of views of statuary. Another occurred in writing, as in theoretical treatises such as Filarete's (see below). Hence came about a flourishing art in small-scale bronze: at first medals, then plaquettes and statuettes (Plates 47, 144, and 147). Where the heroic mode seemed either too expensive or too ostentatious, the ideal full figure gave way to the more modest portrait bust, of which we have the first securely dated examples only in the 1450s. This was a midway stage between memories of Antiquity, the composition of the medieval bust reliquary, and a sense of actuality quite different from either (Plates 70, 76, 101, and 141A).

Difficult as a full translation of the idea of *statua* into three-dimensional reality may have been, that idea nevertheless remained. Where it could not conquer opposing ideas, as indicated above, it became involved with them. The notion of a measured, generalized, yet living image, such as was achieved in past ages of high human *ingegno*, had found its way by 1500 into very nearly everything that can be classed as sculpture in Italy, in greater or lesser degree, even into the most tradition-bound genres of devotional iconic figures (Plates 129 and 160).

One problem of modern interpretation is in estimating the degree of humanistic assimilation, and of giving full value to the originality of fifteenth-century sculptors in working out what might be too easily undervalued as 'hybrid' or 'provincial' variants (Plates 100 and 103). Another problem is giving a proper value, as sculpture, to relief compositions in which the notion of *statua* is modified to provide a 'scene' involving the composition and interaction of several figures in analogy to the Albertian *istoria*, or narrative-presentation, as in painting. The often-cited 'pictorial' qualities of Quattro-cento relief may be really sculptural in feeling as much as in execution. And their range from the magically subtle low relief (*stiacciato*) of Florentine origin to the complicated 'layered' relief done about 1480–1500 (Plates 107, 131, and 134) covers a large field of experiment.

The Theoreticians: Alberti, Ghiberti, Filarete, Pomponio Gaurico

Useful landmarks in the topography of ideas about sculpture in fifteenth-century Italy are the theoretical writings which occur over the period bounded roughly by the dates 1430 and 1500. The earliest is Alberti's *De Statua*, of about 1433 according to most recent estimates, whose intellectuality may be relieved by Ghiberti's somewhat later *Commentarii*, where the theoretical conciseness of Alberti's definition of *statua* is put into the context of the remarkably varied and pragmatic approach of a practising master of the first half of the century, as much interested in *istoria* in relief as in the free-standing statue.[12] In Filarete's *Trattato dell'Architettura*, written, it would now appear, in 1461–2, the subject matter shifts to the place of sculpture in an architectural pro-gramme ranging from the interior of a single building to a whole city. Though dis-appointingly superficial in its treatment of sculpture both as craft and art, which the author was quite qualified to discuss, the treatise has the immeasurable value of pro-viding views into sculptors' reputations and opportunities at that time. It also proposes ideal situations in which sculpture might be used to monumental and public effect in ways which no other age has surpassed in imaginative power (Plate 120A), fantasy or even, occasionally, inspired eccentricity.

Passing over for the moment Leonardo's scattered and often uncomplimentary views on sculpture (which may date in considerable part from his disappointed later years in the early sixteenth century),[13] I would mention instead the late-fifteenth-century treatise begun towards 1500 by Pomponio Gaurico, whose direct knowledge of the sculpture of his time ranged from the kingdom of Naples to Florence, Venice, and Padua, and who may very well have been influenced by Leonardo *en route*.[14] His treatise contains fulsome information on technique and much more on aesthetic and philosophical aims. It is written from the point of view of a young, enthusiastic, and rather pretentious layman connoisseur. It contains critical judgements, sometimes acidulous, and it stresses, rather than the public function of sculpture, the delights of private enjoyment consistent with the ambient which produced the plaquettes and small bronzes of the Venetian–Mantuan–Paduan area in the early period of Riccio (see Plate 147).

All these treatises have a humanist bearing. Taken as a group, in chronological order, they reveal the isolation and definition of an ideal of sculpture as *statua* rather than as *figura*, *imago*, or *simulacrum* and the changes of emphasis on that idea, through the actuality of time and taste. Pomponio Gaurico may appear to some today to be the narrow end of a funnel as far as breadth and grandeur of a heroic mode are concerned; but his approach embodies a significant outgrowth of neo-Platonism from earlier Epicurean naturalism. And his emphasis on the small but well-wrought and expressive object accurately represents a fairly widespread trend of taste in the last years of the century. The first of these treatises on sculpture, Alberti's, provides on the other hand the most direct insight into the nature of *statua* in the large.

Beginning with *Natura* as a basic concept, Alberti disposes fairly rapidly of questions of aesthetics to get at the heart of the matter, as he must have seen it through the difficulties of his contemporaries and perhaps his own experiments in the art. One aspect concerns the technical means of controlling accurately the process of carving from chosen designs. This is interesting as regards a sense of largeness of scale in the finished statue and in that it foreshadows the use of *modelli* as a preparation. More important perhaps is Alberti's twofold definition of *statua*. Just as all men are generically alike, so in statuary there must be a rule to create a norm valid for all figures. Similarly, because no two men are precisely alike in all characteristics ('voice for voice, nose for nose'), it is necessary to find a means of differentiation from the norm.

The first process, that of finding the norm, he calls *dimensio*. As a guide to the practical solution of problems of ideal conformity, he adds as an appendix to his treatise the most original and complete mathematical canon of proportions of the entire century, in three dimensions. This is on a modular system and differs in important respects from the Roman Vitruvian canon.[15] In life and nature, however, there intervenes the element of time. Live bodies move from moment to moment; each pose implies a whole sequence of differing figures ('in corporibus . . . variae sequantur figurae'). This kinematic aspect of sculptural composition Alberti calls *finitio*. To master it, he urges a study of anatomy upon the sculptor, and notes that under close observation the measures defined in the canon will change as the pose deviates from the upright standing figure of static measurability. From this it would appear that anatomical studies were early encouraged, not in opposition to the ideal canon, but as a means to strengthen its use. The way was also open to expressive suggestion of an inner vitality deep within the mass of the figure, as the effects of a given movement were linked step by step logically to its mechanical and emotional cause. Outward expression in the figure could thus be connected with a core of imagined personality.

A great value in Alberti's pithy treatise lies in its workable suggestion of a way in which the general and the particular, the norm and the unique, the ordinary and the extraordinary, may be combined in sculpture into a new equivalent of man in nature and in historical time. Upon this flexible basis it might be possible to link the image of man to the mathematical order underlying the universe about him, a Stoic idea as much as a neo-Platonic one. It was also possible to provide that image with the dignity and harmony of universal and eternal measure, the Pythagorean notion to be taken up

with gusto by the Italian neo-Platonists. At the same time the possibility remained open, via expression of movement, of variety of pose and of meaningful alteration of the canon of proportions, to particularize individual departures from it, a naturalist aim to be seized upon by Leonardo, who can be classified under no single philosophic school.

The general notion of *statua* among sculptors in Tuscan Italy must antedate Alberti's treatise by ten or perhaps twenty years. But Alberti's work provides the first and probably most explicit definition that is available to us of Renaissance sculptural aims and programme for action.

Practical Considerations; Workshop Organization

One aim of the theoreticians was essentially practical. This was to help form, through influential citizens or princes, a climate of ideas which might favour the new doctrine of art they were preaching. It should be evident from what has gone before that the new art was not likely easily, or rapidly, or uniformly to be assimilated. It had to meet the resistance of other aims of sculptural activity and the all-too-inconsistent actuality of the economic and social world.

Patronage for sculpture in fifteenth-century Italy came increasingly from two lay classes: the merchants and the princes. But the older medieval patterns of patronage dominated by ecclesiastical personalities and institutions did not by any means disappear: think only of Rome, the Santo in Padua, or the Casa Santa of Loreto. In the *programme*, and the term here should be taken as inclusively as possible to mean the total planning of a work of art for a specific place or purpose, patronage and sculptor came together. Probably only a rather bare minimum of the highest quality in sculpture in fifteenth-century Italy escaped a definite programme and was placed on sale to chance comers in a shop.

Shop-merchandise seems to have been limited chiefly to relatively inexpensive casts, squeezes, or variants in malleable materials such as stucco, cartapesta, or sometimes terracotta, of well-known compositions in marble or stone. Such reproductions and variants were nearly always originally painted in clear contrasting colours and enriched with gilt. The quality of those that have survived has a broad range. They are virtually never documented. The older cataloguers' optimistic habit of ascribing such productions to the hand of a master-sculptor is dying out today. Instead scholars invoke the 'shop' of the master. This usually means that the design originally was the master's, the execution being that of some assistant. The most promising method of classification depends on a connoisseur's eye, which discriminates the shades or degrees of quality leading from a presumed 'original' down through repetitions and variants of decreasing sharpness and lessening subtlety of surface or composition.[16] As a class, these stuccos and terracottas need a great deal more study. We still know surprisingly little about them, and less about the probably wide variety of little shops that made or distributed them. But we know that the practice of making painted stucco reproductions of famous pieces of stone sculpture began in Florence (for one example) well before 1400.[17]

For the great majority of the sculptural pieces and ensembles of the fifteenth century with which we shall have to deal, a programme of subject matter, scale, materials, expense, and time-limit for execution was normally contracted between patron and artist. Until quite late in the century it was usual for the sculptor to belong to a guild, more often of the stone-and-wood carvers than any other. There was no specific or exclusive sculptors' guild in Florence, nor does an exclusive pattern of a single guild seem to have met with any success elsewhere in Italy at this point. At first, as shown in Nanni di Banco's relief on Or San Michele, the sculptor was associated with the turner of columns and the fashioner of capitals (Plate 18B). By 1415 a Florentine sculptor could enter his guild at fifteen years of age, but he could sign no contract in his own right as a legally independent person until some years later, usually at the age of twenty-one but sometimes at eighteen. Until he became established as a known and competent work-man, he was required to have guarantors bound to make good any losses or damage to materials he might incur. The patron often supplied the stone or marble for carving or the bronze for casting, and thus retained the 'rights' on the material if the work of art were left unfinished. The artist supplied his own tools, and often, but not always by any means, the salary of his assistants.[18]

The organization of the sculptor's workshop, or *bottega*, varied according to time and place. We have today no continuous view into the *bottega* as an institution. But the few glimpses that we may put together into something approaching a general picture may clarify several questions which the reader is certain to have at some point on his mind. First the master in name appears indeed as the master in fact, even though his name may appear in connexion with work clearly executed by an assistant, according to modern evaluation of stylistic evidence. He provided or approved the designs, assigned and supervised the allocations of work to his assistants (*discipuli*), and represented himself and his assistants in legal matters pertaining to commissions. He was trained by a master in all phases of his art, and in his due turn he became a leader himself. The de-lightful, sardonic little relief on the back of the fifteenth-century doors of St Peter's in Rome shows the situation graphically with the master (Filarete) followed by a fairly long line of his named 'disciples' trotting behind him in single file, each apparently in his appointed place in the studio hierarchy. The relief supplies first names and nicknames of the assistants (Plate 55B). A higher degree of association seems implied by the word *compagno*.

The number and tasks of assistants might vary considerably, depending upon the amount of work to be done over a period of time, or according to the size and com-plexity of a given commission. The largest shop on record over a long period must have been Ghiberti's in Florence, but as time goes on it is becoming increasingly apparent that Donatello had a very large shop or corps of assistants too, often on so temporary a basis, as would appear from the internal evidence of style alone, that the search for the identity of the helpers poses formidable problems. Occasionally partnerships between masters were formed for limited periods – as for example in the case of Donatello and Michelozzo in Florence and also in Rome. In North Italy the family 'dynastic' firm held sway, extending through more than one generation (see pp. 193–7). In Rome, after

1460, partnerships for single commissions seem to have been frequent, as for example between Mino da Fiesole and Andrea Bregno, or Mino and Giovanni Dalmata (Table on p. 161). In these cases the divisions of labour on the various parts of a large ensemble must have been clearly established before work began; the divisions can generally be traced today through analysis of style in the monuments themselves.

It is evident all through the period from 1400 to 1500 that, whether on the scheme of partnership, or on that of master and assistants, the general rule and practice was collaboration. The pattern of the isolated single master responsible for the execution of the piece as well as for the design, as we think of Michelangelo, did not arise until late in the century, and by no means generally. The firm establishment of the single artist and of the single 'hand' appears to coincide with the triumph of humanistic adulation of individual masters of Antiquity.

Patterns of Patronage; Programmes and Costs

At the beginning of the century patronage was principally corporate. We find in Florence for example, where the documents are better preserved and published than elsewhere, a wealth of detail on committees acting for great institutions in the role of patron. These might be standing committees for the building and maintenance of architectural programmes, such as the committee of prominent citizens who were wardens known as the Operai of the Duomo. The larger guilds or trade corporations, through their governing boards of consuls, would also on a continuing basis make available funds for construction and for sculpture. Thus the powerful Arte della Lana, or wool guild, through its consuls assisted in the patronage of sculpture for the Florentine Duomo and from time to time dictated policy on the Duomo's sculptural programmes. The still more powerful Arte della Calimala, the merchants' guild dealing in foreign trade goods, supported the maintenance of the baptistery; it was the Calimala which organized and controlled the competition for the Florentine baptistery doors in 1401–2, and thereafter supplied funds and materials, revised the original contract, and supervised the progress of the work (see pp. 36 ff.). For the whole series of lesser programmes which involved the tabernacles with sculpture on the exterior of Or San Michele in Florence each guild acted independently, choosing and paying the artist or artists. The first documented example of Medici patronage of sculpture is the subscription made by Cosimo, Pater Patriae, and his father to the considerable fund raised among all the members of the Cambio Guild (the bankers) for the niche and statue ordered by the guild from Ghiberti in 1419 and made in 1419–22.[19] At other times and places imposts to pay for a sculptural programme were made on other corporate groups. An interesting example is the levy on salaries of the university professors in Bologna in 1473 to provide funds for the sculpture of the upper portion of the Shrine of St Dominic (see pp. 184–5).

Within the corporate system of patronage it was to be expected that individuals should arise with firmer ideas, greater interest in the arts, and fuller purses than their colleagues. As the century advanced, the more personal type of family or individual patronage became more general. There arose in this way the relationship between the

ageing Donatello and Cosimo de' Medici, focused on the Medici interests in the decoration of S. Lorenzo in Florence and of their town palace and villas. Cosimo's grandson, Lorenzo, maintained Donatello's follower, Bertoldo, almost as a private artist of his own; in this pattern he acted less like a burgher than a prince.

Individual princes of the Church in Rome financed an enormous quantity of sculpture in the form of funerary monuments, altars, or ciboria: in honouring their churches or their families they also honoured themselves (Plates 92 and 97). The duchess of Burgundy, a member of the Portuguese royal family acting through her agent in Florence, was the chief patron of the epoch-making and most elaborate mortuary chapel in S. Miniato including the tomb by Antonio Rossellino and his associates (1461–6) in which was buried the young royal cardinal of Portugal (Plate 73).[20] The Crown of Aragon became the patron of the great entrance gate, filled with sculpture, to the 'new' Castello at Naples (Plate 69). The great families of the doges in Venice saw to their monumental funerary monuments, authorized by the senate, when the doge himself did not make provision for his monument (Plates 138–9). The more evanescent 'tyrants' of smaller states – the Manfredi in Faenza, the Montefeltri in Urbino, the Bentivoglio in Bologna, or the Malatesta in Rimini and Cesena – became as a matter of course patrons of sculptors. The individuality of their tastes and interests is well illustrated by Sigismondo Pandolfo Malatesta, who poured his personal treasure into the elaborate sculptural programme of his 'Tempio' in Rimini as long as that treasure lasted (Plates 64–6). Significantly, when his personal fortune failed him, the great project petered out in mid-course, never to be completed.

It would be an error to think of the heart of the Early Renaissance movement as courtly or princely. But it would be as great a failing to attribute a preponderant influence in patronage to the middle classes in Italy as a whole.[21] There exists some uncertainty as to the extent and importance of a 'bourgeois' patronage for fifteenth-century sculpture in Italy. What we do find without any question is evidence of a high-minded, virtually aristocratic 'citizens' patronage'. This could be translated into action by way of the guilds, as we have seen in the case of Or San Michele, the cathedral, and the baptistery in Florence. Or the government of a republic such as Florence might vote the state funerals and permission to erect commemorative monuments of great chancellors such as Leonardi Bruni and Carlo Marsuppini (Plates 59 and 72) in S. Croce, which became ultimately a Florentine kind of Westminster Abbey. A somewhat similar case is the monument in Padua to the *condottiere* Erasmo da Narni known as Gattamelata, voted by the senate in Venice and completed partly with public funds and partly by funds supplied by his family. These were official monuments, erected not to private individuals but to personifications of *virtù* or *magnificentia*, who had '. . . done the state some service'. The character of such monuments is hardly more 'bourgeois' than the character of Shakespeare's Othello.

It is true that there was opportunity in Italian civic culture for sculptural monuments to the memory of more modest lives – for example the extraordinarily fine bust (Plate 70A) and the tomb at San Miniato al Tedesco of the Florentine physician, Giovanni Chellini.[22] To a perhaps more undiscriminating eye and a lighter purse there was

undoubtedly the appeal of the glazed terracotta ware of the Robbia workshop, mostly after 1470. Much of the production of that shop ultimately became frankly commercial. But for purposes of architectural decoration fine designs were still to be translated towards the end of the fifteenth century into that durable and flashily effective medium (Plate 150A).

Only late in the century, and more ordinarily at the very beginning of the sixteenth century, do we find the growth of inexpensive memorials made of terracotta formed from a cast of a death-mask added helter-skelter to crudely modelled chest and shoulders. The earliest are roughly contemporary with the compulsively serried rows of burghers' portraits so prominent in the Florentine frescoes of Domenico Ghirlandaio; they coincide also with a decline quantitatively, and in many respects qualitatively, in programmes of sculpture in Florence. 'Bourgeois' patronage in so far as it can be isolated at this date seems to imply a collective market and a taste best satisfied by repetition, which could be shared by the broadest possible base of the population without much regard for quality of workmanship or originality of concept. If it had taken over, it might have given rise in sculpture to the anomaly of an urban folk-art. Economic circumstances rather than theoretical societal alignments, however, had the upper hand.

Far more than in painting, the patronage of sculpture in fifteenth-century Italy had to cope with heavy expense both of materials and of workmanship. Ghiberti's first doors for the Florentine baptistery (1403-24) were estimated by him to have cost 22,000 florins, with probably close to a quarter of the total going towards materials alone. To try to fix the equivalent in modern monetary value is a risky if not an impossible operation.[23] It is instructive to note, in comparison, that for his work on the entire Sistine Chapel ceiling Michelangelo almost a century later was paid somewhat less than a seventh, or 3,000 florins, of which approximately only one-thirtieth went for materials and plasterers' assistance.

Three thousand florins was the cost estimated by a modern scholar for the sculpture alone of the high altar of the Santo in Padua by Donatello; the entire sequence of choir frescoes in S. Maria Novella by Ghirlandaio (1486-90) cost only approximately a third of that sum. Castagno's equestrian figure of Niccolò da Tolentino in the Florentine Duomo, painted in 1456, is believed to have cost twenty-four florins; on the other hand, Donatello's bronze equestrian Gattamelata, finished only a few years before, has been estimated conservatively at 1,650 florins. Fra Angelico's monumental tabernacle of 1433 for the Guild of the Linaiuoli, even with its marble frame designed by Ghiberti, amounted to somewhat less than a quarter of the 945 odd florins allocated to design, materials, and casting of Ghiberti's bronze statue for the Cambio's niche on Or San Michele of some twenty years before.[24]

These examples could quite easily be extended. The essential point of the matter does not concern a philosophy of values; it simply reveals the plain fact that in relation to painting, sculpture of any quality in fifteenth-century Italy was most costly. A programme of great sculpture was not private, or even public, indulgence. It was by custom and necessity carefully planned. The details of each programme, beginning with the very materials of its making, were in themselves something of an economic event.

Artistic Geography: Location and Transport of Stone; Regional Zones and
Local Schools; Sculptors' Travels and Influence

From the point of view of availability of materials alone, particularly stone, it is possible
to establish a geography of style in Italy. There is hardly a province of Italy which does
not contain some type of stone, however poor, which can be used for carving. But the
range of quality is very broad. The Quattrocento saw the emergence and consolidation
of two main geographical patterns in the traffic of two types of stone for sculpture.

The first was connected with the quarries of white marble in the Apuan Alps on the
west coast just north of Pisa (see lower map on p. 16). This marble was by and large the
most sought-after, being cited by Alberti in *De Statua* as equal to Greek Parian marble.
The west coast Italian marble was quarried, as it is still today, from the peaks lying behind
and above Carrara, Pietrasanta, and Serravezza. The blocks were brought down to the
beaches for shipment by water. They could then be moved northward to Sarzana and
Genoa and thence overland, or by ship clear around the peninsula and up the Po
Valley to Milanese territory, where they gradually began to displace for fine sculpture
the local Lombard marbles from the areas of Como and Domodossola. Or, with Pisa
as another transhipping point, the Apuan marbles were sent by boat up the Arno to-
wards Florence, being transferred at Signa (where the river narrows to difficult rapids)
to ox-cart. Or thirdly, they could move southward to Rome, Naples, or Sicily by sea.

Along the Arno Valley, as in the earlier times of the Pisani, one finds a certain unity
of style along with the use of Apuan marble. Up the west coast from Piombino to
Sarzana there existed from 1450 until after 1500 a school of Apuan marble-carvers with
its own characteristics of style (Plate 109). To save shipping space and weight, it was the
custom up to about 1450 for Florentine sculptors to rough out their statues at the quarry
or to finish their sculpture at near-by Pisa, as in the well-known case of the Brancacci
Monument by Donatello and Michelozzo for S. Angelo a Nilo in Naples. Following the
travels of west coast marble were the sculptors who were trained to carve it: not only
Florentines but at least two generations of that prolific family of sculptors, the Gaggini
of Genoa, who can be traced precisely along the route of marble shipments, first in
Florence, then in Naples, and finally in Sicily (Plates 136 and 137).

This west coast pattern contrasts with a second very important traffic in sculptors'
stone (see upper map on p. 16). Pola was the chief dispersal point for a marble-like
stone, capable of a polished finish, but far more varied in texture and colour than the
Apuan white marble, ranging from a bluish white to a warm grey-pink, traversed like
the *craquelé* in porcelain by innumerable delicate black lines (Plate 44). This is the famous
sasso d'Istria quarried on the Istrian peninsula at the head of the Adriatic, called also, from
the best quarries, *pietra d'Orsera* and *pietra di Rovigno*. Shipments by water went as far
south on the east coast as Ancona and up the Po Valley as far as Ferrara, and even beyond
to Bergamo in transhipment. Along these routes are marked stylistic connexions which
include centres on the far side of the Adriatic at Zadar (Zara), Šibenik (Sebenico), and
Dubrovnik (Ragusa).

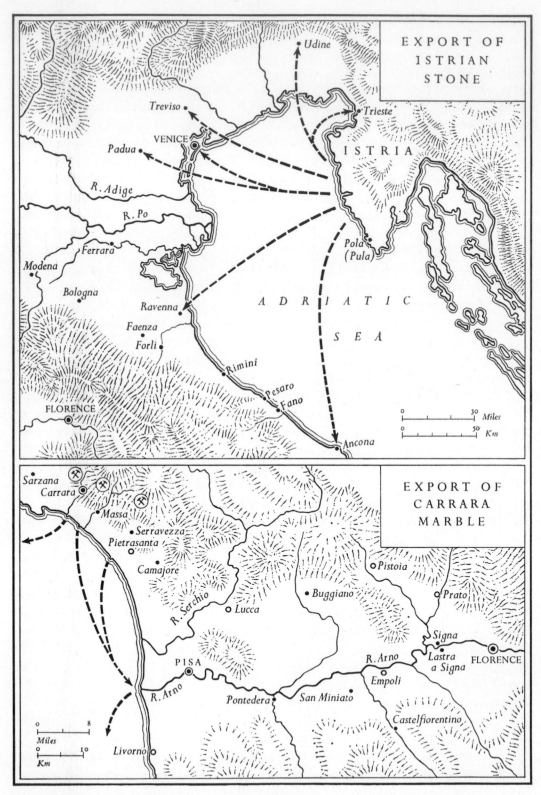

EXPORT OF
ISTRIAN
STONE

Udine

Treviso

VENICE

ISTRIA

Padua

R. Adige

R. Po

Ferrara

Modena

Bologna

Trieste

Pola
(Pula)

Ravenna

A D R I A T I C

Faenza

Forlì

S E A

Rimini

Pesaro

Fano

FLORENCE

0 30 Miles
0 50 Km

Ancona

EXPORT OF
CARRARA
MARBLE

Sarzana
Carrara

Massa

Serravezza

Pietrasanta

Pistoia

Camajore

Buggiano

Prato

R. Serchio

Lucca

Signa

Signa

Lastra
a Signa

FLORENCE

R. Arno

PISA

R. Arno

Empoli

0 8
Miles

Pontedera

San Miniato

0 10
Km

Livorno

Castelfiorentino

16

Apart from these two wide-ranging trade-patterns there were a number of more localized situations.[25] In the Po Valley there were the white and rosy marbles of Verona and the softer, coarse-grained limestone of Vicenza called *pietra di Nanto*. The lack of an outstanding local sculptors' stone in the province of Emilia, on the other hand, encouraged sculpture in terracotta and a modeller's rather than a carver's style. At Lucca, a hard, marble-like stone was extracted from the near-by Monte Pisano quarries and was used for sculpture (Plate 21B). Sandstone of varying types, known as *masegna* in Bologna and Venice and *macigno* in Florence, was used mostly for architectural ornament, but occasionally in independent reliefs. Of this type the cool grey *pietra serena* quarried in the hills near Fiesole, Maiano, and Settignano was the most prized. The practice of carving the stone near the quarries gave rise to local families of expert stoneworkers, and several well-known sculptors carry the names of those localities or of the stone itself (the dalle Masegne of Venice, Desiderio da Settignano, and Benedetto da Majano of Florence).

In Central Italy the local stone is travertine or better varieties of it, such as the *pietra caciolfa* of Perugia, a fairly fine-grained, grey-yellow stone, extremely easy to carve when newly quarried, but which hardens on contact with the air. Round Urbino the fine white to cream-coloured limestone, *pietra gentile*, was used for sculpture in the Abruzzi (quarried at both Aquila and Sulmona). Near Siena white marble was available, but of poorer quality by far than the Apuan variety (Plate 20). At Rimini and in Rome the lack of marble was partly supplied by imports, but far more frequent was the use of Antique marble facings taken directly from ancient Roman buildings or monuments in the city itself, or from a neighbouring source. A good example of such pilfering is the case of Sigismondo Malatesta's Tempio in Rimini, where the marble slabs for sculpture were taken from Early Christian monuments in Ravenna.

Other sculptors' materials, such as clay and bronze, were freer of the restrictions of local availability or expensive and often difficult transport. Stuccos were made of conglomerates of lime and pulverized stone, or marble, as a rule strengthened by tow or horse-hair. Clays for terracotta could apparently be found without difficulty as needed. The traffic in copper, tin, and lead, the chief ingredients of the alloy of bronze, is extremely difficult to trace. We know of imports from as far away as the Low Countries for structural bronze in the case of Ghiberti's second gates.[26] In fifteenth-century Italy there must have been a good deal of melting down of older objects locally for re-use of the metal. Not all bronze sculptors set up foundries for their own work: they made use instead of existing foundries for bells and other more utilitarian metal objects, as for example Donatello and probably Verrocchio. The location of workshops for small bronzes has been usually identified with a mere handful of centres, for the most part in North Italy, in Venice, Padua, and Mantua. But this can hardly be accurate; the working of small bronzes must have been more generally distributed and have included Rome, perhaps Naples, and almost certainly Milan, as well as the main Tuscan centres.

At all events the situation as regards the availability of stone for sculpture sketched above presents a closer relationship to the geography of style. There are two phenomena.

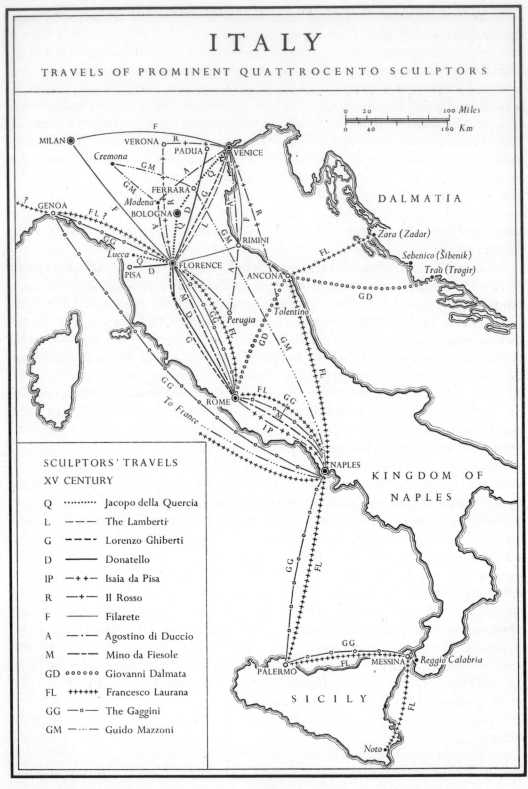

ITALY

TRAVELS OF PROMINENT QUATTROCENTO SCULPTORS

SCULPTORS' TRAVELS
XV CENTURY

Q	··········	Jacopo della Quercia
L	— —	The Lamberti
G	- - -	Lorenzo Ghiberti
D	———	Donatello
IP	—+ +—	Isaia da Pisa
R	—+—	Il Rosso
F	———	Filarete
A	—·—	Agostino di Duccio
M	- - -	Mino da Fiesole
GD	∘∘∘∘∘∘	Giovanni Dalmata
FL	++++++	Francesco Laurana
GG	—∘—	The Gaggini
GM	—·· —	Guido Mazzoni

One is a regional geography, corresponding to several zones with certain local characteristics (see the map on p. xxvi). The largest and most definite would be the North Italian zone centring on Lombardy and exerting influences on the Po Valley to the Venetian zone, to the Ligurian zone (Genoa), and to some extent of course on the cities of the Emilian plain, chief of which was Bologna. The Tuscan zone, including the territories of Florence and Siena, was separated by the Apennines from the Po Valley and developed a differentiated, vigorous, and influential school. Related to it was the school of the west coast area, already mentioned. Beyond the central mountain-spine, from Venice south down the Adriatic there was a narrow east coast zone in close relationship with the Dalmatian coast area, connected, by the straight Roman road running north-west from Rimini, with the Emilia and southern Lombardy. Central Italy and the adjoining Abruzzi to the south-east present a zone which is more a meeting place of influences than a major creative area. The same must be said of Rome, Naples, and Sicily.

This would lead us to a second artistic map which, rather than emphasizing 'schools' or 'zones' in a static situation, would instead indicate the factors of interchange of influences and of a dynamic tendency towards unity through the journeys and sojourns of individual artists and their corps of assistants. The Italian sculptor of the fifteenth century was likely to be mobile. He often moved from centre to centre as programmes of sculpture came into activity. These centres were primarily urban seats of culture. The map adjoining, which presents only a part of the movement of Italian sculptors over the peninsula between 1400 and 1500 (for lack of room to show more), reveals a fairly solid network following both sea routes and the main overland road system, which differs not at all from the medieval, or actually, the ancient Roman system. Centres along these roads naturally benefited from the passage of travelling artists, as in the case of Agostino di Duccio at Modena and of Mino da Fiesole at Siena and Volterra. Another map could show the movement of works of art carrying influences often from fairly distant points, from Florence to Naples, for example.

Thus emerges a double image. On the one hand there was a tendency towards the formation or prolongation of local 'schools', and on the other a counter-tendency towards unity through interchange and ceaseless movement from one centre to another. The centres, or nodes of activity, in either case emerge very clearly. In the mainstream of stylistic development the tendency towards unity was to become the stronger. But in this event, although much was gained from a European point of view, there was an undoubted loss in that lively variety and local vigour which characterized the fifteenth century in Italy and which can still be observed in surviving lesser modes of expression today.

Collaborative Programmes of the Late Trecento: Naples and Rome

Fifteenth-century Italian sculpture grew out of a vigorous movement in plastic art which had its rise in the 1380s. There is, as we have seen, a body of patterns of procedure and of influence, of programmes and types, of patronage and regional

characteristics, to be met with in a study of Quattrocento sculpture. All relate in greater or less degree to artistic events of the last two decades of the fourteenth century. For this development one should begin by looking at Italy as a whole rather than at Florence.

There is first to be admitted quite frankly a rather negative result. For the kingdom of Naples (together with Sicily, the largest geographical area by far of the Italian states) still under Angevin rule, the period just before 1400 can best be described as lethargic. Neapolitan sculpture of the Late Trecento by 1410 was nevertheless moving out of the doldrums of the older mixture of style provided by the Tuscan tradition of Tino di Camaino and echoes of the mid-fourteenth-century French court style. The presence of North Italian currents of style and 'foreign' sculptors, including Florentines, is attested in the early Quattrocento. But the change from the Trecento style in Naples was on the whole very slow in coming.[27]

In Rome, the long absence of the pope in Avignon over at last, there was still nothing that looked like a settled Curial establishment until after 1419/20, when Martin V set up his residence at the Lateran. For sculptors Rome was ceasing to be a place of famine, gradually providing commissions (typically funerary monuments) from about 1400 on. We find a trace of an early Paolo Romano active in the first quarter of the Quattrocento (not to be confused with the Paolo Taccone of the third quarter of the century). But in Rome also the elements of a true school of sculpture were slow to form.[28] The contrast with North Italy is striking.

Lombardy, 1380–1400: Peninsular 'International' Trends; Basis for a later Regional School

Lombardy under the Visconti dukes of Milan, the largest state of North Italy, had become by 1380 the most active Italian political power. Very much on the contemporary pattern of the duchy of Burgundy, just over the two main western passes of the Alps, the Milanese duchy indulged in conspicuous expenditure in an ornate court. It harboured an ambitious programme of expansion, aimed at nothing less than control of the entire peninsula. This was no paper scheme. By 1395 Milan had fought one inconclusive war with the republic of Florence, was preparing for another, and had already obtained the vassalage of Siena, Pisa, and Perugia in the strategic Central Italian area. Under Gian Galeazzo, who ruled from 1385 to 1402, the brilliant Visconti 'tyranny' began to single out ways of expressing its power and splendour in plastic art.

The outstanding ducal programme was the building of the Charterhouse, or Certosa, not far outside the city of Pavia. This, begun in 1396, was an interesting analogy to the dukes of Burgundy and their Chartreuse of Champmol just beyond the gates of Dijon, which had been founded in 1383. The Certosa of Pavia, like the Chartreuse of Champmol, was to be the monumental mausoleum of the dynasty. Its construction and sculptural decoration were to continue through the fifteenth well into the sixteenth century. The sculptural programme for the most part dates from the late years of the Quattrocento. Another project, more civic than dynastic in character, near the centre of the city of Milan, was the cathedral. This was to be rebuilt completely and was in-

tended to surpass in dimensions and richness of effect any Gothic cathedral that had been finished north of the Alps or in Spain. It was completed only in the nineteenth century.

The cathedral sculpture workshops opened in 1387 and became overnight a magnet for artists of notably varied media and geographic origins.[29] An extremely elaborate programme of sculpture, much, if not all of it, accented by gilt and bright colour, was to play a major role in the visual effects of both exterior and interior. This sculpture was marked by three characteristics. The first was a strong North European and late medieval flavour of style. The second was the subordination of sculptural design and emplacement to architecture. The third was domination of sculpture by the visual effects of goldsmith-work and painting, and specifically not so much of mural painting as of the small-scale luxury tradition of miniature book-illustration. Richness of effect and lightness of scale remain as more or less permanent features of Lombard sculpture all through the Quattrocento (Plate 130).

At Milan in the first period to about 1395 the 'foreigner' 'Pietro di Francia' and under him for a while 'Giovanni Faronech' (Hans von Farnech) were architects, engineers, and designers more than sculptors. Their schemes controlled such Lombards as Giovan-nino de' Grassi and Jacopo da Campione, both active as sculptors from the early 1390s until 1398. Of these two, the first was more notable as a naturalist, as a painter, and as an *enlumineur* of manuscripts.[30]

Quite evidently, the results of dual control depending so heavily on 'foreign' man-power were far from satisfactory. In 1396 a ducal decree went out to all magistrates of the Milanese state, instructing them to report the names and whereabouts of the sculptors known in their localities. Another wave of artists, more of them Italian, fol-lowed. By 1399/1400 the sculptors Filippo degli Organi from Modena and the dalle Masegne from Venice (very briefly in Milan) had come to work with such 'oltremon-tani' as 'Rolando da Banillia' (Roland de Banyuls?) and the more famous Jacques Coene, the miniaturist originating in Bruges, joined very little later by the sculptors Peter and Walter of Munich from South Germany. From Lombardy came the sculptors Matteo Raverti and Jacopino da Tradate (active from 1401), who were to remain as fairly permanent fixtures.[31] They worked on the interior decoration in high relief of the sacristies and on the sculptural decoration of the windows of the choir. The sculptural treatment of windows became a Lombard speciality. A forest of pinnacles was to receive free-standing statues. By 1400, on the rising buttresses, were already placed the earliest among the characteristic colossal and sometimes fantastical as well as realistic statues of atlantes, the '*giganti*' which support water-spouts and gargoyles (*doccioni*). Among the armoured knights (Plate 3) and heraldic wild-men was a protohumanist semi-nude Hercules, later to be joined by a series of decorous yet boldly designed *colossi* in the full nude *all'antica*.[32]

There was thus established in the heart of Lombardy a vigorous polyglot sculptural centre which soon came under the domination of Lombard stone sculptors. It was a focus for the so-called 'International Style' in Italy of 1400–25. For a considerable part of the fifteenth century thereafter it was an enclave of northern Late Gothic influences merging with peninsular trends. After the French invasions at the end of the fifteenth century

it was, as far as sculpture was immediately concerned, the major source of Italian influence on the rest of Europe.

Milanese conditions were at first very confused, virtually bordering on the chaotic. Nor were they such as to favour strong individual styles in sculpture. For one example, Raverti's finest statue for the cathedral was censured in 1404 for having departed from the design provided.[33] Nor was there produced immediately a strong area-style. Nevertheless, at Como, Pavia, and Bergamo there was by 1410 new sculptural activity. Of unquestionable durability were the habits of collaborative workshop production – the 'team' engulfing the 'individual', the 'master-design' controlling the craftsman's 'execution'. This pattern was to condition the major sculptural output of Lombardy, through the Amadeo, the Mantegazza, and the Rodari workshops, right up into the sixteenth century (Plates 130–2). It was to colour, through Lombard influence, the sculptural habits of southern France and much of Spain to 1550.

Lombard influences by 1390–1400 merged with Venetian and Florentine influences in the neighbouring area of the Emilia, whose chief city was Bologna. At this time the major programme in Bologna was the gigantic fabric of S. Petronio – a civic rather than an episcopal or ducal enterprise, planned on an even larger scale than Milan Cathedral. Here we find a meeting place for sculptors coming from centres both north and south of Bologna. On the base of the façade was begun a series of reliefs of demi-figures, continued under the windows of the nave in an original and striking way. We also find shortly before and shortly after 1400 the 'academic' type of tomb or funerary monument for professors of law for which the university in Bologna was famous. Among the sculptors of this period in Bologna may very well have been the Florentine known as Andrea da Fiesole.[34]

Venice, 1380–1410: Programmes and Patterns of Influence; the dalle Masegne

In 1382 the Venetians opened a campaign of decoration of the upper storey of the basilica of St Mark (façade and north flank), where the striking *doccioni*, or standing male water-spout figures, are related to the Milanese type.[35] In the 1380s work was also begun on the decoration of the present Doge's Palace. The original decoration of the huge central window (under construction in 1403) to the south on the Molo was related to the Milanese emphasis on plastic figural decoration for window design. The Milanese Raverti was later called (about 1420) with others from Milan to work on the Cà d'Oro, just as somewhat earlier the dalle Masegne had been attracted to Milan. But the style of Venetian sculpture is not to be confused with Lombard.

Although Venice was virtually as open through trade to influences from northern Europe, there was still a good deal left of the Byzantine tradition, and contacts with the east continued. Lingering also around the work he left in Venice there was something of the *gentilezza* of Nino Pisano, who with his assistants had carved the very beautiful Madonna with flanking figures of the Marco Corner Monument in SS. Giovanni e Paolo. Into this rather complex artistic ambient came an expression of the western

European naturalism of the last decades of the fourteenth century. It is to be found, mingled with some eastern deposits of subject matter, in what is left of the series of capitals carved for the lowest arcade of the Doge's Palace, in which a host of small-scale figurines appear in the fronds of richly carved foliage.[36] More prominently, at the two corners of the palace on the Molo front, just above the lowest arcade, are inserted two large groups in Istrian stone, the one to the east being the Drunkenness of Noah and the other on the Piazzetta representing the Temptation and the Fall.[37]

Well known in English letters since Ruskin's classic passage on them was published in *The Stones of Venice*, these reliefs unite a determined naturalism with a drive towards the expression of architectonic function. The corner-edge of the building is boldly replaced by a free-standing natural form, in one case a vine and in the other a vigorous fig tree. About these twisting axes, on either side, the figures take their places in a narrow and precarious space. Three of the figures are nudes or semi-nudes after nature rather than the Antique; with clear and controlled gesture, particularly of open hands, they act their roles frankly and directly. They call to mind Cocteau's phrase applying to Venice as a whole: '. . . il y a quelque chose de fou et de profondément honnête dans ce décor . . .'.

The dating of these reliefs and their authorship are still far from definite.[38] A related artist, or one quite close in style, was responsible for the probably slightly later allegorical image of 'Venetia', a naturalistically handled heraldic figure of charm and authority, placed within a roundel of the second-storey arcade nearly mid-way up the Piazzetta side of the palace. Whether in this work it is possible to identify the hand of Bartolommeo Buon or Giovanni Buon, known through documents as active from at least 1382, is uncertain. But it would seem beyond dispute that the Buon 'family style' emerged from this general ambient and continued to dominate a considerable segment of Venetian sculpture to about 1450 (see Plate 45, A and B).

On the mainland, close by at Padua, there was forming by 1400 a most important humanist centre, a counterpart at the very least to Florence. The small medals, virtually coins, made in the 1390s in Padua or Venice for the Carrara family, then tyrants of Padua, are among the earliest if not the earliest known revivals of Antique honorific coins.[39] From them in part derive the medals of the genre introduced by Pisanello in Ferrara and Mantua some forty years later (Plates 46A and 47A).

By 1400 influence from Venice was already expanding on the pattern to be found in much of the fifteenth century. This was to move down both coasts of the Adriatic, a Venetian *mare nostrum*. The penetration was as far south on the Dalmatian side as Zadar (Zara) and Dubrovnik (Ragusa), and on the Italian side as far as Ancona in the Marches, and ultimately from there still farther south into the Abruzzi, up the valleys from the east coast.[40]

The early Venetian export style was primarily that associated with the brothers Pierpaolo and Jacobello dalle Masegne. Trained, it would seem, in Venice, with a large debt to the tradition of Nino Pisano, they were deeply influenced by more recent trends from northern Europe. Active in Venice at various times to about 1410 (Pierpaolo, the elder, died there in or about 1403), they were prominent as a working tandem in

D

Bologna in the 1380s and briefly, as noted above, in 1399 in Milan. Pierpaolo worked for a short time alone in Mantua.

The style, or better styles, of the dalle Masegne cannot lightly be summarized.[41] The work of each brother has not been completely sorted out, and one is entitled to suspect assistants for their larger commissions. Their earliest documented work, of 1383, is the monument of Giovanni da Legnano originally in S. Domenico, Bologna, designed on a formula for tombs of legists or university teachers that was to last in Bologna and in Tuscany well beyond 1450. The monumental marble retable documented as by the dalle Masegne for the high altar of S. Francesco in Bologna is far more complex and less unified in style. It was begun by 1388, and is a mine of important experiments in movement and characterization.[42]

The space of sculpture was for the dalle Masegne always related to an architectural environment. But the drama their sculpture steadily presents is a search for expressive contact with the space of the natural world. A remarkably soft, atmospheric envelope overlays the landscape when it appears in relief form on the S. Francesco retable (Plate 1A). The statues of the Virgin, St John, and the Apostles on the iconostasis-like rood screen of St Mark's in Venice (inscribed with the names of both brothers and the date 1394) are harder and more metallic in style, perhaps better to harmonize with the central crucifix in silver which surmounts the row of carved figures. Severe in form and at times emotional in expression, the movement of the figures is a twist and counter-twist outward in space. They belong in the free space we associate with nature. Suggested deep within these figures is a wiry energy and something of an uncompromising independence.

The dalle Masegne 'severe style', whether actually theirs or an early reflection of it, is found quite early down the east coast at Pesaro and Fano. Later it appears on the west coast north of Pisa. It seems also shortly before to have penetrated central Tuscany from Bologna, to make an alliance with a well-founded metallic tradition in silver as well as with a trend in marble-working. The styles of Brunelleschi, as a silversmith and bronze-caster before 1405, and of Jacopo della Quercia, as a leading marble carver by 1405, can be understood only within the general context of the style the dalle Masegne helped to spread.

Tuscany, 1380–1400: Trends in Silver and Marble; the Workshops of Florence Cathedral

The last two decades of Tuscan Trecento sculpture are apt to present on first view very much the same apparently blind façade as does Late Trecento Tuscan painting in the somewhat cheerless genus, for example, of Niccolò di Pietro Gerini or Mariotto di Nardo. It may seem hard to find the individual that might really be an artist behind the outcroppings of competent but prosaic shopwork. One should try to push beyond this view, as has been done in studies of painting.

As regards sculpture, the period admittedly is by no means completely investigated. And the prospect for discoveries of quality is for Sienese sculpture in any case dimmer

than for Florentine. Little seems to have survived after 1350 from the brilliant and in-fluential Sienese school of marble sculpture of the first half of the Trecento. The revised enlarged remodelling of the Duomo in Siena was left in a state so incomplete that only one portal (to the east) was actually built; one can well ask who there might have been in Siena in 1385 able to carve sculpture worthy of it.[43] The programme of saints in marble decorating the piers of the outdoor chapel (Cappella del Campo) attached to the façade of the Palazzo Pubblico, begun in the 1370s, dragged on into the fifteenth century. Its sculpture, shared by several masters, is in overall view none too impressive – mannered and finicky, inverted towards the earlier Sienese linear tradition in painting. This stone-carving appears as a dying movement.[44]

In contrast there was in Siena what must be counted as a strong and lively continuity in the medieval tradition of gilt and painted devotional figures carved in wood, and for similar devotional and liturgical needs there was a continued activity among gold- and silversmiths.[45]

The line between work in precious metals and sculpture is particularly difficult to draw in Tuscany just before and just after 1400. In Florence, the Late Trecento font in the baptistery was, to be sure, carried out in marble; but the altar was conceived as com-pletely in silver and enamels, and was entrusted for its antependium and retable largely to the silversmith Leonardo di Ser Giovanni and his shop, over the years 1367 to 1387.[46] The earlier historiated reliefs provided an area for experiment between the eras of Andrea Pisano and the young Ghiberti. The miniature architectural settings house silver statuettes, some of which may well foreshadow certain possibilities of design later to appear in large-scale statuary.

The more venerable and even larger silver altar of St James in Pistoia Cathedral re-ceived important modifications and additions after 1381 and 1394. The fifteenth-century report by his biographer that Brunelleschi worked in this later campaign towards 1400 is borne out by documents and recent stylistic studies (Plate IB).[47]

Against these trends in small-scale figural art in silver stands the activity of stone-carvers in Florence, centring on the decoration of the cathedral, the leading large-scale programme of this period south of Bologna.

The sculptors attached to the Duomo worked on other programmes in Florence as well. Just finished before the period 1380–1400 was the enclosure of the arched openings of the guild church of Or San Michele, under the direction of the vigorous experi-menter Simone di Francesco Talenti (son and pupil of the Trecento architect of the Duomo). By 1380 the decoration of the well-known Loggia dei Signori (Loggia dei Lanzi) was beginning, adjacent to the Palazzo Vecchio. Talenti carved the corbels re-ceiving the vaulting ribs of the interior, revealing at a relatively early date the influence of Antique motifs in subject matter (powerful little herculean angels). On the exterior, at a lofty level between the openings of the arches on two sides, were placed during the 1380s a series of monumental high reliefs of the cardinal virtues, all in marble. They were after designs by the Florentine painter Agnolo Gaddi and were executed mainly by two Florentine sculptors prominent in this period, Giovanni d'Ambrogio and Jacopo di Piero Guidi.[48] *147, 175*

25

Giovanni d'Ambrogio was probably the elder, having matriculated as a master as early as 1366. His style is remarkably pure and balanced, already showing some influence from the Antique. Jacopo di Piero was closer to Talenti, wirier, more obvious in his search for vigour and expression. Contemporary with these two was the sculptor who originated in northern Europe, in Brabant or perhaps West Germany, who was called by the Italians Piero di Giovanni Tedesco; for some fifteen years he worked steadily as part of the Duomo group.[49]

As at Milan, designs for the statuary in Florence were provided in most cases by painters; the cathedral archives contain documents which record the frequent use of such designs in both the 1380s and 1390s. Painters were likewise employed to gild and probably paint important details of the statuary after carving. Somewhat on the order of the case of Milan, we find in the documents evidence of the arrival in 1386 of talent from beyond the Alps: for one, Piero di Giovanni Tedesco. After him in 1400–1 came the Lombardo–Venetian Urbano di Andrea, whose career in Florence was brief, and whose actual work still remains uncertain. The sculptors employed by the Florentine Operai were thus restricted to a few masters with presumably their own paid assistants – never more than three or four masters at a given moment. There resulted, unlike the situation at Milan, a small compact group working towards a general effect of unity of style, but with some opportunity to carry forward limited individual variations and some experiments.[50]

In the early 1380s a group of older sculptors was replaced by a new team of masters which included those listed above. Beginning in 1387, there was assigned a group of statuettes of the apostles, most if not all to the designs of painters and intended for the lateral embrasures of the main portal of the façade. This series is interesting not only for its research into variety of pose, but also because it represents a complete replacement of a similar first series for the main portal which had been finished barely a decade before, in 1377. It may be inferred that during the 1380s the Operai were inaugurating a consciously 'up-to-date' style for the sculptural decoration most in public view.

Beginning in 1383, a series of music-making angels was carved for the projecting arch over the main portal, allocated to the three of the masters named above as a group. Still another series was commissioned in 1390. This was of four larger, life-size figures of martyr-saints, each flanked by a pair of adoring angels placed in profile, which were set up by 1396 in four groups on either side of the main portal at the second level above the ground. Still largely extant, though scattered, it was shared by Piero di Giovanni Tedesco and Giovanni d'Ambrogio. Between 1396 and 1401 was commissioned and finished an ambitious series of over-life-size statues of the Church doctors for the façade, by Piero di Giovanni Tedesco and by a younger follower of Giovanni d'Ambrogio, Niccolò di Pietro Lamberti, whom we shall meet again very soon.

This dry and rather matter-of-fact catalogue of work commissioned and accomplished is necessary at this point. It provides the basis for several general conclusions, of which one is the prevalence in Florence of the series, frequently divided between two or more artists. One might think this would tend to produce a deadening uniformity of style. Precisely the opposite seems to have occurred. By 1385 individualized styles may

be discriminated with some ease in a given series of figures, and the individuality of hand and personality becomes more apparent in the 1390s. Secondly, in many cases the setting for the proto-Renaissance figures was a very much earlier Gothic niche, which might produce an effect of constraint or in some cases of a dramatic contest which has much to do with the artistic effect. Donatello was to meet situations of this sort in his famous campanile statues.

For the period from 1380 to 1400 in Florence the sculptural mass of the figure remains dense and solid, the silhouette relatively unbroken. But there is a stir of life rather than of decorative arabesque in the folds of drapery and in the forms of the body suggested beneath them, particularly in the work which can be ascribed to Giovanni d'Ambrogio. Remarkable is the apparent strength of a Tuscan norm of style, reinforced doubtless by designs provided by such painters as Agnolo Gaddi, which in a few years could assimilate the northern Gothic style brought to Florence towards 1385 by Piero di Giovanni Tedesco. One senses a discipline which sets limits to the suggestion of movement and characterization. But in several of the adoring angels of the martyr-saint series there is a completely unified and gentle upsurge of movement which expresses marvellously the difficult theme of adoration, as much in the schematic form of the total mass as in the telling imagery of physical type and gesture. An excellent example, though it should be placed higher for optimum viewing, is the angel-figure by Piero di Giovanni Tedesco now in the Metropolitan Museum of Art.

Pressing for attention now is the sculpture partly in relief, partly in the round, for the lateral portals of the nave of the Duomo. The older pair of portals nearest the façade to the west was begun on a scheme left by Arnolfo di Cambio and finished much later only after some important changes. From the point of view of the sculpture which ultimately found its way on to them, neither is sufficiently unified to throw much light on a general trend of primary interest to fifteenth-century art, though through increasingly sharpened study in recent years they are yielding valuable insights in detail. Of the pair to the east, known as the Porta dei Canonici and the Porta della Mandorla, the latter presents a far more consistent history over the crucial thirty years between 1391 and 1423.

There, if anywhere, it is possible to find a picture of a collaborative programme in sufficient detail to satisfy two major objectives of our inquiry. The first is to find some sense of the quality and nature of artistic aim in this period of significant stylistic change. The other is to allow a glimpse into the conjunction of two generations at work together in the decades immediately preceding and immediately following the year 1400. The younger was the remarkable generation of Jacopo della Quercia, whose name was invoked at the beginning of this Introduction.

PART TWO

CHAPTER 2

EMERGENCE OF PERSONALITIES AND PRINCIPLES, TUSCANY 1390–1410

THE decade 1390–1400 in Tuscany saw the effects in sculpture of what may legitimately be called the beginnings of a Roman revival which had appeared by 1385. On the other hand in the decade began the apogee in Tuscany of a Gothic wave, part of the vast European movement known as the International Style. Thereafter, little by little, and with ups and downs, the prestige of the Roman Antique began to reclaim the attention it had already begun to attract in the decade 1390–1400, and to retake the ground momentarily captured by the International Style. Greater emphasis than ever before was laid upon the discovery of formulas to present as public art ideas of human dignity and power through freedom – in other words, *virtù*. The movement might be called civic humanism.

It was first enunciated, it would seem, in Tuscany and specifically in Florence. But the ideal alone solved nothing and instead posed questions. How far was it feasible to retain the civilized grace, the *gentilezza*, of the Late Gothic? To what extent could the preliminary revival of the Antique of 1390 to 1400 be made to reflect the urgency of contemporary events and the immediacy of actual living? What metaphors of imagery could be devised to carry the heavy freight of new compound issues, such as community–individual, tradition–renovation? How, precisely, were the forms to embody this imagery to be conceived, to say nothing of their materialization in stone or bronze?

The answers to these questions, and to others like them, could not be found at once, and indeed the process of their modification and reframing from one generation to the next was to challenge the creative powers of the sculptors and to occupy the minds of patrons of sculpture in Italy during most of the fifteenth century. We know so little of the instinctive and conscious drives of the artists, or of the day-to-day, informal thought and discussion which may have been decisive, that we are in no position to generalize. The evidence from a number of different kinds and areas of documentation has been accumulating in barely sufficient quantity and quality to put forward some guide-lines, or some direction-posts. These indicate the general notions which follow.

Far from disappearing after 1400, the pattern of collaboration on large programmes centring upon the sculptural 'population' of architecture continued for a time more strongly than ever. Such programmes had a pronounced public and civic bearing, and they were shared by several sculptors at one time, each with his own shop of assistants.

29

The programmes of this sort, of which the Porta della Mandorla of the Florentine Duomo may be taken as a classic example for the beginning of the fifteenth century, may be thought of as a soil from which sprang increasingly individual shoots of style. Such collaborative programmes were not retardative or old-fashioned, though admittedly they were directed towards finishing up what the Trecento, in most cases, had started but not completed. They provided the training ground for such individualists as Brunelleschi, Nanni di Banco, and Donatello; for within the collaborative scheme was room for the individual. Beginning by 1390, and certainly in full evidence by 1400, was the tendency to liberate the individual sculptor and to give him the responsibility of carrying through his ideas personally, either more or less alone or at the head of a competent shop. For this trend, the competition and commissioning of the baptistery doors in Florence (1401–3), stressing as it did individual prowess, was an important index.

While that competition has symbolized for many historians the opening of an era, it is also legitimate to think of the contest as the climax to the lively preparatory movement occupying the decades between 1380 and 1400. The two surviving trial-pieces for the competition show contrasting approaches in style and spirit. In each piece it is possible to identify several strands, or directions, of style: both the grace and the realism which went to make up the Late Gothic International Style, and a revival and adaptation of motives taken from Roman or Greco-Roman Antique sources. In 1401 this kind of stylistic contrast and synthesis was new, but the elements were familiar. All three of those contrasting facets of style had appeared before 1400 in the Florentine or Venetian orbits, and had been given public expression in the workshops of the Florentine Duomo. The contrasts can be as startling to modern eyes as that illustrated on Plate 1. Here the gently naturalistic, almost lyrical expression and the soft atmospheric relief style of the S. Francesco Altar in Bologna of *c.* 1390 by the dalle Masegne may be compared with the violently naturalistic definition of appearance linked to emotion of the Prophets of *c.* 1400 on the Altar of St James at Pistoia which have been attributed to Brunelleschi. The third element, that of the Antique and its revival, both in form and spirit, was to appear by 1393 along with the lyrical element in the sculpture of the Porta della Mandorla.

The young lions of the new movement in Tuscany fell by birth-date into two groups. The first group, born about 1375, comprised Jacopo della Quercia (b. *c.* 1375) and his slightly younger contemporaries Filippo Brunelleschi (b. 1377) and Lorenzo Ghiberti (b. 1378). This was the generation of Leonardo Bruni, the great chancellor–humanist of Florence, of Poggio Bracciolini, humanist at the Curia in Rome, and of Vittorino da Feltre and Guarino Guarini, humanist lights maintained by Este patronage in North Italy. Of the same age, or very close to it, were the Florentine sculptors who came into prominence first in their generation, apparently completely trained in the Duomo programmes as stone-carvers: Niccolò di Pietro Lamberti and Lorenzo di Giovanni d'Ambrogio. Younger by about ten years, in other words at a mid-way point between the generation of 1375 and the next to follow, were Donatello and Nanni di Banco, whose names as sculptors appeared first on the Duomo rolls in 1406. We must assume that at that time they were both just coming of age and reaching their independence as individual masters.[1]

The drama of the period 1390–1410 was threefold. There was first the emergence of a number of strong personalities among the sculptors, and the first unfolding of an era so rich in talent that it still seems utterly astounding. There was secondly the interplay between several elements of style: the 'new' Late-Gothic International, the remains of Trecento Tuscan, and renewed interest in the Antique. There was finally the question of what the emerging new style should do, how it might function, as an expression of spirit and ideals and as an active force in the definition of image and form for public purposes.

The Porta della Mandorla: Younger Sculptors of the First Phase, 1391–7

The Porta della Mandorla of the Florentine Duomo provides the best way into some understanding of the formative phase of civic humanism in Tuscan sculpture. There is general agreement on the main lines of its chronology. This results basically in three phases, beginning with the year 1391 and ending finally in 1423. They can be most easily visualized with the aid of the diagram on p. 33 (Figure 1).[2]

The first phase, finished by 1397, included the lower portions, up to the springing of the arch and the two lower (bearded) prophets (Figure 1, A–E). The second campaign began in 1404, after an interruption perhaps connected with the war of 1400–2 between Florence and the Milanese under the Visconti. It was placed under the direction of Giovanni d'Ambrogio and was finished by 1409. It included the arch (Figure 1F) and the first unsuccessful versions of the two small statues of beardless young prophets flanking the gable (Figure 1G). Towards the end of the campaign, in 1409, it was decided to try out an Annunciation group on the ledge under the arch (Figure 1H). It seems to have been moved into place in 1414 but was certainly removed before 1489 (see p. 51), when the present mosaic was put up. This brings us to the third and final phase, begun in 1414 under the direction of Nanni di Banco. The main element is the great high-relief Assumption in the gable, which gives the portal its name because of the prominent almond-shaped glory or mandorla around the Virgin at the centre. It is documented as by Nanni di Banco and was in place in 1422, along with statues of beardless prophets (undocumented) and two low-relief heads of a prophet and prophetess documented as by Donatello (Figure 1, I–K). A Trecento statue of a prophet dredged up from the Opera reserves was placed on the crown of the gable in 1423. It need not concern us here, but there will be occasion later, in the next chapter, to return to Nanni's Assumption relief, which stands as one of the high-points of the decade 1410–20.

When finally assembled, the portal was nothing less than a sonorous hymn of superbly carved marble in praise of the Virgin of Florence, Our Lady of the Lily. But its music was in a mixed mode, hitherto unknown. References to the Virgin's purity are in the major compositions. These also played back into the medieval Florentine civic iconography: the Annunciation under the arch faced in the general direction of the famous miraculous image of the same subject enshrined a few hundred yards away to the north in the SS. Annunziata. The Assumption in the gable echoed the main subject of the verso of the great Trecento shrine by Orcagna in Or San Michele a few hundred

feet away to the south. A choir of angels, in hexagonal frames on the oblique re-
veals, were witnesses from Eternity. Old Testament prophets – small statues – provided
a historical foreshadowing of the new dispensation brought to the world through the
Virgin in the person of the teaching and suffering Christ. He was so represented in two
reliefs symbolically placed first at the centre of the lintel and then at the keystone of the
arch.

Then emerges the movement of a counter-theme. Mythical and heroic motifs deriv-
ing clearly from pagan, Antique, and non-theological virtues, the exploits of Hercules –
who is made to stand for the cardinal virtue of Fortitude as well as for *virtù* in general –
dominate the ornamental sections of the reveals, jambs, and lintel.[3] It is probable that
the unusual bear beside a tree in the right corner of the Assumption relief is a direct
reference to an Antique motif.[4]

For the campaign of 1391–7 the documents suggest a well defined picture of the
procedure followed in assigning and executing the sculpture. The sculptors were each
entrusted with assigned sections of marble, which they had to carve either personally or
with the help of their own assistants according to the direction of the *capomaestro* of the
cathedral fabric. In his hands was the design of the portal as a whole, which we may
suppose to be a detailed painter's drawing earlier agreed on by the Duomo authorities,
the Operai. It was his responsibility to see to it that the design was followed so closely
that the separate pieces of marble, when finished, fitted together truly. Arrangements
were business-like. For the decoration in relief of the jambs and the reveals, for example,
the sculptors were paid by the *braccio* (in Tuscany a unit of length of about 23 inches),
and they were expected to deliver to an agreed schedule.

In actuality the sculptors were human and remained, quite strikingly, individuals.
Delays occurred, and errors were made. The hexagonal angel-reliefs, five to each reveal
of the doorway, may be seen even today to have strayed out of line, and do not balance
one another precisely. It was necessary to order an extra bit of foliated decoration to fill
out the right jamb (Figure 1D). Greater or less discontinuities of form and style occur
regularly at the joints of the various sections. During the second campaign, in 1408,
one sculptor, Niccolò Lamberti, was reprimanded after complaint by the veteran
Giovanni d'Ambrogio, then in charge, for not following closely enough the master-
design, and was fined twenty-five florins (approximately a full three-months' wage)
until he made good his errors. Whether he did so is not apparent from the fragmentary
documentation. The incident reveals more than the existence of personal divergence. It
suggests a tension between an older authority and a growing, younger personality. The
complications attendant upon fitting together the work of so many different hands may
be sensed from our diagram, with attributions, of the sections of relief sculpture in the
doorway below the arch.

It must be stressed that at this date, a little before 1400, each sculptor retained an
individual way of treating identical types of motifs, whether figure, or ornament, or
relation of figure to ornament. The full, yet delicately modelled, well-proportioned
forms of Giovanni d'Ambrogio's angel-figures contrast with the coarser, more con-
torted forms of Jacopo di Piero Guidi. The rather drier and more linear style, with

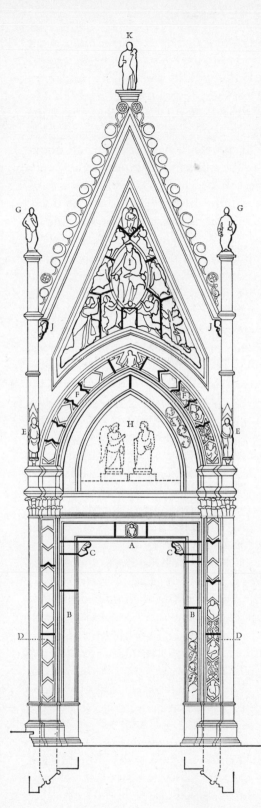

Figure 1. Florence, Duomo, Porta della Mandorla. Diagram of emplacement of sculpture and allocation of hands to various parts of the programme, 1391–1423

FIRST CAMPAIGN, 1391–7

A Lintel. Sections by Piero di Giovanni Tedesco and Lorenzo d'Ambrogio(?)

B Jambs. Left side: sections by Lorenzo di Giovanni d'Ambrogio(?) and one associate (Niccolò di Pietro Lamberti?). Right side: Piero di Giovanni Tedesco(?)

C Consoles. Left side: Giovanni d'Ambrogio. Right side: Piero di Giovanni Tedesco

D Reveals. Left side: sections here attributed to Niccolò di Pietro Lamberti, Piero di Giovanni Tedesco, and Lorenzo di Giovanni d'Ambrogio. Right side: sections here attributed to Giovanni d'Ambrogio and Jacopo di Piero Guidi

E Figures of Prophets in Tabernacles: Lorenzo di Giovanni d'Ambrogio

SECOND CAMPAIGN, 1404–9

F Arch reveals. Left side: Niccolò di Pietro Lamberti. Right side: Antonio and Nanni di Banco. Keystone: Donatello(?). (Uppermost sections of arch are modern replacements. Originals are in part preserved in the Museo dell'Opera del Duomo)

G Figures of young Prophets. Left side: Bernardo Ciuffagni. Right side: shop of Nanni di Banco

H Annunciation Group. Here attributed to Nanni di Banco. 1407–8(?). First discussion of placement under arch, 1409 (placed there, 1414). Removed before 1489 and replaced by mosaic to design of Domenico Ghirlandaio

THIRD CAMPAIGN, 1414–22

I Relief of the Assumption of the Virgin: Nanni di Banco and assistants (probably including Luca della Robbia). 1414–23. Finished after his death before 1423

J Heads of Prophet and Sibyl: Donatello. 1422

K Figure of Prophet: fourteenth-century statue owned by Opera in place by 1423 instead of St Stephen (or St Lawrence?) commissioned in 1422 of Ciuffagni but not executed

0 10 FEET

0 3 METRES

APPROXIMATE SCALE

33

flat-faced types, of Piero di Giovanni Tedesco may be traced in the mid-section of the left reveal of the doorway, and via the right corbel-figure into the right and centre sections of the lintel and the whole of the right jamb, with its slightly humorous little putti. One close associate must be supposed for part of Giovanni d'Ambrogio's share. Here we meet an attractive younger style which is well worth the trouble of isolating and identifying.

Who this associate may be is indicated by the prophets in tabernacles just above (Figure 1E). A comparison of these prophets with the uppermost left angel and a nude viol-playing ephebe standing in the acanthus scroll beneath, a composition of entrancing grace and charm, shows the same authorship for both. The prophets are documented as by Lorenzo di Giovanni, Giovanni d'Ambrogio's son, who became an independent master in 1396.

Brief as his career seems to have been (it was apparently cut off by untimely death in 1405), Lorenzo di Giovanni d'Ambrogio appears today as a figure of historical consequence. His documented key-figure of a prophet of 1396-7 is shown on Plate 2. It is relatively small, about one and one half *braccia* tall, but it possesses monumental scale. The stance subtly suggests movement, the weight balanced, *all'antica*, on the advancing left foot, the ever-so-slight twist of the body slipping under the heavy drapery towards a climax in the sharper turn of the well-modelled head with its intelligent, piercing gaze. Here is a more poised and more graceful expression of related tendencies to the north, which in the contemporary Apostles by the dalle Masegne in S. Marco in Venice come out in a relatively violent torsion of the head and body. The contrast with Milanese sculpture of about 1400 is even more dramatic (Plate 3). The pose of the two outstretched arms may recall Sluter's portentous Zachariah of the Chartreuse of Champmol; but whatever there may be of Sluter or the dalle Masegne here is tempered by a far gentler spirit and by a mind drawn towards intellectual principles underlying anatomical structure, smooth surfaces, clearly defining shadows, and accurate foreshortenings. These are major facets of Florentine style; the statue in question already prefigures the lyrical mood of a Desiderio or a Bernardo Rossellino.

In contrast to this suave and romanticizing style is a vigorous figurine of a Hercules placed in an acanthus scroll (Plate 4B) on the left reveal, fairly close to viewing level. This figure has long been known as a milestone for the study of the nude in the Early Renaissance. Its authorship has been a matter of doubt, but there is some reason to suppose that the responsible sculptor was the then young Niccolò di Pietro Lamberti.[5] Earlier critical literature had pictured Lamberti in the 1390s as an older man. This is hardly accurate. As we saw in the brief sketch of the *dramatis personae* given at the beginning of this chapter, he was born probably about 1375, a contemporary of Jacopo della Quercia, but two years older than Brunelleschi, whom he admired for a time, and only three years older than Ghiberti, whom he apparently did not. As far as we can tell, he was trained entirely in Florence under Giovanni d'Ambrogio and in 1393, the documented date for the section of relief sculpture in question, was at the beginning of a long and somewhat chequered career.

The first phase, then, of the Porta della Mandorla places in opposition the styles of

two generations active in Florence; and for the younger generation there seem to have been two divergent possibilities of direction. Elements related to the International Style of Lorenzo di Giovanni's manner foreshadow an aspect of marble style in later Florence: clarity of edge and surface, mingling of discipline and charm, a touch of melancholy. The young Lamberti proposed a sterner classicizing manner. About 1395 he presented a 'stoic' approach, whereas his contemporary Lorenzo di Giovanni might be said to adumbrate an 'epicurean' expression. To compare Lamberti's Hercules (*statua virile* in miniature) with a Roman prototype is not just to see a source of inspiration, but to sense a new type of formal environment and a whole new way of using that inspiration (Plate 4, A and B). The young Florentine artist of the 1390s is more rigorous in his presentation of structure than his Roman forebear. There is now a suggestion of geometric order, and the figure appears to emerge from, rather than to inhabit, the ornamental acanthus scroll. It presses insistently against an invisible surface-plane and seems on the verge of advancing from the intellectual realm of myth and the space of art into the world of actuality.

The date of this first portion of the Porta della Mandorla coincided exactly with a remarkable decade of early humanist enthusiasm in Florence which saw a revival of Greek, as much as of Latin, learning. This was associated with a renewed consciousness of the mission of a free and enlightened city-state formed on the ancient Attic model. The details of the drawing up of the portal's programme are lost; but some choices of imagery in the jambs and reveals, particularly the themes which derive in subject matter from the Hercules cycle, fit perfectly with what is known of humanist interests of the decade 1390–1400. They were merged at just this time with political issues of great moment and with a public function for sculpture, when the traditionally free republics of Tuscany were being threatened by the Visconti tyranny. It may well be that we have here one of the clearest contemporary manifestations in art of what has been termed the crisis of Early Renaissance ideas.[6]

Although as far as the styles of the sculpture are concerned the word crisis may seem too strong, it is reasonable to point out a striking mutation of values. The demonic is more than ever banished. The saintly and angelic makes room for a charming and as yet tentative expression of the heroic in a classical mould. Strong Hercules, confident in pose with the light rippling over well-formed muscles, as a symbol of *virtù* and its corollaries, Fortitude and the Active Life, is balanced by the image of a gentle, nude musician who could be made to stand, as Orpheus will not much later, for the life of contemplation. Thus becomes apparent the possibility of a new variety and eloquence. The philological approach of Boccaccio's Genealogy of the Gods shifts from words to visual forms. The imaginative re-creation of an heroic age leaves the scholar's study for the public square. In the hands of these sculptors the older romantic Petrarcan distance-view of the Antique seems to change to something like a familiar and ardent grasp.

The Competition for the Bronze Doors of the Baptistery of Florence, 1401–3; Emergence of Ghiberti and Brunelleschi

The sources supply the vivid word *combattimento* for the method selected to determine who was best fitted to receive the richest single plum of Florentine patronage in the opening years of the fifteenth century. The 'combat' or 'tournament' for the commission of the new bronze doors of the baptistery was announced during the winter of 1400–1, by the wealthy and politically powerful merchants' guild of the Calimala, patron-guild of the baptistery. The announcement came abruptly during a lull in the Florentine–Milanese war, after a summer marked by a serious outbreak of plague which in quasi-miraculous fashion saved the city from certain siege and probable capture. The announcement may have been prompted by recent progress on the Duomo programme of sculpture, particularly for the façade, under the patronage of the Arte della Lana; the two great rival guilds in Florence were engaged in something of a *combattimento* for prestige by way of great public art programmes.

The story of the competition for the great doors of bronze is perhaps the most familiar in all Early Renaissance art history. The quite unforeseen conclusion was to catapult the young Lorenzo Ghiberti, at the time of the announcement absent on a job of mural painting in Pesaro, into a position of virtually unequalled prominence.[7]

This is the proper time to introduce the career of Ghiberti, along with that of his lifelong rival, Filippo Brunelleschi. A novelist could hardly be expected to create out of purest literary imagination two more differing temperaments. Both men were almost exactly of the same age: but the advantage of birth and paternal upbringing lay clearly on Brunelleschi's side. Ghiberti was the son of a ne'er-do-well and was forced at the height of his fame to bring a case to law to establish his legitimacy. The shadow of financial and social insecurity fell across him early, and the solid bourgeois values of property ownership and of family succession appear to have dominated his mature point of view. Two self-portraits, one on the first doors and another on the second, of about twenty years later, give us his features at two quite different stages of his career. The first is tightly-modelled, polished, guarded, more a mask than a true portrait. The second is more relaxed, easy-going, the image of a successful man who can at last afford to be himself; it is suggestive of good humour, shrewdness, and tenacity. Brunelleschi's death-mask in the Opera del Duomo, which was used for his marble monument by Buggiano for the Duomo, suggests, in so far as such a macabre human document can, a generous, witty individualist, slight of stature and small-boned, full of energy and courage, hard on himself and, if one can judge from the anecdotes retailed by his biographer, by no means sparing of others.

Neither man started off in his ultimate vocation. Ghiberti, as indicated above, began as a painter; how successful he was it is impossible to say. Brunelleschi started, as we have also seen earlier, as a silversmith with evident talent for sculpture. His later career as an architect showed the most original mind of his times in a field in which originality is often most difficult to achieve. He is said to have been a close friend of the

mathematician–geographer Paolo Toscanelli, and is credited with the first practical solutions to the challenge of mathematical perspective in painting. He also appears to have gone fairly early, and more than once, to Rome, where he was reportedly tireless in studying and measuring Antique remains. He never stopped changing and developing in his ideas and capacity to create.[8]

In 1423 Ghiberti was relegated to a secondary place relative to Brunelleschi in the coveted job of building the great dome of the cathedral. But this setback was exceptional in a steady series of triumphs, leading from the baptistery competition of 1401–3 to the commission, uncontested, for the second doors in 1424, to statuary, reliquaries, cartoons for stained glass windows, and even a morse and tiara under papal patronage. Ghiberti became fascinated by the Antique, not theoretically and in a way platonically, as was Brunelleschi, but passionately and for its physical possession, as a collector in the manner of the bourgeois humanist Niccolò Niccoli, his acquaintance, or of another of his patrons, the humanist bourgeois Cosimo de' Medici. Ghiberti was not an intellectual, but he enjoyed linking himself with intellectuals, or with intellectual positions, and with learning. Such, certainly, is the impression created by his unfinished theoretical work, the *Commentarii*, which reveals him at his best when least theoretical and most personal, as in the Second Book, which includes his glowing account of his own achievement. This last is deceptively boastful in tone. Its factual basis is much higher than might seem possible. When he wrote towards the end of his life that there was 'little of quality' done in Florence in his lifetime that he did not 'have a hand in designing', Ghiberti was not far from a general truth. There was indeed not a great deal which his influence, either at second or third hand, if not at first, did not touch, over a period of some thirty years.

All of this was still latent when, hearing in 1401 at Pesaro of the Calimala's announcement, Ghiberti rushed back, as he tells us in the autobiographical portion of the *Commentarii*, to enter the competition for the baptistery doors. After a preliminary sifting of the entrants, on whom we have no information beyond Ghiberti's considerably later statement that they came from 'all the lands of Italy', seven contestants were chosen. These were, in addition to Brunelleschi and Ghiberti, Niccolò Lamberti (as we have seen, an active and not 'unprogressive' marble sculptor in Florence for a decade previous), Niccolò di Luca Spinelli (from Arezzo, brother of the painter better known as Spinello Aretino, and a known sculptor himself in terracotta and marble, probably with goldsmith training), Simone da Colle (from the point of view of art history a wraith, presumably born on Florentine territory, but known only as a bronzefounder), and finally, Jacopo della Quercia and Francesco di Valdambrino, Sienese stone and wood carvers whose work will be considered shortly. However diverse these contestants may have been in age and temperament, they all were from Tuscany.

The subject given was The Sacrifice of Isaac. This theme demanded an unusual variety of human types and of animals, rocks, and plants; it had the elements of a really searching test of ability in representation. But it may also have been because of its symbolism (the salvation of a chosen people as much as of an individual) and because, after all, it was a strikingly dramatic and complex action that this particular subject

was chosen. Each artist was required to enclose his composition in a quatrefoil frame of prescribed pattern and dimensions. The jury numbered no less than thirty-four, and it included painters, marble carvers, and goldsmiths from Florence and several other un-specified Italian centres.

A judgement was reached in due course, but not, it seems plain, without a bitterly disputed decision between the two finalists. The air of Florence was characterized nearly twenty years after as still 'bilious' from partisan recriminations. Only late in 1402 or early in 1403 was the commission at last entrusted by the consuls of the Calimala to Ghiberti. This action was accompanied by an unusual procedure whereby the guild, probably as a measure of precaution against future criticism, asked the jury for their opinions in writing. One would give a great deal to be able to read those opinions, but they seem to have been lost long since, along with all but two of the competition pieces.[9]

In his *Second Commentary*, Ghiberti wrote of the competition of 1401 as a 'demon-stration of many aspects of the art of figural sculpture (dimonstratione di gran parte dell'arte statuaria)'. The demonstration was partly purely technical. Who of the con-testants could best design, model, and cast a complicated composition in bronze? But more importantly on trial were a number of different personal styles. The effect of Ghiberti's triumph was to place him in a key-position of influence on his own generation and the one succeeding it. It sent Brunelleschi into architecture, doubtless his true vo-cation in any event, and Quercia into his itinerant career, troubled by an ideal of form which no programme available to him could ever quite satisfy. If either of these last two men had won, instead of Ghiberti, the history of Italian Quattrocento art would have to be rewritten with truly fundamental changes.

It is important to realize that the issue to be decided between Brunelleschi and Ghiberti was not the cliché of conservatism versus the *avant garde*. Both artists were still young, under twenty-five. Both knew as much as the artists of the Porta della Mandorla of the Antique, and were cleverer than they in finding ways to adapt the Antique to 'modern' uses. Both were in touch with the larger currents outside Florence to the north which are recognized now as manifestations of the early-fifteenth-century Inter-national Style. Despite this common ground, the two trial pieces of the finalists, very fortunately preserved side by side today in the Bargello, show fundamental differences.

Brunelleschi (Plate 6B) stressed a rigorous, planar composition in which he may well have been encouraged by the earlier architectonic style of Niccolò Lamberti on the Porta della Mandorla before 1397, although he had already indicated his solution in his own preceding work at Pistoia (Plate 1B). The figures and elements of landscape in the central area are sharply separated and are presented to the observer with emphasis on the profile. All elements, except for the forms in the lower right and left, tend to press up against a single imaginary plane. Playing against this convention is a realistically active, at times seemingly hyperthyroid, presentation of the subject matter, in which some motifs from the Antique are incorporated in 'modern dress', for one the Spinario-like servant at the lower left. All this intense action is held in breathless check by the geo-metry of the diagonals, triangles, and axes suggested by the complicated Gothic ground

and frame. This consisted of a lozenge intersected by four secondary circles (see Figure 2). The geometric schema appears to have affected deeply the building up from the ground of the wax model preliminary to the casting. It controlled the placement of figures and secondary elements of subject matter, formed into a firm and extraordinarily taut structure, as if under tremendous tensile pressure and strain. It reinforced an abstract quality in the space and carried through to the finish an insurance of order.

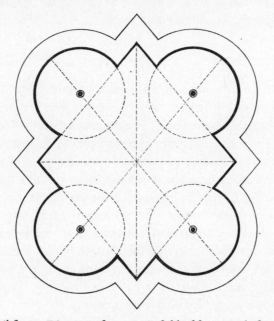

Figure 2. Quatrefoil frame. Diagram of geometric field of forces. Relief unit for competition of 1401 and for Ghiberti's first doors of the baptistery of Florence

Ghiberti (Plate 6A) may well have begun his composition with somewhat the same sense of the geometric nature of the frame and ground. But in modelling up the forms into light and space he reached other conclusions. The masses are contained more loosely in a decidedly thicker spatial envelope which has a connexion with the 'painterly' atmospheric style of the dalle Masegne at Bologna (Plate 1A). They twist gracefully, in such a way as to weave a kind of overlay of swinging linear rhythms upon the geometric armature. The mood is far gentler than Brunelleschi's. In classical dramatic terms, it represents a pause in the strophe rather than an arrest of action at the crisis. There is an echo of Lorenzo di Giovanni's lyrical linear sweep, and the delicate little nude of the boy Isaac recalls certain of the figurines *all'antica* of the reveals and jambs of the left side of the Porta della Mandorla in its first phase before 1397. But the psychological drama expressed in the turn of body and head, the suggestion of a touchingly mute and child-like heroism in the face of inexplicable doom move far beyond the expressive vocabulary of that portal.

Brunelleschi proposed a stark, stoic interpretation, more obviously in key with the mood of a republic fighting in 1401 for its existence against the Milanese threat.

Ghiberti's solution was psychologically less obvious as well as formally more elegant. Spatially, it had less to do with an architectural function. It is quite possible, as has been suggested, that Ghiberti's trial piece won not only because of its technical excellence and economy of materials (the section of his cast had been found to be noticeably thinner than Brunelleschi's) but also because of its graceful bow to the International Style. The appeal of that fashion to the leaders of the Florence of the relatively aristocratic Albizzi oligarchy about 1400, as well as to the internationally oriented Calimala, must be cited as a factor in Ghiberti's victory.[10]

Ghiberti's First Bronze Doors: Development in Style; Early Influence

The subject matter of the first doors of the baptistery is the New Testament. According to plan, determined probably before 1403, the doors were to be placed on the east front of the baptistery, rather than as at present on the north side. Each valve was to contain ten narrative scenes (*istorie*) in five registers, as shown in the table adjacent. Each of these scenes was to be framed within the same type of quatrefoil frame and of the same dimensions (about one *braccio* across) as in the trial pieces (see Plate 7A). These quatrefoils were in turn to be enclosed in each of the rectangular openings of the lattice-like framework. A Late Gothic type of frieze of naturalistic leafy ornament with small animals and reptiles playing in the fronds was to cover the front of these rectangular framing elements. At the corners of the squares of the frame was placed a small quatrefoil from which emerged a classicizing motive of the head of a prophet or prophetess.

When closed, the valves presented twenty scenes of the New Testament beginning with the Annunciation at the lower left and ending with the Pentecost at the upper right. One reads these scenes from the bottom row up and right across both valves from left to right. Below the Gospel scenes, as a kind of plinth, a row of the Four Evangelists and another row of the Four Church Doctors were to echo the subjects planned for the façade of the Duomo directly opposite. The parts emerging in relief (decorative heads, friezes, figures, and architectural settings) were finished in massy gilt. The remainder, including the inorganic elements of landscape, was left in contrasting silky, brown–black bronze. The very successful cleaning of the doors after the Second World War has dramatically revealed the exceptional brilliance and richness of their intended effect.[11]

Save for greater complexity of the overall view, gained through higher relief and more elaborate plasticity, Ghiberti's first doors with their quatrefoil frames repeat the format of Andrea Pisano's doors which had stood for approximately seventy years before 1401 on the south side of the baptistery. This conservatism of schema should not conceal the originality of Ghiberti's own approach, both as to imagery and composition in relief.

To carry out so intricate a programme, with some interruption from other commissions, required a full twenty years, beginning in 1404. A first phase ended with a short intermission and a new contract in 1407. Then in groups of four or five the remainder of the reliefs seem to have been modelled and cast. One phase appears to have

XVII *Procession to Calvary*	XVIII *Crucifixion*	XIX *Resurrection*	XX *Pentecost*
XIII *Agony in the Garden*	XIV *Betrayal at Gethsemane*	XV *Flagellation*	XVI *Christ before Pilate*
IX *Transfiguration*	X *Raising of Lazarus*	XI *Entrance into Jerusalem*	XII *Last Supper*
V *Baptism*	VI *Temptation*	VII *Expulsion of the Money Lenders*	VIII *Christ at the Sea of Galilee*
I *Annunciation*	II *Nativity*	III *Adoration of the Magi*	IV *Christ in the Temple*
A *St John*	B *St Matthew*	C *St Luke*	D *St Mark*
E *St Ambrose*	F *St Jerome*	G *St Gregory*	H *St Augustine*

Table 1. Ghiberti's first bronze doors, 1404–24 :
arrangement of subjects

covered the years 1407 to 1413, the next those from about 1414 to 1416 (when Ghiberti is thought to have made a trip to Rome), the last from about 1416 to 1419 or 1420. Five years between 1419 and 1424 must be estimated as a minimum for casting the great lattice-frame and for a considerable amount of additional work. This included inserting the reliefs into the frame and solidifying them into place by refiring; applying the back with its fine lions' heads *all'antica*; modelling and casting the majority of the small heads of prophets and prophetesses; and finally the all important and time-consuming chasing and the gilding of the reliefs.[12]

All this was done in Ghiberti's own shop and with the aid of a steady flow of assistants. These included, as we shall see, for a period between 1404 and 1407, Donatello, and for a few years later, the young Paolo Uccello.[13] The foundry established for the doors must have become a technical centre of the first importance for bronzecasting in Florence. The long process which the making of the doors entailed was a dominant factor in the developments of the first quarter of the fifteenth century both in sculpture and painting.

For Ghiberti, as much as for his assistants, the doors were a school. The earliest phase, before 1407, already shows some adaptation to the demands of monumental relief. But in one of the most interesting of the reliefs to be dated before 1410, the Adoration of the Magi (Plate 7A), there is quite definite evidence of a decision to simplify the exuberance of detail of the trial piece, and at the same time to retain a chain-like sequence of curvilinear rhythms. These sequences are more than graceful festoons; they guide the eye on regulated journeys. And as the eye travels, the mind becomes conscious of an equivalent of the lapse of time, moment by moment, and something akin to the scansion of poetic verse. One consequently feels the solemnity of the moment in this relief as depicted as part of the flow of time received as a measure of the emotion. Already too there is evidence of grappling with the problem of space. This meant, in its simplest terms, providing a spatial ambient sufficiently large and natural to be suitable for an *istoria*, and yet at the same time sufficiently restricted to be in harmony with the abstract and ornamental character of the monumental frame and ground.

The concept of space which results from this double pull is complex and admittedly ambiguous. It is difficult for us today to see it as fully comparable to painting, even though Ghiberti in his first doors is believed to have drawn on some compositional solutions in paintings and enamels. The figurines of his foregrounds tend to come out strongly and purposively into the observer's space; the confining front plane of a painting simply does not exist. At the same time there is no real relation in imagery with anything that could be called a convincing projection of space at the back of the frame, and only in the very latest reliefs (probably after 1415) is there an approach to a solid logic of constructed space. We are faced less with 'relief' than with an abstract ground-plan against which emerge and sink back in greater or less mass and complexity of pose and suggested movement a vivid equivalent of humanity in miniature.

In the placement and choice of pose of the figures, a field of forces set up by the geometric structure of the lobed frame is felt steadily, as in Brunelleschi's trial-piece, as a guide in composition. It is worth while here to pause and recognize the possibility that

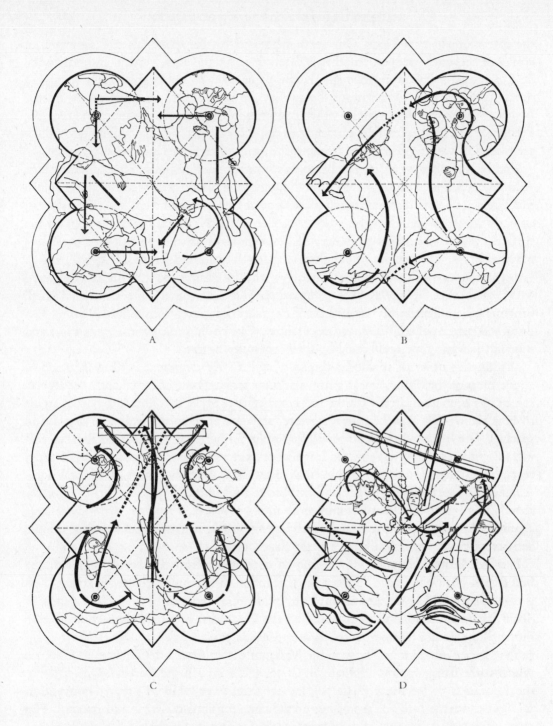

Figure 3. Lorenzo Ghiberti: First bronze doors, early reliefs, c. 1404–16. *Florence, Baptistery*

Schemas of composition

A Nativity, *c.* 1404–7 C Crucifixion, *c.* 1407–13
B Temptation, *c.* 1407–13 D Christ in the Storm, *c.* 1414–16

the forces are of two kinds. One set is suggested by the diagonals and segments of circles of the frame proper. Another is determined by the axes, vertical and horizontal (and diagonal), extending through the field enclosed by the frame. Of importance naturally is the nodal juncture of the axes at the centre. Only a little less so are the points at the centre of the circles which comprise in their outer segments the lobes (see Figure 3). The principle of design demands respect for a geometric ground on to which are placed in varying degrees of freedom the graceful figurines in three dimensions.

The variety of expression available to this system of designing is extraordinarily rich. Admittedly schemata can do very little to suggest the plastic reality of sculpture. But in this case the lines of movement and placement of figures may be charted (Figure 3). In an early relief, presumably of before 1410, such as the Nativity, the eye is kept on the surface and led around the periphery of the scene as is usual in painting of the International Style. The conflict of stability (in the well-anchored figure of Christ, close to the centre of one of the circles of the lobes) with instability (contrasting placement of Satan) establishes the *istoria* of the Temptation. The Crucifixion is a perfectly balanced, ornamental, and unearthly equivalent of dogmatic certainty. Christ in the Storm is a disturbed pattern of confusion and uncertainty. One could multiply these examples and remain for some time spellbound by their ingenuity alone.

Within this unity of method a thread of stylistic development is clear. A phase of about 1410 of maximum linear grace, willowy proportions, and swaying movement, which has been associated with the full International Style, is followed by what seems to be a clearly-felt impulse towards greater stability of mass and clarity of interval in spacing. The latest reliefs, in all probability after Ghiberti's first presumed Roman visit in 1416, such as the Arrest and the Flagellation, stress firm horizontal floor-bases and a rectangular schema of design within and against the quatrefoil (Figure 4). In the Flagellation the opportunity to isolate and emphasize the central figure of Christ is eagerly seized. The figure of Christ becomes an example of *statua*. It is given a grandiose scale against columnar architecture, and a striking dignity in its pathos between the double activity of the symmetrical figures of the flagellants.

It is interesting that most of the known derivations from Ghiberti's reliefs of the first doors, beginning from roughly 1415, abandon the complex quatrefoil frame. This is true of such widely diffused examples of influence as those to be found in Valencia in Spain (alabaster reliefs in the cathedral by the Florentine expatriate known as Julia lo Florenti), in Venice (main arch reliefs of the façade of St Mark's by the Lamberti), and in the series of stone reliefs now in the Museum of the Opera del Duomo in Florence which come from a pulpit originally in Castel del Sangro in the Abruzzi. One of these, the Adoration of the Magi (Plate 7B), loosely takes over Ghiberti's spatial convention without the same force of modelling or the same tensions of frame and ground. The transposition fails, but the failure is most instructive in what it reveals of the subtlety of Ghiberti's conception of surface–frame relationship before 1410. Attentive adaptation of the compositions of a number of the reliefs and some of the Evangelists and Church Doctors was made by the goldsmith Niccolò di Guardiagrele, a major channel of influence from Ghiberti's shop beyond Rome, deep into the Abruzzi (altar frontal,

Teramo).[14] Closer to Florence, the Sienese goldsmith–bronzeworker Giovanni Turini, as will appear later in connexion with the font of the Sienese baptistery, was by 1424/7 already beginning to borrow quite unashamedly individual motifs which he worked into his compositions.

We may conclude therefore that there were several directions and kinds of influence from Ghiberti's first doors. On the one hand there was a receptive area in allied gold-smith-work and small-scale bronze relief; on the other, there was a possibility, partially sensed rather than successfully developed, of adaptation to more monumental stone. Well before they were finished, the first doors exerted influence outside Florence and at great distance, and a direct continuation is observable until about the middle of the century (cf. Plate 7A and Plate 40).

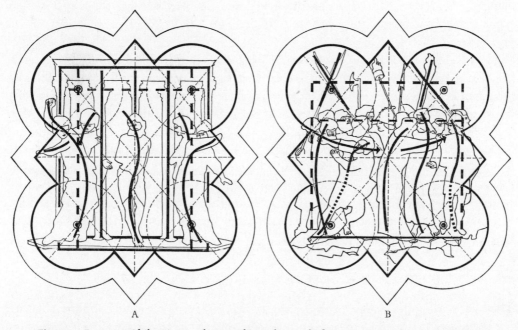

A B

Figure 4. Lorenzo Ghiberti: First bronze doors, later reliefs, *c.* 1416–19. *Florence, Baptistery*

Schemas of composition

A Flagellation B Arrest of Christ

Ghiberti's first doors open upon two perspectives of historical interpretation. There has been a growing tendency to consider them as an integral part of the International Style, virtually an extension of North European Late Gothic, a position reinforced by the artist's admiration for the mysterious 'Master Gusmin from Cologne'. Even the ambiguities of space-composition are cited to support this classification. This view has sound reasons behind it, particularly as regards the earliest reliefs.

But it is possible also to look on the doors as standing in essential ways outside and beyond the International Style, particularly in its northern courtly aspects. It is possible that something of the qualities of the later reliefs is present in a less obvious way in the earlier compositions before 1415; and it is also possible that Ghiberti saw in his 'Master

Gusmin' more than the pattern model of a northern court artist. In a striking psychological transfer to his own situation, Ghiberti described Master Gusmin in his *Commentarii* as both a respectable, religiously-minded man and an independent, as a sympathetic teacher of a younger generation of artists and as a master with a definite personal style, in certain respects (heads and nude portions of figures) 'equal to the ancient Greek sculptors'. This is a rather good description of Ghiberti himself. Furthermore, in the process of designing his reliefs, Ghiberti seems to have followed more rigorous geometric principles than is usual for the International Style of about 1400. He also appears to have begun to use, consciously and quite early, a geometric schema to bring out some of the immediate dramatic and affective impact of '*istorie*', which were later to be defined by Alberti in connexion with painting. To describe his method and the principles underlying his work on the first doors Ghiberti recalled them in his *Commentarii* with the terms 'ingegno' and 'disciplina' – bywords of Renaissance artistic vocabulary.

The result, as we see it on the doors themselves, is not the International Style of the Limbourg Brothers with their meandering and timeless pageantry involving nameless picturesque personages against a background of the *pourtraicture* of a real and still identifiable château (the calendar of the *Très Riches Heures* at Chantilly). With Ghiberti these terms of figure and ground are precisely and perhaps consciously reversed. Against a background which is now uncertain and unknowable, we see in the foreground the emergence of a *mimesis* of the action and interaction of the human will and passions. Bound into an expression of flowing yet purposeful movement in the figures is a sense of the passage and urgency of time, still somewhat abstract perhaps, but already beginning to suggest historical time, the medium for human experience as the Renaissance was to ponder its meaning and worth.

Early Tuscan Statuary: First Known Phase of Jacopo della Quercia

The relationship of the Late Gothic International Style to Tuscan developments during the decade 1400–10 has a bearing on the beginnings of Ghiberti's close contemporary, the Sienese Jacopo della Quercia. Like Ghiberti, Quercia appears to have instinctively pushed beyond the gracefully decorative or realistically genre-like aspects of the northern court style to expression of meanings of greater depth and broader human application. Unlike Ghiberti, Quercia's genius was for carving in stone, marble, or wood rather than work in metal. Perhaps this technical bent was not a minor factor in his defeat in the competition for the baptistery doors.

We know practically nothing of Jacopo della Quercia as a person. There is no sure birth-date, and there is (*pace* Vasari) no sure portrait. Of his private life there is on record not a shred of more than an incident or two, and even these must be largely reconstructed from circumstantial evidence. His cognomen 'della Quercia', meaning oak-tree, possibly derives from the *contrada* or urban subdivision of that title in Siena, where his grandfather, Angelo di Guarniero, came from. It was in Siena too that Jacopo, probably like his father Piero d'Angelo, grew up.[15] The documents available indicate

that he was a man of authority. He was not loath to take on responsibilities, and he certainly was not one to shrink from the most ambitious tasks or difficult challenges. He was eager, it would seem, for both achievement and novelty and had trouble in finishing his work, often allowing several sizeable jobs to run on at one time. The bare facts of his travels between Siena, Lucca, and Bologna in a fairly steady succession may indicate what one feels from studying his work: that is, that he was restless and difficult to satisfy. He seems to have strained towards the expression of ever more powerful themes cast on an increasingly heroic scale.

There are three principal phases of Quercia's life-work. The first, up to about 1410, will be treated in this chapter. The middle phase, revolving largely around the commission of the Fonte Gaia, the most prominent single sculptural monument in Siena, continued to about 1420. Then from 1420 to his death in 1438, within the focus of his activity principally on the sculpture for the façade of S. Petronio in Bologna, he experienced a last, still extraordinarily creative and impressive phase. These last two periods we shall treat in context with the programmes which they embraced, or related to, in successive chapters following this one. It is necessary now to consider the early development of his style.

The destruction of Jacopo's trial-piece for the baptistery doors has meant an irretrievable loss. Vasari's laudatory but on the whole very shaky account of the career of the sculptor mentions before 1400 an *ad hoc* temporary equestrian funerary monument in Siena of inexpensive perishable materials.[16] Of this there now is no trace. We are left with the uncomfortable feeling that we can look today at no securely documented work from Quercia's hand before 1408. Nevertheless older arguments about the date or attribution of the monument of Ilaria del Carretto Guinigi in Lucca (Plate 9A) have died down, so that there is general agreement as to what Quercia's style was about his thirtieth year, or about 1406, which the circumstantial evidence for the dating of the Ilaria Monument provides.

There has been no lack of scholarly effort in trying to fill in the missing early period with attributions of varying degrees of persuasive power. These relate to supposed activity not only in Siena, but in Lucca, Florence, Bologna, and Venice. A standing Madonna in Siena Cathedral and a Madonna of Humility in the National Gallery of Art in Washington may represent his earliest extant work in marble.[17] In 1391, following the Milanese-inspired Malvito uprising in Siena, he may have left that city for a few years. His painter–carver father, Piero, at all events is known to have left Siena for Lucca in 1394. There Jacopo was to be found again in residence with his Sienese assistant and partner, Francesco di Valdambrino, in 1405–6, which is the likely date for the Ilaria Guinigi Monument (Plates 9, A and B, and 10, A and B).

The evidence for Quercia's early style which may be derived from a study of the effigy of Ilaria is intriguing. It points not only to long practice in working marble but also, to judge from the handling of surface effects and subtly modulated shadows, to some experience in painting and carving in wood. There is a suggestion of first-hand contact with Milanese or Venetian style of about 1400.

The virtually contemporary Madonna and Child of 1407/8 at Ferrara (Plate 8),

traditionally given to Quercia and generally accepted as his today, indicates still another source of style. This figure is less painterly and more plastic. In its full, yet lively, forms and in its effect of a fresh naturalness mingled with a solid monumentality, the Ferrara Madonna relates in a striking way to the dalle Masegne altarpiece in S. Francesco at Bologna (cf. Plate 5B). The Angel of the Annunciation seems so close to Quercia's style that it seems possible he actually worked on it. It is likely that this first contact with the dalle Masegne in Bologna came very early, i.e., after 1391 and before 1397, particularly since the two likeliest candidates for attribution to his hand as a young man, both likewise in marble, evoke the Masegnesque style in Bologna as much as purer Sienese traditions. An early journey out of Italy to France is far more hypothetical; but given the strong 'international' ties of Lucca with the territories bordering the western Mediterranean about 1400, it should not be entirely ruled out. At this present stage of Quercia scholarship one can probably do no better than to keep open the possibility of a most varied kind of training and early career.

For the period 1400–10 in Italy, which we are now examining, the Ilaria Monument is absolutely capital. What we can see today, however, in the cold and dimly-lit north transept of Lucca Cathedral, is in reality no more than a suggestive ghost of the elaborate monument as conceived. This is to be thought of as installed under a splendid canopy, the whole glowing with accents of gilt and colour and set off like a jewel in the narrow, enclosing space of the candle-lit Guinigi Chapel in the cathedral nave.

The date of the monument seems most reasonably to be set in the year immediately following the untimely death after childbirth (December 1405) of the first, and much beloved, wife of Paolo Guinigi, then lordly and wealthy master of the city–state of Lucca. The scheme of the monument with its recumbent effigy, and with a naturalistic dog at the feet as a symbol of fidelity, is more French than Italian. But there exists no effigy in France, even by a Sluter, which conveys so eloquently the facts of death calmly accepted and nobly transcended. The total quiet, stressed by the long, unbroken line of drapery from the waist to the feet of the young mother (Plate 9A), helps to create the impression of lasting peace. Not only the beautiful head with its marriage-headdress (Plate 9B) but the entire body must be considered as *post mortem* portraiture. If a death-mask was used as model for the face, Quercia must have tempered its data somewhat to produce a deliberately idealized version. The stately transposition of nature towards the ideal is emphasized by the introduction of Roman Antique funerary genii bearing garlands of fruit and foliage on the sarcophagus below the bier. As has been suggested long since, the model for the base of the monument must have been an actual pagan sarcophagus, doubtless one still preserved among those in the Campo Santo in Pisa, only a few miles away. Thus the Antique, as one might expect from our view of the Porta della Mandorla and the baptistery trial-pieces of Brunelleschi and Ghiberti, makes a striking appearance here as well.

Only one side of the sarcophagus is by Quercia. The side turned at present towards the transept wall must be attributed to his Sienese companion, Francesco di Valdambrino, who was also an unsuccessful entrant in the competition of 1401–3, and whose presence in Lucca is documented precisely at this time (c. 1405–8). A comparison of his

Figure 5.
Funerary Genius, corner figure, sarco-
phagus, Roman Imperial Period.
Pisa, Campo Santo (from Lasinio)

interpretation of the Antique with Quercia's shows a precise, consciously articulated, and smoothly finished rendering (Plate 10A). Quercia's corner-figure at the head of the monument is fuller in mass and more generalized and richer in modelling (Plate 10B). It is more robust and more unified. It also differs importantly from the pre-sumed Roman prototype (see Figure 5) in that arms and hands are brought compactly inward towards the upper body and centre of action, and thus help to establish a more symmetrical and more powerfully contained unit.

The winged genii in Lucca are important not only because of the revival of the Antique which they demonstrate, iconographically among the very first large-scale renderings of the Renais-sance putto, but also because they contain evi-dence of thinking before 1410 about the sculptural handling of the humanistically oriented standing figure. One would have to move forward several years – to about 1412 – to find Quercia's next contribution to the free-standing statue in the un-named and lonely young Apostle that he carved as one of a never-completed set for the decoration of buttress-summits on the exterior of the cathe-dral in Lucca.[18]

The First Statues of the Fifteenth Century for Florence Cathedral: Emergence of Donatello, Nanni di Banco, Ciuffagni

The earliest Quattrocento essays in statuary take as their main theme masculine youth. They are the 'kouroi' of the Renaissance.

The first recorded work of Donatello and Nanni di Banco is in connexion with the Florentine Duomo and with problems leading towards the challenge of the free-standing statue. It would seem that Donatello and Nanni were contemporaries. For a time their paths ran parallel. Though one may have learned a good deal from observing the other, each retained his own independence, competing colleagues, and respectful rivals.

The birth-date of Nanni (Giovanni di Antonio Banco) is not known, but if he matriculated, as is known, in the Guild of the Maestri di Pietre e Legnami in 1406 (actually late in 1405, Florentine style), he could have been born some time in the neighbourhood of 1387, since he normally would at that time have come of age at eighteen. Donatello's birth-date, which is also not known, may be taken as 1382, 1383,

or 1386; in 1406, the same year that Nanni matriculated in the guild, he was, according to the Duomo records, an independent artist. Nanni remained until 1408 in association with his father, Antonio. The father matriculated into the Florentine stoneworkers' guild in 1376, but as far as we know never produced any figure sculpture up to the time his name was linked in the Duomo records with his son's. The fairest inference to be drawn is that the figure sculptor of the family was Nanni, and not the father.

From the Porta della Mandorla Nanni went on to important commissions for Or San Michele (see p. 59), and returned to the Duomo workshop to finish the Porta della Mandorla in 1414. He died 'young', according to the tradition picked up by Vasari, in 1421. He was married, and he occupied from time to time positions of responsibility. He was consul of his guild and *podestà* at various times for small towns in Florentine territory.[19] Beyond these basic facts, from which a reasonably acceptable chronology of his work may be drawn up, there is virtually nothing to indicate what he was like as a person or as an artist, except of course his work.

Of all the sculptors of Italy prior to 1420 Nanni was the most enthusiastic reviver of ancient Roman forms. He was also perhaps the Italian sculptor of the whole fifteenth century who most valued effects of weight and mass; he had a unique feeling for the displacement of form in the air and space of the physical environment of art and life.

In contrast to Nanni di Banco, Donatello (Donato di Niccolò di Betti Bardi) had a career of remarkable length, for he was still active and inventive as late as the 1460s.[20] Donatello never married, and did not at any time seek out or accept civic responsibility in the form of public office. From the time he was an apprentice-assistant in Ghiberti's shop between 1404 and 1407 (and for a short period as a salaried assistant in 1407) to the time of his last illness and death in 1466, there is a steady record of his whereabouts and general scope of activity. But except for laconic answers to tax inquiries there is surprisingly little of his words, to say nothing of his thoughts, recorded in his lifetime. There is even no certainty as to what he looked like, though it is quite possible that his apparently very close friend Masaccio portrayed him as one of Peter's bearded companions in the fresco of the Healing by the Shadow in the Brancacci Chapel; an old copy of a head and shoulders with inscribed name beneath in a group portrait, which used to be attributed to Paolo Uccello, exists in a rather poor state in the Louvre. What we see of him is mainly through the eyes of the sixteenth century, which adored him as the Florentine precursor of Michelangelo. The picture we get from these later sources presents an exceedingly sharp-witted, but essentially kindly person, pointedly careless of business, completely wrapped up in his art. He appears to have been much interested in the visual side of the drama, and, just like an actor, he projected his own image to the world, giving the impression of a rough-hewn man of the people, but actually quite able to hold his own with great men of the highest calling, the delight of such a sophisticated connoisseur of human distinction as Cosimo de' Medici. Vasari's 'portrait' is regrettably vague and already more than a little mythological. We must get used to the notion that the few bare facts that have come down in reputable sources tell us very little of the extraordinarily complex individual that his work hints at rather than reveals.

To borrow a simile which has been used in connexion with a similar problem in social history, it is almost as if we had to reconstruct the character of Samuel Pepys from the naval records alone – without the diary.

What one finds in Donatello's work is boldness and strength allied with a capacity for pathos that had no parallel among his contemporaries and constantly seems ready to step out of the fifteenth century to challenge the invention of all periods of art. Where this vision came from, and the source of such inventiveness and range, are alike mysterious. One thing is apparent: it would seem he was not precocious but, if anything, rather on the slow side in maturing. It was not until about 1410, or shortly after, that the measure of his real capacity became apparent.

The Duomo records seem to indicate that Donatello was entrusted in 1406–8 with work on the Porta della Mandorla which used to be identified with one of the two young beardless prophets crowning the lateral finials. Neither of these figures on the monument today can be considered as by his hand. Probably the document applies to a relief, not a statue, but if a statue it was rejected; whether it simply did not measure up to desired standards or whether it failed in effect because of an error of scale on the part of the portal's original designer we cannot know. One of the prophets now in place (to the right) may be given with some confidence to Nanni di Banco's shop between 1414 and 1421: the other is quite probably an attempt at an 'angel' by his then younger contemporary Bernardo Ciuffagni, adapted for use here as a 'prophet'.[21] Both figures can be interpreted only as weak shots in the dark, and neither throws any light on Donatello's beginnings. Taken as a pair, they are useful to us mainly as indications of the abysmal sacrifices of quality and of unity of style that the Operai of the cathedral were beginning to be willing to make about 1415 in order to get the Porta della Mandorla finished at last so as to move on to the more lively question of major statuary for the façade and the campanile.

Far more challenging are the two statues of an Annunciation preserved in the Museo dell'Opera del Duomo. There has been almost as much discussion about this pair as about the young prophets discussed above. The figures in the Opera Museum have been for some time hypothetically identified with the Annunciation figures originally designed for the arch of the Porta della Mandorla. The existence of such a marble group is attested by the Duomo records, but the interpretation of the documents still lacks, by a good deal, unanimity among scholars and critics.[22] The scale of the figures in the Museo dell'Opera, like much of the sculpture of the portal, is very delicate. There could well have been some question as to its suitableness for the space under the arch. The schematic rendering to approximate scale given in Figure 1 indicates (in dotted outline) that the group in the museum would not be hopelessly overpowered by these surroundings. But besides the question of programme there is the question of interpretation of style and date.

The Museo dell'Opera Annunciation presents a striking juxtaposition of Roman influence and Gothic style. The contrast jolts the modern eye with its forceful incongruity (see Plate 5A). The close-cropped head of the Virgin Annunciate recalls that of an Antique male athlete. The Angel has the stormy look of a maenad. Both are influenced

by the Roman revival of Arnolfo di Cambio, who about a century earlier had himself designed or carved important statuary for the Duomo façade. The sharp and dramatic expression of the group is a departure from the more generous forms and more relaxed psychological mood in the Querciesque Angel of the dalle Masegne shop in Bologna about 1390–5 (Plate 5B). In contrast, the Florentine Angel projects an effect of urgent vitality and at the same time of considerable density and weight of mass. It makes a valiant attempt to bring together the separate strands of gothicizing and classicizing tendencies which had already made their appearance on the Porta della Mandorla before 1397.

This effort to harmonize opposing types and styles of expression is characteristic of the decade 1400–10 in Tuscany. But the directness and power of this particular Annunciation is unique. This is a bold leap into experiment. It moves beyond the younger masters of the first campaign of the Porta della Mandorla to take a new position. The expression seems to fit a younger temperament shortly after 1400 rather than shortly before, and might suit with the least violence to what few facts we have the notion that it is an early work of Nanni di Banco, who, in a partnership with his father, divided the carving of the arch with Donatello(?) and Lamberti between 1404 and 1409. In 1414, as master in charge of finishing the portal, Nanni would have been in a position to reclaim his earlier work and to use it to fill the place for which it was designed.

In any event in 1408 the Operai of the cathedral commissioned from Nanni di Banco and Donatello two life-size statues of prophets to stand on the summits of buttresses on the exterior of the tribuna adjacent to the Porta della Mandorla. It is worth emphasizing that these early figures were intended to be completely free-standing, unhampered in any way by the spatial enclosure of a niche. But their very high emplacement put forward new problems of pose, proportion, finish, and scale. Both Donatello's and Nanni's figures, when completed, were apparently judged insufficient to carry from such a height and were not used as originally intended. Donatello's figure seems to have been that sold to the Signoria in 1416 to be used in the Palazzo Vecchio as an icon of freedom. Nanni's figure was pressed into service a little later to decorate the façade of the Duomo.

Donatello's prophet David of 1408–9, evidently recut in certain details in 1416, is now in the Bargello.[23] The sculptor depicted the prophet as an idealized youth, the victor over Goliath, whose head lies in a wide opening between his feet. Such is the classic pose for the David figure; yet this announcement of one of the most famous of all Renaissance themes is cast in an almost effeminate mould, swathed in a voluminous cloak, and in its swaying pose is handled virtually like an enlargement of an early Ghiberti figurine, but in marble rather than in bronze.

Nanni di Banco's competing youthful prophet combines a sensuous and powerful head *all'antica* with a swinging pattern of carefully delineated drapery (Plate 11B). The Isaiah, once erroneously called a Daniel, is interesting also because, not unlike Donatello's contemporary David, when viewed from the left side its proportions and movement fail to come together into anything like a convincing design. Seen from the front, however, and slightly from the right, as illustrated here (see again Plate 11B), the

movement of pose and drapery unite into a paradoxically ponderous yet flame-like, upward-moving thrust. Undoubtedly the intended placement of the figure affected its design from the beginning. Just as important is the precarious balance, and above all unity, of the pose. One is strongly reminded here of Wölfflin's striking phrase, which he applied at one time to Italian Renaissance statuary in general, namely, that the 'whole body becomes gesture'.

Early-Fifteenth-Century Wood Statues of the Sienese School

In contrast to Nanni's pioneering step towards the definition of Renaissance *statua* in the Isaiah, the intimate, frankly devotional, painted wooden *figura* of the young S. Ansano, done by Francesco di Valdambrino for a Lucchese church at the same date, may appear to belong either to another world or to another century (Plate 11A). Yet it too, with its careful balance of articulated parts, its fresh and direct communication of youthful beauty, establishes a new standard.

Almost immediately after carving this free-standing figure, Francesco moved back to Siena and received in 1409 a commission for four seated figure-reliquaries of local saints for Siena Cathedral.[24] These no longer exist, except in the pitifully reduced form of three busts (one statue having been entirely destroyed). The Sienese seated figures were almost exactly contemporary with the seated Evangelist series for the Florentine Duomo, which were carved largely in the period 1410–15 and will thus be considered in the following chapter.

Some time between 1400 and 1415 in Siena, a decisive step was made in the genre of polychrome wooden figures which carried that art beyond the gentle, quietly idealistic standards of a Francesco di Valdambrino, whose later work, almost entirely in polychrome wood, continues impulses received from Quercia. The evidence is a mourning Virgin and St John for a Crucifixion, commissioned originally for Siena Cathedral from Domenico di Niccolò dei Cori, best known probably for his intarsie in the chapel of the Palazzo Pubblico.[25] From the point of view both of their proportions and of their more expressive emotionalism, they stand in contrast to the imposing yet blocky and solid figures attributable to the same master about 1400, in which the style of Nicola Pisano was revived, much as Nanni di Banco in Florence was bringing back echoes of Nicola's follower Arnolfo di Cambio. It has been well noted that Domenico's effort towards a new eloquence in gesture and facial expression points to a revival of the dramatic elements of Pietro Lorenzetti's art and to the more contemporaneous 'pleurants' of Burgundian sculpture. As earlier in Florence, here too in Siena we seem to find a classicizing first phase and a gothicizing phase following immediately thereafter.

NEW DIRECTIONS, TUSCANY 1410–20

THE decade 1410 to 1420 was vitally important for the development of fifteenth-century sculpture in Italy. During this period, what might have become a sapping conflict in Tuscany between International Gothic and the classicizing trends of a Tuscan Roman Revival was all but definitively resolved on a pattern which later was to have meaning for other parts of the peninsula. A general line of procedure was thus laid down. At the same time a fairly sizeable number of divergent stylistic paths were looked into and indeed, up to a point, actually explored. Among the master-sculptors there was a good deal of rivalry and independence. Sculptors could, and did, shift their directions frequently and with remarkable rapidity.

It is hard therefore to characterize in an easy phrase the new mode which was then on the way to establishment. It contained elements of both earlier conflicting trends, now however transformed. In examining the major monuments of the decade one is struck by the variety not only of programme but of style. It seems certain that in the continued assimilation of influences from the Antique the naturalist tendencies of the Late Gothic if anything were intensified. At the same time, such Antique elements were recast into a more flexible mould, suited to express with greater confidence than ever before not only Roman *gravitas*, but a new vigour and a new lyricism, should the occasion and subject of the programme require them.

The seated Figure and the Evangelist Series for the Cathedral of Florence: Nanni di Banco, Donatello, Lamberti, Ciuffagni

The seated figure offered a quite different set of problems to the fifteenth-century sculptor than did the standing figure. The latter emerged with some naturalness from an elongated regular block of stone. Its parts followed in sequence, with relatively little variation in plane in three dimensions. The inevitable challenges to the artist were to suggest that the figure had fullness and meaning on the sides which do not come entirely into main view, that the weight of the upper parts of the body, particularly the head, is carried logically to the lower members for clear support (*ponderatio*), and that in placing and articulating the parts (head, hands for example) a balance was maintained between movement and repose in opposite pairs and members such as arms or legs and between the actual inertia of the materials used and the suggested possibility of movement. This last was in Albertian terms for art the very index of life, in both a physical and psychic sense. To the standing figure it was also easiest to apply a module or mathematical canon of proportions of the parts. From the time of Polycleitus' canon, the standing figure in repose or in the mildest kind of action is the norm for such studies in measured proportions.

For the seated figure, however, a steady vertical sequence in plane was not 'built in' from the block itself. Instead, the sculptor was forced to deal with a difficult contrast between one primary front plane of the upper body, a second plane at right angles jutting outward in the lap and thighs, and still another front plane established from the knees to the feet. Moreover, since it renders one of the more static human postures, the seated figure raised an uncomfortable dilemma as to how meaningful movement might be suggested. The artist must choose between a twist, with the pelvis as fulcrum, which might be interpreted as mere squirming, or the suggestion of an abrupt shift to the standing position, which might well destroy an expression of grave quiet and ease, perhaps the great advantage from the point of view of artistic expression of the seated pose.

Early Renaissance sculptors seem to have been fully aware of these problems, even though they perhaps might have used somewhat differing language to discuss them if they had chosen to write about them in detail. The evidence is suggested by the four Evangelists intended to flank the main portal of the Florentine Duomo (Plates 12, 13, 14B, and 15B).

The commissions given in 1408 for three of the statues followed upon a first idea which apparently was to divide the four figures between Niccolò Lamberti and Lorenzo di Giovanni, a plan which had to be abandoned because of Lorenzo's death in 1405.[1] In the final disposition Lamberti retained one figure only, the St Mark; two others, the St Luke and the St John, were allocated respectively to the rapidly rising younger men, Nanni di Banco and Donatello. The commission for the remaining figure was to be offered as a prize in a competition between the three sculptors named above for excellence in their figures as allocated. This idea was quickly discarded by the cathedral authorities. In 1410 the St Matthew was given to the young Florentine contemporary of Donatello and Nanni, Bernardo Ciuffagni, whose name first appears on the Duomo rolls in 1409. Almost immediately we find in the documents traces of resentment towards the intruder on the part of the three original sculptors. Ciuffagni seems to have started to sniff about the cubicles of his colleagues in search of ideas. Donatello, for one, insisted on having a lock put on the door to the work-space assigned to him.[2] There is no doubt as to the growing value being put on independence and originality.

There were two features that the four statues had in common. They were designed for placement in niches and this put a premium on a frontal view. Secondly, we know from visual records of the Duomo façade, before the sculpture was removed in the late sixteenth century, that the niches, although at ground-level, were set somewhat above the heads of observers, so that the view was necessarily from below, with the angle of vision more abrupt as one approached the optimum viewing distance, of about eight to six feet.

Given the loss of the architectural setting, it is impossible today to do more than estimate very approximately the degree of optical corrective that a sculptor would have had to take into consideration because of the low viewing point for the figures. It is important none the less to underline the theory that a corrective of some sort was in some cases intended. It may appear perhaps less necessary for the stalwart St Luke by

Nanni di Banco (Plate 12), which was placed immediately on the left of the main portal, but a comparison of the usual commercial photograph with one taken with the lens placed on a level with the figure's mid-point rather than below its feet, as would occur under the original viewing conditions, would show a number of meaningful changes in composition. The broadening pose of the arms links the lower mass with the upper and suggests a pyramidal organization of the whole. The head at the summit is slightly tilted; the lowered eyes start a glance which directly meets and holds the eyes of the observer. Thus is reconstructed in the viewer's eyes a most powerful and compelling design. The corresponding figure intended for the other side of the doorway, Donatello's St John, was apparently organized on an even more thoroughgoing optical basis.

If seen face on from the same level, the St John presents a disappointing, puzzling design. One would discover a long-bearded head, the glance directed unaccountably sideways; then an unconscionably elongated torso; finally, stunted legs swathed in overcomplicated drapery. Seen from below, on the other hand, as in Plate 13, the figure organizes into a much more understandable unity. The proportions come far closer to nature. The torso shortens and assumes structure. The folds of drapery over the knees and lower legs take on shape and directional movement. The head, foreshortened, suggests energy and nobility. The gaze of the eyes projects meaning, as the saint looks off from some imagined rocky promontory on Patmos to his visionary goal.[3]

The organization of masses is thus directed by a principle which is much less tactile and concerned with measurable solids than optical and illusionistic. The unity of the figure as a whole is achieved through foreshortenings not only in the dimension of height, but also in that of depth. The awkward juxtaposition of planes at right angles in the lap simply disappears with the flattening of the figure by actual measurement, though not in visual effect, in its dimension of depth. A clearer Early Renaissance statement of optical primacy could hardly be found than the St John of 1408-15.

It should be noted that the application of an optical principle to sculpture is not precisely the same as in painting. In sculpture there is far more tension between measured reality and visual effect, and 'artificial' perspective is never free from 'natural' conditions. In actuality the figure of Donatello's St John was carved rather loosely from the block on a rectangular schema; in visual effect it may be seen as a clearly-defined pyramidal design with graduated intervals for the placement of knees, shoulders, and crown of head which approach a mathematical progression, as shown in Figure 6. As the axis of the main masses veers from the axis of the pyramid to the right (lower mass) or to the left (head), there is a suggestion of movement and life. Meanwhile, the pyramid achieved by optical means ensures the impression of stability and brings the tensions to a state of balance.

A statue of this scale and of such moral, as well as physical, weight is much more than an exercise in formal ingenuity. Once in place, it functioned as a sober, dignifying presence in the life of the city about it. So Donatello's St John must have been seen by Michelangelo, who recalled its design as it was intended to be viewed in his Moses done for the tomb of Julius II which is now in S. Pietro in Vincoli, Rome. In such

terms the statue was felt in the background of a great public ceremony in Florence as painted about 1480 (Plate 15A); but in the painted image, the Late Quattrocento realist, a contemporary of Antonio Rossellino and Ghirlandaio, recorded characteristically for his period and purpose what 'was there', rather than what the sculptor of 1410 apparently counted on being 'seen' from a specific point in urban space and civic environment.

The two remaining Evangelists should not be dismissed casually. Possibly Lamberti's figure would gain almost as much as Donatello's from a lower viewing point. In the

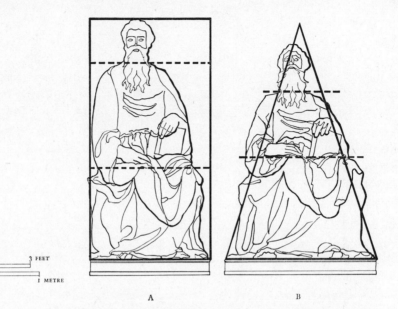

A B

Figure 6. Donatello: St John the Evangelist, from the façade of the Duomo, 1408–15.
Florence, Museo dell'Opera del Duomo

Schemas of composition depending on observer's point of sighting (after photographs).
A From same level as the statue
B From below the level of the statue as required by intended position

fifteenth century, as one passed Lamberti's figure adjacent to Donatello's in approaching the portal, one would have looked up to see a powerful and noble head (Plate 15B). But here the convoluted curves of the already dying fashion of the Late Gothic in Florence, carried pervasively from the drapery into the beard, ears, and hair, risked interpretation as mere surface pattern rather than as connected with a deeply founded inner being. So also would have appeared the elaboration of fold on fold of drapery. Ciuffagni's St Matthew (Plate 14B) is striking in another way, for it betrays an effort to include bits of Lamberti's gothicizing manner and also to combine the best of two possible worlds in Nanni di Banco's psychological solution (glance of the eyes) and Donatello's treatment (torso, hands, and lower draperies). The mark of the unoriginal eclectic is already upon it. There should be no question now as to the interpretation of the document which indicates that Donatello was aware that Ciuffagni was stealing

his ideas, when he requested a lock to insure the privacy of his own loge on the cathedral premises.

In 1415, when the Evangelists were finally finished, Lamberti's statue was given the short end in payment, and the artist, already out of fashion in swiftly-changing Florence, set out to make a new career in Venice with his son Piero di Niccolò. Ciuffagni left Florence in 1417, to return only after the field of competitors was partially cleared for him by Nanni di Banco's unexpected death in 1421. Ciuffagni almost certainly joined the Lamberti in Venice; for there are traces of the Venetian phase of the Lamberti as influences on his later work, such as the Isaiah now in the Florentine Duomo. The major programme which the Lamberti took over in the north was the decoration of the upper portion of the façade of S. Marco. This was certainly no minor plum of patronage. The younger Lamberti was active also for a brief time in the pay of the Strozzi, and probably the Bankers' Guild, of which the Strozzi were prominent members. He worked also in Padua. We shall review his work in connexion with Venetian sculpture in a later chapter (p. 99).

It is perhaps easier to see today, in retrospect, where the reins of power in sculpture for the full decade 1410–20 in Florence were to lie. What the four figures of the Evangelists provided then, as now, was the revelation of four distinct variants of style. On them each sculptor, according to his free choice, set his own view as a man and artist and wagered his future.

The Earlier Tabernacle Programmes of Or San Michele, 1400–15

This is the most convenient place to introduce one of the greatest of all fifteenth-century sculptural programmes: the decoration of the massive exterior pilasters of the guild church of Or San Michele in Florence (Figures 7 and 8 on pages 61 and 62).[4]

As a building and sculpture programme, Or San Michele was unique in its method of joining civic and religious functions. The church was adapted from the grain-hall of the city early in the Trecento, and during the latter part of that century the arched openings between heavy supporting piers (*pilastri*) on the street-level were closed (see above, p. 25). But well before this, in 1339, the major guilds of the city had each been assigned a pilaster to decorate with a niche and statue of its patron saint at street-level (see Figure 7). The scheme was remarkable in that it not only isolated the *figura* or *statua*, which was not true of the northern Gothic portals with statues standing in rows or series in the embrasures, but brought the sculptured figures right down to the level, literally, of 'the man in the street'. The rhythmic alternation of tabernacles with sculpture and the huge voids of the arched openings as first built was original and grandiose.

Only the Arte della Lana appears in 1340 to have proceeded to put up its figure, a marble St Stephen, on the west side adjoining the main entrance and opposite its own guild-hall. Towards the end of the fourteenth century, interest on the part of the guilds in the original project revived with the revival of the art of sculpture. In 1386 it was decided that the emblems or *istorie* under the niches as identification of the patrons and their guilds were to be carved and not painted. 1399 is the date carved under the niche

of the Physicians and Apothecaries, under the patronage of the Virgin. In 1406 the guilds were again urged to do their duty in providing sculpture and, in the period from 1400 to 1410, statues for the niches of the Arte della Seta (Silk Merchants and Gold-smiths), the Giudici e Notai (Judges and Notaries), and the Vaiai e Pelliciai (Furriers) made their appearance, the last two by Niccolò Lamberti, with the figure of the St James of the Furriers' niche probably in large part by his son Piero di Niccolò.

In 1409 Lamberti appears to have been given the commission for the niche and statue of St Mark for the Linen Weavers' Guild (Linaiuoli e Rigattieri). But at the most he retained only the design of the framing elements. In what appears today to have been a dramatically symbolic shift in public taste, the important statue was instead assigned in 1411 to the young Donatello. According to documentary evidence, it was finished by 1413.

A little earlier, perhaps in 1410, perhaps in 1411, Nanni di Banco was allocated the first of three tabernacle niches, complete with statuary and reliefs, which he was to do for Or San Michele, probably between 1411 and 1415. The loss of all documents makes a confident dating difficult, if not impossible. At any event, the important fact was the establishment of still another locus of rivalry between Donatello and Nanni di Banco.

It is natural that the question of precedence in certain discoveries as between the two artists should arise, and onlookers of the twentieth century are likely to take sides. The seemingly insuperable problem of closely dating Nanni di Banco's work on Or San Michele renders a competitive comparison risky. What a view of the two artists' roughly contemporaneous work suggests is a dialogue, with each participant supporting quite a different approach from that of his interlocutor, and in his responses meeting the other's argument with brilliantly original formulations.

According to the most attractive of several chronological theories, Nanni's group of the Quattro Coronati (done for the Stone- and Woodworkers' Guild of which both he and Donatello were members) represents his first work finished on Or San Michele. If so, it could well be earlier than, and certainly no later than roughly contemporaneous with, Donatello's St Mark. A comparison of two statues, the St Mark and one of the four saints by Nanni, on Plate 16, reveals much in common as far as the organization of pose is concerned, particularly as regards the opposition in contrapposto of straight and bent, working (bearing) and relaxed elements.

The differences are as remarkable as the likenesses. Donatello's figure was the more compactly constructed, the more logical in its distribution and support of weight, the more imaginative in surface-effects including drapery, and the more unified in its sequence of planes and silhouette. It was more sensuous in its flow of beard and fleshy face, and fluid sequence of passages which move downward in a kind of cascade of forms. Its unity, though, was largely a visual matter, and the allowance for optical effects already noted in the construction of the St John (see again Plate 13) appeared in the markedly shortened legs and lengthened torso.

Nanni's figure rejected illusion in so far as it could. It was deeply involved in an interaction between the space of actuality and the presence in that space of heavy, tangible forms. The contours were less a continuous containing boundary than a means

to accentuate the depth of rounded solids in three full dimensions. The figure proclaims a solid, intractable existence.

Although Vasari published uncritically the sixteenth-century belief that the St Mark, like the all too evidently inferior St Peter (surely Ciuffagni's) of the Butchers' Guild, was a joint commission shared by Brunelleschi and Donatello, the documents leave absolutely no doubt as to Donatello's responsibility for, and sole authorship of, the St Mark. Vasari's text retails the way in which the impressiveness of the St Mark was recognized only when the statue finally was placed in its niche:

'This figure he executed with such judgement and love that when it stood on the ground its merit was not recognized by those unqualified to judge, and the consuls of the guild [Linaiuoli e Rigattieri] were not disposed to accept it. But Donatello asked them to let him set it up, since he wanted to demonstrate that with some retouching the figure would appear entirely different. This was done. Donatello screened the statue from view for fifteen days and then, without having touched it otherwise, he uncovered it. Whereupon everybody was filled with admiration and praised the figure as an outstanding achievement.'[5]

Figure 7. Or San Michele, Florence, plan at level of niches. Location of guild niches and their statues, fifteenth century

WEST FRONT

A Farriers' Guild (*Manescalchi*) Nanni di Banco: St Eligius, *c.* 1411–14
B Wool Manufacturers' Guild (*Lana*) Ghiberti: St Stephen, 1428
C Bankers' Guild (*Cambio*) Ghiberti: St Matthew, 1419–21

NORTH FRONT

D Armourers' Guild (*Corazzai*) Donatello: St George,* begun *c.* 1415
E Wood and Stone Workers' Guild (*Maestri di Pietra e Legname*) Nanni di Banco: Four Crowned Saints, *c.* 1411–13
F Shoemakers' Guild (*Calzauoli*) Nanni di Banco: St Philip, *c.* 1412–14
G Butchers' Guild (*Beccai*) Ciuffagni: St Peter, *c.* 1415 (?)

EAST FRONT

H Magistrates' Guild (*Giudici e Notai*) Niccolò Lamberti: St Luke,† *c.* 1405–10
I To 1459, *Parte Guelfa*, Donatello: St Louis of Toulouse,‡ *c.* 1423–5. After 1459, Merchant's Court (*Tribunale della Mercanzia*) Verrocchio: Christ and St Thomas, *c.* 1463–80
J Wool Merchants' Guild (*Calimala*) Ghiberti: St John the Baptist, 1414

SOUTH FRONT

K Silk Manufacturers' and Goldsmiths' Guild (*Seta*) Sculptor uncertain (Jacopo di Piero Guidi?): St John the Evangelist§
L Doctors' and Pharmacists' Guild (*Medici e Speziali*) Sculptor uncertain (Lorenzo di Giovanni d'Ambrogio?): Virgin and Child, 1399
M Furriers' Guild (*Vaiai*) Sculptor uncertain (Piero di Niccolò Lamberti?): St James, *c.* 1415(?)
N Linen Weavers' Guild (*Linaiuoli*) Donatello: St Mark, 1411–13

* Removed to Bargello, Florence, replaced by cast in bronze.
† Removed to Bargello, Florence, replaced by bronze of same subject by Giovanni da Bologna.
‡ Removed to Museum of S. Croce, Florence.
§ Removed to Museum of the Ospedale degli Innocenti, Florence, replaced by bronze of same subject by Baccio da Monte Lupo.

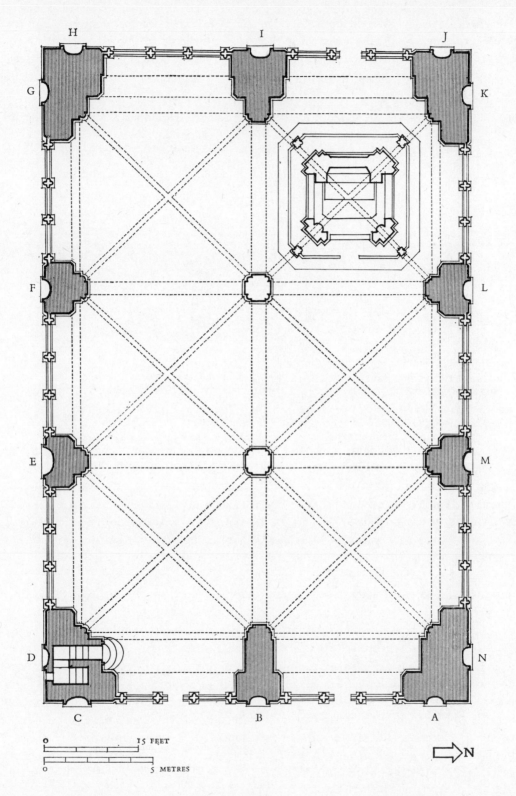

H I J

G K

F L

E M

D N

C B A

0 15 FEET

0 5 METRES

 N

61

The anecdote has at worst the possibility of a complete fabrication by a sixteenth-century mind, and at best only the value of spoken tradition liable to distortion; but it may contain the germ of historicity that Donatello's interest in optical effects was still alive in 1411–13, and that the St Mark was designed accordingly.

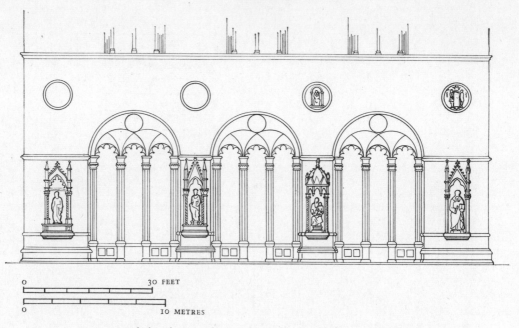

0 30 FEET

0 10 METRES

Figure 8. Or San Michele, Florence, lower elevation of south front. Guild niches and statues.
In roundels to the east: Guild insignia in glazed terracotta by Luca della Robbia
and shop inserted after 1450 (corrected after Mazzanti)

Another Vasarian story of how Donatello stepped in like a *deus ex machina* to recut Nanni di Banco's Four Saints so that they would fit into their niche is not borne out by evidence available today.[6] When, for reasons of safety during the Second World War, the statues were removed from their niche for the first time since they had been installed, it was found that two of them are indeed cut down at the back; but the way in which they fit against portions of the carved curtain-background left in the rough indicates that the final scheme of grouping was planned from the beginning. There is no escape from this evidence that what one sees on the monument is all Nanni's.

Here, in opposition to the subtly veiled classicism of Donatello's St Mark, is the contrast of a very frank use of Roman sources and inspiration in the strongly charac-terized human types and in many passages of the drapery to evoke the historical martyr-dom of the four saints under Diocletian. The Antique sculptural source used by Nanni is not known with certainty, but it could easily have been a Roman sarcophagus, still extant, which stood in the early fifteenth century beside the south portal of the bap-tistery in Florence.[7] There, not merely the drapery of the togas but also the drapery hung in the background strongly suggest the raw material of Nanni's pervasive rhythms of folds and overlays of drapery. A Roman *gravitas* is emphasized by the weight and

hardness of the marble as much as by the human imagery. The actors in the drama are apparently conversing tersely, with controlled emotions and quiet courage, as the moment of their execution approaches.

Space plays a major role. The figures have been gathered compactly round a central void which is accentuated by the concave plan of the base. The base therefore, as often happened in later Renaissance sculpture, entered here into the figural composition. Through this device the figures were linked more forcefully with the space of the building and its immediate urban surroundings: the space of streets and squares, the normal world of the politically and economically minded Florentine citizen. It is impossible to avoid the impression of identity between such an evocation of a heroic Roman or Early Christian past and the fifteenth-century 'present', which in Florence still at this moment was dominated by a drive to defend the front at least of a republican citizens' liberty.

Donatello's St George for the Armourers' Guild (Spadai e Corrazzai), though a few years later, belongs to this same general moment of Florentine trial by the sword. It proposes a startlingly different expression from that suggested by Nanni's Four Saints, and marks a new departure (Plate 22). Unlike Nanni's group, its emphasis was not upon corporate courage and restraint, but upon individual action, and the inward struggle for decision required to take action. The figure, though somewhat above life-size, was not so cramped or hedged by its surroundings. On the contrary, it was given in its original placement a striking expression of spatial dynamics and freedom. For structural reasons depending upon a staircase in the church behind it, the niche is uniquely shallow among those of the Or San Michele (see Figure 8). What might appear to be a disadvantage was turned by Donatello to a formal victory. From its niche the statue seems to have emerged more forcefully than any of the others. The alertness, or *prontezza*, as sixteenth-century criticism used the term admiringly, in this heroic image of a young warrior-saint is the characteristic above all others that is singled out for praise in the successive Renaissance eulogies of the work which go back at least to Filarete, about the mid fifteenth century. To us today more remarkable still is Donatello's embodiment of a dramatic moment – not only in the life of his city, but in the imagined life of a human being when, under stress, the character of a youth is moulded into that of a man.

Originally, from the presence of small holes bored into the marble, it is thought that the figure may have worn a wreath or even a helmet in bronze, and the right hand is carved to hold a sharply protruding and menacing sword or lance, doubtless also of bronze. The open stance, with weight unevenly distributed towards the left foot while the body turns inward towards the figure's right, is a striking pose, midway between defence and attack. The anxious look of the face, turned slightly to our right against the recoiling movement of the body, suggests an interior crisis. The meaning of the glance is less a challenge to the enemy than an invocation to divinity for moral strength. It may be thought of as a humanist equivalent of the response in the liturgy of the Assumption, a subject which at about this time of the carving of the St George was taking form in the carved frontispiece of the Porta della Mandorla: 'Da mihi virtutem contra hostes tuos'.

The precise date of Donatello's St George is not known. The records of the guild have not been found, and related documents in the Duomo archives purporting to refer to sale of stone by the Cathedral Operai to the guild for the statue carved by Donatello in 1415 or soon thereafter have been shown to be inapplicable. The most recent estimates provide a date of about 1415 for the statue and about 1417 for the tabernacle niche and its equally important historiated relief, which we shall examine shortly in the context of developments in relief style.

Nanni di Banco's Last Phase on the Porta della Mandorla and Quercia's Middle Phase on the Fonte Gaia

The two other statues to be attributed to Nanni di Banco on Or San Michele recall the Four Saints in effects of magnificent density of material, suggesting basalt rather than marble and, in imagery, a superhuman substance rather than flesh and blood. There is a contrast between them which may be a clue to their ordering in time. The grim St Eligius, for the Manescalchi or blacksmiths, is a personification of a severe, stoic rigour. The St Philip, for the Calzaiuoli, is gentler and more pliant. The latter seems to lead most naturally into the sculptor's last phase, dominated by the great Assumption of the frontispiece of the Porta della Mandorla, for which the commission was given in 1414.[8]

Here classicizing elements, the head of St Thomas and some heads of attendant angels, are mingled with softer, freer curvilinear rhythms in flowing draperies which, with the occasional use of tall and graceful proportions, recall the International Style, but in a completely new context of immediacy and vigour. Plate 19, which reproduces an oblique view of the central part of the composition, provides an idea of the unusual range of depth in relief and the mastery of scale and pose, which sets off the Virgin in an island of calm and dignity amid the songs and rising movement of the 'army of angels', in the phrase of the liturgy, which raises her to heaven. Thus with Nanni a hard, stoic interlude was followed by a release to a new and freer, a more joyful and more exact expression of movement.[9]

Nanni di Banco was said to have died before his time, and is known to have left the Assumption 'incomplete' at his premature death in 1421. The consensus of scholarship today interprets that reference in the documents as meaning that the several parts had not been as yet assembled. We do not yet have an analysis of what changes were made and adjustments contrived in the assemblage, nor do we have any evidence on the make-up of Nanni's late workshop. If he did have assistance, it was of very high quality and could have come from only one probable source, as we shall see a little farther on. When the Assumption was finally raised into position in 1423, it was a fitting tribute that two low-relief heads of a prophet and sibyl of 1422, needed to complete the total grand design, were supplied by Nanni's earlier rival on Or San Michele: Donatello.

A striking parallel to Nanni di Banco's final style is to be found in Quercia's middle phase. As early as 1409, Quercia had been entrusted with the commission for the great public fountain on the Campo in Siena opposite the Palazzo Pubblico. The work proceeded slowly because of the intervening commission for the Trenta family chapel

in S. Frediano at Lucca. There, with his assistant Giovanni da Imola, Quercia began with figures for the slab-tombs and later (after 1415) provided the altar design in a Gothic style. Forced to leave Lucca hurriedly as the result of a charge of immorality, Quercia returned to Siena and to the fountain, called the Fonte Gaia, in 1414. The Fonte Gaia was designed by Quercia with a long, rather low back, decorated by figures in niches in relief. Lateral wings with free-standing statues at their ends extended outward to enclose a fairly sizeable rectangular pool, fed by spouts in animals' mouths at the sides. The fountain was carved and built of local, whitish marble. The first programme was modified and enlarged after Quercia's return to make room for more figures, notably a Creation of Eve and an Expulsion, and for humanistic references in imagery to the mythical origin of Siena in Roman Antiquity.[10]

The original portions of the sculpture, now preserved in the loggia at the rear of the Palazzo Pubblico in Siena, have suffered from weathering and quite a bit of accidental breakage. To visualize the quality of the sculpture and the character of the effects of the whole requires some mental and aesthetic effort of reconstruction. There is evidence of polychromy, and the chances are strong that there was originally intended a fairly complex scheme of gold, white, and several colours, including red and green.

For the ornamental sections of the carving, carried out between 1415 and 1419, Quercia had assistance. The part of his earlier colleague Francesco di Valdambrino, whose hand was once identified in the group of Rhea Silvia and her children set up on one of the lateral wings, has recently been questioned. But the figure of Acca Laurentia by Quercia to the left as one faces the Fonte is the best preserved piece of the whole ensemble, and also one of the boldest experiments in sculpture of the entire decade (Plate 20). Here, gentle reminiscences of the Antique are deluged by active curves and reverse-curves. Thus comes about a transformation into an expression of a charming, joyful, even playful, exuberance which looks forward prophetically to the Late Baroque or Rococo.

Closer to Nanni's seriousness is the full, flowing, yet decisive modelling style in terra-cotta to be associated with Dello Delli, the important painter sculptor from Florence who worked for a time in Spain. The Coronation of the Virgin of about 1424 for the lunette of the main portal of S. Egidio in Florence (Plate 18A) is attributed to him, as well as a striking Man of Sorrows originally over a lateral door, and now in the Victoria and Albert Museum.[11] This sculpture is of terracotta. The clay of the Coronation is painted white, and if this covering were original, it would take a prominent place among the forerunners of the della Robbia technique. It suggests also the influence of Donatello's huge experimental 'White Colossus', which we shall meet in another section of this chapter.

The Relief Styles of Donatello and Quercia, to 1422

The first relief style of Nanni di Banco, as it appears in the small scenes beneath his statues on Or San Michele, holds in the actual depth of a shelf-like space nearly full-round figures (Plate 18B). The mode very nearly escaped relief entirely to become small-

scale statuary, as did indeed the figurines of Ghiberti's foregrounds. The first relief that can confidently be ascribed to Donatello moved in a different direction.[12]

The marble *istoria* of St George (Plate 21A), placed under the statue of that saint in Or San Michele about 1417, introduced a subtler mode which emerged quite naturally from the optical interests which went into the composition of Donatello's earlier statuary. Though today badly discoloured, battered by weather, and clogged with grime, the St George relief is the first milestone, in fact the *editio princeps*, of the style of relief-carving which was given the name in Florence of *stiacciato* or *schiacciato* (i.e., 'flattened-out' relief).

Some elements of the foreground are brought irregularly forward in some bulk, but they are provided with the suggestion of an envelope of atmosphere of their own. These few protuberances by skilful overlaps are brought back into a tightly-stretched unified skin-plane which is scarcely broken in surface relief to suggest a deep, though not limitless, space.

The artistic principle is frankly illusionistic. It suggests spatial relationships which do not in material fact, as in Nanni di Banco's relief style, exist. By surface tension it tends to exclude the space of the actual world, in order to define one particular space, one special light, and even one kind of weather. For its fullest effect it demands a single fixed viewing point on the part of the observer, and one incidentally much closer to the niche than the optimum viewing distance required by the statue.

Strictly speaking, a completely coherent system of perspective does not control Donatello's St George relief.[13] But something approaching it is provided by the drawing and modelling of the little arcaded hall seen at the extreme right. To what extent Donatello collaborated with Brunelleschi in the earliest days of fixing the principles of what later became rules of mathematical, 'artificial', perspective is highly conjectural. During the years 1410–15, however, there is evidence of Donatello's fascination with what Michelangelo was to call the 'giudizzio dell'occhio', and the optical correctives of the St John of the cathedral façade might be a prelude related to 'natural perspective' which a more architecturally minded experimentor like Brunelleschi could have used in his own thinking. It is perhaps not at all beside the point that Donatello's St John flanked the very doorway that Brunelleschi used for his sightings in making one of his first perspective constructions. It must be acknowledged also that for some five or six years at a minimum after the St George relief was carved, the Renaissance system of perspective was not used to our knowledge by a painter, let alone by another sculptor.

Shortly after 1420 Quercia pursued a rival relief system. About 1421 he returned to Lucca to finish the work left incomplete in the Trenta Chapel in S. Frediano. The main body of the gothicizing retable, which follows both the scheme of a painted *ancona* and the dalle Masegne altar of S. Francesco in Bologna, had been completed in the large figures and pinnacles by 1420. Now, with the Fonte Gaia behind him, Quercia returned to finish in a new style the predella reliefs, of which the scene of St Lawrence's martyrdom is the finest (Plate 21B).

With every invitation to project a pictorial illusion of space, Quercia appears consciously to have avoided it. The arcade in the background, as much as the gridiron in

the foreground, is not put into perspective. A uniform consistency of relief marks the figures, though the forms grow noticeably thinner as they approach the back plane. The result is a unity of effect, but with a heightening of the physical aspects of the drama depicted. The tremendous suggestion of substance and of latent power in the heroic nude of Quercia's saint makes the mounted figure of Donatello's St George seem like a flickering apparition. Masaccio could have seen this St Lawrence by Quercia at Lucca on his way between Florence and Pisa in 1426. Perhaps that memory was instrumental in the creation of Masaccio's painted nudes, particularly the stupendous kneeling figure in the foreground of the Baptism of the Brancacci Chapel.

Lost Figures for Florence Cathedral; the Prophets for the Façade and Campanile

Embedded in the archives of the Florentine Duomo is the mention of a David in marble for which Donatello was paid in part in 1412. It is possible to speak of the 'David of 1412', as it has come fairly recently to be known, in this way because, although three existing marbles have been proposed in writing as candidates for the figure, a con-clusive identification still remains to be made.[14] In spite of commissions from the guilds at Or San Michele, Donatello, like Nanni di Banco, continued to take on work for the Duomo in the decade 1410–20. It was in this connexion that he collaborated with Brunelleschi in 1415–16 on a second lost figure, or more exactly on a project for which the experimental figure is now definitively gone.

The Late Renaissance and Baroque programme of placing a row of huge, gleaming statues high on the architrave of a colonnade, or on the roof, as light accents against the blue background of the sky, appears to have appealed in a preliminary form to the imaginations of fifteenth-century Italian architects and sculptors. At that time the relationship was partly with Late Gothic finial figures, and probably partly also with recovered descriptions of ancient Roman statuary.

We have seen in the previous chapter that marble statuary carved only to the scale of life in 1408–9 had apparently failed visually when tried out at roof-level on the north tribuna of the Duomo next to the Porta della Mandorla (p. 52). The problem con-tinued to be pursued, for it presented a challenging dilemma. The colossal figure required for adequate visual effect presented enormous difficulties in carving and in ultimate placing, if of marble; and if a lighter material was used, such as terracotta, the question still remained as to how to guarantee its surface, particularly if painted, against the weather.

One ingenious solution proposed by Donatello and Brunelleschi was a huge stone core, to be covered with thin plates of pliant lead, gilded. They went so far as to present a small-scale model of stone covered with gilded plates of lead in 1415. A terracotta 'Giant' by Donatello, apparently without a permanent casing, was indeed put together and raised into place. It was not gilded but was several times coated with white pigment, and stood for a long time on the north tribuna of the Duomo, as the late-sixteenth-century fresco by Poccetti in the cloister of S. Marco in Florence and other visual sources testify. The documents speak of a 'White Colossus': 'Homo magnus et albus'.[15]

The experiment has historical meaning well beyond the striking *hubris* of the attempt. Out of such demands for a light, yet durable, architectural sculpture was to come the well-known Robbia technique of glazing the terracotta surface, at first brilliant white against a blue ground. But long after the Robbia technique was established, the authorities of the cathedral persisted in an attempt to solve their problem with marble. And out of their tenacity was to come, from an unsuccessful effort made by Agostino di Duccio about 1460 and later declined by Antonio Rossellino, the colossal David by the young Michelangelo of 1501–4. Ironically enough, once carved at last, that marble 'Giant' escaped, for other more pressing needs, the intended visual and iconographic function on the cathedral for which the fifteenth century sought in vain to find a wholly satisfactory technical and formal solution.

On another front, about 1415, the cathedral authorities proceeded towards the completion of two much earlier medieval programmes, with more conventional life-size statuary in marble. Their intent was to fill the eight remaining empty niches on the east and north faces of the campanile at third-storey level, and to complete a long row of statues in niches on the third level of the façade.

It has been one of the major tasks accomplished by modern scholarship to bring light into earlier confusion of dating and attribution of the sizeable number of statues to be connected with these two overlapping programmes covering the years 1415 to 1435. The evidence for present-day conclusions, with valuable insights into method, may be found in recent summaries, to which the reader is here referred.[16] For our purposes at present the following table must suffice as an indication of the scope and dating of each programme:

CAMPANILE SERIES
1. *East Face. Removed 1940. Now Opera del Duomo*

ARTIST	SUBJECT	DATE
Donatello	Beardless Prophet	commissioned 1414, begun 1416, finished 1418
Giuliano da Poggibonsi	Bearded Prophet*	commissioned 1422, finished *c.* 1423/4
Donatello and Rosso	Abraham and Isaac	begun and finished 1421
Donatello	Bearded Prophet	commissioned 1415, begun *c.* 1418, finished 1420

2. *North Face. Shifted to West Face 1464. Removed 1940. Now Opera del Duomo*

ARTIST	SUBJECT	DATE
Rosso and Donatello(?)	Young Prophet ('St John the Baptist')†	commissioned 1419, finished 1420
Donatello	'Zuccone' (Jeremiah)	begun 1423, finished by 1426
Donatello	'Popolano' (Habakkuk)	partly finished 1427, finished 1435
Rosso	Obadiah ('Abdia-Ulia')	begun and finished 1422

FAÇADE SERIES
Removed c. 1587. Now Duomo

ARTIST	SUBJECT	DATE
Ciuffagni and Rosso(?)	Prophet (so-called 'Poggio'; probably the documented 'Joshua')‡	begun 1415–17, finished 1421
Ciuffagni	Isaiah§	begun c. 1423, finished 1427
Ciuffagni	King David	begun c. 1425, finished 1434/5

Table 2. Florence Cathedral, sculpture of 1415–35

* At one time identified erroneously with the 'Joshua' for the campanile, assigned by the Operai to Ciuffagni and re-assigned to Donatello and Rosso in 1421.

† Formerly attributed to Donatello. Inscription 'Ecce Agnus Dei' on scroll and label (not signature) 'Donatello' on plinth are later additions (1464?). Apparently intended as part of the façade series and carved of two pieces of marble, one for the head alone. Height with plinth 7 ft 7½ in. (2·07 m.). Stylistically, the head is to the design if not the complete execution of Donatello.

‡ Formerly attributed to Donatello and apocryphally labelled a 'portrait' of Poggio Bracciolini. The head is carved separately. The statue was apparently intended originally as a 'Joshua' for the campanile, but was used instead on the façade; height with plinth 6 ft (1·82 m.). Its status is particularly uncertain, but stylistically it is dominantly in Ciuffagni's manner.

§ The block was originally assigned to Rosso, who supervised the roughing out. By 1424 it had already been re-assigned to Ciuffagni.

We shall consider at this point only the statues finished by 1422. Though not as fine as the early figures on Or San Michele, which accompanied them in date, these Prophets in the campanile series are nevertheless invaluable for a general view of the decade 1410–20, as much as for our view of Donatello's own personal development. There is one gothicizing and attitudinizing figure; a noteworthy exception. It is the Bearded Prophet usually conceded to be by a minor follower of Ghiberti, Giuliano da Poggibonsi. Otherwise the series was dominated by Donatello, either through his own work or through his influence. For a very brief period up to 1417 we find the activity of his imitator, Ciuffagni, who returned after 1421.

By Donatello's own hand is certainly the strong, strikingly veristic head, done between 1416 and 1418, of a beardless, older prophet, which mingles a close study of nature with what appears attention to the Roman Antique.[17] The drapery of the figure in question is noticeably weaker and may be due to the hand of an assistant, perhaps Nanni di Bartolo, called Il Rosso, who by 1419 was a fully fledged younger master and by 1421 was raised to the status of virtual partner to Donatello.

Rosso's Florentine artistic personality was never a very strong one. It is the more difficult to grasp, since his career after 1423 must be picked up bit by separated bit in scattered work in North Italy and on the east coast, where he readily adapted himself, it would seem, to local or regional demands. His signed Obadiah (Plate 23B) for the campanile, dated as finished in 1422, is lyrical rather than dramatic, built around the expression of a graceful advancing movement. It makes an agreeable and tactful contact with the observer.

The placement of the campanile figures, so high above the pavement, would render attention on the part of the sculptor to fine detail virtually useless for visual effect. Moreover, the steepness of the angle of vision is not at all comparable to that required

to see the seated Evangelists of the façade. Donatello's stylistic response was to emphasize the forms by enlargement of parts (heads, hands, feet), and to underline the features and the draperies as well with deeper undercutting than he had ever used before. The figures are heavier, denser than in his earlier work, and seem contemplative rather than active. The exaggeration in size alone of hands and feet may have been required by the high placement of the sculpture. But, as in Michelangelo's David of 1501–4, also intended for just such a height, it may be an expression of a growing consciousness of parts of the human body through the artist's own body – not seen outwardly as in a mirror, but in a kind of recognition and projection of self through self-realized anatomy. The psychological basis for this view is well known, and its application to Donatello's sculpture offers a most interesting prospect for further research.[18]

Available documents state clearly that Rosso collaborated with Donatello on the most striking statue of the series, which was carved apparently quite rapidly between March and November 1421. This was the group representing the Sacrifice of Isaac (Plate 23A). Most informed opinion today gives the design and major parts of the carving of both the towering, patriarchal Abraham and the small, crouching, naked child to Donatello. Here *statua* took over *istoria*, somewhat in the abrupt way *istoria* had taken over *statua* in the St George relief four years before.

Combined in the closely knit group of the Abraham and Isaac was the presentation of two markedly contrasting roles in a human drama. The active and passive actors were bound together by invisible bonds of the moral principle of obedience, and as well of a moment in time sensed as history.

The moment depicted was not that of the height of the action, as in Ghiberti's and Brunelleschi's trial pieces of exactly twenty years before. It has been well pointed out that Donatello here chose the moment after the decision, the far subtler instant of transition from crisis to relief. The knife falls away. Tension and strain of muscles and will are on the point of relaxation. The patriarch, mutely and sluggishly turning and looking upward, is on the point of seeing the truth. The physical dimensions are about to be increased by a new dimension of spiritual perception.

The tall and narrow design was imposed by the shape of the shallow Gothic niche high up on the campanile which the group was intended to fill. Like the St George of Or San Michele, however, the forms did not sink back into the shadows of the niche but emerged forcefully into the light and space of the world of men and of action. These forms worked dramatically against, rather than in harmony with, their intended environment. Today, removed from its niche and standing in the Museo dell'Opera, the group makes a very different impression. The drama of the tension between *statua* and architectural setting is sadly missing, even though the forms of the sculpture are immeasurably easier to see.

The New Humanism and the Human Figure: Ghiberti at Or San Michele;
Donatello and Brunelleschi

Clear humanist principles in the *arte statuaria* appeared dramatically in the years just before 1420 in Ghiberti's St Matthew on Or San Michele (Cambio niche). The statue offers a contrast not only with Donatello's Abraham but in an even more remarkable way with the St John the Baptist which Ghiberti had completed only six years before for the Calimala, likewise for Or San Michele. The Calimala statue was a great technical achievement. It was the first casting in Florence of a large, over-life-size, free-standing figure in bronze since Late Antiquity. Stylistically, however, it was still dominated by the swaying, indeterminate movement and swinging drapery favoured by the International Gothic Style. If we take Donatello's or Nanni di Banco's development as a norm, it was by 1414 already outdated.[19]

Two years after the St John for the Calimala, the artist appears to have gone to Rome, where the Antique, in all its romantic and historical overtones, made a deep impression on him – indeed one which is reflected, as we have seen, in the last designs of the quatrefoil *istorie* of the baptistery doors. In 1419 Ghiberti was commissioned by the wealthy Guild of the Cambio to make a bronze St Matthew, which was to be even larger than the Calimala statue, 4½ *braccia* in height, or almost half again as large as life (Plate 24). In 1420 the finished model was completed, ready for casting. In 1422, after some parts, including the base, had been recast to correct flaws or errors in the first attempt, the figure was in place. At least in part it gleamed with bright gilding (almost entirely gone today) against the brilliant marble of its niche.

Ghiberti's St Matthew went beyond Donatello's St George and the campanile Prophets, or Quercia's polychrome wood Annunciation at San Gimignano of the same time, in an overt, determined, and monumental recovery of the Antique. Ghiberti's figure now suggested the Roman orator type or actor. The gesture was expository, and the drapery was so disposed as to recall something of a toga. The proportions give the impression of a Byzantine adaptation of the Vitruvian canon, that is to say, definitely more elongated, with a larger head, than the *statua virile* established according to the system to be promulgated a little later by Alberti in *De Statua*.

In accord with a statement which Ghiberti took over from Vitruvius in his own *Commentarii* (Third Book, 43–4), the mid-point of his figures was taken at the umbilicus, but the data of Vitruvius' 'men' within square and circle were apparently combined, giving a head–torso to legs ratio of nearly 4 : 5.[20] The proportions differed radically in this respect from those of Donatello's earlier St Mark on an adjoining wall of Or San Michele (Plate 16B). The 'leggy' proportions of the St Matthew give to the figure, despite its huge size, an effect of elegance and lithe buoyancy, characteristic of Ghiberti's aesthetic ideals in general; this original canon appears also in some figures of the 'Gates of Paradise'.

The statue was set in a niche which sacrifices a relief below to provide as large an opening as possible for the figure. The arch was unencumbered by cusps or tracery of

any sort, and in an original way its broken, Gothic form was adapted to contain a classical shell-form behind the statue's head. Finials were metamorphosed into miniature statues. These were once called an 'Annunciation', but are generally now recognized as prophetesses or sibyls. They echoed the design of the bronze statue, and recalled the *parti* of the Porta della Mandorla; but they were carved on a larger scale and more vigorously than in the earlier programme, and emerged more clearly against the dark *macigno* stone. The artist of these two small figures was certainly not Ghiberti; nor do they both fall within the stylistic orbit of Michelozzo. One could possibly be by Piero di Niccolò Lamberti, who was in Florence at just about the time the niche was made. If this should be true, it would indicate once again the continuing force of the pattern of collaboration in Florence.

The documents state that Ghiberti received assistance from a younger man who was shortly to begin to rise to prominence both as a sculptor and architect. This was Michelozzo di Bartolommeo, who makes his entry on to the stage of art history in connexion with Ghiberti's St Matthew. When the evidence is weighed, there seems to be no reason for supposing Michelozzo's intervention in the design of the great figure of the saint. He was earlier employed as a die-maker in the Florentine mint, which provides a good reason for his being selected by the Cambio to help in this project. That very training would best have been utilized in casting and in chasing the bronze once it had been cast. Michelozzo's part in the design of the tabernacle niche is uncertain.

It is known that, after having acted as *compagno* to Ghiberti until 1424 (date of the completion of the first baptistery doors), Michelozzo began a kind of partnership with Donatello which was to last for some ten years. Over this period Michelozzo was to develop very rapidly as a carver of marble and also as a bronzeworker and designer. He presumably began his association with Donatello in assisting with the Parte Guelfa Tabernacle and its patron statue of St Louis of Toulouse on Or San Michele (Plate 25). The commission was, as far as we know, to Donatello alone. According to the documents the statue was already begun in 1423 and perhaps not too far from completion, and in 1425 there is documentary evidence that both niche-setting and statue were ready and in place. Although this dating stands outside the limits of the decade 1410–20, there are several reasons for considering the statue and its setting here rather than in the next chapter.

It seems clear that the setting of the Parte Guelfa Tabernacle represented the next step beyond the Cambio niche in eliminating vestiges of Gothic ornamental vocabulary. Donatello's huge figure in bronze-gilt, moreover, represented a direct answer to Ghiberti's St Matthew, which it exceeded in height. There was a related but more advanced firmness of concept and optimism in the manner in which the *statua* was presented: now it completely filled and grandly dominated its architectural environment.[21]

Technically, the St Louis is unique in Donatello's work, and indeed among all major works of the fifteenth century in sculpture. Except for the mitre, crozier, head, and gloved hands, it was built up of a number of bronze plates, moulded and fire-gilt separately and then assembled. This technique was required by the size of the statue,

which could hardly have been fire-gilt as a whole. It somewhat recalls *repoussé* goldsmithwork of the Middle Ages, but even more the idea proposed about 1415 by Brunelleschi and Donatello for covering with metal plates the terracotta 'Giant' for the north Tribuna of the Duomo. But there was a difference: here the concatenation of metal plates was built on air and metal bars.

It is worth noting that when Ghiberti turned to the last great Early Renaissance statue for Or San Michele (the bronze St Stephen for the Guild of the Lana, of 1426–8), he paid homage to the medieval type of the original Trecento marble image which his own displaced. Nevertheless, in the seemingly medievalizing design of the new statue he used much the same Vitruvius-inspired proportions which had appeared six years before in his St Matthew.[22] Donatello's momentary conversion to a canon, important for a complete definition of Italian Renaissance *statua*, apparently came afterwards. This was probably in connexion, as we shall see in the next chapter, with an extended visit to Rome, and contact with archaeological preoccupations of a more persuasive intensity there than he had found in Florence up to 1420.

Over the decade 1410–20 in Florence brooded the presence of the artist of the Quattrocento who seems to have sensed the possibilities of the heritage of the Roman Antique with most remarkably mature judgement. Filippo Brunelleschi began, as we have seen in the silver figurines for the Pistoia altar, with a strong northern and 'expressionist' bias which he adapted to an even stronger sense of tight-strung geometries of form. The years immediately following his failure in the baptistery competition have not as yet been filled in with much more than rather flimsy hypotheses. Accounts of an early trip to Rome cannot easily be discounted. Probably there is no topic so ticklish as this mysterious period in Brunelleschi's career.

He was a short, slightly built man, with one of the sharpest of minds on record and apparently one of the most electric of personalities. As far as sculpture in the second decade of the fifteenth century is concerned, he appears as something of an *éminence grise*, on the whole invisible but always a power in the background and very probably a steadily active influence on his contemporaries. One would give a great deal for an accurate account of the meetings and conversations that must have taken place between Brunelleschi and other artists, particularly Donatello. We have already noted their collaboration in 1415, and Brunelleschi's influence may be connected with the proportions, and their effect upon the expression of *prontezza*, of the St George.

A Crucifix in wood, now hanging in the Gondi Chapel in S. Maria Novella (Plate 17), is traditionally ascribed to Brunelleschi's hand.[23] It might well be the figure referred to in early-sixteenth-century accounts which Brunelleschi supposedly carved in answer to a challenge by Donatello in a private competition. Our difficulty today is to find firm grounds for believing in the historical validity of such later accounts, including Vasari's anecdote, of the contest. It has been acutely pointed out that a 'competition' between two artists is a stock theme from the lore of Antiquity, and might well have been revived to bolster a 'Brunelleschi boom' beginning in the late fifteenth century.[24] On the other hand, there may be a foundation in fact for the anecdote even so, which need have been nothing more complicated than roughly contemporaneous commissions

of Crucifixes from each of the two artists. Donatello's 'rival' Crucifix is generally taken to be that now in S. Croce, and has been usually dated, without documentation, about 1412. This suggests a date of 1410–15, in accord with a perfectly possible interpretation of the data of style, for the piece attributed to Brunelleschi.

The Gondi Crucifix in S. Maria Novella is closely patterned after natural appearances. But it emphatically asserts a standard of pondered proportions established in a taut, virtually mathematical, rigour and in cleanly articulated masses. These elements of style could have influenced Ghiberti's thinking between about 1415 and the Cambio's St Matthew (see again Plate 24).

Precisely in the years when Ghiberti's statue was in gestation, 1418–20, the competition for the dome of the cathedral brought together Brunelleschi with several sculptors – Ghiberti, in the first instance, and also Donatello and Nanni di Banco. In addition to the 'optical' approach in sculpture adopted for a time by Donatello and the 'plastic' approach of Nanni di Banco and Quercia, there was also room in Tuscany for an 'architectural' approach. Here was sought an expression of structure in space, equilibrium of clearly differentiated parts, and mathematically established proportions.

Too rigorous divisions between these three categories should probably be avoided. There was apparently interchange between the three attitudes, and their boundaries were far from impermeable. Even in Donatello's early visual projection in sculpture, it is difficult to avoid, as we have seen, the evocation of Brunelleschi's name. One may concede that Brunelleschi's influence as an architect could have played a part in the setting for Donatello's St Louis of Toulouse. Conversely, when Brunelleschi's dome was finally raised – 'large enough to cover the whole people of Tuscany with its shadow', in Alberti's superb phrase – its first effect, to the eye and mind, was sculptural.

To a large extent the developments between 1410 and 1420 in sculpture were concerned with the relation of exterior effects to the suggestion of interior life and overall meaning. This relationship was sought by different artists always in differing ways, even in comparable circumstances of programme. However varied, this was the artistic background for Leonardo Bruni's definition of sculptural style which he made at the time of the allocation of the Old Testament doors for the Florentine baptistery in 1424 (see the Introduction, p. 3): *illustri* (that [the work] may appeal to the eye) and *significanti* (that it may have import worthy of memory).

More than any other single statement, this appears today as a key to the style in the process of gradual formation up to approximately 1420. For the word 'style' at this point one can hardly invoke the meaning of a set of strictly formulated characteristics. The meaning here must approach the early-eighteenth-century lexicographer's usage as denoting a recognized and recognizable 'mode suitable for the production of beautiful and skilful work' – suitable also, one must add, for public function in the spirit of an age that was itself beginning to seek in earnest its own identity and definition.

PART THREE

DEFINITION, 1425–35

IN 1424/5 Ghiberti's first baptistery doors were finished and in place, only temporarily as events were to prove, in the position of honour on the building's east face. Just as the competition for the choice of their sculptor opened a chapter in the history of art, so their completion closed one phase of an exceptionally vigorous development in sculptural style and ushered in another.

The fact of the commissioning of the final baptistery doors in the same year, 1424/5, did not have immediate results of historical interest. Ghiberti, who received the second commission without question of a rival, modified the schema of imagery provided by Leonardo Bruni at least twice, and did not move on the actual work on the reliefs until some eight to ten years later. From the point of view of the history of art, Ghiberti's second doors belong to the middle of the 1430s rather than to the mid 1420s. About 1425, at the beginning of another crucial decade in the development of Renaissance sculpture, the direction of invention, both in bronze and marble, was given in two quite different programmes, one in Florence and the other in Siena. The first was the monumental tomb erected inside the Florentine baptistery from about 1424 to 1427, on the design and workmanship of Donatello, Michelozzo, and their recently founded shop, to perpetuate the memory of the schismatic Pisan pope who had taken the name of John XXIII.

The Coscia Monument: Definition of the Florentine Wall-Tomb of the Quattrocento

Baldassare Coscia, for a time known and accepted by a faction of the Western Church as John XXIII, died in Florence in 1419, just four years after his deposition at the Council of Constance. He left in his will the expression of his wish to be buried among his supporters and sympathizers in Florence. In 1421 his executors, who included in their number Giovanni Averardo di Bicci de' Medici, reached an agreement with the Calimala for permission to have him buried in the heart of the city in the baptistery, dedicated to the saint whose name he had taken when he believed he had been elected pope in 1410. The executors of his will had at first in mind a chapel in the baptistery, but so great an interference with the spatial unity of that great interior was not likely to be justified. In the end, at what moment we have no way of knowing, a wall-tomb was decided upon. There is some evidence available that in 1424 work on it had begun,

but there are no documents which provide any hint of the undoubtedly interesting way in which the design evolved to its final form or how, precisely, the labour was divided between the two associated sculptors and their aides.

For a long time and from a period relatively early in the monument's history, it was common talk that Donatello had had the major role in its making. The general scheme of the monument as it was put together is illustrated on Plate 26.

Under a curtained canopy of marble simulating cloth, between two huge columns which form part of the baptistery's own impressive architecture, is seen in marble the demi-figure of the Virgin holding the Child against a shallow shell-niche of classical design. Immediately below her, and still at a considerable height, is the recumbent form in bronze of Coscia himself, stretched out in full pontificals, just as his body was undoubtedly shown in state at the time of his death. The bier is supported by two lions imitated by different hands from an Antique model, very likely from a porphyry original still preserved as a stair-post in the Palazzo Capponi (then Palazzo Uzzano) in Via dei Bardi. Below the effigy is a narrow zone carrying an inscription which includes the famous controversial phrase 'quondam papa', written in splendid Roman capitals on a scroll held by two seated and winged putti, carved in marble. Just below between four corbels is the papal coat of arms flanked by the Coscia arms. Still lower, in niches between pilasters, are marble figures in half-relief of the three Christian virtues. Below them, finally, a plinth carries festoons of fruit between winged cherub's heads, all in low relief and in marble.

This prosaic enumeration of the elements of the Coscia tomb is justified for two reasons: it may serve to point out the variety and copiousness of the motifs and imagery; and it may help to emphasize the clear and direct way those elements are put together. There is no confusion or interlarding of the parts here. Though necessarily vertical in its main impression, because of the narrow space allowed between the columns, the total scheme inspires a feeling of a truly classic balance because of the horizontal accents and the symmetrical disposition of all the elements around a central vertical axis. Here the innumerable smaller details taken from classical sources find a harmonious home. So successful was the solution of the very awkward programme, and so intriguing the mixture of the varied elements, that the Coscia monument became the model for the Quattrocento wall-tomb whenever an elaborate or particularly impressive expression was wanted. The main elements of Donatello's and Michelozzo's definition of a new type can be followed plainly in differing variations right to the end of the century (see Plates 59, 72, and 91). They can be traced still farther into the sixteenth and possibly seventeenth centuries.

Michelozzo's fruitful intervention in the architectural aspect of the final solution of the Coscia monument must probably be acknowledged today, though perhaps not without some debate.[1] It would seem natural enough that he would have left Ghiberti's shop after his part in the completion of the first doors was over, to join forces with his new 'compagno' primarily in order to help with the formidable architectural problem presented by the programme of the Coscia tomb. More surprising, though, in view of the older guide-book opinion mentioned above, is the dominant role accorded by

modern scholarship to Michelozzo right from the planning state in the execution of the monument as a whole. Michelozzo here makes his first generally recognized appearance as a sculptor in stone. All three marble Virtues, as well as the very impressive marble Madonna and Child, seem to be quite definitely by him, and the left-hand putto in the inscription-zone should be attributed to him also. An assistant or assistants, as yet unidentified, worked on the remainder of the marbles. Only the bronze effigy is to be attributed to Donatello. But this piece in itself is a major contribution and at the end rivets one's attention to the exclusion of all the rest of the monument. The cast is technically superb, powerfully as well as beautifully chased; the characterization, moreover, of the dead prelate is a triumph of creative portraiture. The subject was as forceful as he was in many ways unpleasant, and Donatello's recreation of life-in-death vividly brought into being an extremely difficult characterization in the head: 'heavy-lidded', as it has been recently and aptly described, 'porcine, yet even in death still twitching with animal energy and animal appetites'.[2] Donatello's newly formed interest in the capabilities of bronze which the Coscia effigy dramatically underlines was to have another, yet closely related, outlet in the second of the two great programmes of the mid 1420s, which we are now about to examine.

The Font of the Siena Baptistery: Ghiberti, Donatello, and Quercia and the Bronze Relief

We must go back to the year 1416 to find the beginning of the programme for the monumental font which stands in the centre of the baptistery in Siena. In that year the Sienese consulted with Lorenzo Ghiberti and several marble-workers on the problem of designing a marble basin for the new font. A year later, in 1417, after an exchange of visits between Florence and Siena, a model was prepared. It was rapidly approved, and as a result a novel scheme, apparently born in Ghiberti's inventive mind, was accepted for action. The great novelty of this scheme, at least for Italian practice, capitalized on Ghiberti's own speciality. This was to introduce reliefs of bronze rather than of marble into the sides of the hexagonal basin, which was to rise directly from a low-stepped base, in turn resting on the pavement of the church. Bronze statuettes were probably at this time also suggested to soften the angles of the hexagon. Above, in all probability, was to be a secondary upper basin in bronze, set upon a column, reminiscent certainly of the general scheme of the Nicola Pisano fountain in Perugia. At the junction of the scalloped edges of this second basin were presumably to be little bronze putti in attitudes of joy or praise. On a lighter column rising on axis from the upper basin was to stand, surmounting and commanding all, the figure of the Baptist, doubtless in bronze likewise.[3]

The upper portion of this first version of the font seems to have been left in the planning, or model, stage. But the reliefs for the principal, or lower, basin, on subjects of the Baptist's life, six in number, were allocated as early as 1417. The reliefs were to be submitted for approval to the cathedral authorities when cast and when finished, that is to say fully chased. They were then, and only then, to be gilded. Two of the reliefs,

including the prize plum, the Baptism of Christ, were to go to Ghiberti. Two were to go to Quercia, then very busy on the completion of the Fonte Gaia (see above, p. 64). Two, finally, were to go to Turino di Sano and his son, Giovanni Turini, goldsmiths capable of working bronze, of Siena.

The long and complicated story of the progress of the Siena font need not detain us here. Two incidents, however, require attention. The first concerns a delay of some five years on Ghiberti's and Quercia's part in even beginning their reliefs; in 1423 one of Quercia's subjects, Herod's Feast, was taken from him and given to Donatello, who was also to be given, as events turned out, two of the statuettes of Virtues between the reliefs and two of the putti. Thus the decision to get on with the work in 1423 brought in the collaboration of a second Florentine, of quite a different style and temperament from that of Ghiberti or the Turini firm of Siena. The ultimate distribution of the reliefs and statuettes is shown in Figure 9.

The second development concerns Quercia's own contribution. At long last, in 1427, when Donatello's and Ghiberti's reliefs were delivered, he got on to his bronze relief, the Annunciation to Zacharias. Then, between 1428 and 1430, he was put in charge of finishing the font as a whole. It was at this time that the final design of a monumental marble tabernacle came into being, very possibly according to Quercia's idea and from the point of view of style of his own execution, at least, as far as the figures are conceived. The half-relief figures of prophets in their shallow niches derive very clearly in general type from Michelozzo's sober Virtues in niches of the Coscia monument, which was probably finished in 1427 and therefore available to Quercia. But the emotional style of each strongly individualized Prophet is Quercia's own and in the purest vein of his last and greatest manner. The *parti* of his polygonal tabernacle with its domed roofing and lateral niches was to be the model for the classic free-standing altar-tabernacle of the Quattrocento, to be followed closely by Desiderio at S. Piero Maggiore in Florence (now in the National Gallery of Art in Washington), Benedetto da Majano in San Gimignano, and Mino da Fiesole in an elegant, square rather than polygonal, variant in Volterra. By 1434 (date of the bronze tabernacle door on the altar side) the font was at last complete, a remarkably harmonious composition as a whole, in view of the variety of materials and personal styles of the many different artists who over the years had contributed to its making (Plate 27).

The bronze reliefs provide a uniquely useful arena of comparison between the styles of Ghiberti, Donatello, and Quercia in the last five years of the 1420s. For Ghiberti the rectangular, virtually square, field of the relief provided a much-needed step away from the quatrefoil frame, as we have already noted in an earlier chapter. That he should have decided upon this simpler geometric field as early as 1417 (see the account of planning given above) is a fact very much worth keeping in mind. The finished relief of the Baptism, which dates from between 1424 and 1427, tells its story very well from a distance, with its striking composition of the Baptist on one side of the lonely figure of Christ, standing angels on the other with the Almighty, and a heavenly host above. The arm of the Baptist over Christ suggests a natural arch. It is the first of the reliefs, gleaming with its gilt finish in the light provided by the opening door to greet the visitor

as he enters the baptistery (Plate 27). The method of relief-modelling here, which starts with virtually free-standing figures in the foreground and ends like a whisper in the suggested distance in markedly lower relief, is already a presentiment of the system Ghiberti was to use for the second doors of the Florentine baptistery; it is best discussed in detail in the context of that particular programme, which is treated in the next chapter. But one should not fail to note now that its relative simplicity and clarity is in

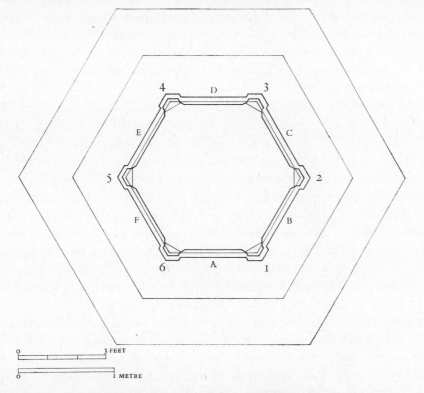

Figure 9. Monumental font, Siena baptistery.
Diagram of plan of base with locations of compositions in bronze gilt

RELIEFS (commission and delivery dates)

A Ghiberti: Baptism of Christ, 1417–27
B Ghiberti and Giuliano di Ser Andrea: St John before Herod, 1417–27
C Donatello: The Feast of Herod, 1423–7
D Jacopo della Quercia: Annunciation to Zacharias, 1417–30
E Giovanni Turini: Birth of St John, 1417–27
F Giovanni Turini: St John Preaching, 1417–27

STATUETTES

1. Donatello: Faith, finished 1429
2. Donatello: Hope, finished 1429
3. Giovanni Turini: Justice, finished 1431
4. Giovanni Turini: Prudence, finished 1431
5. Goro di Ser Neroccio to Quercia's design (?): Fortitude, finished 1431
6. Giovanni Turini: Charity, finished 1431

perfect accord with the flat, planar function of the containing side of the basin which it ornaments, and makes a startling contrast with Donatello's and Quercia's far more complicated solutions which, in turn, contrast almost as violently with each other (see now Plates 28 and 29).

It is worth remembering that in 1423, when he received the commission for Herod's Feast, Donatello was just beginning to work with bronze as a medium. His first bronzes, the St Louis of Toulouse for the Parte Guelfa and the smaller reliquary bust of S. Rossore for Pisa, date in their inception apparently from that very year 1423, and he may well have begun to think about the Coscia effigy at roughly the same time, or very little later. The Siena relief offered an opportunity hitherto unavailable to Donatello, to work in a medium allowing a great deal more finesse and precision of detail than marble, which aesthetically as well as technically responds best to a broader and more unified treatment of planes. This opportunity he seems to have grasped eagerly and used it for experiment in spatial construction, which in its complication and sophistication was well beyond anything that had been attempted by him or by any Renaissance sculptor up to that moment.

The chief part of the sophistication of Donatello's solution of the artistic problem posed by the Feast of Herod, or Salome's Dance as it is sometimes called, does not depend on its 'progressive' use of perspective alone. It consists of a triple relationship, suggested rather than baldly stated, between (1) the pragmatic data involved in actual viewing of the relief in place (the so-called 'giudizzio dell'occhio') with (2) the pseudo-mathematical data of a more absolute kind involved in the early use of the one-point perspective system, and (3) a use of both to heighten the emotional effect already inherent in the subject. This centres on the grisly presentation of the Baptist's head on a food-salver to Herod and his councillors while Salome dances and the head is ceremoniously brought in procession from Herodias in the background, with musicians playing solemnly as if it were a course formally being served at a fifteenth-century banquet, such as they were chronicled at the court of Burgundy.

A recent analysis of the Siena relief by Donatello has placed it prominently within the context of spatial developments in late medieval and Renaissance art. There brought out is the fact that the scene is spatially constructed so as to be seen from a close and relatively high viewpoint, a factor which must be related to the relatively low position of the relief on the font – at approximately knee-level. It has also been pointed out that the orthogonals of the incised lines of the floor and members of the ceiling do not meet at a single point of juncture, as Alberti was very soon to insist they should.[4]

Instead there appear to be two 'centric points' one slightly above the other, each precisely equi-distant from the top edge (in one case) and the bottom edge (in the other case) of the frame. It would seem that this symmetrical divergence of vanishing points could hardly have been the result of ignorance or carelessness, or of a deliberate reversion to a Trecento principle, particularly if it is assumed that the St George relief (Plate 21A) of some eight to ten years earlier was based on firm, if still rudimentary, knowledge of the principle of one-point perspective.

What is the reason for the discrepancy? Is it that Donatello could conclude that a markedly downward direction of vision would tend, as the surface of the relief met the eye in a foreshortened plane, to bring the two separate points together in the observer's mind and thus produce a 'correct' effect, where the single point would only produce a somewhat distorted 'foreshortened' effect? Or did he count on an effect of conflict

which might arise because of the divergence of perspective points precisely where, in a 'normal' view of the harmony of nature, they would coincide at one 'centric point' in the aesthetic which Alberti was to preach in the 1430s? The argument in favour of 'unnatural conflict' has a powerful buttress certainly in the classically unnatural, indeed blood-chilling, subject which the age of Freud and the generations of Wilde, Hofmannsthal, and Richard Strauss knew well enough how to present in other than sculptural terms. A double vanishing point, but on the same horizontal, rather than the same vertical axis, occurs in Uccello's Flood in the Chiostro Verde of S. Maria Novella. This has been explained, not too convincingly, as related to binocular vision.[5] The plain fact in the fresco, however, as in the relief of Donatello's Herod's Feast, is the 'unnatural' event portrayed and the emotional conflict that it deservedly should cause in the observer who could be expected to come to the work of art, much as we in general do today, with a benign world-view of human existence predicated on a logical sequence of cause and effect in the realms both of nature and of theology. The inference is that subject matter dealing with the collapse of natural law and divine goodness alike *should* be a jolt and *should* give rise to tensions. The effect of tension would well be carried out in Donatello's Siena relief not only by a stretching of an interval between two points which should be one, as well as by the strident divergence of the figures in the foreground, but by the very marked compression of the layers of volumes of the background space. This feeling of compression seems to build up a force which, when released, adds a still greater impact to the explosive effect of the foreground action.

Within this new sense of a totality of space constructed on the basis of tension rather than of harmony, everything else falls into place. Surfaces carefully and elegantly worked vie tirelessly with effects of depth for attention. Diagonals into depth are constantly cut by conflicting horizontals. The brilliant effect of light falling on the smooth, polished gold of the dominant foreground planes is counteracted by the broken light of the middle distance and by the mysterious shadow which falls like a curtain of opaque darkness over the upper portion of the relief as a whole and creates a unified volume where all else is cut up into fragmented parts. Any one formal or spatial tendency seems to be negated immediately by a varying or contrary device. The result is that we seem at the last to be left with choices that we cannot articulate and reactions that we cannot rearrange into normal patterns of experience. Our groping eyes and minds are constantly led back to find new clues to understanding, as the artist probably hoped they would be, into the work of art itself.

Quercia's Annunciation to Zacharias has in common with Donatello's Herod's Feast the architectural setting, which both *istorie* admittedly required. There is also a similar effect of shadow at the top suggesting an immeasurable volume between the frame and the architecture behind it. The scale of the figures in relation to the architecture and to the frame of the composition as a whole is similar again. Both reliefs, too, suggest stage-settings rather than a section of space taken out of reality. But once this point in the comparison is reached, resemblances begin to fade fast.

Quercia, according to his earlier practice, seems quite deliberately to have avoided any effect whatsoever which might suggest one-point perspective. His figures move

in a non-perspective space. His architecture is built on parallel diagonals, not on convergent orthogonals, and seems to recall, even beyond the Romanesque in time, a kind of pre-Roman, pseudo-Etruscan antiquity.[6] The figures come from a more heroic, less nerve-wracked human stock than Donatello's. They seem for many reasons, dependent on modelling as much as on proportions, to weigh more, to be larger and somehow more impressive, though less intelligent, than Donatello's more sensitive and fragile actors. They obey mysterious inner rhythms that determine a slower-moving tempo in the narrative. Tensions here relax. Untapped forces capable of immense power, if and when they might be released, are suggested.

Whereas Donatello's complex composition was to bear a close and vital relation to developments in both Quattrocento painting and sculpture, as Masaccio's contemporary Trinity suggests and Benedetto da Majano's reliefs on the pulpit of S. Croce of some fifty years later attest (Plate 106), Quercia's relief finds no such companionship. Its style seems to skip the remainder of the Quattrocento. The only fifteenth-century analogy is in Quercia's own work of approximately the same time in Bologna. It was there that the young Michelangelo was to discover the power of Quercia's last phase, which through Michelangelo's transformation of its influence was destined to affect profoundly the vision of the High Renaissance.

The Epic Style, I: Monumental Statuary and Relief in an Architectural Setting by Quercia at S. Petronio in Bologna

In 1425 Jacopo della Quercia signed a contract to design and execute the central portal of the church of S. Petronio in Bologna. Though the huge façade of S. Petronio had been begun late in the Trecento (see p. 22 above), work had not proceeded above the dado-like plinth. The challenge was enormous. Quercia came to this assignment from the triumphant conclusion of the Fonte Gaia, a programme which occupied very much the same central position in the urban space of Siena that the main portal of S. Petronio still holds to this day in Bologna. Humanist sculpture in such Italian settings does not merely decorate architectural surfaces in the public eye. It serves to incarnate in stone a whole ethos of being and action within the city–state; it assumes, in visual terms, the function of the literary epic.

In the contract of 1425 there is a reference to a drawing prepared by Quercia, as the original design for the portal. This visual evidence is lost, but the wording of the contract contains enough information to reconstruct the elements of the programme conclusively. On the lintel there were to be three scenes concerned with the birth and infancy of Christ; above, in the lunette, were to be statues of the Virgin and Child, of S. Petronio, the city's patron, and of the pope presenting his legate (kneeling) to Bologna; above in a frontispiece was to be an Ascension of Christ in relief surmounted by a representation of Christ on the Cross; flanking finials were to support statues of St Peter and St Paul; in the arch and down the vertical supports there were to be no less than twenty-four prophets, and on the faces of the pilasters supporting the lintel fourteen scenes from the Old Testament, seven to each side flanking the entrance.

Some of this scheme seems to come from the Porta della Mandorla in Florence which was analysed earlier (see Figure 1), and the arrangement of four figures in the lunette, one of whom is shown kneeling, has still earlier precedent in North Italy.[7] The imagery has not been fully unravelled, but there is one level of meaning which can be accepted, I think. It underlines the preparation of the world in Old Testament history and prophecy for the coming of Christ, and it suggests briefly His sacrifice in order to concentrate on the founding of the Church in Rome (Peter and Paul) and its meaningful continuation into the 'present' of the fifteenth century, in its leadership symbolized by both a Roman pope (Martin V) and his spiritual and diplomatic representative in Bologna (the city of S. Petronio).

It is necessary to sense the topical aspect of the message carried by this imagery in order to understand the second and determinant stage in the history of the portal. In 1428 there was a sudden and unexpected turn of events. A citizens' uprising in Bologna ejected the papal legate in somewhat the same unceremonious way as the Venetian Pope Eugenius IV was to be thrown out of Rome itself in 1434. A significant part of the original imagery, therefore, of the portal became obsolete in 1428, at least as far as the immediate present and foreseeable future were then concerned. A change in the statuary-programme was urgently required, and it would appear that a new contract, or at least a serious modification of the first contract, was drawn up in 1428. This provided for the elimination of the figures of the kneeling legate and the pope intended to stand at the Virgin's right hand and the substitution of a single figure to balance the S. Petronio on the Virgin's left. It is a fair inference from stylistic as well as iconographic data that St Ambrose (ultimately carried to completion early in the sixteenth century) was the subject selected. At the same time, it would seem, the Old Testament scenes in relief in the jambs were reduced from fourteen to ten, and the scenes of the birth and infancy of Christ on the lintel were expanded to the number of five.

Before 1428 Quercia had been busy collecting coloured marbles and Istrian as well as Apuan marble for the portal, as we know from a number of published documents. Because the Christ Child of the central group of the lunette turns markedly downward and towards the Virgin's right, it must be presumed that Quercia had already well begun, if not actually finished, the Virgin and Child for the lunette; for only the planned presence of the statue of the kneeling legate would account for this particular placing of the Child.

The recent discovery of more documents and the identification of a visual source for the scheme of 1428 among the Renaissance drawings for the completion of the façade of S. Petronio throw much-needed light on Quercia's intentions and progress on the portal.[8] We know now that by 1434 the statue of S. Petronio was finished and put in place. This means that the lintel had been carved by 1434 and that the Old Testament reliefs on the jambs which support the lintel must be dated before 1434 also. The arch of the lunette was apparently finished structurally by the time of Quercia's death in 1438, but the remainder of the upper portions of the portal as projected do not seem ever to have been begun.

When one realizes that the lintel alone of the portal, as it stands today, even with

some slight modifications in the portal after a rebuilding of 1510, is some thirty feet above the paving below, it is possible to begin to sense the immensity of scale that Quercia's total project entailed. This grandeur of scale, together with the solemn spirit that enlivens the sculpture that has come down to us, deserve for the style evolved by Quercia at S. Petronio the descriptive adjective, 'epic'.

Perhaps the first thought that comes to mind when one thinks of Quercia's fully developed Bolognese style is contained in the phrase 'sculptural power'. And the second which hurries close upon the heels of the first is 'restraint with feeling'. The statue of S. Petronio, who carries a symbolic model of the city of Bologna (Plate 31), may stand for the ideal that Quercia seems to have had in mind at this time, late in a career which had taken him to many different places to cope with many difficult challenges. The mature mind of the sculptor imagined for his S. Petronio a tranquil pose, in evident equilibrium yet very much alive in the athletic body suggested beneath the full and active drapery. The drapery is very important. It is not so much drawn, as one senses it in Michelozzo, for example (Plate 34), as it seems to grow into form plastically under the action of the vigorous hand-and-arm-power of direct modelling. If the marble figure evolved from a model in wax – a matter which cannot be either confirmed or denied today – it is certain that the translation into the final stone did not sacrifice either monumentality of scale or elasticity of modelling in the complex convolutions of the drapery. Can one call this drapery 'Gothic'? Does it not in fundamental ways differ both in effect and function from the drapery, let us say, of a Sluter and his followers? The head, which appears 'realistic', is also related to Late Antique expression and type. It is not descriptive of age alone; it also bears the marks of the experience of living and suffering as a human being. The vital forces within the figure seem to flow in restrained circulation rather than to pulsate excitedly or to push towards a release. The full power is latent. Though partially concealed, it is none the less present.

The Old Testament (Genesis) reliefs are generally better known than the statuary of S. Petronio. In the New Testament reliefs of the lintel, Quercia seems to have gone back to the inspiration of the related earlier monumental, yet emotion-laden, style of Nicola Pisano at his grandest in the Pisan pulpit.[9] The supporting architectural function of the reliefs on the jamb-facings set a different formal problem, and here Quercia reached more obviously original conclusions. Let us take one relief to stand for the series (Plate 30).

The landscape-space is abstracted very much along medieval principles, but the undulation of the surface and the precise way in which the rocky elements of landscape yield gently to accommodate freely the figures has no obvious medieval prototype. The closest analogy is perhaps the far less subtle landscape-relief of the dalle Masegne in one of the panels of the high altar in S. Francesco in Bologna (Plate 1A), which Quercia must have known from his youth. The relief of the figures which occupy, as they do generally in all his Genesis series, the foreground and nearly the entire height of the panel is relatively full. But rarely do the figures lose contact with the ground by undercuttings or jutting projections. In Quercia's developed system the surface-value is not maintained by stretching or tension against a suggestion of depth, but

instead by a continuous movement of light rippling over each rectangle as a whole. While the technique is clearly that of the flat chisel, handled with extraordinary sureness, the reliefs might easily be thought of as transpositions of repoussé metal.[10]

The Genesis series starts at the top of the left jamb (as the observer looks at the portal) and goes down in order, from the Creation of Man to the Labours of Adam and Eve; on the right jamb, the series continues with the Sacrifice of Cain and Abel, passes through the Story of Noah (Plate 32A), and ends at the bottom with the Sacrifice of Isaac, which of course provided the clear typological bridge into the New Testament material in the lintel and planned frontispiece above. Given the importance of the subject of the Church in the original programme, Eve is understandably given a prominent role in the first, left-hand reliefs. The Creation of Eve, chosen for illustration here (see again Plate 30), is one of the handsomest and most impressive of the series. It marks a clear departure from the Fonte Gaia 'sarcophagus-style', much undercut relief of the same subject, and is pervaded by a gentle, almost lyrical, emotion. As the body of the first man is made to yield a second body, the tree behind him divides in two. As Eve is drawn up to a standing position by the powerful grasp of the hand of her Creator she looks askance at her own hand, by which, as a human, she must learn to make her way in the world.

It seems hardly credible that Quercia alone should have been able to carve the considerable quantity of sculpture that the portal, even in its incomplete state, contains. He is known to have had a shop of assistants, but what precisely were the personalities of his helpers and to what extent they were permitted to take artistic responsibility for work on the portal are questions which have as yet no answer. One has the feeling that Quercia, particularly as he grew older and took on responsibilities of an administrative order both at S. Petronio and in connexion with Siena Cathedral, did not easily take to assistance in executing his own creative ideas in sculpture. There seems to be evidence of shopwork in Bologna on other commissions such as a fairly large, but dull, funerary monument in the church of S. Giacomo, and a small, but weak, tabernacle (now Bologna, Museo Civico), but there is relatively little obvious shopwork on the S. Petronio portal. The portal seems to have been considered the master's own. After 1430 he was of necessity, according to the pattern of divided attention which had always plagued him, drawn frequently back to Siena from Bologna. He was more financially than really artistically involved in the programme of the Casini Chapel in Siena Cathedral for which a sculptural memorial to the founder, Cardinal Antonio Casini, was planned. Part of a lunette with a Madonna and the cardinal on his knees with his patron saint behind him survives in private hands in Italy. The motif is strikingly similar to that planned in 1425 for the lunette of the S. Petronio portal in Bologna. The fragment for the lesser Siena programme represents one of the last extant works upon which Quercia's own genius, though there only too obviously unconcentrated, was stamped.[11]

*The Epic Style, II: Last Statuary by Donatello for the Florence Campanile;
Michelozzo and the Brancacci and Aragazzi Monuments; Interlude in Rome, 1431–3*

The Genesis reliefs of the S. Petronio portal provide a final confirmation, if one were still needed, of the gulf separating the formal aims of relief that were held by Quercia on the one hand and Donatello on the other. At the time that Quercia must have been at least sketching out his S. Petronio reliefs in his mind, that is by 1430, Donatello had probably just completed his masterpiece in marble relief: The Giving of the Keys to St Peter, a subject which he associated with the Ascension (since 1861 in the Victoria and Albert Museum; Plate 32B). The long, narrow shape of the relief suggests a predella, and it has been brilliantly posited that the marble was intended for the altar of the Brancacci Chapel in the Carmine in Florence,[12] where Masolino and then Masaccio had been working between roughly 1420 and 1427 on the frescoes of the vault and three walls. The subject-matter of the relief clearly is in harmony with the painted imagery, which is devoted largely to the story of St Peter. But the style is also in harmony with the surroundings. A shallow *stiacciato* handling of the pure crystalline marble surface, intact and glowing in its unweathered state, approaches the subtlety of painting. The atmospheric effects of distance, working with diminishing sizes of trees and clouds, carry the illusionistic devices of Donatello's St George relief (see Plate 21A) a step further in the direction indicated very clearly by the background of Masaccio's Tribute Money on the east wall of the chapel.

But the Brancacci relief, which is what it should be called, is in a semi-private mode; its scale is as delicate as its modelling. Donatello's public work in a more 'epically' conceived style in the decade 1425 to 1435 is better seen in his statuary, for which two examples are particularly indicative of the trend of his own researches into form and expression at that time. These are the two latecomers to the north face, originally, of the Florentine campanile, already mentioned in connexion with the campanile campaign that began in 1415. The two statues in question are probably the best known of all Donatello's statuary after the St George; they seem to owe nothing to any hand or mind other than his own.

The first (Plate 33B) was begun in 1423 and was finished just about at the time the partnership with Michelozzo began in 1425. It is the famous 'Zuccone' or 'Pumpkin-head', as it was early nicknamed by the irreverent Florentines in reference to the strikingly bald head. For years it was considered to be a representation of the Prophet Habakkuk. But more recent reconsideration of the documents relating to it point conclusively to an identification as the Prophet Jeremiah.[13] The large sweep of the mantle leads the eye up to the haggard face, with great pools of shadow defining the eye-sockets beneath the furrowed brow. The expression is that of a sorely troubled and yet probing vision, and the depth and sharpness of the modelling underline the intensity and psychological depth of this 'portrait' of the tragic genius of prophecy. Later anecdotes suggest that Donatello looked on this statue as a major challenge to his art and that he considered it his own challenge to current criticism. One of his favourite ironic mock-

oaths was supposed to have been 'By the faith I have in my "Zuccone"!' No other sculptor in Italy at the time could have possibly approached the subtlety of Donatello's combination of feeling and monumentality that is revealed here. When a follower of Quercia's, Giovanni da Imola, imitated Donatello's mannerisms of composition, as for example in one of the wooden statues of a group from Quercia's studio preserved in S. Martino in Siena, he missed the psychological pathos completely, and, in working towards an effect of power, achieved only a kind of blustering impressiveness (Plate 33A).[14]

By 1427, in view of the endemic war with Milan which had once more broken out in epidemic proportions, the consuls of the Arte della Lana, in agreement with the Operai of the Duomo, had called a temporary halt to payments for statuary for the cathedral. Exception to the cease-work order was to be made in the case of statues that had already been ordered and started but were still unfinished.[15] The exception must have seemed necessary because of the second of the two prophet-statues for the north face of the campanile which Donatello had begun by 1427, probably immediately after the relief of Herod's Feast was off his hands. This was the Habakkuk of the Duomo documents, which used to be known, erroneously, in the literature as a Jeremiah (Plate 35B). Though begun in 1427, the statue was not completed until 1435.[16] The reason for the unusual eight-year period of gestation was Donatello's removal, with his 'compagno' Michelozzo, to Rome for a stay of nearly three years over the period 1431 to 1433. We shall turn shortly to a consideration of the reasons for this Roman visit and the effect which it had on Donatello's and Michelozzo's development as artists. In the case of the Habakkuk, when Donatello was able to resume work on it in 1434/5 after his return to Florence, it would seem that he put into it an increase of power in modelling and a slight shift of massing in favour of more Albertian proportions as compared with the earlier Jeremiah. The glaring, stubborn expression of the head betrays a more overt, less inward, psychological attitude, in harmony, it should be said, with the picture of the resentful and courageous man of God suggested by the Old Testament text of the *Book of Habakkuk*. The nickname given the statue by the Florentines in homage to its rough and unkempt appearance was 'Il Popolano', an epithet corresponding to the mood of Florence on the overthrow of the Albizzi 'aristocratic' rule in 1434, which made possible the return of Cosimo de' Medici from exile and the beginning of the long-lived Medici-controlled 'democratic front' right to 1494. Both statues, together with their two companions of an earlier date, were moved from the more obscure north face of Giotto's campanile in 1464 to the well-lit east face. From this vantage they were to look down upon the square to which the doors of the cathedral façade and the main doors of the baptistery open – in other words, upon the spiritual centre of the city.

In his tax-return (*Portata al Catasto*) of 1427, one of the major sources of our knowledge of the partnership between himself and Donatello, Michelozzo mentioned specifically two funerary programmes outside Florence for which he and his partner had accepted commissions and upon one of which a good deal of work had already been done.[17]

The first of these programmes was the monument of Cardinal Rainaldo Brancacci,

who seems to have ordered his tomb before he died in 1427. He was to be buried in Naples in the church of S. Angelo a Nilo (known in the Renaissance as S. Angelo a Seggio di Nido), which he had founded in 1385. Whether because of Donatello's connexion with the Brancacci branch in Florence or not, the commission was not a surprising one. The reputation of the Coscia monument had probably already begun to circulate throughout the peninsula; it was Rainaldo Brancacci, moreover, who had crowned Coscia pope. And since 1420 perhaps, as we have seen on an earlier page, there had been Florentine sculptors in Naples who had been working on the immense monument of King Ladislas in the church of S. Giovanni a Carbonara. By 1426 Donatello and Michelozzo had moved temporarily to Pisa, where the marble components of the Brancacci monument were to be carved and from whence they were to be shipped to Naples. Thus the commission must have been settled by the early part of 1426 or in the previous year. The design as executed shows a scheme based on the type of the Neapolitan Trecento tomb which Tino di Camaino had probably been responsible for bringing to Naples from North Italy and Tuscany and popularizing there in the first place before 1315. The essential characteristic of the type (Figure 10) is that the sarcophagus is raised and made to seem to rest on the shoulders of three caryatid-figures often given the attributes of Christian Virtues. The Madonna with the Child in half-length, as in the Coscia tomb (but here flanked by two saints), is placed above the effigy, which in turn rests on the sarcophagus. Its face is decorated by a relief of the Assumption of the Virgin flanked by the cardinal's arms. Above in the frontispiece, in a deep roundel, is the demi-figure of God the Father flanked by nude putti-angels blowing the trumpets of the Last Judgement. The impression of the monument as a whole is one of a mixture. Some motifs were clearly taken from revived classical sources, others, in programme at least, belonged to the fashion of the Trecento. The clearest example of this kind of mixture is shown on Plate 34, where the medieval motif of an angel holding back a curtain is put into sober, classicizing forms immediately adjacent to a strongly classicizing pilaster and capital. At the angel's feet is the vividly modelled head of the cardinal, taken, it would seem certain, from a death-mask. Every part of the marble sculpture, except for the small relief of the Assumption (by Donatello) and the demi-figures and trumpet-blowers (by an assistant), seems to have been done by Michelozzo, whose personality emerges here very much more strongly than in the Coscia monument.[18]

His masterpiece, the second monument mentioned in the *Catasto* of 1427, was the tomb of Bartolommeo Aragazzi, erected about 1438 in the Duomo at Montepulciano. Bruni in a letter to Poggio Bracciolini describes how he met on the road some of the components of the Aragazzi monument, including the effigy, when they were being transported to Montepulciano from Florence about the year 1430. Thus some of the monument's elements must date from before the stay of both Donatello and Michelozzo in Rome. Others, as in the case of the Habakkuk earlier discussed, must have been either finished from 1434 on or even in some cases begun after 1434.[19] The Aragazzi monument has unfortunately been dismantled; its parts are scattered – from the Victoria and Albert Museum to various parts of the cathedral at Montepulciano including the high altar (Plate 35A). Reconstructions of the original design are questionable; but there is no

question as to the hand and quality of the parts of the monument that have come down to us. This is where we may touch most surely the combination of icy neo-classicism *avant la lettre* and warm human emotion that characterizes Michelozzo's personal and often admirable style (Plate 36B).

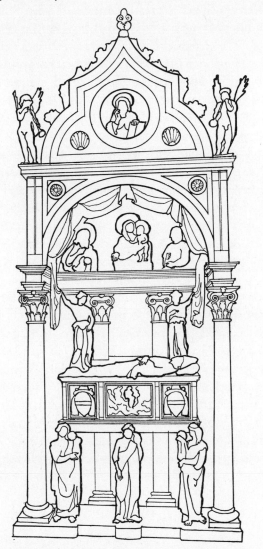

Figure 10. Michelozzo and Donatello: Brancacci Monument, 1426–30.
Naples, S. Angelo a Nilo. Emplacement of sculpture (from a photograph).
Figures to scale of life

This is probably the best place to discuss briefly the Roman stay of Donatello and Michelozzo. The reasons for their going are still not at all clear. In 1430 they had been drawn into the siege of Lucca by the Florentine army, and it has been suggested that they went to Rome in that year to avoid 'further unpleasantness'.[20] Certainly there was no dearth of work in their shop in Florence, even though the Duomo workshops were

still, in 1430, closed down. There must have been some positive attraction: perhaps work in marble for Martin V, who was to die in 1431, perhaps in bronze (doors of St Peter's, Martin's own tomb?). Once in Rome, opportunities might certainly have opened up very rapidly. A marble tabernacle, which first clearly defines the Early Renaissance wall-tabernacle type, is preserved in the sacristy of St Peter's and shows Donatello's design and in part his hand. The role he and Michelozzo might have taken in the tomb of Martin V is discussed below (pp. 115–16). Vasari wrote that Donatello was employed by the new pope in the making of decorations connected with the coronation of the Emperor Sigismond. There is in fact good evidence that, once in Rome, neither Donatello nor Michelozzo wanted very much to leave, and in 1433 a special deputy had to be dispatched on behalf of one of their patrons in Tuscany to fetch them home.

From the point of view of the general history of sculpture in Italy, this particular Roman sojourn had very obvious repercussions of great historical importance which we shall examine in due course. The impact on Donatello and Michelozzo is far less obvious, and open to quite a broad range of opinion. We are limited here to a few suggestions rather than to a detailed exposition of the results of the stay as far as our two Florentine sculptors are concerned. One suggestion that must be made is the possibility of frequent meetings and the development of a friendship between Donatello and Alberti. Out of this contact may have arisen a new realization on Donatello's part of the place of proportions and of the module in a revival of the principles of the Ancients, and Donatello's practical views are not to be discounted in considering the genesis of Alberti's book *De Statua*, which seems to have been written while Donatello was in Rome, as brought out earlier in the Introduction (see p. 8). Out of such discussions of theory could best have come Donatello's essays in the application of a modular system of proportion in the 1430s on his return to Florence (Table 3): one in marble (now in the National Gallery in Washington) and the other in bronze (now in the Bargello), and both on the subject of the adolescent David.[21] There seems to have been a psychological as well as purely stylistic break from his earlier development on Donatello's part, that coincides with his Roman visit. In the case of Michelozzo his earlier, more than latent classicism seems to have been reinforced.

MEASUREMENT FROM GROUND	CANON OF *DE STATUA*[*]	DONATELLO'S MARTELLI DAVID	DONATELLO'S BRONZE DAVID
To ankle-bone	3 degrees	3 degrees	3 degrees
To knee-muscle	1 foot, 7 degrees	1 foot, 7 degrees	1 foot, 7 degrees
To groin (*os sacrum*)	3 feet	3 feet	3 feet
To waist	3 feet, 7·9 degrees	3 feet, *c.* 7 degrees	3 feet, *c.* 7·5 degrees
To sternum	4 feet, 3·5 degrees	4 feet, 3 degrees	4 feet, 3·5 degrees
To Adam's apple	5 feet, 1 degree	5 feet, 1 degree	5 feet, 2 degrees

Table 3. Proportions in Donatello's Martelli and bronze Davids

* In Alberti's proportional 'exempedum system' appended to *De Statua*, the body is divided theoretically into 6 'feet', each foot in turn subdivided into 10 'degrees', and each 'degree' into 10 'minutes'. The module is taken as one 'minute', or 1/600th part of the total height of the body. Only a few selected key internal height-measurements are included here; the total number of measurements used by Alberti for his canon comes to no less than 60 (equal to the number of 'degrees').

The 'Singing Galleries' in Florence Cathedral and the Problem of presenting Continuous Action in Relief Sculpture; the Emergence of Luca della Robbia

Even before going to Rome, Donatello had given evidence of interest in the possibilities of presenting action in a succession of stages in a continuum in time rather than taken out of a continuum and highlighted, as in the concept of *istoria*, as an occurrence of a moment or two. This is seen in his bronze relief for the Siena font (Plate 28), which set forth a narrative consisting of several events in a system of superimposed, or more accurately 'subimposed', bands with the direction of action alternating between right-to-left (far background strip) and left-to-right (middle distance strip) to end in right-to-left again (high-relief zone of foreground). The use of three concurrent action-strips does not mean necessarily that Donatello was a 'medieval' artist. Though a continuous narrative with more than one event shown in a single pictorial frame was very frequently used with evident enjoyment by medieval artists from the period of the Vatican Virgil well into the fifteenth century, the problem of continuity in the visual presentation of an action in art involves the still larger philosophical problem of formulating the nature of time, and can hardly be pigeon-holed in any single style, period, or era of history. Actually in Rome itself, the major single source of Antique motifs for the Renaissance relief-style, apart from sarcophagi, was a classic example of the sculptural presentation of action in continuity: the spiral strip-relief of the Column of Trajan, which by 1450 was one of the tritest of the several symbolic landmarks used by painters in Early Renaissance representations of the Eternal City. Its sculpture was in fact, as will be seen in a later chapter, a mine of motifs and style for Quattrocento sculptors working in Rome or associated with Roman workshops. The Antique art of the column is reflected in Michelozzo's post-Roman work more obviously than in Donatello's; the latter must have pondered the more general problem of presenting sculpturally the continuity of events in time rather than binding his imagination to a limited use or re-use of any specific image or motif.

The artistic question of how to present continuous action arose in Florence in connexion with the programme for the organ- or music-lofts, or the 'Cantorie' as they are generally rather inaccurately called. This was formulated in 1431/2, while Donatello and Michelozzo were still away in Rome. They were to find the question very much a live one on their return.

In 1431 the lapse of three years since the edict of 1428 allowed the Consuls of the Arte della Lana and the Operai of the Duomo to lift the ban on new sculpture for the cathedral. At that moment it was decided to shift the earlier emphasis on the sculptural decoration of the façade and campanile to a new campaign of sculpture for the interior, and more especially the eastern portions connected with the cult. The reasons for this shift, from which the already snail-like progress on the façade-sculpture never recovered, are not all clear, but it should be recalled that the dome was in 1431 already very near to being closed and the space beneath it in the choir soon to be freed completely for liturgical use. Connected prominently with the decision were certainly plans for the

91

consecration of the huge church, which was scheduled for the Feast of the Annunciation, 1436.

In 1432 a competition was held for a new and more fitting reliquary for the head of St Zenobius, the city's historical male patron saint. The competition was won, once again, by Lorenzo Ghiberti. But the splendid bronze shrine, one of Ghiberti's finest accomplishments ('insigni ornatu' as the inscription stated), to be placed in the central easternmost chapel, where it still is today, was not complete until 1439/40. It was only then, with the pope at Florence for the Ecumenical Council transferred from Ferrara, that the consecration actually took place (see for a reference to the event Plate 15A). High also on the list of agenda drawn up by the Operai in anticipation of the consecration was a new organ, ordered from Prato, and two organ-lofts which might also be used for other small instrumental groups or small singing groups. One such loft which actually did receive an organ in the fifteenth century was planned to go over the door to the north sacristy ('delle Messe') and a companion gallery was agreed on to go over the opposite door to the south sacristy ('dei Canonici'). Work began on the north loft first, possibly in 1431 or more likely in 1432. Its sculpture ranks close to the summit of fifteenth-century achievement. It was commissioned from a newcomer to the first rank, but a quite obviously qualified Florentine stone-carver, named Luca della Robbia.[22]

Luca, the first of the most famous family-dynasty of Renaissance sculptors, was born of an elderly, well-to-do father who owned considerable farm property and rented a town house in addition. The family name of 'Robbia', from *rubea*, means 'red', and specifically the madder-root from which one of the most important red pigments for dyeing and painting was derived in medieval and Renaissance artistic and commercial practice. The root was also put to some medicinal use; the family town-house incidentally was in the via S. Egidio, the street on to which the Hospital of S. Maria Nuova opens, behind the Duomo. The father had no known occupation connected with art, except possibly the rather prosaic one of purveying madder-root. Luca came therefore to sculpture on the basis of a precocious talent alone. He held on to the family properties after his father's death, however, and was for many years a prominent member of the Physicians' and Pharmacists' Guild, of which membership, it must be said, may also have been obligatory in connexion with his later 'factory' for the production of coloured glazed terracotta sculpture. He never married, and there is evidence that at one point in his late middle years he seriously considered entering monastic life.

Born in Florence in 1400, Luca della Robbia belonged to the same artistic generation as did Michelozzo, who was only four years older, and with whom for a time he was later to be associated. That artistic generation also included Masaccio, who was born in 1401, and Alberti, born in 1402/3. We know a great deal about Luca's later life, but we know precisely nothing about his training and career before 1431. His name first turns up in a trustworthy document only in 1427, when a *Catasto* entry reports his age and the fact that he was still living in his father's house. One inference is inescapable: he can hardly have been entrusted with so important a commission as that of the first Cantoria in the Duomo without being well known to the Operai and without enjoying

their full confidence as a sculptor. This would indicate that he was trained in the Florentine cathedral shops. From many points of view, but not least his intimate and influential connexion with sculpture-campaigns for the Duomo up to 1421, it seems most probable that Nanni di Banco was Luca's master.[23]

In 1433 Luca became a member of the Sculptors' Guild (Workers in Wood and Stone), and it may be confidently assumed that by then his own shop required for the Cantoria commission was fully formed and that he was well launched on the task before him. Luca's Cantoria (Figure 11) carried on its front face two long narrow bands on which in handsome letters closely derived from Roman sources (Plate 39) the first two-thirds of the Vulgate version of Psalm CL were inscribed. A third band with lettering completing the psalm was to run along the base below a row of brackets which supported the gallery proper. The reliefs were designed by Luca to go in two rows, with four panels divided by double-pilasters to a row; the upper row was set between the bands of the inscription on the gallery's projecting face; the panels of the lower row were set in relative shadow between the brackets and just above the bottom band of the inscription into which its imagery was directly keyed. It is necessary to visualize precisely the relation of the reliefs to the inscription, for, as is well known, the reliefs illustrated as closely as possible the words of the psalm which in familiar terms enjoin the faithful to 'praise the Lord in His holy places' by singing, by dancing, and by sounding a variety of musical instruments, including the organ. On the sides of the box-like projection the 'Alleluias' at the psalm's beginning and ending were suggested by two reliefs of standing choirs of young boys and young men singing earnestly. Two bronze putti holding candelabra at one time set on the edge of the gallery are not mentioned until the mid sixteenth century (by Vasari) and do not seem to have been part of the original programme.[24]

The imagery in marble, so appropriate to the intended function and place of the gallery it enhances, helps to define a new principle in the organization of Renaissance relief. Rather than composing a series of more or less self-contained *istorie*, the artist was forced to find a way to accompany physically with the material forms of sculpture the flow of words in the inscription. His solution was to 'scan' the poetry, as if by metric feet, or better perhaps in this case, by cadence. Then he composed a visual equivalent of the verse-cadences in units of design with images of young children or adolescents performing various offices of musical praise on a platform of heavenly clouds corresponding to the constellations of meaning in the words. Thus there came into being a new definition of sculptural composition. It expressed and was designed to emphasize continuity. But it found expression in a succession of closely-linked but independent visual units. These are not unlike the stanzas of a poem or, more precisely, the verse-units of Dante's *terza rima*, to which, as a Florentine, the artist's sensibility would have been well attuned.

The Second Cantoria, to stand opposite Luca's, was allocated to Donatello after his return from Rome, the contract being signed in mid November, 1433. The contract provided apparently for the same type of separate relief-panels as those in Luca's Cantoria, but interestingly enough at a rate of pay lower than that stipulated in the

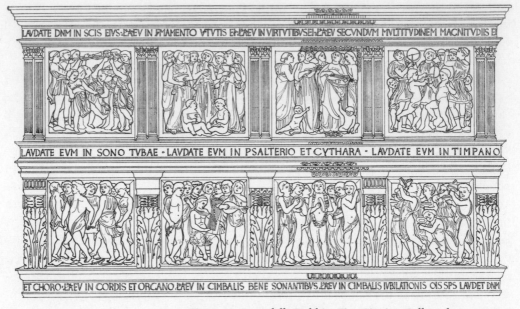

Figure 11. Luca della Robbia: First Singing Gallery, begun *c.* 1432.

agreement made with the younger master. Donatello appears to have begun work under these conditions, but did not tolerate them for long. The documents hint at an interesting situation. At a point which is very difficult, if not impossible, to locate precisely, Donatello switched basic schemes of composition. He was evidently unwilling, or unable, to adapt the theme for his Cantoria reliefs to the scheme of discrete, separately-framed panel-units which he had agreed to work with. The date of this all-important shift in design is elusive. The change is apparently reflected in documents referring to disbursements by the cathedral authorities in 1435 and could well, therefore, have been decided in 1434; we can assume on the same kind of documentary evidence that it was an accomplished fact by 1436.[25] By that date we can say with certainty that Donatello had embarked on a very personal and original solution (Figure 12). This involved three different, but related, devices. The first was to provide an unbroken frieze of dancing putti, carved in two long blocks only, of marble. The second was to set off the figures in relief by introducing a gilt mosaic background behind them. The third was to suggest a sense of screened syncopation by placing mosaic-covered free-standing colonnettes at fixed intervals in front of the sculpture. In the shadowed lower zone, below the gallery proper and between the supporting brackets, were two bearded decorative heads in bronze *all'antica* (for a time believed lost, but not long ago re-identified) and shallow reliefs of little genii standing beside motifs symbolic of eternal life. Both Luca's and Donatello's Cantorie were taken down late in the sixteenth century; the re-assembled parts now in the museum of the Opera del Duomo in Florence are authentic as far as the sculpture and brackets go, but the ornamental framing in each case is a modern reconstruction, and not altogether trustworthy. Nevertheless the confrontation of the two

94

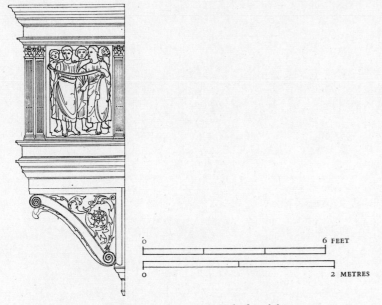

6 FEET

2 METRES

Florence, Duomo. Reconstruction, corrected after del Moro

Cantorie is breathtaking. The contrast between them is as striking in our day as Donatello must have intended it to be in his own.

The impression of Bacchic abandon of Donatello's dancers should not be allowed to conceal an extremely subtle and well-considered solution not only to the problem of presenting movement in a relief-composition but to the challenge of making the design count visually from a considerable distance in a none too well illuminated part of the cathedral. The gleam of the gilded mosaic, echoed by the gilt applied to the brackets and presumably by the gilt accents of the original ornament of the framing, suggested at once a certain vitality and activity to the eye by purely abstract means. The forms of the imagery of dancing putti set up an irregular but still rhythmic beat that is emphasized by the sweeping gestures of arms and swinging legs; their convolutions are carried on beneath the movements delineated on the front plane and are given seemingly infinite variations in secondary patterns in the compression of a rather shallow depth; this internal movement, so to speak, fades off, finally, against the flicker of reflected light of the back plane. Thus, while the current of motion is given a general direction from right to left, there are enough counter-currents, twists, and turnings of the contorted bodies and their draperies, together with sufficient secondary movements in depth, to succeed in containing this violent processional dance and to suggest in a remarkable way that it is moving without a conceivable break in a flattened circle with no beginning and no end. Without a beginning or an end, time ceases to be. Thus, by suggestion, time is here eliminated, and we are brought to the point where we recognize that this pagan ritual dance, just as in the case of Luca's concerts, is taking place in eternity and therefore in Renaissance terms in a Christian heaven.

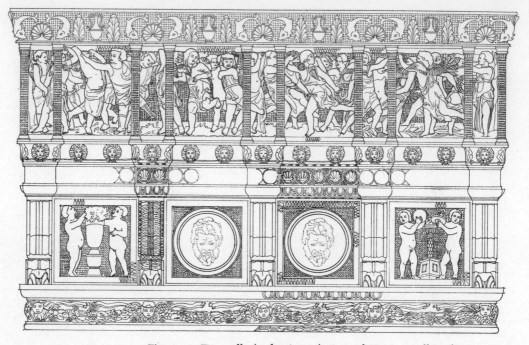

Figure 12. Donatello (and assistants): Second Singing Gallery, begun *c.* 1434.

The execution of the carving in Donatello's Cantoria is in general left sufficiently in the rough to reveal the planes from some distance – a detail which Vasari wrote of with implied approval. The design is surely all Donatello's, but the left-hand block (Plate 36A) shows the intervention of assistants far more than its companion. It is more hesitant in design than the right block. There are arguments favouring a later date for the left block, but all in all it seems more likely to have been the earlier. The documents of the Duomo accounts indicate that the carving was done principally between 1435 and 1438. The gallery, like Luca's rival unit, was in place by 1440.

In execution, Luca's panels are far more carefully finished than Donatello's. In their original emplacement their delicate detail would have been to a large extent lost to the viewer on the pavement of the church below. The documents appear to indicate that the artist recognized the danger of the visual effect of his work early in the game. In 1434 he re-negotiated the terms of his contract, asking for more payment in view of the fact that he was to improve the quality of his work on 'larger' blocks of stone. The increase in size in the block could have been in depth as much as in height or width, and the improvement could have been directed towards higher relief for better visibility, with more definition in the shadowed as well as lighted areas to tell from a distance. A distinction between a first group of reliefs (before 1435) as opposed to a second (in 1435) can be made; the comparison (Plates 38B and 39) brings out a truly impressive increase in the power of the modelling, and with that increase a no less certain gain in effect from a distant viewing-point. The 'new' style was subsequently developed in a number of the reliefs of the front of the gallery and probably on the lateral reliefs also.

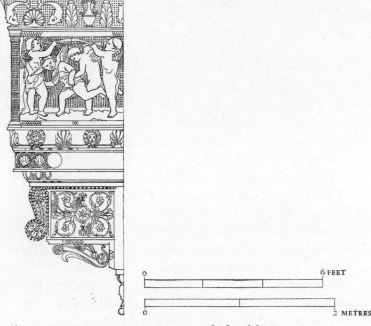

Florence, Duomo. Reconstruction, corrected after del Moro

The naturalism of Luca's dancing and music-making children has been commented upon so often and at such length in the literature on Renaissance sculpture that I hesitate to add more words here. But it must be said in this place that its novelty in the 1430s was relative only. The source of the engaging blend of naturalism and classicism in the Cantoria sculpture was in the frontispiece of the Porta della Mandorla (see Plate 19), upon which Luca very probably worked as an assistant to Nanni di Banco. There he would have learned his system of relief, and at that time he would have come to appreciate under Nanni's guidance the beauty of classical motifs and figure-style which ever afterwards he was to translate into white forms, as clean as if they had been washed by time and weather. The more serious expressions of the singing adolescents and young men of the 'Alleluia' panels (Plate 38A) have much in common with the sympathetically realistic approach of Masaccio's work. As a young man Luca may have known Masaccio, and he seems to have admired him. Luca's method of composition in his panels, finally, which recalls the organization of reliefs on Trajanic monuments (such as the Arch of Benevento), seems also to have deeply impressed Michelozzo. There is a discernible influence from the Cantoria on Michelozzo's framed reliefs for the Aragazzi monument that were, to all appearances, part of the work done after 1434 (Plate 36B) and therefore would depend on Luca's example rather than vice versa.

<p style="text-align:center">★</p>

While Donatello was busy on the design-problems of the second Cantoria for the Duomo, in the unannounced yet nonetheless real competition with Luca della Robbia's

gallery, Michelozzo seems to have taken more responsibility for the monumental out-door pulpit erected on the south corner of the façade of the Duomo in Prato. This project was to be the last of the large enterprises undertaken jointly by Donatello and Michelozzo as partners.

The Prato pulpit (Plate 37), consisting of a circular parapet set on a capital of bronze and capped by a picturesque circular marble canopy, was planned as early as 1409 as a 'modern' replacement of a rectangular Trecento pulpit which had been used in the same general location. Its function, like that of its predecessor, was to provide a vantage point to show upon certain fixed occasions to large crowds the relic of the Virgin's girdle, normally stored away in safety in a specially appointed chapel, the Cappella della SS. Cingola, inside the church. The contract for the Renaissance monstrance-pulpit, which went back to 1428, or somewhat before the partners' Roman interlude, called for Donatello's own hand in the relief sculpture intended to decorate the parapet. After the interruption caused by the trip of both sculptors to Rome, work was resumed in 1433; some changes in the original scheme were possibly made then, or, as seems more likely, a little later, in 1434 or 1435. Work was completed in 1438.

Recent scholarly opinion is unanimous in accepting the bronze capital at the pulpit's base, one side of which was cast in December 1433, as of Michelozzo's design and execution. The consensus of present-day scholars is just as definite that the series of seven marble panels (originally contracted for as six) of dancing putti against a gilt mosaic ground cannot possibly, despite the terms of the contract, be from Donatello's own chisel. One panel only may, very doubtfully, be ascribed to Donatello's hand; another may be accepted as in part by Michelozzo. But the remainder seem to be executed by at least two, as yet unidentified, members of the shop, of uneven ability.[26]

The artistic reputation of the Prato pulpit as marble sculpture has dropped in the present day to a very much lower level than it enjoyed in the older critical literature. The sixteenth- and seventeenth-century guides, as well as a religious drama of about 1450 (published over a century later), wrongly but enthusiastically list Donatello as sole author of the pulpit and its sculpture. Yet the pulpit is nonetheless interesting today for other than reasons of antiquarian lore, and for one particular reason which even the perceptive nineteenth-century historians and critics either did not realize or failed to value at its historical worth. The scheme at Prato, which divides the dance of the putti into rectangular panels, separated by double pilasters, is a striking combination of the schemes of both Donatello's and Luca's Cantorie as ultimately carved and put into place in the Duomo at Florence. But it would seem that at Prato we have a far more intriguing phenomenon than merely an echo of competing types of designs or a compromise between them. The Prato frieze shows us what Donatello's panels for his first, aban-doned, scheme for his Duomo Cantoria might have looked like. Indeed the seven Prato frieze-panels may very well have been taken directly from the group of eight *modelli* made for the first version of Donatello's Cantoria, with such modifications as needed, under understandable pressures of completing an ageing commission, for their adapta-tion to a different, but closely related setting.

CONSOLIDATION, 1435–50

THE period 1435 to 1450 in the development of sculpture in Italy may be characterized as one of consolidating the impressive gains of the previous quarter of a century. By 1435 it was no longer possible to speak of the *stile nuovo* as really 'new'. Alberti's codifying theoretical works on the New Painting as well as the New Sculpture had already appeared, and the developments which had their beginnings in Tuscany were being spread, like Alberti's words, to other parts of the peninsula. Thus we find in North Italy and particularly in Venice a new humanist note in sculpture in its development there up to 1450, and under Eugenius IV, a vigorous pope of Venetian origin but with strong ties with Tuscany, particularly Florence, one can see the beginnings of a Renaissance school in Rome. Meanwhile in Florence Ghiberti was completing his *magnum opus* of the third and final set of doors for the baptistery (on which a first programme had been given in 1424), and his influence was being exerted increasingly on a new generation of younger men. Finally, within these fifteen years are dated Donatello's reliefs and doors for the old sacristy of S. Lorenzo under Medici patronage and virtually all the bronze statuary and reliefs of his Paduan period (1443–53).

NORTH ITALY AND VENICE TO 1450

Florentine Sculptors in the North

Those who may have a tendency to speak disparagingly of North Italian and Venetian sculpture as being 'provincial' in comparison to Florentine art, would do well to remember the fact that a very sizeable part of the sculpture produced north of Bologna and east of Milan between 1425 and 1450 was made or strongly influenced by artists born and trained in Florence. As early as 1403 the Venetians had tried to lure Niccolò Lamberti away from Florence to conduct operations on the new wing of the Doge's Palace. After having been outdistanced by Donatello and Nanni di Banco, the elder Lamberti left Florence for Venice in 1416 and after 1421 was, with his son Piero, permanently established there. The Venetian work of the Lamberti centred on the sculptural decoration of St Mark's, but also extended to Padua.[1] A lesser Tuscan, Giovanni di Martino da Fiesole, was associated for a time with the younger Lamberti. For a not inconsiderable period, between 1417 and 1422, Ciuffagni absented himself from Florence, and there are some indications that he joined the Lamberti during that time in Venice. There are, finally, the cases of two Florentines who adapted their styles to the more gothicizing International Style conventions then in favour in North Italy and whose work there requires now a brief comment.

The first of these sculptors was Nanni di Bartolo, called 'Il Rosso', who began, as we

saw earlier (Plate 23), as a younger 'compagno' to Donatello. According to the Duomo documents, he had left Florence in February 1424; it is assumed that he was called away to Venice. He was probably associated with the Lamberti in Venice during the 1420s, but we find him on the east coast in the Venetian zone of influence at Tolentino *c.* 1432–5, when he worked on the sculpture of the portal of the church of S. Nicola.[2] The architectural frame of the portal is a strange mixture of Romanesque and Gothic motifs, and the sculpture finds an uneasy position on it, particularly the uppermost group of the Venetian patron St George, the Princess Sabra, and the dragon; the mounted figure of the saint seems to have been derived from direct study, however, of an Antique model. More impressive is the Brenzoni Monument in S. Fermo Maggiore in Verona, which seems to have been begun late in the 1420s but was finished only in 1439 (Plate 41). Here, under an enveloping canopy flanked by Pisanello's beautiful frescoed Angel and Virgin of the Annunciation, was presented, as a kind of dramatic tableau, the Resurrection. The figures of Christ and the two flanking angels are usually considered to be by another hand than Rosso's and are Veronese or Venetian. The angel holding the lid of the sarcophagus from which Christ rises and the three sleeping soldiers of the foreground are interesting studies of pose: the first, of great muscular effort, contrasted with the utterly relaxed forms of the sleepers. The monument is inscribed with a normally complimentary reference to the sculptor, whose Tuscan origin is emphasized: QVEM GENVIT RUSSI FLORENTIA TUSCA JOHANNIS/ISTUD SCVLPSIT OPVS INGENUOSA MANUS.

In S. Anastasia in Verona is also to be found a chapel whose walls, instead of being frescoed with *istorie*, were entirely faced with terracotta reliefs. The sculptor in charge was another Florentine, Michele da Firenze, earlier known in the literature as the 'Master of the Pellegrini Chapel' from his masterpiece in S. Anastasia. Other than his name, which is given by a document related to the Pellegrini Chapel, we know nothing at all definite of the life or career of this 'Michele from Florence'.[3] Beginning with the terracotta Rozzelli tomb in Arezzo (home in Roman Antiquity of the famous ceramic Aretine-ware with low-relief decoration) and continuing through a number of smaller devotional reliefs which were probably made in his shop in Florence in the 1420s and 1430s, the output which may be attributed to this specialist in terracotta or to his entourage was large. We should think of this terracotta sculpture as painted in bright pigments and, in the architectural details, gilt. The sculpture in the Pellegrini Chapel dates from about 1435 and was doubtless originally polychrome, a most important factor in the style; for without its effects of colour, the forms look flabbier and the spatial organization more naïve than was intended. The section of one wall in the Pellegrini Chapel illustrated on Plate 40 presents the characteristically gentle style of the master and his shop, in this case revealing a fundamental debt to Ghiberti (see Plate 7A). The difficulties of transporting good stone for sculpture into the area of Verona, and indeed into almost all of the Emilia, may explain the extraordinary fifteenth-century development there of terracotta sculpture and sculptural ornament for architecture. An influence from this mainland style is found between 1432 and 1437 in Venice in the painted terracotta wall-tomb in the church of the Frari of the Beato Pacifico.[4]

Venetian Sculptors and Trends

Venetian sculpture between 1430 and 1450 had a flavour of style all its own, despite the import of Florentine sculptors in the first quarter of the century. The basic ingredient of the Venetian style remained the powerful influence of the dalle Masegne. The monument to Doge Antonio Venier of the early years of the Quattrocento, reorganized into Vittoria's doorway into the Cappella del Rosario in the church of SS. Giovanni e Paolo, contains the stylistic testament of the dalle Masegne in Venice.[5] From the central figure of the Madonna and Child and flanking Sts Anthony and Dominic comes a major current of style which swept the city about 1430/5.

It has been customary in fairly recent times to isolate an anonymous master-sculptor from this general development in Venice and to call him, from the highly-finished altar in the Mascoli Chapel in St Mark's, the 'Master of the Mascoli Altar', or more simply, the 'Mascoli Master'.[6] Plate 42 illustrates this important work, to which no document assigns a named author and which must necessarily be dated in a rather impressionistic way by a dedication recorded for 1430. The extremely ornate and metal-hard style of the altar-retable may be contrasted with a contemporary Lombard relief set in the lunette of the Collegiata of Castiglione d'Olona and dated by inscription 1428 (Plate 43A). The much fuller, more simplified and monumental forms have as their later corollary the rounded forms of the first style of Amadeo. The much more nervous style of the altar-retable of the Mascoli Chapel has a closer affinity to the very beautiful lunette sculpture in relief at the entrance to the Corner Chapel in the Frari, which recent scholarship has given almost unanimously to the 'Mascoli Master' (Plate 43B).[7] But there are still notable differences between the two which can hardly be explained by differences either in the materials used, in function, or in emplacement. The Frari Madonna is much more human and gentler in mood; the Child is far more closely related to the Antique. The converging uprights of the Virgin's throne imply a knowledge of the principles of Florentine perspective, and the drapery of the Madonna's robe is clearly patterned after the lower drapery of the seated figure of St Ambrose by Ghiberti on his first baptistery doors, newly in place, it will be recalled, in 1424. Ghiberti himself was in Venice in the winter of 1424/5 and possibly again in 1430.[8] His influence on the sculptor of the Frari lunette is one of the few striking reminders of his stay in Venice. While there are some Ghibertian traits in the Mascoli retable, such as in the gesture of the St Mark and the drapery of the St James, these echoes are faint and seem lost in quite a different total stylistic complex. The upshot of such a comparison both of execution and of stylistic sources would indicate that the 'Mascoli Master' and the 'Frari Master' are not one and the same personality. Somewhat the same conclusion would, I think, await a careful comparison with other reliefs and statuary which have been attributed to the 'Mascoli Master', and a serious question is accordingly raised as to whether his modern invention as a historical person with legitimate claim to stand as a 'master' (that is, with sufficient 'œuvre' to justify the title) is backed by the visual evidence. It would seem, in fact, the wisest course at this time to drop the

'Mascoli Master' from the rolls of Venetian sculptors, and in so doing to recognize general style-trends rather than personal styles as a fairer means of evaluating the historical situation in Venice about 1430 and for a few years thereafter. This conclusion does not mean that our search for historical formulations of personal styles should not continue, but it does serve to keep within reasonable bounds our expectations of being able to make firm attributions in a difficult period of transition.

One must understand the bases of this position before proceeding to an examination of the sculpture which was carved for the Ducal Palace in the formative period in the development of Renaissance sculpture in Venice under discussion here. The sculpture of the Ducal Palace is not at all well documented for the period we are interested in. Exact dates and precise details on how large-scale enterprises were sub-let, as it were, to individual masters are simply not available for Venice in the way they are for the better-documented sculpture of the cathedrals of Florence or Milan. The contemporaneous sculpture in Venice is, however, no less attractive.

In 1424, work on the wing of the Ducal Palace facing the Piazzetta had been resumed. The palace was, as has been well said, the 'visible and coherent symbol of the "Serenissima"'. The themes of its sculpture had to carry a heavy freight of public moral meanings, and embraced the unusual variety of knowledge and experience needed in the wide world that the Venetian Republic laid claim to. Thus, the long series of capitals which had been begun many years earlier in the street-level loggia of the palace were continued, and the earlier corner groups of statuary in high relief on topics from the Book of Genesis were completed by a final group symbolizing Justice under the subject of the Judgement of Solomon. After 1435 two great structures were added to the newly completed wing, both of which were to carry sculpture in some quantity. The first of these, the Porta della Carta, which provided the main entrance into the palace, was completed by 1442. In the next decade the great builder Doge Francesco Foscari began the so-called Arco Foscari, a building with a broad passageway at ground level leading from the Porta della Carta into the courtyard of the palace, at a higher level connecting the Doge's Palace with St Mark's, and at roof level crowned, on analogy with the much larger and more grandiose *parti* evolved in the upper regions of the cathedral of Milan, by a miniature forest of spires or *guglie*, each surmounted by its own statue.

The Judgement of Solomon on the corner of the Doge's Palace nearest to the Porta della Carta (Plate 44) presented nothing that was particularly new in scheme; it followed conservatively the pattern set by the earlier corner-compositions of the palace, even to the organic form of a tree-trunk which grows up through the centre of the composition and underlines the architectural existence of the building's corner at that spot. But the style, as opposed to the stiffer, more Milanese style of the earlier corner-sculpture, is a smooth-flowing, rather relaxed expression with clear references to the Antique (head of Solomon, nude babies, inscription on Solomon's tunic). There is a record that the capital with scenes symbolizing the theme of Justice, immediately under the Judgement of Solomon, was signed originally on the abacus: 'Duo Sotii Florentini'. Precisely who the 'two Florentine compagni' were, and whether the inscription was meant to refer

to the Justice group as well as to the Justice capital, is not known. But the chances are overwhelmingly strong that the capital, its inscription, and the group were all conceived as a unit, and should be so considered today. The style of the Solomon group is full of Florentine overtones. The two Florentines of the inscription have been at times identified with Piero di Niccolò Lamberti and his partner-assistant Giovanni di Martino da Fiesole, who worked together in Padua (Fulgosio Monument in the Santo) and in Venice (monument of Doge Tommaso Mocenigo of 1423 in SS. Giovanni e Paolo). The style of both these tombs does not much recall the style of the Solomon group, which suggests rather the more graceful manner of Nanni di Bartolo (compare Plate 44 with Plate 23B). A firm attribution remains elusive.[9]

More typically Venetian was the splendid portal adjacent, in the 'florid style' which lasted in Venice until about 1450. It was originally bright with gilt and notes of colour. At a date a good deal after its completion it was given the name of Porta della Carta because of the official notices printed or written on paper posted on it (Figure 13). The portal carried the inscription in Gothic lettering OPUS BARTHOLOMEI, a sure indication that the portal as a whole, in its architecture and in the direction of its sculpture, was considered the responsibility of Bartolommeo Buon, the son of Giovanni Buon, who, as we saw earlier, was an architect of the Doge's Palace and probably a sculptor also.

Bartolommeo Buon with his active workshop represented still another aspect of Venetian sculpture in the period before 1450. His training and outlook appear to have been completely Venetian and his long activity, always, it would seem, restricted to work in Venice, may be traced from 1392 to his death in the mid 1460s. The Porta della Carta was his masterpiece. The work, rather exceptionally, is well documented. The contract with Buon was signed in 1438; its completion is recorded in 1448/52. Buon's part as sculptor was apparently restricted to the upper portions, where the figure of Justice provides an idea of his personal style of about 1440 in so far as the bland, generalized forms can be characterized as a personal expression (Plate 45A). A splendid, massively conceived tympanum with the Madonna of Mercy for the Scuola della Misericordia (now in the Victoria and Albert Museum) is given by a Renaissance source to his hand and is datable by documents for the architecture to between 1441 and 1445.[10] After this time it seems probable that his style veered sharply towards the Antique. The influence of the Antique is certainly well marked in a Charity which survived the Quattrocento fire of the Scuola di S. Marco. This statue may serve to illustrate Bartolommeo's last phase (Plate 45B).

On the Porta della Carta there are also two other styles illustrated by the Virtues in niches of the lateral supports and the head of the kneeling doge (copy now on the monument, original in the Palazzo Ducale). The two upper Virtues are stiff in gesture and chunky in proportion; the lower two, particularly the Temperance, show a far more graceful style, and have been connected variously with the hand of Piero Lamberti and Antonio Bregno or Antonio da Rigesio, a Lombard of talent and energy, who by 1450 had probably already set up a large and busy workshop in Venice.[11] Antonio Bregno soon became, it appears, the chosen artist of Doge Francesco Foscari. To Bregno, as successor to Buon in ducal favour, was given the direction of work on the

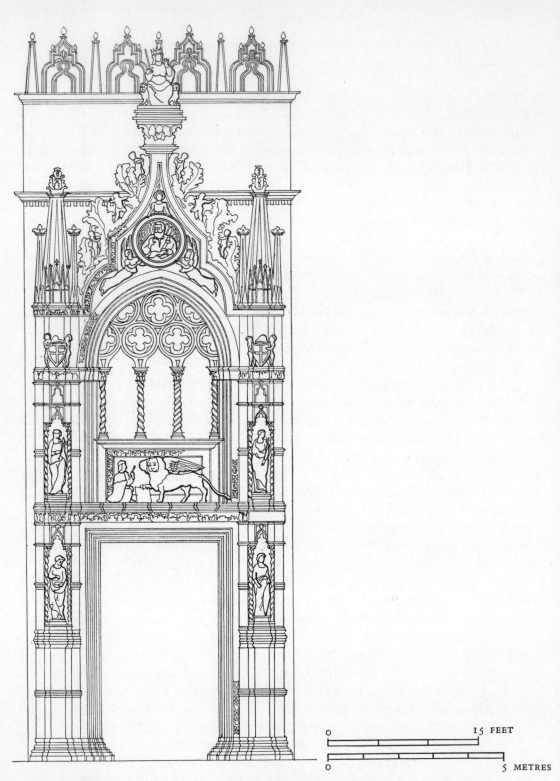

0 15 FEET

0 5 METRES

Figure 13. Bartolommeo Buon: Venice, Palazzo Ducale, Porta della Carta, 1438 (contract)–1448/52.
Schema of emplacement of sculpture (after Cicognara)

structure and decoration of the Arco Foscari just inside the Porta della Carta. The scheme was an ambitious one, and work continued on it for a long time after the death of Francesco Foscari in 1457. The statuary of the Arco Foscari was never easy to see; its style is heterogeneous in the extreme, and its execution extended over at least thirty years after the period it is our task to examine in this chapter. But its historical importance is greater than the visual impact of most of its art. The Arco Foscari, indeed Bregno's arrival in Venice and rapid success there, opened a new era. Florentine impulses, which had had a certain influence temporarily, gave way to a close relation once again in Venice, as in the first years of the Quattrocento, to currents from Lombardy.

Pisanello and the Origins of the Renaissance Medal

To complete this account of sculpture in North Italy between 1435 and 1450 it is necessary to look now, very briefly, at the pioneering work of Antonio Pisano, known as Pisanello, in the small-scale relief genre of the medal.

Antonio Pisanello, who usually signed himself Pisanus Pictor, was a painter of unusual ability in fresco as well as on panel, a draughtsman of magical qualities, and an architect of decidedly more modest talent and achievement. As a sculptor, he specialized in the making of honorific medallions in low relief of gold, bronze-gilt, bronze, and lead which must have been the delight of his patrons and have charmed amateurs of intimate, small-scale art and of history through portraiture ever since.

His origins are obscure; it is as a fully formed artist attached to the smaller courts of Northern Italy, at Ferrara with the Este family and at Mantua with the Gonzaga, that he makes his documented appearance in art history. His training seems to have been in the ornate yet naturalistic tradition of the North Italian painters, illuminators, and sculptors such as Giovannino de' Grassi (see p. 21). And in the courtly atmosphere of the Milanese-dominated mainland cities (as opposed to Venice) he must have been fully aware of the art of the courts north of the Alps. A strong 'international' aspect of his training and point of view explains better than any other single factor his experimenting between 1435 and 1440 with the medallic genre.

The Renaissance medal sought to revive only to a very limited degree an archaeologically correct version of Imperial Roman honorific medallions. It is rather as a slightly enlarged version of modest Roman coins that the earliest Italian examples made their appearance at the court of the Carrara in Padua towards the end of the Trecento (see p. 23). More important still was a series of medallions made, it is thought, in or near Paris at about the same time on the subjects of the Christian Emperors Constantine and Heraclius and connected in their imagery on the reverses with the story of the True Cross. The originals in gold were sold as Roman 'Antiques' about 1400 to the Duc de Berry. From these gold examples, long since melted down, descend in varying degrees of quality numerous examples in bronze that are preserved today (good examples in the Bibliothèque Nationale in Paris and the Kress Collection (formerly Dreyfus) in the National Gallery of Art, Washington).[12] Pisanello's earliest recorded medal (Plate 46A), celebrating the arrival of the Byzantine emperor, John

Palaeologus, on Italian soil for the Council of Ferrara in 1439, is clearly dependent on the type of those sold about forty years earlier to the Duc de Berry. But he rapidly developed his own manner over the next few years in a stream of ever more brilliant and stronger designs. These can be traced in succession to commissions for Lionello d'Este, Lodovico Gonzaga, Sigismondo Malatesta, and many others until in 1448 Pisanello was called by Alfonso of Aragon to the court of Naples (see below p. 135). The Neapolitan series is his finest, and most clearly substantiates the claim that the painted profile-portrait in Italy had its strongest ancillary support in medallic art. His own painted portraits, which were in profile, in a tradition much related to earlier French practice (portrait of Jean le Bon), may in one or two cases have actually preceded his portraits on medals. Where the medal played a still more important role was in designs for reverses (see Plate 47A). It was usual practice to cast medals with, in honour of a distinguished person or in memory of a notable event, the portrait on the obverse and a little scene or some emblematic device related to the subject on the reverse. A whole language of symbolic forms grew up around the designs used for reverses.[13]

Pisanello's immediate follower as a medallist was the Veronese Matteo de' Pasti, whose activity both as medallist and architect at the Malatesta court we shall soon encounter. His use of pliant, actually at times fluent, planes and picturesque outline differed a good deal from Pisanello's more sober style (Plate 46B). By 1450 the genre was established, and artists with easily recognizable individual styles such as Guazzalotti, active mainly in connexion with the Curia in Rome, Enzola of Parma, and Sperandio of Bologna, to name but a few, were soon to be working prolifically in it.

PROGRAMMES IN RELATION TO ARCHITECTURE

Ghiberti's 'Gates of Paradise'

Mention was made at the beginning of Chapter 4 of the commissioning in 1424/5 of the second doors of the Quattrocento series for the baptistery in Florence. And in that connexion, it was noted that some eight to ten years were to elapse before Ghiberti, who as 'eccellente maestro' had been given the commission, was actually to get to the work of modelling and casting. When the doors were commissioned it was assumed that they would follow the scheme successfully initiated by Andrea Pisano and adapted by Ghiberti to his New Testament doors of 1404–24. Now it was time to approach the Old Testament doors, which were planned at first to go on the north side of the baptistery. A preliminary version of the programme was outlined by the humanist, later Chancellor, Leonardo Bruni in 1424 in a letter to the Calimala, with results which in all candour appear today to be almost totally lacking in originality, either theological or visual. The tone of the instructions he handed on with his scheme of subject matter was, to say the least, haughty. It takes little imagination on a reader's part today to picture Ghiberti's reaction as one of impatience with the academic superiority assumed by a rhetorician of words and of determination to find a new rhetoric, suitable to the programme of course, of visual forms. It is known that two other Florentine humanists,

I	II	III	IV
Creation of the Sky and Stars	Creation of Man and Woman	The Fall	The Expulsion from Paradise
V	VI	VII	VIII
Cain kills Abel	The Animals enter the Ark	The Sacrifice of Isaac	Isaac blesses Jacob
IX	X	XI	XII
Joseph sold into Egypt	Pharaoh's Dream	Joseph recognizes his Brothers	Moses and the burning Bush
XIII	XIV	XV	XVI
Moses and Pharaoh	The Passage of the Red Sea	Moses on Sinai	The Sacrifice of Aaron
XVII	XVIII	XIX	XX
The Entry into the Promised Land	David and Goliath	David crowned King	The Judgement of Solomon
XXI	XXII	XXIII	XXIV
Samuel	Nathan	Elijah	Elisha
XXV	XXVI	XXVII	XXVIII
Isaiah	Jeremiah	Ezekiel	Daniel

Table 4(a). Schema of Leonardo Bruni's programme for
the Gates of Paradise (after Krautheimer)

Niccolò Niccoli and Ambrogio Traversari, attacked Bruni's scheme, and they may have helped Ghiberti.

The scheme proposed by Bruni and the scheme of subject matter as finally worked by the sculptor are outlined here for comparison. Ghiberti, on his way towards his own final solution, first reduced the twenty-eight panels of Bruni's scheme to twenty-four. (There are a total of twenty-four compartments in the rear frames of the valves as executed.) When he took his major step in reducing the twenty-four compartments to ten, he made the most important decision of his life and could well write with some pride in his *Commentarii* that the Calimala gave him full liberty to plan and execute the doors 'in whatever way', as he wrote later, 'would turn out most perfect and most ornate and richest'[14] (Plate 48).

The deposits of medieval aesthetic attitudes left in the adjectives 'most perfect, most ornate and richest' are balanced by remainders of medievalism in the succession of the topics provided in the Bruni programme. Where possible, Ghiberti appears to have kept the twenty stories of the Old Testament suggested by Bruni, but he merged those stories where he could as incidents into larger stories which stand for the total view of an important biblical patriarch or prophet. The increase of unity beyond a purely visual kind is geometric in this kind of progression. Where Bruni had suggested three panels on the Joseph story, Ghiberti united the same number of incidents into the space of one of his panels (see Plate 50). In another of his panels, on the subject of Cain and Abel, he put together no less than five sub-subjects, or *effetti*, as he called them in his *Commentarii*. All in all he raised the total of Bruni's twenty incidents to twenty-seven of his own *effetti*. By placing the figures of Prophets in shallow niches in the frames, he was able to increase Bruni's eight to his own twenty. And he found room both at the top and at the bottom for reclining figures of Eve and Adam and of Noah and his wife Puarphara.

The most recent, and masterly, analysis of the programme of the doors as finally worked out by Ghiberti lays stress on the topical nature of their principal meanings.[15] One of these meanings appears through the agency in particular of Ambrogio Traversari, a noted patristic scholar, to have found a major expression in the Solomon panel. Under the guise of the meeting of Solomon and Sheba, this was to adumbrate the desired union of the Eastern and Western Churches – the principal aim of the Council planned before his death in 1431 by Martin V and brilliantly carried forward by his successor (see below, p. 116). Perhaps the scene of the reunion of Joseph and his brothers in a prominently placed panel (Plate 50) is related to the same general topic of ecclesiastical reconciliation. Thus out of the older medieval *topoi* new meanings of overpowering significance in Italian Church-politics for the years between 1430 and 1440 could be distilled, and the imagery of the doors as a whole given greater freshness of spirit as well as unity of vision.

To attempt to find one single theme which embraces totally the imagery of these last doors is to stretch unduly the boundaries of historical probability. There are doubtless a number of themes to be identified. It was not the unity or clarity of the message that would have counted primarily in Ghiberti's view. The complex mingling

	Eve			Adam	
Ezekiel (?)	**I GENESIS** 1. *The Creation of Adam* 2. *The Creation of Eve* 3. *The Expulsion from Paradise*	Jeremiah (?)	?	**II CAIN AND ABEL** 1. *Cain at Work* 2. *Abel at Work* 3. *First Parents at Work* 4. *Cain kills Abel* 5. *God curses Cain*	Joah (?)
Elijah (?)	**III NOAH** 1. *The Animals and Noah leave the Ark* 2. *Noah's Drunkenness* 3. *Noah's Sacrifice*	Jonah	Hannah (?)	**IV ABRAHAM** 1. *The Angels' Visit* 2. *The Sacrifice of Isaac*	Samson
?	**V ISAAC** 1. *Esau and Isaac* 2. *Isaac blesses Jacob while Esau hunts* 3. *Rebecca prays*	Rachel (?)	?	**VI JOSEPH** 1. *Joseph put in the Well* 2. *The Distribution of the Grain* 3. *Joseph makes himself known after the Arrest of his Brothers*	?
Miriam	**VII MOSES** 1. *Moses receives the Law* 2. *People at Mt Sinai*	Aaron	Joshua	**VIII JOSHUA** 1. *The Carrying of the Ark* 2. *The Carrying of Stones* 3. *The Destruction of Jericho*	Gideon (?)
Judith	**IX DAVID** 1. *Clash of Armies* 2. *David kills Goliath* 3. *David returns to Jerusalem in Triumph*	Nathan	Daniel (?)	**X SOLOMON** 1. *The Arrival of Sheba's Retinue* 2. *The Meeting of Solomon and Sheba*	Balaam (?)
	Noah			Puarphara	

Table 4(b). Schema of Ghiberti's final arrangement of subjects on the Gates of Paradise (after Krautheimer)

and fine adjustment of innumerable small details and refinements created a unified impression mainly in the sense of endlessly interweaving strands of sentiment and visual delight. The analogy was closer to music than to verbal rhetoric or philosophy.

The organization of Ghiberti's second doors, or the Gates of Paradise, according to Vasari's version of the famous phrase used by Michelangelo to describe them, is only in appearance simpler than the overall design of Ghiberti's first doors. The second doors are actually more elaborate. The inner framework carries heads in roundels *all'antica* (Plate 47B), as did the first doors; but instead of a running frieze of naturalistic plant-ornament, the *freggio* of the second doors presents between the heads a variety of distinctive floral designs and, in extremely high relief, no less than twenty-four 'statues in miniature'. They are of superb quality (Plate 49A) and are among the first evidence of what was later to become a Renaissance passion: the taste for exquisitely reduced sculpture, or small-bronzes.[16] The outer frame in ungilded bronze consists of an inner and an outer jamb; the inner side, or soffit, is given to a running pattern of ornamental floral motifs in low relief, as carefully conceived and lovingly designed as Art Nouveau ornament by Louis Sullivan, which it somewhat resembles.[17] The outer jambs are given floral and print motifs in very high relief interspersed with charming vignettes of animal life, here a squirrel busily nibbling at a nut, there a quail apprehensively looking up from its feast of berries.

The series of ten reliefs is as well known as any ensemble of Renaissance art either in sculpture or in painting, to which it has been often compared. A few prosaic facts, however, are needed before we can summarize their character. Each relief is designed on a square, just about one and one-third *braccia* to a side. The surfaces were completely gilt. They were all cast, seemingly as a complete group, by 1436, with the time-consuming work of cleaning and chasing the rough-cast forms going on until 1443 or 1444 and the fire-gilding accomplished only at the very end of the work, which was not complete until 1452.[18] At that time it was decided that, because of their quality and splendid effect, the doors should be put into the main entrance on the east face of the baptistery opposite the façade of the Duomo, while the first doors representing the life of Christ, which had been intended for that position, were to be moved to the north face. This arrangement still holds.

The cleaning of the Gates of Paradise after the Second World War revealed the original heavy gilding which sheathes the modelling of the reliefs in a reflected light. In this respect, as well as in the choice of rectangular fields, Ghiberti was clearly following out a line of direction already established in his smaller reliefs for the Siena font. The Baptism is the closer of his two designs to the system that he finally consolidated in Florence in the second doors, for which he may have begun his earliest sketches as early as 1430, or only three years after he had delivered the Baptism to Siena. Where he found a marked divergence from his earlier solution was in the combination of several different phases of a story, or *effetti*, that he had worked out in the preliminary organization of his design. It would not be accurate to classify the system of concurrent *effetti* with the definition of continuous action which was summarized in the work primarily of Donatello in the previous chapter. There is no systematic order or direction of

action in the reliefs. The *effetti* in any given relief do not function as a series of linked moments in a continuum of progressing time and are located in the foreground or the background, or on the left or right, as the case may be, by considerations of visual equilibrium rather than of dramatic action. The heaviest relief is, as at Siena, given to the figures of the front or near-front plane. Then, from forms which are just about in the round, the relief lessens in bulk and accent in the middle distance and falls away still farther in the far background (Plate 50). A good example of 'middle-distance-to-far-background' relief is illustrated by the group of Noah, Puarphara, and their children as they make their exit from the Ark (Plate 49B). The composition of the group derives from painting, in contradistinction to Quercia's roughly contemporary treatment of the same subject (Plate 32A); in Ghiberti's case his debt to the central group in Masaccio's Tribute Money is apparent.

To what extent precisely Ghiberti applied the rules of perspective-construction as codified in Alberti's *Della Pittura* to his own problems of space-suggestion in his reliefs is far from clear. There are three reliefs only out of the series of ten that contain the kind of architectural setting recommended by Alberti; the landscape-settings of the other seven, with the figures in them, are not nearly as strictly organized into a perspective effect as in the main relief for the Shrine of St Zenobius, which was finished in 1439, or three or four years after the publication of *Della Pittura*. There has been some speculation as to whether in fact the Alberti-like settings in the second doors were really dependent on Alberti's treatise; if they were, there would be some additional evidence, of course, for the date of their composition and the older tendency to date them after 1436 rather than before 1436 (the year in which the documents unequivocally indicate that they were in fact already cast) would receive some support. It has been rightly pointed out that the publication date of Alberti's treatise is not a decisive factor, since some rudiments of the system advocated by Alberti were already known in Florence through Brunelleschi's work in perspective, and in any event Ghiberti could have consulted with Alberti in Florence in 1434 or even possibly in 1428.[19]

Though the evidence of the use of a highly developed perspective-system by Ghiberti cannot be used to pinpoint the date of some of his designs, such use does have a great importance for our own view of the development of Renaissance relief in general. That Ghiberti used a perspective-system in the second doors can hardly be questioned. The question arises, though, how sophisticated precisely that system was. There is a conflict of views on the system employed by Ghiberti for his Story of Isaac. One recent analysis speaks of a 'golden point in space' beyond the hall 'to which all lines recede', whereas another would indicate (as in Figure 14A) that there is no single 'centric point' at all, and the orthogonals in fact meet at several scattered foci.[20] It is likely that the disagreement depends quite literally on a difference of viewpoint. If one were to point a modern camera, or one-eyed 'perspective-machine', at the Isaac relief from a position a little more to the right than dead centre, and a little below the midpoint of the relief as suggested by the position of the Isaac relief on the doors (see Plate 48), a 'corrected' perspective would be recorded; the orthogonals would tend to come together, though not completely, it must be said, in one point (see Figure 14B,

which is traced from such a 'corrected' photograph in which the position of the lens corresponds more closely to the position of the average viewer's eye as he stands on the pavement directly before the doors). The second diagram also indicates by dotted lines a geometric surface-organization which seems to be locked into the perspective scheme, and thus reconciles the progression into depth with the surface-interest which

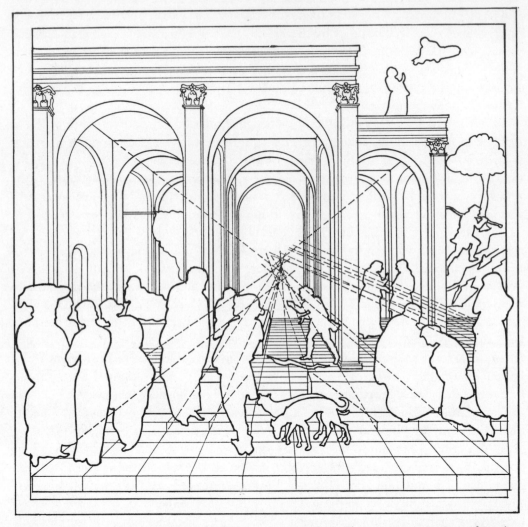

Figure 14. Lorenzo Ghiberti: The Story of Isaac, *c.* 1435 (casting). *Florence, Baptistery, Gates of Paradise.* A Schema of perspective (after Krautheimer)

a door-panel, after all is said, should have. While it is apparent that Ghiberti did apply what he felt to be a one-point perspective system to his design as he visualized it in place, the variables connected with the viewing of the finished relief are plainly such as to preclude any characterization of the process as 'scientific'. That process would seem to be as much related to the 'giudizzio dell'occhio' as to geometric accuracy. The apparent lack of a thoroughgoing module puts an even greater premium on the sensi-

tivity and elasticity of the artist's mental processes. The net impression from so summary an analysis of an extremely complicated artistic situation is likely to be the conclusion that Ghiberti's means of suggesting a spatial environment for his figures were very sophisticated indeed. The 'worlds' that the Gates of Paradise create in each of the panels are enchanted places (Plate 52).

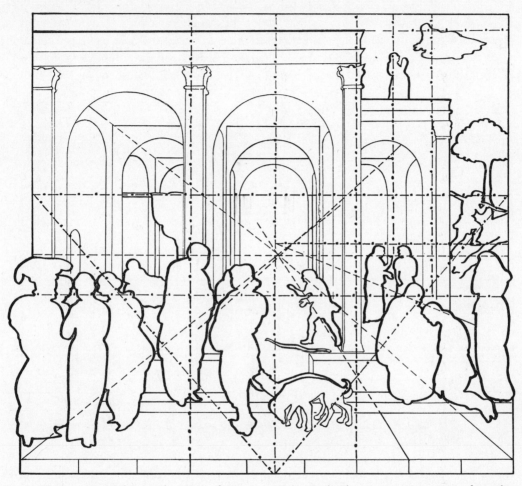

Figure 14. Lorenzo Ghiberti: The Story of Isaac, *c.* 1435 (casting). *Florence, Baptistery, Gates of Paradise.*
B Variation of apparent perspective system from lower point of vision; linear surface organization

Donatello in S. Lorenzo

At the time that Ghiberti was already finishing the panels of his second doors, Donatello was preparing for the Medici his designs for sculpture in the architectural setting recently completed by Brunelleschi of the Sagrestia Vecchia of S. Lorenzo. The programme included a number of different categories of sculpture. First should be listed the pairs of bronze doors which are set into the controversial porticoes flanking the chapel at the south end. The doors measure only 8 ft 6 in. by 3 ft 7 in. (2·35 m. by

1·10 m.), and are consequently so much smaller in scale than Ghiberti's that it is hardly legitimate to make a detailed comparison between the two programmes. Suffice it here to say that as usual Donatello had a differing and original solution. His doors also have ten panels, like the Gates of Paradise, but each panel contains against an abstract back-plane two figures shown in a great variety of dialogues ranging from animated discussion to withdrawn indifference. The saintly subjects are arranged in one set as Martyrs (headed appropriately by the protomartyrs St Stephen and St Lawrence) and as Apostles, Evangelists, and Church Fathers in the other. But the true topic of the panels goes deeper than this surface-imagery into suggestions of the mysterious nature of relationships between one human being and another, while the general scheme of

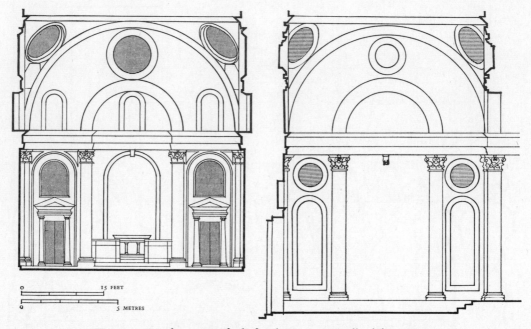

Figure 15. Emplacement of relief sculpture in Brunelleschi's interiors
A Florence, S. Lorenzo, Old Sacristy B Florence, S. Croce, Pazzi Chapel

framed rectangles seems to have been suggested by Early Christian example (such as the doors of S. Sabina, which Donatello might have studied while he was in Rome, or Early Christian ivories of a type like that of the Probianus Diptych).

The dates of the doors are not known precisely; it is usually thought that they were begun some time after 1435, say 1438, and were certainly finished by 1443, when Donatello left for Padua (see below, p. 124).[21] Presumably the sculptor proceeded to active work on the sculpture of the sacristy after he had settled the main design-elements of his Cantoria for the Duomo. The sacristy programme included two other categories of reliefs: first the two pairs of Medici family saints in painted stucco placed in aedicules over the bronze doors; and secondly a series of eight huge roundels, four with the seated Evangelists and four with scenes from the life of St John Evangelist (referring to the patron of the founder, Giovanni di Bicci de' Medici, buried with his

wife in the centre of the sacristy). The roundels (Figure 15A) are high above the observer, and in order to help make the stucco forms tell from a distance they were painted in apparently highly contrasting tones.

The most dramatic of the St John series of roundels is the one which represents the saint rising to Heaven from a constricted architectural scene (Plate 51). The comparison with Ghiberti's architectural construction (Plate 50) is a remarkable one. Donatello's architecture could have no reasonable plan; its spaces are forced together and seem to push the saint upward as if he were being squeezed from a vacuum. The exaggerated perspective brings together the verticals at their summits, somewhat, as one critic has well put it, like the view upward from a Manhattan canyon. The ascensional lines have a visual as well as expressive function; the lines lead the eye upwards beyond the tondo frame into the far larger circular plan of the cupola.

In Brunelleschi's *Life*, the author stated that Brunelleschi took violent offence at the intrusion of Donatello's sculpture in the architecture he had, after all, designed.[22] But in general the early sources reflect approval of Donatello's work in the sacristy. In his fifteenth-century treatise on architecture Filarete noted, in a reference to a famous phrase in Alberti's *Della Pittura*, that Donatello had made his Apostles 'look like fencers' rather than intellectual disputants, but in his description of the Utopian city of Sforzinda in the same work, he gives to the ideal cathedral there imaginary bronze doors by Donatello as well as by Ghiberti and by himself.[23] The imaginary doors all had a basis in actual commissions.

Filarete in Rome

Antonio Averlino, called Filarete, was born in Florence *c.* 1400. He is best known as a theoretical writer on architecture, but he was a distinguished practising architect after 1451 at the Milanese court and a sculptor in bronze of the first importance for his age. His training was apparently in Florence as a goldsmith and probably not, contrary to the older theories, in the workshop of Ghiberti. His art appears incompatible at virtually every point with both Ghiberti's theory and practice. But it is nonetheless significant historically.

Besides a number of small-scale bronzes, including the first Quattrocento reproduction of the equestrian statue of Marcus Aurelius then outside the Lateran (preserved in Dresden) and a splendid processional cross (still preserved in the Duomo of Bassano), Filarete left behind him as a *magnum opus* the central bronze doors of Old St Peter's in Rome (preserved and in use in the new fabric in the same general emplacement).[24]

He seems to have come to Rome in 1433, and could have had a brief but important connexion with Donatello and Michelozzo there. On their departure he became established as the leading sculptor of Rome, and organized the first Renaissance bronze foundry in the city. The undated and undocumented bronze tomb of Martin V (d. 1431) in S. Giovanni in Laterano follows the Florentine type defined by Donatello and seems to have been cast and chased by Filarete and his shop (Plate 53). The model for the head and the overall design of the tomb has been denied to Donatello himself, but

both may well have been prepared before his departure in 1433 by Michelozzo, whose partnership with Donatello kept him in Rome, it will be remembered, until that date. The design of the great bronze doors of St Peter's must have been drawn up and approved in its first stage before 1434, when Eugenius IV was forced hurriedly to leave the city (Figure 16).

Filarete's bronze doors for St Peter's are larger than Ghiberti's Gates of Paradise, even including the outer frame. They consist of several sections cast separately and joined together. At the top are two large panels, one to each valve, representing the seated teaching Christ and the Virgin enthroned. Two even larger panels below, in the central section, represent on the left valve St Paul, on the right valve St Peter, who offers his keys to Pope Eugenius kneeling at his right. Below these panels, finally, are two square panels, one representing the sentencing and execution of St Paul and the other the sentencing and execution of St Peter. The frames are particularly elaborate; they consist at the top of winged putti supporting the arms of Eugenius and the papal arms; down the sides are splendid arabesques of acanthus with profiles, both antique and modern (Plate 54A), interspersed in the foliage with animals, birds, and scenes from mythology and the like; on the reverse of the lowest edge of the frame is a charming frieze representing the master with his assistants ('discipuli') who weave their way in a 'dance of life' away from Intemperance, symbolized by a figure holding a jug, or an ass (Plate 55B), in order to approach Virtue and Right Judgement (Giudizzio), symbolized, as in medieval bestiaries, by a dromedary. The play on the idea of Virtue ($\dot{\alpha}\rho\dot{\epsilon}\tau\eta$) in the artist's own cognomen of Filarete gives the inner relief the value of a signature. On the outer face the relief is signed no less than twice, and the artist's Florentine origin is mentioned in the inscriptions.

The doors have very recently (1962) been cleaned, and the data of style and manufacture are at long last evident, where before the accumulation of hardened dust and oxidation of the metal surfaces had prevented a clear view.[25] The cleaning did not uncover gilding, which one might otherwise have thought was there originally. In contrast with the dark bronze surfaces would have been the bright accents of champlevé enamels spotted here and there in details of the costume (Plate 54B) or of the architecture in the two lowest panels. Every square inch of the surface was chased, in some areas with extreme ornamental attention, in most areas with great finesse.

During the course of manufacture a change in design seems to have occurred. The original floral motifs under the four upper panels were deleted, and in their place were introduced reliefs relating to the great Council of Ferrara–Florence of 1438/40 (Plate 55A). These scenes represent the travels and arrivals of the various 'foreign' delegates, not only the Byzantines but the Maronites and Armenians, and also the principal events of the council, such as the solemn joining of the Eastern and Western Churches. Thus the papal patron was given additional prominence in the imagery, but as well we are given a valuable hint on the chronology of the work. The frame must have been complete in its first state by 1439, or even 1438. The figure style of the inserts is somewhat different from that of the lowest scenes, which presumably were completed before the frieze-like 'modern' historical scenes of the council were designed, necessarily

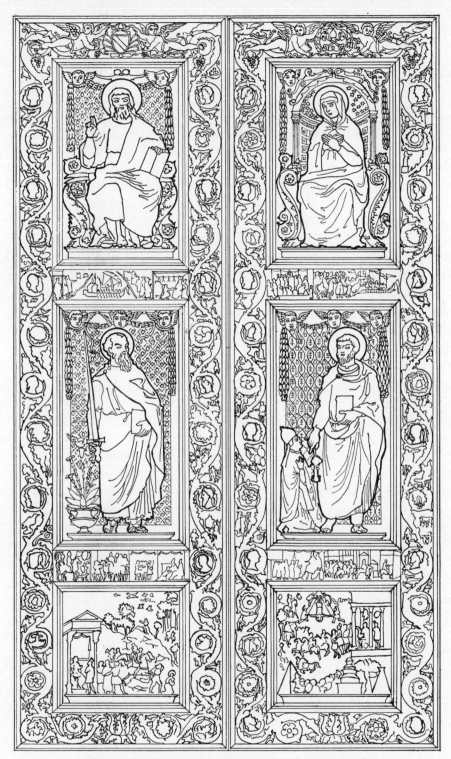

Figure 16. Filarete: Doors, begun *c.* 1435. *Rome, St Peter's.*
Location of principal themes (after a photograph)

after 1440 but not much after 1442 or 1443, since the doors were complete on firm documentary evidence by 1445, in time for the Feast of the Assumption of that year. In 1447, the sculptor was discovered midway in a pious theft of the relic of the head of St John from St John Lateran. He was forced to leave Rome hurriedly and, as far as is known, was never able to return.

The mark of his influence on the Renaissance sculpture in Rome is nonetheless very deep. Filarete's was the dominant personality in the Latium area until the formation of a second Roman School towards 1465. A number of fifteenth-century plaquettes and medals are connected with the style of the doors of St Peter's, and though these cannot be given to Filarete's own hand, they show the continuing activity in bronze of the shop he left behind him. The impress of his influence on marble sculpture was less evident, but nonetheless a large factor in the art of such an Early Renaissance master as Isaia da Pisa, as will be pointed out in the following chapter. The art of the doors of St Peter's has given rise to varying critical reactions. Its departure from the norm of the Florentine humanist style as established, let us say, by Ghiberti in the second doors presents at the outset grave difficulties in assessing the value of Filarete's achievement. It is apparent, though, that the Florentine norm had little to do with the particular local demands of the programme for St Peter's. These demands produced results of general interest for our view of the total development of fifteenth-century art in Italy as a whole. They may be summarized under three headings.

The first and most obvious characteristic is archaism. Not only the original subject-matter but its organization and manner of execution must be thought of as deliberate revivals, or more accurately, re-interpretations, of earlier medieval style. Where Florence was experimental in a number of differing ways, Rome was experimental in ways of re-asserting tradition. Thus the strongly iconic quality of the main figures answers to a purpose which the Calimala in Florence would never have had as its own. The medievalizing staring visage of St Peter (Plate 54B) fitted the Roman purpose, where it would never have been understood in Florence. The ornamental diaper-work of the backgrounds and the use of enamels are medievalisms which have their place in Rome, particularly the Rome of Martin and Eugenius. They suggest that there was never the slightest break between the martyrdoms of Peter and Paul and their own present. Significantly, the figure of the kneeling Eugenius is taken, with only a few archaizing modifications, from the marble monument of Boniface VIII preserved in the Lateran.

The second characteristic is the range and quantity of the motifs taken from the Antique. The treatment of the Antique in Rome is not so nostalgic as in Florence, nor so often given cryptic expression under non-Antique guises of subject-matter. In Rome Antiquity is not a time forever lost, but something alive, to be rediscovered from moment to moment. The Antique is everywhere; it is tangible spiritually and intellectually. Even as early as 1435, when so little comparatively was yet above ground, there must have been a noticeable feeling for its everyday presence. In Filarete's doors the myriad little subjects taken from Aesop and classical mythology as well as from direct casts of ancient coins or medallions are witnesses to the joy of chance finds. They

enliven the foliated frame of the doors of St Peter's with a spirit different from the sober and more formal re-use of the Antique in the jambs of the Porta della Mandorla, which come closer than anything else in Florence to the Roman models used by Filarete. One must have a twentieth-century feeling for revivalistic and *objet trouvé* art in order to feel Filarete's approach.

The third characteristic is the tendency towards flatter relief, and in compensation richer and more ornate handling of surfaces. This is true of the two lower reliefs of the doors of St Peter's, which derive in their system of composition and use of the square frame directly from Ghiberti's panels of the Gates of Paradise. Modelling in depth is to a great extent played down deliberately in order to give play to devices to enhance surface. This characteristic was to remain as an important hallmark of Roman Renaissance sculpture until the 1480s.

Developments in Florence to 1450: Buggiano; the Middle Period of Luca della Robbia; the Emergence of Bernardo Rossellino

Beside the work of Donatello and Ghiberti, with their immediate workshops, there were in Florence up to 1450 three currents of style which deserve a word now. The first should not detain us long, but it has a certain interest in connexion with the Donatello–Brunelleschi controversy of the 1440s which was mentioned a little earlier and the highly ornamented archaistic style just examined in Filarete's doors. The sculptors most closely associated with Brunelleschi after 1435 were his adopted son, Andrea Cavalcanti (called Il Buggiano from his birthplace close to Florence on the road to Pisa), and Luca della Robbia.

Out of Eugenius IV's stay in Florence in the 1430s, where his headquarters were established in the Dominican convent of S. Maria Novella, grew the need, apparently, for a new pulpit for that church. The design is traditionally given to Brunelleschi, and thus would date from before 1446, when he died. The execution, we know from documents, was by Buggiano. The rather blatant revivalism of the classical ornament and the strong flavour of archaism in the reliefs (Plate 56B) break harshly into the aesthetic atmosphere of fluent harmonies established by Ghiberti, or of actively plastic expressionism then being developed by Donatello. The pulpit completed in 1453 seems to be part of a little enclave of papal conservatism in Florence. The sculptor was also to come under the influence of Luca della Robbia. The carving of the decoration of two marble lavabos in the sacristies of the Duomo dates from the 1440s (Plate 56A). The coexistence of two such different styles in one artist is already an index of eclecticism.

Meanwhile about 1440, in close relation to architectural needs, and perhaps specifically under the influence of Brunelleschi, Luca della Robbia was developing his well-known technique of coloured glazed terracotta sculpture. It is not possible to say with any assurance when he began to work in this medium, which was all too soon to become so important a part of the commercial aspect of Florentine sculpture. Some devotional reliefs of the Madonna and Child have been at various times assigned to the 1420s, even before the Cantoria reliefs.[26] But the lack of documentation in connexion with

K

these isolated pieces raises insurmountable difficulties at present in reconstructing the experimental process which led to the datable results. It would seem that architectural requirements, rather than the colouristic latitude of painting, lay behind Luca's motivation. In Florentine art there had already been, some time before, the experiment of the large white painted terracotta Prophet for the Duomo (see p. 67) and it would appear that the terracotta Coronation of the Virgin by Dello Delli of c. 1424 for the exterior lunette of S. Egidio (Plate 18A) was painted white, in contrast to the polychrome figures done by the same artist for the interior of S. Egidio. The 'white style' would seem to point to the architectural advantage of placing high up on structures relatively light terracotta sculpture in the round or near-round; white paint or white glaze would tell at a distance as a substitute for the white note of colour in Tuscan or Pisan marble.[27]

The first dated use of polychrome glazed terracotta by Luca della Robbia is as ornamental inserts in the marble tabernacle (Plate 58) that he carved for S. Egidio (later moved to the parish church of Peretola on the outskirts of the city). The date of completion is 1442. In the same year he was commissioned to design and execute in the glazed terracotta technique the lunette sculpture in high relief for the overdoor of the north sacristy of the Duomo. This was finished and in place in 1445 (Plate 57). After only a slight interval in time, in 1446, came the commission for the Ascension to go into the lunette over the door into the south sacristy opposite. In 1445 Luca, in partnership with Michelozzo and Maso di Bartolommeo, had already been awarded the contract for the bronze doors of the north sacristy.[28] At this point it must be recognized that Luca della Robbia in his middle period was veering away from marble-carving towards modelling in clay for terracotta, and its subsequent glazing, or in wax for casting ultimately in bronze. As one might expect, his style at the same time began to lose its earlier echoes of Nanni di Banco and took on influences from Ghiberti.

The point of balance in Luca's case between the current represented by Brunelleschi and that by his old arch-rival Ghiberti is to be found in the sculptural decoration of the interior of the Pazzi Chapel in S. Croce. It would seem that in the Pazzi Chapel, as opposed to the Medici-sponsored and Medici-controlled old sacristy in S. Lorenzo, Brunelleschi was able to keep under his own direction the sculpture that was to be inserted into the architecture. He evidently learned from his experience with the old sacristy. There is a difference in the Pazzi Chapel not only in the scheme of emplacement of the sculpture but in its character as determinable by technique as well as style and imagery. In the Pazzi Chapel (see Figure 15B) large roundels of the Evangelists are retained, but placed in the pendentives; smaller roundels with the seated Apostles are placed in the lower area, but sufficiently high to catch the light. All the Pazzi Chapel roundels are in glazed terracotta. Not only do their surfaces gleam, but the colours are very much more distinct, and their effect is far cleaner and more precise, in harmony with the total architectural effect of the interior. The Apostle series, dating according to most modern estimates from about 1445, presents the figures in white against a subtly gradated blue ground that suggests a design of concentric circles with cosmic overtones of imagery. There are still echoes of Luca's earlier dependence on Nanni di Banco in some of the figures, though hints of Ghiberti's crispness of modelling are

already present. The Evangelist series is unusual for Luca in the width of range in colour and the biting realism of heads and such details as the hands and feet. Probably only the execution of the reliefs is to be given to the della Robbia shop; the *modelli* were certainly by another master, quite possibly Brunelleschi himself, as most recent criticism has tended to point out.[29]

Thus we can trace Luca's progress from his earlier period in the late 1430s, when he was close to the influence of two of the great innovators of the *stile nuovo* (Nanni di Banco in the reliefs of the Arts for the campanile and Masaccio in the unfinished reliefs for the Altar of St Peter in the Duomo), to a point where Ghiberti's extraordinary influence in Florence in the 1440s began to take over.

Another Florentine sculptor about ten years Luca's junior, Bernardo Rossellino (1409–64), seems to have missed completely the influence of Nanni and Masaccio and to have been virtually from his beginnings mainly under Ghiberti's spell. As so frequently happens in this period, we are left with a blank as far as reliable information about the youth and training of this important sculptor-architect is concerned. His family, the Gambarelli, were from Settignano, and we can be fairly sure that they were there because of their intimate connexion as purveyors or cutters of the stone with the quarries at near-by Settignano. A 'Magister Bernardus architector' appears in a document as working in the Vatican in the summer of 1433.[30] It is difficult to imagine to whom other than Bernardo Rossellino the statement may refer, and it is therefore quite possible that he was called to Rome by Eugenius IV as one of the group of Florentines that included Donatello, Michelozzo, and Filarete. His first sculpture was commissioned by the Misericordia of Arezzo in the winter of 1434; so he must have been by then a sculptor of recognized ability. Purely on stylistic analogies, his master in stone carving is more likely to have been Michelozzo than anyone else. When some time, probably in 1445/6, Bernardo Rossellino was given the commission for the monument of Leonardo Bruni (who was incidentally a native of Arezzo), he designed two rather ungainly, plumply long-limbed boys as supporters for the Bruni arms at the top of the monument (Plate 59). They are reminiscent in most respects of the earlier trumpet-blowers of Michelozzo's Brancacci Monument in Naples (Figure 10), and it is possible, though at present far from provable, that Bernardo was associated as an assistant to Michelozzo with the preparation of that monument. In 1435 and 1436 he carved wall-tabernacles for the Badias in Arezzo and Florence, and between 1441 and 1444 he was employed by the Operai of the Florentine Duomo, though not on a frieze of putti in wood for the Sagrestia delle Messe, for which Luca della Robbia was preparing at the same moment the glazed terracotta lunette. Then, in 1444, he received the commission for an Annunciation for the Compagnia della Misericordia of Empoli, a commission which was reconfirmed, with a stipulated finishing date of only four months, in 1447 (Plate 60, A and B). Here the influence of Ghiberti is quite obviously in the ascendant, although there is a noticeable difference in execution between the two figures, which may be the result of a collaboration with another sculptor or assistant, or possibly simply the result of an interim of several years separating the finishing of one and the completion of its companion.

The interruption was likely to have been caused by the commission for the splendid tomb of Leonardo Bruni that still stands in S. Croce as the principal monument to Bernardo Rossellino's own reputation as well as to Bruni's memory. With Donatello away in Padua and Luca della Robbia busy on work for the Duomo, the most likely candidate to receive the commission was Bernardo. The famous chancellor died in 1444, leaving as his wish to be buried in S. Croce 'without pomp' under a simple marble slab set in the floor of the church; the monument that we know today was the result of a campaign begun by the citizenry of Arezzo, to which the Florentines soon added, it would seem, their own weight and funds. The final decision to raise so large a monument is not likely to have been reached very soon after Bruni's death, so that a starting date for the monument in 1445 would represent an extraordinarily prompt beginning: 1446 seems a more reasonable date. And in view of the size and elaborateness of the monument, it could well have been worked on by Bernardo and his shop until 1449/50. All these dates are necessarily tentative, since no documents are available.

The general scheme of the Bruni Monument was a modification of Michelozzo's and Donatello's Coscia Monument in the baptistery (compare Plates 26 and 59). But there are some echoes also of Michelozzo's Brancacci Monument (Figure 10) in the proportions. The recumbent figure of the deceased on his bier, with the large features powerfully modelled after a death-mask (as seems certain), covered with the fluent drapery, all recall the effigy of Aragazzi at Montepulciano rather than Donatello's bronze Coscia. The Roman eagles of the bier and above all the beautiful flying angels who present the inscription on the face of the sarcophagus come straight from Ghiberti, but are given a more direct and unequivocal reference to the Antique. Vasari was the first to mention that there was a younger assistant's hand present in the lunette which includes at half-length the Madonna and Child in a roundel flanked by a pair of adoring angels. The presence of assistant's work in the upper portions need not surprise us, though a discussion of the shopwork in the Bruni Monument will more fittingly be introduced in the next chapter than here. Better emphasized now is the decisive way in which still another move was made to produce in the design of this monument a rich and yet essentially clear organization of the many elements that constituted the Florentine wall-tomb. Bernardo Rossellino's solution represented an essential step forward in architectural sculpture. In 1449 work had presumably advanced sufficiently towards completion for him to accept the commission for the wall-tabernacle of S. Egidio, the door of which was cast after Ghiberti's design by Ghiberti's shop.[31] The closeness of Bernardo Rossellino to Ghiberti at this moment is underlined by the double commission. The rapidly shifting temper of taste in Florence about 1450 is likewise indicated; for Bernardo's delicate marble aedicule peopled by fluttering angels replaced the simpler and nobler tabernacle by Luca della Robbia (Plate 58) which had been carved only seven years before.

ELABORATION, 1450–65

THE note of splendour in its originally fresh effects of colour and wealth of finely chiselled ornament that the Bruni Monument brought to S. Croce opened a new age. 'Magnificentia' began to appear as a more frequent term to describe human greatness. The homage to the memory of great men began to rival the homage paid to the shrines of saints in an earlier period. In some cases, as in the huge marble shrine begun, but never finished, to the memory of Sigismondo Malatesta, there developed a *bona fide* humanist cult of relics in which the dust of a great philosopher or philologist would be sought out and preserved with all the respect and mystical attachment of true religious piety. But the highest place was reserved for the man of heroic actions who, in the ideal of the Renaissance, might combine the glory of a life of military triumphs with the wisdom of a Platonic guardian of the state. This was the height of *virtù*, and to celebrate the personal achievement and qualities of magnanimity of a great leader was to become by 1450 the first and most important function of sculpture in Renaissance Italy.

Not only did the monuments to the fame of dead leaders become more grandiose and elaborate, but portraits in sculpture of the living great, or at least the living distinguished, began after 1450 to come into prominence. In Florence a new generation, born about 1430, of marble sculptors headed by such well-known names as Mino da Fiesole, Antonio Rossellino, and Desiderio da Settignano were more successful on the whole as portraitists and carvers of imaginative ornament in glowing marble of unequalled purity than they were at constructing a human body or putting a pose into action. The panoply of ornament and the sheer beauty of delicate and subtle effects in marble were to stand in a remarkable contrast with the more rugged, expressionist forms of Donatello's late bronzes. It was Donatello who was to have the major influence on the younger group of sculptors in Siena. To Mino and Antonio Rossellino were to go the major responsibility for new schools of sculpture about to come into their own in Rome and Naples. Meanwhile, as we shall see, from the shop of Desiderio was to come a group of still younger men, of whom one, Andrea del Verrocchio, was to be the Florentine leader in art in the 1470s.

THE GLORIFICATION OF VIRTÙ: MONUMENTAL PROGRAMMES IN PADUA, RIMINI, AND NAPLES

Donatello in Padua

After making his will in 1441, the retired *condottiere* general of the Venetian land-forces, Erasmo da Narni, nicknamed Gattamelata, 'the Cunning Cat', died peacefully of a stroke in Padua. In his will he arranged for a monument befitting his 'Magnificentia'.

Grateful for his earlier services, and probably also as part of the war of nerves which expansionist Venice under Doge Francesco Foscari was at the time waging on the mainland, the Venetian senate gave official orders to raise a public monument to the old soldier's memory. The general was to be buried in the Santo, the most famous Franciscan pilgrimage-centre of North Italy. Presumably an equestrian monument in stone set into the wall, of the type of the slightly earlier Sarego Monument in S. Anastasia in Verona, was originally in the minds of the senate and of the surviving members of the family who were to supervise its making. Presumably also because of the dearth of sculptors in Venice capable of making an equestrian figure of monumental proportions, it was necessary to look elsewhere than in Venetian territory for the sculptor. The choice fell on Donatello in Florence. He left his native city in 1443 for the north of Italy, where he was to make his principal headquarters for the next ten years in Padua.

Recent scholarship has stressed the primary position of the Gattamelata Monument in the sequence of commissions that Donatello was to receive in the north, not only in Padua but in Venice, Mantua, and Modena as well.[1]

The choice of Donatello as sculptor for the monument may have been connected with the hiring of two Florentines, Antonio di Cristoforo and Niccolò Baroncelli, to make in bronze the equestrian statue of Niccolò III d'Este at Ferrara in 1441/2. Probably the plans for such a monument at a place so close to Padua as Ferrara and the probability that it was inspired from the famous Antique equestrian statue, the 'Regisole' in Pavia, on territory which the Venetians were eyeing hungrily, influenced Donatello's own view of the programme as he would have liked to execute it. By 1447, therefore, it would seem certain that the decision had been taken to make the Gattamelata memorial of bronze (with a high stone base), out of doors and as a frank revival of a Roman Antique hero's or emperor's equestrian portrait (Plate 62). It is not the first example in Florentine art of the equestrian theme put to the use of honouring a military leader; but it is the first time, it would appear, that a *condottiere* was presented in the armour of Antiquity and in the guise which Antiquity has reserved for the holder of only the highest secular power.[2] The extremely detailed decoration of the armour with Roman motifs, the fine walking horse derived from the Antique quadriga on the façade of St Mark's in near-by Venice, the Caesar-like head (no portrait in the usual sense), all reinforce the idea that Erasmo's achievement as a man and leader was fully worthy of comparison with the *virtus* of the Ancients. The excuse for this elaborate charade, this extraordinary presentation of an individual who might otherwise have started to slip towards oblivion, was simple, and for Renaissance minds of about 1450 undoubtedly powerful: it was, as a document of 1453 explains, because of 'his outstanding fame (. . . insigni fama ipsius)'.

The Gattamelata rises from the square close to the north-west corner of the façade of the Santo on ground that was used until the eighteenth century as a cemetery. The monument was never used as a tomb, notwithstanding statements made in modern times to that effect, for Erasmo, with his family, is buried in the chapel ordered by his widow in the interior of the church. The placing of the image on sanctified ground, however, must have had significance for the times. This frank reincarnation of a pagan

type did not, apparently, seem out of place in a Christian context. The notion of the soul, which was seen as the vital source of true *virtù*, could hardly have been visualized at the time except in the traditional religious terms of the Church. So it was high above hallowed ground that the statue of Gattamelata was placed: a monument to a new artistic conception of the hero.[3]

The documents do not state exactly when the statue was begun and finished. It would seem likely that it was cast by 1447/8 and virtually completely finished in the chasing, ready to go up on its tall pedestal, by 1450. But it was only in 1453, two years after the rival Este statue was in place, that the bulky horse and rider were finally put into position. Hardly were they up when Donatello, who must have felt his main reason for coming to Padua was fulfilled, was on his way south in the direction of Tuscany once again.

*

Before he left Padua he had done a considerable amount of religious sculpture for the Santo authorities. With a steady corps of five able assistants who were specialists in bronze and a fluid group of stone-workers under his orders, Donatello put his hand to at least three major projects. As early as 1444 he cast a powerfully heroic and tragic Crucifix which was destined to be placed over the choir screen.[4] For a brief period Donatello supervised work on the screen, which was begun before his arrival. Finally, in 1447 he made a contract to furnish a number of reliefs in bronze, including four large ones on subjects taken from the life of St Anthony, and several statues, including one of St Francis and one of St Louis of Toulouse. These were all for a new high altar for the church, for which funds were first given in 1446. By the Feast of St Anthony on 13 June 1448, seven statues had been cast, including, besides the two already mentioned, images of SS. Prosdocimus, Daniel, Justina, and Anthony. These, with the main reliefs and with secondary reliefs also in bronze of angels, together with the symbols of the Evangelists, were set up for public display in the choir in a temporary wooden construction. In the next year more bronze reliefs were added, bringing the final number to no less than seventeen. By June 1450, the stonework, including eight 'colone' and an over-arching cover or 'chua' (*coiffe* in French) was ready and the bronzes, some of which were never completely chased, installed.

In 1582 a new Mannerist altar was completed and the bronzes redistributed on it, with the result that Donatello's original arrangement has been irretrievably lost. A number of attempts have been made to reconstruct its appearance from the data of the documents and an eye-witness description by Marcantonio Michiel written about 1520 (Figure 17). The problem is a real one and has a particular importance. Among the altar-programmes of the Renaissance this was the most elaborate. It poses once again the recurrent question of how the emplacement of Quattrocento statuary and reliefs might be solved. The range of these modern reconstructions is broad indeed. None so far seems to be wholly persuasive. We have nevertheless the original bronzes; these reveal a new sense of contained pathos in the statuary and a developing expression of drama and movement in the storiated reliefs (*istorie*).

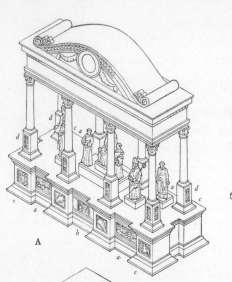

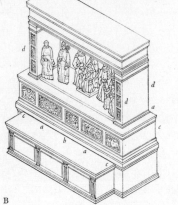

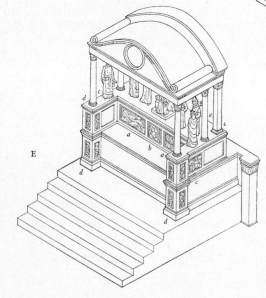

Figure 17. Donatello: High altar, 1447–50. *Padua, Santo.*
The problem of reconstructing Donatello's design.
Diagrams of various solutions

A After von Hadeln (1909) a *Istorie* reliefs
B After Kauffmann (1935) b Dead Christ and
c After Planiscig (1947) Angels relief
D After Janson (1957) c Evangelist reliefs
E After Parronchi (1963) d Angel reliefs

Both the series of seven statues and the series of four large reliefs were modelled and cast within the same short period of about a year, or a trifle more. It is hardly reasonable, therefore, to look for any marked stylistic progression within each series. The statues, as it has been noted several times in the scholarly literature, were not intended to be seen individually but as a group, more particularly a *sacra conversazione*, to face from their position on the high altar the main body of the church of the Santo. The central Madonna and Child was represented frontally and hieratically as a single tightly articulated and enclosed columnar mass. The figures of the saints on either side of the Madonna were conceived as discrete compositions with a main frontal view and with the utmost restraint in their gestures, which serve as a device more of visual linkage than of individual expression. The freshness of youth (St Justina and St Louis of Toulouse), the courage of asceticism (St Francis), the tragic dissolution of old age (St Prosdocimus) were here given contrasting characterizations. The last-named (Plate 61B) carried over the facial distortions of some of the putti of the Florentine Cantoria of a few years previous into quite a different bodily image of quiet stasis. The figure appears to huddle into itself, and what action there is suggests the reflection only of a state of inward being, of querulous contemplation. A comparable figure at Ferrara seems empty (Plate 61A).

With the reliefs representing miracles in the story of St Anthony, Donatello attacked quite another problem. From the documentary evidence it seems perfectly clear that three of the four reliefs were cast during the spring of 1447 and that the last, which is to be identified as the Story of the Miser's Heart, was ready for casting in the immediately ensuing weeks of the summer of that same year. The precise chronological order of all four reliefs is not important. Just as in the case of the statues just discussed, the reliefs appear to have been made as virtually concurrent variations on a theme rather than as four separate experimental steps in a development, whether conscious or accidental.

Nevertheless two pairs are to be discriminated according to subtle stylistic differences. One was given clear tripartite architectural settings projected on a strict one-point perspective scheme with a low vanishing point; in this first pair the foreground figures were modelled in very high relief, and the theatrical settings, though varied, were alike designed to suggest relatively shallow dimensions in depth. In the first (The Miracle of the Speaking Babe) the scale of the architecture was reduced to a point far below the scale of nature, and the fashionably costumed figures were made to emerge from its low and narrow apertures much as one imagines the actors to have squeezed through the little openings of the perspective *coulisses* of the Palladian theatre that can still be visited at Vicenza. In the companion-piece (The Miracle of the Ass at Rimini) the setting was changed to the three coffered openings of an Imperial Roman triumphal arch. Under the central arch Donatello inserted the Christian altar about which according to the legend the miracle evolved – a striking prefiguration of Alberti's virtually contemporaneous adaptation of the Roman Arch of Augustus at Rimini to his Renaissance façade for the church of S. Francesco there (see below, p. 129). The low point for the perspective recalled Masaccio's arch-enframed Trinity in S. Maria Novella in Florence of about 1425, but associated with a far greater Roman sweep of space in the Paduan

version, and with added excitement in the concerted action of the crowd, represented as thronging what once again appears as a stage-like rather than as a 'real' environment. This undoubted emphasis on stage-imagery was, on the circumstantial evidence available to us, related to actual performances of miracle-plays devoted to St Anthony at Padua.

The second pair of reliefs was conceived with deeper and far more complex spatial constructions and with flatter relief in the figures, which are now even more numerous than before. Here the perspective schemes provided for a higher and more distant viewing point, and in most reconstructions of the original altar this second pair (the Miracle of the Angry Son and the Miracle of the Miser's Heart) have been imagined as decorating the front of the high altar, facing the pilgrim as he made his approach to the sanctuary from the long body of the nave. The visual placement strongly suggests that a logic of relationship existed between the spatial imagery chosen for each relief and the essential meaning of the *istoria* presented. In the Miracle of the Miser's Heart, the stage was set with little open skeletonic structures symbolizing 'houses' facing a central 'street' leading to the portal of a large 'church'. The spatial relationships between these structures at first appear to make up a coherent whole; only on second and third glance does it become apparent that the two sides of the 'street' do not match up and that, where one would expect a terminal wall in the right background, a whole new space suddenly opens out. There a flight of stairs leads from an invisible source to a tiny blind portico, and a ladder starting mysteriously from nowhere in particular juts up to a point just short of entry to a window. It would seem that this space of paradox, in which normal conditions of predictability of locality are twisted into unexpected contradictions, was connected in Donatello's mind with the dénouement of the saint's story in which the *locality* precisely of the miser's heart was found to be not, as was to be expected, within his breast but in his strong-box.

The most striking of the series of the Santo reliefs, the Miracle of the Angry Son, is illustrated on Plate 63. The spatial composition stresses, not a preconceived order, but violent contrast, to produce effects of dislocation. The right-hand building in the foreground is wrenched out of normal perspective, so that the orthogonals of the ground-plane adjacent completely miss the centre-point for the orthogonals of the remaining structures. A huge, mysterious void (not so far to my knowledge securely identified with any specific building-type or programme) contends with the compressed figures in violent action of the central group in front of it. Behind it rises in opposition the mass of an equally mysterious building seen on the bias, in conflicting two-point perspective. This space of *disjunction* may well have been intended to underline the point of the incident depicted, in which the boy who had angrily kicked his mother had cut off his offending foot in remorse. The moment of climax in which the foot is being rejoined to the body by the saint's charitable intervention is the moment chosen for the action. Donatello's choice of the Antique motive of Pentheus mythically dismembered by the Maenads for his central group, but with an inversion of the original meaning, as acutely pointed out by Aby Warburg and his followers, underlines the sense of paradox which the architectural imagery so aptly projects in support of the figural imagery of the actors of the miraculous *istoria*. That Donatello was consciously

making use of the classical theme is proved by the gratuitous introduction of two figures reminiscent of a river-god and a reclining nymph against a rocky background in the left foreground, with their own wild landscape behind them.

Out of such variety of solutions to the problem of relating space to action in the reliefs at Padua there emerged a remarkable step forward in the imaginative and expressive uses of the humanist mode. Not by following the Albertian norm, however, nor by a literal re-use of the Antique was this achieved. It was rather, in Donatello's case, by the liberty of breaking the mould of a system, or by an unexpected counter-interpretation of a classical model, that he was able to reach such startlingly new conclusions. The Paduan St Anthony reliefs in bronze, by their elaboration of surface-finish (including innumerable accents in gold and silver) no less than by their elaboration of imagery and composition, represent Donatello's reaction and clear personal answer to Ghiberti's reliefs of the east portal of the Florentine baptistery, the designs of which were settled, as we have seen, some years before Donatello left for Padua.

A number of originally conceived little reliefs were carved just before 1450 either for the supporting pilasters of the Santo's altar-cover or for the choir screen (Plate 64A).[5] The design alone, and not the execution of these 'statuettes in relief', can be assigned to Donatello; here he seems to be staking in marble a counter-claim to the quality and expressiveness of Ghiberti's small bronze Prophets and Prophetesses of the Gates of Paradise, though it is a question more of the general type and scale than of any particular pose or individual motif. These low-relief figures lead directly to the second of the great Quattrocento programmes conceived around the theme of glorification of *virtù*.

The Decoration of the 'Tempio Malatestiano' at Rimini

Sigismondo Pandolfo Malatesta, Lord of Rimini and Fano and Captain General of the Armies of the Pope, after passing through critical dangers to his life and career in 1446, gave orders to construct in thanks to his patron a chapel dedicated to St Sigismund. This was to be built on the south flank of the existing Gothic fabric of S. Francesco at Rimini. By 1450, the year of the Jubilee in Rome and of Sigismondo's recognized conquest of the beautiful and witty Isotta degli Atti, the original scheme had changed to a far more ambitious one. No less than a complete encasement of the church's nave in gleaming white marble and the raising of a domed structure over the eastern portion was planned by no less an architect than Leone Battista Alberti. The interior, with open chapels alternating with closed chapels flanking a unified broad nave, was to be given the richest sculptural decoration of any Renaissance building up to its inception.

The rebuilt S. Francesco, or the 'Temple' (Tempio Malatestiano), as it came to be known in Albertian architectural terminology, was never finished. The complete façade and the shape of Alberti's huge dome, as planned, is known only through the reverse of a small medal of the patron by Matteo de' Pasti. But enough of the new nave was actually built and enough of its sculpture was actually carved to provide an impressive idea of what was intended: in its totality of imagery a programme worthy

of a monograph in itself.[6] For our purposes here, a certain number of basic facts are needed before a summary of the style, or better styles, of the sculpture can be attempted.

It would seem definite that none of the sculpture antedates 1449. In that year Agostino di Duccio, a Florentine then about thirty years old, who had had experience as a first-class sculptor of marble at the Duomo workshops, is first mentioned as in Rimini. In the next year we learn that one of the elephant-bases for the huge pilasters at the entrance to the chapel dedicated to St Sigismund was in place. Work then proceeded at a sufficiently steady pace for this first chapel to be dedicated in 1452. Alberti's *locum tenens* on the building-site was Matteo de' Pasti, the Veronese medallist whose relation to Pisanello was mentioned in the preceding chapter. In addition to supervising the architectural aspects of the programme, he may also have had a good deal to say about the placing and design of the sculpture. The execution of the sculpture, from the evidence that can be gathered from very scattered documentation, was entrusted to Agostino and his corps of assistants, one of whom, we know, was his younger brother.

The plan of the programme as executed is shown in Figure 18. On the exterior casing, between the piers supporting Alberti's Roman aqueduct-like arcades, space was available for sarcophagi. Here were to be buried the most distinguished scholars, poets, and philosophers of Sigismondo's court; in order to swell the number of these distinguished burials, Sigismondo went so far as to disinter the remains of the fifteenth-century Platonist Gemisthus Pletho, and had them brought from the Morea to his Temple in Rimini.[7] As one enters the Tempio through the main entrance at the west, the first impression is breathtaking. The subdued clarity of light and the simplicity of the unified volume of space of the nave is contrasted in a masterly way with the endless activity of the lightly modelled sculptural forms which cover three faces of each of the twelve great pilaster-like supports. On one's immediate right is the Chapel of S. Sigismondo, which was the first to be begun and finished and in which, by and large, the sculpture of the highest quality is concentrated. Then on the right follows the Chapel of the Relics, which belongs to the same early campaign as the Chapel of S. Sigismondo. The interior was already finished in 1449; the fresco inside of the patron and his saint by Piero della Francesca dates from 1451. The contemporary carvings of the door carry on the theme of small figures and handling of relief that Donatello had chosen for his own marble reliefs in Padua. The slightly later door-frame of the Chapel of the Virgin is more frankly humanistic in its subject matter (Plate 64B).

There was quite probably a hiatus in the work at this point, in 1452, while the schemes of sculpture for the additional chapels were being determined and the *modelli* for the assistants to follow were being prepared. Agostino's next campaign of sculpture would have been in this case concentrated on the Chapel of the Ancestors, across the nave from that of S. Sigismondo. In addition to the sarcophagus with its double relief representing his own military triumph and an Apotheosis of Athena, there were Prophets and Sibyls to be carved for the faces of the piers. The style by this time had changed from the rather full and idealized figures of the Virtues of the Chapel of S. Sigismondo to a much shallower relief with illusionistic suggestions of depth (Plate 65A). Agostino's dependence upon his probable early experience in Donatello's shop is

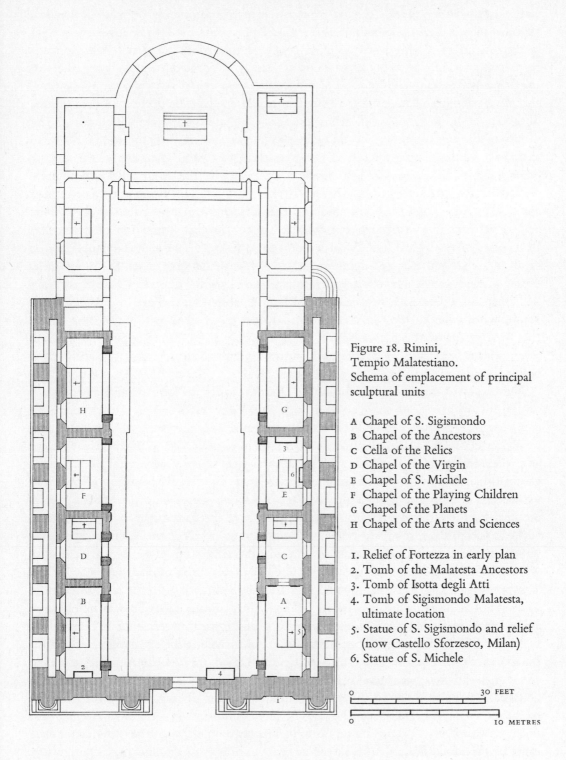

Figure 18. Rimini,
Tempio Malatestiano.
Schema of emplacement of principal
sculptural units

A Chapel of S. Sigismondo
B Chapel of the Ancestors
C Cella of the Relics
D Chapel of the Virgin
E Chapel of S. Michele
F Chapel of the Playing Children
G Chapel of the Planets
H Chapel of the Arts and Sciences

1. Relief of Fortezza in early plan
2. Tomb of the Malatesta Ancestors
3. Tomb of Isotta degli Atti
4. Tomb of Sigismondo Malatesta,
 ultimate location
5. Statue of S. Sigismondo and relief
 (now Castello Sforzesco, Milan)
6. Statue of S. Michele

0 30 FEET

0 10 METRES

well illustrated here; for the Isaiah is an extremely interesting transposition of Donatello's St John (Plate 13). A document speaks of the elephant-bases still to be installed in 1454 in the Ancestors' Chapel; so one must conclude that work there was still far from complete. Probably by 1455/6 the middle chapels, decorated with shallow reliefs of angelic music-making children and playing putti, were under way, and the more complex imagery of the Chapel of the Planets was just begun. The decorative programme of this chapel is astrological and strongly tinged with an other-worldly Platonism.[8] The motifs of the representations of the planet-divinities and signs of the zodiac show an extraordinarily attentive interest in the minutiae of classical lore; the verve, on the other hand, of the designs and the subtlety and sweep of the linear relief style mingle with the intellectual elements to set up a new and surprisingly Romantic view of man and the universe, quite beyond anything that fifteenth-century sculptors or painters had as yet attempted (Plates 65B and 66A). This is the first intimation of Botticelli's Romantic 'mythological style', which seems to have had very much the same Platonic idealism as a foundation of expression in visual forms and very much the same linear means of describing their nature and movement. Last of the chapels is that of the Arts and Sciences, where Agostino's own hand may be absent and where his brother Otta-viano, who seems to have arrived at Rimini only in 1455/6, quite likely was left in charge after Agostino's departure for Perugia in July 1457. There appears in this late series a static and non-linear style of sculpture which seems to be at the antithetical pole to Agostino's personal style (Plate 66B).

The career of Agostino di Antonio di Duccio covered a long period, and a good deal of the geography of Italy between Rome and Venice. Born in 1418 in Florence, his beginnings as an artist were influenced not only by Donatello but by Michelozzo, and to a lesser degree by Luca della Robbia.[9] By 1440 he was already an independent master and was called to Modena, where he carved the reliefs of the marble altar of S. Gemi-gnano for the cathedral, which are signed and dated 1442. He was assisting Michelozzo in the SS. Annunziata in Florence in 1446 when he was accused of stealing silver destined for the covering of the venerated painting of the Annunciation in that church, and was forced to escape from Florence to find a refuge in Venice. A lunette now pre-served in the church of the Salute in Venice shows his style there. From Venice he went to Rimini and to what must be assumed as the position of chief sculptor for the Tempio. From 1457 to about 1462 he was in Perugia, in charge of the sculpture of the Oratory of S. Bernardino (see below, p. 144). In the mid 1460s he was in Florence again, where he took up the challenge of the 'Giant-Prophet' in terracotta in Donatello's wake and began unsuccessfully another 'Giant' in marble, which Michelangelo was to transform ultimately, in 1501–4, into his famous David, now in the Accademia. In the 1470s Agostino was once again based on Perugia, where his late work for the Cappella della Maestà delle Volte in the cathedral may be seen in fragmentary form in the museum. From Perugia, late in his life, he sent sculpture for a tomb to Amelia, just north of Rome. In 1481 his name no longer appears in the available records, and he must be presumed dead.

This career, which was spent in the north of Italy and in Umbria far more than in

Florence, parallels the career of the painter Piero della Francesca. Though the paths of the two artists crossed in the Tempio Malatestiano and quite possibly later in Perugia, their styles were utterly different. Where Piero for the most part achieved in his painting a sculptural stillness of monumental static forms and was drawn inexorably to complex mathematical relationships of proportions and perspective, Agostino sought his solutions in surface-play and in the rushing impulses of quite unmeasurable linear rhythms. In some respects his art suggests a Platonic and non-naturalistic foretaste of aspects of the art of Leonardo da Vinci. Much as in Leonardo's case, the dynamic qualities of water in motion appear to have fascinated him. His most successful reliefs at Rimini are either on the subject of water or suggest a metamorphosis of the lithe and twisting shapes of hair or flowing folds of drapery into aqueous equivalents (Plate 66A). In one of these reliefs, which presents not the story of Noah but a highly charged poetic image of the Platonic version of the voyage of the human soul to take up its temporary abode in the sublunar world (Plate 65B), the drama is sustained not by the figure rowing in its frail craft, nor even by the fascinating orientalizing landscape, but by the animation of the wind-tossed and dragon-infested sea, as it swirls upwards and around the landscape under oppressive water-filled clouds.

The question has been raised as to the likelihood of a division of the sculpture at Rimini between two major sculptors; and the name of Matteo de' Pasti has been proposed for the sculptor who was hypothetically in charge of sculpture of the Chapels of S. Michele (or of Isotta), of the Planets, and of the Arts and Sciences.[10] Such a line between binary responsibility for the sculpture of the chapels is hard to draw when one is confronted by the sculpture itself. There seems to be a truly great variety of primary, secondary, and even tertiary hands in the execution of the sculpture and deliberate shifts, perhaps for variety's sake, of imagery and of relief-style from chapel to chapel. Agostino's control of the *modelli* and general overseeing of the execution up to the Chapel of the Arts and Sciences (the last chronologically of the series) seems not only possible but most likely, particularly with regard to the Chapel of the Planets, where his whole artistic personality, as I see it, is so much involved. However, the type of relief in the Tempio which at times approaches closely medallic relief (as in Plate 65B) might very well show the influence of Matteo de' Pasti's ideas, and perhaps at the *modello* stage in some cases a large degree of collaboration. Matteo's influence undoubtedly is present strongly in the ornamentation of the interior, and not only in the many heraldic designs, which suggest nothing so much as the reverses of medals. To make of him a sophisticated sculptor in stone, however, does not appear warranted without more evidence.

What seems clearest in the mysterious interweaving of different styles and sculptural modes in the Tempio is the steady sense of a single unifying idea behind the entire sculptural programme. If the Tempio could have been finished, that idea would presumably have been overwhelmingly evident, and the problems plaguing us in the area of attribution would perhaps fall into line and seem much less important. The celebration of Sigismondo's *virtù* as both military leader and prince, as both lover and scholar – the promise, in short, of the immortality of his fame as much as of his soul:

these were the guiding forces which brought the architecture and the sculpture of the Tempio into being. The immensity of the programme as it grew and the elaborate precision demanded for its execution was not likely to leave room for the free expression of artistic individuality. Such was the price that artists were forced to pay when they entered the service of 'Magnificentia' on so grand a scale.

The Triumphal Arch of the Castelnuovo in Naples

While the programme of the Tempio Malatestiano was in formation and ultimately entered the phase of execution, two sculptors came to Rimini in connexion with the work or plans for the work there. The first of these was a certain Isaia da Pisa, who turned up in 1448 before the sculpture-campaign had actually opened. He had come from Rome where he had taken over the important funerary monument in the Lateran Church of the Portuguese Cardinal Chavez, which Filarete had barely begun before his hasty departure the year before. Though the cardinal's monument has been dismembered, most of its principal elements still remain in different settings in S. Giovanni. Characteristic of Isaia's style, which we shall meet soon in Naples and later in Rome, is the statue of Temperance, in which an Antique source is translated into bland, full forms, as if the sculpture were filled pneumatically with air or an equivalent light, spiritual substance (Plate 67B).[11] The reason for Isaia's apparently rather brief visit to Rimini is not known, but it is possible that he was being considered as sculptor-in-chief for the Malatesta programme. Sigismondo's connexion with the papacy, at that time still cordial, would lend weight to the idea that a Roman sculptor might be the first called. The second sculptor with a style related to Isaia's in its rotund translation of the Antique (see Plate 67A) was a Dalmatian artist of Venetian training, Giorgio da Sebenico. He appeared in Rimini conveying stone for sculpture in 1455; whether he stayed to carve it does not appear in the documents. The style of neither sculptor has much to do with any aspect of Florentine style; yet it was from such elements that developed along the east coast, in Rome, and in Naples that a considerable part of mid-fifteenth-century sculpture in Italy was to emerge.

During the 1450s the focus of activity south of Florence in sculpture was not in Rome but in Naples, and specifically in connexion with the huge triumphal arch being raised as an entrance to the 'New Castle' on the Neapolitan shore by Alfonso of Aragon, in opposition, as it were, to the older Angevin fortress, a little way up the bay to the north. In 1442 Alfonso had asserted his rights of inheritance against the Angevins, and with the moral support of the pope drove the French out of the kingdom of the Two Sicilies. A temporary triumphal arch, recalling the customs of Ancient Rome, was set up when he made his ceremonial entry into Naples early in 1443. There seems to have been a plan to repeat that temporary arch in more permanent materials in the centre of the city, but difficulties of an urbanistic kind arose and ultimately a second, far more original, scheme was evolved. This was to adapt the Roman triumphal arch in general type to a function as a monumental entrance to the royal Aragonese castle.

It is generally assumed that Alfonso put in charge of the project in its first stages a

Catalan sculptor of some distinction: Guillermo Sagrera. In 1448, Sagrera was recently arrived in Naples. But in Naples also, on the king's invitation, was Pisanello from North Italy, to whose influence at least the first known drawing of a scheme for the arch must be attributed.[12] It would now appear that Alfonso gave to his own country-men commissions concerned primarily with the architecture and architectural decoration of his new castle, but that the monumental entrance arch was reserved for artists of what he hoped was to be his new homeland on Italian soil. Pisanello's design was soon superseded, but it provided the basis of the final solution (Figure 19).

This was to superimpose two triumphal arches *alla romana*, and to place between them a processional frieze of figures in high relief (Plate 69); then above the second arch was set a row of four niches, each with its statue of a Virtue; The whole was topped by a 'chua' with two semi-nude colossal river-gods *all'antica* and statues, somewhat over life-size in scale, of St Michael, St George, and St Anthony Abbot. The mingling of past and present was suggested by the processional frieze, which in greatly simplified form reproduced the order of march and the pageantry of Alfonso's actual entry into Naples in 1443. His own heroic military spirit and the *virtus* of his race were given expression in two side-reliefs visible as one passed under the arch at ground level into the castle courtyard (Plate 68, A and B). A second and slightly later inner arch was to present once again the arms of the house of Aragon and the coronation of Alfonso's successor, Ferrante.

Alfonso himself was shown in his triumphal procession as a man of peace and a Christian knight, for the symbolic reference of the flame at his feet is to the Siege Perilous of Arthurian legend. Christian piety is suggested by the trio of saints placed at the very summit of the whole design: two of them great warriors, but the third a humble anchorite of the Theban desert. Their position on a level immediately adjacent to the pagan river-gods underlines the mixed humanist and late medieval character of the arch as a whole. There could hardly be a greater contrast (yet at the same time a more striking ensemble) than between the entrance in marble and the dark towers of pure Catalan importation that frame it. The same kind of mixture of humanistic aspiration towards the knowledge of the ancient world and a pietistic desire to prepare for the Christian world to come in eternity marked Alfonso's own complex character, as we may catch a glimpse of it through the pages of the contemporaneous biography of him by Vespasiano da Bisticci.[13]

The chronology of the arch is a complicated matter to reconstruct. There were three main phases which require a rather careful accounting here.

The first phase lies between 1444 and 1451. It was the pre-Castelnuovo preparatory phase, and concerned planning for the free-standing arch that, in the thinking of the king and his advisers, preceded the arch as we see it today. During this first period, three marble statues, one representing Parthenope (the classical patron of Naples) and the others symbolizing Peace and War, were sent from Rome through the good offices of the pope in 1447. At least one version of the elevation of the arch incorporating the papal gift was put on paper. This has come down to us in the drawing preserved in the Boymans Museum. It is inscribed with an indication that it was to go for file to the

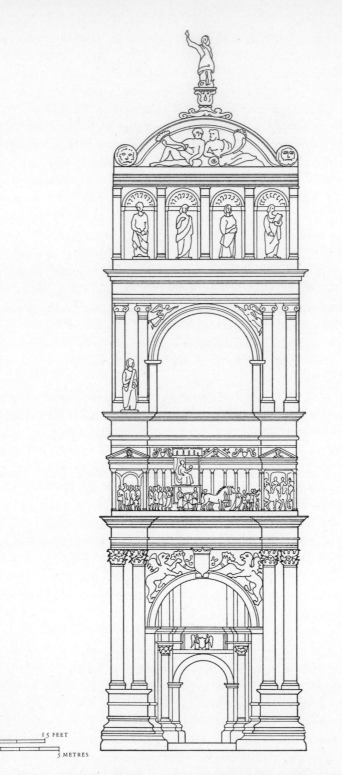

Figure 19. Naples, Castelnuovo, Triumphal Arch of Alfonso of Aragon.
Schema of emplacement of completed sculpture (after Liberatore)

136

protomagister of the king, a Catalan named Bonshoms. The drawing appears to present Pisanello's idea of a fitting design for the arch, and it must date from before 1449, because in that year Pisanello left and Bonshoms was superseded as *protomagister* by the Catalan Sagrera. It would appear that at that time the king entrusted the aspect of design of the arch to Italians, and the aspect of construction to his own Catalans. By 1451 the idea of the free-standing arch seems to have been abandoned, and contracts were signed for a monumental entrance to the castle. In 1452 the towers flanking the site of the entrance appear to have been finished.

This brings us to the second phase, or the design and execution of the arch as it came into actual being. A hurry-call went out for the services of a Lombard sculptor (probably a sculptor-architect) named Pietro da Milano, then working at Ragusa (Dubrovnik) on the coast of Dalmatia. Pietro left Ragusa in May 1452 and presumably went directly to Naples. There he was soon joined by a number of other artists. A monthly disbursement made in May 1453 lists Pere Joan, a Catalan, as in nominal charge, and three Italian sculptors, Francesco Laurana, Paolo Romano, and Domenico Gaggini; it specifies no less than thirty-three assistants for the sculptors. Exactly what this huge group accomplished is not clear; possibly it was actually very little, for only in 1455 were the designs sufficiently in order to permit the laying of the foundations of the present arch. In that year and for part of the following the Florentine Mino da Fiesole was in Naples, and presumably in the king's employ.[14] Now the pace began to pick up. In 1456 two additional sculptors arrived: Isaia da Pisa and Andrea dell'Aquila. Work on the processional frieze was probably started by then, and the two lateral reliefs at ground level were probably finished, or close to completion, since in 1457 the whole lower arch was in place. In 1458 work was contracted and probably finished on the upper statuary (four Virtues and three Saints), divided according to the definitive contract among six sculptors: Domenico Gaggini, Paolo Romano, Pietro da Milano, Isaia da Pisa, Laurana, and one other, whose identity is uncertain. Payments went on throughout February 1458. Then the king died. Naples and the kingdom were threatened by invasion. Work on the arch ground to a stop, but fortunately with most of the sculpture carved before the sculptors were disbanded.

The final phase began in, or shortly before, 1465. In that year Pietro da Milano returned to take charge of completing what needed to be done in the way of sculpture (possibly the huge river-gods of the 'chua'). On 31 May 1466 the exterior arch was finished. The interior arch was designed by Pietro for Alfonso's heir, Ferrante, who was by now safely in control of the kingdom. This inner arch dates from 1467 to 1471. The sculpture of the relief showing the coronation of Ferrante exists only in part by Pietro da Milano; the central group, if actually made, has long since been removed. Payments on the arch, in one form or another, went on to 1486.

The triumphal arch was never wholly complete in its sculpture. Certainly the second, higher arch must have contained sculpture in addition to the heart of Alfonso that was intended to hang there. Perhaps the Parthenope from Rome was supposed to be used there, flanked by Peace and War (of which War is possibly the rather broken statue which still stands in front of the columns to the left at that level); perhaps an

equestrian statue of the king, as shown in the Boymans drawing, was intended. Without this climactic and central image, the arch never achieved either its full visual effect or its maximum meaning. Nevertheless the wealth of figurative sculpture, over and beyond the tremendous amount of finely executed decorative or ornamental sculpture, is overpowering. The tribute to the 'Magnificentia' of Alfonso is more concentrated than that to Sigismondo's in the Tempio at Rimini, but what it lacks in extent it makes up in its hugeness of scale and in the multitude of direct references to the most impressive aspects of Imperial Roman art.[15]

The attribution of the existing sculpture to specific artists remains a puzzle in most respects. The documentation makes clear that not Laurana so much as Pietro da Milano was the Italian artist most conspicuously involved throughout the history of planning and execution, and it is perhaps to his mind that we should credit the bulk of the design of the monument as a whole and the choice of elements taken from the Antique. It is, however, on the Naples arch that Laurana makes his entry into art history. His later distinguished career in Sicily, in Provence under René of Anjou, and in Naples under Ferrante as a medallist, portraitist in marble, and sculptor of religious statuary and reliefs makes it unusually tempting to try to locate his first documented work, which was in connexion with the arch between 1453 and 1458. Possibly one of the lower lateral reliefs (Plate 68B) is by him; possibly also the group of the Bey of Tunis and his followers in the procession; possibly the Prudence of the four Virtues. The high quality of the companion lower lateral relief (Plate 68A) makes the question of its authorship even more frustrating. Its style is closest to Gaggini's. Its subject, surely, is concerned with a younger man than Alfonso, and therefore it may have to do with his succession, by his son Ferrante. In the processional frieze the distribution of hands seems to have been according to blocks of marble (Plate 69). Here we can make out a number of contrasting personal styles. To the left behind the king the courtiers show the manner of Pietro da Milano. The king seems to have been done by Isaia da Pisa. Before him the classicizing horses and the maidens leading them reveal the manner of Paolo Romano, whose later work in Rome we shall meet in the next chapter. The gay and rapidly-moving musicians next in line to the right clearly show the style of the Genoese Domenico Gaggini, which we shall have further occasion to discuss in connexion with Genoa and Sicily.

Thus it may be possible bit by bit to recover most of the authorship of the various parts of this huge complex of sculpture. This, however, represents far too large a task for the space available here. What emerges from this summary examination is a remarkable fact. So far there has been no occasion to mention the work of a prominent Florentine sculptor whose presence in Naples for a brief period at the height of the arch's sculptural campaign in 1455/6 is known. Can we find Mino da Fiesole's hand in the sculpture of the Naples arch? There is one possibility: the figures of the two courtiers who are seen against the triumphal chariot of Alfonso are of good quality, and the heads seem in particular to recall his portrait style. Possibly Mino began the central group of the frieze; when he left the kingdom to return to Rome and then to Florence, Isaia da Pisa might have been called in to take his place.

The Generation of 1430 in Florence: Mino da Fiesole, Antonio Rossellino, and Desiderio da Settignano

According to research fairly recently published in Italy the artist we know as Mino da Fiesole was born at Papiano in the Casentino, on Florentine territory. The nearest town of any size is Montemignano. Coincidentally, an artist whose name was recorded in the Spanish documents as 'Dominico de Monteminyao' turned up in Naples, about 1455. The identification of that artist with Mino is not, despite recent publication,[16] certified. But the theory at least opens up a view that has value in a general way: that is, that Mino, after beginning his sculptor's career at Fiesole with training near the Florentine quarries, travelled, even before 1460, as far afield as Naples and was associated there with work at the court.

His main master was probably not Donatello nor (even less probably) Desiderio da Settignano, as the nineteenth century, following a garbled tradition picked up by Vasari, for a time believed. It was almost certainly Bernardo Rossellino; Mino's fellow-'discipuli' were thus Desiderio, who was born a year earlier, according to one accepted date, in 1428, and Antonio Rossellino, who was born in 1427. By 1453, or before he was twenty-five years of age, Mino had been given the commission to portray in marble Piero de' Medici. The inscribed bust is now in the Bargello and is the earliest dated portrait bust of the Renaissance that has come down to us. It is possible that a surviving companion-bust of Piero's brother Giovanni de' Medici was done at the same time, though the style appears to be a little surer (Plate 76A). With this beginning in Florence Mino was called after the Medici commission to Naples, stopping in Rome in 1454 to portray in marble the Florentine banker-in-exile, Niccolò Strozzi (now in Berlin). A splendid profile portrait of Alfonso, now in the Louvre, is based on the precedent of Pisanello's medals of the king, but reveals an original and powerful directness of study from life (Plate 70B). There is good evidence of Mino's activity as court portraitist beyond this; one of the best examples is the portrait of Alfonso's general Astorgio Manfredi of Faenza, which is dated 1456 by inscription (now Washington, National Gallery of Art). The style is precise, extremely detailed, firm.

The quality of realism which erupted in Florentine portrait sculpture in the mid 1450s had a period of preparation in which Bernardo Rossellino's strongly modelled heads after death-masks must be presumed to have played a decisive part.[17] His younger brother and pupil, Antonio, soon evolved a personal manner which stressed a new sensitivity towards light and shade and more subtle modulations of detail on the surfaces. The key example is the bust of the humanist physician Giovanni Chellini of San Miniato al Tedesco (now Victoria and Albert Museum), which is dated 1456 by inscription. The head is modelled so closely after nature that a life-mask may be presumed as the basis, taken when the subject was eighty-four (Plate 70A). Whereas in his Medici busts Mino had used costume all'antica, a reflection from Donatello's Gattamelata, Antonio Rossellino's Chellini bust is given contemporary dress. The style departs from the linearity and precision of Mino's manner and clearly shows the influence of Desiderio. The relationship with a relief by Desiderio of an emaciated and beardless St Jerome in

the Desert (now Washington, National Gallery of Art; in the fifteenth century believed to have belonged to the Medici) is striking (Plate 71).[18]

Desiderio came from a family of stone-cutters and sculptors from Settignano. His father is mentioned in a document as a stone-cutter: 'scarpellino'. His elder brothers Francesco and Geri matriculated in the guild of sculptors in 1447 and 1451. Two years later, in 1453, Desiderio was enrolled in the same guild as a master. He lived and worked in partnership with his brother Geri. Modern scholarship has rejected the older theory of Desiderio's beginnings, which used to make of him a pupil of Donatello. Donatello's absence from Florence during exactly the years Desiderio would have had to study with him precludes the relationship of master and pupil. Instead, the influence from Donatello would have come after 1453, still in Desiderio's youth but when his style had already become fairly well formed; the beautiful *stiacciato* background of the St Jerome relief already mentioned is a telling bit of evidence of Donatello's transient influence on him (see again Plate 71). Desiderio's training as a member of Bernardo Rossellino's shop seems to be borne out fully by the character of his style. Collaboration with Mino and Antonio Rossellino may have occurred in the tomb of the Beata Villana dei Botti in S. Maria Novella, begun by Bernardo just before his departure from Florence for a two years' stay in Rome.[19]

The developed style of Desiderio is to be found in his monument of Carlo Marsuppini that stands opposite the Bruni Monument, after which it was patterned, in S. Croce. The humanist Chancellor Marsuppini died in 1453; he was given a state funeral, and presumably the commission for his wall-monument was given soon after. The logical recipient would have been Bernardo Rossellino, but since he was absent from Florence (see above), the next in line would have been Bernardo's closest and most able follower; the date of the commission probably coincided with Desiderio's entry as a master in the guild and provides as good an explanation as any for Mino's departure for Rome and Naples so soon thereafter.

The design of the Marsuppini Monument (Plate 72) is extremely close to that of the Bruni Monument (Plate 59). But Desiderio made certain important changes, such as the introduction of the charming heraldic arms-bearing boys at the spectators' own level rather than at the summit and the placement, instead, in the upper regions of two older boys who support the heavy festoon of funerary foliage. In type these older boys appear to have been derived from an Antique source, such as the re-used sarcophagus, then above ground, in the Aracoeli in Rome (Figure 20). The result is to lower the centre of gravity, as it were, in visual interest and to make more of the subtlety of the carving. This monument is an example of the most loving attention to detail imaginable, and as the motifs mount higher above the ground, allowances in the carving are evident to provide for a steady and uniform scale of visibility to the eye of the observer on ground-level. Perhaps this is what Vasari meant when he said that the Virgin and Child in the upper roundel was 'worked in the manner of Donatello (. . . *lavorato secondo la maniera di Donato . . .*)'. The chromaticism of the coloured marbles behind the effigy and painted details, of which traces of a green, for example, remain on the drapery beneath it, must have provided an effect of great richness. The care in execution must

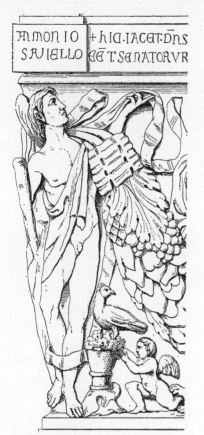

Figure 20. Faun, sarcophagus corner figure, used as part of medieval tomb. Roman Imperial Period. *Rome, S. Maria in Aracoeli*

have demanded considerable time; and it is entirely possible that the work on the monument covered five or six years, even allowing for help, as for example in the carving of the small boy to the right. This betrays Antonio Rossellino's early manner, whereas the little boy to the left is clearly Desiderio's from first to last. We shall return to this question of assistance a little later.

Desiderio's output was not great in quantity, but its quality was extraordinarily high. The often-quoted words of Giovanni Santi's rhymed *Chronicle*, '. . . il vago Desider sì dolce e bello', applied as much to his style as to his personality. There was a kind of lightness of touch in his work that utterly transformed the marble into a new and rare substance. He used effects of light and shade like a painter. The forms do not find their being in the substance of mass so much as in the gradation and contrast of tones. Planes disappear and surfaces glow. As it has been vividly put, the transitions of Desiderio's figures and reliefs are 'like rolling country', whereas in Mino's style they are 'like a mountain chain . . . from which sharp ridges run into dark valleys'.[20] The delicacy of his conception and handling of form is seen in the few portrait busts that are to be attributed to him. They are not of men but of children (Plate 76B) and of women. A few attributed Madonna reliefs (Philadelphia Museum; Turin; Bargello) came doubtless from private commissions, as did the beautiful tondo relief of the Christ Child with the Boy St John and the Roman emperor's profile in the Louvre.[21] His only other public work besides the Marsuppini Monument was the Altar-Tabernacle of the Sacrament for the church of S. Lorenzo (Plates 88, 89B, 90), though in 1459 he entered a competition for sculpture connected with the Chapel of the Madonna della Tavola in the Duomo of Orvieto, on which there is no evidence of his further work or interest.

The extreme subtlety of Desiderio's style contrasts with every other sculptor's in Florence during the 1450s and 1460s. This is particularly true of the fully mature style of Luca della Robbia, which adapted influences from Ghiberti into a Classical expression. It makes Desiderio's comparable work look downright Romantic (Plate 75A). In addition to the north sacristy doors of the Duomo, which were in production in the 1450s (finished finally only in 1469, or even possibly later), and the marble Federighi Tomb now in S. Trinità (1455–6), the principal programme Luca was working on was

the sculptural decoration of the two chapels on either side of the sanctuary in the Pieve of S. Maria at Impruneta, the famous fair and pilgrimage-site not far south of Florence.[22] The Impruneta programme contained the most ambitious use of the glazed terracotta technique by Luca for statuary (standing saints flanking the two tabernacles). They probably preceded the moving group of the Visitation in S. Giovanni Fuorcivitas at Pistoia, for which only a *terminus-post* dating is available: after 1445 (Plate 75B). The older attribution to Luca's nephew Andrea della Robbia appears today untenable on any grounds. The style seems to fit best into the early or middle years of the 1450s.

A progression from surface-effects and rather shallow relief and light masses towards a fuller and livelier form characterized the development of Antonio Rossellino. The chief monument upon which his reputation rests is the tomb of the Cardinal of Portugal in S. Miniato, Florence.

The untimely death in the summer of 1459 of James, Cardinal of Portugal, a member of the Portuguese royal house, set in motion one of the most important Florentine programmes of the whole century. The cardinal, who was only twenty-five when he died, had expressed the wish in his will to be buried in the Florentine church of the Olivetan Order, S. Miniato al Monte. The pure character of the young prelate was the very opposite of that of the anti-pope, Coscia, who had been buried in the baptistery. On the model of the first programme of the Coscia Monument, the cardinal's tomb was conceived as the principal unit of a total design embracing a whole chapel erected from 1460 to 1466. The tomb with its chapel, on the flank of the famous old Romanesque building on the summit of the hill above the Via Crucis celebrated by Dante, must inevitably have suggested from the beginning a comparison with the earlier Coscia Monument. It also marked a notable change in style from Desiderio's virtually contemporaneous Marsuppini Monument in S. Croce (cf. Plates 72 and 73).

It would appear that the commission for the cardinal's tomb was originally to have gone to Desiderio. This is the inference to be drawn from the fact that Desiderio had the death-mask, which he did not hand over until it was needed, in 1463.[23] Probably because of the pressure of other commissions and plans in Desiderio's own work from 1459 to the end of 1461, the tomb was given instead to Antonio Rossellino, who signed the final contract, with his brother Bernardo as co-author. It seems certain that the dominant personality was by now Antonio's; he made the most of his opportunity. The final contract was signed in December 1461. The date of completion of the monument may be set somewhat before October 1466, when the chapel was dedicated. As was to be expected in so large and magnificent a monument, Antonio had the help of several assistants, including that of his elder brother Bernardo, who was responsible for the kneeling angel to the left, completed before his death in 1464.[24]

The stylistic advance on Desiderio's Marsuppini Monument was in the first place spatial. All the sculptural elements were brought into the ample and deeply-shadowed niche made by the enclosing arch (Plate 73). The lower portions were enlarged and raised, and the proportions of the upper portion were enlarged and its elements brought down, thus bringing an increase in overall unity. Two flying angels, as if free to move in space, support the tondo containing the image of the Virgin and Child. Larger

kneeling angels on either side, bringing a crown and a palm (originally in bronze gilt) to the saintly young cardinal, take the place of Desiderio's festoon-bearing ephebes. The standing young boys of the Marsuppini Tomb were changed into little funerary geniuses, who are brought closely into the central area by their seated perch on the lid of the sarcophagus, which is itself copied from an ancient sarcophagus in Rome. On the sides of the base are carved Mithraic themes of struggle and triumph; Antique ephebes holding cornucopias flanking a central motif of a death's head over a garland with unicorns, which stand for the cardinal's well-publicized virginity. The direct references to classical lore are thus increased, while the unity of design-elements, spatial freedom, and verve of movement are vastly enhanced. Whereas in his Madonna of the Marsuppini Monument Desiderio emphasized a flattened containing plane and the figures tended to separate, Antonio brought his Mother and Child together into a unified projecting mass over which the light was made to play in a lively, even a gay, way (Plate 74, A and B). The focus of the whole design is in the head of the cardinal, whose realism is transformed into a radiant expression of utter calm and perfect peace (Plate 77).

The S. Miniato monument was later copied almost precisely, element for element, in the tomb of Maria of Aragon in the Piccolomini Chapel of S. Anna dei Lombardi, also called the church of Monte Oliveto, in Naples. The execution of the Naples tomb, which was still unfinished as late as 1479, was mainly in the hands of Antonio's shop, which included by then Benedetto da Majano. The second version, though handsome and influential, as we shall see in the next chapter, cannot begin to compare in quality with the Florentine original. After this remarkable performance for the S. Miniato chapel, Antonio did not again rise to the same level of achievement, though a roughly contemporary figure such as the St Sebastian of the Collegiata in Empoli must be counted the finest expression of the nude in the figure sculpture of this particular phase of Florentine art. Either through his personal work or increasingly after 1470 through his shop, he extended his influence and that of Florence to Faenza (Arca di S. Savino in the Duomo), Ferrara (Roverella Monument, in collaboration with a Milanese sculptor, in the church of S. Giorgio), and Venice (altar in the Chapel of St John Baptist, S. Giobbe).[25]

The Classicizing Movement in Marble, c. 1460: Il Greco at Urbino and Andrea Guardi on the West Coast

A related expression in marble-carving stemming from Bernardo Rossellino's example is to be found in the work of Andrea di Francesco Guardi, who left Florence to work on the west coast in the area of Pisa, and in the style of Michele di Giovanni da Fiesole, called Il Greco, who played the most important part in the sculptural decoration of the Ducal Palace of Federigo da Montefeltro in Urbino about 1460. A strong classicizing accent is evident in the personal artistic speech of both (Plates 86B and 87A).

It is possible that Guardi began as an actual member of Bernardo Rossellino's shop at the time of the Bruni Monument. At Pisa he did in an interesting archaizing style

the Virgin and Child for the overdoor of the campanile. Illustrated on Plate 86B is a detail that shows his strong attachment to the Antique, which was nourished by constant reference in Pisa to the large collection of Roman sarcophagi in the Duomo and Campo Santo.[26]

The chief index to Il Greco's classicism is the splendid monumental fireplace in the Sala d'Iole of the palace at Urbino. Statues of Hercules and Iole decorate the supports, and the lintel and overmantel present two superimposed friezes, parts of which are illustrated here (Plate 87A). The elements of both friezes were taken from sarcophagi. The more interesting of the two, with its delicate figurines set against an abstract ground, represents a Bacchic procession derived from one of the Antique sarcophagus types well known to the Quattrocento. The best preserved example was in S. Maria Maggiore in Rome (now in the British Museum). But there were other fragmentary examples of the same type to be seen nearer, in Pisa and Lucca.[27] The contrast with the more emotional interpretation of Antique motifs by Agostino di Duccio on the façade of S. Bernardino in Perugia between 1457 and 1461 (Plate 86A) represents essentially the difference between the heritage of Ghiberti and that of Donatello.

Donatello's Last Period in Florence and Siena; Sienese Sculpture of the Third Quarter of the Quattrocento: Vecchietta, Federighi, Francesco di Giorgio, Neroccio

In 1477 a statue of the Boy St John the Baptist was ordered of Antonio Rossellino and placed over the entrance of the Opera of the Florentine baptistery off the piazza of the baptistery (S. Giovanni); on the long scroll held by the figure (now in the Bargello) were incised the words, AGITE PENITENTIAM. What must be described as a wave of penitential emotion had swept the city during the 1450s, and its continuing endemic existence during the succeeding decades does much to explain the power of the upheaval triggered by Savonarola as the century began to draw to its close.[28] The most powerful exponent of the early phase of this penitential mood was Donatello in his last phase, after his return from North Italy in 1453.

Evidently during 1456 he carved the formidably expressive Penitent Magdalen for the baptistery, where it still stands (Plate 79). The statue continues a mode which is to be found in the slightly earlier St John Baptist also, in painted wood, which he had made for the Frari in Venice. In 1457 he went to Siena, where he contracted for three very important jobs. The first was a set of bronze doors for the Duomo, of which a trial cast of a group of figures representing the Lamentation over the Body of Christ survives (Victoria and Albert Museum).[29] The second was for a statuary group of Judith and Holofernes, which never left Florence and went into the possession of the Medici (now on the *ringhiera* of the Palazzo Pubblico in Florence). The third was a statue of St John the Baptist in bronze which arrived in Siena minus the right forearm (later supplied by a Sienese sculptor) in 1457; it has been set up in the baptismal chapel on the north side of the cathedral.

The Baptist (Plate 80A) is presented as a haggard, prematurely old ascetic, worn

down by fasting, the pose suggesting a certain physical feebleness, while the eyes seem to burn from within the great pools of shadow formed by their deeply-hollowed sockets. In the Judith, Donatello returned to the sculptural theme of a tall standing figure associated with another at a lower level with which he had experimented earlier in the Sacrifice of Isaac of the campanile series (Plate 23A). The later bronze work was to be free-standing fountain statuary, and required a composition in the full round rather than one to be seen from one point of view only (Plate 78, A and B). This is the first, pioneering Renaissance effort to combine multiple views into a plastic unity. Traces of effort are evident. The movement of the forms is in a staccato rhythm with angular breaks. The standing Judith is placed so that she faces the figure of the seated Holofernes. His head twisted back against Judith's thigh becomes the fulcrum of the movement of the observer's eye around the group. The action is curiously restrained, and amounts more to suggestion of pressures of various kinds than to actual movement: the pressure of the right foot of Judith on the groin of Holofernes, the pressure of her left foot on the right wrist of Holofernes, contorted behind him, the pressure of the two heavy bodies on the cushion over the triangular base from which the water for the fountain was to spurt from the corners. The meaning of this *istoria* in bronze has much to do with the triumph of humility and continence over pride and lust.[30] The group therefore retains an allegorical, virtually sacramental, gravity and mystery. Drama freezes into ritual. In this tragedy there is terror but no pity.

The bronze group of Judith and Holofernes was finished *c*. 1461. Thereafter, until his death in 1466, Donatello's attention was mainly on the two monumental 'pulpits' in bronze for S. Lorenzo. The programme called for the revival of the early medieval scheme of two *ambones* to be placed at either side of the head of the nave, from which were to be intoned at their proper moments in the liturgy the passages from the Gospels and the Epistles. It must be emphasized that this particular reversion to a medieval precedent – the revival of *ambones* – is unique in Florentine Quattrocento sculpture. It must undoubtedly have been an offshoot of the penitential, anti-humanistic movement of the 1450s. The sculpture imagined by Donatello for the faces of the parapets was as unique and strange as was the general programme.

The subject matter of the two *ambones* was divided into *istorie* of events of the Passion leading to the climax of the Crucifixion and Deposition for the Gospel *ambo* and *istorie* based on events after the Deposition (with one scene, appropriately, of the martyrdom of St Lawrence) for the Epistle *ambo*. Recent scholarship has stressed that, though Donatello did not live to see completed more than a part of the series of the reliefs, the design of the great majority came from his *modelli* (some were cast, even though not 'finished'), and the small remainder show the imprint of his ideas. The interested reader is urged to consult a readily available authoritative summary of the truly thorny problems of attribution that the *ambones* present.[31] It is possible here only to touch upon a few of the more important historical aspects of the reliefs. There are three such aspects that deserve close attention.

The first is the imaginative suggestion of a number of different kinds of spatial environment for the various actions that are depicted. The main face of the Epistle

ambo, which has been set up in the final bay on the north side of the nave, is divided into three scenes by buttress-like *conventions* rather than representations of architecture. The spaces between them are given a very narrow depth; the action looks as if it were taking place on a medieval stage (Plate 81). On this precarious, narrow platform Christ is shown with a rushing multitude as he descends into hell and is greeted by the preternaturally elongated and terribly emaciated figure of the Baptist. The next scene, the Resurrection, takes place without a break in the figures. The huge, gaunt figure of Christ rises with the cerements of the grave clinging to him as if they were still damp from the sweat of the death-agony. The figure is pressed against the background. This very compression of space and time enhances the dramatic content more even than the details of imagery. It has been acutely pointed out that in an adjoining lateral relief, The Maries at the Tomb, the perspective focus is well above the area of action, and is actually to be found in the ball-frieze above the relief. The perspective thus indicates the true direction of attention, which is not to be concentrated on the desolate confusion of the tomb but on the invisible risen Christ above. In the Martyrdom of St Lawrence, on the other hand, a heavy ceiling is introduced which seems to weigh down upon the actors and stresses the prostration of the saint, which is marked within the scene by the echoing horizontal of a long pole forcing him down upon his gridiron.[32]

The second aspect is already suggested in the first. It is the absolutely uncompromising use of every possible means to express emotion and suffering. We seem to be looking at times at twentieth-century expressionist art rather than at the forms imagined by a Quattrocento master.

The third aspect is the virtually complete denial of any order, of any harmony. It is a biting, cruel, and yet remarkably persuasive rejection of the Gates of Paradise and all that they might stand for as an artistic credo.

The total lack of documents relating to the commissioning or execution of the S. Lorenzo 'pulpits' places their criticism on so conjectural a basis that one hesitates to be either over speculative or too dogmatic. The presence of assistants' hands is on the whole more plainly to be seen in the Gospel *ambo* than in its companion. A passage such as that illustrated on Plate 82 shows an assistant's touch in the shallow relief. This is almost certainly, as we shall be able to ascertain more clearly in a later chapter, the work of Lorenzo Bertoldo, who, with Bartolommeo Bellano, was Donatello's chief pupil in his last phase. The heads of the two young men who are bowed in grief near the head of the sarcophagus are probably portraits, and appear to represent younger members of the family who were the sculptor's patrons for the S. Lorenzo 'pulpits'. The one closest to Christ, in the position of honour, is probably the elder son of Piero de' Medici, Lorenzo; and behind him stands his younger brother, Giuliano. In this case the detail in question would be datable soon after 1469, when Lorenzo, with Giuliano as his second in command, became the head of the family.

There remains one more aspect of Donatello's last activity in Florence to be mentioned. There is some intriguing evidence in contemporary and near-contemporary sources that he took charge of the programme of the colossal prophets for the Duomo, on which he had worked as early as 1410. He must have designed and half-completed

perhaps a second terracotta *Gigante* before Agostino di Duccio was called in to continue under his supervision in 1463. At his death in 1466 the marble colossal David begun by Agostino was abandoned, perhaps not so badly 'botched' as the later documents and the opinionated Vasari would indicate. Agostino's role would then have been less as an independent and far more as an amanuensis for the enfeebled but still courageous Donatello of his last two years or so of life. It is inspiring to think of his last years as involved still with the colossal programme of his youth.

<p align="center">*</p>

Donatello's precept and example loomed on the whole beneficently over the sculpture produced in Siena in the third quarter of the fifteenth century. In 1451 one of Donatello's aides in Padua, Urbano da Cortona, received with his brother, Bartolommeo, the commission for the rather elaborate programme of marble reliefs decorating the Chapel of the Madonna delle Grazie in Siena Cathedral. This series survives in some quantity today in the cathedral, with myriad reminiscences of Donatello's work both in Padua and in Siena (Herod's Feast for example, in the baptistery). Urbano's style was eclectic, but at times capable of a certain clarity which can be seen in the funerary monument of Cristoforo Felici (d. 1463), also in Siena Cathedral (Plate 87B). In 1462 he was given one of the marble benches, for decoration in relief, that stand in the Loggia di S. Paolo or, as it was also called, the Loggia della Mercanzia.[33]

This loggia, which bears a rather distant relationship to Or San Michele in Florence, was started by Quercia before his death in 1438. It is an outdoor hall open on three sides, with statues in front of shallow niches (to Quercia's design) placed on the exterior faces of the piers. The programme of sculpture was initiated in 1451. At this time Antonio Federighi (*c.* 1400–90) came into public view; as Quercia's chief follower, he was given three of the six statues of the loggia. The S. Vittorio illustrated here (Plate 85A) is reminiscent of Quercia in its pattern of drapery and general suggestion of strength; but the costume *all'antica* and the rather forced air of vigour in the pose show that it belongs to a later age.[34] The St Peter (Plate 85B) and the St Paul were allocated in 1458 to an older man who began as a painter in touch with Florentine developments, and who after Donatello's stay in Siena concentrated on sculpture. This was Lorenzo Vecchietta (1412–80). The St Peter has something of Donatello's very much earlier St Mark for Or San Michele about it, but changed into a looser, less disciplined expression, motivated by an obvious pull towards naturalism. Vecchietta found his own natural medium in bronze. In 1467 he began the new bronze ciborium for the church of the Scala Hospital, of which the door that is missing from the ensemble is probably the bronze door, decorated with a representation of the Resurrection, now in the Frick Collection in New York (Plate 83). It is the late Donatello who is invoked here, but even so the startling discrepancies of scale in the figures and landscape and deliberate error in the perspective of the sarcophagus reveal a mystical temperament which must have been fundamentally alien to Donatello's.

During his sojourn in Siena between 1457 and 1461, Donatello was given the

commission for a S. Bernardino in marble for the Loggia di S. Paolo in 1458, but nothing appears to have come of it. But from his own hand came in all probability the kernel of the expressive design of the Madonna over the Porta del Perdono of the cathedral. Probably also as an interpretation of one of his *modelli* was made the charming little marble relief of the Madonna and Child in the Piccolomini Palace, of which so many replicas and variants came into being that they gave rise to the spurious notion that there was an actual 'Piccolomini Master', to be numbered among the sculptors of Siena.[35]

In the atmosphere of stimulation that Donatello must have created, two younger Sienese artists came into their own during the 1460s. These men were Francesco di Giorgio (1439–51/2) and Neroccio dei Landi (1447–1500). Both received their training with Vecchietta, whom they were rapidly to outstrip. In 1468/9 they entered into a partnership which was to last seven years. They were equally at home in the arts of painting and sculpture, though Neroccio was to be primarily a carver, while Francesco di Giorgio was to be known as a modeller and worker in bronze.

These were two very different temperaments that indicate in their contrast something of the range of expression in Siena in the third quarter of the century. The earliest known sculpture by Francesco di Giorgio is the St John the Baptist in painted wood carved by 1464 for the Compagnia di S. Giovanni Battista della Morte in Siena (Plate 84A). The influence of Donatello's Baptist is strongly countered by a sense of the heroic in the muscular, full limbs.[36] In 1468 Neroccio is recorded as having made a St Jerome in painted terracotta, now lost. The St Catherine of 1470 which is Neroccio's earliest extant piece is idealized in a non-ascetic way equivalent to that of Francesco's Baptist; but instead of the vehemence of the Baptist, she is all gentle withdrawal and enclosed reverie (Plate 84B).

Younger Masters in Florence in the 1460s: Desiderio's Shop

There remains now a brief inquiry to be made into the identity and aims of those in Florence corresponding to the younger generation of Sienese sculptors. There are three artists in particular whose emergence in the late 1450s and early 1460s should be mentioned in this place.

The first was trained quite outside the Florentine circle of marble-workers, as a goldsmith. This was Antonio del Pollaiuolo, who was born in Florence in 1432. We meet him first in connexion with the great silver cross (1457–9) for the altar of the baptistery, which is now preserved as one of the greatest treasures of the museum of the Opera del Duomo. His part in the baptistery Cross was the base with its engravings of Virtues and of Moses and the Law which prefigure his mature power as a draughtsman. The influence of the late phase of Donatello is not absent in the organization of his seated figures of the Baptist between buttresses, which he cleverly succeeded in associating with elements of the cathedral dome (Plate 80B). But there is an idealism here which escapes both the pessimism and the profundity of the S. Lorenzo reliefs. The developed aspects of his sculpture will be treated in Chapter 8 (see p. 178).

The last years of Desiderio's life, between 1461 and 1464, when he died, are a blank as far as any record of his artistic activity is concerned. Conditions of health in the plague-ridden cities of fifteenth-century Italy were at best so precarious that it is hardly possible to speculate on the cause of his relatively early death, or to suppose that it might have been preceded by some lengthy organic illness or disability. In any event his last documented work, in part in place by the end of the summer of 1461 (Plate 90), shows a new style of relief (Plate 89B) and evidence of the hands of several assistants. This was the Altar of the Sacrament, presumably a Medici-sponsored work, in S. Lorenzo.[37] It is here that are probably to be found the first traces of his best-known pupils' styles. The first of these younger men, Francesco di Simone Ferrucci da Fiesole (1438–93), was the son of a Florentine carver who had made the handsome marble frame on Ghiberti's design for Fra Angelico's Linaiuoli Altar of 1433 (now in the Museum of S. Marco in Florence). Francesco di Simone's first work of independent stature was probably the monument of Barbara Manfredi in S. Biagio at Forlì (Plate 89A). It reveals a thorough training in the carving of ornament and an ability to model a beautiful head. This his training under Desiderio would have developed. Later, in the 1470s and 1480s, he was to come more plainly under the spell of his co-student in Desiderio's shop, Andrea di Cione, called Verrocchio.

Andrea's training as a stone-sculptor was from the evidence of style with Desiderio, not, as the older view would have it, with Donatello. And as a sculptor of bronze he probably was not trained in Donatello's late studio either, but in Vittorio Ghiberti's shop. Vasari transmitted a garbled tradition that the young Verrocchio had carved the Madonna of Bernardo Rossellino's Bruni Monument. Apart from style, the dating makes this implausible, since at the time Verrocchio, who was born in Florence and apprenticed to a goldsmith, would not have been as yet fifteen years old. The basis of the tradition passed on to Vasari in mangled form was quite likely that Verrocchio had had a part in the upper portions of Desiderio's Marsuppini Monument; if so, the figure of the ephebe to the observer's right, which differs in style from that of its companion-piece, might conceivably be by the young Verrocchio.[38] A still more convincing proof of Verrocchio's early activity in Desiderio's shop is the candelabrum-bearing angel now placed on the left in the modern re-arrangement of the S. Lorenzo altar (Plate 88). The differences in style between the two standing angels are numerous. The relative solidity of the angel on the right is not in Desiderio's manner, though the design was undoubtedly his alone. From the S. Lorenzo altar (as indicated above, a Medici job), Verrocchio would have gone to his documented work in the 1460s in the Medici old sacristy in S. Lorenzo. To be dated close to 1465, rather than, as used to be the custom, in the 1470s, would accordingly be the related work in bronze such as the Medici Candlestick (formerly in Berlin), the Careggi Putto (now in the Palazzo Vecchio), and the Young David (now in the Bargello). These last named pieces will be discussed in Chapter 8, in the context of Verrocchio's more mature bronze style (p. 171 ff.).

PART FOUR

CHAPTER 7

REGIONALISM AND ECLECTICISM, 1465–1500

FOUR historical accents in the sculpture of the last third of the Quattrocento will appear in the four chapters which are to follow. It will be recognized in the first place that the continuation of the spread of the Florentine style was marked after 1465 by a difference of tone and a lowering in intensity. To the sharp impact of a strong individualist of the stature of a Donatello there succeeded the more pervasive influence of a much blander mixture of less striking personal styles. Eclecticism, which had occurred at rare intervals before (for example in Ciuffagni and Buggiano), now became far more prevalent. One is hard put, as the reader will discover for himself, to describe the style of a Francesco da Laurana except in terms of an unusually gifted and poetic mingling of several stylistic currents.

At the same time, the age-old Italian characteristic of localism, shown in an unrelenting tenacity of local traditions and local pride, was if anything enhanced. Never at any period before or since was Venetian sculpture more differentiated from Tuscan sculpture, or Roman sculpture, in a redundant phrase, more 'Roman'.

Thirdly, there is evidence of the phenomenon that art historians rather loosely designate as that of 'lateness', which has so frequently been pointed out in a number of period styles that it has acquired currency as a term in these studies. Between 1465 and 1500 in Italian sculpture there was apparent a kind of 'Spätstil' exuberance which prefigures in some ways the Baroque, together with a turning towards a more obvious realism and some tendency to repetition, coarseness, and commercialism. Over the last third of the century there was an enormous rise in the quantity of sculpture produced; what had been until 1450 a young art now took hold and proceeded to expand. A striking design now was apt to call forth repetitions, versions, and variants. Small-scale bronzes began to multiply, as had occurred before in Antiquity, in answer to a steadily growing demand for informal and private needs for statuary.

Lastly, there are to be detected some symptoms of weariness. The inventiveness of the earlier stages of the humanistic mode seems, at one point, to have started to dry up. This is particularly true of Siena and Florence, where that mode had first appeared. In the years surrounding 1485, sculpture in Tuscany entered a new and critical phase. Where the direct heritage of Donatello was running out rapidly, an effort became necessary to revive the tradition of figure style. It is not generally stressed in histories of Florentine art that twice in the last quarter of the fifteenth century competitions were held to determine how best to finish the façade, with of course its sculpture, of Florence

Cathedral – in each case with no effect. A younger generation of artists, however, was finding opportunities for expression, often in programmes that were small in scale but demanding in technique. The revival of figure sculpture on the grand scale must be counted as one of the glories of the High Renaissance after 1500. But the crucial formative stages of that flowering may be traced back to the late decades of the fifteenth century in Florence and to a brilliant new generation which included in its older bracket Andrea Sansovino and Giuliano da San Gallo; in its younger, Michelangelo. Had all three by some catastrophe not survived beyond 1500, their names would nevertheless have found places of honour in the annals of Renaissance art.

<p style="text-align:center">*</p>

The phenomena of eclecticism and regionalism were not mutually exclusive in fifteenth-century Italian sculpture. Both were linked securely to consciousness of style. As the inventive personal styles of leading Florentine masters, such as Verrocchio and to the same extent Antonio Rossellino, made their impact upon centres outside Florence in the 1470s, elements of those styles were selected and fused by lesser masters into new combinations. Some of these combinations took root in regions where local demands or traditions gave a particular, and often vivid, colour to what might appear to the unalerted eye to be merely 'provinical' echoes of a metropolitan style (see Introduction, p. 8). In other cases the eclectic process of recombining elements of style seems to have had the effect of a secondary source of invention – a means of keeping alive some slight spark of life in certain programmes – mostly, ironically, funeral monuments – which might otherwise have been frozen into repetitious moulds or have decayed into a banal sequence of thoughtless imitations. These dangers were real enough, as experience in Rome in the 1480s and 1490s could show.

A good example of the ingenuity and complexity of the eclectic pattern of development within an artist's style may be spotlighted in the career of Francesco di Simone Ferrucci, whose monument to Barbara Manfredi in Forlì I briefly discussed in the previous chapter. Having started, as we already know, as a younger collaborator of Desiderio, he swung over in the next decade into Verrocchio's stylistic camp. The history of his funerary monument for Alessandro Tartagni in S. Domenico at Bologna (carved about 1480) opens up a view into this process which was more sophisticated and complicated than might at first glance appear. The original *modello* drawing for the monument has fortunately been preserved.[1] In it, it is apparent that Francesco wished to follow closely Desiderio's monument to Carlo Marsuppini (Plate 72), even to the paired figures of small boys holding shields at the base and of youths bearing festoons at the summit. But the energetic poses of the figures as drawn by Francesco strikingly reveal Verrocchio's influence, and one of the small shield-bearers, as actually drawn, was intended to repeat, in spirit, the jaunty stance of the Careggi bronze David (Plate 118A). The supporting pilasters were intended to be richly decorated from the start with foliate motifs growing from a vase that point to those of the framing of Verrocchio's Medici tomb in the old sacristy of S. Lorenzo. A frieze of playing putti at the base (drawn but

never executed in marble) recalled Donatello's upper frieze for the S. Lorenzo ambones. Last, but far from least in visual weight, Francesco's introduction in his drawing of seated figures to represent the three Theological Virtues against the panels above and behind the effigy follow quite obviously the lead of Mino da Fiesole. In this case there is a combination of an idea Mino first carried out with standing Virtues in a tomb of 1466 and the poses of the seated Virtues in the lower part of the monument of Paul II in Rome (which will shortly be discussed).

When the Tartagni Monument was actually commissioned and erected, its original design was simplified and its cost presumably reduced by elimination of the four supporting subsidiary figures. The Virtues were retained and were executed very much in Verrocchio's style, despite their origin in Mino's imagination. An element of compensation for the loss of the four secondary figures is the insistent, omnipresent, ostentatiously carved ornamental motifs, which belie to a considerable extent the simplification of the monument which was actually taking place.

The process of simplification had already begun to take over in Mino's own work, as one can see in the monument to Hugo von Andersburg in the Badia of Florence, begun apparently shortly before 1470, though not assembled until after Mino's return from his last Roman sojourn in 1481. The thin projections of the architectural motifs and the elongated proportions of both effigy and Caritas above it provide an impression of brittle elegance mingled with unresolved tensions (Plate 91) both in pose and quality of suggested movement. It makes one think of the proto-Mannerism in painting of Botticelli's Primavera, and even more of Piero Pollaiuolo's San Gimignano Coronation of the Virgin of virtually the same date (1483).

Mino's position in the eclectic current of the 1460s and 1470s was on the available evidence a central one, or very close to it. A consideration of its importance leads directly into a view of the developments of sculpture in Rome after 1460.

SCULPTURE IN ROME, 1460–85

1460–5: Isaia da Pisa, Paolo Romano, Mino da Fiesole

A second and far more expansive phase of fifteenth-century sculpture in Rome began to gain momentum about the year 1460, or just about the time that it is thought that Mino da Fiesole returned to the papal capital for a second stay. The first stay appears to have bracketed his sojourn at the court of Alfonso of Aragon at Naples in 1455–6 (see above, p. 137). He was to remain in Rome this time until 1464, as far as one can conjecture from the admittedly sketchy evidence.

An earlier chapter described the efforts of Popes Martin V and Eugenius IV to enlist and to establish Florentine talent in the Quattrocento Roman artistic arena. The key to the development after 1460, as indeed for later periods in Rome, was not merely the material aspect of papal patronage but the kind of interest and leadership in the arts that a given pope might encourage among the members of the Curia and the lay nobles of the city. A list of the fifteenth-century popes makes evident several points of interest.

Martin V	(Oddone Colonna, of Rome)	1417–31
Eugenius IV	(Gabriele Condulmer, of Venice)	1431–47
Nicholas V	(Tommaso Parentucelli, of Sarzana)	1447–55
Callixtus III	(Alfonso Borgia, of Valencia)	1455–8
Pius II	(Enea Piccolomini, of Siena)	1458–64
Paul II	(Pietro Barbo, of Venice)	1464–71
Sixtus IV	(Francesco della Rovere, of Savona)	1471–84
Innocent VIII	(Giovanni Battista Cibò, of Genoa)	1484–92
Alexander VI	(Rodrigo Borgia, of Valencia)	1492–1503

Table 5. Popes in Rome of the Fifteenth Century

It should be noted that the Quattrocento pontiffs after the reinstatement of the papacy in Rome by Martin V, himself a Roman of the powerful Colonna family, came with but one exception from North Italy (Venice or the Ligurian Republic) or from Spain. The presence of the Aragonese as neighbours in the kingdom of Naples provided a strong political reason for the election of the two Borgian popes. The pontificates of neither were distinguished for papal patronage of sculpture. As will become evident, the origins of several sculpture-minded popes in North Italy were probably related to the origins and training of the majority of the most influential sculptors called to Rome in the 1460s and 1470s. In connexion with the pontificate of the only Tuscan pope of the Quattrocento, Pius II, whose family was of Sienese origin, it is of interest to note that the only bronze effigy to be cast in Rome between those of Martin V and Sixtus IV (both by Tuscan artists) was commissioned during his pontificate from a Sienese; this was Vecchietta's figure for the Foscari Monument in S. Maria del Popolo.[2] It would seem that it was this same Tuscan pope, Pius II, who carried into sculpture in Rome the impetus given to architecture in the rebuilding of the city begun in the 1450s by Nicholas V, with the advice unquestionably of the Florentine Alberti and with the active help of the Florentine Bernardo Rossellino.

A basic structure of walls, streets, and monuments, even though the majority were in ruins, persisted from the Rome of Antiquity to the Rome of the Quattrocento. But memories of a more than local urban or antiquarian greatness and the dream of a recoverable greater grandeur inspired the movement initiated by Nicholas V immediately after the Jubilee Year of 1450. Nicholas's biography by Gianozzo Manetti makes clear the balance between a deeply-felt power of tradition and a strong incentive towards 'modernity' in his grand design. This was to begin with a continuation of Eugenius IV's orientation towards the elbow of the Tiber and St Peter's, as opposed to the more isolated and land-locked Lateran. A newly rebuilt Borgo Leonino, what seems to have been planned as a completely rebuilt St Peter's, and a new resplendent Vatican were interlocking parts of a single project.[3] There was to follow an even broader campaign of urban renewal under Sixtus IV. From the time of Pius II on, there began a movement, encouraged mostly by Sixtus, to re-do or to build churches (for example, SS. Apostoli, S. Agostino, S. Maria del Popolo, S. Pietro in Vincoli) as seed-beds around which the rebuilding of whole quarters of the city might develop. These churches also provided interiors in the new style, which encouraged the commissioning of 'up-to-date' altars

and tomb-sculpture. The majority of sculptural programmes remained, as before, funerary monuments.

There is no solid modern systematic survey of Roman Quattrocento sculpture available in print; what can be done here will in no way attempt even to block out the main lines of such a survey, except to bring up for discussion consecutively some salient questions. Most of them need continued investigation and would deserve future publication as a whole.[4]

Before 1460 there was no true school of sculpture with its own aesthetic aims and self-perpetuating momentum in Rome. In Filarete's wake, after 1445, there came into local prominence two men: Isaia da Pisa and Paolo Taccone, called Paolo Romano. Isaia was absent from the city during most of the 1450s and does not seem to have had any part in a papal tomb after he had supplied the effigy for that of Eugenius IV.[5] What remains of the monuments of Nicholas V and Callixtus III, now in the Grotte Vaticane, betrays a marked conservatism and the work of still anonymous and rather unsure hands. The breakthrough came with the diaspora of the workshops of the Arch of Alfonso in Naples in 1458–9. This marked the return of Isaia and Paolo Romano to Rome. Both artists were to collaborate very soon after, in 1462, on the new monumental marble reliquary for the relic of the head of St Andrew which Pius II sponsored for St Peter's. Whereas Isaia's revival of Antique style stressed thin, rather delicate draperies and a 'numinous' inflation suggested within the form, Paolo Romano appears to have been inspired by a more solid and massive approach; on the Naples arch his supposed share of the procession frieze (Plate 69) reveals a remarkable adaptation of the Hadrianic style which he must already have formulated in Rome itself before 1455. Their presumed companion on the arch at Naples, Mino da Fiesole, joined them in Rome with still another variant of the humanistic revival of Roman sculpture. From this point a steady expansion began to take place, as indicated by the table on p. 156.

We must face now an anomaly of scholarship which has persisted even into very recent publication. This is the belief in the historical existence of another 'shadow-sculptor', constructed without documentation a little on the lines of the 'Piccolomini Master' discussed earlier (see p. 148). The responsibility for this creation goes back to Vasari, who gave to it a name, that of 'Mino del Reame' or 'Mino del Regno', and an *œuvre* that in style bears striking resemblance to the style of Mino da Fiesole.

It would seem on the face of the matter rather too much of a coincidence that there should be in Rome about 1460 (where sculptors with recognizable styles were few) two sculptors with the same, very rare name of Mino, and that the attributions of works to both should overlap. One source for Vasari's error of identity helps to explain his apparent gullibility. It would seem clearly to be in Pomponio Gaurico's theoretical treatise on sculpture, which can hardly be looked on as an authority on the facts of the Roman school of *c.* 1460–5 (see the Introduction, p. 8).[6] On his way from Naples via Rome to Padua and Venice at the end of the century Pomponio (who wrote in the fanciful manner of Filarete, whose architectural treatise he imitated) seems to have picked up the remains of a garbled tradition which involved a Neapolitan artist whose name was vaguely remembered as either 'Mino or Dino'. Only in Rome could this

ARTIST	MONUMENT	PLACE	DATE
1. Artist unknown	Tomb of Callixtus III	St Peter's★	c. 1460
2. Mino da Fiesole and shop	d'Estouteville Ciborium for the high altar	S. Maria Maggiore	c. 1461
3. Isaia da Pisa and Giovanni Dalmata	Tabernacle of S. Andrea	St Peter's★	c. 1463
4. Paolo Romano	Statue of St Andrew	(now cemetery, Ponte Molle)	1462–3
5. Mino da Fiesole and shop	St Jerome Altar for S. Maria Maggiore	(now Palazzo Venezia)	1463(?)
6. Vecchietta	Foscari Monument (effigy)	S. Maria del Popolo	1463–4
7. Paolo Romano	St Paul	(now Ponte S. Angelo)	1464
8. Shop of Paolo Romano	Tomb of Pius II for St Peter's	(now S. Andrea della Valle)	c. 1463–5
9. Andrea Bregno	Tomb of Cardinal d'Albret	S. Maria in Aracoeli	1465
10. Andrea Bregno	Borgia Altar	S. Maria del Popolo	1473
11. Mino da Fiesole and Giovanni Dalmata	Tomb of Paul II	St Peter's★	c. 1475
12. Mino da Fiesole, Giovanni Dalmata, and others	Ciborium of Sixtus IV for high altar	St Peter's★	c. 1480
13. Andrea Bregno and Giovanni Dalmata	Tomb of Cardinal Roverella	S. Clemente	c. 1475
14. Andrea Bregno and Mino da Fiesole	Tomb of Cardinal Pietro Riario	SS. Apostoli	c. 1477
15. Andrea Bregno and shop	Tomb of Raffaello della Rovere	SS. Apostoli	c. 1477
16. Cristoforo di Geremia(?)	Reliquary of the Chains of St Peter	S. Pietro in Vincoli	c. 1478
17. Uncertain master in current of Andrea Bregno and Mino da Fiesole	Tomb of Marcantonio Albertoni	S. Maria del Popolo	c. 1479
18. Mino da Fiesole	Tomb of Francesco Tornabuoni	S. Maria sopra Minerva	c. 1480
19. Bregno shop with Luigi Capponi(?)	Altar of Guglielmus de Pereriis (papal auditor)	Lateran	c. 1485
(Discovery of the Apollo Belvedere, 1485)			
20. Antonio and Piero Pollaiuolo	Tomb of Sixtus IV (bronze)	St Peter's★	1484–93
21. Luigi Capponi	Altar	S. Gregorio Magno	c. 1485
22. Shop of Luigi Capponi	Ciborium of the Holy Lance	St Peter's★	c. 1492
23. Antonio and Piero Pollaiuolo	Tomb of Innocent VIII (bronze)	St Peter's	1492–8
24. Michelangelo	Bacchus	(now Bargello)	1496–7
25. Michelangelo	Pietà	St Peter's	1498–1500

Table 6. Selected Key-Monuments by Fifteenth-Century Sculptors in Rome (1460–1500)

★ Now in the Grotte Vaticane under St Peter's.

confusion have arisen; for Vasari's view of the Florentine phases of Mino's work, though biased in favour of his rival Desiderio, is reasonably clear, since the tradition itself remained fairly straight in Florence. In Rome, in view of Mino's previous work at the court of Alfonso, he might very well have been first known as 'del Reame' (i.e. from the kingdom of Naples) rather than as 'da Fiesole'; the latter cognomen might have had meaning for the generality in Tuscany, but not so certainly in Rome. In 1460, as just pointed out, the normal provenance of sculptors coming back to work in Rome was precisely 'del Reame'.[7]

If one discounts the Vasarian tale, which may be attacked also on grounds of serious inconsistencies in his *Vite* of Mino da Fiesole and 'Mino del Reame', there remains no shred of corroborating evidence from any independent Renaissance source and none, as might be expected, from any document. As far as I know there never has been any such evidence. There can have been only one historical Mino in Rome at one time, and this must have been the sculptor we call in biographical dictionaries, Mino da Fiesole. The work signed OPVS MINI in Rome should be regarded as from his shop which, with that of Paolo Romano, began to dominate the Roman scene in 1460–5.

This digression on a case of mistaken identity has been doubly necessary in so far as it may throw light not only on matters of historical doubt but also on the differences between Florentine and Roman Quattrocento concepts of artistic individuality. The prevailing pattern in Rome between 1460 and 1485 was the large shop, or *bottega*, under the general responsibility and direction of a master. Where else but in Rome would a sculptor 'sign' his work, as did Filarete, with a relief showing the master *and* his numerous assistants (Plate 55B)? The large *bottega*, with the master's activity devoted to planning and installation more than to the labour of actual carving, may be explained in Rome on the one hand by customs of work which came down all the way from Antiquity via the guild of *marmorii periti* in the Middle Ages, and on the other by sudden demands for rapid, large-scale production. From the sparse documentation that is available, it would seem that in the 1480s a sizeable monument could be expected to be got ready within a matter of only four or five months. The rate of production was, therefore, much higher, and the quality correspondingly lower, than in Florence; and as we shall see, the questionable quality of *bottega* work suggested increasingly in the 1470s a pattern of collaboration between masters (rather than between master and assistants) for exceptionally fine or important commissions. These came in explosive succession.

Pius II had in mind the remodelling of the whole entrance front of St Peter's with a 'benediction pulpit', similar presumably to that of the Lateran, and also with two colossally-scaled figures of St Peter and St Paul to flank the monumental steps leading to the atrium.[8] His preferred sculptor was Paolo Romano, believed to be the same Paolo who had worked at Naples. For Pius's ablest seconder in artistic matters in Rome, who was the French Cardinal Guillaume d'Estouteville, the favoured sculptor was Mino da Fiesole. More accurately, one should probably have to say here: Mino and Co.[9]

The heterogeneous character of Mino's Roman shop of the 1460s is illustrated by the reliefs in varying styles of execution which survive from the huge ciborium made in 1461–3, according to an apparently incomplete inscription, by d'Estouteville for the

high altar of S. Maria Maggiore. The painted *ancona* on which Masaccio must have worked with Masolino on commission from Martin V had already given the basilica's decoration a Florentine character. But Mino's marble ciborium surpassed in magnificence and scale any liturgical programme in Florence (see Figure 21). As a programme type it perpetuated in new, Renaissance formal vocabulary a liturgical function which had had in Rome a continuous history since earliest Christian times.

Mino's control of the project as chief master must be granted; the *modelli* to be followed by his still unidentifiable assistants must surely have come from his own hand. Echoes of the solemn spirit of the processional of the Naples arch appear in the four *istorie* that decorated the ciborium. The architectural setting of the relief illustrated (Plate 92A) recalled Florentine massing, however, and also the setting of the same subject which Masolino had depicted in the painted altarpiece. Here we find Mino's recognizable tendency to accentuate the back-plane, and to compress rather than to deepen the space given in illusion by the perspective. Both in scale and format the ciborium reliefs repeat the Early Christian mosaic *istorie* of the nave of the basilica. Thus, to the observer there would be continuity and harmony between the earlier *istorie* and those of the Quattrocento as he faced the high altar from the nave.

A comparison of this style with that of the rival shop of Paolo Romano is offered on Plate 92B. The flattened figures and rather stilted movements of the d'Estouteville relief yield to a fuller plasticity, a more generous sense of space, and an even closer resemblance to the mood of the frieze of the Naples arch (see again Plate 69) in this relief from the monument of Pius II, now reassembled in a baroque framework in S. Andrea della Valle. There is some documentary evidence that Paolo Romano had begun the monument of Pius II after his death in 1464, and had started the effigy. From what can be judged from the sculpture in its present skied position in its much later setting, the effigy seems to have been finished by a different hand. Still another and more gifted sculptor appears to have worked on the relief we have just been discussing, and may also have been responsible for the lateral Virtues and the upper relief, in which Pius is shown as being presented to the Virgin.[10] The style of this *anonimo* appears to be very close to a striking equestrian relief of Roberto Malatesta, which was originally also in St Peter's (now in the Louvre).

Generally accepted in the literature as by Paolo himself is the oversize St Paul, datable 1464, the year of his great patron's death (Plate 93). Though much restored, the statue holds its own as an impressive passage of sculptural rhetoric in the company of the much later marbles decorating the Ponte S. Angelo. It proves that by 1465 the capability of making very large statuary which would be fit for an Imperial-scaled setting was already present in Rome.[11]

1465–85: *Andrea Bregno, Giovanni Dalmata, Mino da Fiesole, and Luigi Capponi*

In 1464 Pietro Barbo of Venice, distinguished as a patron of architecture in Quattrocento Rome and also as a rapacious collector of antiquities, became pope as Paul II. The name indicates an echo of Paul I's policy of the distant eighth century of turning away

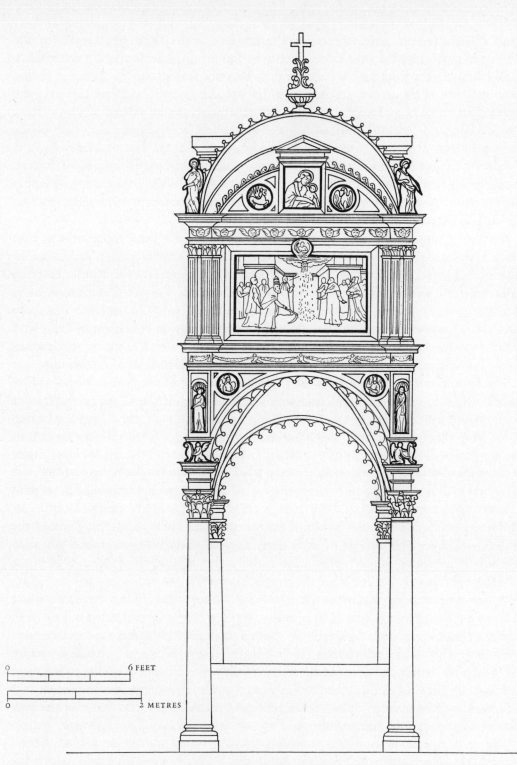

Figure 21. Mino da Fiesole and workshop: d'Estouteville Ciborium, 1461–3, before dismantling. *Rome, S. Maria Maggiore* (from De Angelis)

from Byzantium and concentrating on the heritage of the Western Roman Empire. From 1464, or 1465, dates the first evidence of the presence in Rome of a remarkably capable newcomer from North Italy, Andrea Bregno. He introduced almost at once a new standard of finesse and delicacy into the Roman ambient, without however the mannerisms of Mino, whose place he immediately began to take as head of a large shop. One of Bregno's first commissions was the monument erected after the death of the Cardinal Louis d'Albret (of the French royal house) in 1465. The St Michael of the d'Albret Monument, which is often confusingly italicized in the literature as Lebretto, recalls the figure of the same subject attributable to Agostino di Duccio in the Tempio Malatestiano. Bregno brought with him, then, more than local experience in Lombardy, which was his place of birth and earliest training.[12]

Another sculptor who rose to prominence at about the same moment was Ivan Duknovic, born in Traù on the Dalmatian Coast, which was then under Venetian control and influence. As Giovanni Dalmata, he was to work until 1480 in Rome; between 1480 and 1490 he was in the service of Matthias Corvinus, king of Hungary, based in Budapest, and still later in Venice and on the Italian East Coast.[13] At Rome he appears to have taken over the business of Paolo Romano, and worked in collaboration both with Mino da Fiesole (in Rome once again, c. 1470–c. 1480) and with Bregno, who remained active but with apparently steadily decreasing powers until the end of the century.

The largest and in some respects the most characteristic of the funerary wall-monuments of Quattrocento Rome was the tomb of Paul II, which, it seems probable, was begun before his death in 1472, and indeed may have been the magnet that pulled Mino away from Florence and back to Rome for the third time. The surviving elements of the tomb are divided unequally between the Louvre and the Grotte Vaticane; they indicate that from the beginning there was a fixed division of labour between Mino and Giovanni Dalmata. These elements, together with a late engraving published by Alonso Chacon (Ciacconius) in 1677 and somewhat earlier but fragmentary sketch-notes in one of the Grimaldi codices in the Vatican Library, reveal the design and placement of the sculpture (Table 7). On a plinth of putti, garlands, and masks, all'antica, rose a base with five panels decorated in high relief with the Creation of Eve, the Fall, and the three Theological Virtues. On the sides above this base were two superimposed niches on each side with standing figures of the Evangelists. Above and behind the effigy was a relief of the Resurrection. Above, in a lunette, was the Last Judgement, and to crown all a kind of heavy sunburst of glory with a seated God the Father surrounded by angels (Plate 96). The allotment between the two artists respected where possible a vertical axis down the centre, but also it seems to have followed a scheme of giving to the share of each sculptor alternating zones in a horizontal sense. The shares were balanced.

Mino's style here seems to be drawn towards great elegance and finish in the two Virtues that he carved close to the eye of the observer. In his Last Judgement, quite a bit above, he appears to have been pushing towards what was for him unusual sculptural vigour. He must here have been emulating the effect of modelling and search for powerful movement and surface activity that marked Dalmata's style at its best and boldest (see again Plate 96).

Above lunette:
God the Father in glory
[GIOVANNI DALMATA]

Supporting Angels	In lunette:	Supporting Angels
[MINO DA FIESOLE]	Last Judgement	[GIOVANNI DALMATA]
	[MINO DA FIESOLE]	

Under lunette:
Row of cherub-heads
[MINO DA FIESOLE]
Ceiling of cubiculum

On side:	[GIOVANNI DALMATA]	On side:
two Evangelists in niches	Resurrection relief	two Evangelists in niches
[MINO DA FIESOLE]	[GIOVANNI DALMATA]	[GIOVANNI DALMATA]

Effigy and sarcophagus
[GIOVANNI DALMATA]

Faith	Creation of Eve	Charity	The Fall	Hope
[MINO DA FIESOLE]	[GIOVANNI DALMATA]	[MINO]	[MINO]	[DALMATA]

One half of plinth (now Louvre)	One half of plinth (now Louvre)
[MINO DA FIESOLE]	[GIOVANNI DALMATA]

Table 7. Allocation of sculpture on the monument of Paul II* to Mino da Fiesole and
Giovanni Dalmata (with their botteghe)

* All extant fragments (except as noted) in the Grotte Vaticane.

Bregno's style is difficult to describe, since it is both admirable and a little colourless. It may conveniently be compared with that of the more dramatic Dalmata in the monument in S. Clemente of Cardinal Bartolommeo Roverella, who had served at one time as legate to England (Plate 94, A and B). In the usual pattern of collaboration of the 1470s, there is definite division of labour. Bregno's mourning shield-bearing boys are carved with a direct, clean touch, but are virtually without expression, save that of a genial equanimity. Dalmata's curtain-holding angels just above are carved with respect to the observer's angle of vision (a habit learned from Mino perhaps) and are stronger, somewhat coarser in touch, and more granular in finish. It is worth recalling here that Bregno was given in Rome the *nom-de-métier* of 'Polycleitus'.

Bregno's influence is strong in a group of monuments which presented in the 1470s a revival of a type for the tomb in Rome. This was a scheme which brought heraldic devices and the effigy together in a single shallow and low-ceilinged chamber: a method of simplification in design which had already taken a related form, derived from the Tuscan monuments, in Siena (see Plate 87B). The salient problem of style-criticism in Bregno's work has been, and continues to be, a clear differentiation between the hand of the master and that of his numerous followers. 'Si gran compositore e con bellezza' are the terms used by Giovanni Santi in his laudatory verse on Bregno in his own lifetime; perhaps it is the *bottega*-leader and innovator of tomb-types that we should look for today in approaching his art, rather than strongly developed individual feeling for, and ability to project, sculptural forms *per se*. The ingredient of his example is an important part of the monument of the great cardinal Pietro Riario (a favoured member of the family of Sixtus IV) in SS. Apostoli (shown on Plate 95). There is also a certain dryness

of modelling and precision of detail, as well as spare elegance in the ornament, which suggest a different hand and mind: possibly that of Luigi Capponi, still another Tuscan, who seems to have come to Rome in the 1470s and belonged to a later generation than that of Bregno's, in whose bottega he probably began in Rome. The combination of the type of the low-ceilinged chambered tomb with an altar-reredos above provided yet a further measure of sophistication in the late 1470s. In another category of variant, yet related closely in style, the low tomb-chamber was combined with an arch framing a fresco (Giovanni Basso-della Rovere and Albertoni Monuments in S. Maria del Popolo). Such close association of painting with sculpture in funerary monuments was traditionally 'Roman', going back to Early Trecento monuments of the pontificate of Boniface VIII, and beyond them, surely, to the painted *arcosolia* of Early Christian art.

Capponi's relation to the Albertoni Monument just mentioned is hypothetical. No less than two different sets of artists seem to be mentioned in documents which at one time or another have been linked with the monument. One set included Gian Cristoforo, the son of Isaia da Pisa, who was later to go to Lombardy, where he was employed on the monument of Gian Galeazzo Visconti, the founder of the Certosa in Pavia. Another artist who seems to have been mentioned in the Albertoni documents was a mysterious 'Jacopo', follower of an equally mysterious 'Andrea da Firenze'.[14] A quiet yet remarkable eclectic fusion of Florentine and Roman motifs occurs in a small and exquisite relief of the Virgin and Child of about 1470; it is signed by a 'Magister Andrea' (Plate 98B). This 'Andrea' could hardly have been Andrea Bregno, or – even less likely – Donatello's follower, Andrea dell'Aquila.[15] The delicacy of scale and characteristic Roman Quattrocento captivation by decorative surface-interest point towards the pontificate of Sixtus IV.

There seems to be a *romanitas* that comes through the overlay of varying personal styles and non-Roman origins of the artists of Quattrocento sculpture in Rome. This is in good part a reflection of growing appreciation for Antique art. Luigi Capponi's altar in S. Gregorio Magno and the reliquary-frontal for S. Pietro in Vincoli – attributable possibly to Cristoforo di Geremia – betray in varying degrees regard for small-scale Antique works of art. Sixtus IV ceremoniously brought to the Capitoline a sizeable group of antiquities which, as a fascinatingly early example of a civic art-collection, laid the foundation for the two celebrated museums containing Antique sculpture that are there today.[16] The imagery of the reliefs of Sixtus IV's ciborium of *c.* 1475-80 for the high altar of St Peter's was derived from the traditional representations of incidents from the legend of St Peter and the martyrdoms of both St Peter and St Paul, such as might have been found in the paintings of the atrium of old St Peter's itself; but the sculptural style depended clearly upon Imperial Roman relief sculpture, such as that on the column of Trajan, or upon Early Christian sarcophagus sculpture preserved in quantity in the Roman churches, or upon lower reliefs on coins and gems (Plates 97 and 98A).[17] When the Apollo Belvedere was discovered in 1485, its influence was not felt immediately in similar large-scale statuary in Rome. But there was in the elongated and graceful proportions of the angels of the ciborium of the Holy Lance, the elaborate marble oratorium commissioned by Innocent VIII for St Peter's, or in the nude St Sebastian of

marble in S. Maria sopra Minerva, attributable to Michele Marini, more than merely a passing brush of its lithe, slightly supercilious elegance. It would seem that the fates of style had decreed that the time was not yet ripe for the unearthing of the Laocoön.

Central Italy, 1475–1500: Silvestro dell'Aquila, Francesco da Laurana, and Domenico Rosselli

The paradox that regionalism and eclecticism might be co-terminous may be illustrated by the art of the Abruzzese sculptor, Silvestro di Giacomo da Sulmona, called from his centre of activity, Silvestro dell'Aquila. This was no local or provincial product; he had received training in Tuscany and knew Rome and Naples.[18] A local school of wood-carvers persisted in the chief centre of the mountainous and withdrawn area of the Abruzzi. Silvestro's St Sebastian of 1478 for S. Maria del Soccorso in Aquila, recently cleaned and now in the re-ordered museum at Aquila, is of painted wood and was closely related in programme to local production (Plate 100A). In style, however, it reveals a far more thorough knowledge of the facts of human anatomy and, more importantly, the control and interpretative power needed to create an eloquent *statua*, though with a more operatic air of emotional display than would be usual in Tuscany at the time. The chief Tuscan influence here would seem to be from Antonio Rossellino.

In the somewhat later marble monument to Maria Pereira Camponeschi (still being worked on, according to the documents, as late as 1496), the tomb type evolved by Silvestro combined Tuscan and Roman characteristics. The small-scale saints in niches of the frame continued clearly the normal Roman *parti*, such as has been described earlier. The two mourning putti, however, derived without intermediary either from Rossellino's Cardinal of Portugal Monument, or, as is far more likely, from Benedetto da Majano's reproduction of the Rossellino monument, the tomb of Maria of Aragon in S. Anna dei Lombardi in Naples. The touching motif of the double effigy, with that of the small child placed beneath the mother's Roman-style bier as if on a truckle-bed, appears to be unique (Plate 99). The child died in infancy not later than the end of 1491; after her husband's death at about the same time, Maria Pereira Camponeschi (who belonged to the Aragonese royal house) left Aquila, but not before providing for her small daughter and for herself a fitting monument close by the shrine of the Franciscan saint, Bernardino. Silvestro was also commissioned at the very end of the 1490s to make the marble shrine for the saint, but the style of that monument is mixed, with a great deal of Late Quattrocento Roman influence; in its gilt accents against white marble, it contrasts with the sombre greys of the Camponeschi double tomb. The style of the latter combines a lyrical perception of physical beauty with a good deal of energy in the forms of the sculpture and with a remarkable honesty in rendering the appearance of varying textures, whether of hair or cloth.

Around Silvestro developed less a 'studio' than a congeries of less distinct and semi-independent personalities under his influence who interpreted the Tuscan style, as defined by 1475 by Rossellino and by Verrocchio, to the Abruzzi in the old, traditional technique of painted wood (Plate 100B), in painted terracotta, and, more rarely, in

marble or stone. The older attribution of the large, elaborate polychrome tabernacle-altar in S. Maria del Soccorso in Aquila to Donatello's one-time assistant, Andrea dell'Aquila, can no longer be maintained. Andrea, who was part of the *équipe* of the Naples area until 1458, may have returned to his native Aquila, but there is nothing which would fit his Donatellesque manner in the Abruzzi.[19] The unknown artist of the agreeable Annunciation of the altar of S. Maria del Soccorso belonged to a later generation and, in a way reminiscent of Francesco di Simone Ferrucci, was an eclectic who had turned from Rossellino towards the sculptural values of Verrocchio.

The protean capability to adapt the new humanistic style to a very wide variety of regional and programmatic demands was shown on a still higher aesthetic level by Francesco da Laurana. The character of his complicated art depended on the circumstances of a career so picaresque that it deserves an outline here.

After leaving Naples at the break-up of the workshops gathered together by Alfonso, he spent three mysterious years either in his native Dalmatia or possibly as an itinerant artist elsewhere. By 1461 he was in Provence in the service of Alfonso's dynastic rival, 'King' René, count of Anjou. It would seem likely that some of the interim between Naples and Provence had been spent in a way to bring to his notice the more refined aspects of the Florentine style of that time. A series of Angevin medals between 1461 and 1466 shows a remarkable adaptation of something not unlike the Desideriesque *stiacciato* low relief to the general formula of Pisanello. Then, in 1466, he went to Sicily, where his first large commission was the decoration of the marble entrance arch of the Mastrantonio Chapel in S. Francesco in Palermo, which he shared with an itinerant Lombard, Pietro da Bonitate, who had recently settled in Palermo. A personal style of any strength is difficult to isolate here, and it would seem that, chameleon-like, Francesco was adapting himself to his new surroundings. A series of standing polychrome Madonnas began with that in Palermo Cathedral, taking, as the contract specified, a famous Trecento Virgin by Nino Pisano in Trápani as a model; a second signed Madonna of 1471 is at Noto in South Sicily, and another, undated and unsigned, is now in the museum in Messina.[20] Then there followed a probable land-journey over the toe of the Italian boot (with traces of his passage in work attributable to him at Andria and Santeramo) until he arrived in Naples, in 1473–4. Here he was given work by the Aragonese court, once again firmly established in the Castelnuovo. It was at this time that he began a series of portraits in marble of eminent ladies that today largely supply the basis for his reputation.

Recent scholarship has divided the portrait busts (now scattered between Berlin, Florence, Palermo, Paris, New York, Vienna, and Washington) into four categories.[21] The first and possibly the earliest of those that survive is represented by the unique posthumous marble portrait now in the Bargello of Battista Sforza, countess of Urbino (Plate 102A). The slow turnings of the smoothly polished surfaces define a composition of related curving planes that take on a close to purely abstract value of harmony and quiet. Though relating to earlier Florentine style, in fundamental ways this represents a differing concept not only of portraiture but of the expressive capabilities of marble as a material for sculpture from that of either Desiderio or Rossellino (compare Plates 76B

and 77). Like Rossellino, Laurana had a death-mask to work from[22] (the countess had died in 1472, in childbirth). A comparison of what is believed may be the cast made from the original moulds (Plate 102B) with the finished marble states more graphically than any number of words can describe the process of metamorphosis from the crude data of reality to a higher synthesis, or if you will, a higher 'reality'. The neo-Platonic intellectual climate of the court of Urbino may well be reflected here.

Whether or not Laurana actually went to Urbino to carve the posthumous portrait is not provable; he could have carved the bust perfectly well in Naples from the death-mask sent to him there, or he could have made the short stay required for the work in Urbino.[23] The three other categories of portraits of beautiful women depended on his employment by the royal family in Naples. The earliest, of 1473–5, would be the inscribed bust of Beatrice of Aragon, who married Matthias Corvinus in 1476 (now in New York); from before 1477, when Laurana left Naples again for Provence, would date the portrait of Ippolita Maria Sforza, wife of Alfonso II, grandson of Alfonso I (slightly differing versions in Washington, National Gallery, and New York, Frick Collection, with a more elaborately finished but reportedly irreparably damaged example in Berlin). The last category includes a series of versions (Palermo, Paris, and possibly Vienna) of the presumed portrait of Ippolita's daughter Isabella, who became duchess of Milan in 1489.[24] If the pattern of marriage as the occasion for these portraits holds good here, as other evidence of costume and the like would support, this type represents the last stage in a series which also presents a stylistic progression (Plate 101 and frontispiece). At the end, abstract shapes, particularly a Brancusi-like predilection for ovoid forms, dominated. There nevertheless comes through the whiteness and smoothness of general effect a feeling for delicately contrasting textures and feminine bodily beauty, combining a sensual smouldering warmth with the chilly remoteness required by the formality of the programme.

Between the last two groups of Aragonese portraits just discussed, Laurana was in Provence. Here he did sculpture and decorative carving with the lesser-known Lombard Tommaso Malvito in the Chapel of St Lazare in the cathedral of Marseille, helping in this way to establish by 1477 an early foothold for the Renaissance style in France. This work was followed immediately by René of Anjou's last commission before his death; a penitential Calvary relief which has been installed in St Didier at Avignon. In this large marble composition Laurana again adapted himself to a late-Gothicizing style foreign to his natural bent. A series of six enigmatic, subtly carved women's masks in marble must come from this second Provençal period; and there are two tombs, one in relief evidently for the shrine of the saint hidden in the darkness of the crypt of Ste Marthe in Tarascon, which seem to bear the imprint of his hand. The tomb relief of Aprile Speciale of 1495, now in the Museo Nazionale in Palermo, may indicate that he once more returned to Sicily before his death in 1502. Between the geographical triangle of Naples–Sicily–Provence, and between lingering Late Gothic tendencies and the humanistic trends of the new Renaissance style, his versatile eclecticism has escaped, as all art should, a convenient historical pigeonhole. It was as much an 'international' courtly phenomenon of Mediterranean and Slavic scope as it was Italian, though the frame of reference steadily remained that of sculptural and political developments on Italian soil. Still to be more

thoroughly studied is the Provençal activity of the artist; from Marseille he may well have been in touch with Northern France (Loire region and Maine), as indicated by the fine *gisant* of a tomb in Le Mans perhaps attributable to his own hand.

The brilliance of Laurana's career is brought out by a brief consideration of the art of Domenico Rosselli, who carried the Florentine style into the Marches. In a very much more restricted radius and on the whole for more obscure patrons, Rosselli, without *réclame* even in his own lifetime, carried out still another and more humble aspect of the continuing development of sculpture in Italy in the last quarter of the century.

His early years on the west coast near Pisa brought him into the general Florentine orbit for his training, which must have been in the Rossellino workshop. By 1472 or 1473 he had migrated to Pesaro, and his activity was afterwards mainly, if not entirely, restricted to the Marches and to Umbria. He worked on the decorative sculpture in the palace of the dukes in Urbino, did a tomb there, and then shifted his centre of operations about 1480 to Fossombrone, where he died in 1497.[25] Plate 103 presents his dated and signed *ancona*, in Umbrian stone with gilt and polychrome accents, for the high altar of the cathedral at Fossombrone. Here sculpture, as happened in the coastal art, very frequently took over the function of painting. With its stiffly standing saints surrounding the Madonna and with its predella scenes in low relief below them, this is in effect a duplicate of a painted altarpiece, though in stone. There was as a general rule in Rosselli's style an inhibiting factor which kept bringing his reliefs down towards two-dimensional rather than fully sculptural schemata, and in his figure-style he tended towards static poses. But, though modest in his ambitions, he was much more than 'un povero di spirito', as he was at one time called. His work brings up in another form the problem in criticism of any eclectic style, in this case complicated by indefinable yet very real connexions with the traditions and spirit of a specific province. There is something of the soil itself and of the anonymous people who live close to it that occurs here in a muted way which cannot be called properly 'provincial'. It is, rather, an autonomous expression, valuable in its own right.

TUSCANY AND REGIONAL TRENDS IN THE EMILIA AND ON THE WEST COAST, 1475–1500

Andrea della Robbia and Benedetto da Majano of Florence; Matteo Civitale of Lucca

Fifty years ago the position of Andrea della Robbia among Quattrocento sculptors would have been very close to the summit in both popular and scholarly esteem. It is difficult to understand how this might have been, since his limitations not only in originality but in sculptural power seem today only too apparent. As a favourite nephew of Luca, he inherited the family bottega and its growing business, which was not restricted only to Florence or its immediate neighbourhood. Andrea's speciality was the coloured glazed terracotta technique first developed by Luca. Andrea added more colours to the palette of Luca and sought, not without some danger to the sculptural

aspect of his art, to duplicate the compositions and effects of painting. It has been repeatedly pointed out how much he took from the painters Domenico Ghirlandaio and Lorenzo di Credi. This was one aspect of his eclectic turn of mind.

The second was a softening and sweetening of Luca's already gentle late manner by borrowing motifs and effects of modelling from the shop of Antonio Rossellino. His early work was his best. The celebrated series of *bambini* (begun in 1463–6) in roundels on the loggia-front of the Hospital of the Innocenti (foundlings' hospital and nursery) in Florence does not contain any strict repetition of pose or of type. Conceivably they could be idealized portraits of his own numerous family of children.[26] His most important and successful use of glazed terracotta in a large-scale programme of the 1480s was in the series of altars for the principal church of the Franciscan shrine-centre of La Verna, situated high in the mountains of the Casentino. The compositions vary in closeness of relationship to painting, and some stand midway between painting and sculpture (Plate 105). Many of the motifs of the La Verna altars were adapted to smaller designs for private chapels or oratories. Multiplication of replicas or close variants from popular prototypes which were exported all over Tuscany and beyond became by 1490 the rule. At that time, as we shall see, the dwindling invention in Andrea's designs was supplemented by translating the designs of other sculptors into the *terra invetriata* medium.

The mantle of Antonio Rossellino fell not on Andrea della Robbia but on the stone-and-marble sculptor Benedetto da Majano. Born and brought up in the quarry village of Majano, he was a carver rather than a modeller, though *modelli* in clay for work in marble are mentioned in the inventory of his studio at his death (1497). Benedetto's work was strongly coloured by his early association with Antonio Rossellino. Three periods may be distinguished in his style.

The first was centred on the shrine of S. Savino in the cathedral of Faenza, on which he collaborated with his architect-sculptor brother Giuliano. For some time the reliefs, which strongly reflect in some cases the style of Ghiberti, were given to Rossellino, so close also is the relation to his own master. A marble bust of the young John the Baptist now in the Faenza museum, which has also been frequently attributed to Rossellino, seems to date from the same period.[27] After working with assistants on the altar of S. Fina at San Gimignano (Collegiata, finished 1475) he returned to Florence, where, under the patronage of the wealthy merchant Pietro Mellini, he began his second period.

The bust he did of his patron (now in the Bargello) continued in even more meticulous detail the kind of naturalism that Rossellino, working from a life-mask, had poured into his Giovanni Chellini portrait some twenty years before (see Plate 70A). The later portrait adds an element of greater weight, but also of some pomposity. The Mellini pulpit in S. Croce carries a series of five reliefs (originally planned as six) representing events in the life of St Francis and of his immediate followers. The subjects are similar to those of the series of frescoes by Giotto, close by in the Bardi Chapel in S. Croce. The reliefs were encased in an elaborate architectural frame and combined several prototypes in style (Plate 106). The general *parti* of the virtually square reliefs is not that of Ghiberti's second doors of the Florentine baptistery, as might be expected, but of the bronze-gilt reliefs by Ghiberti, Donatello, Quercia, and others of the baptistery font in

Siena (see again Plates 28 and 29).[28] The shadowed separation at the top between the frame and the back-plane of the relief is a sure index of this source of inspiration, which Benedetto could easily have studied while working in near-by San Gimignano. Close to Donatello and also Ghiberti is the projection in high relief of the front-plane figures. The gradual reduction of relief thereafter is more on Ghiberti's method than Donatello's. The composition is 'copious', as Alberti would have said. A clear focus is on the central figure, however, which in its swinging movement is close to Verrocchio's style (see Plate 113), but even closer to Pollaiuolo's, whose executioner as designed for the Death of the Baptist in the series of embroideries for the *paliotto* of S. Giovanni in Florence it repeats. Around the borrowed, forceful gesture the remainder of the motifs and contrasting gestures and poses fall into place. The relief was originally gilt in the sky-background and in many details of the architecture and figures, and its general effect must have been more incisive and more brilliant than what we see today.

After working on the monument of Maria of Aragon for S. Anna dei Lombardi in Naples (1481), in which the S. Miniato tomb by Rossellino and his shop was repeated virtually in duplicate (see above, p. 143), Benedetto provided the altar for the Mastrogiudici Chapel, in the same Neapolitan church, in 1489. In this work the programme of a painted *ancona* complete with its predella in low relief was dutifully carried out in marble (Plate 107). The central relief (one is tempted to write 'panel') is a virtuoso solution of the very difficult problem of putting solid forms into perspective. The altar, as will be shown in a succeeding chapter, follows not only a Rossellino design but also one by Benedetto's younger contemporary, Andrea Sansovino.

Work for the Strozzi family and for the Signoria of Florence (the elaborate door for the Sala dell'Udienza of the Palazzo Vecchio) preceded Benedetto's last period, in many ways his most interesting. By 1485 he had become dean of his generation of sculptors in Florence and was beginning to give his work greater bulk and sculptural weight. The Naples altar reveals a desire to close the forms, to simplify outlines, and to reduce the interest in silhouette in favour of an interest in mass. An unfinished St Sebastian and an impressive Madonna were left after he died to the society of the Misericordia in Florence, where they can be still seen today. A partially completed Coronation group of two figures, now in the Bargello, is all that remains of the unfulfilled commission from King Alfonso II of Naples to provide the central group for the decoration of the Porta Reale in his capital. It was for this programme rather than for the Porta Capuana (as is generally published) that the Bargello group was intended.[29]

Parallel to Benedetto's, but between it and the double stylistic current of Antonio Rossellino and early Verrocchio, was the style of Matteo Civitale, whose activity after early training in Florence was centred on such west coast cities as his native Lucca, Pisa, Sarzana, and Genoa. His eclecticism, working in somewhat the same way at about the same time as that already pointed out in Benedetto's pulpit reliefs for S. Croce, drew him back to earlier Sienese monuments. The fragmentary and not quite finished relief of Faith from an undetermined Lucchese programme can be dated about 1475, in stylistic relationship to the Angels of 1473–6 surviving from the now dismembered Altar of the Sacrament of the cathedral in Lucca. This characteristic example of Civitale's

style (Plate 104) combined the poses of two of the Virtues of Jacopo della Quercia's Fonte Gaia (the Hope and the so-called Wisdom). The earlier monumental style of Quercia's goddesses was reduced to an intimate scale and to what amounted to an informal portrait of a charming, evidently stylish patrician girl, her hair dressed in the latest fashion. An echo of the *parti* of the early Coscia Monument by Donatello and Michelozzo (see again Plate 26) was sounded in Matteo's St Regulus altar-tomb of the 1480s (Lucca, Duomo). The predella followed to some extent Quercia's at S. Frediano in Lucca (Plate 21B), but with a different method of relief which cuts the figures sharply from the ground, surrounding their shapes with shadow and air; this device had first appeared on the Altar of the Sacrament by Desiderio and his shop in S. Lorenzo in Florence (Plate 89B).

In his last years, Civitale worked on the important programme of statuary for the Chapel of S. Giovanni in the cathedral of Genoa, where his successor was the younger and more original Andrea Sansovino, whose art we shall consider shortly in a later chapter. In this Genoese statuary (Plate 110B) an interesting phenomenon occurred. Evidently, under a 'modern' influence, Civitale attempted a more expressive type of pose, and freed his forms so that they moved one against another in a more daring counterpoint in space than he had ever attempted before.

A number of rather rustic Annunciation and Nativity groups have been attributed to Civitale's own hand, without any documentary basis.[30] Some may have been connected with his nephew Masseo and others with as yet unknown and more remote followers in the Lucchese region. An example in painted wood (Plate 110A) with its clean simple lines and delightfully stilted elegance is outside the Tuscan mainstream, but very much worth attention and further study. In many ways, as in the case of Civitale himself, there is a parallel to be drawn here with Silvestro dell'Aquila and the closely contemporary sculpture of the Abruzzi.

Emilian and West Coast Sub-styles

Two regional styles help to complete this view of the mid-Italian sector. In the Emilia, to the north and north-east of Tuscany, there was little of importance in statuary, but a distinctive style in relief. Tying into the manner of Domenico Rosselli in the Marches, this style sought its effects in very low relief, but, unlike the Florentine *stiacciato* relief, with a maximum of non-atmospheric clarity (Plate 108A). The marble reliefs of the shrine of S. Terenzio in the cathedral of Faenza on the old Roman Via Flaminia to Lombardy of about 1485 mingle this low-relief clear style with elements of Lombard art already in evidence by then at Bergamo (Plate 108B).[31] On the west coast, just across the peninsula, local sculptors had developed two opposed styles. One, epitomized by Donato Benti, who had had Florentine training, was delicate in scale and very elegant, making the most of the material of fine-grained marble of Carrara or Pietrasanta (Plate 109B). The other, a little way up the coast towards Genoa, using precisely the same materials, retained until a surprisingly late date medieval characteristics, emphasizing a timeless, virtually iconic power of semi-abstract forms (Plate 109A).

CHAPTER 8

ACTIVISM AND REALISM, 1465–95

WITHOUT contrast and movement sculpture, like the drama, fails to hold an audience. The socio-economics of the production of marble sculpture in fifteenth-century Rome, with its stress on collective standards of taste and quality, tended towards the monotonous. This tendency grew partly out of a deep-lying conservatism. It was probably inevitable in view of the stereotyped character of programmes of marble funerary art which had the upper hand in the Rome of the Renaissance. To adapt words of W. H. Auden,

> . . . The heavy page
> Of death . . .

was difficult to turn. By 1485 the situation was ripe for a change.

In Tuscany, and a little to the north in Bologna and Modena, attention had turned to those problems of suggesting movement and immediacy of emotion in sculpture which had fascinated in differing ways both Ghiberti and Donatello. In some cases this tendency might be restricted to simplifying form for an accent of pure gesture, as had occurred in the art and circle of Civitale (Plate 110A). In other cases a more pervasive sense of graceful movement might free the figure from its ground-hugging weight, adding an effect of flickering light actively bouncing off the complex surfaces to create a compelling impression of vitality. A pair of bronze candelabrum-bearing angels for the high altar of the cathedral in Siena by Francesco di Giorgio of the 1490s is generally cited in the literature as a prime example of this direction of sculptural thought.[1] Plate 111 presents one of a companion pair of angels for the same programme by Giovanni di Stefano, the son of the painter called Sassetta, born in 1444 and thus a little younger than Francesco di Giorgio (born in 1439), though of the same artistic generation. This second pair of bronze angels for the high altar is remarkable for lightness of touch in establishing the composition and for the intricacy of surface detail, which catches and shoots back shafts of light as if they were arrows of active luminosity. With finely chased bronze such effects were possible, where in marble the surfaces soaked up the light rather than so brilliantly reflecting it. The difference in effectiveness of medium is to be seen in Giovanni di Stefano's rather heavy attempt at marble statuary in his S. Ansano of the Chapel of the Baptist in the same cathedral.[2]

Stepping up the level of emotional intensity as well as of visual excitement might appear to run counter to the classicizing stylistic trend of the second half of the century. Actually no difficulty was encountered in this quarter. Following in Donatello's wake, Tuscan sculptors such as Bertoldo selected the most active Dionysiac themes from Antiquity to carry the expressive freight of Christian imagery in the new emotional mode; mourning Marys now were derived from frenzied Maenads (Plate 112B).[3] Even

in the cool intellectual climate of Urbino, this activist style found apparently a welcome home. The beautiful Crucifixion relief containing as donors the kneeling figures of Duke Federigo and his son which has since migrated to Venice is characteristic of the highly faceted, light-reflecting style in bronze of Francesco di Giorgio's maturity (Plate 112A). The energy that was noted earlier in his early painted wood figure of the Baptist (Plate 84A) in the 1470s and 1480s erupted into a brilliant series of reliefs, including some small-scale bronze plaquettes.[4]

The technique best adapted to this highly charged manner of approaching sculpture was obviously not stone-carving. The effects desired were too volatile, the impressions sought too immediate in impact and too momentary in representation, though in some cases marble was adapted to the style with definite modifications and concessions in forms (Plates 115A and 124A). This was a modeller's paradise; the prime materials and the guiding techniques attached to them were wax (as the first stage of bronze-casting) and clay. Two parallel and to some extent interconnected movements of the last third of the Quattrocento carried the principal burden of the activist and realist trends. One had its centre in Florence, with tentacles reaching out to Venice in the north and to Rome in the south. The protagonists for this phase of Quattrocento sculpture were Verrocchio and Antonio del Pollaiuolo. The other phase was centred beyond the Apennines in the Emilia and related Po Valley cities, and touched not only Venice in the north but Naples, and, via Naples, ultimately France.

Tuscan Activism: Verrocchio, 1465–88

The beginnings of Andrea di Michele Cione, called Andrea del Verrocchio, belong to the mid Quattrocento and have already been sketched in Chapter 6 within the limits of the scanty knowledge available (see p. 149). Few Florentine artists were worse served by Vasari, whose *Vita* of Verrocchio has provided on the whole as many riddles as trustworthy facts. Out of twenty statements connected with details of his life or with works of art done during that life, five cannot be checked for lack of data, five are in the main correct, and ten are wrong either totally or in some serious way, such as in confusion of date or of technique. Fortunately there are available in published form a considerable number of documents which help to clear up the difficulties created unwittingly by Vasari; upon them the summary given here largely depends.

The inventory of Verrocchio's work for the Medici family that was drawn up in January 1496 (1495, old style) by his younger brother is the central item of documentation for the artist's career in Florence. A translated version of this list provided on an adjacent page reveals the scope of Verrocchio's Medici commissions, which ranged from portraiture and the design of standards and of parade-armour for tournaments to more permanent sculpture for fountains.[5] In these types of commissions is to be seen the characteristic pattern of activity of a court artist of the fifteenth century north of the Alps. The patronage of the great private individual, in imitation of the dukes of Burgundy, let us say, had already taken over, while Piero the Gouty was head of the dominant Medici branch (1464–9). The purpose of the inventory of 1496 was to

establish claim to payments still owing on Verrocchio's work; and judging from the tone as well as the content of the sculptor's tax-statements, which extend from 1457 to 1480, he was far from well paid by either Piero or his sons, Lorenzo, in this case ironically called the Magnanimous, and the ill-fated younger brother Giuliano. After 1480, just as Donatello had left Florence for Padua in 1443, he transferred his activity, though not completely his large Florentine *bottega*, to Venice, where he died in 1488.

1. A David with head of Goliath*	Extant (now in Bargello)
2. A red nude [flayed Marsyas]*	Extant (?) (now in Uffizi?)
3. Small child of bronze with three heads of bronze [lost] and four lion's 'mouths' of marble [for the base]*	Extant (now in Palazzo Vecchio)
4. A fountain-figure of marble	Extant (?) (now in old sacristy, S. Lorenzo?)
5. A storiated relief with several figures	Extant (now in Bargello)
6. Adornment [painting] of all the heads above the doorways of the courtyard [of the Medici Palace] in Florence	Lost
7. [Painted] portrait on panel of Lucrezia Donati	Lost
8. [Painted] standard for Lorenzo's [de' Medici] Tournament	Lost
9. A figurine of a lady for [the crest of] a helmet [for Lorenzo de' Medici]	Lost
10. [Painting] of a standard with a putto ['spiritello'] for the Tournament of Giuliano [de' Medici]	Lost
11. [Marker] for the grave of Cosimo [de' Medici] at the foot of the high altar of S. Lorenzo	Extant
12. The tomb of Piero and Giovanni de' Medici	Extant (in old sacristy, S. Lorenzo)
13. Lettering cut into the [face of the] above tomb	Extant (as above)
14. Twenty masks after nature [for carnival?]	Lost
15. [Parade] armour [in part] for Duke Galeazzo [Visconti, of Milan]	Lost

Table 8. Verrocchio's Medici Commissions
(From the inventory made by his younger brother, Tommaso, 27 January 1495)

* Indicated as for the Medici villa at Careggi.

For the history of Renaissance sculpture the first and third items of the Medici inventory are the most important. The document states that these figures, extant and fully identifiable today, were made for the Medici villa of Careggi, which later, under Lorenzo, was to become famous as the chief seat of the Florentine Platonic Academy. The literature on Verrocchio normally has situated the two bronzes close to 1470, and in the case of the David often a little later. Reasons for advancing the timetable in Verrocchio's early career have been given in Chapter 6 (see p. 149). The fountain-figure of a putto holding a dolphin which was set up until recently in the first court of the Palazzo Vecchio is datable to the period of Piero il Gottoso, and from the point of view of style to about 1465 (Plate 114B). The motif of the running boy and the picturesque handling of the forms found an echo in the grille of the Cappella della Cingola in the cathedral in Prato, in the section probably by Pasquino da Montepulciano of the mid 1460s at the latest (Plate 114A).[6] Verrocchio's type of young child, taken from attentive

study of nature, is still in this little figure close to Desiderio's (Plate 76B). The bronze has been cleaned and reveals some casting flaws, one notably in the forehead; but in general the casting is of remarkably high technical quality, fresh and clear even in very delicate passages and (unlike Filarete's bronzes) relatively little re-cut. It would indicate that Verrocchio in the mid 1460s was a master of the highest accomplishment in bronze, not only in comparison with others in Florence but in all Italy.

The David for Careggi, now in the Bargello (Plate 118A), was sold by the Medici to the Florentine Signoria in 1476 and was placed in their palace in a position of honour at the head of the principal stairway. The date of sale had, as far as the documents go, no relation to the date of execution, except as a rather rough *terminus ante*. The figure does not seem to be technically as advanced as the Boy with a Dolphin. The surfaces are highly chased, and in some areas much cut after the metal had cooled. The composition is based on a single view – that in which the head is turned squarely towards the observer and the diagonal of the bent forearm is repeated and extended by the diagonal of the sword. The head of the giant ('testa di ghulia' of the document) was cast separately, another indication of a relatively early date, since a separate casting would greatly simplify the technical problem. The evidence from the piece itself would thus add up to a date somewhat before 1465 and provides us with a basis of evaluating Verrocchio's prowess as a worker in bronze at about the time the Mercanzia were looking about for a sculptor for their *pilastro* on Or San Michele, which they had just taken over from the Parte Guelfa (see above, p. 72, and below, p. 174).

The usual later dating of the Medici bronze David has depended upon Vasari's statement that it was made only after Verrocchio had returned from the service of the pope (Sixtus IV) and of the agents of the Medici Bank in Rome, the Tornabuoni. A Roman sojourn for Verrocchio in either the 1460s or 1470s is not documented. Its likelihood is reduced by the unusual number of his eminent and time-consuming commissions in Florence. He had become, by 1465, the head of a complicated business enterprise: the *bottega* which was concerned not only with painting and sculpture but with the ephemeral decorative art connected with tournaments and the like that the inventory of 1496 presents.

Vasari mentions a series of twelve silver or silver-gilt Apostles for the altar of the Sistine Chapel as the main reason for Verrocchio's journey to Rome. It seems very unlikely that the commission for these Apostles would have come before 1480, when the decoration of the Sistine Chapel was taken in hand. The tomb of Francesca Tornabuoni (who died in childbirth in September 1477), that according to Vasari Verrocchio made, is not extant, though a *bottega* frieze in marble which might fit the subject is in the Bargello.[7] There is specific and unavoidable evidence that Verrocchio was deeply involved in Florentine commissions between 1477 and 1483, in which year he went off to Venice. There is, finally, in Rome itself, nothing that survives that can be securely linked to his hand. It is possible that Vasari confused the commission for the silver Apostles with that of another artist (see below), and it would not be impossible, in view of the number of sculptors named Andrea in Rome, that he jumped to unwarranted conclusions in assuming as actual Verrocchio's supposed stay in Rome.[8] A 'Roman period'

of Verrocchio must therefore be looked on with extreme scepticism, even though it cannot be entirely eliminated as a remote possibility.

The major commission in Verrocchio's Florentine period did not come from the Medici but from the Magistracy of the Mercanzia (or Mercatanzia), who in 1463 determined to commission sculpture to fill the niche that they had taken over from the Parte Guelfa on the exterior of Or San Michele. Donatello's St Louis of Toulouse, which had occupied the niche since about 1425 (see Plate 25), was removed to the Franciscan church of S. Croce, as an appropriate refuge for the image of a saint that stood so high within the Franciscan Order. For a time it appears that the Mercanzia was interested in attracting Luca della Robbia to make their new statuary. At that juncture Luca was busy with the bronze doors for the north sacristy of the Duomo; Verrocchio was in touch with the older artist, since he sold him in 1464 some bronze metal for the Duomo job. Probably by 1465 the commission for the Or San Michele niche was in Verrocchio's hands, and in 1466 began a long series of payments which were to extend beyond the date of his death.[9]

The documents do not specify when the composition of two figures was determined. By 1468 Verrocchio was placed on a salaried basis, and it is generally assumed that the design was then fixed. In 1470 metal was weighed in preparation for casting at least one figure. This, for reasons of style, was the Christ (Plate 116B). The later St Thomas, who reverently yet purposively thrusts the fingers of his right hand towards the wound in the Saviour's side (Plate 116A), followed very closely an earlier design in a fresco in the Duomo (Bicci di Lorenzo in the Cappella di S. Tommaso in the south tribuna) which in turn went back to the marble Angel of the Annunciation originally planned for the Porta della Mandorla (Plate 5A). Verrocchio's Christ also followed the frescoed parallel subject in the Duomo.[10]

The originality of the group as conceived by Verrocchio was clearly not in the subject-matter, nor in the types selected to carry the *istoria*, but in its style. This was actually double. In the earlier Christ the drapery emphasizes planes; it defines its own forms as a structure in space built of deep shadows and strong lights. In the St Thomas, the drapery is more pliant. It emphasizes the total plasticity of the figure beneath and rounds off in its complex, yet less angular patterns, the gentle movement. The St Thomas is the more classicizing of the two in detail, even to the rather archaeological reconstitution of the Antique mode of sandals worn by the saint and the trouser-like covering of the ankle that can be observed on the inner leg. The illustrations provided here bring out the separateness of the two figures as regards their style; perhaps as much as a decade lay between their designs. But the impact of the composition as a whole was in fact the major part of Verrocchio's achievement. He turned the closed niche of Donatello's earlier programme into a kind of portal, with the movement flowing from the St Thomas inward from the space and light of the street towards the darkened consecrated space behind the figure of Christ.[11]

An intermediary stage between the contrasts of figure and drapery style of the late 1460s and the late 1470s is provided by the relief in silver for the altar frontal of the baptistery, which was commissioned in 1477 and finished in 1480, according to a rela-

tively complete set of documents (Plate 113).[12] Within a space constructed on perspectival principles seven figures are arranged in a composition designed to bring out to the maximum the drama of the *istoria* of the Execution of the Baptist. He kneels facing left, a strongly modelled ascetic not unlike the Christ of Or San Michele. Behind him is contrasted the athletic body of the executioner, seen *da tergo*, with the musculature of the back acting as a powerful central accent against the ornate and artificial forms of the armour of the soldiers who are grouped as witnesses. On the right two officers quarrel in a dialogue of erupting violence. To the left a group of three younger ephebes express in daintier fashion their courtly dismay. In no less than three places in the composition Verrocchio used the arches of the architecture as a frame for figures. Thus the action is frozen at its height and the pattern of the setting locked securely into the pattern of forms of the actors. There is no other relief of the second half of the century that is more worthy to stand beside the great inventions of Donatello, Quercia, and Ghiberti.

Verrocchio's genius might have fared better in subsequent critical estimates if he had been able to finish the cenotaph in marble of Cardinal Niccolò Forteguerri in the cathedral of Pistoia. A concise and detailed modern analysis of the documents and of the style of the Quattrocento elements, which were finally put together in 1753 with other additions, makes clear Verrocchio's part in the original programme.[13] This was to provide the total scheme of composition, the *modelli* for the sculptural elements (in all at least ten, including the inscription), and in some cases the actual carving of the chief details of the figures (heads, hands, feet, and some drapery).

The monument was never intended as a tomb, for the cardinal had been buried in Rome, but as a memorial to his *virtù* as a distinguished churchman and to his generosity in founding a collegiate school (La Sapienza) for the benefit of his native city of Pistoia. The large number of surviving documents indicates that the committee in charge had difficulty in reaching a decision both on the design and on who was to execute it. In January 1474 a competition between no less than five sculptors was opened which resulted in the preliminary choice of Verrocchio as recipient of the commission. Doubts as to the clear superiority of his design, and the legitimacy of the costs estimated by Verrocchio, brought Piero del Pollaiuolo, then a part-time resident of Pistoia, into the tangle. His rival model was finally rejected on the advice of Lorenzo de' Medici who had been called in to arbitrate. Only in 1478 was Verrocchio able to call the commission securely his own. By 1483, just before he left Tuscany permanently, he had received fifty *fiorini larghi* on account, having completed the work, as he stated, in 'good part'.

Missing at that time were the figures of Charity and of the Cardinal, probably planned in a kneeling pose. Accounted for in varying stages of final polishing and detailed carving were (1) the seated figure of Christ in a mandorla supported by four flying angels, and (2) the standing figures of the remaining two Theological Virtues. The work of carving was done in Verrocchio's own studio in Florence, and the marbles were brought to Pistoia only after his death. In 1511 the missing Virtue and the Cardinal were supplied by an admirer of Raphael, Lorenzo Lotti, in the classicizing style. Lotti contracted to make some additional minor figures, including two angels, which were mentioned in 1511 as indicated in 'the model'. These last were never done, and there is

a legitimate question as to whether 'the model' of 1511 was that by Verrocchio or a new one prepared by Lotti. The Late Baroque setting for all these fragments from at least two, and perhaps three, Renaissance schemes has destroyed any other internal evidence which might have survived.

The monument was the most important one of its kind of the last quarter of the fifteenth century in Tuscany. It would be of intense historical interest to be able to reconstruct the design Verrocchio had in mind. Figure 22, a purposely schematic drawing from a terracotta sketch in the Victoria and Albert Museum, projects the essentials of the placement of the figures as the final fifteenth-century scheme may have intended.[14] The traditional mandorla motif supported by angels was given by Verrocchio a completely new dynamism. It would seem also as if a subtle accentuating perspective of scale were involved which reduced the size of the figures in the upper zone and enlarged the bulk of the figures nearest the observer's eye. The distance stylistically between this concept and the frontispiece of the Porta della Mandorla by Nanni di Banco and his shop is clearly considerable (see again Plate 19). The carving technique is uneven in quality, a situation to be expected with the participation of assistants on so large a task. What is almost certainly Verrocchio's own personal style of about 1480 is to be seen in the detail reproduced on Plate 115A.

The other large commission begun by Verrocchio was finished by another hand. In 1475, at the age of seventy-five, the *condottiere* Bartolommeo Colleoni of Bergamo died, leaving in his will to the Venetian Republic, which he had well served, a large portion of his wealth and the request that a commemorative equestrian statue in bronze be erected to him in the Piazza San Marco. The parallel with Donatello's Gattamelata Monument in front of the Santo in Padua was if anything too obvious. In 1479 three artists were asked to submit large-scale models of a horse in competition. These three were Bellano, Leopardi, and Verrocchio. All three had had experience in bronze-casting, but Verrocchio's horse, modelled it would seem in wax and sent to Venice in 1481, won the day. In 1483 he moved to Venice, where there were excellent bronze foundries, to complete the commission. He fell ill in 1488 and made his will, in which he recommended his chief assistant in Florence, Lorenzo di Credi, to the Venetians to complete the work. Nothing had been cast up to Verrocchio's death; a Venetian document of 1488 states in recording Lorenzo's transfer of the commission to another Florentine (apparently a bronze technician) that the figure and horse were still 'in clay'.[15] In 1496 the work was finished, under the direction of Leopardi, who was probably responsible for the carefully chased detail. The huge statue was set up on a high pedestal, as high as that of the Gattamelata, in the Piazza SS. Giovanni e Paolo close by the entrance of the Scuola, if not the church, of S. Marco (Plate 117).

The statue measures some thirteen feet in height; in other words it was designed as well over life-size, and about three feet taller than its predecessor in Padua. Unlike Donatello's equestrian monument (see again Plate 62), Verrocchio's is best viewed from an oblique angle, and the view from the rear is just as impressive as that looking towards the face. No attempt is made to clothe the hero in the trappings of Antiquity. The details of the armour carry out the total reference to modernity. It is indeed not the

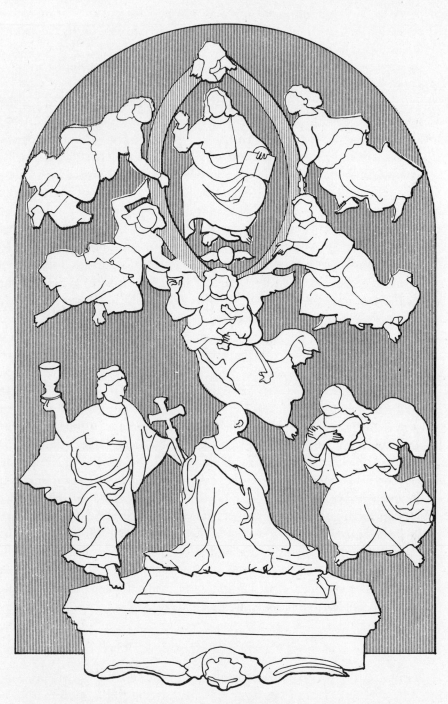

Figure 22. Verrocchio: Forteguerri Monument, commissioned 1473. *Pistoia, Duomo.*
Suggested schema of composition before Baroque modifications (after a photograph of the
terracotta relief in the Victoria and Albert Museum)

detail so much as the harsh vigour of the pose of the rider and the surging power of the steed beneath him that count. Though he did not live to see it cast, the work of art was nonetheless Verrocchio's in all essentials.

There remain for a brief consideration two important aspects of sculpture to which Verrocchio put his hand. The first is that of reliefs of the Madonna and Child which may be looked on as counterparts to his paintings on the same theme. One of these, in terracotta, survives in the original, from the Hospital of S. Maria Nuova and now in the Bargello. It seems to date from about 1475. A mysterious, but to all appearances very beautiful, earlier handling of the subject exists today only in stucco variants, of which the finest (I think) is the one now in the Oberlin Allen Memorial Museum.[16] Verrocchio was evidently also a gifted portraitist. The full-scale *modello* in clay of a bust of Giuliano de' Medici in the National Gallery of Art in Washington probably represents a commission that for one reason or another was never executed in final form; for if it had been a fulfilled Medici commission it surely would have appeared in the inventory of 1496. This work (Plate 115B) has a braggadoccio about it that already foreshadows the Colleoni; it seems to me superior to the portrait busts in marble of ladies attributed to him (one in the Bargello and the other in New York) which, if they are actually by Verrocchio, fail to offer a fitting programme for the expansive quality of his natural style.[17] The large number of doubtful or controversial attributions to Verrocchio would require space for discussion which is not available here. Two disputed terracottas may, it seems to me, be important late works by Verrocchio himself. One is the fragmentary *modello* of an Entombment formerly in the Kaiser Friedrich Museum in Berlin; it might just conceivably be connected with some commemorative monument commissioned by 'a doge' in Venice which Vasari called in error a 'tomb'. The other is a charming terracotta running Putto on a Globe in the National Gallery of Art in Washington, which is a much later handling of the same theme as that of the picturesque and early Boy with a Dolphin. It would seem to me to be designed as a fountain figure, and it is best explained as the *modello* for a bronze figure intended for the firmly documented fountain ordered by Matthias Corvinus of Hungary and for which marbles had already been ordered before Verrocchio died. A fountain shown in an idealized 'city-scape' of the Walters Art Gallery could well be an echo of Verrocchio's design, which was, as events turned out, never executed in final form.[18] In this connexion it is well to consider the probability that the five years spent in Venice could not all have been completely devoted to the model of the Colleoni.

Antonio and Piero del Pollaiuolo in Rome

The careers of Verrocchio and of his major rival Antonio del Pollaiuolo contained remarkable parallels. They both began in Florence as goldsmiths, and each was given in 1477 a relief to make in silver for the baptistery altar. They were both painters as well as sculptors. They both worked for the Medici, and they both appear to have left Florence at about the same moment, about 1483, to continue their work in environments more promising for great things in sculpture. Antonio del Pollaiuolo was

apparently very slightly the elder, having been born in 1431/2, according to the most reliable estimates. He was also a better and more dedicated painter than Verrocchio appears to have been. Though there is no evidence that he ever learned to carve marble, he was a truly great engraver and a master of the difficult art of the small-scale and intimate bronze statuette, fields which Verrocchio is not known to have entered.

The two documented programmes on which a sure knowledge of Antonio del Pollaiuolo as a mature sculptor must rest came to him relatively late in his career. The first was the elaborate and splendid monument of Sixtus IV now set up in the Grotte Vaticane under St Peter's in Rome, and the second the only slightly less successful monument of Innocent VIII, which was reassembled with an egregious, but historically fascinating, error in its design in the seventeenth century in the Baroque nave of St Peter's. These two monuments take a place at the highest level of Quattrocento tomb sculpture.[19] They fill the gap among the categories of monumental sculpture open to a late-fifteenth-century artist in which, as events worked out, Verrocchio had never found complete fulfilment in figure sculpture.

The moment when Antonio del Pollaiuolo first turned his hand to sculpture is not recorded and probably, in any case, could not now be isolated. From his early years as a goldsmith, as pointed out in Chapter 6, he had the power to turn a miniature figure in precious metal into monumental sculpture in everything but name (Plate 80B). His paintings reveal a remarkable and consistent tension between a quasi-Flemish appreciation of the minutiae of nature, the dynamism of landscape as early seen by Leonardo, and the acrobatics of violent movement in the human form developed from close study of Antique sarcophagi and from what almost certainly must have been among the early Renaissance forays into anatomical research.

The difficulties of arranging his work in acceptable chronological sequence are immense, particularly since he was always shifting from one medium to another, and firmly anchored dates for his work before he went to Rome are rare. He seems also to have had as a constant partner his younger brother Piero (1443-96); exactly where one left off and the other took on in their collaborations is seldom altogether evident. What does seem abundantly clear, however, is that of the two, Antonio was considered by his contemporaries immeasurably the greater. It was his *disegni* that mattered; and his drawings were sought after and treasured as studio-aids even before 1475 in leading humanistically-inclined centres, such as Padua. It was Antonio who was called by Lorenzo de' Medici in 1489 the 'leading master of the city [of Florence] . . .'. 'In the opinion of all knowledgeable people,' he went on to write, 'perhaps there never was a better.'[20]

The circumstances surrounding Antonio's call to Rome are not over clear to us today. Before 1480 he had provided a design for a liturgical embroidery to be used in Assisi which carried a portrait in profile of Sixtus IV as pope, kneeling before a standing St Francis. Given his apparently steady production in gold- and silverware, Antonio rather than Verrocchio would have been the logical choice for the maker of the Apostles to decorate the Sistine Chapel altar (see above, p. 173). Some years before his death, which occurred in 1484, Sixtus had given thought to his burial-place in St Peter's and

had begun the construction of a new chapel on the south side (Cappella del Coro, or of the Canonical Offices) which was to house his tomb, in a central position in front of the altar and surrounded by the stalls. The chapel and tomb programmes constituted a unit and would seem almost certainly to have been conceived together. A contemporary witness, finally, asserted that the funerary monument of Sixtus IV had taken ten years to complete. Since the monument is known to have been finished by 1492–3, it is quite possible that Antonio had come to Rome in connexion with its planning a year or two before 1484.[21]

The monument of Sixtus IV broke radically with that of his predecessor, Paul II. It was in the first place of bronze, rather than marble. And it followed, though with certain changes and elaborations, as will be pointed out, the type of recumbent image earlier established by the Lateran monument of Martin V in which Filarete and Michelozzo had had apparently a major part. A drawing and descriptive notes made by Grimaldi early in the seventeenth century reveal that the Sistine monument originally rested on a green marble base. The base of the earlier monument to Martin V was of white marble, and probably lower. The problem, artistically speaking, now hinged on the possibility of retaining the dramatic closeness and immediacy of effect produced by the effigy (which in the monument to Sixtus IV must have been almost shockingly close to the appearance of the lying-in-state of the pontiff's body just before burial) and at the same time of suggesting by form and imagery the more remote and more permanent values associated with his office and family. This double aim was achieved by keeping the effigy below eye-level and giving it a maximum of veristic detail (Plate 121). Around it were ranged images of the Theological and Cardinal Virtues in relief, a long inscription, and the arms of the pope and of his nephew Giuliano (later to become Julius II), who saw the work through to completion.[22] Then, on the surfaces of a sharply sloping intermediary zone between the marble base and the Virtues, were placed in sequence high reliefs with allegories of the Liberal Arts.

A first and continuing visual impact comes from the effigy. But the secondary symbolic material has a powerful appeal of its own. It is impossible to take in the whole monument in one glance. One must walk round it. This induced peripatetic approach was certainly part of the original scheme. For example, the figure of Charity, behind the head of the effigy, is upside down when considered in connexion with the effigy's face, and only by walking round so that one is behind the pope's head can it be 'read' right side up (with, incidentally, the inscription giving the artist's name and the date of completion facing in the same direction). Thus one makes a pilgrimage with lowered head round the equivalent of a bier, 'reading' the images of the 'arts' of the medieval and Early Renaissance curriculum with appropriate quotations culled from authorities revered by the scholastics painstakingly lettered on to the pages of open books shown in connexion with each figure.

The reliefs of the Liberal Arts constitute the most original part of the style of the monument. They are inspired from a wide range of Antique sources, and are of varying quality, betraying some collaboration, probably with Piero del Pollaiuolo, who could have come to Rome after 1483. The Theology seems to be among those nearest to

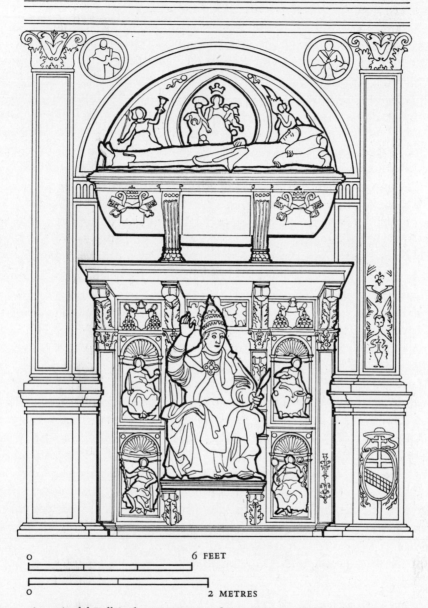

Figure 23. Antonio del Pollaiuolo: Monument of Pope Innocent VIII, 1492–8. *Rome, St Peter's.*
Schema of composition before Baroque modifications (after a photograph of a
sixteenth-century drawing, formerly(?) in Berlin)

Antonio's own personal style (Plate 119). On an irregular ground he has had to place a
recumbent figure with stage-properties of symbolic imagery in very plain evidence.
He has made the figure stretch to cover as much of the ground as possible, and he has
made it seem to be active without disturbing its recumbent pose. The problem of
achieving balance in action was that essentially of his well-known small-bronze group
of Hercules and Antaeus which was in the Medici household in Florence in the fifteenth

century (Plate 118B).[23] Here the stretch of limb and the exercise of tensile as much as of constricting forces provide a masculine counterpart to the female Theology in relief. The Hercules group was designed in such a way that from no point of view is it possible to see the head of either protagonist face-on; the interest shifts, as a consequence, to the action of the bodies. With its averted face, this is what seems to happen with the Theology; it is the languid gesture of reaching for an arrow, contrasted with the firm grasp on the bow, and the athletic litheness of a clean-limbed Antique Diana that come to the fore. In this way, as has been recently shown, the pre-Renaissance association of the Virgin, and thus the Church, with the moon-goddess found a reverberation in the taste of humanist Rome.[24]

The Virtues of the Sixtus monument were repeated almost attribute for attribute and form for form on the monument of Innocent VIII (designed and completed between 1492 and 1498). The original assemblage of the sculpture, all in bronze, was set up at the crossing in Old St Peter's immediately next to the marble Oratory of the Holy Lance which Innocent had commissioned shortly before his death. The relic had come to Rome late in his pontificate and is shown in the hand of the seated pope on his bronze monument, as a trophy of his ecclesiastical *virtù*.

Originally the positions of the seated figure and the recumbent effigy were reversed from what one sees today on a wall of the north aisle of the nave (see Figure 23). The seated pope 'in life' was originally brought down to the observer's own level, whereas the effigy 'in death' was raised high above, in front of the crowning lunette with its relief figures of the three Theological Virtues. This scheme of skying the effigy had a precedent in the marble monument of Pius II (which also commemorated the acquisition of a famous relic) in St Peter's itself, but the major prototype was probably the Coscia Monument by Donatello and Michelozzo in the Florentine baptistery (see again Plate 26). The double representation 'in life' and 'in death' was far from a novelty in Italian tomb-design. It had occurred, for example, in the fourteenth and early fifteenth centuries in the Angevin funerary monuments in Naples. But the emphasis on an active gesture and the impression of close immediacy undoubtedly did constitute a new departure. Michelangelo's bronze Julius II for Bologna may well have followed this pose, in its inception at least. It was still later used, as is well known, to impressive effect by such later Roman sculptors as Guglielmo della Porta and Lorenzo Bernini.

The Historical Problem of Leonardo da Vinci as a Sculptor

Consideration of the sculpture of Verrocchio and of Antonio del Pollaiuolo leads us towards the most baffling of the many problems posed by the history of Renaissance sculpture. That Leonardo da Vinci was capable of making sculpture and certainly began, even if he did not finish, a task of towering importance in the history of Italian sculpture in the fifteenth century there can be no doubt whatsoever. Nothing of that art that can be securely linked to his hand, however, has survived. We have numerous studies for sculpture and many pages written on the theory of sculpture in relation to painting, but of sculpture by Leonardo there is not a single documented extant piece,

or fragment of a documented piece, that can be identified. Our normal methodology of starting with the object and the document related to the object here has no application. The problem is further complicated because by temperament and artistic bent Leonardo was a painter first of all and only perhaps by curiosity or ambition was he a sculptor. When he described the aim of painting as the creation of 'relief' in chiaroscuro he was most likely following Alberti's well-known definition of painting, which did in 1435 have much more to do with sculpture than in Leonardo's time, or at least in Leonardo's own approach to painting. His obsessive interest in change, in flow, in atmospheric effects of distance and of smoky shade were in fact anti-sculptural in the sense in which the Quattrocento in general looked on sculpture. And yet, in some marbles by Desiderio there are more than hints of such a painterly attitude. The question still remains as to whether Leonardo, who was through his apprenticeship and early partnership with Verrocchio a *bottega* grandson of Desiderio, might not at various times in his long career have been drawn to a series of experiments in proto-Baroque or even proto-Impressionist sculptural expression. With such high stakes in view, the search continues for evidence of his own hand in (1) small-scale *modelli* or sketches in clay, or (2) solidifications of such work in small-scale bronzes, or (3) in collaboration with Verrocchio, or (4) as an independent master either in Florence or Milan. There are as yet no universally accepted positive results.[25]

This is not the place to consider the hypotheses that have been made with regard to specific works. We stand on firmer ground in examining briefly the basis for a more general evaluation of Leonardo's role in the development of Renaissance programmes and theory of sculpture. As a young practitioner he could have had experience both in marble-carving and in bronze-casting in Verrocchio's *bottega*. In his well-known letter of self-recommendation to Lodovico Sforza he specified that he could 'carry out sculpture in marble, bronze or clay', and he offered to make the equestrian monument 'to the immortal glory and eternal honour' of Francesco Sforza. The 'bronze horse' was in fact the major commission given him by Lodovico when he migrated to Milan in 1481. Studies in equine anatomy and technical sketches of methods of casting illustrate the *Notebooks*, and there is no doubt that along with his projected treatises on painting and human anatomy, or 'human movements', Leonardo had in mind a separate treatise on the anatomy of the horse, and doubtless was working on it rather than on his model for the finished statue. So dilatory was he that in 1489 Lodovico seems to have looked around for another sculptor. From this time probably date two drawings for an equestrian monument of Francesco Sforza by Antonio del Pollaiuolo (one in Munich and the other in the Lehman Collection, New York). With the few drawings by Leonardo that may be related certainly to the Sforza Monument, the Pollaiuolo drawings indicate that the type then under consideration for the Milanese equestrian statue was different from both Donatello's and Verrocchio's. The horse is shown as rearing, with forelegs in the air; beneath them, as a structural prop, was to be a semi-recumbent figure. In one of the Pollaiuolo drawings this figure was specified as an allegory of the city of Verona, Francesco Sforza's chief prize in his campaigns against the arch-enemy, Venice. The rearing horse for Milan seems to have originated in the illustration for

Filarete's architectural treatise which preceded Leonardo's Milanese sojourn by at least two decades (Plate 120A). A second phase in the evolution of the design reverted to the type of walking horse of the famous Antique Regisole of Pavia, close to Milan, the site of the Certosa begun by the Visconti whom the Sforza had supplanted. The ambivalence in Leonardo's (or perhaps the Milanese) mind with regard to walking and rearing types continued in his closely related studies of the early sixteenth century for the Trivulzio Monument, also for Milan (Plate 120B).[26]

Leonardo's Sforza Monument was to have been almost precisely twice the height of Donatello's Gattamelata. The colossal scale was an indication not only of technical *hubris* but of stylistic change. Donatello's respect for a humanist scale linked him to the earlier part of the century. The problems of casting the enormous Sforza group would alone have placed the whole project in some doubt. It is known that Leonardo got as far as the completion of the clay *modello* of the horse, which stood for several years in the courtyard of the Castello Sforzesco. There is no evidence that it was ever cast, or that the full-scale modelling of the rider was ever begun.

In his *Paragone*, or comparison of the arts, Leonardo poured out his frustrations as a sculptor. He saw the art, as opposed to painting, a prisoner to the physical conditions of actual light and of course of actual space. It did have, however, in his view the advantage over the 'freer' or 'more liberal' art of painting in that several views of a given figure or object could be presented in one and the same figure. The mirror back and front views of figures in action in Pollaiuolo's Martyrdom of St Sebastian and in the engraving known as the Battle of Naked Men probably represent a Quattrocento comment on the relative merits of painting and sculpture in this respect. In artistic theory it is possible to trace repercussions of this particular point in the comparison of the two arts through the European academies right up to Cubist painting. Whether or not Leonardo might have been able to start a 'painterly' approach to sculpture is not a subject which yields much at this juncture of our knowledge. But it is conceivable that, in reaction against his views, Michelangelo's early 'sculptural' kind of painting was given additional impetus.

Activism and Realism North of Florence: the Current of Niccolò dell'Arca and of Mazzoni

In or about the year 1463 an itinerant sculptor who signed himself Nicola d'Apulia arrived in Bologna. The self-styled likeness in name to the great medieval Nicola (Pisano), who had also worked in Apulia, was certainly not accidental. The marble shrine of St Dominic, known as the Arca di S. Domenico, which had been carved in the shape of a reliquary-sarcophagus by Nicola Pisano and his team of assistants was in need of modernizing. An upper structure of marble with free-standing figures and a new base with reliefs, also in marble, were specified and finally commissioned in 1469 to the newcomer, who thereafter was generally known as Niccolò dell'Arca.

The new crown for the shrine was intended to carry an impressive quantity of free-standing sculpture (Plate 122). At the summit of an elaborate pinnacle was placed the

powerful figure of God the Father. Then, at each corner of the upper level, were placed the standing figures of the Evangelists. Two angels adore the Christ of the Pietà on the front of the monument, and a Resurrection was planned but never executed for the rear. At the lowest level, standing on cleverly conceived scrolls, are eight saints, four of whom are local protectors. In addition to the Resurrection, Niccolò failed to carve three figures: a St Vincent later changed to a St Proculus, a St Petronius (which he had apparently begun), and a Kneeling Angel. These figures were to be completed soon after his death, which came in 1494, by the young Michelangelo (see below, p. 214).

Though slight in scale – the figures are hardly more than statuettes – this sculpture is carved with the confidence and non-niggling finish of the more usual human-scaled figure style of the time. They project a sense of large size and dramatic importance quite incommensurate with their measurements. Where Niccolò was trained, and indeed what exactly was his origin, cannot be established. There can be no question, however, as to his extraordinary talent and difficult temperament. Contemporary sources speak of him as if he were not altogether sane, using adjectives to describe him like 'fantasticus', 'barbarus moribus', 'agrestis'. 'He withdrew from everyone' (*omnes a se abiecit*) and he was 'stubborn in the extreme' (*caput durum habens*).[27] It is usually thought today that he did not work on the marble figures for the Arca much beyond 1473 – at the outside, beyond 1478. In that year was put up his huge signed and dated Madonna della Piazza on a façade adjacent to that of S. Petronio. The drapery is in fact bolder than anything on the Arca, and the Child has echoes of the vigour of modelling of Verrocchio. Verrocchio's influence might have been brought to Bologna by Francesco di Simone at just this time. But there was not much that Verrocchio himself could have supplied to enliven further the figures that Niccolò's vivid and personal sense of form had evolved (Plates 123, A and B, and 124A).

Something of Jacopo della Quercia subsists in Niccolò's marble style, but the principal elements of design, particularly in the heavy drapery, seem also to recall French or Burgundian practice of the mid fifteenth century. He may conceivably have gone to France before settling in Bologna, but this hypothesis still awaits confirmation. Strikingly Italian, in any event, is his major work in terracotta: the Bewailing of Christ in the Bolognese church of S. Maria della Vita (Plate 126). A close relationship between his marble style and modelling style is ascertainable (Plate 124).

The Lamentation has lost its original polychromy in considerable part, and the exact placement of the figures remains a puzzle. The large group has been moved at least three times since it was first installed in S. Maria della Vita, which in Niccolò dell'Arca's day was a hospital-church. Two modern restorations have removed overpaint and repairs. Missing may be the figure of Joseph of Arimathaea, which is supposed to have represented a member of the Bentivoglio family (presumably destroyed in an anti-Bentivoglio uprising). The kneeling Nicodemus on the left has been traditionally called a self-portrait of the artist, who may well have presented the group, or a portion of its expense, as an *ex voto* to the hospital. The age of the Nicodemus as represented is part of the evidence that this Lamentation dates from about 1485 rather than from 1463, as a citation from a later document has asserted. The style of the grieving figures is so

advanced in its freedom and intensity of expression that the later date has appeared virtually mandatory (Plate 125). This, however, is a conclusion based on scholarship now twenty years old and may be open to revision after renewed examination of both the documentary and the stylistic evidence. There is still a possibility that the group belongs to the 1460s rather than the 1480s.

The Lamentation of S. Maria della Vita relates to a series of ultra-realistically conceived groups in terracotta in the area just to the north of Bologna which started at the earliest only in 1473. The principal artist concerned with these groups, always in painted terracotta and invariably on the subject of the Nativity or of the Bewailing of the Body of the Saviour, was Guido Mazzoni, born at Modena. The generally accepted list of his fairly sizeable production in this realistically dramatic genre is given below. It shows that his work was in demand not only at Modena but at Ferrara, Venice, and Naples. From Naples, in 1495, he went to France in the train of the conquering Charles VIII and was employed as sculptor of that king's monument in St Denis (destroyed in 1793).

The realism of Mazzoni was based on the acceptance of life-casts or death-casts as raw material for art. Vasari's biography of Verrocchio, vague enough in other respects, must be respected in its circumstantial description of studio properties that included life-casts not just of faces but of hands, feet, legs, and even torsos. The use of life-casts

SUBJECT	PLACE	DATE
1. Nativity	Busseto, S. Francesco (all but completely lost)	c. 1473
2. Lamentation	Busseto, S. Francesco	c. 1475
3. Lamentation	Modena, originally for the Ospedale della Morte, now in S. Giovanni della Buona Morte	1477–80
4. Nativity	Modena, originally for the Osservanza, now in Duomo crypt	c. 1480–5
5. Lamentation	Cremona, S. Lorenzo (lost)	c. 1480–5
6. Lamentation	Ferrara, S. Maria della Rosa	1485
7. Lamentation	Venice, for S. Antonio di Castello (fragments extant now in Padua, Museo)	1485–9
8. Lamentation	Naples, S. Anna dei Lombardi (re-arranged)	1492

Table 9. Terracotta Groups by Guido Mazzoni in Italy (after Venturi)

in wax for *ex-voto* images, clothed in real clothes, was frequent enough to cause overcrowding in the areas around sacred images or in places believed to possess particular sanctity (see Introduction, p. 6). Death-masks for tomb-sculpture were certainly used during most of the Quattrocento;[28] what Mazzoni accomplished was to move the effect of absolute likeness into the realm of the illusion of life.

There is to be found in his Nativity or Lamentation groups a definite development. Towards the beginning of the series they have a marked dependence on life-casts for hands and faces, and they even use glass in the representation of the eyes (Plate 128A). Later, a freer parallel to the mask, with greater emphasis on emotional expression, was evolved (Plate 127). How much all of these veristic groups depended on Mazzoni's personal leadership is not clear. It seems probable that other masters were also active in the genre before 1500. One of them seems to have been responsible for the much over-

painted but compelling Bewailing now in the oratory of S. Giovanni at Reggio Emilia (Plate 128B). Important groups in painted terracotta of about 1490 included one by Vicenzo Onofrio at Bologna and, in a more lyrical style and rhythmic composition, the group attributed to the Sienese Giacomo Cozzarelli in the Osservanza in Siena (Plate 129). The genre continued into the sixteenth century, but with inevitably lessening impact on the mainstream of sculpture in Italy. Michelangelo's famous words before a painted terracotta group by Begarelli in Bologna were to the point: 'If this clay were to become marble, woe to the statuary of the Ancients.' But in 1490 as in 1530, the prestige of the Ancients in Northern Italy was hardly in danger. Nonetheless the influence of the painted realistic genre, whether in clay or wood, was soon to lead to a vigorous development outside Italy, particularly in Spain; ensembles conceived as early as 1490, such as the remarkable North Italian 'Holy Mountains' with life-like re-enactments of the Life and Passion of Christ (see especially the one at Varallo in Piedmont), provided a vital intermediary step.

INTERMEZZO: NORTHERN ITALY, 1465–1500

POLITICAL independence and vast wealth ensured for the republics of Genoa and Venice and for the duchy of Milan equally independent artistic development throughout the second half of the fifteenth century. Through trade, Northern Italy remained in constant touch with Europe as a whole. Channels of artistic communication were more than ever open to Tuscany, Central Italy, Naples, and Sicily. Debts to the exterior must certainly be acknowledged, but the balance of artistic exchange from the Lombard point of view was favourable. As mediators between Late Gothic Europe and humanist Italy, Milan and Venice lost none of their hard-won individuality. As catalysts, they preserved intact their own identities.

Patronage of sculpture in Lombardy and Venice, as in the earlier decades of the fifteenth century, remained fairly well concentrated in the hands of the rulers or of their deputies. Thus in Venice the major commissions depended upon decisions of the doges and the chief families who supplied the doges to the state. In Milan and Pavia it was the succession of Sforza dukes coming to power in 1450 that provided the impetus, controlled the destiny of family-dynasties of sculptors, and set the example for patronage, at times princely and at other times ecclesiastical, in such centres as Como, Cremona, and Bergamo.

Both in Venice and Lombardy there was an extraordinarily large financial reservoir for the huge costs that ceremonial sculpture of the period entailed. From the written sources it would seem that few European courts in any period were able to sustain so heady a mixture of intellectual refinement and conspicuously wasteful luxury as that of Lodovico il Moro, the last of the Sforza dukes. The Castello at Pavia already contained a 'hall of mirrors', and he was able to employ as decorator of two impressive rooms in the Castello in Milan no less a wall-painter than Leonardo da Vinci. 'Hands into which ducats and precious stones fall like snow': these words were chosen by Leonardo to describe his own relation to the court in Milan. He once jotted down, as an idea for a *tableau vivant*: 'Poverty in a hideous form running behind a youth; Il Moro covers him with the skirt of his robe and with his golden sceptre he threatens the monster. . . .'.

Most of the art which reflected directly such an environment of courtly expenditure was ephemeral. It consisted of dress, or of pageant-scenery, or of jewellery, or of delicate *objets de vertu* rather than of concretions, however vague, of *virtù* in the sense of the word the older Florentines had known and understood. Except for a small percentage of highly prized pieces, this luxury art has not survived. Goldsmith-work was the chief art of the Milanese court. Gem-intaglios, engraved crystals, enamels had the status of major pictorial art on a par with painting. In harmony with this trend in Lombardy, even monumental sculpture tended steadily to become more delicate in scale, more exquisite

in technique (Plate 130). Where before local marbles from Gandoglie or Lugano had sufficed, only the purest and whitest Carrara marbles were considered fit for Milanese chisels. These marbles were imported in quantity and at fantastic expense over lengthy and complicated water routes. Where terracotta had been used with frequency in Lombard cities without easy access to good stone, it continued to be used, at Cremona for example, with ornamental motifs of the highest refinement in imitation of work in precious or semi-precious metals.

In Padua, Venice, Mantua, and presumably Milan also, small-scale statuary and small-scale reliefs or plaquettes in bronze, beautifully chased and sometimes enriched with details gilt or inlaid in precious metals, became increasingly the mode. In this way an elegant private taste in art found expression at first for a limited audience, but soon won as converts most of the remainder of Europe, from Seville to Moscow. The defeat of the Milanese troops and capture of the duke himself by the French under Louis XII in 1500, far from marking the end of a brilliant epoch, actually served as a means of artistic survival and more rapid propagation; the military victors in matters of artistic taste willingly submitted to the vanquished. To this day in France, Spain, Austria, and England the Renaissance in its various national manifestations is still tacitly assumed as post-dating the fructifying campaigns of 1498–1500 in the valley of the Po. It has indeed long been evident that the art of Milan and Pavia was a most logical meeting place for interchange between the shifting currents of courtly European style in sculpture and architecture at the end of the Quattrocento. In his two sojourns in Venice, bracketing the turn of the century, Dürer was to find somewhat the same kind of bridge between his northern traditions and the Italian Renaissance in painting.

The Lombard Workshops of Milan and Pavia: A First Phase, to 1485

A revival of sculpture in Lombardy came concurrently with a revival in architecture, for much the same reasons but with differing results. In 1451, within a year of his accession to the dukedom, Francesco Sforza persuaded the architect–sculptor–goldsmith Antonio Filarete to come into his employ; and in the same year he asked for a survey of the state of construction at the largest single Visconti monument he had inherited – the Certosa at Pavia. Filarete's services were retained solely as an architect until 1465, though, as we shall have to surmise on a later page, his influence on the types and uses of sculpture within architectural settings cannot be discounted.

In 1461, in order to eliminate inertia and inefficiency ('propter multa inconvenienta et scandalia gravia'), the duke personally took over both the administration of the finances and the direction of the building committee (Fabbrica) of the Certosa in Pavia. In 1462 Guiniforte Solari, in the footsteps of his architect father, was made 'ingegnere generale' for the Certosa, and an extensive campaign of sculpture, the first actually at the priory, was begun.[1]

Much more than the Duomo in Milan, the Certosa at Pavia provided the starting point for subsequent developments. The general framework for sculpture at the cathedral in Milan had been settled before 1400. Whereas literally hundreds of statues

were still waiting to be carved, their design and execution provided in actuality even slighter challenge. Relatively few statues were carved, and, once finished, their very location, high up on the piers in the dark interior or even higher up on the buttresses and *guglie* of the exterior, tended to remove them from visual efficacy. The situation at the Certosa was reversed. Though the programme of the monastic cloisters, the church, the refectory, etc., was ultra-traditional, there was in the courtly, luxury-loving monastery a unique opportunity for extensive and elaborate sculptural expression to be seen and savoured. Work began with many marble capitals and all the revetment in terracotta of the arcades of the two cloisters (Plate 132A). By 1466 the terracotta reliefs of the lavabo of the minor cloister were ready for part gilding. In a similar style, but more elaborately contrived, is the neighbouring portal from the minor cloister into the church. This portal shares with a small relief of a Madonna with Angels, which has found its way to the sacristy of the Misericordia in Florence, the earliest signature of the dominant figure in Lombard sculpture of the second half of the Quattrocento, Giovanni Antonio Amadeo.[2]

He was born in Pavia. In 1466, when his brother Protasio was paid to add gilding to what may have been his first known work, Amadeo was only nineteen years of age. His training is not known. Current opinion favours the theory that he was formed in Lombardy, and that his early style, rounded and rather simple in its direct plasticity, emerged from lingering traditions within the Milanese area (see Plate 43A), thus effectively by-passing the gratuitous older theory that he must have been formed as an artist by contact with Florence. If there is a hint of Florentine flavour in his early style, it is possible that it may have come through contact with Filarete, who up to 1465 was still on the ducal rolls. The evidence of the terracotta panels for the arcades of the minor cloister, in the design of which Amadeo must have had an important part in collaboration with a certain Rinaldo de'Stauris (see again Plate 132A), shows a concept of a mixed style in which motifs of ornament and putti *all'antica* are mingled adroitly with elements of Gothic form (in Filarete's vocabulary, Gothic is *alla moderna*). The use of terracotta is traditionally Lombard, however, and probably reflects the ideas of Guiniforte Solari, who also supervised the related terracotta decoration of the windows of the second storey of the Ospedale Maggiore in Milan after Filarete's departure.

The grandiloquent and fanciful tone of the passages on sculpture in Filarete's treatise on architecture, which he wrote while in the duke's service, brought in quite a different relationship of sculpture to architecture than that of the theoretician–sculptor–painter–architect Francesco di Giorgio; Filarete imagined a much freer, less mathematical relation of the human figure to an architectural environment (Figure 24). That freedom came closest to actuality in the Colleoni burial chapel attached to the transept of S. Maria Maggiore in Bergamo. Here, in the decade 1470 to 1480, Amadeo had the opportunity to prove himself as an architect as well as a sculptor.[3] The front combined a Romanesque geometric pattern of white and coloured marbles, on the order of the façade of S. Francesco at Pavia, with an exuberant intermingling of marble statues of Virtues, busts of Caesar and Trajan, heavy Hadrianic *rinceaux* as in Filarete's doors for St Peter's in Rome (Plate 54A), roundel-reliefs of Roman emperors alternating with

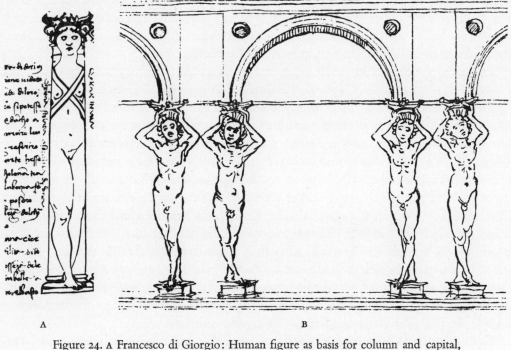

A B

Figure 24. A Francesco di Giorgio: Human figure as basis for column and capital,
from Turin MS. of his *Trattato*
B Filarete: Project using sculptural figures in lieu of columns and capitals,
from Florence MS. of his *Trattato*

lozenge-shaped reliefs of the saints, and rectangular reliefs of the Genesis story on the
plinth balanced by reliefs of the legendary deeds of Hercules. The romantic revival of
Antiquity at Bergamo, so unlike that of Brunelleschi's light-filled yet sober Pazzi
Chapel, to which Amadeo's Colleoni Chapel offers the most obvious North Italian
parallel, was constantly involved with the picturesque.

The tomb of Colleoni, who died in 1475 (see above, p. 176), was put together on the
Trecento model of Bonino da Campione's monument of Bernabò Visconti in Milan,
with elements carved by Amadeo and at least two assistants. Plate 131A presents a relief
on the Colleoni Tomb in Bergamo which seems to be only in part by Giovanni
Antonio's own hand, but it shows as clearly as any example the trend of his influential
style about 1475. The composition of this Road to Calvary is organized in its central
area completely round the directional thrusts and angles of the Cross. On the left, the
faces of the crowd look towards us; on the extreme right, the back of one of the two
thieves is turned against us; in this way the sense of an irregular processional movement
across the stage-like foreground is vividly presented. The figures in the foreground are
in very high relief. The background, as in the contemporary relief style in Rome, is
given a much lower relief, but with a minimum of diminution either in detail or action.
Somewhat the same system was used by Giovanni Dalmata's followers in Rome (Plate
97), and there is a curiously insistent reminiscence of the spatial organization of Uccello's
Medici Battle Scenes. The most striking aspect of the relief, however, is internal. This

is the contrast in style between the flowing, closely joined figures following Christ on the observer's left and the angular, detached figures preceding Him. The change in style can be explained only in part, and at that rather weakly, by the subject matter. There seems to be here a reflection of a new stylistic principle.

This new principle is to be found in the work of Amadeo's contemporaries at the Certosa, the brothers Cristoforo and Antonio Mantegazza. The two artists present a strikingly parallel case to that of the dalle Masegne brothers at the end of the Trecento. Their beginnings are mysterious, and a clear distinction between their personal styles is still undecided, particularly as regards the elder, Cristoforo. It is certain that they were Milanese, as a ducal document asserts in the phrase, 'sculptori subtilissimi e nostri carissimi cittadini milanesi'. Previous to the appearance of Cristoforo in 1464 as a member of the *équipe* working on the terracottas of the major cloister of the Certosa, their training must have been in the Milan Cathedral workshops, and a powerful, rather eccentric statue of St Paul the Hermit, made presumably between 1460 and 1470 for a position on a window of the north transept, has been attributed to Cristoforo.[4] In 1473 work began in earnest on the sculpture of the Certosa façade, and was at first entrusted entirely to Cristoforo and his brother. Amadeo, although busy with his Colleoni commission in Bergamo, but the son-in-law by then of Guiniforte Solari, the architect in charge, was in 1474 given one half of the façade sculpture.

There is no way of knowing exactly of what the programme of sculpture of 1473 consisted. Probably Filarete's influence encouraged retention of a façade design with relatively little sculpture, as in the Ospedale Maggiore of Milan, except for a series of historiated reliefs on the plinth, as at Bergamo; a fresco by Bergognone in the transept of the Certosa shows what must be a pre-1473 model of the church with a façade of that type. It is not certain either what Cristoforo and his brother actually accomplished for this first version of the façade, and when exactly they did it. Records exist for payments to them in 1476 and 1478 for work done at the Certosa other than on the façade. Possibly rather on the late side then, after 1480 and perhaps after Cristoforo's death in 1482, are to be dated eleven surviving reliefs from a remarkable series of Genesis *istorie* parallel to the series already noted at the base of the façade of the Colleoni Chapel at Bergamo. Whether by Cristoforo or not, they betray the vigorous originality and powerful vitality of what is felt to be the older brother's manner.

In the Expulsion from Paradise (Plate 131B), a hugely scaled combined figure of Christ and God the Father, rather than the usual Angel, forces out of a dimly-sensed Eden the sinning Adam and Eve. The tensions of emotion are expressed in the crackling drapery of the Almighty and in the taut muscles of Adam's back, while Eve, withdrawn into her own thoughts and in a consciously conventionalized pose, is caught half awkwardly, half gracefully between movement and arrest of movement. She is a touching Renaissance foreshadowing of a Degas ballet-dancer. The figures completely dominate their space, and in this respect differ from Amadeo's, which are in balance with landscape or architectural environment. Where Amadeo had stressed rounded forms, the Mantegazza concentrated on angularities. They broke wherever possible the axis of a torso or of arms and legs, giving the drapery-forms sudden and surprising turns

of direction, twisting abruptly the view of body and head from profile to full front or full back, extending the pose in all possible directions so that the figures stretch to spreadeagle a maximum of the shallow space allowed them by the rectangular frame. The calculated violence of this Quattrocento Expressionism *avant la lettre* is impressive; it was almost exactly contemporary with Niccolò dell'Arca in Bologna.

In the 1480s the Mantegazza expressionist style captured for a while Amadeo himself, and its influence is the dominant feature of the reliefs of the Shrine of the Persian Martyrs signed by Amadeo in 1482 for S. Lorenzo in Cremona.[5] It deeply affected lesser Lombard masters like the Cazzaniga family in Milan and the Rodari brothers in Como, and remained a powerful influence at the Certosa itself until 1495, the date of Antonio Mantegazza's death. It is present as late as 1498 in parts of the Shrine of S. Lanfranco at Pavia by Amadeo and his shop (Plate 134).[6]

The Lombard Workshops of Milan and Pavia: A Second Phase, to 1500; the Gaggini in Genoa and Sicily

The extent of stylistic change between approximately 1465 and 1485 in Lombardy may be judged by a comparison of the arcades of the Certosa cloisters and the terracotta frieze of the baptistery of S. Satiro in Milan (Plate 132, A and B). The sculptor of the S. Satiro frieze was for a time erroneously taken to be the goldsmith–medallist Caradosso. He is now recognized as Agostino Fondulo of Crema, the author of a naturalistically painted terracotta Lamentation, dated 1483, in the main body of the same church of S. Satiro.[7] Fondulo was a major exponent in Lombardy of the technique of clay-modelling. From wreath-frames in his S. Satiro frieze appear realistic busts of men and women, apparently modelled from life-masks, but given a classicizing air, as if they were *imagines clipeatae*. On either side putti play games or musical instruments and betray a knowledge not only of Donatello's reliefs in the Santo in Padua but also of Luca della Robbia's Florentine Cantoria (see again Plate 38B). Thus, by the mid 1480s, Tuscan influences were at work in Lombardy, and the earlier, rather frenetic revival of Antiquity, as at Bergamo, had begun to calm down and approach a more classical expression. In the Duomo workshops in Milan and at the Certosa a new phase opened about 1490 with a new cast of sculptors belonging to a new generation.

An important clue to these developments in the north was the calling of a sculptor from Rome: Gian Cristoforo, as he was called in Lombardy, Romano. The movement which had brought Lombard sculptors such as Andrea Bregno to Rome was now reversed. The graceful Roman style of the ciborium of Innocent VIII, with its delicate, though rather dry, emotional detachment, was brought to Milan and Pavia by Gian Cristoforo and soon had as a convert Benedetto Briosco. Benedetto's background prior to 1491 was in the shops of Milan Cathedral. A St Agnes now in the Museo del Duomo, dated as finished in 1491 in the cathedral documents, reveals a mood of quiet and *gentilezza* expressed in attractive, brittle elegance (Plate 133). Briosco collaborated with Gian Cristoforo on the monument of Gian Galeazzo Visconti in the church of the Certosa at Pavia and with Amadeo on the main, central relief of the Shrine of S.

Lanfranco already mentioned; there the contrast with the remainders of the Mantegazza style is a striking one.[8]

The new trend is evident in the façade of the Certosa (see again Plate 130). In 1490 the Solari grip on the design was broken when Pietro Antonio was called to work on the Kremlin in Moscow. In 1491 Lodovico il Moro sent an agent to the Certosa to review the financing of the building and the contracts of the sculptors. This is most probably the *terminus post* for the sculpture and design of the façade as finally executed up to the first arcade.[9] This version of the façade was much richer in colouristic effects and far more complex in detail than the earlier one attributable to the Solari. The shift-over in 1491 evidently placed Amadeo in the saddle, though up to 1495 Antonio Mantegazza remained, as the documents state, as a *compagno* to him. To Amadeo's direct influence should therefore be ascribed not only the roundels of Antique emperors of the plinth (including a version in marble of the Constantine of the famous pair of medals which once belonged to the duc de Berry), but probably also the vertical reliefs of Old and New Testament *istorie* and the designs of the seated prophets. The Apostles of the four buttresses were on the other hand apparently the responsibility of Antonio Mantegazza. The earlier discarded Mantegazza reliefs of subjects from Genesis were finally inserted in the mid-Cinquecento upper portions.

Among the many sculptors brought in after 1491 most prominent were a cousin of the Mantegazza, Antonio della Porta (called Il Tamagnino), from either Porlezza or Saronno, and his nephew Pace (or Pasio) Gaggini.[10] These are names we shall meet shortly in connexion with sculpture in Genoa. On 3 May 1497 the church of the Certosa was consecrated; the façade up to the first arcade, without the portal, was more or less complete, except for a fair amount of semi-independent statuary. It seems likely that work was pushed very hard, at Lodovico il Moro's insistence, in order to fulfil within the centennial the original vow of the Visconti founder to construct the Certosa, which had been begun in 1397. To Lodovico, who was not yet duke of Milan in 1491, but duke of Bari, this pious duty, like his marriage to Beatrice d'Este in the same year, may have had the value of forwarding the legitimacy of his claim to the Milanese dukedom.

In 1499 Amadeo resigned from the directorship of the sculpture of the Certosa façade and became chief architect of Milan Cathedral. He left in charge of the Certosa portal, already begun before his departure, Benedetto Briosco, who was confirmed as sculptor-in-chief in 1501. Briosco's charmingly conceived and adroitly executed reliefs of the portal made a bridge between the Quattrocento and the first quarter of the Cinquecento in Lombardy, the age of Fusina and Bambaia.

The sculpture of the Certosa façade played between the polarities of a romantically orientated classicism and an elegant naturalism. It would seem that Amadeo's elastic concept of style was moving in the 1490s towards the classical pole. Attributed to him are two roundel reliefs in the National Gallery of Art in Washington, with which a third which has come to rest in the Louvre may be associated. That representing Lodovico il Moro (Plate 135A) appears from the inscription to antedate 1494. It would thus be approximately contemporary with the Sforza additions to the interior portals in the

transept of the Certosa church, to which Briosco's name has been tentatively attached. The influence, if not the hand, of Briosco is apparent in the clarity and delicacy of the National Gallery relief; it provides an illustration of the high quality and finesse of the marble style of the ducal shops of the 1490s, which here translate into a monumental expression a design which could have come from a medal by Caradosso.[11]

The other aspect of the Certosa sculpture of the 1490s, that of an elegant naturalism, is best illustrated by the effigies of Beatrice d'Este and Lodovico il Moro now in the Certosa, having been removed there from their original resting place in the Sforza church of S. Maria della Grazie in Milan (Plate 135B). These two recumbent figures are all that remain from an elaborate monument, broken up in 1564, which incorporated at ground level an impressive and apparently ultra-realistic image of Christ in the tomb.[12]

1. FIRST BRANCH:

Giovanni (active as an architect in Milan and Pavia after 1428-c. 1470)

Guiniforte (architect at Pavia, b. 1429-d. 1481) Francesco (sculptor, mentioned 1464-71)

Pietro Antonio (architect and sculptor active A daughter (married Giovanni Antonio
in Lombardy from before 1481 to 1490) Amadeo)

2. SECOND BRANCH:

Bartolo

Cristoforo, Il Gobbo (sculptor and architect, Andrea (painter, b. 1460-d. 1515)
active c. 1480-c. 1525; d. 1527)

Table 10. The Dynasty of the Solari

The sculptor was Cristoforo Solari, called Il Gobbo ('the hunchback'), a member of the prolific artistic dynasty of the Milanese area, as shown in the adjacent chart. He was brought in by Lodovico Sforza as Antonio Mantegazza's successor at the Certosa in 1495. The untimely death in 1497 of the Duchess Beatrice diverted Solari from the work on the façade to the effigy of the duchess, for which there survives the contract of 14 September 1497. To this commission the one for the duke's effigy must have been added very soon after. Solari had been in Venice in 1489: but the style of the Sforza effigies is not properly speaking Venetian. It belongs instead to an international movement of extreme realism and polished detail that culminated in Meit's monuments in the transalpine church of Brou in the Franche Comté. In 1501 Cristoforo Solari was attached to the Duomo workshops in Milan, where his inherent eclecticism was immediately reflected in a softened and pseudo-Leonardesque classicistic style which

could hardly be more opposed to that of the effigies now in the Certosa. The contrast between Late Quattrocento and Early Cinquecento styles was thus in this case expressed with unusual clarity.

Lombard masters played the major role in Genoa from 1450 to 1500. The lengthy Gaggini dynasty of sculptors, originating at Bissone in connexion with marble quarried in that neighbourhood, dominated the field in Genoa, beginning with Domenico, whose name has cropped up in an earlier chapter dealing with the Arch of Alfonso of Aragon in Naples. There is reliable evidence that Domenico had more than a passing contact with Florence in his training. Filarete wrote of him in his *Trattato* as a 'pupil' of Brunelleschi. In 1446, after the death of Brunelleschi, he seems to have returned to North Italy, and in 1448 was given the commission for the marble entrance-screen of the baptismal chapel of the cathedral in Genoa. In the execution he had assistance, notably from his kinsman Elia Gaggini, the presence of whose flattened, rather wooden relief style has often been pointed out in the literature (for example the *istoria* of the Preaching of the Baptist shown on Plate 136A).

Domenico Gaggini during his Florentine sojourn was inevitably impressed by Ghiberti (figures of Prophets and a more elaborate relief style reminiscent of the second baptistery doors) and apparently also by Brunelleschi's protégé Buggiano. His marble style derives from the latter, but with personal transformations. The Genoa Angel of the Annunciation (also shown on Plate 136A) is carved with a remarkable feeling for lightness and movement which can be picked up in his marching Musicians in the Naples Arch of 1455–8 (Plate 69). With the break-up of the Naples royal workshop in 1458, Domenico went to Sicily, where he struck root for the rest of his rather long career.[13]

While active in Palermo during Laurana's stay there, his style so closely approximated that of Laurana that there is still some problem in sorting out attributions of several portrait busts (now in the Museo Nazionale, Palermo), reliefs on holy-water stoups (cathedral, Palermo), and at least one tomb (cloister of S. Francesco, Palermo). A long series of standing Madonnas by Domenico in Palermo, Messina, and Siracusa are a parallel to Laurana's Sicilian Madonnas; but they are endowed with greater vivacity. His gifted son, Antonello, carried on his tradition through the closing decade of the Quattrocento into the next century (Plate 137A). Antonello's evident search for an ideal beauty was related to the classicizing trend already observed in Lombardy at the same time. It seems probable also, as the example chosen here for illustration suggests, that Antonello and his immediate circle were influenced by Benedetto da Majano's late work in Naples (see again Plate 107).

Patronage of sculpture in Sicily from 1475 to 1500 was primarily ecclesiastical, except for that exercised by certain noble families such as the Mastrantonio or Speciale in Palermo. The result, quite unlike the pattern of development in North Italy, was in general the diffusion of a single style over the extensive coastal area of the island, with no dominant focus of development such as that provided by the ducal workshops in Lombardy. The core of the Sicilian Late Quattrocento style was that brought from the mainland of the peninsula by Domenico Gaggini.[14] Aragonese imports were seemingly

minor. The surprisingly large amount of surviving Quattrocento work in Sicily that is scattered through a very considerable number of churches and some local museums still calls for thorough study. The expansion of the Gagginesque style as shown in a monument for a small centre west of Palermo and dated 1485 by inscription, shows three trends together: (1) the stolid, literal style of the effigy, (2) the vitality of movement which enlivens the Ecce Homo relief of the sarcophagus flanked by (3) ornamental motifs and armorial bearings still infused with a Late Gothic feeling for luxuriant yet precise organic plant-motifs (Plate 137B).

In Genoa after the exodus of Domenico and Elia Gaggini, there was no large central programme. The chief monuments of sculpture were many doorways, some elaborately contrived as in the Certosa of Pavia or the Duomo at Como, but mostly characteristically centred on carved lintels only.[15] The most frequent subject matter inherited from a transposition presumably by Domenico Gaggini of Donatello's famous Or San Michele relief was that of St George and the Dragon (Plate 136B). Local slate as well as imported marble were used as materials. A certain brilliance and precision of surface detail is apparent. The return of Pace Gaggini and Antonio della Porta from the Certosa of Pavia after 1501 infused new life into the Genoese workshops and brought about in the Raoul de Lannoy Monument, set up at Folleville in France, a noteworthy export of the Italian style to the north before 1510.

Venetian Monumental Sculpture, 1465-1500: the Lombardi and Antonio Rizzo

Venetian sculpture of the second half of the fifteenth century moved forward at a steady and majestic tempo from the positions established about 1450 by Bartolommeo Buon at the Scuola di S. Marco (Plate 45B) and by his younger collaborator, Antonio Bregno, on the Porta della Carta of the Palazzo Ducale. The power and the glory of the *Serenissima* in the golden period of Giovanni Bellini and Carpaccio is reflected even more impressively in sculpture than in painting and yields little in this respect to architecture, whose aims it often shared. It would be futile to look in sculpture for the kind of warmth and lyricism that the colour of Bellini sustained. But the Bellinesque interpretation of human dignity and sense of restrained pathos could, and did, find expression in an unbroken series of sculptural monuments of superlative quality, as suggested by the chart on p. 198.

The first of these monuments was the tomb, generally conceded to be by Bregno's own hand, of Doge Francesco Foscari. A detail is given on Plate 138. Grouped around the effigy of the doge at the centre of the design are the four cardinal Virtues; they are seen not as allegories or symbolic *imagines* but as actual mourning personalities. They were conceived as figures *all'antica*, and also as occupying specific places in an actual ceremonial situation, dominated by the realism of the mask of the dead doge. Their forms, with the remainder of the monument, were undoubtedly heightened by polychrome accents. On either side silent soldiers, holding back the medieval tent-like baldacchino over the central group, stand on Antique columns crowned with Corinthian

SCULPTOR	MONUMENT	PLACE	DATE
1. Antonio Bregno	Doge Francesco Foscari (d. 1457)	Venice, S. Maria dei Frari	c. 1460(?)
2. Pietro Lombardo	Doge Pasquale Malipiero (d. 1462)	Venice, SS. Giovanni e Paolo	c. 1463(?)
3. Pietro Lombardo	Antonio Roselli	Padua, Santo	1467 (finished)
4. Antonio Rizzo (with much assistance)	Doge Niccolò Tròn (d. 1473)	Venice, S. Maria dei Frari	c. 1480
5. Pietro Lombardo (with assistance)	Doge Pietro Mocenigo (d. 1476)	Venice, SS. Giovanni e Paolo	1481 (finished)
6. Pietro Lombardo (with much assistance)	Doge Niccolò Marcello (d. 1474)	Venice, SS. Giovanni e Paolo	c. 1485–90(?)
7. Pietro Lombardo (with Antonio and Tullio Lombardo and others)	Bishop Giovanni Zanetti (d. 1484)	Treviso, Duomo*	1485 (contract) –c. 1490
8. Pietro Lombardo (with assistance)	Jacopo Marcello (d. 1488)	Venice, S. Maria dei Frari	c. 1490(?)
9. Tullio Lombardo (with Antonio Lombardo and others)	Doge Andrea Vendramin (d. 1478)	Venice, SS. Giovanni e Paolo	1492 (already advanced)–c. 1495
10. Tullio Lombardo (with Antonio Lombardo and others)	Doge Giovanni Mocenigo (d. 1485)	Venice, SS. Giovanni e Paolo	c. 1500

Table 11. Major Venetian Tombs, 1450–1500

*Follows type of monument of Lodovico Foscarini (d. 1480) by Pietro Lombardo, formerly in S. Maria dei Frari (destroyed).

capitals like statues of Pliny's Rome, while above them is a representation of the Incarnation symbolized by the Annunciation at the base of a florid Gothic finial. The combination and interpenetration of such varied elements represents a point of departure from which was to evolve a more uniform and consistent mode.

The protagonists in this trend were three members of still another branch of the Solari family, known in Venice as the Lombardi: Pietro (c. 1438–1515) and his two sons Antonio (c. 1458–c. 1516) and Tullio (c. 1460–1532). Born at Carona, the birthplace of Andrea Bregno, who migrated about 1465 to Rome, Pietro Lombardo seems to have had first-hand knowledge of Florentine sculpture and architecture. He was as much an architect as a sculptor, as events were to prove. One of his first works, the Roselli Monument in the Santo at Padua (finished in 1467), is a highly original and imperially scaled variant of the wall-monument developed in Florence by Bernardo Rossellino and Desiderio. Pietro's presence in Venice is not documented until 1474. But the earliest of the tombs in Venice by the Lombardi, the Malipiero Monument, is more 'Lombard' than the Roselli Monument and might even conceivably antedate it, although this hypothesis must be hedged with more than usual caution. The fact is that it was only with the Pietro Mocenigo Monument of c. 1476–81 that the fully characteristic personal

style of Pietro Lombardo made its appearance (Plate 139). And even here undoubtedly there must have been collaboration with assistants, in all probability his sons.

It is not easy to define with the overworked vocabulary of art history the nuances that separate the style of Pietro from that of his sons, and by the same token to discriminate between the styles of Antonio and Tullio. All three worked side by side on the sculptural decoration of the precious neo-Byzantine coffer of a sanctuary that is in the church of S. Maria dei Miracoli in Venice (1481–9), and presumably also as a team on the façade of the near-by Scuola di S. Marco.[16] On the whole Pietro's style was the most virile (Plate 140A). His forms appear to have been blocked out in strongly defined preliminary planes. He was careful to exaggerate a shade or a line so that it would tell from a distance. The delicate lyricism of an Angel in the National Gallery of Art in Washington usually attributed to Pietro would better fit the current view of his son Antonio (Plate 140B).[17] Tullio Lombardo's personal style appears to have been from the start more classicizing, and in its earliest results more truly classic.

A comparison of two reliefs with closely related subject matter has been invoked by fairly recent scholarship to indicate the basic cleavage in aesthetic attitude between Tullio and Antonio before 1500.[18] Antonio's style (Plate 142A) has been shown to be more closely related to painting and to the mood of idyllic appreciation of nature that is associated with Giorgione. Tullio, on the other hand (Plate 142B), was much less pictorial. His figures exist in a far more abstract space, actually more dependent upon a subtle relation with the observer's space, as suggested by forms that break out of the frame into our world. The rhythms established by the gestures of the figures, and the spaces between the figures are strongly defined. The full forms of the classical Antique are sought, and to a remarkable degree found, without risking in the slightest the suggestion of academic borrowings. Tullio is known to have owned at least one marble figure that was believed in Venice to have been Antique. He was much admired as a kind of reincarnated rhetorician of the language of Antique forms, as his name might have suggested, by his friend the theoretician Gaurico. He belonged to the heart of the movement that with infinite taste and romantic yearning produced Aldus's typography, and in particular the illustrated edition of 1499 of the *Hypnerotomachia Poliphili*.

The very opposite was the art of Bregno's successor, Antonio Rizzo. Born at Verona, purveyor of some columns of Veronese marble to the Certosa of Pavia in 1465, Rizzo came to settle permanently in Venice in 1466. His contribution to the series of doges' funeral monuments, the Tròn Tomb in the Frari, is an arid effort to impress by sheer size and multiplicity of detail; it comes off poorly in competition with the contemporary Pietro Mocenigo Monument of the Lombardi.[19] Where Rizzo succeeded, it was somewhat in the way Bregno had succeeded earlier: by infusing an impression of authenticity of breath and vivid life into individual statues. Such is the value of his Adam and his Eve for the Arco Foscari of about 1485 (Plates 141B and 143A). The nude Eve is influenced by Flemish or German figures. It makes a striking contrast with the classicizing nudes of Tullio Lombardo (Plate 143B).

In the long run it was Tullio who showed the way towards the Cinquecento. The crucial monument was the tomb of the Doge Andrea Vendramin, set up at first in the

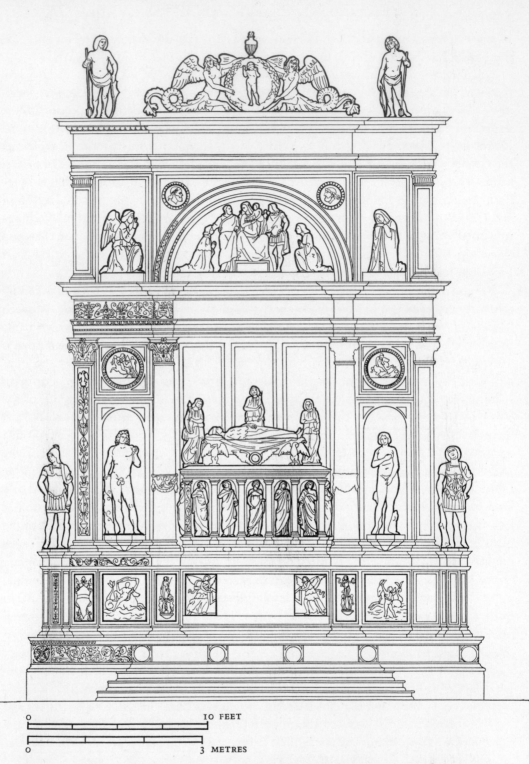

0 10 FEET

0 3 METRES

Figure 25. Tullio Lombardo: Monument to Doge Andrea Vendramin, 1492–5, before removal
from the Servi church to SS. Giovanni e Paolo and dispersal of figures of escutcheon-bearers
and of Adam and Eve (from Cicognara)

church of the Servi and moved in the early nineteenth century to the great Venetian
S. Croce: SS. Giovanni e Paolo. In its present state the monument does not do justice
to the original impact of the sculptural programme (see Figure 25). Two shield-bearing
ephebes were originally at the summit (formerly Berlin); the striking military captains
were placed as flankers rather than in niches; and the niches were filled instead by the
figure of Adam (now Metropolitan Museum; Plate 143B) and presumably of Eve
(whereabouts no longer definitely known).[20] An eye-witness, Sanudo, described the
monument as being put together in the Servi in 1493; he felt that it would be nothing
less than 'la più bella di questa terra', and the reason was the quality (literally, the
dignity) of the marble sculpture, as he put it, 'per li degni marmi vi sono'.[21] The motif
of the Roman triumphal arch here makes its definitive appearance in Venetian tomb
architecture as the term of a development from the Pietro Mocenigo Monument of
1476–81, probably by way of the Doge Jacopo Marcello Monument, also by Pietro
Lombardo, of about 1490. The next step along this way was the strongly classicizing
setting and marble relief sculpture of the Shrine of St Anthony in the Santo at Padua,
commissioned in 1501. Tullio was apportioned two of the relief-*istorie* depicting the
saint's miracles, which were not executed until many years later; Antonio was given
one which he seems to have finished in 1505, in a style very close to that of the Adam of
the Vendramin Monument.

Some Aspects of Bronze Sculpture in Northern Italy, to 1500: Bellano, Riccio, 'Antico'

The importance of bronze as the material for sculpture preferred above any other by the
Quattrocento humanists cannot be pointed out too often. That Antiquity placed a special
premium upon bronze as the material for *statua* in the account of Pliny the Elder (see
the Introduction) was a persuasive factor, probably more for North Italy even than for
Florence. Near a portal of the cathedral of Como, attributed to Tommaso Rodari, are
still to be seen the imaginary portraits of Pliny the Elder and Pliny the Younger, whose
letters contain illuminating and moving accounts of his interest in 'Corinthian' small-
scale bronzes or table-statuary, popular in Hellenistic times. At Pavia there was still
standing all during the fifteenth century the 'Regisole', an Antique equestrian statue of
bronze. The emphasis upon bronze in Donatello's work for Padua or that of Baroncelli
for the Este at Ferrara about 1450 was quite in line with a regional heritage. Filarete
found willing ears for his urging of bronze sculpture in his *Trattato*, written in Milan.
In 1490 the citizens of Piacenza were considering action upon his theoretical suggestion
and were speaking of the making of doors in bronze for their cathedral, a plan which
aroused the interest and perhaps cupidity of Leonardo da Vinci.[22]

It was one thing to talk of bronze sculpture and quite another to bring it into being. The
insuperable difficulties, beginning as early as 1473, of creating the Sforza Monument
should be sufficient warning on this point. Not Milan or Pavia in any case were to provide
the learned humanist ambient apparently needed to foster the recalcitrant art of bronze-
casting so much as Padua, Mantua (home of both Vergil and Mantegna), and Venice.

It is feasible here only to suggest a view of the outlines of the subject. At Padua the chief figure was Bartolommeo Bellano (c. 1434–96/7). He was born at Padua and was the son of a goldsmith.[23] Perhaps he was a member of Donatello's team of assistants there as an apprentice, but his name does not figure in the documents. His hand has been tentatively identified among those who attempted to finish the S. Lorenzo *ambones* after Donatello's death, and he had the important commission of a seated statue of Pope Paul II for Perugia which was inscribed with the date 1467. The details of his connexion with the papacy are lost; he was back in any event at Padua in 1469. There, except for a trip with Gentile Bellini to Constantinople in 1479/80, he remained, having received in 1483/5 the contract for ten bronze reliefs for the choir screen of the Santo.

The series of ten Old Testament *istorie* by Bellano represented for the period a programme of outstanding importance and no little difficulty. He had finished by 1488, after at least one false start, the Story of Jonah, of which a second version in all likelihood is now the one to be seen in the Santo (Plate 145B). It is evident that Bellano was captured by the dramatic side of Donatello's art, as shown in the violent contrast of activity and movement and an eloquent use of voids; the story has rarely been told in such vivid language of design. Bellano also made free-standing small-scale sculpture. An incense-burner for use at banquets, now in the Victoria and Albert Museum, was given by Bellano the shape and imagery of the Mountain of Hell (Plate 144). The real smoke issuing from it when in use was a witty reference to the subject matter, and the Lucretian view of Tartarus would have put a civilized brake upon misuse of serious Epicureanism at the table.[24]

In the 1490s Bellano was engaged on large-scale bronze sculpture for the Pietro Roccabonella Monument in S. Francesco at Padua. He died before its completion in 1498, and the statement of the Anonimo Morelliano in the early sixteenth century that the monument was completed by Bellano's chief pupil, Andrea Briosco, called Il Riccio, is generally accepted. Bellano had the misfortune to be followed by a more 'modern' and extraordinarily talented man in a situation, on a lesser historical scale, not unlike that of the relationship between Cimabue and Giotto as commented upon by Dante. Gaurico, who was Riccio's close friend and admirer, called Bellano a 'bungler' (*ineptus artifex*). The stricture was too harsh. But it reflected the point of view of a generation younger than Bellano's which appreciated the effortless impression of a great deal of classically-inspired detail combined into a full, yet not too crowded composition. Although it was composed after 1500, I have selected for purposes of comparison with Bellano one of two reliefs which Riccio was asked to make as a completion to Bellano's series in the Santo in 1506 (Plate 145A). The drama of Bellano's scene disappears in favour of a ceremonial procession against a background which suggests the space of nature, but does not allow the anecdotal aspects or charm of nature to intrude upon the densely organized foreground, defined by human figures and their immediate concerns.

Riccio's position as a fifteenth-century figure is not fully clear. The portions of the Roccabonella Monument attributed to him are not exempt from the criticism of ineptitude on so large a scale. Gauricus tells us in his *De Sculptura* that he had training both as a goldsmith and as a sculptor in the mode of Mazzoni in terracotta. A fascinating bronze

bust in Venice has been linked by an old inscription to either Riccio or Rizzo (Plate 141A). If it were Riccio's, an attribution which seems infinitely more likely than the alternative, it would throw valuable light on his formation, for the bust is clearly a compilation of casts from nature: the face, perhaps even the fashionable wig, and certainly the drapery hung *all'antica* over the shoulders. In this one telling instance, naturalism of the Mazzoni kind was linked to humanist subject matter and technique.

The triumph of the taste for the Antique came not only at Padua, and slightly later in Venice, but also at Mantua. There is evidence that Mantegna put some of his well-known admiration of the Antique into sculptural expression.[25] A younger and perhaps even more typical Mantuan figure was Pier Jacopo Alari Bonacolsi, who took the nickname of 'L'Antico'. His patrons were the princely family of the Gonzaga, who sent him to Rome in 1497 to make reductions in small bronzes of the most famous pieces of Antique sculpture. One of these, a free reduction after the Apollo Belvedere, now in the Cà d'Oro, shows Antico's characteristic love of very smooth, highly finished surfaces and a delicate contrast between darkest patinated bronze and gilding (Plate 146). This North Italian elegance, reminiscent of the Lombard atmosphere of the Sforza court in Milan or of the sculpture of the younger generation on the façade of the Certosa in Pavia, should be contrasted with the rather rough-cast yet more moving expression in Florence. The beautiful statuette in the Philadelphia Museum which is signed by Adriano Fiorentino may be labelled either an Eve or a Venus (Plate 147). The ambiguity is characteristic of the historical moment, as the fifteenth century was fast approaching its close.

CODA: FLORENCE, 1485–1500

IN 1490 the inscription composed by Angelo Poliziano to record the finishing of the frescoes commissioned by the Tornabuoni for the choir of S. Maria Novella would not have been out of place either in Milan or Venice. It celebrated the beauty and nobility of Florence in 'riches, victories, arts, and architecture' which were then being 'enjoyed in abundance, in health, and in peace' ('An[no] MCCCLXXXX quo pulcherrima civitas opibus victoriis artibus aedificiisque nobilis copia salubritate pace perfruebatur').

The use of the past tense was prophetic. The dramatic facts are familiar enough. Within two years the mainstay of the Medici and associated banker-merchants' rule in Florence, Lorenzo il Magnifico, had died, ravaged by uncontrolled gout against which the waters of neighbouring spas were unavailing. Within four years French troops under Charles VIII had taken Florence and Lorenzo's sons had been thrown out of the city by the Florentines intent on establishing Savonarola's dream of a theocracy, a 'kingdom' in which Christ was in theory recognized as head of state. In 1498, after Savonarola's fall, the traditional republic was re-instated by the anti-Medici as well as anti-Savonarola factions. The century ended with Florentine territory once more threatened by the armed invasion of Cesare Borgia and with discussions of setting up an elected head of government for life on the model of the Venetian doges.

After such violence and change, the myth of the 'Golden Age' of Lorenzo de' Medici, 'opibus . . . artibus . . . nobilis', might at one time have seemed credible. It would be understandable in a later generation that from a vantage point of greater security could look back on the crisis of the 1490s.[1] In reality, while the period 1485–1500 in Florence cannot today be shown to have been a Golden Age, it was far from being a hiatus in the history of the arts. It produced work of subtlety and some variety. It saw the preparation of the 'classic period' of the Rome of Julius II. And it laid the foundations of the ambivalently anti-classical Cinquecento movement to be called Renaissance Mannerism.

Intellectual and Social Environment: the Problem of Sculpture at the Fin-de-Siècle

The creative temper and to a great degree the patterns of patronage in sculpture in Florence during this critical period were affected by a set of intellectual and aesthetic attitudes linked chiefly to the Medici in the minds of most historians. Even a cursory glance at the evidence will show that the role of the Medici in the sculptural development after 1485 in Florence was neither central nor determining. But the element of Medici prestige based on the subtlety of Medici perceptions in the realm of the visual arts was a historical reality. A factor in the artistic environment was still the body of neo-Platonic doctrines emanating from the Academy situated near the Medici villa of

Careggi. The word environment is used here advisedly, because the role of neo-Platonic thought at the end of the Quattrocento in Florence in relation to actual creation in the arts was on the whole indirect. It had mostly to do with the formation of aesthetic principles, or elucidation of what the twentieth century has called the 'psychology of art'; Ficino's writings were less concerned with the problems connected with making art, and thus with style, than with the problem of talent and potential.[2]

In this respect, ideas had changed greatly since Alberti's *De Statua* and *Della Pittura*. Taken literally, Florentine neo-Platonic metaphysical humanism, with its doctrine of transcendent reality, called into question the whole basis of the art of sculpture; indeed in theory it challenged the continued existence of sculpture in Florence as a 'major' art. Marsilio Ficino's aesthetic of light, his *lucidus ordo*, was not easy to relate to the material being of sculpture in a world of sensate reality. His emphasis on mathematics and the constructional role of the *artifex divinus* provided a meaningful set of parallels to architecture in the first instance, next to painting and to music, but not to sculpture. When he came to sum up the 'liberal arts' towards the end of his life, his list excluded sculpture, though it included 'grammar, poetry, rhetoric, painting, architecture, music, and the ancient singing to the lyre of Orpheus'.[3] Prometheus, the brother of Pandora's Epimetheus, and Vulcan were quite evidently in his scheme of values on a lower level. This list of the arts of 1492 makes an interesting companion-piece to Ghiberti's list drawn up about 1445 (see Introduction, p. 3). The high place of bronze sculpture in the writings of Antiquity read by Ghiberti had no comparable effect on the metaphysically orientated group at Careggi. There, poets were studied rather than history of artists; myth took the place of *istoria*.

Even so, pitchforked out of mind as it might be, sculpture as a topic for thought still made its presence felt. Ficino himself fell into a sculptural metaphor when he described the lover as 'carving in his soul the image of the loved one (amans amati figuram . . . sculpsit in animo)'. The metaphor of the self-sculptor was taken up by Pico della Mirandola in the *Oratorio de Hominis Dignitate*. If man is in the image of God, Ficino had argued, then there is 'within man a statue of God (est in homine statua dei)'; the Late Quattrocento Florentine concern with the neo-Platonic *topos* of the *deus absconditus* thus at least made use of ideas about sculpture.[4]

Such metaphorical discussion in Florence had a part in the framework of ideas for Gaurico's theoretical treatise, *De Sculptura*, written, as previously described, in Venice by a Neapolitan émigré who had picked up a good deal from his passage through Florence. Gaurico relegated to a restricted and lower sphere questions of the physical making of sculpture (*technike*) and played up instead as a general theme the elements of drawing (*graphike*) and 'animation' (*psychike*). The relation of his emphasis on drawing to sculptural practice is a matter which deserves a special study; it seems evident that sculptors' use of graphic means to work out compositional problems or to study relationships of forms was on the increase in the last quarter of the century in Florence.[5] The evidence is not so clear for Venice; but the forms of a statue by Tullio Lombardo seem to the modern eye to have been 'drawn' before being carved, or more accurately to retain in linear definition of contour and thinness and precision of shadowed accents

a mode of vision that the practice of drawing would encourage (Plate 143B). The mixture of coldness and sensuality in the emotional content of Tullio's work is in some considerable part dependent upon the anti-materialistic *technike* of drawing mingled with the tangible polished surfaces of creamy marble. In Gaurico's view, the contemplation of sculpture was a private rather than a public matter, and a statuette or a plaquette as efficacious a support for humanistically inspired thought as a naturally-scaled statue or a similarly-scaled relief. The danger of course here was that graphism might lose connexion with the weight and density of the Early Quattrocento's feeling for bronze or marble and that the acceptance of minutely scaled forms as a vehicle for generous concepts might destroy not just a technical tradition of large-scale casting or carving but the psychological identity of humanity itself, *at its own scale*, with its sculptural image. The questions posed before 1500 which Gaurico's treatise codified were serious ones that any student of twentieth-century sculpture can appreciate. They threatened in fundamental ways a number of continuities based on the premises of Alberti, Brunelleschi, and Donatello.

In Florence the already weakening pattern of corporate patronage of the early Quattrocento had all but ceased to exist. In or about 1480, and again in 1490, the Arte della Lana attempted, by the old device of a competition among artists, to get action on a new façade design for the Duomo which had been on the list of agenda in public works since 1429; the decision on the choice of a winning design was passed on to the arbiter of taste, Lorenzo de' Medici, who counselled (probably wisely) delay.[6] But the result of postponement was the complete loss of an opportunity for a sculptural programme of the old-time heroic type. Florence now had another kind of prestige in the semi-private, semi-public museum collections of the Medici: ancient coins and engraved gems, medals, and the like on the one hand and Antique marbles restored by such 'moderns' as Donatello and Verrocchio on the other. 'Modern' programmes of sculpture in general were left not to corporate bodies but individuals to order: the Strozzi, the Sassetti, the Scala, or the Guicciardini. As will be seen, the character of style changed somewhat with the changing character and aims of commission. In most cases a diminution in scale may be ascribed to the fashion of collecting small-scale Antique objects.

Finally, over this *fin de siècle* in Florence there hovered an aura of recent glories reinforced by obsession with the distant past. In sculpture the memory and legend of Donatello was the greatest single force.[7] His relation to the Medici and his deep knowledge of the Antique ensured for his disciple Bertoldo a special place in Florence. He was given the best of the few Medici commissions and was made curator or keeper of the Medici collections of Antique sculpture, which were moved some time between 1480 and 1490 from the family palace and garden on the Via Larga to the garden and casino owned by the Medici close by S. Marco.

The older belief in a true 'school' of art under Bertoldo's curriculum can no longer be entertained. The S. Marco garden would seem to have been related more to our modern conception of a museum than to an academy: a place of quiet, where beauty might be contemplated through art. Conscious of his prominence in the life of the City,

and also genuinely interested in artists of all kinds, Lorenzo seems to have opened the garden to sculptors for enjoyment and study. This experience can hardly have entailed systematic teaching, and certainly could not, as early as 1490, have taken the place of the guilds or of the system of the apprentice in the *bottega*.[8] But as a supplement to systematic training, as an encouragement to enlarge intellectual and aesthetic horizons in the younger generation of artists, the Medici garden was already part of a new chapter in the history of taste and of artistic cultivation.

Varieties of Style, 1485–1500: Late Bertoldo and Benedetto da Majano; Giuliano da San Gallo and Andrea Sansovino; Andrea Ferrucci

The work of Bertoldo and of Benedetto da Majano appears as a continuation of earlier stylistic trends. Never a monumental sculptor and as far as is known always an artist in bronze, Bertoldo remained essentially a court sculptor for the humanist tastes of Lorenzo de' Medici. Devoted mainly to statuettes, designs for a few medals, and a series of plaquettes, he ventured only once into a composition of major complexity. This was the bronze relief of a battle scene which seems to have formed part of the Medici collection (Plate 152A). It is a reconstitution, or restatement, of the theme of a relief on a damaged Roman Imperial sarcophagus in Pisa. The action is violent, without beginning, visible climax, or end. The space of the action is cramped, virtually abstract. The interlocking forms are individually clear and preternaturally hard, not unlike the Quattrocento figure style of Signorelli in painting.

The late style of Benedetto da Majano, in marble rather than in bronze, was in obvious contrast. Generous scale and full-bodied forms were directed towards an expression of ease and of a certain grandeur. The Madonna in a roundel of the tomb-monument of Filippo Strozzi (contract of 1487) in S. Maria Novella continued the type of Rossellino's S. Miniato Madonna, but with more emphasis on circular rhythms and in a blander mood. Its popularity as an image is attested by stucco reproductions and close variants, if not copies, in marble (Plate 156A). The unfinished St Sebastian which he left to the Confraternity of the Misericordia is one of the extremely few examples of Florentine statuary of the last quarter of the fifteenth century. Mention has earlier been made of sculpture intended for a commission of Alfonso II of Naples (now in the Bargello).[9] As the foremost representative of the mid-century marble-carving tradition in Florence, his shop must be thought of as of primary importance in the 1480s and 1490s.

Among the younger men, easily the most talented was Andrea Contucci from Monte San Savino, near the Sienese border, called Andrea Sansovino. He was born about 1460 according to Vasari, who was in close touch with his life story and owned a relief by him. His training according to Vasari was with Antonio del Pollaiuolo; this would explain his elastically vigorous modelling and interest in movement, but not his uncanny control of the chisel. To gain this mastery, it would seem likely that he passed through the bottega of Benedetto da Majano. His major work before 1500 is the Altar of the Sacrament in S. Spirito, for which the chapter released space to the

Corbinelli family in the north transept of Brunelleschi's church, newly completed in December 1485.

Here is the Late Quattrocento counterpart to Desiderio's Altar of the Sacrament in S. Lorenzo (see above, p. 149). The architectural framework for the sculpture (Figure 26) was, however, far more sophisticated. It derived in part from Rossellino's altar in the Piccolomini Chapel in S. Anna dei Lombardi in Naples and paralleled Benedetto da Majano's altar in the same church (Plate 107). But a major difference was in the far bolder suggestion of the Arch of Constantine in Rome.[10] Tullio Lombardo had come to much the same conclusions in the architecture of his Vendramin Monument (see again Figure 25), but the variety of sculptural style in Tullio's case was on the whole less striking than in Sansovino's.

The antependium presents the medieval theme of the body of Christ supported by the mourning Virgin and St John in low to medium relief. The theme is the same as that used in Desiderio's S. Lorenzo antependium (Plate 89B). Andrea's relief style now stresses the plane of the altar front and connects the figures more frankly to the background plane (Plate 151A). In the niches on either side of the central tabernacle stand statues representing St Matthew and St James Major. The delicate scale of the monument as a whole was carried on in the statuary, and in the St James there is apparent an expression of mystical detachment that suggests a religious parallel to the metaphysics of Ficino and Pico della Mirandola and seems to prophesy the visions of Savonarola (Plate 148). The predella below carries in the centre the Last Supper, which may be compared favourably with Ghirlandaio's compositions, and a scene on either side from the lives of the two standing saints. The pictorial character of the predella reliefs is remarkable, and represents the farthest extension in Quattrocento Florentine sculpture of spatial and atmospheric representation (Plate 149A). The scene chosen for the *istoria* of St James is the confounding by the apostle of the pagan magician Hermogenes; it is difficult to avoid the thought that the choice of subject was a religiously inspired ironic commentary on the place of magic in the neo-Platonic view of the world.

In still another style of relief, in which the space is shredded by sharply differentiated planes and dark shadows, are the roundels of the Annunciation (Plate 150B). These reliefs are placed above the statues, and hence above the spectator's eye; the low vanishing of the perspective corresponds to that visual relationship, and also places the vanishing-point, in a spiritually meaningful way, squarely in the centre of the tabernacle. The elongated proportions of the Virgin Annunciate respect the relatively low position of the spectator's eye, clearly in Donatello's much earlier tradition, but the forms reflect contact with the Pollaiuoli in their proto-Mannerist proportions, the rapid flight into space of the perspective, and the suggestion of fluttering movement in the drapery.

In 1491–3 and 1496–1500 Sansovino was out of Florence on an architectural and possibly also a sculptural mission to Portugal.[11] Before he left for his first sojourn he had possibly finished the Corbinelli Altar in S. Spirito and his major work in terracotta, glazed in the della Robbia shop, an elaborate altarpiece in S. Chiara at Monte San Savino. A smaller marble wall-tabernacle in the church of S. Margherita at Montici in the hills just outside Florence is probably his first known work in the Florentine area.

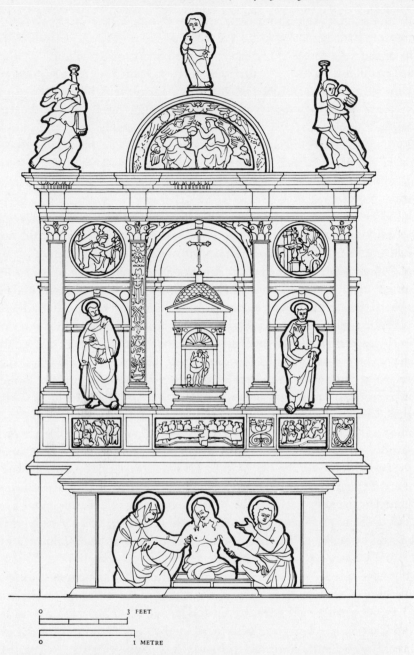

Figure 26. Andrea Sansovino: Corbinelli Altar, 1485–90. *Florence, S. Spirito.*
Schema of composition before Baroque modifications (after Huntley)

It combines echoes of the Pollaiuoli which modify considerably the data of the marble style of the heritage of Antonio Rossellino or of the *bottega* of Benedetto da Majano.

Where Sansovino received his training as a marble sculptor is a question upon which the sources are silent. The design of the ornament in S. Margherita at Montici suggests a close contact with the ideas of Giuliano da San Gallo, with whom Vasari associated

209

Sansovino in the programme of architectural sculpture in the sacristy of S. Spirito.[12] The relationship with San Gallo was a fruitful one, it would appear, as was that with the workshop of the della Robbia. The frieze of the portico of San Gallo's Medici villa at Poggio a Cajano, not far from Pistoia, has been attributed to Andrea Sansovino, and the polychrome glazing to the della Robbia shop (Plate 152B). The use by Andrea della Robbia of other artists' terracottas for glazing was not infrequent at the end of the Quattrocento. A good example is the Evangelist in a roundel on a pendentive of San Gallo's church of S. Maria in Carceri at Prato shown on Plate 150A. Here there are two styles, that of the Angel, which seems to be rather close to Andrea della Robbia's son, Giovanni, and that of the St Matthew, closer to Sansovino.[13]

The influential position of Giuliano da San Gallo in the sculpture of the late 1480s and 1490s in Florence cannot be doubted, but his own prowess as a sculptor is not at all clear. The works associated with his name illustrated in this volume (Plate 154, A and B) are usually given in the critical literature to assistants from the point of view of execution. Delegation of power in the making of a work of art was not at all infrequent up to a point in the *bottega* system of Quattrocento sculpture in Italy, but so definite a division between designer and executant does appear to escape the fifteenth-century norm in sculptural procedure and suggests a relationship with architectural practice. In San Gallo's case this would be understandable. He was above all an architect, and seems to have entered the field of sculpture by way of making architectural models and decorative wood-carving.[14] The Hercules statuette on a fireplace in the Gondi Palace, to San Gallo's design and begun about 1490, has a marked relationship to the bronze style of Bertoldo (cf. Plates 152A and 154A).

San Gallo's early stay in Rome, between 1465 and 1480, had an influence on his view of the Antique. This was a sober and disciplined view. The tomb-monument of Francesco Sassetti in the family chapel in S. Trinità in Florence is based on the Antique type of the *arcosolium*. The sarcophagus ordered by Sassetti before his death in 1490 is of black marble; the sculpture is reduced to a series of small roundels and a miniature frieze in the frame of the niche. The sombre tonality of the *pietra serena* is an admirable foil to the subject matter. The death scene (Plate 154B) was taken almost without any change from a Roman sarcophagus (Figure 27).[15]

With the near demise of statuary in Florence after 1485, the connexion of sculpture with architecture was most often expressed in the form of the frieze. Figures in miniature were set in varying ways against the background plane. In the reliefs in the courtyard of the Casa Scala which have been attributed to San Gallo (now Palazzo Gherardesca in the Borgo Pinti), Bertoldo's *plaquette* style was somewhat enlarged and the reliefs executed in a coarse neo-Etruscan manner in stucco, painted finally to imitate bronze (Plate 155B).[16] A similarly humanistic theme with emphasis upon neo-Platonist subject matter (here the worship of Eros) appears on the frieze of a somewhat later overmantel by Benedetto da Rovezzano, now in the Bargello (Plate 153B). The relief style in this case creates a well-defined platform for the action of figurines which move in a spatial context revived from the practice of Nanni di Banco and especially Ghiberti, with much of Ghiberti's delicacy of movement and detail in a now more obviously

classicizing mode. A related type of relief, but more heroic in expression, was formulated by Andrea di Piero Ferrucci, trained by Francesco di Simone Ferrucci, in the font sculpture in the Duomo of Pistoia (Plate 149B). Ferrucci's style here approaches, but without the clarity, the style attributed to Sansovino at Poggio a Cajano. In general Ferrucci continued the Florentine eclectic current (see above, p. 152), but with increasing emphasis on Antique motifs, as in his remarkable temple-front altar of the 1490s in the cathedral of Fiesole.[17] The contrasting current of Antonio del Pollaiuolo did not die out completely in Florence, despite the master's removal before 1485 to

Figure 27. Death scene from a Meleager sarcophagus, Roman Imperial Period (from Robert)

Rome. In the entrance hall of the Guicciardini Palace in Florence is a stucco relief of Hercules and Caecus which in a rather lax and turgid way reflects Antonio's figure style and interest in landscape (Plate 155A); it would seem to be based on a *modello* drawing.[18]

Michelangelo and Fifteenth-Century Sculpture

An apparent exception to the Late Quattrocento dual trend of diminished scale and learned humanism would seem to be Michelangelo's development before 1500. This is not entirely the case. As an independent painter and architect he seems to most of us to belong to the Cinquecento in spirit as well as in date.[19] His precocity was in his sculpture. He was born in 1475. As a glance at the table on p. 212 will show, the listing of his achievement as a sculptor before he was twenty-five is impressive. Is it to be thought of as a prelude to a sixteenth-century career, or was it sufficiently part of its own time to warrant the youthful Michelangelo's inclusion among the sculptors of the Quattrocento? On balance, the second alternative, that of including the young Michelangelo among the Quattrocento sculptors, seems perfectly justifiable. Or to put it in a different way, no view of the accomplishment of Quattrocento sculptors could be called anything but incomplete without some consideration, however brief, of Michelangelo's work before 1500.

1. Head of a Faun *c.* 1489–90
 (trial piece)

Lost
Sources: Condivi, Vasari. By tradition thought to have been made in the Medici garden

2. Madonna of the Stairs (relief) *c.* 1490
 (no commission known)

Florence, Casa Buonarroti
Source: Mentioned by Vasari (1568 edition), who retails facts from Lionardo Buonarroti – who gave it to Duke Cosimo I, 1566–7. Given back by Cosimo II to family in 1617. Date at present under new discussion

3. Battle of the Centaurs (relief) 1490–4
 (unfinished)

Florence, Casa Buonarroti
Sources: Condivi, Vasari. Mentioned to Federigo Gonzaga in a letter of 1527. Always remained in the family

4. Crucifix for S. Spirito (wood) 1490–4

Florence, S. Spirito(?)
Sources: Condivi, Vasari. Perhaps to be identified with a crucifix newly located in S. Spirito (1962). Presumably never left S. Spirito. As of 1964 doubts have been raised against its acceptance, but sentiment in its favour is also strong

5. Marble Hercules 1492–4
 (no known commission)

Lost
Sources: Condivi, Vasari. Originally in possession of Strozzi. Sold to Francis I. Set up at Fontainebleau by Henry IV; lost since *c.* 1713

6. Statuettes for Arca di S. Domenico, Bologna 1494–5
 (to complete decoration left unfinished by Niccolò dell'Arca)

Bologna, S. Domenico
Documented: Original documents quoted by Fra Lodovico da Prelormo, *Memorie*, 1572 (from fol. 126, Liber Edificorum, A). Have since remained with monument

7. S. Giovannino 1495–6
 (for Pierfrancesco dei Medici)

Generally believed lost
Sources: Condivi, Vasari. Made for Pierfrancesco dei Medici. The head supposedly in Girardon's Cabinet in the seventeenth century. A new candidate has recently been proposed in New York City

8. Sleeping Cupid 1496
 (no known commission)

Lost
Sources: First mentioned in letters of summer of 1496. Offered by Milanese art dealer in Rome as an Antique. Bought by Isabella d'Este from Cesare Borgia in 1502. Sold to Charles I of England, 1631

9. Bacchus 1496/7
 (possibly begun on commission for Cardinal Riario; bought by Jacopo Galli)

Florence, Bargello
Sources: Condivi, Vasari. Mentioned by Aldovrandi (*c.* 1550) and drawn by Heemskerck, 1532–5, in Galli's garden of antiquities in Rome. Purchased by Francesco de'Medici, 1572. Placed in Bargello, 1873. Right hand and cup are not original

Table 12. Michelangelo's Earliest Work in Sculpture, *c.* 1490–1500

10. So-called Cupid-Apollo 1497(?)
 (for Jacopo Galli)

Lost
Sources: Condivi, Vasari (as a Cupid). Confusion as to subject since Aldovrandi about 1550 writes of an 'Apollo' in Galli's possession by Michelangelo. Not the Cupid in the Victoria and Albert Museum

11. Pietà 1498
 (for Cardinal Jean de Villers de Groslaye with Jacopo Galli as intermediary)

Rome, St Peter's
Documented: Signed. (Contract of 27 August 1498.) Intended for a chapel of St Petronilla (Chapel of the Kings of France). Later transferred twice in St Peter's to present location in a chapel on the right side of the nave

Table 12. Michelangelo's Earliest Work in Sculpture, *c.* 1490–1500 (continued)

The consideration presented here will be, in any event, brief. It will be restricted to an examination of only one topic of several that come to mind. This is the limited but challenging question of the relation of the style of his first decade as a practising sculptor to the style trends of the Late Quattrocento in Italy as a whole.

The subject of Michelangelo's training as a sculptor was never treated by a completely trustworthy source. Who was his master, or were his masters, may never be established. His temperament is not known to have been particularly marked by generosity, and it is possible that he was simply unable to talk to his biographers about his beginnings except in vague or self-congratulatory terms. Thus, while it is believed today that he did spend twelve or fifteen months as an apprentice before his fifteenth year in Domenico Ghirlandaio's painting *bottega*, reasonable doubts may be raised by Vasari's account of his self-taught experiments under Bertoldo's benign supervision in the Medici Garden. It must be remembered that Bertoldo was a bronze-worker, not a carver, which the young Michelangelo was not only by predilection but in fact. Michelangelo's early preserved work has a fine sensitivity for marble as a material for art that presupposes training with a professional, perhaps in the shop of Benedetto da Majano, who, as earlier suggested, must have had as assistants a number of the more talented younger sculptors in Florence (Plate 156B).[20]

There are nonetheless striking hints in the scant evidence with regard to the youthful Michelangelo's connexion with the Medici garden and Bertoldo. The famous 'first work', the Head of a Faun (no longer extant) mentioned prominently by the Cinquecento biographers Vasari and Condivi, might quite reasonably have had a connexion of some sort with the Antique statues representing Marsyas belonging to the Medici before 1492 which were restored by Donatello and Verrocchio. The Madonna of the Stairs, at one time in the Medici collections (Plate 151B), could have been in part an essay in rivalry with Andrea Sansovino's S. Spirito antependium (compare with Plate 151A). It has long been connected with Donatello's and Desiderio's *stiacciato* relief style in the literature, but the key-motif of the staircase also appears in one of Benedetto da Majano's pulpit reliefs in S. Croce (see again Plate 106). And the profile figure of the Virgin, in particular in certain details such as the rubbery left hand and impossibly small

feet attached to heavy ankles, has a good deal to do with what has been suspected as Bertoldo's style in Donatello's S. Lorenzo *ambones* (see again Plate 82). Thus it would seem likely that the very youthful Michelangelo's beginnings as a sculptor followed a complex eclectic pattern, absorbing elements from several sources, including the study of Masaccio and Giotto, and using for models reliefs in bronze as well as marble. If the painted wood Crucifix recently re-discovered in the claustral buildings of S. Spirito is really the 'lost' Crucifix in wood known through Condivi and Vasari,[21] a hitherto unsuspected streamlined proto-Mannerist phase was virtually contemporary with the stocky, muscular figure style of the so-called Battle of Centaurs and Lapiths (Plate 153A).[22]

Michelangelo's battle scene appears today in striking contrast to Bertoldo's, which it probably was consciously intended to rival (see again Plate 152A). Rather than the tangle of wiry forms of Bertoldo's Antique reconstruction Michelangelo (whether or not on Poliziano's suggestion of the subject) created a rhythmic, swinging design with a heroic central figure on the vertical axis. The forms seem to grow like organisms out of the marble block. Their struggle is animated by a suggestion of ebb–flow and rising–subsidence alternations of great natural forces in movement. The story of the myth now appears more obviously as a parallel to some phenomenon in nature in a prehistoric phase of life on earth; it escapes the neatness and elegance of the classical reconstruction of Benedetto da Rovezzano's Late Quattrocento style (see again Plate 153B) and calls to mind something of the late Donatello in S. Lorenzo. Contemporary with the Battle relief (left unfinished) was the now lost statue in marble, also on a scale evidently over lifesize, of a Hercules. This passed very early into the hands of the Strozzi family.[23] Between 1492 and 1494 Michelangelo presumably made his serious anatomical studies on cadavers supplied him by permission of the prior of S. Spirito.

In 1494, with the threatening arrival of the French in Florence, and evidently fearful of Florentine enemies also, Michelangelo took flight to North Italy. He was for a short while in the Venetian and Paduan area and settled down finally at Bologna, where he was given the commission of completing Niccolò dell'Arca's sculpture of the Arca di S. Domenico by two standing figurines and a kneeling Angel. Niccolò had died in 1492, and one of the two statuettes appears actually to have been begun by him: the S. Petronio.[24] The obvious prototype for both Niccolò's original conception and Michelangelo's completion was in Quercia's moving image in the tympanum of the portal of S. Petronio (see again Plate 31). Michelangelo's Kneeling Angel (Plate 156B) is only a few inches tall, but it possesses a scale that is already monumental, and the uncertainties evident in the Madonna of the Stairs now quite evidently had begun to be resolved. The second standing statuette, a S. Proculo, is believed to be a self-portrait. A psychological pattern of self-identification with his statuary that one associates with the mature Michelangelo was thus already in evidence before the sculptor's twenty-first birthday; but it must be said that it made its appearance in a programme clearly in the Quattrocento in its intent, its meaning, and its origins.

The next stage took place in Florence after Michelangelo's return late in 1495 or early in 1496. It is not represented in surviving pieces. As far as is known, the 'lost' S.

Giovannino for Lorenzo di Pierfrancesco de' Medici and the 'lost' Sleeping Cupid are still lost.[25] The latter was finished in the spring of 1496. There is no commission recorded, and it appears to have been carved in a kind of unprovoked contemplative competition with the Antique. The oldest surviving record, written immediately after Michelangelo is believed to have finished the piece, states that there was already doubt as to whether it was Antique or modern. It is not certain whether Michelangelo made the Cupid as a mystification, or for his own pleasure, or as a replacement for a lost Medici piece, or as a covert protest against Late Quattrocento collectors' enthusiasm for the Antique. Some sort of defence could probably be made for any of these reasons.

The model for Michelangelo's pseudo-Antique was almost certainly an ancient Sleeping Cupid brought back by Giuliano da San Gallo in 1488 from Naples as a gift from Ferrante of Aragon to Lorenzo de' Medici, who presumably placed it in the family collections that were dispersed in 1494. Michelangelo's Sleeping Cupid of 1496 was in any event offered for sale by a Roman dealer in June and July of the same year; apparently it was bought at the time by Cesare Borgia as a first step in a long journey which ended, according to the last sure record, in the dispersal of the collection of Charles I of England, which it entered by purchase in 1631.

The adventure of the Sleeping Cupid was connected wth Michelangelo's removal to Rome. He arrived in June 1496 on the trail of his little statue, which he apparently wished to buy back because he felt too low a price had been placed on it. Through Lorenzo di Pierfrancesco he made immediate contact in Rome with Cardinal Raffaele Riario, the owner of the splendid palace later to be known as the Cancelleria and of an impressive collection of antiquities. A patron even more important for the young sculptor was Jacopo Galli, a Roman banker-connoisseur of taste and enthusiasm. The garden of his house, which backed against the property of Cardinal Riario, was arranged as a museum of Antique sculpture, much as had been the Giardino Mediceo in Florence.

Michelangelo was to spend four years in Rome. There, in relative seclusion and in living conditions of simplicity amounting to penury, as Donatello had earlier lived in Florence, he worked on three major pieces. One was a Cupid (or an Apollo), a life-size standing figure, now lost.[26] The second was the slightly earlier Bacchus, which stood for some years in Jacopo Galli's garden and is now in the Bargello. The third was the Pietà commissioned in August 1498 by the French cardinal Jean de Villiers de la Groslaye with Galli as intermediary. This is now in St Peter's.

In the Bacchus (Plate 159), the full recovery of the Florentine Late Quattrocento casualty, the *statua*, was virtually completed. Its closest analogy is not, curiously enough, an Antique in Rome such as the Apollo Belvedere but rather, in its androgynous character and clarity of contour, the Adam by Tullio Lombardo (Plate 143B), which Michelangelo could have seen in Venice in 1494, when the Vendramin Monument was receiving its finishing touches. The daring effect of loss of equilibrium suitable for the presentation of the subject is actually so carefully plotted, so harmonious in its transitions, that the movement does not appear to define so much a stagger as the beginning of a slowly whirling dance: in Ficino's phrase, 'a Baccho festivam in motu membrorum concinnitatem'.

The Pietà destined for one of the chapels of St Petronilla, known also as the Chapel of the Kings of France, connected to Old St Peter's, was totally opposed to the Bacchus in programme and resulted in a radically differing organization of form (Plate 158). The overpowering figure of the Virgin was given sufficient scale to dominate the group of two; in subtlety of restrained emotion and in sheer complexity of drapery it surpassed anything in the Corbinelli Altar by Sansovino, though the two are still quite comparable. The figure of Christ reveals the fruits of Michelangelo's anatomical research and was polished meticulously. The finished head (Plate 157) resulted in a fascinating dialogue between nature and formal convention. In type it is most close to certain heads by Andrea Ferrucci, and was certainly the model for Cellini's Crucifix now in the Escorial.

A copy of the Pietà was put up in S. Spirito in 1549; at that time, in the midst of the Counter Reformation, the composition was called a 'Lutheran caprice'.[27] What was attacked in this unexpected criticism was probably not the Germanic origin of the *Vesperbild* to which the iconographic type of Michelangelo's group is related, but its aestheticism, which stood in clear opposition to the norm of devotional images in much of sixteenth-century Tuscany. Those 'figure da sotterar la fede e la devotione' were apt to belong to another current surviving from the Quattrocento: the realist, polychrome *tableau-vivant* category of sculpture whose popularity was on the increase in 1500 (Plate 160).

<p style="text-align:center">*</p>

Thus a double source of style in sculpture was in full evidence as the century came to its chronological close: the sophisticated marble mode of which the Pietà is an excellent example, and the counterbalancing long-lived, motionless art of coloured terracotta, closer as expression to the earth and appealing to literal minds. Both modes tended in differing ways to escape from time, though they could not escape from history.

In the refined and highly literate poetical and philological humanists' minds the century's achievement in sculpture seemed in a slightly dream-like way an epic of success. Where Ghiberti in Book I of his *Commentarii* had tentatively summarized Pliny's account of classical Greek sculpture as an inspiration for his own time in 1450, the author of the laudatory *De Illustratione Urbis Florentiae* of about 1500 unblushingly asserted that the 'glory of sculpture had passed from the ancient Pelasgians to the Florentines'. Donatello, now equated with Phidias, had created 'speaking marbles'; Verrocchio, the equal of Lysippus, had trained a whole generation of artists, including painters; Desiderio, the new Praxiteles, had been removed 'in the flower of youth'.[28]

It will be evident to the modern reader that this particular pairing of names of 'moderns' with 'ancients' was not in the least random. In the judgement of future time, as more is learned about Italian Quattrocento sculpture, such claims may appear more than learned fancy. In any event, this much is clear: having begun in Vasari's definition of his 'Second Age' with the 'hope of rivalling nature herself' in Quercia's sculpture, the Quattrocento ended according to its own lights in meeting on equal terms the artistic acme of the distant past.

LIST OF PRINCIPAL ABBREVIATIONS

A.B.	*Art Bulletin*, New York.
B.M.	*Burlington Magazine*, London.
Berlin Jahrbuch	*Jahrbuch der preussischen Kunstsammlungen*, Berlin.
H.W.J., Donatello	H. W. Janson, *The Sculpture of Donatello*, 2 vols. Princeton, 1957.
P.-H. (1955)	John Pope-Hennessy, *An Introduction to Italian Sculpture, Italian Gothic Sculpture*. London–New York, 1955.
P.-H. (1958)	John Pope-Hennessy, *An Introduction to Italian Sculpture, Italian Renaissance Sculpture*. London–New York, 1958.
R. K., Ghiberti	Richard Krautheimer with Trude Krautheimer-Hess, *Lorenzo Ghiberti*. Princeton, 1956.
Storia (1908)	Adolfo Venturi, *La Storia dell' arte italiana*, VI, *La Scultura del Quattrocento*. Milan, 1908.
Thieme-Becker	U. Thieme and F. Becker, *Allgemeines Lexikon der bildender Künstler*, 37 vols. Leipzig, 1907–50.
Vasari-Milanesi	G. Vasari, *Le Vite de' piu eccellenti pittori, scultori e architettori, etc.*, critical ed. by G. Milanesi, 8 vols. Florence, 1878–85.

CHAPTER I

p. 1 1. Vasari-Milanesi, II, 109: the *Proemio* for Part II of the *Vite* (1568 ed.).

p. 2 2. For the relation of Alberti's writings to the idea of Nature as a generating source of art see the introductions of Malle and Spencer to their editions of *Della Pittura* (Florence, 1951, and Oxford–New Haven, 1956). The notion of Nature as an artist has been superbly elucidated by J. Baltrušaitis, *Aberrations* (Paris, 1957), 47 ff. See also H. W. Janson, 'The "Image made by Chance" in Renaissance Thought', *Essays in Honor of Erwin Panofsky* (New York, 1961), I, 254–64. Alberti began his *De Statua* with a description of the invention of the arts as an imitation of 'the shapes and bodies produced by nature . . . either in the trunks of trees, in the earth itself, or in some other materials of the kind, which were so disposed that by altering somewhat their form they might be made to resemble the figures of living animals'. In our day the cult of the *objet trouvé* (see in particular Picasso's sculpture) seems to validate this stage of discovery imagined by Renaissance humanists. For the relation of Alberti's ideas to Antiquity, see E. H. Gombrich, in the *Journal of the Warburg and Courtauld Institutes*, XX (1957), 173 and J. Bialostocki, 'The Renaissance concept of Nature and Antiquity', *Acts of the 20th International Congress of the History of Art* (Princeton, 1963), II, 19–30.

p. 3 3. O. Morisani (ed.), *Commentarii* (Naples, 1957), 20; *R. K., Ghiberti*, 308 and 310–14 (on the humanist aspects of the *Commentarii*).

4. For Ghiberti's emphasis upon optics, see *R. K., Ghiberti*, 307–8 (evaluates Schlosser's and ten Doeschate's findings). See also, more recently, Parronchi's account of Ghiberti's sources of optical theory in *Paragone*, CXXXIII (1961), 24–9. The often quoted passage early in Ghiberti's Book III on the delicacy of modelling in an antique that could be appreciated 'only by touch' is not evidence for a tactile approach to sculpture in Ghiberti's period. Far from it, its presence in Book III is, according to Professor Krautheimer, an 'insertion', though perfectly authentically Ghiberti's; it would stand, then, as evidence for the usualness of visual apperception.

5. In Book I of his *Commentarii*, Ghiberti describes the work of Lysippus in a way that verges on identification with his own aims. Tacitly a distinct parallel is made, and this already sets Ghiberti apart from the Middle Ages and from most of his contemporaries. Comparisons of medieval and Renaissance sculptors with Antique sculptors in a vaguely adulatory way are not regular, but certainly are not surprising when they occur. Characteristic of this genre are the loosely conceived, clumsy, and emptily ringing verses in the epitaph composed in Bologna for one of the less 'classical' of the Quattrocento sculptors, Niccolò dell' Arca:

Nunc te Praxiteles, Phidias, Policletus adorant
 Mirantur tuas, o Nicolae [*sic*], manus
 (K. Frey (ed.), *Vasari, Vite*, etc., I,
 Munich, 1911, 716).

Pointed and clearly-thought-out parallels between 'ancients' and 'moderns' in the Quattrocento came on the whole late in the century and in circles that knew enough about Antiquity to possess a relatively mature point of view: for one example, the list of sculptors composed by Ugolino da Verino, about 1500, paraphrased by A. Chastel, *Marsile Ficin et l'art* (Geneva–Lille, 1954), 184. There the praise is focused, sculptor to sculptor; it seems knowledgeable, unsentimental, and to mean everything, or almost everything, that it says.

6. An example of the use of the term 'pictor' for p. 5
'sculptor' in early texts is: 'Donato Niccolai Betti [Donatello], pictori, pro faciendas picturas marmoreas', in G. Poggi, *Il Duomo di Firenze* (*Italienische Forschungen, Kunsthistorisches Institut in Florenz*, II) (Berlin, 1909), 33, document 199, dated 12 August 1412. The usual terminology in the Latin documents of the Quattrocento for our English 'sculptor' included in the last quarter of the Trecento in Florence *scultor, scolpitor, scharpellator, intagliator, incisor marmi*. In the Quattrocento *intagliator, scarpellator, scultor*, and finally *sculptor* were used with their Italian equivalents of *intagliatore* or *intagla le fighure, scarpellatore* or *ischarpellatore*, and *scultore*. Interchangeable, apparently with no particular shade of increased status, is the use of the term 'master': *magister scarpelli, magister intagliator figurarum, magister sculture* (*maestro d'intaglio*); payments were made only to 'masters',

so that this would be understandable in the account-documents that are most frequent. The usage sketched here is digested from the uncommonly complete archival material for Florence Cathedral provided by Poggi. Towards 1450 *statua* was usual in Florentine usage for a finished figure; *figura* was then used for the roughly blocked-out stone.

p. 5 7. See K. Jex-Blake and E. Sellers, *The Elder Pliny's Chapters on the History of Art* (London–New York, 1896), 15–35 (*C. Plinii Secundi Nat. Hist.*, XXXIV). Pliny uses the term *statua* for an image of some size cast in bronze. Bronze was, properly speaking, the medium for the *ars statuaria* as opposed to modelling in clay (*plastice*) or carving in marble (*sculptura*). Renaissance usage referred to marble just as much as to bronze as the medium for *statua*. Ghiberti's great bronzes for Or San Michele (1414–28) are the first Renaissance equivalents to the Antique *statua* in Pliny's restricted sense of the term: they are in bronze and they are unusually large. Their size alone would differentiate them from Pliny's *signum*, which the Romans used to indicate objects of slighter scale and of varied subject matter, including sphinxes. On Pliny's 'hierarchy of materials' for varying types and functions of sculpture, see E. H. Richardson, *The Etruscans* (Chicago, 1964), 90–1.

8. Poggio Bracciolini, *Epistolae*, ed. T. de Tonellis (Florence, 1831); a clear commentary in *R. K.*, *Ghiberti*, 302–4, which compares the Late Trecento approach of Giovanni Dondi (in Rome also) with Poggio's 'genuine love of ancient art', and his respect for Donatello's 'judgement on the quality of a work of ancient art'. The invocation of Donatello's name in this context of ideas concerns more than connoisseurship.

9. A great traveller and indefatigable note-taker and draughtsman, Cyriac brought distant monuments of Antiquity out of the realm of legend into a form where they could be considered as reality. Recent studies of his journeys and activity are B. Ashmole, 'Cyriac of Ancona and the Temple of Cyzicus', *Journal of the Warburg and Courtauld Institutes*, XIX (1956), 179 ff.; C. Mitchell, 'Ex libris Kiriaci Anconitani', *Italia Medioevale e Umanistica*, V (Padua, 1962), 283–300.

p. 6 10. See in Vasari's *Vita* of Verrocchio the account of the *ceraiolo* workshop of Benintendi Orsini in Florence; also J. Pohl, *Die Verwendung des Naturab-gusses in der italienischen Porträtplastik der Renaissance* (Bonn, 1938), *passim*. As late as 1630, it seems,

there were still no less than 600 life-size wax votive figures in the church of SS. Annunziata in Florence, and it was necessary to brush aside the figures to make one's way into and through the church.

11. Other examples of monumental equestrian p. 7 statues in Quattrocento sculpture are the Borso d'Este Monument in Modena (after 1451) and the Giovanni Vitelleschi Monument in Rome (1426). For the revival of Antique column-monuments and statues on columns in Italy: W. Haftmann, *Das italienische Säulenmonument* (Leipzig–Berlin, 1939), 111–51. Not treated by Haftmann are: (1) the large, rearing equestrian figure of Alfonso I planned at one time (*c.* 1448) for the Arch of the Castelnuovo in Naples, and (2) Filarete's scheme for a similar equestrian monument for the father of Francesco Sforza (see Plate 120A). This last seems to have deeply influenced Leonardo's and Antonio Pol-laiuolo's projects for the Sforza Monument in Milan. Leonardo's second scheme showed a walking horse similar to the 'Regisole' of Pavia. The same evolution from rearing horse to walking horse apparently took place in the process of design of the Trivulzio Monument (1505–8; cf. Plate 120B), which of course Leonardo never had the opportunity to bring into actual being either.

12. The preferred text of *De Statua* is still the p. 8 edition of H. Janitschek, in *Leone Battista Alberti's Kleinere Kunsttheoretische Schriften*, in Eitelberger von Edelberg, *Quellenschriften für Kunstgeschichte*, XI (Vienna, 1877). Janitschek's opinion that the work was written in 1464 at the earliest was based on the dedication present in only one manuscript. This surmise cannot stand up against evidence in the text of *De Statua*, in which reference is made to *Della Pittura* as still unpublished, though apparently then being written. The influence of surveying techniques in the measuring devices described in *Della Statua* would also place the treatise relatively early. A date about 1430–5 appears to be a far safer estimate. For an early argument favouring this date, see Mancini, *Vita di Leon Battista Alberti* (Florence, 1882), 134.

13. See for Leonardo, I. A. Richter, *Paragone, a Comparison of the Arts* (London, 1949). A new edition of Filarete's treatise by J. R. Spencer is in the press and is expected to supersede the older edition of von Oettingen (see Bibliography), which is not complete and is often out of date in its approach to art-historical questions. For the date of composition see J. R. Spencer, in *Rivista d'Arte*, XXI (1956), 93–103.

14. Pomponio's *De Sculptura* was published in Florence in 1504, though written a few years earlier (see Bibliography). A portion on technique was translated into English and published by Sir Eric Maclagan in the catalogue of the Burlington Fine Arts Club Exhibition of 1913.

p. 9 15. Alberti's canon is expressed in his 'Exempedum' system of feet, degrees, and minutes which divided the height of a man into 600 proportional units. See E. Panofsky, 'Die Entwicklung der Proportionslehre als Abbild der Stilentwicklung' (English translation in *Meaning in the Visual Arts*, New York, 1955, 55 ff.) for an analysis and comparison with other canons.

p. 10 16. Some shops (such as Neroccio's) produced versions in inexpensive materials (cartapesta, stucco, terracotta) of reliefs or even of painted compositions (G. Coor, *Neroccio dei Landi* (Princeton, 1961), *passim*). Both Ghiberti and Donatello have at various times been considered as issuing versions from their own shops. In some cases (such as Rossellino's Madonna of the Candelabra) the range of quality is such that several shops must have been involved. Piece-moulds or simpler 'squeezes' were both used. Cennini's *Libro dell'Arte* already shows knowledge of the use of piece-moulds. Traffic in terracotta Madonnas (definitely in the plural) is mentioned for a moderate price in the account book of Bartolommeo Serragli published in part by Corti and Hartt in *A.B.*, XLIV (1962), 162. The standard, but by now rather badly dated, catalogue of this material is C. von Fabriczy's 'Kritisches Verzeichnis der toskanischen Holz- und Tonstatuen', *Berlin Jahrbuch*, XXX (1909), Supplement, 1–88.

17. The practice in Florence must go back into the Trecento. Painted stucco versions of about 1385 of the 'Madonna and the tickled Child' over the lateral door into the campanile of the cathedral are in the Rijksmuseum, Amsterdam, and the Yale Art Gallery; C. Seymour, Jr, in the *Bulletin of the Yale Associates in Art* (1955).

p. 11 18. Customs on payment of assistants by the master differed as between Florence and Siena, for example. There was no hard and fast rule on supply of materials except according to institution. In the cathedral of Florence the marble did not belong to the rights of *magisterium* of the individual master-sculptor but was owned by the cathedral Opera, which still retained its rights, even if the block were left unfinished. Agostino di Duccio's unfinished David later completed by Michelangelo is a well

recognized example of this practice. The term *laborerium* referred to the work actually done by the master or his assistants in the physical making of sculpture.

19. For the Cambio's role in the St Matthew of p. 12 Ghiberti for Or San Michele, see A. Doren, *Das Aktenbuch für Ghiberti's Matthäusstatue an Or S. Michele zu Florenz (Kunsthistorisches Institut in Florenz, Italienische Forschungen*, 1) (Berlin, 1906). Documents for the Lana St Stephen which are extremely revealing are published in *R.K., Ghiberti*, 385–8. An up-to-date study of the relationship of the guild-system to conditions of making sculpture and the development of style by Professor John Coolidge of Harvard is in progress.

20. Some outlines of the patronage pattern for p. 13 this complex programme were given in Vespasiano da Bisticci's *Life* of the cardinal. Now valuable details are available in recently discovered bankers' documents for which a monograph has now been published; see G. Corti and F. Hartt, in *A.B.*, XLIV (1962), 155, and G. Corti, F. Hartt, and C. Kennedy, *The Chapel of the Cardinal of Portugal in S. Miniato* (Philadelphia, 1964).

21. Insights into individual courtly and middle-class patronage are provided by M. Wackernagel, *Der Lebensraum des Künstlers in der florentinischen Renaissance* (Leipzig, 1938), *passim*. The position of middlemen-agents between patron and artist is now becoming clearer, thanks to the Cambini Bank documents being made available by Corti and Hartt (see above, Note 20). An interesting example of a Quattrocento art dealer is the merchant Bartolommeo Serragli, whose contacts extended from Florence as far south as Naples. The Medici as private patrons (in particular Giovanni and Piero the Gouty, his brother) used the Cambini Bank for payments for works of art from individual sculptors such as Desiderio da Settignano. For other aspects of patronage see the older classic study by Aby Warburg on bourgeois society and art in Florence in *Gesammelte Schriften* (Leipzig–Berlin, 1932); also the numerous studies by E. Müntz on the Medici collections in Florence and art at the papal court in Rome; and the descriptive accounts by E. Malaguzzi-Valeri of art at the court of the dukes of Milan (see Bibliography, pp. 255, 256).

22. The best study on the general topic of the growth of personal memorials in the fifteenth century is J. Pohl, *op. cit.* (Note 10 above). The most extensive collection of death-mask portraiture of the Quattrocento is in the Victoria and Albert

Museum; E. Maclagan and M. Longhurst, *Catalogue of Italian Sculpture*, 2 vols (London, 1932), 90–1 (plates 62–3). Death-masks of departed members of the family of course were common in Roman times and were preserved piously in households. Florentine custom was thus partly neo-realism and partly, probably, a matter of dimly-sensed tradition.

p. 14 23. The accounting for the costs of Ghiberti's first doors of the baptistery is fully treated in *R. K., Ghiberti*, 106–12. Ghiberti in the *Commentarii* stated that the costs were 22,000 florins. Strozzi, the digester of the lost Calimala documents, gave a figure of 16,024 florins (the difference being in the cost of the jambs). The problem of an accurate translation into modern equivalents of currency is baffling. What commodity can one use for a price-norm sufficiently general to be comparable with present costs and sufficiently flexible to contain adjustment to inflationary trends? Professor Roberto Lopez of the Yale History Department has kindly suggested to me the book-trade. But for my present purposes this has not worked out too well, though I should be the first to admit that my computing skills are amateurish. I shall therefore leave the question open here.

24. The tables in H. Lerner-Lehmkuhl, *Zur Struktur und Geschichte des Florentiner Kunstmarktes im 15. Jahrhundert* (Münster, 1936), give a concise overall summary. The best indications for the costs of Donatello's works at Padua are given in *H. W. J., Donatello*, II, in his lengthy sections on the Santo sculpture, pp. 169–81.

p. 17 25. The documents for the cathedrals of Florence and Milan, the Certosa di Pavia, and the Doge's Palace in Venice provide the major source for the summary given here. A useful modern secondary work on Italian quarries producing stone for sculpture as well as architecture is F. Rodolico, *Le Pietre delle città d'Italia* (Florence, 1953).

26. Italian Renaissance bronze for sculpture came from many sources, including melting previously-cast bronze or materials that could also be used for other purposes such as bells, or even cannon. The Calimala considered importing 17,000 pounds of brass metal (*ottone*) for Ghiberti's second baptistery doors from Flanders: *R. K., Ghiberti*, doc. 219, p. 416. A picture of the process of amassing sufficient materials to cast the Judith of Donatello from a variety of sources and people is given by the Cambini accounts: Corti and Hartt in *A.B.*, XLIV (1962), 165. The leader in the modern study of the

technical aspect of Renaissance bronze alloys and casting has been Cavaliere Bearzi of Florence.

27. On Neapolitan sculpture of the Late Trecento p. 20 and Early Quattrocento, see L. Venturi, *Storia dell'arte italiana*, IV (1906), 312–20, to be supplemented by the studies of R. Filangieri in *Napoli Nobilissima*, 2nd ser., I (1920–1), and of O. Ferrari in *Bollettino d'Arte*, XXXIX (1954), 11–24. The principal monument is the extraordinary tomb of King Ladislas in S. Giovanni a Carbonara, now freed of its Baroque trappings. But this is relatively late: of the 1420s, and partly the result of Florentine influence (see Plate 14A). The most original sculptor of Late Trecento style in Naples was Antonio Babboccio (portal of the Duomo). He was active also at Messina. For the most recent sketch of this period see R. Causa in *Sculture lignee nella Campania* (Naples, 1950), 73, 105–6.

28. The first pope to be buried in Rome since Boniface VIII was Urban VI (d. 1389). Fragments of his monument are preserved in the Grotte Vaticane. Evidence of awakening activity are the monument of the English Cardinal Adam Easton (d. 1398) in S. Cecilia (noted by Ghiberti when he was in Rome *c.* 1416) and part of the monument of Cardinal Philippe d'Alençon (d. 1397) now in S. Maria in Trastevere (with apparently an early use of a death-mask). The ecclesiastical effigies of this period in Rome are marked by heavy conservatism, a trait to continue in the fifteenth century. Of sculptors very little is known. A still mysterious 'Paolo' (Magister Paulus) signed two tombs between roughly 1405 and 1420 (Bartolommeo Carafa, who died in 1405, in S. Maria Aventina and Cardinal Stefaneschi, who died in 1417, in S. Maria in Trastevere): *Storia* (1908), 52–9; G. S. Davies, *Renascence, The Sculptured Tombs of the Fifteenth Century in Rome* (London, 1910), 40–54; G. J. Hoogewerff, in *Mededeelingen van het Nederlandischen Institut te Rome*, IV (1927), 143 ff. Hoogewerff's hypothesis that the d'Alençon monument contains work by Giovanni d'Ambrogio of Florence is unsubstantiated.

29. Documents on the opening of the Milan p. 21 workshops: *Annali della Fabbrica del Duomo in Milano*, I (Milan, 1877). Recent summaries: C. Baroni, *Scultura gotica lombarda* (Milan, 1944), 123–64, and *P.-H.* (1955), 33–5, both with illustrations. Older, but still essential: U. Nebbia, *La Scultura nel Duomo di Milano* (Milan, 1908).

30. The 'foreign' sculptors in the Milanese workshops before 1400 are treated by H. Sieben-

hühner in his war-time volume on Milan Cathedral (1943). The interesting phenomenon of the union of miniature-painting with monumental sculpture must go back to the High Medieval practice of 'drawing' designs for statuary or of statuary (e.g., Villard de Honnecourt). For Giovannino de' Grassi's work as a miniaturist see P. Toesca, *La pittura e la miniatura nella Lombardia* (Milan, 1912), 294–323. A summary of his work in the cathedral shops between 1389 and 1398 is given in *P.-H.* (1955), 202–3.

31. For Raverti and Jacopino da Tradate, who dominated the Milan shops after 1401: U. Nebbia's large volume (see above, Note 29), *passim*. See for a summary *P.-H.* (1955), 203–4.

32. For dates and illustrations: U. Nebbia (as above, Note 29). The Milan *doccione*-figures had a certain influence on smaller figures performing the same function on St Mark's in Venice and perhaps very briefly on the Duomo sculpture in Florence. A Boy (nude?) holding an Otter was ordered from Ciuffagni as a water-spout figure in 1423; 'docciam marmoris albi cum uno puero supra stringentem (!) utrem', as given in Poggi, *op. cit.* (Note 6), document 429, p. 79.

p. 22 33. The statue is Raverti's documented S. Babila, designed for a pier inside the Duomo. The relevant text quoted by Baroni and Nebbia runs: 'declaraverunt dictam figuram non esse bene neque laudabiliter laboratam, nec completam iuxta designamentum . . .'. Another example relating to a Prophet on the exterior, of 1404, is quoted by Baroni (*op. cit.*, 138): 'non bene laborata . . . juxta formam designamenti'. A parallel case in Florence occurred in 1408, when Niccolò Lamberti was censured on the complaint of the *capo*, the by then old-fashioned Giovanni d'Ambrogio (see Chapter 2).

34. The minor Florentine Andrea da Fiesole was also active in Bologna (see C. Gnudi, 'Intorno a Andrea da Fiesole', *Critica d'Arte*, III, 1938, 23–9) from about 1410 to 1420; and the Virtues in roundels of the Foro dei Mercanti may also be Florentine (A. Venturi, *Storia dell'arte italiana*, IV, 1906, 832–9 with illustrations). Influences from Venice after 1388 included the dalle Masegne shop at S. Francesco and the Venetian demi-figures of saints within quadrilobes of the façade plinth of S. Petronio (A. Venturi, *ibid.*, 824–32, figures 685–92). The atrociously repainted polychrome Madonna della Pace in the interior of S. Petronio

must be counted as a documented work of 1393 by the same Hans von Farnech who was a little earlier active in the shop of Milan Cathedral.

35. Recent scholarship in Italy has veered very strongly towards seeing Milanese influences as dominant in Venice during the period 1385–1420. The extent and power of such influences still need to be sifted more carefully. Perhaps the Milanese invasion in sculpture was not as great as suggested, and must almost certainly have post-dated the dalle Masegne. The place of Giovanni Buon in this period seems vaguer than ever before, as of current writing.

36. P. Paoletti, *L'Architettura e la scultura del* p. 23 *Rinascimento in Venezia* (Venice, 1893), provides only a very general basis. Instead consult P. Toesca, *Il Trecento* (Turin, 1951), 414 ff.; G. Mariacher, 'Matteo Raverti nell'arte veneziana del primo Quattrocento' and 'Aggiunta a Matteo Raverti', *Rivista d'Arte*, XXI (1939) and XXXII (1940); also 'Appunti per un profilo della scultura gotica veneziana', *Atti del Istituto Veneto di Scienze, Lettere ed Arti (classe di scienze morali e lettere)*, CIX (1951), 225 ff. and 237 ff. Good for descriptive purposes: G. Rossi and G. Salerni, *I Capitelli del Palazzo Ducale di Venezia* (Venice, 1952). A promising new study of these capitals and of the angle-sculpture outside the Doge's Palace is now (1964) being prepared by Mrs Wendy Stedman as an M.A. thesis at Yale University. Not always sufficiently stressed is the fact that a sizeable proportion of the capitals at ground level on the building are modern replacements of worn or damaged originals which are preserved in a museum within the palace.

37. Relevant literature includes the following: the studies by Mariacher quoted in Note 36, above; A. G. Meyer, *Oberitalienische Frührenaissance: Bauten und Bildwerke der Lombardei* (Berlin, 1897–1900), I, 59 ff.; *Storia* (1908), 27–32; L. Planiscig, 'Die Bildhauer Venedigs in der ersten Hälfte des Quattrocento', *Jahrbuch der Kunsthistorischen Sammlungen in Wien*, N.F. IV (1930), 47–111; C. Baroni, *La Scultura gotica lombarda* (Milan, 1944); M. C. Visani, 'Proposto per Matteo Raverti', *Arte Veneta*, XVI (1962), 31–41.

38. Of the three groups, that of the Judgement of Solomon will be treated in Chapter 5. Of the remaining two, the Fall is by the original artist of the capital below it; the Drunkenness of Noah appears to be by two hands, the Noah by one (close to Raverti) the Sons by another (Milanese or

Venetian?). The dates of both need not be far apart, from a stylistic point of view; possibly as early as 1410, possibly as late as 1420.

p. 23 39. On Paduan humanistic medals and coins before 1400, see J. v. Schlosser, 'Die ältesten Medaillen und die Antike', *Jahrbuch der Kunsthistorischen Sammlungen in Wien*, XVIII (1897), 64 ff.; G. F. Hill, *Portrait Medals of Italian Artists of the Renaissance* (London, 1912), 7. Recent opinion agrees that the Carrara series is based on an actual effort to portray the subjects as well as to revive an Antique genre.

40. This Venetian stylistic expansion would include: portal of S. Domenico, Pesaro, and monument of Paola Malatesta, S. Francesco, Fano (*Storia*, 1908, figures 2, 3): Leonardo Riccomanno: main altar, Sarzana (Duomo). Possible influences from Venice may be seen in the façade design and sculpture of the Ospedale in Sulmona, in the Abruzzi. These influences appear to meet influences from Ghiberti (heads in roundels) of the Annunziata, Sulmona. To be noted, finally, is the penetration of a Germanic style into Central Italy and the Abruzzi by way of Milan. After leaving Milan, Walter of Munich is found at Orvieto in 1410–11, at Sulmona in 1412, and at Aquila in 1432.

p. 24 41. Recognition of the historical importance and aesthetic interest of the brothers dalle Masegne has increased in the modern literature beginning with R. Krautheimer, 'Zur Venezianischen Trecentoplastik', *Marburger Jahrbuch für Kunstwissenschaft*, V (1929), 193–212. Further studies have been those of C. Gnudi of 1937 and 1950, and of P. Toesca, in *Il Trecento* (Turin, 1951), 420–7 (all summarized in *P.-H.*, 1955, 204–5). The still unsolved problem is a clear differentiation between the styles of the brothers. Where Krautheimer and Gnudi saw Jacobello in the rood-screen figures of St Mark's, Pope-Hennessy retained the label, based on the inscription, of a joint work shared between the two. I, for one, am not clear as to what the inscription actually means. Is it to be interpreted literally, or as a kind of trade-mark? The apparent presence of at least three hands in the Apostles makes one incline to the latter alternative. In Bologna I find my choice of Jacobello's work at odds with Gnudi's, who sees in the remarkable Virgin Annunciate Pierpaolo, where I would see Jacobello at least in part. If the documented Pierpaolo effigy at Mantua is taken as really by Pierpaolo, it reveals a rather flaccid hand. The evidence, in other words, is both too little and too vague.

42. Published by I. Supino, *La Pala d'altare di Jacobello e Pierpaolo dalle Masegne nella chiesa di S. Francesco a Bologna* (Bologna, 1915). A closer stylistic study is still desirable. The presence of many hands is obvious; perhaps, as suggested in Chapter 2, the young Quercia may be among them.

43. Begun in 1339, the construction of the huge p. 25 new wing of Siena Cathedral which was to have formed the nave of the 'Duomo Nuovo' lost momentum at the time of the plague in 1348 and was never completed. After 1350 work instead was concentrated on the area of the present baptistery. A portal already completed in that area was the one which had influence on the architectural frame of the Porta dei Canonici and Porta della Mandorla of the Duomo of Florence (G. Brunetti).

44. The programme of the Cappella del Campo dates back to the 1370s, but its sculpture (never completed entirely) was produced slowly over the next two decades. Active as sculptors were: Mariano d'Angelo Romanelli, Bartolommeo di Tommè (called Pizzino), Matteo d'Ambrogio (called Sappa), Lando di Stefano (known as a wood carver).

45. The most important modern study of Sienese wood sculpture in the Middle Ages and the Early Renaissance is E. Carli, *La Scultura lignea senese* (Milan–Florence, 1954). He shows that of one large programme of the period 1370–1400, only a pitifully small handful of figures survives. This was the elaborate choir decoration in gilded and painted wood in the Duomo. Surviving Madonnas and groups of the Annunciation, continuing the tradition of the earlier Trecento and acting as a bridge to the Quattrocento styles of Francesco di Valdambrino, Domenico di Niccolò dei Cori, and Quercia, include a pair of statues by Piero d'Angelo della Quercia, Jacopo's father; the documents were first published by E. Lazzareschi, 'La Dimora a Lucca di Jacopo della Quercia . . .', *Bollettino senese di storia patria*, XXXII (1925), 63–97. P. Schubring, *Die Plastik Sienas im Quattrocento* (Berlin, 1907), introduction, suggests the background of Sienese goldsmith work of the Quattrocento. More complete: I. Macchetti, 'Orafi senesi', *La Diana*, IV (1929), 8–110.

46. The altar-dossal of the baptistery in Florence represented for its time a major monument, on a par certainly with the St James Altar of the cathedral of Pistoia. Work on the Florentine altar went on intermittently from 1366 (date of commission)

with Quattrocento additions in which Verrocchio and Antonio Pollaiuolo shared (see Chapter 8). The altar has been removed from the baptistery and is in the Museo dell'Opera del Duomo. It may be looked on as the surviving masterpiece of a flourishing and historically very important art of which only a very small fraction is extant. The documents were published by G. Poggi, *Catalogo del Museo dell'Opera del Duomo* (Florence, 1904), 65 ff.

47. Basic older monographs: G. Beani, *L'Altare di S. Jacopo apostolo nella città di Pistoia* (Pistoia, 1899); P. Bacci, *Gli Orafi fiorentini e il 2° riordinamento dell'altare di S. Jacopo* (Pistoia, 1905). Recent work focused on Brunelleschi: P. Sanpaolesi, 'Aggiunte al Brunelleschi', *Bollettino d'Arte*, XXXVII (1953), 225–32; C. Ragghianti, 'Aenigmata Pistoriensia', I, *La Critica d'Arte*, V (1954), 433–8; summary in *R. K., Ghiberti*, 50–1. The upper portion contains the figures of the prophets Isaiah and Jeremiah, and Sts Gregory the Great, Augustine, and Luke, attributed on the basis of style and documentation to Brunelleschi. The drawing for the upper portion was supplied by the Pistoiese painter Giovanni di Bartolommeo Cristiani by 1394. In 1399 there was a new plan to add lateral faces. On one of these faces (now reconstructed on the observer's left) were placed apparently Brunelleschi's figures, finished in 1400, just before the baptistery competition (see Chapter 2).

48. For the Or San Michele and Loggia della Signoria workshops, K. Frey, *Die Loggia dei Lanzi* (Berlin, 1885), is still fundamental. See also W. R. Valentiner, 'Simone Talente scultore', *Commentari*, VIII (1957), 235–43.

49. Frey's *Loggia dei Lanzi* sets out the evidence (see Note 48 above). For a definition of Giovanni d'Ambrogio's career and of his style as against Jacopo di Piero, see C. Seymour, Jr, 'The Younger Masters of the First Campaign of the Porta della Mandorla', *A.B.*, XLI (1959), 5–6; for the style of Giovanni d'Ambrogio alone see also G. Brunetti's monographic study in *Rivista d'Arte*, XIV (1932), 1 ff.; a summary is in *P.-H.* (1955), 198–9. M. Wundram has identified the Duomo Opera 'Annunciation Master' with Giovanni d'Ambrogio (see below, Chapter 2, Note 22): 'Der Meister der Verkündigung in der Domopera zu Florenz', *Festschrift für H. K. Roseman* (Deutsches Verlag, 1960), 109–21. p. 26

50. The standard study and point of departure for the sculpture workshops at the Duomo in the period 1370–1400 is still H. Kauffmann, 'Florentiner Domplastik', *Berlin Jahrbuch*, XLVII (1926), 141 ff. and 216 ff. More recently: P. Toesca, *Il Trecento* (Turin, 1951), *passim*; G. Brunetti on the Porta della Mandorla and Porta dei Canonici (begun before 1400), in *Belli Arti*, I (1951), 9–15; W. and E. Paatz, *Die Kirchen von Florenz*, III (Frankfurt, 1952), *passim*. The documents upon which the summary given here is based are all in G. Poggi, *op. cit.* (Note 6). Almost all of the pre-Renaissance Duomo statuary has been brought together recently in the Museo dell'Opera del Duomo in Florence, where it may be most effectively studied. The scattered remainder is in the Bargello; the Louvre; the Metropolitan Museum, New York; the Fogg Museum, Harvard University; and finally the Städel, Frankfurt am Main. On record as destroyed in 1945 are several pieces formerly in the Kaiser Friedrich Museum, Berlin.

NOTES TO PART TWO

CHAPTER 2

p. 30 1. The division of these seven sculptors into generations in a biochronological sense does not work out. But there does seem to be a division between something like 'generations' in an art-historical sense. The group Quercia–Brunelleschi–Ghiberti with the sub-group Niccolò di Pietro Lamberti–Lorenzo di Giovanni d'Ambrogio belonged chronologically in one bracket, and up to 1400 were certainly to be considered a most promising 'younger generation'; indeed, four of the five – a very high percentage – were selected for the baptistery competition of 1401. The second, later, and much smaller bracket included Donatello and Nanni di Banco, a mid-generation biochronologically, but art-historically and stylistically speaking a unit. The exact birth-date of Donatello is not known, but tax documents indicate the span 1382–6. Nanni's birth-date is completely unknown. It has been set as late as 1390 (Vaccarino) in a rather tendentious way; on balance, c. 1385–90 seems far more acceptable. Nanni and Donatello were clearly on an exact par in 1408–9, when they were each assigned a Prophet for the north tribuna of the Duomo. This date, rather than 1406 (i.e. the commission of the smaller prophets of the Porta della Mandorla), represents a joint artistic coming-of-age, though Donatello was apparently a little the elder. Thus eight to ten years, the difference between c. 1400 and 1408/9, separated the two groups historically on the basis of age-plus-performance.

p. 31 2. The chronology of the Porta della Mandorla is based on the relatively complete set of Duomo documents published by G. Poggi, *Il Duomo di Firenze* (*Italienische Forschungen, Kunsthistorisches Institut in Florenz*, II) (Berlin, 1909), *passim*. The analysis of the first phase to 1397, based on a joint study of the style (or styles) of the sculptural elements and the documents made in the graduate seminar at Yale University, was published recently: C. Seymour, Jr, 'The Younger Masters of the First Campaign of the Porta della Mandorla', *A.B.*, XLI (1959).

p. 32 3. The studies of Saxl and Panofsky bearing on the jambs and lintel sculpture clearly establish the debt, between 1392 and 1394, to early Florentine interest in classical Antiquity. For the Hercules theme on the portal as symbolic of Fortitude and of *virtus generalis*: E. Panofsky, *Renaissance and Renascences* (Stockholm, 1961), 149–50, note 4. Panofsky there suggests that the other cardinal Virtues, namely, Temperance, Prudence, and Justice, are also represented in the Porta della Mandorla, namely in the reveal-sculpture.

4. The bear at an oak-tree on the lower right of the Assumption has given rise to questions regarding the meaning of its presence. For Vasari, the reason was already lost (*Vita* of Jacopo della Quercia, to whom he erroneously gave the relief); he thought it might refer in some way to the devil. Recently H. W. Janson (*Acts of the 20th International Congress of the History of Art*, vol. II, Renaissance Section) has linked the bear with Antique and Early Christian symbolism of the wilderness. For this line of thought a versicle for the liturgy of the Immaculate Conception, which is of course theologically linked to the Assumption, offers support. The versicle runs:

Quae est ista quae ascendit de deserto?

Another line of reasoning points to Artemis, whose relation to the girdle and to bears (young virgins in Athens) as mythological commonplaces may have associational value here, in so far as Artemis may be thought of as a *figuratio* of the Virgin. How much they might have meant to Florentines in or around 1400 needs to be checked. It is worth noting that in the Book of Isaiah, which so deeply concerns the absolute purity of the Virgin, the bear, the desert, and the girdle are all present more or less together. The liturgy of the Assumption uses imagery of the tree (plane-tree and olive-tree), but the juxtaposition of the bear with oak-tree occurs in a fifteenth-century scene depicting Diana at the chase (Bracciano, School of Pisanello). This telling example is owed to Professor Colin T. Eisler, 'The Athlete of Virtue', *Studies in Honor of Erwin Panofsky* (New York, 1961), I, 87. A bear in conjunction with a tree had earlier occurred in a similar position in Orcagna's marble *Assumption*. There is nothing that would preclude a composite meaning from all these types of sources.

p. 34 5. The question of the author of the Hercules of the left reveal of the Porta della Mandorla has been a vexed one. For an account of previous attributions and a defence of the attribution to Lamberti: C. Seymour, Jr, 'The Younger Masters, etc.' (see Note 2, above). Arguments for eliminating the apocryphal 'Hercules Master' are given there.

p. 35 6. H. Baron, *The Crisis of the Early Italian Renaissance* (Princeton, 1955), *passim*.

p. 36 7. A lively factual view is given by Ghiberti himself in Book II of the *Commentarii*: 'In my youth in the year of Christ 1400 I left Florence because of the corruption of the air [plague] and bad state of the city [Milanese war and state of siege]. I left with an eminent painter whom the Lord Malatesta of Pesaro had summoned; he had us do a room which we painted with greatest diligence. My mind was largely turned to painting; the reason thereof was the works [commissions] which the lord promised us, and also the partner[ship?] [*la compagnia*] I was with continually showed me the honour and advantage which we should acquire. However at this point it was written to me by my friends that the Regents [*governatori*] of the Temple of St John the Baptist [the baptistery] were sending for masters who should be skilled, of whose work they wanted to see proof. From all regions [*le terre*] of Italy a great many skilled masters came to submit to this trial and contest. I asked leave of the lord and of my partner. When the lord heard of the matter, he immediately gave me leave; together with other sculptors we came before the Committee [*operai*] of the said temple . . .' (with some adaptations, from *R. K., Ghiberti*, 12).

p. 37 8. Brunelleschi's biography: the principal source is the biography believed to have been written by his follower, Antonio Manetti. The most recent edition is E. Toesca's (Florence, 1927).

p. 38 9. A perennial question is whether Vasari had access to the judgement reports or to some kind of digest of them. His version of the reasons why the losers lost is so restricted that it seems impossible that he ever had anything like a full and fair account on his desk. His own account of the competition is in any event badly garbled; Vasari–Milanesi, II, 223 ff. and 334 ff. In his two fulsome accounts he confused Niccolò Spinelli d'Arezzo with Niccolò Lamberti, also from Arezzo originally, and added the name of Donatello to the list without the slightest shred of historical justification that has been uncovered to date. For a discrimination between the two Niccolòs: U. Procacci, in *Il Vasari*, I (1927–8), 300 ff.

10. In technique, Ghiberti's piece must have been p. 40 clearly preferable. It was hollow-cast and perhaps in one piece, whereas Brunelleschi's was made up of solid-cast units dowelled and soldered on to the base plaque. Professor Krautheimer was the first to my knowledge to suggest by inference the interesting idea that the international connexions of the Calimala had a relation to the preference being given to Ghiberti's International Style. The power of what may be considered as 'external pressures' on so delicate a matter of stylistic choice is disturbing, but there seems to be no escape from the conclusion offered in *R. K., Ghiberti*, 49, 54–67. In general, it must be admitted, as does Krautheimer, that Ghiberti's account was definitely slanted in his own favour; but this was as an artist rather than as a consciously ambitious representative of a passing fashion in style.

11. The doors were cleaned under the immediate direction of Cavaliere Bruno Bearzi and were put back into place very soon after the Second World War. They are already showing the effects of new dust, dirt, and impurities in the atmosphere. For an account of the cleaning, see F. Rossi, 'The Baptistry Doors in Florence', *B.M.*, LXXXIX (1947), 334 ff.; G. Poggi, 'La Ripulitura delle porte nel Battistero fiorentino', *Bollettino d'Arte*, XXXIII (1948), 244 ff.

12. The chronology used here is that of Kraut- p. 42 heimer, with particular reference to his use of the documents and later estimate of the time required for chasing the rough-cast reliefs; *R. K., Ghiberti*, 106–7, 110–12, 121–32. Only three of the reliefs are considered by Krautheimer to have been executed by an assistant (probably Giuliano di Ser Andrea): Christ in the Storm, Last Supper, and Arrest in the Garden. The designs of these three reliefs must, however, be considered entirely Ghiberti's own; this would, I think, imply that the wax *modelli* were largely Ghiberti's also.

13. The documents list eleven assistants in the first period, i.e. 1404–7; it would appear (Krautheimer) that they were active on an intermittent basis, as needed according to the progress of work. After 1407 the assistants were employed on a more uniform basis and with fewer interruptions. Eight names are listed (Krautheimer) with varying degrees of responsibility. See *R. K., Ghiberti*, 108–9.

14. E. Carli, 'Niccolò di Guardiagrele e il p. 45 Ghiberti', *L'Arte*, XLII (1939), 144, 222.

p. 46 15. P. Bacci, *Francesco da Valdambrino* (Florence, 1936), 31–54.

p. 47 16. The only record is Vasari's late mention. The extension of this genre to a suppositious authorship by Quercia of the wood of the equestrian Savelli Monument in the Frari in Venice (Valentiner) is not acceptable.

17. C. Seymour, Jr, and H. Swarzenski, 'A Madonna of Humility in the National Gallery of Art and Quercia's Early Style', *Gazette des Beaux-Arts*, XXX (1946); E. Carli, 'Una Primizia di Jacopo della Quercia', *Critica d'Arte*, VIII–IX (1949–50). For the possibility of an attribution of the Washington Madonna to Domenico di Niccolò dei Cori, see *P.-H.* (1955), 211. For a newly found wood *Annunziata* see M. Wundram in *Berlin Jahrbuch*, VI (1964), 39–52.

p. 49 18. Now in the interior of the cathedral, in the north transept, close by the Ilaria Monument; P. Bacci, *Jacopo della Quercia* (Siena, 1929), 50–1; illustrations opposite pp. 44, 64.

p. 50 19. The biography of Nanni by Vasari is little short of a disaster, largely because of Vasari's bias in favour of Donatello. It is necessary, therefore, to reconstruct Nanni's career from documentary sources. The fullest treatment available, though unfortunately biased against Donatello, is R. Vaccarino, *Nanni* (Florence, 1951), 11–15.

20. Vasari's *Vita* is not only fuller for Donatello than for any other Quattrocento artist, but seems to be based on a firmer foundation of oral tradition than most. Even so (Janson) there are at times reasons to question seriously Vasari's statements. In his introductory section to his two-volume work (*H.W.J.*, *Donatello*), Janson gives a well balanced view of the biographical evidence and provides many insights into Donatello's admittedly mysterious character. A summary of the career, which is mainly a summary of his chief works, is given in *P.-H.* (1958), 269–70.

p. 51 21. See *H.W.J.*, *Donatello*, II, 219–22 for the rejection of both smaller Prophets as Donatello's work. The one to the left seems to me to correspond very well to a re-carving of an Angel commissioned from Ciuffagni in 1409 and documented in G. Poggi, *op. cit.* (Note 2), document 176, p. 30. The one to the right seems clearly to be from Nanni's shop after 1414.

22. Among the possibilities of attribution published recently by scholars such as Toesca, Valentiner, Brunetti, and Wundram, the choice is between the so-called 'Hercules Master' (my Niccolò Lamberti), Jacopo della Quercia, Jacopo di Piero Guidi, and Giovanni d'Ambrogio. Bibliography before 1951 is given by G. Brunetti in *Belle Arti*, I (1951), 9–15. From the point of view of style, I would place the two figures in the second phase of the Porta della Mandorla (i.e., 1404–9) and would give them to one of the two masters of that phase, namely Nanni di Banco. Whether his father, Antonio di Banco, had a part in their carving is difficult to affirm or to deny. We know nothing of his style except in conjunction with his son's earliest work; the mixed style of the Annunciation figures may reflect two hands, but again this does not impose itself as a necessary conclusion after study of the statues themselves. Anything before 1408/9 by Nanni di Banco would in any event be recorded as work of the father and son as a firm. The question is still open; see Wundram's argument in favour of Giovanni d'Ambrogio in *Beiträge zur Kunstgeschichte, Eine Festgabe für Heinz Rudolf Rosemann* (Deutsche Kunstverlag, 1960), 109–21.

23. *H.W.J.*, *Donatello*, II, 34–8; illustrated, I, p. 52 plates 1–6; *P.-H.* (1958), plate 2.

24. P. Bacci, *op. cit.* (Note 15), 152–212, figures 14–26. For the S. Ansano of Lucca, *ibid.*, 104–12.

25. The statues were cleaned of a white surface-p. 53 coat and several polychrome repaintings and were first shown in 1944 with their original polychromy as dramatically recovered under the direction of Professor Enzo Carli. They were identified as two 'lost' figures that flanked a Crucifix in Siena Cathedral by P. Bacci, *op. cit.* (Note 18), 52–9; their style was discussed at some length and perceptively by E. Carli in *La Scultura lignea senese* (Milan-Florence, 1954).

CHAPTER 3

1. Documents discussed in G. Poggi, *Il Duomo di* p. 55 *Firenze* (*Italienische Forschungen, Kunsthistorisches Institut in Florenz*, II) (Berlin, 1909), XXXV–XXXVIII; the programme factually described in *P.-H.* (1958), 272.

2. Poggi, *ibid.*, 31, document 186, of 17 July 1410: '. . . quod capelle in quibus fiunt et intaglantur quactuor evangelistas de marmo, clauduntur de assibus ita quod non videantur . . .'; p. 35, document 210, of 24 January 1415: '. . . per una chiave per la chiusa della capella dove lavora Donato di Nicholo ai Betto Bardi . . .'. It would

seem that Donatello was one of the forgetful people that mislay keys.

p. 56 3. There is some question as to whether the glance suggested by engraved pupils of the eyes is authentically Donatello's work (Janson). In *P.-H.* (1958), 272, the opinion is stated that the pupils were probably carved at the very end of the work, in 1415. This presupposes, and I think correctly, that Donatello worked on the figure in two periods: *c.* 1410 and then, when he was less busy and after the essential composition was determined, *c.* 1413–15. The pattern of payments as earlier noted in H. Kauffmann, *Donatello* (Berlin, 1935), would seem to bear out this chronology. This theory does not at all affect the stylistic primacy of the St Mark which Janson wished to preserve. The application of an optical corrective based on presumed optimum viewing distance and position has been studied by Parronchi in connexion with Ghiberti, under the rubric of 'misure degli occhi', *Paragone*, CXXXIII (1961), 18–42. There the two-point medieval 'perspective' of Peckham is invoked rather than the Brunelleschian single-point (Albertian 'centric point') system. The pyramidal visual scheme resulting from Donatello's correction would seem to have a single axis and thus to be related to Brunelleschi's experiments rather than to Ghiberti's and Uccello's adaptation of Peckham as suggested in Parronchi's work. Donatello's optical geometry had the value of an early application of the phrase 'giudizzio dell'occhio' (as 'callipers within the eye') later used by Vasari in speaking of Michelangelo.

p. 58 4. Most complete modern description: W. and E. Paatz, *Die Kirchen von Florenz* (Frankfurt, 1940–54), IV, 480 ff. Convenient summaries in English in *R. K., Ghiberti*, 71–4; *P.-H.* (1955), 209. The attributions in one or two cases given in my summary, particularly as regards the work of the Lamberti and Ciuffagni, differ from the above. On the work of the principal sculptors, Ghiberti, Donatello, and Nanni di Banco, there is today no reason for doubt or disagreement, except possibly in the close details of dating.

p. 60 5. De Vere translation, slightly modified. Vasari used a closely parallel anecdote, for which there is also no method of cross-checking in a document, in describing Michelangelo's method of dealing with a criticism made by Soderini of his marble David of 1501–4. While there is a chance that both anecdotes represent a Vasarian treatment of the age-old *topos* of the professional's ability to fool the amateur, it is still a fact that Vasari applied this type of anecdote only to Donatello and Michelangelo, both occupying a unique place in their generations, both apparently at one time or another interested in the 'giudizzio dell'occhio', and the latter bearing to the former a special relationship of artistic affinity in aesthetic aims.

6. Photographs made by the Soprintendenza alle Gallerie of the empty niche and the backs as well as the fronts of the statues by Nanni show that the two left-hand figures were carved separately and the two right-hand figures in one large block. The backs show slight *reprises* made doubtless in the final fitting, but nothing of the order of the radical solution suggested by Vasari.

7. Now back in this place. Mentioned by Dante; illustrated in A. Chastel, *Art et humanisme à Florence* (Paris–Lille, 1959), plate XLI B.

8. Documentary photographs of all these pieces p. 64 by Nanni are available at the Soprintendenza alle Gallerie in Florence. See the fine photographic series by Mallenotti (now I.D.E.A.) in R. Vaccarino, *Nanni* (Florence, 1951), plates 44–97. The chronological order of the Or San Michele statuary used here is essentially that of Planiscig, Paatz, and Krautheimer (St Eligius, Four Crowned Saints, St Philip). Vaccarino's order differs (Four Crowned Saints, St Philip, St Eligius). I would place all this statuary stylistically within the bracket 1412–15, with most of 1414 out because of heavy civic duties away from Florence. The frontispiece of the Porta della Mandorla is better documented: see Vaccarino, *op. cit.*, 47–8, with the majority of payments coming late, i.e. 1418 on. This would indicate a slow start after 1414 (date of commission). The style is somewhat mixed, indicating assistants' hands; one I would identify with the beginning phase of Luca della Robbia: C. Seymour, Jr, 'The Young Luca della Robbia', *Allen Memorial Art Museum Bulletin*, Oberlin, XX (1963), following a line first suggested in *P.-H.* (1958), 26.

9. The problem of representation of the angels' flight is treated by H. W. Janson in *Acts of the Twentieth International Congress of Art Historians*, II (Princeton, 1963).

10. The phases of revision of the Fonte Gaia p. 65 programme based on the drawing on parchment divided between the Metropolitan Museum of Art and the Victoria and Albert have been recently studied by R. Krautheimer in *Bulletin of the Metropolitan Museum of Art*, X (1951) and in Dr Anne

Coffin Hanson's monograph on the Fonte Gaia (dissertation, Bryn Mawr, 1961, published by the Oxford Press, 1965). Mrs Hanson argues against Francesco di Valdambrino's part in the programme, returning the right-hand standing female figure ('Rhea Silvia') to Quercia. The evidence against Francesco's part is in part circumstantial, and repairs to the figure in question have altered the impression of its style; nonetheless Mrs Hanson has argued positively for Quercia's hand.

p. 65 11. U. Middeldorf, 'Dello Delli and *The Man of Sorrows* in the Victoria and Albert Museum', *B.M.*, LXXVIII (1941), presents the most recent treatment of Dello Delli as a sculptor. Possible relationships with Luca della Robbia's beginnings in terracotta are suggested in C. Seymour, Jr, *loc. cit.* (Note 8).

p. 66 12. The finest description of Donatello's style in this relief is in *H.W.J., Donatello*, II, 77–8.

13. A critique of the views of White (in *Birth and Rebirth of Pictorial Space*) and of Janson (in *H.W.J., Donatello*) is given in *P.-H.* (1958), 273. Pope-Hennessy sees a discrepancy between a relatively primitive use of linear perspective and a relatively advanced rendering of space and atmosphere. He argues from this that *stiacciato* reliefs were in 'a high degree of probability' produced by Donatello before this one (date left uncertain). A preliminary phase of Donatello's *stiacciato* relief was later proposed by Pope-Hennessy as present in the Baptism relief of the font in the cathedral of Arezzo: 'Some Donatello Problems', *Studies ... dedicated to ... Suida* (New York, 1959), 47–52. The relief in question had been attributed by F. Schottmüller in 1909 to Donatello, but in the period between the St George relief and the Victoria and Albert Giving of the Keys of about 1425. Kauffmann had related the Arezzo relief to the period of the Siena bronze relief (stylistically difficult to follow today because of the difference in media) and to an assistant (still plausible). The Arezzo Baptism seems to me closer to Michelozzo in several details than to Donatello. This line of thinking would lead towards a further investigation, not only of Michelozzo's earliest marble style, but also of his relationship as 'compagno' to Donatello *c.* 1423–5. As far as I can judge at present, Donatello's earliest extant relief style is still to be found in the St George relief.

p. 67 14. The most recent candidate for the lost 'David of 1412' or 'David II' is the Martelli David (now in Washington, National Gallery of Art; proposed by Janson, in *H.W.J., Donatello*, II, 21–3; reasons against this theory are given in Chapter 4, Note 21). The documentation in G. Poggi, *op. cit.* (Note 1), 33, document 199, is ambiguous: '... Donato Nicolai Betti, pictori, pro faciendo picturas S. Johannis evangeliste e David profete ...' (date of 12 August 1412). The most likely interpretation within the context of Donatello's payments advanced by the Operai over the period 1410–15 seems to me to be that the advance made on 12 August 1412 refers to a commission only of this 'David profeta' and that the design, perhaps a coloured drawing, for this projected statue was so far uppermost in the mind of the recorder that the words *pictor* and *picturas* crept into the text (see Introduction, p. 5, for a general discussion of the usage of *pictor* for *sculptor* in Florence). It would seem that money was to be advanced at this time to block out the figure at the quarry, for the question of the material is brought up under the same heading as in the future (subjunctive of the verb, *deficiat*). A search of the documents published by Poggi between 12 August 1412 and 8 October 1415, when the St John Evangelist was finally paid up in full, indicates that only advances to account for the total of 150 florins for the St John were made in that period. The inference must be that there were no further advances made on the David of 1412 and at best it remained a roughly blocked out *figura*. This *figura* could well have been sold to the Arte del Corazzai in 1415, and that it was from it that the St George was carved by Donatello (see Siebenhühner's report of a document of sale in *Kunstchronik*, VII (1954), 266 ff.). A negative result arises from the interpretation of the document of sale by Siebenhühner, which has been shown by Wundram to have had nothing to do with the sale of the marble for statuary, but instead with the purchase of guild property by the Operai of the Duomo. Nevertheless, the 'document' aside, there are several reasons favouring the possibility of the sale of the roughed out 'David II' *figura* to the Corazzai, as follows:

(1) The 'David II' completely disappears from the Duomo documents after 1415. (2) A new solution for the exterior Prophet series is seriously proposed by Donatello and Brunelleschi in precisely that year, which would have made the marble Duomo Prophet series obsolete, thus releasing the 'David II' block. (3) Furthermore, the over-lifesize scale of the St George would have corresponded to the over-lifesize block that we should assume was ordered in 1412 (if the proposed size of the 'David

II' were not somewhat over-lifesize, how could the problem of scale be better met than with the lifesize statue of the 'David I' in 1408/9?). Another candidate for the metamorphosis of the 'David II' might be the so-called 'St John the Baptist' of the campanile series (see also Note 16, below). However, this last statue was, though a little over lifesize in scale, carved in two pieces, the head being a separate piece. The conclusion must be that a block was used for the body of that two-piece statue smaller than the block supposed to have been ordered for the 'David II'. (4) One should add that the sale by the Operai of the Duomo of the 'David II' *figura* roughed out by Donatello in 1412 to the Corazzai in 1415 would ensure that the sculptor of the guild's St George could proceed from his own starting point and not from another's. Donatello's position in Florence in 1415 was sufficiently eminent to secure this advantage, which it is inconceivable he would have let pass if there was a choice. (5) Finally, work on the St George in 1415/16 would explain why Donatello was so slow in starting and finishing his two Prophets, commissioned in 1415 for the campanile.

15. G. Poggi, *op. cit.* (Note 1), 77, document 417.

p. 68

16. See primarily J. Lányi, 'Le Statue quattrocentesche dei Profeti nel campanile e nell'antica facciata di Santa Maria del Fiore', *Rivista d'Arte*, XVII (1935), 121–59; *H.W.J.*, *Donatello*, II, 33–41; *P.–H.* (1958), 276–8; A. Nicholson, review of Janson, *A.B.*, XLI (1959), 203 ff.; M. Wundram, 'Donatello und Ciuffagni', *Zeitschrift für Kunstgeschichte*, XXII (1959), 85 ff.; W. R. Valentiner, 'Towards a Chronology of Donatello's Early Works', *Festschrift Friedrich Winkler* (Berlin, 1959), 71–83; R. and N. Stang, 'Donatello e il Giosue', *Acta ad archeologiam et artium historiam pertinentia* (Institutum Romanum Norwegiae), I (1962), 113–30. I am grateful to Professor Irving Lavin for bringing the Stang article to my attention.

Just at present disagreement centres primarily on the attributions to be given to the so-called 'St John the Baptist' and the Prophet at one time identified as a 'Poggio Bracciolini'. The first has been identified with the *figura* of 'David as Prophet' ('David II') of Donatello, mentioned in 1412–15 (Valentiner in 1959, but the theory was outlined verbally by Prof. Middeldorf already in 1955). The preferable attribution to Rosso has the backing primarily of style and a number of documented payments (Lányi and Janson), but very possibly the design was initially provided if not greatly influenced by

Donatello; most recently it has been given to Rosso, Donatello, and Ciuffagni and dubiously identified as the intended 'Joshua' from the documents (R. and N. Stang). The separately carved head has been given to Rosso by Janson, but I can see none of Rosso's soft charm in it and feel it could well be by Donatello himself, or at least on his *modello*.

The second controversial piece is the so-called 'Poggio', which recently has been once more given back in part (the separate head) to Donatello, with the body to Rosso (R. and N. Stang). This is a thesis which I cannot follow from the point of view of style. The statue, on the contrary, seems most likely to have been the 'Joshua' spoken of several times in the documents that was begun by Ciuffagni in 1415–17 and reassigned to the firm of Donatello and Rosso in 1420 (Janson and Wundram). Janson has well pointed out that the head is not a first step toward the Beardless Prophet of 1415–18 but a slightly later 'specimen of Donatello *maniera*'; I cannot agree, though, that it is by Rosso. Surely it is by Ciuffagni (Wundram), and is to be linked with 'a marble head' of Poggi's document 270 for 4 April 1424 (*Duomo di Firenze*, 47).

17. *P.–H.* (1958), plate 17. p. 69

18. The relation of the modern psychological p. 70 notion of the body-image applicable to Donatello's work has been treated by Dr Hellmut Wohl, M.A. thesis (typescript), New York University, 1952.

19. *R. K.*, *Ghiberti*, plates 3–5. p. 71

20. O. Morisani, ed., *Commentarii* (Naples, 1947), 210–12. Cf. Leonardo's drawing of Vitruvian 'Man'.

21. For the most recent discussion of the niche p. 72 as an architectural setting and the statue's place within it, see M. Lisner in 'Zur frühen Bildhauerarchitektur Donatellos', *Münchner Jahrbuch der bildenden Kunst*, 3rd ser., IX–X (1958/9), 72–7.

22. *R. K.*, *Ghiberti*, plates 14–17. p. 73

23. This superb piece is identifiable with one cited by Manetti; at no time was the statue in the Gondi Chapel attributed to any other artist than Brunelleschi. Though the argument for accepting this Crucifix as his is based on silence with regard to alternative attributions, one can think of no other sculptor to whom the Crucifix, which is of totally convincing quality and stylistic character, might be given. Recently (1961) cleaned. Accepted by Sanpaolesi (1962).

24. The Donatello Crucifix of the Vasari story is generally still identified with that in S. Croce:

H.W.J., *Donatello*, I, plates 7–10. For a recent rival claimant see A. Parronchi, 'Il Crocefisso di Bosco a Frate', in *Scritti in onore di M. Salmi* (Rome, 1962). Janson's position to the story retailed by Vasari is sceptical; perhaps unduly so in that it tends inevitably to remove from our natural view the possibility of finding and believing in the Crucifix by Brunelleschi. On the other hand, his positive opinion on Donatello's authorship, rather early (*c.* 1412), of the wooden Crucifix in S. Croce seems to be completely justified on stylistic grounds, even though documentary evidence is lacking.

CHAPTER 4

p. 76 1. *H.W.J.*, *Donatello*, II, 59–64. A contrary opinion is given more recently by M. Lisner, in *Münchner Jahrbuch der bildenden Kunst*, 3rd ser., IX/X (1958/9), 79–81, with the most up-to-date publication of the Calimala documents, *ibid.*, 117.

p. 77 2. *H.W.J.*, *Donatello*, II, 64.

3. P. Bacci, *Jacopo della Quercia* (Siena, 1929), 275. The documents are presented in two parts: (1) the origins of the font, 79–147; (2) the tabernacle, 153–276.

p. 80 4. J. White, *The Birth and Rebirth of Pictorial Space* (London, n.d.), 149.

p. 81 5. A. Parronchi, in *Paragone*, CXX–CXXI (1959). The principle invoked is the medieval *perspectiva communis*, as presented by John Peckham, rather than the *construzione legittima* as codified by Alberti. It is important to note that the title of the Siena relief as given by a document of 1427 stressed not the Dance of Salome but the 'unnatural' aspect of the story: 'Quando fu recata la testa di san Giovanni a la mensa de re'.

p. 82 6. This may be a characteristically Querciesque method of interpreting by architectural style the Late Medieval contrast between the Temple under the Old Law (Romanesque) and the Temple under Grace (Gothic) first brought out by Panofsky in connexion with Netherlandish painting (see *P.-H.* (1955), 212), though the comparison with Ghiberti's St John before Herod is not strictly apposite since the architecture, though 'modern', is not Gothic, nor does it represent the Temple. We probably have to deal here with a 'cousinly' relationship with the northern tradition rather than with direct relationship of descent from the north.

p. 83 7. See the Madonna and Child with flanking saints and rather monstrous kneeling donor of the lunette of S. Lorenzo at Vicenza, illustrated in *Storia* (1908), figure 4.

8. J. Beck, 'An Important New Document for Jacopo della Quercia in Bologna', in *Arte Antica e Moderna*, XVIII (1962). Dr Beck's further finds, including the very important 'rediscovery' of the copy of Quercia's drawing for his final scheme,

form part of his doctoral dissertation for Columbia University. The chronology presented here follows his meticulous analysis of the documentation and elements of the architecture and the sculpture on the monument. When published, Beck's work will supersede the older publication of the documents in I. B. Supino's monograph *Le Porte di S. Petronio* (Florence, 1912).

9. See C. Seymour, Jr, in *Acts of the Twentieth International Congress of the History of Art* (1961) (Princeton, 1963), I, 207–26. p. 84

10. During the course of study and photography on a scaffold in 1955, a superficial cleaning of the jamb-sculpture was attempted. The difficulties were too great to complete the job (which one day one hopes fervently will be done, for the health of the sculpture if not for its more effective presentation); but I could ascertain then that one of the jamb-reliefs was coloured green. There was no way then of establishing the date of the colour, but it did seem to cover the relief completely. Conceivably the reliefs were intended to imitate Antique bronze; this at least is a possibility, given the style of the sculpture. p. 85

11. P. Bacci, *op. cit.*, 279–350.

12. J. Pope-Hennessy, *Donatello's Relief of the Ascension, etc.* (Victoria and Albert Museum, London, 1949), 11–12. p. 86

13. See *H.W.J.*, *Donatello*, II, 37–40.

14. The attribution to Imola is suppositious only but seems to have good stylistic reasons behind it (Carli). The Madonna of this S. Martino group is by a different hand, closer to Quercia's own. Possibly Federighi is present here. p. 87

15. Documents for this hiatus in the sculpture of the Duomo are given in G. Poggi, *Il Duomo di Firenze* (Italienische Forschungen, Kunsthistorisches Institut in Florenz, II) (Berlin, 1909), 52.

16. *H.W.J.*, *Donatello*, II, *loc. cit.*; documented in Poggi, *op. cit.*, documents no. 322–3, 57–8. The expression of the figure admirably carries out the biblical text of Habakkuk, 1:2: 'Why dost thou shew me iniquity, and cause me to behold grievance? for spoiling and violence are before me: and there are that raise up strife and contention.' Or

even more appositely for its intended place on the campanile (2:1): 'I will stand upon my watch and set me upon a tower and will watch to see what he will say unto me and what I shall answer when I am reproved.'

p. 87 17. The *Catasto* document of 1427, with other documents for Michelozzo, was most recently published by R. G. Mather in *A.B.*, XXIV (1942), 226–39. See also G. Marchini, in *La Rinascità*, VII (1944), 37 ff. The older literature contains the studies of C. von Fabriczy, 'Michelozzo di Bartolommeo', *Berlin Jahrbuch*, XXIV (1904), and F. Wolf (1900). The unpublished doctoral dissertation on Michelozzo by H. W. Janson is on deposit in Harvard University. The best recently-published study of the life and works of Michelozzo, with considerable attention to the sculpture, is O. Morisani, *Michelozzo Architetto* (Florence, 1951).

p. 88 18. For the documentation of the Brancacci monument see Mather, *op. cit.*, Morisani, *op. cit.*, 87–8, and *H.W.J.*, *Donatello*, II, 88–92. Morisani feels that the major part of the work of assembly and construction in Naples was done by the still stylistically vague assistant in the Donatello–Michelozzo firm, Pagno di Lapo Portigiani: and that Michelozzo might have come to Naples in connexion with the commission but only for a short visit. The inscription is generally considered today to date from the time of the installation of the sculpture, and is therefore not a later seventeenth-century addition, as sometimes thought. The occasionally published opinion that the head of the central Virtue and of the effigy are by Donatello seems to be without foundation; the technique is precisely the same for those parts as in the parts recognized by all to be Michelozzo's. An interesting transposition (in reverse) of the right-hand Virtue is found on the otherwise *retardataire* monument of Cristoforo Gaetani at Fondi (Arch. Fotograf. Gall. Mus. Vaticani, XI-25-6).

19. Summary of documentation in O. Morisani, *op. cit.*, 88–9. The famous letter from Bruni to Poggio Bracciolini is not dated, but could be possibly of 1430 or thereabouts; it enumerates the parts of the monument then reported as seen as follows: '... imago eius, quam cernis, altera vero parentis, quam iuxta se collocari iussit ... columnae marmoriae, et statue due non satis fabricatae basesque et arculi et hipostilia ...'. What the 'other image of his father' might be is hard to say; most likely it refers to one of the two reliefs, with Aragazzi's 'Farewell to his Family' (Plate 36B),

intended to be near, i.e. 'beside', the effigy; the 'statue due' phrase surely refers to the 'Hope' and 'Faith' (Plate 35A) now on the cathedral altar. This would leave the V. and A. angels and the St Bartholomew for a post-Roman phase. A document of 1437 enjoins Michelozzo to finish the sculpture and get the monument up without further delay. This suggests a finishing date of *c.* 1438; but payments were still due as late as 1469.

20. See *H.W.J.*, *Donatello*, II, 100. Discussion of p. 89 the work by, or at times falsely attributed to, Donatello while in Rome is found, *ibid.*, 95–102, 232–5. Besides the tomb-slab in the Aracoeli, the major work is the marble tabernacle now in the Sagrestia dei Beneficiati in St Peter's (undocumented). For the reconstruction of the altar-tabernacle of the papal Chapel of the Sacrament (originally in the Vatican) of which it was most probably a part, see V. Martinelli, in *Commentari*, VIII (1957), 167–94. For the identification of a relief now in Torrita as a further part of the *ensemble* see J. Pope-Hennessy, in *Studies in the History of Art*, *dedicated to William E. Suida* (New York, 1959), 57–9. Pope-Hennessy rightly rejects Martinelli's suggestion that the Victoria and Albert Giving of the Keys was part of the Vatican altar, but his doubts as to Michelozzo's part in the Victoria and Albert Dead Christ and Angels do not seem so well founded; the stylistic comparison with a part of the first of the reliefs on the Prato pulpit is a good one, but there may be other conclusions to be drawn (see below, Note 26). To sum up, there is seriously nothing against the part of Martinelli's thesis that would bring together the St Peter's tabernacle and the Dead Christ and Angels of the Victoria and Albert as prime parts of an altar on which Donatello, Michelozzo, and at least one unnamed assistant worked in Rome; Pope-Hennessy's addition of the Torrita Risen Christ to that programme seems wholly justified, as does the rejection of the Victoria and Albert Giving of the Keys. Martinelli's reconstruction of the Altar of the Sacrament in the Vatican is important because it supersedes Gnoli's earlier theory that the tabernacle now in the Sagrestia dei Beneficiati was originally intended, purely as a wall-tabernacle, for a place in St Peter's (followed by Janson); here then is the model for Desiderio's later Altar of the Sacrament in S. Lorenzo and Sansovino's still later Altar of the Sacrament in S. Spirito (both in Florence).

21. Until a few years ago the usual dating of p. 90 Donatello's Bargello bronze David was considered

to be in the post-Paduan 1450s (Kauffmann). For reasons of style, the statue must now be dated in the post-Roman 1430s (*H.W.J.*, *Donatello*, II, 77–86). The so-called Martelli David in marble (now in Washington) was considered until fairly recently to be from the post-Roman 1430s. It has been suggested by Janson that it should be dated earlier, in or about 1412, or possibly 1420–30 (*H.W.J.*, *Donatello*, II, 21–3). Still more recently, it has been suggested that the Martelli David is not by Donatello, but instead by Antonio or Bernardo Rossellino (J. Pope-Hennessy, in *B.M.*, CI (1959), 134–9, as by Antonio; F. Hartt, in *B.M.*, CIII (1961), 387–92, as by Bernardo). In this unusually wide divergence of opinion, I prefer to stay, in Janson's company, with the older attribution to Donatello, though Janson's argument for a 1412 dating from the Duomo documents does not seem well founded (for the 'David of 1412' see my remarks in the previous chapter). The stylistic data indicate to me a date in the 1430s, in the period of the Michelozzo partnership, for the original carving (before later emendations); and the reason for Donatello's failure to finish the piece would appear to be that he, probably with Michelozzo as collaborator, ran into insurmountable difficulties in trying to adjust its parts to a modular system of proportions. This marble David and the bronze David appear to be in their measurements uniquely close in Donatello's statuary to the Albertian modular system appended to *De Statua*. As both Kauffmann and Janson pointed out, the modular system so rigorously applied to the marble relief of Herod's Feast at Lille is unique in its genre and shows Albertian influence from *Della Pittura*. Janson's dating of the Lille relief is 1433–5 (*H.W.J.*, *Donatello*, II, 129–31), and this would thus key into the supposed date of the marble David. The bronze David seems to represent a second and more successful application of the modular system to statuary (the hat a memory of Alberti's *definitor* device set on the head of the statue to aid in control of measurements). Of course a modular system of the precision of Alberti's would be far easier to apply to a statue by the process of addition in modelling than of subtraction in carving. The 'modular' David commission was probably Medician (see Kennedy's convincing argument transmitted by Janson). From the possession of the Medici the unfinished marble David would have passed finally into the hands of the Martelli, and it would be as a kind of collector's status-symbol as well as a political symbol that the image of the marble David appears in Bronzino's

Martelli portrait of the sixteenth century. Even should we discount the very serious difficulties in matters of style that still plague an attribution to either Rossellino brother, there does not seem to be a comparable reason for the appearance of the Martelli David's representation in the Bronzino portrait, or indeed for the existence of small-bronze statuettes that are related to the Martelli David, if it were no more than an unfinished cast-off begun by Antonio or Bernardo Rossellino. The student should be warned that the tentative and unfinished character of the piece, together with the later re-cutting of some key-passages, will continue to present difficulties of interpretation; there will probably always be an area here of some disagreement.

22. A. Marquand's monograph (Princeton, 1914) p. 92 remains basic for documentation, but the older literature is becoming rather dated; a good recent summary is L. Planiscig's (Florence, 1948).

23. *P.-H.* (1958), 26; C. Seymour, Jr, in *Allen Art* p. 93 *Museum Bulletin* (Oberlin College), XX (1963), 92–119.

24. For a time these were identified with the bronze pair in the Musée Jacquemart-André, Paris, and were associated with Donatello's Cantoria. They were eliminated from Donatello's *œuvre* in 1939 by Lányi, who attributed them to Luca as part of his Cantoria. Stylistically the putti are impossible for Luca, and seem instead to be within Donatello's orbit, possibly by a follower in North Italy.

25. G. Poggi, *op. cit.*, documents no. 1295, 1299. p. 94 These seem to provide the first evidence that a long block ('lapidem marmoris sepulture') rather than a shorter square block was the unit finally selected by Donatello. For discussion of the change in course of work and in division of the work between Donatello and assistants see *H.W.J.*, *Donatello*, II, 127–9.

26. Documents were most recently published by p. 98 M. Lisner, in *Münchner Jahrbuch der bildenden Kunst*, IX/X (1958/9), 117–24; for summaries of the work and chronology, G. Marchini, *Il Duomo di Prato* (Milan, 1957), 57–61; see *H.W.J.*, *Donatello*, II, 108–18; and *P.-H.* (1958), 275. The distribution of hands on the reliefs is a matter still undecided. One panel was finished in 1434 by Donatello according to a letter of Matteo degli Organi (of Prato, but then in Florence). Donatello's 'own' panel is identified as panel No. 3, reading from left to right,

of the parapet (Cruttwell), No. 4 (Marchini), No. 3 or 4 (Janson), and only possibly No. 4 (Pope-Hennessy, who does not feel that the panel of 1434 need be autograph). No. 3, to my eye, seems the earliest from the point of view of style and the closest to the Roman period; perhaps these are sufficient reasons, besides the subjective one of quality of design and execution, to give it to Donatello himself as of 1434. It is hard to be at all sure. The heads of the two right-hand figures of No. 1 seem to me to be by Michelozzo; the other heads show two quite different styles, neither of them likely to be from Donatello's own hand, though his influence is of course pervasive throughout. No. 1 is linked by Pope-Hennessy with the 'assistant's hand' of the Victoria and Albert Dead Christ and Angels.

CHAPTER 5

p. 99 1. The Lamberti in Venice still require a great deal more study; see G. Fiocco, in *Dedalo*, VIII (1927/8), 287–314, 343–76, and L. Planiscig, in *Jahrbuch der Kunsthistorischen Sammlungen in Wien*, N.F. IV (1930), 47–111. Margit Lisner more recently has proposed that the younger Lamberti, just before removing to Venice, collaborated with Donatello on the arch of the Onofrio Strozzi tomb in the sacristy of S. Trinità in Florence (in *Münchner Jahrbuch der bildenden Kunst*, 3rd ser., IX/X (1958/9), 94–100). In Venice the elder Lamberti appears to have worked solely on the sculpture of the upper portions of the exterior of St Mark's; the son helped him there and, with Giovanni di Bartolommeo da Firenze, may well have done the tomb of Raffaelle Fulgosio in the Santo in Padua; with Giovanni di Martino da Fiesole he certainly did the monument of 1423 to Tommaso Mocenigo in SS. Giovanni e Paolo in Venice. After this he worked in Verona and in Venice, again on the Cà d'Oro. He may have worked on the Justice capital and the Solomon relief of the Doge's Palace (Pope-Hennessy), which is also more definitely given by others to Nanni di Bartolo (Mariacher).

p. 100 2. *Storia* (1908), 212–22; *P.-H.* (1955), 217–18. See also L. Planiscig, *loc. cit.*, 76–88. Nanni is last mentioned as at Carrara, presumably roughing out a statue, as late as 1451.

3. The article which fixed the identity of the 'Master of the Pellegrini Chapel' as Michele da Firenze was Fiocco's in 1932 (see Bibliography).

Michele's work in North Italy is strongly coloured by Ferrarese and Venetian styles. Attributable to him before his northern sojourn is the Rozzelli tomb in S. Francesco at Arezzo; he was at Ferrara in 1441 and Modena very possibly in 1442 (altar in the cathedral there). A contrary view by Balogh is cited by Pope-Hennessy, who holds on the whole to the picture given above: see *P.-H.* (1955), 216.

4. Authorship of this important link between the first and second halves of the Quattrocento in Venice is still unclear, though discussed since the days of Paoletti and Planiscig. There are probably at least two hands involved, a factor which explains earlier difficulties in attribution (see the Charity and compare with the Resurrection adjoining as illustrated in *Storia* (1908), figure 65). The most recent tendency has been to see Nanni di Bartolo as the sculptor. The monument was given by Scipione Bon, who had first intended it to be his own tomb. The inscription under the sarcophagus gives the date 1437 as that of the burial of the Beato Pacifico in it.

5. L. Planiscig, in *Jahrbuch der Kunsthistorischen* p. 101 *Sammlungen in Wien* (1916), 176–98. Pierpaolo, who apparently died in 1403, probably began the Madonna; the remainder would have been completed by Jacobello.

6. L. Planiscig, *Venezianische Bildhauer der Renaissance* (Vienna, 1921), 14–20. Earlier scholarship had given the altar either to Giovanni Buon or to Bartolommeo Buon. As discussed below, it is my feeling that the authorship of the altar should for the time being be left anonymous.

7. The chapel was begun after 1422 (L. Paoletti, *L'Architettura e la scultura del Rinascimento a Venezia* (Venice, 1893), 50). A likely date for the relief would then follow as *c.* 1430. Venturi's attribution to Bartolommeo Buon (*Storia* (1908), 987) is not accepted in the modern literature.

8. *R. K., Ghiberti*, 5, 140.

9. The variant positions of Planiscig, Venturi, p. 103 and Fiocco are summarized in *P.-H* (1958), 221–2. Planiscig returned to the older traditional attribution to the Buon; Venturi opted (*Storia*, 1908) for Nanni di Bartolo; Fiocco backed Piero di Niccolò Lamberti. The Lamberti attribution, but with the possibility of Nanni's authorship, is followed by Pope-Hennessy himself. Mariacher has supported the attribution to Nanni and has suggested the dating 1429, 'the year Rosso, as he was called, was

in Venice' (G. Mariacher, *The Ducal Palace of Venice*, tr. M. V. Heberden (Rome, 1956), 21).

10. E. Maclagan and M. H. Longhurst, *Catalogue of Italian Sculpture* (Victoria and Albert Museum, London, 1932), I, 100; summarized and illustrated in *P.-H.* (1955), 224, plate 108. The documentation for the Porta della Carta is to be found in Paoletti, *op. cit.*, vol. I. For the Buon shop see also *P.-H.* (1955), 223, and L. Planiscig, in *Jahrbuch der Kunsthistorischen Sammlungen in Wien*, N.F. IV (1930), 47–111.

11. G. Mariacher, in *Le Arti*, II (1941), 193–8. See also Bibliography under Antonio Bregno. The attribution of the lower Virtues of the Porta della Carta to Bregno is Planiscig's, to Lamberti Mariacher's.

p. 105 12. The most detailed study of the medals and their sources is by Stephen Scher in his M.A. thesis, still unpublished, for the Institute of Fine Arts, New York University, 1961. The fullest treatment of the Duc de Berry medals in their important and complex relationship to northern enamels and illuminated manuscripts is by P. Verdier, in *Journal of the Walters Art Gallery*, XXIV (1961), 9–39. See for their iconography the earlier study by E. Panofsky in his *Studies in Iconology* (Princeton, 1940). In the recent opinion of Roberto Weiss, a major source of Pisanello's medallic style is to be found in these two medals, which he ascribes to Michel Saulmon working in Paris in 1401 or 1402.

p. 106 13. See E. Wind, *Pagan Mysteries of the Renaissance* (New Haven, 1958), 39–56, 79–80. The vast repertory of medallic emblems is given in Hill's *Corpus of Italian Medals etc.* (London, 1930). This still remains the best treatment of Pisanello and of those who followed him in the medallic art.

p. 108 14. O. Morisani (ed.), *Commentarii* (Naples, 1947), 45: '. . . mi fu data licenza [che] io la conducessi in quel modo ch'io credessi tornasse piu perfettamente e piu ornata e piu ricca'. For this summary of the programme's history I am following Krautheimer's excellent presentation, to which the interested reader is referred: *R. K., Ghiberti*, 169–88.

15. *R. K., Ghiberti*, 180–8, in particular.

p. 110 16. For the most recent general discussion of the origin of the Renaissance genre of small-bronzes see *P.-H.* (1958), 99–106, and in briefer form in his introduction to the English, Italian, and Dutch versions of the catalogue of the important Exhibition of Renaissance Bronzes held in London,

Florence, and Amsterdam in 1961–2 (see Bibliography, p. 277). That the creator of the Renaissance bronze statuette was Donatello, as claimed, is doubtful. The earliest known Quattrocento small-bronze statuette is the St Christopher in the Boston Museum of Fine Arts, which is not mentioned by Pope-Hennessy. The Boston figure is dated by inscription, to my knowledge never questioned, as of 1407 – or a good two decades before Donatello's putti or Virtues of the Siena baptistery font. The Boston bronze was published by Dr G. Swarzenski in the Museum *Bulletin* as by Nanni di Banco, but it seems to be much closer to the style of Niccolò Lamberti, as in *c.* 1405. The two Saints in the museum of Città di Castello, next in line of date, are now dated *c.* 1420 and are most authoritatively attributed to the workshop of Ghiberti rather than to the master's own hand (see *R. K., Ghiberti*, 119 ff., figure 42). If the original design for the Siena font was Ghiberti's in 1417 (see p. 77 above), he, and not Donatello, should be credited with the *idea* of the statuettes at Siena, which only about 1423 or apparently after his first contact with the Siena programme Donatello adapted for the decoration of the crozier of his St Louis of Toulouse.

17. *R. K., Ghiberti*, plate 138B.

18. The older theory of the chronology of the Gates of Paradise (beginning with Schlosser) interpreted the documentary evidence to read that only four of the panels were cast before 1437 and that the last four were cast between 1443 and 1447. The basis for so late a dating of the panels was shown to be fallacious by Krautheimer, whose reconstruction of events is followed here (*R. K., Ghiberti*, 162–8).

19. *R. K., Ghiberti*, 229–30, 234–41, 244–9. Kraut- p. 111 heimer does not go so far as to say that Ghiberti's Isaac panel was designable without Alberti's theory, but he points out that whatever Ghiberti may have taken from *Della Pittura* he either consciously modified to suit his own ideas or failed to grasp as parts of a completely coherent, interlocking logical system.

20. In comparison with Krautheimer's careful and sceptical approach, the brief analysis of the Isaac panel by White, in *The Birth and Rebirth of Pictorial Space* (London, n.d.), 162, appears sketchy; but its conclusion may in a symbolic way be retained as a guide to Ghiberti's interests. The drama of Ghiberti's effort was in the conflict of more or less pure theory (as in *Della Pittura*) and the respect for the position of the observer's eye. The latter he might well have had instinctively himself, but he would have found it confirmed by Brunelleschi

and Donatello. Still a third view of the question, which supposes the application of an aspect of Peckham's medieval *perspectiva communis* as well as the more pragmatic approach of the 'misura degli occhi', has more recently been given by A. Parronchi in *Paragone*, CXXIII (1961), 18–48.

p. 114 21. For liberal illustration and discussion of the old sacristy doors, see *H.W.J.*, *Donatello*, I, 216–31; II, 136–40. The stuccos are discussed earlier, *ibid.*, 133–6.

p. 115 22. Antonio Manetti, ed. E. Toesca (Florence, 1927), *Vita di Brunellesco*, 65 ff. An interpretation minimizing the actual disagreement is given by Janson, *op. cit.*, II, 138–40.

23. Filarete, ed. v. Oettingen, *Trattato dell'Architettura* (Vienna, 1890), 298.

24. *Storia* (1908), 524–44, and *P.-H.* (1958), 332, provide summaries of Filarete's career. I am following here Professor Spencer's views on the catalogue of his sculpture. Filarete still presents problems. There is above all no clear picture of the circumstances of his removal to Rome. Did he come to assist Donatello and Michelozzo? Or did he, with Bernardo Rossellino, come to take their places in the projects undertaken for Eugenius that were still unfinished? I would lean towards the latter alternative. This would account for his part in the tomb of Martin V and the position he fell heir to on the doors of St Peter's. Both commissions would otherwise puzzle us, since of his earlier qualifications for such important undertakings there is absolutely no trace in Florence.

p. 116 25. The doors were cleaned under the direction of the Vatican authorities with acids which I have been informed in no way damaged the surfaces; but their action required an artificial patina, after cleaning, to tone down the over-bright appearance of the cleaned coppery bronze. The amount of detail now visible is in extraordinary contrast to their former state. I am indebted to Professor Spencer for his reports of the cleaning of the doors as it progressed and for the use of photographs made under his direction; also to Dr Redig de Campos, Curator of Works of Art in the Vatican, for his friendly cooperation in the study of the doors after cleaning. Indications of the iconographic interest of the foliated borders were earlier provided by Sauer in 1899 and more recently by H. Roeder, 'The Borders of Filarete's Bronze Doors to St Peter's', *Journal of the Warburg and Courtauld Institutes*, x (1947), 150–3.

26. This is true of the older scholars' approach, p. 119 such as M. Reymond's (*La Sculpture florentine*, Florence, 1897–1900). A. Marquand in his still fundamental monograph (Princeton, 1914) lists no glazed terracottas before the Cantoria. The so-called 'Figdor Mirror', figure 20, if authentic, would be rather later.

27. Somewhat opposed to this traditional view p. 120 of the origin of the glazed work is that the function of the 'terra invetriata' was in the first instance not 'preservative' but 'colouristic', by which is meant that the aim was not simply to substitute one substance and medium for another: see *P.-H.* (1958), 28–9.

28. A. Marquand, *op. cit.*, 79–84, 183–200, figures 44–7, 120–31. The bronze doors of both sacristies of the Duomo had originally been allocated to Donatello in 1437. Even after his departure for Padua the Duomo authorities held the doors of the south sacristy for him; they were never made.

29. G. Galassi, *La Scultura fiorentina del Quattro-* p. 121 *cento* (Milan, 1949), 37. At one time older scholarship had held the same theory (Bode, Venturi).

30. *Storia* (1908), 605; the document was published by M. Tyszkiewiczowa in her monograph on the artist (Florence, 1928).

31. For the part of Ghiberti, see *R. K.*, *Ghiberti*, p. 122 204, 207. The tabernacle proper is disappointing from the point of view of style and seems to have been executed by several hands; good illustrations in L. Planiscig's short monograph (Florence, 1948), and *P.-H.* (1958), plates 50–1.

CHAPTER 6

1. See *H.W.J.*, *Donatello*, II, 150–1. Documents p. 124 are summarized and sources given, *ibid.*, 151–5. According to Janson's reconstruction, Gattamelata died in January 1443, and Donatello would have come to Padua by the middle of that year; his commissions for the Santo, beginning with the bronze Crucifix, would have come while the final plans for the Gattamelata were hanging fire. The commissions from Venice and attempts to lure the artist to Mantua and Modena came only after the Gattamelata commission was virtually finished entirely.

2. The earliest Sienese representation of the theme in Simone Martini's well-known fresco of Guidoriccio da Fogliano in the Palazzo Pubblico

shows the *condottiere* in contemporary armour, and this is true also of the Scaligeri Monuments in Verona and the Bernabò Visconti Monument in Milan and of the Florentine Quattrocento painted monuments of *condottieri* in the Duomo which date from the 1430s and 1450s. Presumably it was true of the destroyed bronze monument of Niccolò III d'Este of 1441–51 as well: see W. Haftmann, *Das italienische Säulenmonument* (Leipzig, 1939), 145 ff. The evidence is summarized and Antique precedents listed by Janson (*H.W.J.*, *Donatello*), II, 157–9.

p. 125 3. See *H.W.J.*, *Donatello*, II, 159–61. There Lányi's over-stressing of the Christian religious symbolism is corrected and the character of the monument as a cenotaph and not as a place of actual burial explained; see also H. Keller, in *Kunstchronik*, VII (1954), 134 ff. The placing in relation to the Santo must, however, have had traditional Christian meaning.

4. The unusually complete documents for the Santo choir screen and altar were published by A. Gloria, *Donatello fiorentino etc.* (Padua, 1895), 5 ff., and with additions and corrections by R. Band in *Mitteilungen des Kunsthistorischen Instituts in Florenz*, V (1940), 334 ff. The evidence is extensively summarized in *H.W.J.*, *Donatello*, II, 163–81. There the schemas of reconstruction of the altar, including his own, are discussed. For Pope-Hennessy's slightly later version of the solution see *P.-H.* (1958), 281–3.

p. 129 5. For the iconography of these remarkable little reliefs see C. Eisler, in M. Meiss (ed.), *De Artibus Opuscula XL, Essays in Honor of Erwin Panofsky* (Princeton, 1961), I, 88. The extant reliefs are difficult to recognize, since they have been worked into the present late-sixteenth-century marble screen without order (illustrations in *Storia* (1908), figures 203, 204, 205).

p. 130 6. See above all C. Mitchell's preliminary study in *Studi Romagnoli*, II (1951), 77–90. Professor Mitchell is preparing a full-length monograph on the programme of the Tempio. I am indebted to him for the approach used here. Photographs most recently published, though not completely, are in C. Brandi, *Il Tempio Malatestiano* (Edizioni Radio Italiana, n.d.). Documents are in C. Ricci, *Il Tempio Malatestiano* (Milan–Rome, 1925). The rediscovered original of Alberti's famous letter to Matteo de' Pasti of 1454 is now in the Morgan Library, New York.

7. Weakened structurally by Allied bombardment of Rimini, which was the anchor for the 'Gothic Line' in the Second World War, the

arcades on both sides, with the façade between, had to be taken down and remounted stone by stone. Funds were provided in large part by the S. H. Kress Foundation. The existing sarcophagi are all on the south flank; none were ever placed on the north.

8. Mitchell, *loc. cit.*, shows the use of Macrobius's p. 132 text in Scipio's Dream and the influence of the neo-Platonically oriented humanists Basinio and Valturio at Sigismondo's court. Pope-Hennessy's illustrated essay on the Victoria and Albert Madonna relief, of which the design (surely Agostino's) is so intimately related in spirit to the Tempio programme, stresses the Platonic element of imagery (Victoria and Albert Monographs, VI, London, 1952). The words of Pius II in his *Commentarii* should be recalled: 'He [Sigismondo] has built a church in honour of St Francis, but he has filled it with Antique images, so that it seems a temple for the worship not of Christ but of the pagan Gods'. This attack was rhetorically polemical, unfair to the fine balance between an 'interpreted' Antique paganism and traditional Christianity towards which Italian neo-Platonism was aiming by 1450. See also G. del Piano, *L'Enigma filosofico del Tempio Malatestiano* (Bologna, 1938); J. Seznec, *The Survival of the Pagan Gods* (New York, 1953), *passim*.

9. H. W. Janson, in *A.B.*, XXIV (1942), 326–34. To his list of work prior to 1450 should be added the Salute relief and one of the sides of the sarcophagus of S. Giustina, with perhaps the face, in the Victoria and Albert Museum (75-1879). See G. Brunetti, in *Commentari*, I (1950), 82–8.

10. *P.-H.* (1958), 87–9. The argument there pre- p. 133 sented does not appear to take into consideration the evident stylistic overlaps between some of the Planet and Zodiac reliefs and the Triumph relief of the Ancestors' sarcophagus, which is connected by a document with Agostino's own hand; nor does the discussion suggest the extraordinarily heterogeneous personal styles of several sculptors in the last chapel, one of whom must be Ottaviano, whose manner turns up before 1461 on some of the S. Bernardino reliefs.

11. For Isaia da Pisa see *P.-H.* (1958), 334. A p. 134 longer and more thorough analysis, though necessarily not more than a preliminary study, is in an M.A. thesis by Miss Mary Davison, dated 1959, deposited at Yale University.

12. L. Planiscig, in *Berlin Jahrbuch*, IV (1933), 16– p. 135 28. The publication of the full and complicated documentation of the arch (the Alfonsine Archive

in Naples was unfortunately destroyed in the Second World War) is given in the Bibliography. See, however, the following for varying interpretations of the data: R. Filangieri di Candida, in *Dedalo*, XII (1932), 439–66, 594–626; W. R. Valentiner, in *A.B.*, XIX (1937), 503–36; R. Causa, in *Paragone*, V (1954), 3–23; *P.-H.* (1958), 330–1. New conclusions which considerably modify the results of earlier studies were reached by Dr George Hersey in his M.A. thesis, Yale University, 1961; these are to be published soon in an up-to-date monograph on the arch and its sculpture. I am following Hersey in the broad area of chronology but not in the detail of attribution.

p. 135 13. *Vite di uomini illustri*, etc., ed. P. d'Ancona and E. Aeschlimann (Milan, 1951). Vespasiano da Bisticci knew Alfonso personally, since he was responsible for helping the king in building up his library in Naples; see F. Hartt, in *A.B.*, XLIV (1962), 160, for some new documents.

p. 137 14. W. R. Valentiner, in *Art Quarterly*, I (1938), 61–87.

p. 138 15. I am indebted to Dr Richard Brilliant of the University of Pennsylvania for a number of leads into the question of Antique prototypes for the sculpture and ornament of Alfonso's arch.

p. 139 16. W. R. Valentiner, *loc. cit.*, and *Studies of Italian Renaissance Sculpture* (London–New York, 1950), 73–5. To Valentiner's examples of this Neapolitan period should be added the striking bust, apparently still in French private possession, published by Planiscig in the *Jahrbuch der Kunsthistorischen Sammlungen in Wien*, which is obviously based on a *modello* by Mino. Mino's possible part in the arch proper is suggested above. For a contrary theory of his origins, see L. Carrara, in *Critica d'Arte*, III (1956), 76–83.

17. For example the head of the effigy in the Bruni Monument in S. Croce, begun *c.* 1445/6. Bernardo's continuing interest in maximum realism in presenting an individual is seen in the Chellini Monument in S. Miniato al Tedesco; see U. Middeldorf and M. Weinberger, in *Münchner Jahrbuch der bildenden Kunst*, V (1928), 85–92. The profile of the monument of Neri Capponi (1457) in S. Spirito belongs in this group. On Chellini's connexion with art, see R. W. Lightbown, 'Giovanni Chellini, Donatello, and Antonio Rossellino', *B.M.*, CIV (1962), 102–4.

p. 140 18. Widener Collection; see *P.-H.* (1958), 303–4, for the most recent discussion of its date. My own position is still to lean towards a relatively early dating; it is Donatello's early relief style and not the post-Paduan style that is reflected in the background, and the method of carving the relief is quite different from the relief style of the 'late' Altar of the Sacrament, particularly that of the antependium relief illustrated on Plate 89B.

19. The possible part of Desiderio in the Villana as well as the Bruni Monument is presented by A. Markham, in *A.B.*, XLV (1963), 35–45. The Villana Monument might be further analysed with a view to identifying participation in some of its details by Mino da Fiesole and Antonio Rossellino. The programme (the terms of the contract notwithstanding) could hardly have been more than designed and begun by Bernardo in the short period between the signing of the contract and his departure for Rome. For the first 'modern' suggestion of Desiderio's training in the Rossellino shop see L. Beccherucci, in *L'Arte*, XXXV (1932), 159.

20. W. R. Valentiner, *op. cit.* (1950, Note 16), 91. p. 141

21. Most recent scholarship, with good reasons, has tended to reduce sharply the content of Desiderio's *œuvre* as established for the most part some decades ago by Bode: see *P.-H.* (1958), 304, and Anne Markham in her review of Cardinelli's book in *A.B.*, XLVI (1964), 239 ff. The Louvre 'Caesar' seems safe, but not the *pietra serena* relief of the Boy Baptist in the Bargello, and probably not the Bargello marble bust of the so-called Giovannino (consider the costume!). Doubtful too seem to be the *pietra serena* reliefs in Toledo, Ohio, and Detroit; not the seated Madonna and Child in the Victoria and Albert. Among the older group of female portraits only the mysterious Bargello Lady holds fast. The remaining portraits of ladies in Berlin, Washington, and the Louvre should be spread among Bernardo Rossellino, his shop, and Verrocchio. The terracotta bust of a deacon-saint in the old sacristy of S. Lorenzo has recently been given to Desiderio (*H.W.J.*, *Donatello*, II, 236–7); it should be given instead, with more likelihood, to the young Verrocchio in the period of the Bargello bronze David of the mid 1460s (see below). Three children's busts representing the Christ Child, but based on portraits or life-studies, still seem surely Desiderio's: two are in Washington (Mellon and Kress Collections, National Gallery of Art) and one in Vienna (the famous Laughing Boy of the Benda Collection now in the Kunsthistorisches Museum).

22. A. Marquand, *Luca della Robbia* (Princeton, p. 142 1914), 136–52.

23. The publication, with C. Kennedy and F. Hartt, by G. Corti of newly-discovered records of the Cambini Bank in Florence straightens out the documentation of most aspects of the chapel and tomb of the Cardinal of Portugal. The chronology given here follows the newly published documentation. Final publication is in Hartt, Corti, and Kennedy, *The Chapel of the Cardinal of Portugal in San Miniato* (Philadelphia, 1964).

24. See F. Hartt, in *B.M.*, CIII (1961), 387–8, who quotes from a study made by Professor Kennedy. In addition to the kneeling angel, Kennedy gives to the same hand the right-hand flying angel, the putto at the cardinal's head, and the right-hand half of the relief of the plinth.

p. 143　25. The ceiling of the S. Giobbe chapel, interestingly enough, is by the Robbia shop, following a scheme based on Luca della Robbia's ceiling for the S. Miniato chapel of the Cardinal of Portugal; see A. Marquand, *op. cit.*, 175–80, 213–19.

p. 144　26. See *Storia*, VI, 485 ff.; Papini, in *Bollettino d'Arte*, IX (1915), 275.

27. The identification of Il Greco's hand in the decoration of the Urbino palace (reliefs on fireplaces, friezes, door-frames, window-soffits) is mainly due to C. Kennedy (see Bibliography). For his use of the Antique in the fireplace frieze illustrated on my Plate 87A, see U. Middeldorf, in *Atti del V Convegno Internazionale di Studi sul Rinascimento* (Florence, 1958), 169–70. For Ghiberti's use of the same material (amended by Middeldorf) see R. K., *Ghiberti*, 291, 344, 348, figures 127–8.

28. The 'penitential style' in Florence during the 1450s stressed imagery both of human innocence (the Boy St John) and of human suffering and physical degradation (St Jerome and other ascetic desert-hermits). The mystical Adorations by Filippo Lippi and Castagno's late SS. Annunziata frescoes of the 1450s may be taken as expressions of the anti-humanist mode which has been treated by Mrs Irving Lavin (*A.B.*) and in public lectures by Professor Hartt, who sees St Antoninus as the leading exponent of this movement in Florentine thought. What has been done for painting could of course be extended to sculpture, though the first phases of the mode in Donatello's work (the Habakkuk and Jeremiah for the campanile) go back into a period as early as the 1420s for their conception.

29. *H.W.J.*, *Donatello*, I, 319–30; II, 187–91. Janson stresses the fact that the ascetic Frari Baptist prefigures the Magdalen, though it was made in Venice in quite a different ambient of ideas and reflects the traditional Byzantine type popular in Venice. Vasari wrote that Brunelleschi made a painted wood Magdalen for S. Spirito (no longer extant). For a more precise dating of the Magdalen, as well as for firmer evidence than hitherto available for Donatello's late activity in connexion with the Duomo colossi in terracotta, see H. W. Janson, in *Studien zur Toskanischen Kunst, Festschrift für L. H. Heydenreich* (Munich, 1964), 131–8.

30. I am following Janson's view as to the　p. 145 probable programme for the Judith. Surely the conception was for a public not a private fountain, a factor which makes the older view (as presented by Kauffmann) that it was originally a Medici family commission less tenable. The chronology also fits Donatello's Sienese period from 1457 to 1459. See *H.W.J.*, *Donatello*, II, 198–205, and E. Wind, in *Journal of the Warburg Institute*, I (1937/8), 62 ff.

31. *H.W.J.*, *Donatello*, II, 215–18. After Janson's book had appeared, a date of 15 June 1465 was found inscribed on the Martyrdom of St Lawrence; this relief was therefore modelled and probably cast and chased before Donatello's death: G. Previtali, in *Paragone*, CXXXIII (1961), 48–56.

32. J. White, *The Birth and Rebirth of Pictorial*　p. 146 *Space* (London, n.d.), 166.

33. For the most recent summary of Urbano da　p. 147 Cortona's Sienese period, see J. Pope-Hennessy, in *Studies in the History of Art Dedicated to William E. Suida* (New York, 1959), 64–5.

34. *Storia* (1908), 478; *P.-H.* (1958), 72–4.

35. The Piccolomini relief (now in the Palazzo　p. 148 Chigi) cannot, as emphasized by Pope-Hennessy, in *P.-H.* (1958), 322, be given to Vecchietta, as attempted by G. Vigni, in *Rivista d'Arte*, XVIII (1936), 367–74. Vigni, however, was right in trying to tie the relief into a known Sienese master's style, rather than sticking to the older hypothesis of an anonymous master. The 'master's' so-called *œuvre* on examination turns out to be nothing more than variants or copies of one composition by many different hands and styles (examples in the Metropolitan Museum of Art, New York; Museo Bardini, Florence; Victoria and Albert Museum, London; etc.). The original design (Arnoldi's recent theory) must have been known to be by Donatello, doubtless from his Sienese period (the Virgin derives in part from the Judith).

p. 148 36. E. Carli, in *B.M.*, XCI (1949), 33–9; a reproduction in colour is given in Carli's *La Scultura lignea senese* (Milan–Florence, 1951). The statue is not a mere reflection of Donatello's bronze Baptist; here the younger sculptor was striking out on a path very similar to that to be followed by Antonio Pollauiolo in Florence.

p. 149 37. Photographs in C. Kennedy, *The Tabernacle of the Sacrament by Desiderio da Settignano and Assistants, Studies in the History and Criticism of Sculpture*, V (Northampton, Mass., 1929). A document speaks of the 'walling-in' of the tabernacle in the summer of 1461. This date does not necessarily apply to the two candle-bearing 'angels'. The original appearance of the programme (a true altar, it would seem, and not a wall-tabernacle) is lost. The present installation (1948) is hardly more successful than the older arrangement of 1667. See in this connexion I. Cardinelli, in *Critica d'Arte*, III (1956), 68–75.

38. I am indebted to Middeldorf's outline of Verrocchio's early period summarized in *Mitteilungen des Kunsthistorischen Instituts in Florenz*, V, III (1939), 209–10.

NOTES TO PART FOUR

CHAPTER 7

p. 152 1. O. Sirén, 'Florentine Drawings in Stockholm', *Critica d'Arte*, VIII–IX (1949–50), 274–5, figure 200.

p. 154 2. P. Cellini, 'La reintegrazione di un'opera sconosciuta di Lorenzo di Pietro detto il Vecchietta', *La Diana*, V (1930), 239–43.

3. T. Magnuson, *Studies in Roman Quattrocento Architecture* (Stockholm, 1958), 3–97. A critical reprinting of pertinent passages in Manetti's biography of Nicholas V is provided as an appendix, pp. 351–62. See also R. W. Kennedy, 'The Contribution of Martin V to the Rebuilding of Rome', in *The Renaissance Reconsidered* (*Smith College Studies in History*, XLIV) (Northampton, Mass., 1964), 27–39.

p. 155 4. The Ph.D. dissertation of S. A. Callisen, Harvard University (typescript), is the only recent detailed study of Roman Quattrocento sculpture as a whole. It is focused on Andrea Bregno, and the section on that artist is superior to that on Mino. I am grateful to Dr Callisen for lending me his personal copy of the typescript for study. Apart from this, one must go to the regrettably weak section in Venturi's *Storia* (1908), 939–75, 1101–28; to G. S. Davies's somewhat dated *Renascence, The Sculptured Tombs of the Fifteenth Century in Rome* (London, 1910); and, still older, the articles by L. Ciaccio in *L'Arte*, IX (1906). Brief summaries on Isaia da Pisa, Giovanni Dalmata, and Bregno are given in *P.-H.* (1958), 334–5, 336–7. Very little new research has been published since before the First World War.

5. G. S. Davies, *op. cit.*, figure 19. The tomb-monument has been set up in S. Salvatore in Lauro and only the effigy can be given to Isaia; the remainder is by at least two different hands and somewhat later in the Quattrocento than the effigy.

6. In his *Vita* of Mino da Fiesole, Vasari discussed the Tomb of Paul II, unable to state whether it was by 'Mino del Reame' ('as some think') or 'Mino da Fiesole' (as he feels is 'doubtless' true); he ends with a compromise to the effect that it is 'indeed true' that 'Mino del Reame' made some 'small figures for the pedestal, which may be recognized'. He then adds: 'if indeed his name was Mino and

not Dino, as some affirm'. Mino da Fiesole is called 'Dino' in the strategic list of sculptors made by Filarete in Book VI of his treatise. There, coupled with Desiderio's name, one reads, 'un altro chiamato Dino' (in W. von Oettingen, *Antonio Averlino Filarete's Traktat über die Baukunst* (see Bibliography, p. 253), 706). It is known that Vasari made use of Filarete's treatise as a source in his *Vita* of Paolo Romano, so that the source of the name 'Dino' as used in this context seems clearly to go back to Filarete's treatise, that is, before 1465. But Filarete does not mention a 'Mino del Reame', who would not in any case as Mino da Fiesole have come to Rome until after Filarete's departure from that city. The origin of the label 'Nino' (Ninus), coupled by Gaurico with 'Dino' (Dinus), is Neapolitan and Roman, in other words precisely where Gaurico would have been likely to pick it up. Only two extant marbles generally accepted as by Mino da Fiesole are inscribed (not signed) 'Opus Nini'. These are the Niccolò Strozzi portrait done in Rome in 1454 (now Berlin); and the Astorgio Manfredi portrait done presumably in Naples in 1455/6 (now Washington, National Gallery of Art). The earliest use of the sculptor's name 'Mini' in an inscription is in Mino da Fiesole's Piero de' Medici bust of 1453 (now Bargello); the next earliest is in the ambiguous inscription – doubtless a later recutting of an earlier one – on the base of the Alessandro di Luca portrait of 1456 (now Berlin): the 'Mini' is in fact often erroneously read as part of the name of the subject. It should now be pointed out that these last-named busts were made in Florence and their dates precisely bracket Mino da Fiesole's first trip south, to Rome and Naples. It seems clear that there was in Vasari's mind a large hiatus on Mino da Fiesole's later Roman sojourns, and that he depended heavily on confusing hearsay and cryptic, brief remarks in only two written sources, out of which emerged fully formed the apocryphal 'Mino del Reame'. The name-variants discussed above (i.e., Dino, Mino, Nino) do *not* necessarily refer, as Valentiner had suggested for Mino da Fiesole's name in the first instance, to the Dominico de Monteminyao mentioned in the Neapolitan documents in the reign of King Alfonso I, though Mino must have

been in Naples. What is needed now in confirmation is a professional philological study of the proper names and of the archives as well as the literary sources.

p. 157 7. The chief proponents of the anti-Mino del Reame thesis have been F. Schottmüller, in *Thieme-Becker*, XXIV (1930), and Douglas, in *B.M.*, LXXXVII (1945), 217–24. Their conclusions have not been persuasive. More recently the arguments against the historical identity of 'Mino del Reame' were reviewed and reframed in far more convincing fashion by Dr Sheldon Nodelman in his M.A. thesis (typescript, Yale University, 1959). Vasari's description of 'Mino del Reame's' work and personality occurs in two places: once in the *Vita* of Mino da Fiesole and again in the *Vita* of Paolo Romano (see above, Note 6). In one glaring case (the tomb-monument of Paul II) he gave the same sculpture to both Mino da Fiesole and 'Mino del Reame'. The specific 'competition' stressed by Vasari between 'Mino del Reame' and Paolo Romano is probably nothing more than a garble in the tradition which recorded the rivalry between the two principal *botteghe* in Rome of the 1460s; and to some extent, also, perpetuated by the rival signatures OPVS PAULI and OPVS MINI under the two angels of the pedimental lunette of S. Giacomo dei Spagnuoli (still there to be seen today). Finally, the work usually attributed to 'Mino del Reame' is certainly not by a single hand and looks instead precisely like shopwork under the supervision of a master with Florentine training such as was, indeed, Mino da Fiesole. The pro-'Mino del Reame' school has depended on Schmarsow's very early study, and on Angeli's older monograph of 1905, which in turn lay behind Venturi's brief and obviously superficial treatment in *Storia* (1908), 658–62.

8. The figures remained in place until the rebuilding of the entrance section of the basilica in the seventeenth century, and are still extant, though not in my experience on public exhibition (see *Storia* (1908), figures 756, 757). I have been able to find no confirmation of Angeli's older hypothesis that there was sculpture intended for the 'benediction pulpit' ordered by Pius II.

9. The d'Estouteville patronage is summarized by S. A. Callisen, 'A Bust of a Prelate in the Metropolitan Museum, New York', *A.B.*, XVIII (1936), 401–6. He follows the older ideas of Angeli and Venturi in ascribing the S. Maria Maggiore ciborium to 'Mino del Reame'.

10. G. S. Davies, *op. cit.*, figure 58; the monu- p. 158 ment was moved from St Peter's to S. Andrea della Valle in the seventeenth century.

11. Exactly where this statue was originally intended to stand is not clear to me. The tradition of its rescue by Clement VII, who had it set up on the bridge leading to Castello S. Angelo during his pontificate, does not have any extant documentary evidence behind it. Perhaps this St Paul was intended as a replacement for Mino's rather awkward and sentimental figure of the same subject (see above, Note 8). It shows the influence certainly of Mino's figure.

12. He was born at Osteno near Como and was p. 160 apparently active briefly at Carona (see an altar there in a style very reminiscent of his Roman work). The circumstances of his going to Rome are unknown.

13. Only older fundamental studies are available for his *œuvre* in Italy: H. von Tschudi and C. von Fabriczy, in *Berlin Jahrbuch*, IV (1883), 169–90; XXII (1901), 224–52. There is a considerable modern literature in Hungarian which deals with his work for Matthias Corvinus.

14. A summary of this puzzling incident in the p. 162 documentation of Roman Quattrocento sculpture is given in G. S. Davies, *op. cit.*, 80–3. There were two Quattrocento sculptors who were known as 'Paolo Romano': one, Paolo di Mariano di Tuccio Taccone, is documented as dying between 1470 and 1473; another, known as Paolo de Urbe, was active in 1485.

15. As suggested by Valentiner in his article on Andrea dell'Aquila, in *A.B.*, XIX (1947), 503–36.

16. See W. S. Heckscher, *Sixtus IIII Aeneas insignes statuas romano populo restituendas censuit* (The Hague, 1955).

17. The reliefs from this extraordinarily large and elaborate monument are now arranged in the 'ambulatory' of the Grotte Vaticane. A series of Apostles in niches by several different hands are joined to a series of *istorie*-reliefs in which different hands also seem to be present. According to the early-seventeenth-century sketch made by Grimaldi, the sculpture was arranged as a frieze resting on the four columns of the ciborium and in turn supporting its domical cap. A pair of Apostles flanked *istorie* on three sides; on the fourth presumably were placed the *istorie* reliefs with arcades at their ends as part of the composition.

p. 163 18. The best studies of Silvestro and of the sculpture of Aquila are those by L. M. Bongiorno, *A.B.*, XXIV (1942) and XXVI (1944).

p. 164 19. I am assuming, unlike Valentiner, (1) that Andrea belonged to an earlier generation which was unable to cope with the rapid development after 1465, and (2) that there would be no reason to expect that a Donatellesque style would develop in the Abruzzi.

20. For illustration of this series, see *Storia* (1908), figures 707, 708.

21. W. R. Valentiner, 'Laurana's Portrait Busts of Women', *Art Quarterly*, V (1942), 273–98; R. W. and C. Kennedy, *Four Portrait Busts by Francesco Laurana* (Northampton, Mass., 1962).

p. 165 22. This is the opinion of R. W. and C. Kennedy, *op. cit.* The mask in the Louvre which must be morphologically the source of the Bargello bust was given a later frame; this led Pohl to associate it erroneously with a rather nondescript mask in the Victoria and Albert similarly framed: J. Pohl, *Die Verwendung des Naturabgusses etc.* (Bonn, 1938), 53.

23. There is an assumption that the Battista Sforza bust had to be carved at Urbino; given the death-mask as the point of departure for the bust, it could just as well have been carved in Naples. Federigo da Montefeltro was in Naples in 1474, and this visit may have been the occasion for the commission. A date of about 1475 is in any event a reasonable one.

24. It is usually assumed that the type illustrated by the examples in Palermo, the Louvre, and the Musée Jacquemart-André also includes the painted bust that is now in Vienna. This inclusion seems to me to be a mistake: it is not the same girl. The Vienna portrait may be of still another princess and is a *unicum*.

p. 166 25. The chronology and listing of Domenico Rosselli's work as known up to that point was given by Middeldorf in *Thieme-Becker*, XXIX (1935), 36–7.

p. 167 26. The basic study on Andrea della Robbia still remains A. Marquand's *Andrea della Robbia and his Atelier* (Princeton, 1922). It is liberally illustrated and well documented.

27. Not included in Dussler's conservatively-orientated monograph (Munich, 1925). The overlap between Benedetto and Antonio Rossellino was probably considerable, and a number of works which have been given in the past to Antonio Rossellino should instead be attributed to the young Benedetto da Majano. One of these is the St John from the Oratory of the Vanchetoni in Florence which is now in the National Gallery of Art, Washington (Kress Collection); it probably represents an early replacement for a bust by Desiderio which originally made up a pair with the Christ Child also now in Washington.

28. The terracotta reliefs shared by Berlin and p. 168 the Victoria and Albert appear to be *modelli* for this programme. The survival of such a series represents a great rarity.

29. Dussler, *op. cit.*, plate 35. For a new interpretation by Dr George Hersey see below, Chapter 10, Note 9.

30. A new study of Civitale and of the style of p. 169 the Lucca area is certainly needed. I understand from Professor Middeldorf that it is already projected (summer, 1964).

31. A related series which once decorated the shrine of S. Emiliano in the cathedral of Faenza by the same artist is in the Musée Jacquemart-André, no. 849.

CHAPTER 8

1. A. S. Weller, *Francesco di Giorgio* (Chicago, p. 170 1943), 176–82; *P.-H.* (1958), figure 101, plate 97. Work on the high altar was begun shortly before 1490 (two small corbel-'angelotti' commissioned in mid 1489); payments for the larger standing Angels were made in 1497 (documents quoted by Weller).

2. P. Schubring, *Die Plastik Sienas im Quattrocento* (Berlin, 1907), 107–10, 123–30, figures 48–53.

3. E. Wind and F. Antal, 'The Maenad under the Cross, etc.', *Journal of the Warburg Institute*, II (1937–8), 70–3. For the most recent summary of Bertoldo's career and extant production, correcting Bode's speculative errors, see *P.-H.* (1958), 318–20. His chief pupil, and until *c.* 1486 his aide in taking responsibility for casting complex compositions in bronze (for example the small group of Bellerophon and Pegasus, Kunsthistorisches Museum, Vienna), was Adriano Fiorentino (see below, p. 203 and Plate 147). On Adriano: still the best study, though rather old-fashioned, is C. von Fabriczy's of 1903 (*Berlin Jahrbuch*, XXIV).

4. See Weller, *op. cit.* Until Schubring's *Plastik* p. 171 *Sienas* there was considerable doubt about the authorship of several important reliefs which today

are universally given to Francesco di Giorgio. The Carmine Crucifixion and the so-called Discord, of which stuccos exist in the Victoria and Albert and in the Palazzo Chigi-Saraceni in Siena, were given to Bertoldo (A. Venturi) and to Leonardo da Vinci (Bode).

p. 171 5. Most conveniently published by M. Crutwell, *Verrocchio* (London, 1904), 242–4.

p. 172 6. G. Marchini, *Il Duomo di Prato* (Milan, 1957), 62–5.

p. 173 7. *Storia* (1908), figure 482; probably shopwork which could have been intended for a funerary monument, but would seem later than the 1460s.

8. In his rhymed chronicle, Giovanni Santi mentioned Verrocchio's name immediately next to his mention of Andrea Bregno (quoted *P.-H.* (1958), 336): 'L'alto Andrea del Verrocchio, e Andrea ch'a Roma/Si gran compositore e con bellezza'. This kind of juxtaposition might well have resulted in Vasari's mind in a hazy notion that Verrocchio had made some great and beautiful compositions in Rome, and in view of Mino's commission for the monument to Francesco Tornabuoni in S. Maria sopra Minerva he might have confused Mino's work with the hypothetical one by Verrocchio for the monument of Francesca Tornabuoni also supposed to have been in S. Maria sopra Minerva. Reasons against accepting the Vasarian version of the commission are given by Crutwell, *op. cit.*, and most recently V. Chiaroni in *Studi Vasariani* (Florence, 1952), 144–45.

p. 174 9. C. Sachs, *Das Tabernakel mit Andrea del Verrocchios Thomasgruppe an Or San Michele zu Florenz* (Strassburg, 1904). Summary of the data supplied by the documents: *P.-H.* (1958), 312–13, and L. M. Bongiorno, in *Allen Memorial Art Museum Bulletin, Oberlin*, XIX (1962), 125–9. The latter clearly distinguishes the stylistic differences between the two figures. It is interesting to note that the terracotta *modello* for the Thomas was to be bought by the guild for exhibition in its own quarters, and in order not to allow the 'sketch and beginning of so beautiful a thing to be ruined and to perish' ('per non lasciare guastarsi e perire la boza [*sic*] e principio di si bella cosa'). This is an early indication of the value later periods were to put on the initial sketch (*disegno* and *abozzo*) and seems to be characteristic of Verrocchio's art – see the *modello* still in large part preserved of the Forteguerri Monument, the Giuliano de' Medici, the Running Putto, and the bust of a Deacon-Saint now in the old sacristy

at S. Lorenzo. The last-named used to be given without good reason to Donatello (see Janson), and quite recently it has been provided with as dubious an attribution (Janson and Lisner independently) to Desiderio. The stylistic evidence adduced is not convincing, and there is no evidence at all from the general context of Desiderio's *œuvre* as it has come down to us. The confusion with Desiderio's hand is to be explained probably by the closeness of the young Verrocchio to Desiderio.

10. G. Poggi, *Il Duomo di Firenze (Italienische Forschungen, Kunsthistorisches Institut in Florenz*, II) (Berlin, 1909), cxvi, figure 82.

11. The all-important effects of lighting are best seen in the late morning light (spring–summer months). Most photographs of the group in the niche (such as *P.-H.* (1958), figure 57) emphasize a false overall clarity, without suggesting the mystery of the shadowed niche-space and the power of the great volume of dusky shade between the two figures. The group is virtually unphotographable *in situ*.

12. G. Poggi, *op. cit.*; M. Crutwell, *op. cit.*, 248–9. p. 175

13. C. Kennedy and E. Wilder, *The Unfinished Monument ... at Pistoia* (Northampton, Mass., 1932), *passim*.

14. E. Maclagan and M. Longhurst, *Victoria and* p. 176 *Albert Museum, Catalogue of Italian Sculpture*, 2 vols (London, 1932), 58, plate 42. This small relief has also been called a forgery (Crutwell) and has been attributed to Piero Pollaiuolo (Kennedy and Wilder). It has quite recently been reinstated as a work of Verrocchio or of his studio on 'balance of probability' (Pope-Hennessy): *P.-H.* (1958), 315. It seems hardly possible that it is by Verrocchio's own hand, but it does appear to be of the fifteenth century and must be retained as one of the schemes advanced by Verrocchio for the monument.

15. The document is a statement made by Lorenzo di Credi on 7 October 1488 in which he relinquished the rights left to him by Verrocchio's will to complete the monument, quoted in *P.-H.* (1958) (after Crutwell, *op. cit.* 184; Milanesi, Vasari-Milanesi, IV, 565, note 1). This information contradicts flatly the Vasarian anecdote that Verrocchio died of catching cold during the casting-process. According to the diary of Sanudo, the statue was in place and unveiled on 21 March 1496; the diarist noted that the sculptor was Leopardi, not Verrocchio; this was the beginning of a pro-Venetian tradition that Vasari had to fight, and probably led

him to an over-zealous reconstruction of the facts connected with the piece at Verrocchio's death.

p. 178 16. Most recently discussed in detail by L. M. Bongiorno, *loc. cit.* (Note 9). The conclusion reached there is that the original of the composition known only through contemporary stucco reproductions was done by a follower of Verrocchio. The alternative that it might be an early work by Verrocchio himself, which I am inclined to think likely, is also considered. The better-known Diblee version (now called the 'Signa Madonna') went on sale at Christie's on 2 June 1964.

17. For a listing of earlier attributions of the so-called 'Marietta Strozzi' and 'Simonetta Vespucci' in Washington to Desiderio see C. Seymour, Jr, *Masterpieces of Sculpture in the National Gallery of Art* (New York, 1949), 15–16, 176. I now believe that the 'Simonetta' (Goldmann and Kress Collections), once given to Leonardo (Suida), must be by Verrocchio and of the 1470s. The unfinished 'Marietta' (Widener Collection) should also be given to Verrocchio on the basis of stylistic comparison with the finer passages of the Forteguerri Cenotaph in Pistoia. The Rockefeller bust of the so-called 'Medea Colleoni' has a femininity that moves away from the Washington marble portraits. The perhaps over-famous 'Lady with Primroses' in the Bargello has still another flavour of style which makes it very difficult to categorize; I would not like to use it as a touchstone for Verrocchio's manner in marble. For that purpose the Kennedy–Wilder study of the Forteguerri Cenotaph is by all odds preferable.

18. The Running Boy in Washington (Dreyfus-Mellon Collection) is not considered an autograph piece by Verrocchio in *P.-H.* (1958), 312. The figure has apparently been considerably repaired and is covered by a rather thick coating of modern paint to give the surface a look of uniformity and consistency. This has in all probability blunted the sharpness of detail that one would look for in a real Verrocchio. The piece from the point of view of composition in three dimensions is outstanding, and the motif is reproduced on the central fountain in the late-fifteenth-century panel of the Ideal City in Baltimore (Walters Gallery). It would seem therefore that there are sufficient reasons for retaining it in Verrocchio's *œuvre*, though its state (like that of the much repaired bust of Giuliano de' Medici) is such that doubts have wrongly been raised regarding its authenticity (A. Venturi in *Storia* (1908), 715, notes 2, 5).

19. The most recent illustration and survey of p. 179 sources and opinion is in *P.-H.* (1958), 317–18; important, however, are A. Sabatini, *Antonio e Piero del Pollaiuolo* (Florence, 1944), 53–63, and L. Ettlinger, 'Pollajuolo's Tomb of Pope Sixtus IV', *Journal of the Warburg and Courtauld Institutes*, XVI (1953), 239–71.

20. Quoted by Ettlinger, *loc. cit.*

21. This idea is opposed to the account advanced p. 180 by Vasari. But Antonio's earlier connexions with Sixtus and Sixtus's own interest in the pontificate and his place within its history, as his medals testify (see R. Weiss, *The Medals of Sixtus IV*, London, 1962), would indicate that the tomb might well have been commissioned before Sixtus's death. After all, it was not just a single funerary monument but a whole chapel which was involved; given the rather abrupt shifts of papal policy from pontificate to pontificate in the Quattrocento, it would seem strange if a man as prudent and as aesthetically alert as Sixtus had proved himself to be did not make firm provision for his own tomb.

22. Given in the inscription (in part): IVLIANVS CARDINALIS PATRVO ... MAIORE PIETATE/ QUAM IMPENSA F.(ECIT) CVR(ARE).

23. E. Müntz, *Les Collections des Medicis au XV* p. 182 *siècle* (Paris, 1888), 60. The document quoted by Müntz places the Hercules and Antaeus in the apartments of 'Monsignor Giuliano'. This seems to be an index to the date of the small-bronze group, since Giuliano, the brother of Lorenzo, was killed in 1478.

24. See the remarks of Ettlinger, *loc. cit.* The situation is essentially the same as that posed by the imagery of the Porta della Mandorla (see Chapter 2, Note 4, p. 226), but the terms are reversed.

25. See the studies listed in the Bibliography p. 183 under Leonardo da Vinci. In the past decade the most active proposers and discutants of a sculptural *œuvre* of Leonardo have been J. G. Phillips, R. S. Stites, and W. R. Valentiner.

26. For the most recent summary of this question, p. 184 see *P.-H.* (1958), 68–72. The question is extraordinarily complex.

27. The original quotation is in Borselli, *Cronica* p. 185 *gestorum ac factorum memorabilium civitatis Bononie*, in the usually accessible collection of Muratori, XXIII, 2, p. 113; K. Frey (ed.), *Le Vite di Giorgio Vasari*, I (Munich, 1909), 715–16. Quoted recently by R. and M. Wittkower, *Born under Saturn* (London, 1963),

S

68. Niccolò dell'Arca appears as the type-figure of the enigmatic and solitary artist who has unmistakable genius. Whether he was trained in Naples or had travelled to France is purely a matter of opinion; there is no history for him until he arrived in Bologna. He seems to have been a man hungry for new artistic experience, and as a corollary attracted to a wide spectrum of artistic sources and trends; at the same time he was profoundly original. The modern monograph, unfortunately for some time out of print, is C. Gnudi's (Turin, 1942). I have followed in general his chronology, particularly, however, with regard to the rather late dating (c. 1485) of the S. Maria della Vita Lamentation.

p. 186 28. The Trecento tradition in Cennino Cennini is absolutely clear, even to the taking of most difficult casts from life: D. V. Thompson (ed.), *The Craftsman's Handbook* (current in Dover paperback edition), 123–30. The Quattrocento practice is covered in J. Pohl, *Die Verwendung des Naturabgusses, etc.* (Bonn, 1938), 7–18, 29–65.

CHAPTER 9

p. 189 1. C. Magenta, *La Certosa di Pavia* (Milan, 1897), *Regesto di documenti inediti*, 476.

p. 190 2. The portal in the minor cloister is signed: IOHANNES ANTONIVS DE AMAIDEO FECIT OPVS. The much smaller relief now in the Misericordia in Florence is likewise signed; it was first published by Middeldorf in *Kunstgeschichtliche Studien für Hans Kauffmann* (Berlin, 1956), 136–42.

3. Amadeo was commissioned to construct the burial chapel and presumably to carve the monument of Bartolommeo Colleoni some years before his death, which occurred in 1475. The monument of the general's daughter, Medea, who died in 1470, may have been the reason for bringing Amadeo to Bergamo in the first place. The usually accepted date for the completion of the chapel is 1476, but the general's monument, on which there is a good deal of assistants' work, probably went on for a few years thereafter. Amadeo appears to have finished with the Colleoni assignment by 1479, when he returned for good to the area of Milan and Pavia.

p. 192 4. This emerges from the studies of G. dell'Aqua, in *Proporzione*, III (1950), 123–40; in the Museo del Duomo the statue is attributed to Cristoforo Mantegazza and is dated 1460–70.

5. Now inserted in two relatively modern (1814) p. 193 'pulpits' in the cathedral of Cremona. The presence of hands of assistants is inescapable.

6. The Rodari and Cazzaniga have been casualties in the modern literature. For an earlier survey of the Rodari, see *Storia* (1908), 926–7. Amadeo's follower, Pietro da Rhò, is today considered quite a secondary, if not a tertiary figure. Another Amadeo follower is the so-called Master of the Flagellation (on the Colleoni Monument at Bergamo); his hand is to be found after 1490 in the façade sculpture for the Certosa at Pavia.

7. Illustrated in *Storia* (1908), 916.

8. The connexion of the St Agnes on the cathe- p. 194 dral of Milan with Briosco was already recognized by A. Venturi: *Storia* (1908), 917.

9. This is the conclusion which the documents require. See most recently G. Chierici, in *Scritti in honore di Mario Salmi* (Florence, 1962); and G. Borlini, in *A.B.*, XLVI (1963), 323–36. From them I must differ on several major points of interpretation of the evidence.

10. The styles of these two men at Pavia have not as yet been sorted out.

11. C. Seymour, Jr, *Masterpieces of Sculpture in* p. 195 *the National Gallery of Art* (New York, 1949), 169–70. A roundel with the profile of Gian Galeazzo Maria Sforza, Lodovico's nephew, is also in the Washington National Gallery, to which it came with the Mellon Collection from the Dreyfus Collection, Paris (previously Timbal and Robinson Collections). A closely related roundel of Galeazzo Maria Sforza is in the Louvre (No. 649, from the Arconati–Visconti Collection). The Louvre piece is 4 in. smaller in diameter than those in Washington. The original architectural setting for this Sforza series is not known; possibly it was in the ducal Castello in Pavia or in the ducal quarters in the Certosa of Pavia.

12. F. Malaguzzi Valeri, 'I Solari, etc.', in *Italienische Forschungen, Kunsthistorisches Institut in Florenz*, I (Berlin, 1906), 135–7, 141–3. A description of 1515 provides an idea of the original make-up of the monument: *P.-H.* (1958), 341. It was probably this monument that caused pilgrims to Rome c. 1500 to confuse the authorship of Michelangelo's Pietà in St Peter's with Solari (see below, Chapter 10, Note 27).

13. The considerable talent and great charm of p. 196 style shown by Domenico Gaggini has been brought out by the studies of Bottari, in *Rivista d'Arte*, XVII

(1935), 77–85, and Accascina, in *Bollettino d'Arte*, XLIV (1959), 125–32, as well as in her longer general article of the same year on Sicilian sculpture of the second half of the Quattrocento, 'Sculptores Habitatores Panormis, etc.', in the *Rivista dell'Istituto Nazionale d'Archeologia e Storia dell'Arte*, N.S. VIII. In English a good summary is W. Valentiner's 'The Early Development of Domenico Gagini', *B.M.*, LXXVI (1940), 81–7. There has been a recent tendency, not to my mind always justified, to re-attribute work by Domenico Gaggini to Laurana (for example the effigy of the tomb of Francesco Speciale, now left alone and rather forlorn in the cloister of S. Francesco, Palermo). Domenico yielded nothing to Laurana as a craftsman and was his superior as a figure-sculptor, though not, obviously, as a portraitist.

14. The only book on the Gaggini dynasty in Sicily is the non-current and dated study by G. di Marzo, *I Gagini e la scultura in Sicilia nei secoli XV e XVI*, 2 vols (Palermo, 1883).

p. 197 15. Between 1450 and 1500 sculpture in Genoa remained a dependency of Lombardy on the north-east and to some extent of the Apuan west coast school just down the coast towards Pisa. A recent discussion of Genoese style in architectural sculpture is in R. W. Lightbown's article of 1961 in *B.M.* The development of an expansive school in Genoa came only after 1501, when Pace Gaggini and Antonio della Porta moved back from Pavia. The export of Carrara marble funerary sculpture from Genoa soon thereafter found markets not only in France, but in Spain. For up-to-date summaries see A. Blunt, *Art and Architecture in France 1500–1700* (in this series, Harmondsworth, 1954), 14–17; Marqués de Lozoya, *Escultura de Carrara en España* (Madrid, 1957), *passim*.

p. 199 16. P. Paoletti, *La Scuola Grande di San Marco* (Venice, 1929), *passim*.

17. C. Seymour, Jr, *op. cit.* (Note 11), 106. There the older view is given which should be corrected. A standing Madonna in the museum in Aix-en-Provence seems to be by the same hand, and conceivably could have been related in programme. My feeling at present is that the Washington Angel was one of two on the altar of S. Maria dei Miracoli; traces of burning on the arms would fit the record of an early fire in the church.

18. See Planiscig's perceptive analysis in his *Venezianische Bildhauer der Renaissance* (Vienna, 1921), 209–25. Immediately after 1500 Antonio's

style changed in a pronouncedly classicizing direction.

19. *P.-H.* (1958), figure 154, opposite p. 112.

20. The figure now preserved in the garden of p. 201 the Palazzo Vendramin Calergi usually associated with the Vendramin Monument is surely much later. The two female flanking figures now associated with the monument are by Lorenzo Bregno and came from the church of S. Marina.

21. 'Ai Servi è l'archa d'Andrea Vendramin Doxe [*sic*] che al presente si fabricha che sara diro cussì [su] la più bella di questa terra per li degni marmi vi sono': quoted in *P.-H.* (1958), 354.

22. See his well-known letter to the authorities at Piacenza of 1496.

23. See for Bellano, L. Planiscig, *Andrea Riccio* p. 202 (Vienna, 1927), 27–74. Bellano was evidently first mentioned in Florence, as far as is known, in 1456: G. Corti and H. Hartt, in *A.B.*, XLIV (1962), 158 and 165. This mention would indicate an even closer relationship to Donatello than heretofore supposed.

24. J. Pope-Hennessy, in *B.M.*, XCIX (1959), 100–20.

25. P. Kristeller, *Andrea Mantegna* (London, p. 203 1901), *passim*; G. Paccagnini, in *Bollettino d'Arte*, XLVI (1961). Bonacolsi ('L'Antico') was quite a different type of artist and saw Antiquity in a far less monumental and impressive way, though perhaps no less avidly, than Mantegna. A counter-figure probably associated with the Milanese rather than the Mantuan environment about 1500 is the artist, still not identified with certainty, who signed himself 'Moderno'.

CHAPTER 10

1. The myth of the Laurentian 'Golden Age' in p. 204 Florence was part of the propaganda of the Medici, who were restored to power in 1512. The period between the Pazzi plot (1478) and Lorenzo's death (1492) was in actuality one of increasing economic and financial difficulty and, as far as large programmes of sculpture went, the least productive fifteen years of the entire century in Florence. What must be recognized is that Lorenzo's personal influence and mystique were such that on his death the sense of communal loss was extremely deeply felt, so much so that with him seemed to die a whole age which his great personal brilliance and

charm had gilded. In the minds of his closest intimates and admirers his lifetime had been a 'golden age', if only because it had produced so great a spirit as his (Ficino).

p. 205 2. See R. and M. Wittkower, *Born under Saturn* (London, 1963), 104; A. Chastel, *Marsile Ficin et l'art* (Geneva–Lille, 1954), *passim*.

3. A. Chastel, *op. cit.*, 61; quoting from *Epistolarum Liber*, XII letter written to Paul of Middelburg just after the death of Lorenzo de' Medici.

4. A. Chastel, *op. cit.*, 119; E. Wind, *Pagan Mysteries of the Renaissance* (Oxford–New Haven, 1958), 177, quoting a passage of Maximus of Tyre.

5. Presentation-drawings of sculpture must have existed all through the century, beginning to our knowledge with the Late Trecento practice in Milan and Florence. Recorded sculptors' drawings do not make a real entry, as far as one can tell, until after 1450; two early study-sheets in the Uffizi have been attributed (Middeldorf) to Antonio Rossellino. In the last quarter of the century sculpture-sketches in notebooks become more frequent, and some have been preserved by a number of artists: Francesco di Giorgio; Francesco di Simone; the principal draughtsman of the so called 'Sketchbook of Verrocchio' (Chantilly, Paris); the series on altars published by O. Kurz in *Journal of the Warburg and Courtauld Institutes*, XVIII (1955), 35–53; the Sansovino drawings published by Middeldorf in *B.M.*, LXX (1932), 236–45, and LXXIII (1934), 159–64.

p. 206 6. G. Poggi, *Il Duomo di Firenze* (*Italienische Forschungen, Kunsthistorisches Institut in Florenz*, II) (Berlin, 1909), lvi.

7. The praise of Donatello by Landino in the *proemio* of his edition of Dante's *Commedia* of 1481 is relatively long and quite precise, while for Ghiberti he had only the single word 'notissimo'. Sculptors such as Quercia, Nanni di Banco, and Luca della Robbia simply do not appear at all. Brunelleschi is mentioned briefly not only as an architect but for his work in painting and sculpture. See A. Chastel, *op. cit.*, 182, and O. Morisani, in *B.M.*, XCV (1953), 267–70.

p. 207 8. This seems now to be generally agreed. See A. Chastel, *Art et humanisme à Florence* (Paris–Lille, 1959), *passim*, and E. H. Gombrich in E. F. Jacob (ed.), *Italian Renaissance Studies* (London, 1960), 279–311.

9. This group, considerably restored and perhaps in parts somewhat recut, has been erroneously connected in the past with a project for the Porta Capuana in Naples. Recent study by Dr George Hersey has shown that it belonged in fact to the planned decoration of the Porta Reale, one of several programmes in Naples that were due to Alfonso II. Dr Hersey's paper is scheduled to be published in *Napoli Nobilissima*.

10. G. H. Huntley, *Andrea Sansovino* (Cambridge, p. 208 Mass., 1935), 14–25.

11. A review of conflicting and inconclusive theories, some of which appear to have been presented with some heat, is given by Huntley, *op. cit.*, 32–41. From the Italian side the only source is Vasari, and the documentation from the Portuguese and Spanish sides is sparse and so far has not yielded convincing results in identifying specific extant pieces of sculpture that can be readily associated with Andrea's pre-Roman style. Toledan documents of 1500 mention interestingly enough an 'Andrés florentín', who had carved a St Martin for the cathedral *retablo*.

12. The part of Andrea Sansovino in the S. p. 210 Spirito programme is still open to debate. Huntley, *op. cit.*, 82–7, saw Andrea's contribution as limited to the entrance-bay, and as primarily architectural rather than sculptural. Vasari claimed that he did two capitals 'in his youth' for the sacristy proper (Vasari–Milanesi, IV, 511). On the other hand the documents for the sacristy published by C. Botto in *Rivista d'Arte*, XII (1931), 477–511, and XIII (1932), 23–53 indicate that the carving of the capitals was all done by two lesser craftsmen. This discrepancy between source and document the differing views of Stechow (see Bibliography under Giuliano da San Gallo) and Middeldorf, in *A.B.*, XVI (1934), 107–15, reflect. The more recent volume by G. Marchini, *Giuliano da San Gallo* (Florence, 1942), does not carry the matter effectively further. Nor do I have more to offer towards a solution here.

13. Usually given to Andrea della Robbia and his shop. The series follows the earlier programme in the Pazzi Chapel; here, however, the violent polychromy of the Pazzi Evangelists calms down to a uniform classicizing scheme, white-against-blue. The *modello* for the St Matthew illustrated on Plate 150A could have been by Sansovino; it might conceivably also have been by the young Rustici. For Giovanni della Robbia, Marquand's classic monograph (Princeton–London–Oxford, 1920) remains the best study of a man who was more a Cinquecento than a Quattrocento sculptor, though burdened rather obviously by the family tradition.

14. The major source for Giuliano's early career is Vasari, whose first-hand knowledge of the artist's career can be established. He was taught as a woodworker, made architectural models, and designed (and perhaps executed) the stalls in the chapel of the Medici Palace in the Via Larga in Florence. He went to Rome in the 1460s and returned to Florence c. 1480. What his competence as a stone-carver might have been is frankly guesswork. My own guess is that he was a good sculptor, that he helped Bertoldo on his return to Florence, and that he was the major link between architecture and sculpture in a difficult period in Florence. The problems of identifying his personal style as a sculptor were outlined by Middeldorf in *A.B.*, XVI (1934), see Note 12.

15. The connexion between the relief on the Sassetti Tomb and an Antique source was established by F. Schottmüller early in this century. The Antique source is not known exactly, but the best candidate is the sarcophagus relief formerly in a private collection in Florence: illustrated, E. Panofsky, *Renaissances and Renascences* (Stockholm, 1961).

16. Accepted by Salmi, Chastel, and Parronchi as Late Quattrocento work. The full-scale publication by G. Poggi was never carried through. The courtyard in the Palazzo Gherardesca has been much restored, but it would seem reasonably certain that the reliefs belong strictly with the architectural framework, which certainly seems in the style of Giuliano da San Gallo. A new study of the architecture by Sanpaolesi is included in W. Lotz and L. L. Möller (eds), *Studien zur Toskanischen Kunst, Festschrift für L. H. Heydenreich* (Munich, 1964).

p. 211 17. A distinct advance in this line on Benedetto da Majano's altar in S. Anna dei Lombardi in Naples, which has four classicizing pilasters as a framework (Plate 107). For the altar in London, see E. Maclagan and M. Longhurst's *Victoria and Albert Museum Catalogue* (London, 1932), 72, plate 51B. It borrows from both Sansovino and Benedetto.

18. The archaeological evidence would indicate that the relief belonged structurally to a Late Quattrocento part of the Guicciardini Palace, itself a complex of many periods. I have been informed by the family that there is nothing in the Guicciardini archives that bears in any way on the date or authorship of the Hercules relief; we are therefore brought back to style alone.

19. Useful surveys of the recent literature are given by C. de Tolnay, in *Encyclopedia of World Art* (Sansoni–McGraw Hill), and J. Pope-Hennessy, *Italian High Renaissance and Baroque Sculpture*, II (London, 1963). Both are compiled as of 1961. Most revealing studies on the youthful period before 1500 are C. de Tolnay, *The Youth of Michelangelo* (Princeton, 1943), and J. Wilde, in *Mitteilungen des Kunsthistorischen Instituts in Florenz*, IV (1932–4), 41–64.

20. A recent study along this line of thought, p. 213 though by no means convincing in the visual evidence, is M. Lisner, 'Zu Benedetto da Maiano und Michelangelo', *Zeitschrift für Kunstwissenschaft*, XII (1958), 141 ff.

21. The Madonna of the Stairs was one of only p. 214 three pieces generally accepted as by Michelangelo excluded by Pope-Hennessy in his recent survey of the *œuvre* (see Note 19 above). The newly uncovered Crucifix of S. Spirito has been elaborately published by its finder, Dr. Lisner, in *Münchner Jahrbuch der bildenden Kunst*, 3. XV (1964), 7–36. It has already (1964) created much discussion. The usual dating of the Madonna of the Stairs has recently been called into question by Professor Eisler (1964). It is evident that a consensus on Michelangelo's *juvenilia* is in process of flux.

22. C. de Tolnay, *op. cit.*, 133–7, gives an account of the various interpretations of the subject-matter ending with his own: 'The abduction of Deidameia or Hippodamia'. Vasari and Condivi agree on the anecdote that the subject was suggested by Poliziano and in some mysterious way concerned the legend of Hercules (Condivi: 'Il Ratto di Deineira e la zuffa de'centauri'; Vasari: 'La Battaglia di Hercole co i centauri'). What appears today is more simply an exercise on the theme of primitive humans fighting centaurs before the age of metals (rocks are used as weapons). The top of the marble relief is left rather brutally in the rough, and conceivably its unfinished state may have had meaning for Michelangelo at the time.

23. After being sold to the French king, it was recorded in an engraving of the Jardin de l'Étang at Fontainebleau by Israel Silvestre (reproduced by C. de Tolnay, *op. cit.*, plate 152). The figure appears to have been shown holding a club resting on the ground with a lion's skin wrapped partially round the torso and knotted at the right shoulder. It has at times been suggested that Michelangelo carved the piece for his 'own pleasure' (see Note 26 below). This seems highly unlikely in view of the size of the statue; if of 1493, it might have had to do with a commission from Piero de' Medici, whose name as

a patron of the young Michelangelo seems to have suffered through the well-known anecdote of the snow-statue he asked of Michelangelo as a joke or fantasy. A drawing in the Louvre attributed to Rubens has been recently (1964) identified by de Tolnay with the lost Hercules. Evidence of an underdrawing in different technique and hand would appear to weaken de Tolnay's hypothesis. This in any event needs further checking.

p. 214 24. The sixteenth-century account of Fra Lodovico da Prelormo of the carving of the figures in Bologna is definite on this point. It is published by T. Bonora, *L'Arca di San Domenico e Michelangelo Buonarotti* (Bologna, 1875), 20 ff. Recent study by Professor Gnudi in Bologna has confirmed the data of the sources. The statues are small, on the same scale as Niccolò dell'Arca's figures; S. Petronio with base 2 ft 1 in. (64 cm) in height; S. Proculo with base 1 ft 11 in. (58·5 cm) in height; Kneeling Angel with base 1 ft 8 in. (51·5 cm.) in height. (The metric measurements are taken from C. de Tolnay, *op. cit.*, 137.) According to Condivi the commission for the three statues was arranged by Francesco Aldovrandi, who later undertook to help Julius II in returning Bologna to the States of the Church.

p. 215 25. For a list of candidates for identification with the lost S. Giovannino, see C. de Tolnay, *op. cit.*, 198–200; for the lost Sleeping Cupid, *ibid.*, 201–2, and P. F. Norton, in *A.B.*, XXXIX (1957), 251–7. Another candidate for the 'Lost' S. Giovannino in the possession of Piero Tozzi in New York deserves mention. It has recently been elaborately published (privately printed, New York, 1964).

26. Not to be identified with the kneeling figure in the Victoria and Albert Museum, as asserted in E. Maclagan and M. Longhurst, *op. cit.* (Note 17), 126. Reasons for rejection of that hypothesis were given by Kriegbaum in *Jahrbuch der Kunsthistorischen Sammlungen in Wien*, N.F. III (1929), 247 ff., and by de Tolnay, *op. cit.*, 204. More recently Pope-Hennessy has shown that the piece is an Antique fragment 'completed' in the mid sixteenth century. It is certain, as noted by Prof. Wind, that the hand holding the cup of the Bacchus is a sixteenth-century 'restoration', and that for an indeterminate period before 1553 the statue with missing right hand and cup stood as a broken 'pseudo-Antique' among the Roman antiquities of Galli's garden,

where it was drawn in that condition by Heemskerck: *Pagan Mysteries of the Renaissance* (Oxford-New Haven, 1958), 147–55. In a letter of 1497, the year in which he finished the Bacchus, Michelangelo wrote that he was contemplating doing a piece of sculpture for his 'own pleasure'; the disintegration of the elaborate collaborative programme patterns of the early part of the century was now complete. Two other drawings known to Wind and in the Library of Trinity College, Cambridge, show the Bacchus without hand or cup. They have recently been attributed to Giovanni Bologna during his first Roman stay (1550–3): E. Dhanens, in *Bulletin de l'Institut Historique Belge de Rome*, XXXV (1963), 159–80.

27. G. Gaye, *Carteggio etc.* (Florence, 1839), II, p. 216 500, quoted by de Tolnay, *op. cit.*, 148–9. Four fingers of the Virgin's left hand have been broken and were poorly 'restored' in the eighteenth century. Exceptionally for Michelangelo, the piece is signed: 'Michaela(n)gelus. Buonarot(t)us. Florentin(us). Faciebat.' (on the strap across the Virgin's breast). The reason is very probably connected with the anecdote related by Vasari that pilgrims coming to Rome were under the impression that the Pietà was by Cristoforo Solari (il Gobbo). Pilgrims would indeed have been likely to have seen the Christ of the Beatrice d'Este monument in S. Maria delle Grazie in Milan, which was by Solari (see above, p. 195). Solari's Dead Christ was probably very highly finished (as was the effigy of Beatrice d'Este), and as a newly completed marvel of North Italian sculpture it might very well have seemed to the untutored eye to be by the same hand as Michelangelo's meticulously finished Christ of the Pietà. The growing unity of Italian style about 1500 is underlined by this incident. The Pietà was not begun until 1498; in March Michelangelo was in Carrara for the purpose of selecting the block of marble, and on 27 August 1498 the contract was signed. The sculpture was to be completed within one year, and the price of 450 gold ducats was high. Jacopo Galli, who acted as the sculptor's agent, had promised that the piece would be 'la più bella opera di marmo che sia hoge [oggi] in Roma'. Hence probably the extreme delicacy of detail and the glistening, polished finish.

28. Ugolino da Verino: quoted by A. Chastel, *op. cit.* (Note 2), 184.

BIBLIOGRAPHY

THE lists which follow are selective. They represent a personal choice which in the author's opinion is most likely to be of value in the study of Quattrocento Italian sculpture today. In the case of individual sculptors (see III below), the titles are preceded by brief biographies. The following classification is used:

I. *General*
 A. Literary Sources and Archival Documents
 B. Surveys of the Period as a Whole
 C. Specialized Aspects, Programmes, and Techniques

II. *Regions and Monuments*
 A. Dalmatia and Eastern Europe
 B. Lombardy and Adjacent Areas
 C. Emilia and Adjacent Areas
 D. Naples and Sicily
 E. Rome
 F. Tuscany: Florence and Siena
 G. Venice and Padua

III. *Individual Sculptors* with biographical sketches (in alphabetical order)

IV. *Principal Collections and Exhibitions*
 A. Principal Museum Collections (by country, city, and museum)
 B. Principal Exhibitions since 1900 (by date)

V. *Periodical Literature Guide*
 A. Yearbooks
 B. Periodicals

I. GENERAL

A. LITERARY SOURCES AND ARCHIVAL DOCUMENTS

In this section selected collections only of documents are listed. For leads to published documents that concern a single sculptor, look below under Individual Sculptors in Section III. For general Bibliography on the sources, see SCHLOSSER, J., *La Letteratura artistica*, 2nd ed. Florence, 1956, 349–80, 535–607.

ALBERTI, LEONE BATTISTA. *De Statua*, ed. H. Janitschek, 'Leone Battista Alberti's kleinere kunsthistorische Schriften', in R. Eitelberger v. Edelberg, *Quellenschriften für Kunstgeschichte*, XI, Vienna, 1877, pp. 168–205.
 With translation in German. A new edition is needed.

ALBERTINI, F. *Memoriale di molte statue et picture che sono nella inclyta ciptà di Florentia*, Florence, 1510; facsimile edition, H. Horne, London, 1909.

ALBERTINI, F. *Opusculum de mirabilibus novae et veteris urbis Romae*, Rome, 1510; ed. Schmarsow, Heilbronn, 1886.

BACCI, P. *Documenti toscani per la storia dell'arte*, II, Florence, 1912; new ed., Florence, 1944.

BACCI, P. *Documenti e commenti per la storia dell'arte*. Florence, 1944.

BISTICCI, VESPASIANO DA. *Vite di uomini illustri del secolo XV*. Bologna, 1892–3. (English trans., London, 1926.) Best recent ed.: P. d'Ancona and E. Aeschlimann (Milan, 1951).

BORGHESI, S., and BANCHI, E. *Nuovi Documenti per la storia dell'arte senese*. Siena, 1898.

CECI, G. 'Nuovi Documenti per la storia dell'arte a Napoli durante il Rinascimento', *Napoli Nobilissima*, IX (1900), 81–4.

CORTI, G., and HARTT, F. 'New Documents concerning Donatello, Luca and Andrea della Robbia, Desiderio, Mino, Uccello, Pollaiuolo, Filippo Lippi, Baldovinetti and Others', *A.B.*, XLIV (1962), 155–68.

FILARETE (AVERLINO, ANTONIO DI PIETRO). *Trattato dell'architettura*, ed. von Oettlingen, *Filaretes Traktat*, in *Quellenschriften für Kunstgeschichte*, N.S. III. Vienna, 1896.
 A new, complete facsimile edition and new translation is in preparation by J. R. Spencer, Yale University Press.

GAURICUS, POMPONIUS. *De Sculptura seu statuaria libellus*, Florence, 1504; ed. H. Brockhaus, Leipzig, 1886. Excerpts in English, E. Maclagan, in Burlington Fine Arts Club, *Catalogue . . . Italian Renaissance Sculpture . . .*, London, 1913.

GAYE, G. *Carteggio inedito d'artisti . . . Documenti di storia italiana*. 3 vols. Florence, 1839.

GHIBERTI, BUONACCORSO. B. Degenhart and W. Lotz, 'Il Zibaldone di Buonaccorso Ghiberti', *Mitteilungen des Kunsthistorischen Instituts in Florenz*, V (1937–40), 427, 431.

GHIBERTI, LORENZO. *Commentarii*, ed. O. Morisani. Naples, 1947.

GHIBERTI, LORENZO. Schlosser, J., in *Lorenzo Ghibertis Denkwürdigkeiten*. Berlin, 1912.

LEONARDO DA VINCI. *Paragone*, ed. I. A. Richter. New York, 1949.

[MANETTI, ANTONIO.] *Vita di Filippo di Ser Brunellesco*, ed. E. Toesca. Florence, 1927.

MATHER, R. G. (ed.). 'Documents Mostly New Relating to Florentine Painters and Sculptors of the Fifteenth Century', *A.B.*, XXX (1948), 20–65.

POGGI, G. *Il Duomo di Firenze, documenti sulla decorazione della chiesa e del campanile tratti dell'archivio dell'Opera. Italienische Forschungen, Kunsthistorisches Institut in Florenz*, II. Berlin, 1909.

VALLE, G. DELLA. *Lettere senesi*, III. Rome, 1786.

VASARI, GIORGIO. *Le Vite de' più eccellenti pittori, scultori ed architettori*: 1st ed., Florence, 1550; 2nd ed., Florence, 1568; best critical edition, Milanesi, Florence, 1878–85; in English, large edition, trans. De Vere, 15 vols., London, 1915; smaller edition, trans. Blashfield and Hopkins, 4 vols., New York, 1896. De Vere includes a translation of the theoretical introduction, *De Scultura*.

B. SURVEYS OF THE PERIOD AS A WHOLE

CICOGNARA, L. *Storia della scultura italiana*. Venice, 1818.

MACLAGAN, E. *Italian Sculpture of the Renaissance*. Cambridge, Mass., 1935.

PITTALUGA, M. *La Scultura italiana del Quattrocento*. Florence, 1932.

POPE-HENNESSY, J. *Italian Gothic Sculpture*. London–New York, 1955.

POPE-HENNESSY, J. *Italian Renaissance Sculpture*. London–New York, 1958.

SEROUX D'AGINCOURT, J.-B., L., and G. *L'Histoire de l'art par les monuments, dépuis son décadence au IV^e siècle jusqu'à son renouvellement au XVI^e*, II, IV. Paris, 1823.

SCHUBRING, P. *Die italienische Plastik des Quattrocento*. Potsdam, 1924.

TOESCA, P. *Storia dell'arte italiana*, II, *Il Trecento*. Turin, 1951.

VALENTINER, W. R. *Studies of Italian Renaissance Sculpture*. London, 1950.

VENTURI, A. *Storia dell'arte italiana*, VI, *La Scultura del Quattrocento*, Milan, 1908; VIII, *L'Architettura del Quattrocento*, Milan, 1924.

C. SPECIALIZED ASPECTS, PROGRAMMES, AND TECHNIQUES

1. Aspects of Antique Revival and Humanism

BARON, H. *The Crisis of the Early Renaissance*. Princeton, 1955.

CHASTEL, A. *Art et humanisme à Florence au temps de Laurent le Magnifique*. Paris–Lille, 1959.

GARIN, E. *L'Umanesimo italiano; filosofia e vita civile nel Rinascimento*. Bari, 1952.

KRISTELLER, P. O. *Renaissance Thought*. New York, 1961.

LANCIANI, R. *Storia degli scavi di Roma*. Rome, 1902 ff.

PANOFSKY, E. *Renaissance and Renascences*. Stockholm, 1961.

2. Economic Aspects

DOREN, A. *Studien aus der Florentiner Wirtschaftgeschichte*, I, *Die Florentiner Wollentuchindustrie*, Stuttgart, 1901; 2, *Das Florentiner Zunftwesen*, Berlin, 1908.

LERNER-LEHMKÜHL, H. *Zur Struktur und Geschichte des Florentiner Kunstmarktes in 15. Jahrhundert*. Münster, 1936.

ORIGO, IRIS. *The Merchant of Prato*. New York, 1957.

WACKERNAGEL, M. *Der Lebensraum des Künstlers in der Florentinischen Renaissance. Aufgaben und Auftraggeber, Werkstatt und Kunstmarkt*. Leipzig, 1938.

3. Programmes, Materials, and Techniques

BAUM, J. *Baukunst und dekorative Plastik der Frührenaissance in Italien*. Stuttgart, 1920.

BÜRGER, F. *Geschichte des Florentinischen Grabmals*. Strassburg, 1904.

BÜRGER, F. *Das Florentinische Grabmal bis Michelangelo*. Strassburg, 1906.

CARLI, E. *La Scultura lignea italiana*. Milan, 1961.

COLASANTI, A. *Le Fontane d'Italia*. Milan–Rome, 1926.

HAFTMANN, G. *Das italienische Saülenmonument*. Leipzig–Berlin, 1939.

KRIS, E. *Meister und Meisterwerke der Steinschneidekunst in der italienischen Renaissance*. Vienna, 1929.

POHL, J. *Die Verwendung des Naturabgusses in der italienischen Porträtplastik der Renaissance*. Bonn, 1938.

RODOLICO, F. *Le Pietre delle città d'Italia*. Florence, 1953.

SCHUBRING, D. *Das italienische Grabmal der Frührenaissance*. Berlin, 1904.

WILES, B. H. *Fountains of Florentine Sculptors and their Followers from Donatello to Bernini*. Cambridge, Mass., 1933.

4. Small Bronzes

BODE, W. VON. *Italian Bronze Statuettes of the Renaissance*. London, 1908–12.

BODE, W. VON. *Die italienischen Bronzestatuetten der Renaissance*. Berlin, 1923.

NICODEMI, C. *Bronzi minori del Rinascimento*. Milan, 1928.

PLANISCIG, L. *Piccoli Bronzi italiani del Rinascimento*. Milan, 1930.

5. Medals and Plaquettes

HABICH, G. *Die medaillen der italienischen Renaissance*. Stuttgart, 1922.

HILL, G. *Medals of the Renaissance*. Oxford, 1920.

HILL, G. *A Corpus of Italian Medals of the Renaissance before Cellini*. London, 1930.

MOLINIER, E. *Les Plaquettes*. Paris, 1886.

6. Goldsmithwork

ACCASCINA, M. *L'Oreficeria italiana*. Florence, 1933.

CHURCHILL, S. J. A., and BUNT, C. G. E. *The Goldsmiths of Italy*. London, 1926.

HAFTMANN, W. 'Italienische Goldschmiedearbeiten', *Pantheon*, XXIII (1939), 29 ff., 54 ff.

MIDDELDORF, U. 'Zu Goldschmiedekunst der toskanischen Frührenaissance', *Pantheon*, XVI (1935), 279 ff.

II. REGIONS AND MONUMENTS

A. DALMATIA AND EASTERN EUROPE

DUDAN, A. *La Dalmazia nell'arte italiana*. Milan, 1922.

FOLSNESICS, H. 'Studien zu Entwicklungsgeschichte der Architektur und Plastik des XV Jahrhundert in Dalmatien', *Jahrbuch der Kunsthistorisches Instituts der K.K. Zentralkommission für Denkmalpflege*, VIII (1914), 34–196.

IVEKOVIC, C. M. *Dalmatiens Bau- und Kunstdenkmäler*. Vienna, 1927.

JOLANDA, B. 'I Monumenti del Rinascimento della chiesa parrocchiale di Pest', *Rivista d'Arte*, XX (1938), 60–77.

SCHRAFFRAN, E. 'Mattia Corvino re dell'Ungheria ed i suoi rapporti col Rinascimento italiano', *Rivista d'Arte*, XIV (1932), 445–61, XV (1933), 191–201.

B. LOMBARDY AND ADJACENT AREAS

ARSLAN, E. 'La Scultura nella seconda metà del Quattrocento', *La Storia di Milano*, VII, 691–746. Milan, 1956.

BARONI, C. *Documenti per la storia dell'architettura a Milano nel Rinascimento e nel Barocco*. Florence, 1940.

BARONI, C. *Bramante*. Bergamo, 1944.

BARONI, C. *La Scultura gotica lombarda*. Milan, 1944.

CHIERICI, G. *La Certosa di Pavia*. Rome, 1942.

LEHMANN, H. *Lombardische Plastik im letzten Drittel des XV. Jahrhunderts*. Berlin, 1928.

MAGENTA, C. *La Certosa di Pavia*. Milan, 1897.

MALAGUZZI-VALERI, F. *La Corte di Ludovico il Moro*. Milan, 1913–23.

MEYER, A. G. *Obertitalienische Frührenaissance: Bauten und Bildwerke der Lombardei*. Berlin, 1897–1900.

NEBBIA, U. *La Scultura nel Duomo di Milano*. Milan, 1908.

SALMI, M. 'La Chiesa di Villa a Castiglione Olona e le origini del Rinascimento in Lombardia', in *Miscellanea di studi in onore di Ettore Verga*, 271–83. Milan, 1931.

SALMI, M. *Firenze, Milano e il primo Rinascimento*. Milan, 1941.

VIGEZZI, C. *La Scultura lombarda dell'Antelami all'Amadeo*. Milan, 1928.

C. EMILIA AND ADJACENT AREAS

LAURO, P. *Graticola di Bologna ossia descrizione delle pitture, sculture e architetture di detta città fatto l'anno 1560.* Bologna, 1844.

RICCI, C. *Il Tempio Malatestiano.* Milan–Rome, 1925.

ROTONDI, P. *Il Palazzo ducale di Urbino.* 2 vols. Urbino, 1950.

SERRA, L. *L'Arte nelle Marche, Il Periodo del Rinascimento.* Rome, 1934.

SUPINO, I. B. *La Scultura in Bologna nel secolo XV.* Bologna, 1910.

TARCHI, U. *L'Arte del Rinascimento nell'Umbria e nella Sabina.* Milan, 1942.

VENTURI, A. 'La Scultura Emiliana nel Rinascimento', *Archivio storico dell'Arte*, III (1890), 1–23.

VENTURI, L. 'Studii sul palazzo ducale di Urbino', *L'Arte* (1914), 415–73.

VENTURI, L. 'Opere di scultura delle Marche', *L'Arte*, XIX (1916), 15–20.

D. NAPLES AND SICILY

ACCASCINA, M. ' "Sculptores habitatores Panormi", Contributi alla conoscenza dalla scultura in Sicilia nella seconda metà del Quattrocento', *Rivista dell'Istituto Nazionale dell'archeologia e storia dell'arte*, N.S. VIII (1959), 269–313.

BERTAUX, E. *L'Art dans l'Italie méridionale.* Paris, 1904.

CAUSA, R. 'Contributi alla conoscenza della scultura del 1400 a Napoli', in F. Bologna and R. Causa, *Sculture lignee nella Campania.* Naples, 1950.

CECI, G. *Bibliografia per la storia delle arti figurative nell'Italia Meridionale* (Reale Deputazione Napoletana di Storia Patria). Naples, 1937.

FABRICZY, C. VON. 'Der Triumphbogen Alfonsos I am Castelnuovo zu Neapel', *Berlin Jahrbuch*, XX (1899), 1–30, 125–58.

FABRICZY, C. VON. 'Neues zum Triumphbogen Alfonsos I', *Berlin Jahrbuch*, XXIII (1902), 3–16.

FERRARI, O. 'Per la Conoscenza della scultura del primo Quattrocento a Napoli', *Bollettino d'Arte*, XXXIX (1954), 11–24.

FILANGIERI DI CANDIDA, R. 'L'Arco trionfale di Alfonso d'Aragona', *Dedalo*, XII (1932), 439–66, 594–626.

FILANGIERI DI CANDIDA, R. *Castelnuovo, Reggia Angioina ed Aragonese di Napoli.* Naples, 1934.

FILANGIERI DI CANDIDA, R. 'Rassegna critica delle fonti per la storia di Castelnuovo', *Archivio storico della Provincia di Napoli*, XXII–XXIII (1936–9).
> The critical period for these studies is covered in vol. XXII (1937), 271–323.

MELI, F. *Matteo Carnilivari e l'architettura del Quattro e Cinquecento in Palermo.* Rome, 1958.
> Contains discussion of sculptors.

NICOLINI, F. *L'Arte napolitano del Rinascimento e la lettera di P. Summonte.* Naples, 1925.
> Discussion of a valuable source.

PANE, R. *Architettura del Rinascimento a Napoli.* Naples, 1937.

E. ROME

CALLISEN, S. A. *Roman Sculpture of the Quattrocento.* Ph.D. dissertation (typescript), Harvard University.

CIACCIO, L. 'La Scultura romana del Rinascimento (sino al pontificato di Pio II)', *L'Arte*, IX (1906), 165–84, 345–56, 433–41.

[CIACCONIO] CIACCONIUS. *Vitae et res gestae pontificum romanorum*, III. Rome, 1677.

DAVIES, G. S. *Renascence, The Sculptured Tombs of the Fifteenth Century in Rome.* London, 1910.

[DIONIGI] DIONYSIUS, P. L. *Sacrarum vaticanae basilicae cryptarum monumenta.* Rome, 1773.

DUFRESNE, D. *Les Cryptes vaticanes.* Paris, 1902.

GREGOROVIUS, F. *Tombs of the Popes*, trans. R. W. Seton-Watson, London, 1900; also Westminster, 1903.

MALAGUZZI-VALERI, F. 'Artisti lombardi a Roma nel Rinascimento', *Repertorium für Kunstwissenschaft*, XXV (1902), 49–64.

MÜNTZ, E. 'Les Arts à la cour des papes pendant le XVe siècle. Recueil de documents inédits', *Bibliothèque des Écoles françaises d'Athènes et de Rome*, fascicules IV, IX, XXVIII (1878–82).

MÜNTZ, E. *Les Antiquités de la ville de Rome aux XIVe, XVe et XVIe siècles.* Paris, 1886.

MÜNTZ, E. *Les Arts à la cour des papes. Nouvelles récherches sur les pontificats de Martin V, de Eugène IV et de Calixte III. Mélanges d'archéologie et d'histoire, École française de Rome*, IV (1884), 274–303; V (1885), 321–37; IX (1889), 134–73.

MÜNTZ, E. *Les Arts à la cour des papes Innocent VIII, Alexandre VI et Pie III (1483–1503). Recueil de documents inédits ou peu connus.* Paris, 1898.

STEINMANN, E. *Rom in der Renaissance.* Leipzig, 1899.

F. TUSCANY: FLORENCE AND SIENA

BACCI, P. 'L'Elenco delle pitture, sculture e architetture di Siena compilato . . . da Monsignor Fabio Chigi . . .', *Bollettino Senese di Storia Patria*, X (1939), 197–213, 297–337.

BOCCHI, F. *Le Bellezze della città di Firenze*, Florence, 1591; ed. M. G. Cinelli, Florence, 1677.

BODE, W. VON. *Denkmäler der Plastik Toscanas*. Munich, 1892–1905.

BODE, W. VON. *Florentiner Bildhauer der Renaissance*, 4th ed. Berlin, 1921.

BODE, W. VON. *Florentine Sculptors of the Renaissance*. New York, 1928.

BROGI, F. *Inventario generale degli oggetti d'arte della provincia di Siena (c. 1865)*. Siena, 1897.

BÜRGER, F. *Geschichte des florentinischen Grabmals*. Strassburg, 1904.

CARLI, E. *La Scultura lignea senese*. Milan–Florence, 1954.

CECCHI, E. *Florentiner Plastik des Quattrocento*. Zürich, 1951.

FABRICZY, C. VON. 'Kritisches Verzeichnis toskanischer Holz- und Tonstatuen bis zum Beginn des Cinquecento', *Berlin Jahrbuch*, XXX (1909), Supplement, 1–88.

GALASSI, G. *La Scultura fiorentina del Quattrocento*. Milan, 1949.

KAUFFMANN, H. 'Florentiner Domplastik', *Berlin Jahrbuch*, XLVII (1926), 141 ff., 216 ff.

PAATZ, W. and E. *Die Kirchen von Florenz, ein kunstgeschichtliches Handbuch*. 5 vols. Frankfurt am Main, 1940–54.

REYMOND, M. *La Sculpture florentine*. Florence, 1897–1900.

SCHUBRING, P. *Die Plastik Sienas im Quattrocento*. Berlin, 1907.

SUPINO, I. B. *Arte pisana*. Florence, 1904.

TURBANTI, O. *Il Duomo di Siena*. Siena, 1930.

G. VENICE AND PADUA

FIOCCO, G. 'Sulle relazioni tra la Toscana e il Veneto nei secoli XV e XVI', *Rivista d'Arte*, XI (1929), 439–48.

PAOLETTI, P. *L'Architettura e la scultura del Rinascimento in Venezia*, Venice, 1893; French ed., 1897.

PLANISCIG, L. *Venezianische Bildhauer der Renaissance*. Vienna, 1921.

PLANISCIG, L. 'Die Bildhauer Venedigs in der ersten Hälfte des Quattrocento', *Jahrbuch der Kunsthistorischen Sammlungen in Wien*, N.F. IV (1930), 48–120.

RIGONI, E. 'Notizie di scultori toscani a Padova nella prima metà del Quattrocento', *Archivio Veneto*, ser. 6, VI (1929), 118–36.

III. INDIVIDUAL SCULPTORS WITH BIOGRAPHICAL SKETCHES

In the following section the reader is referred to *Thieme–Becker* and the *Encyclopedia of World Art* for references to earlier literature. Important articles and books before the date of the *Thieme–Becker* article are occasionally given, but the emphasis is in general on the more recent literature.

ADRIANO FIORENTINO (fl. 1480s–d. 1499)

Adriano Fiorentino was mainly a medallist and sculptor in bronze. Trained by Bertoldo, he cast at least one of that master's works (statuette-group of Bellerophon and Pegasus). He travelled to Germany and did a bust of Frederick the Wise of Saxony. He was briefly active in North Italy and also at the court of Alfonso II in Naples.

KNAPP, F., in *Thieme–Becker*, I (1907), 91–2.

FABRICZY, C. VON. 'Adriano Fiorentino', *Berlin Jahrbuch*, XXIV (1903), 71–98.

AGOSTINO DI DUCCIO (1418–81)

Agostino was born in Florence, and was trained in the cathedral shops under Donatello and possibly Luca della Robbia as a stone-carver. He was at Modena in 1442 and in Venice from 1446 to 1449, when he was called to Rimini to work on the Tempio Malatestiano with his brother Ottaviano as his first assistant. He was in Perugia from 1457 to 1463, mainly for the façade of S. Bernardino. He then went to Florence, joined the sculptors' guild, and worked on several marble reliefs of the Virgin and Child. He returned to Perugia in 1473 and was active there until c. 1480. He is not mentioned after 1481.

URBINI, G., in *Thieme–Becker*, I (1907), 127–8.

BRUNETTI, G. 'Il Soggiorno veneziano di Agostino di Duccio', *Commentari*, I (1950), 82–8.

BRUNETTI, G. 'Una Questione di Agostino di Duccio: "La Madonna di Auvilliers"', *Rivista d'Arte*, XXVIII (1954), 121–31.

JANSON, H. W. 'Two Problems in Florentine Renaissance Sculpture', *A.B.*, XXIV (1942), 326–34.

MATHER, R. B. 'Documents Mostly New Relating to Florentine Painters and Sculptors of the Fifteenth Century', *A.B.*, XXX (1948), 20–5.

POPE-HENNESSY, J. *The Virgin and Child by Agostino di Duccio* (Victoria and Albert Museum Monograph). London, 1952.

SANTI, F. 'L'Altare di Agostino di Duccio in S. Domenico di Perugia', *Bollettino d'Arte*, XLVI (1961), 162–73.

ALBERTI, LEONE BATTISTA (1402/3–72)

Alberti was born in Genoa. His parents were exiled Florentine nobles. He was active in Florence and Rome as a humanist, theorist of art, architect, and amateur painter and sculptor. He was the author of *De Statua*, the first theoretical treatise on sculpture of the Renaissance (see above, I). The sculpture attributed to Alberti by modern scholarship consists of portraiture in bronze.

SUIDA, W., in *Thieme–Becker*, I (1907), 196–211.

BADT, K. 'Drei plastische Arbeiten von Leone Battista Alberti', *Mitteilungen des Kunsthistorischen Instituts in Florenz*, VIII (1958), 78–87.

MANCINI, G. *Vita di Leon Battista Alberti*. Florence, 1882.

MICHEL, P. H. *La Pensée de L.-B. Alberti*. Paris, 1930.

PARRONCHI, A. 'Sul "della Statua" Albertiano', *Paragone*, X (1959), 3–29.

AMADEO, GIOVANNI ANTONIO (1447–1522)

Born at Pavia, Amadeo was associated with the Mantegazza on the façade of the Certosa and the decoration in the cloisters. He worked also in Milan and, from 1470 to 1476, at Bergamo on the Colleoni Chapel and tomb. From 1500 on he was active as an architect and an engineer and did important sculpture for the Duomo in Milan. He was first Ducal sculptor and had an extremely influential position and shop.

MALAGUZZI-VALERI, F., in *Thieme–Becker*, I (1907), 367–71.

ACQUA, G. A. DELL'. 'Problemi di scultura lombarda: Mantegazza e Amadeo', *Proporzione*, III (1950), 123–40.

MAJOCCHI, R. 'Giovanni Antonio Amadeo ... secondo i documenti negli archivi pavesi', *Bollettino della Società pavese di Storia Patria*, III (1903), 39–80.

MALAGUZZI-VALERI, F. G. A. *Amadeo scultore e architetto*. Bergamo, 1904.

MIDDELDORF, U. 'Ein Jugendwerk des Amadeo', *Kunstgeschichtliche Studien für Hans Kauffmann*, 136–42. Berlin, 1956.

ANDREA DA FIESOLE (Andrea di Guido)
(fl. c. 1400–c. 1415)

Nothing is known of his early career and training; it is supposed that he was trained in Florence. In 1403 he was already in Bologna, as witnessed by his Roberto and Riccardo da Saliceto Monument (S. Martino Maggiore). A later Saliceto monument (now Museo Civico) is signed by him and dated 1412.

MALAGUZZI-VALERI, F., in *Thieme–Becker*, I (1907), 456.

GNUDI, C. 'Intorno ad Andrea da Fiesole', *Critica d'Arte*, IV (1958), 23 ff.

ANDREA DA FIRENZE (Andrea Nofri)
(1388–1459?)

Andrea Nofri (sometimes called Ciccione) appears to have been active in Florence in early life. Shortly after 1420 he is assumed to have gone to Naples, where he is known to have worked on the monuments of King Ladislas and Fernando da Sanseverino in S. Giovanni a Carbonara. He also worked briefly at Ancona.

[ANON.], in *Thieme–Becker*, I (1907), 453.

FILANGIERI DI CANDIDA, R. 'La Scultura del primo albori del Rinascimento', *Napoli Nobilissima*, 2nd ser., I (1920–1), 89–94.

ANTICO (Pier Jacopo Alari Bonacolsi)
(c. 1460–1528)

Antico was born in Mantua and worked there mostly, except for a sojourn in Rome between 1495 and 1500. He was under the patronage of Francesco and Lodovico Gonzaga and subsequently worked as a silversmith, maker of bronze statuettes, and restorer of antiques for Isabella d'Este.

[ANON.], in *Thieme–Becker*, I (1907), 555–6.

HERMANN, H. J. 'Pier Jacopo Alari-Bonacolsi, genannt Antico', *Jahrbuch der Kunsthistorischen Sammlungen in Wien*, XXVIII (1909–10), 201–88.

BABBOCCIO, ANTONIO (1351–1435)

Active in Naples and Sicily, Babboccio was a marble sculptor in the Late Gothic style. He and his shop worked on the portals of the cathedrals of Naples and Messina.

[ANON.], in *Thieme–Becker*, II (1908), 301.

FERRARI, O. 'Per la conoscenza della scultura del primo Quattrocento a Napoli', *Bollettino d'Arte*, XXXIX (1954), 11–24.

BARONCELLI, NICCOLÒ (c. 1395–1453)

A Florentine bronze sculptor believed to have been trained by Brunelleschi. He worked mostly at Ferrara and for the Este family (1443–53), and was given the commission for the equestrian statue of Niccolò d'Este (no longer extant). Before then he was active in Padua (1434–42).

NICOLA, G. DE, in *Thieme–Becker*, II (1908), 517.

FIOCCO, G. 'Sulle relazioni tra la Toscana e il Veneto nei secoli XV e XVI', *Rivista d'Arte*, XI (1929), 439–48.

RIGIONI, E. 'Il Soggiorno in Padova di Niccolò Baroncelli', *Atti e Memorie della Reale Accademia di Scienze, Lettere, ed Arti in Padova*, N.S. XLIII (1927), 215–29.

BELLANO, BARTOLOMMEO (c. 1434–96/7)

Bellano was the son of a Paduan goldsmith and presumably a pupil of Donatello, first at Padua, then in Florence in 1453. His first documented work, a bronze statue of Pope Paul II, dated 1467, has been lost. Bellano worked primarily in bronze and did ten bronze reliefs for S. Antonio in Padua from 1480 on. He was a distinguished sculptor of bronze figures on a small scale and the master of Riccio.

MOSCHETTI, A., in *Thieme–Becker*, III (1909), 233–6.

BETTINI, S. 'Bartolomeo Bellano "ineptus artifex"?', *Rivista d'Arte*, XIII (1931), 45–108.

PLANISCIG, L. *Andrea Riccio*, 27–74. Vienna, 1927.

SCRINZI, A. 'Bartolommeo Bellano', *L'Arte*, XXIX (1926), 248–60.

BENEDETTO DA MAJANO (1442–97)

Benedetto di Leonardo d'Antonio was born at Majano near Florence in 1442 and probably began in Desiderio's shop. He was assistant to, and artistic heir of, Antonio Rossellino. He joined the Florentine Sculptors' Guild in 1473 and worked on schemes at Siena, Florence, and Loreto. He had commissions for Naples in the 1480s. After 1480 his *bottega* was the most important in Florence. He was at times assisted by his older brothers Giuliano and Giovanni and frequently collaborated with Giuliano, who was primarily an architect.

SCHOTTMÜLLER, F., in *Thieme–Becker*, III (1909), 309–13.

DUSSLER, L. *Benedetto da Maiano*. Munich, 1925.

MATHER, R. G., in 'Documents Mostly New Relating to Florentine Painters and Sculptors of the Fifteenth Century', *A.B.*, XXX (1948), 37–40.

BENEDETTO DA ROVEZZANO (1474–after 1552)

Born at Pistoia and possibly trained by Matteo Civitale and Sansovino, Benedetto was active in Genoa, Florence, and later in England. He was an architect and a sculptor both in stone and bronze.

SCHOTTMÜLLER, F., in *Thieme–Becker*, III (1909), 314–16.

BENTI, DONATO (1470–c. 1536)

Benti was a west coast marble sculptor who had an early association with Benedetto da Rovezzano. He was active at Pisa, Genoa, and Pietrasanta (Tuscany).

[ANON.], in *Thieme–Becker*, III (1909), 354–5.

BERTOLDO (c. 1420–91)

Trained by Donatello, Bertoldo di Giovanni worked on the S. Lorenzo pulpits in Florence, being responsible for parts of the frieze and for the finishing of several reliefs. As an independent artist he did a number of bronze statuettes, reliefs, plaquettes, and medals. He was born and lived in Florence and was on close terms with Lorenzo de' Medici; towards the end of his life he was in charge of the Medici collections of sculpture. He was briefly one of Michelangelo's teachers, though not so influential in this respect as once thought.

SCHOTTMÜLLER, F., in *Thieme–Becker*, III (1909), 505–7.

BODE, W. VON. *Florentine Sculptors of the Renaissance*, 2nd ed., 180–200. London, 1928.

CHASTEL, A. 'Vasari et la légende medicéenne: l'école du jardin de Saint-Marc', *Studi Vasariani*, 159–67. Florence, 1952.

BREGNO, ANDREA (1421–1506)

Born at Osteno near Como in 1421, Andrea Bregno went to Rome in the 1460s. He had a large shop which produced great numbers of tombs and

altars, and he became an enormously popular Roman sculptor.

FRIEDLÄNDER, W., in *Thieme–Becker*, IV (1910), 566–8.

CALLISEN, S. A. Ph.D. Dissertation (typescript), Harvard University.
 On Bregno alone, 126–409.

EGGER, H. 'Beiträge zur Andrea Bregno Forschung', *Festschrift für Julius Schlosser*, 122–36. Vienna, 1927.

LAVAGNINO, E. 'Andrea Bregno e la sua bottega', *L'Arte* (1924), 247–63.

STEINMANN, E. 'Andrea Bregnos Tätigkeit in Rom', *Berlin Jahrbuch*, XX (1899), 216–32.

BREGNO, ANTONIO (fl. 1425–after 1457)

Antonio Bregno was born at Righeggio on the Lake of Lugano and probably was the Antonio de Rigesio da Como who worked on the Cà d'Oro. He did most of the sculpture of the Arco Foscari, working with Antonio Rizzo. He became associated with the Buon workshop about 1426–7.

PAOLETTI, P., in *Thieme–Becker*, IV (1910), 568–9.

MARIACHER, G. 'Antonio da Righeggio e Antonio Rizzo', *Le Arti*, II (1941), 193–8.

MARIACHER, G. 'New Light on Antonio Bregno', *B.M.*, XCII (1950), 123–8.

PAOLETTI, P. *L'Architettura e la scultura del Rinascimento in Venezia, passim*. Venice, 1893.

PLANISCIG, L. *Venezianische Bildhauer der Renaissance*, 30–7. Vienna, 1921.

BRIOSCO, ANDREA, *see* RICCIO

BRIOSCO, BENEDETTO (fl. 1483–1506)

Of North Italian origin. His training and beginnings are not known, though his master may be reasonably supposed to have been Amadeo. He was a marble sculptor of distinction and originality and did his best work for the Certosa di Pavia, where he replaced Amadeo in 1501. His earliest documented work (c. 1490) was for the Duomo in Milan.

MALAGUZZI-VALERI, F., in *Thieme–Becker*, V (1911), 23.

LEHMANN, H. *Lombardische Plastik im letzten Drittel des XV Jahrhunderts*, 67 ff. Berlin, 1928.

BRUNELLESCHI, FILIPPO (1377–1446)

He was born in Florence and was first trained as a silversmith. Early figures by him for the Altar of St James in the Cathedral of Pistoia are extant, as is his unsuccessful entry in the baptistery doors competition. He developed his great interest in architecture after a presumed trip to Rome with Donatello, and came to be the greatest architect of the Early Renaissance. His later sculptural activity included work in wood (see the Crucifix in S. Maria Novella) and possibly, in design at least, terracotta (the Pazzi Chapel Evangelists). His fifteenth-century biography attributed to Antonio Manetti is listed above under I: Sources.

LIMBURGER, W., in *Thieme–Becker*, V (1911), 125–32.

FABRICZY, C. VON. *Filippo Brunelleschi: sein Leben und seine Werke*. Stuttgart, 1892.

FABRICZY, C. VON. 'Brunelleschiana', *Berlin Jahrbuch*, XXVIII (1903), Supplement, 1–84.

RAGGHIANTI, C. 'Aenigmata Pistoriensia I', *Critica d'Arte*, V (1954), 433–8.

SANPAOLESI, P. *Brunellesco e Donatello nella Sagrestia Vecchia*. Pisa, 1950.

SANPAOLESI, P. 'Aggiunte al Brunelleschi', *Bollettino d'Arte*, XXXVIII (1953), 225–32.

SANPAOLESI, P. *Brunelleschi*. Florence, 1962.

SHAPLEY, F. R., and KENNEDY, C. 'Brunelleschi in competition with Ghiberti', *A.B.*, V (1922/3), 31–4.

BUGGIANO (Andrea di Lazzaro Cavalcanti) (1412–62)

Born at Borgo a Buggiano near Empoli, he was an eclectic trained by Brunelleschi who also came under the influence of Donatello and Luca della Robbia. He was active mainly in Florence as a sculptor and occasionally as an architect, and probably executed some designs by Brunelleschi. He was Brunelleschi's adopted son.

BIEHL, W. R., in *Thieme–Becker*, VI (1912), 213–15.

POGGI, G. 'Andrea di Lazzaro Cavalcanti e il pulpito di S. Maria Novella', *Rivista d'Arte*, III (1905), 77–85.

CAZZANIGA, FRANCESCO AND TOMMASO (fl. from 1470; Francesco died before 1486, Tommaso after 1500)

It is believed that Francesco was the older of these two brothers. They were born in Milan. Their style shows the influence of Amadeo and the Mantegazza. They were active in Milan, Pavia, and elsewhere in Lombardy, where they worked entirely in marble.

MALAGUZZI-VALERI, F., in *Thieme–Becker*, VI (1912), 247–9.

CIUFFAGNI, BERNARDO (1385–1457)

He was born in Florence and may have worked for Ghiberti on the doors of the baptistery in 1407. Beginning in 1409, he was commissioned to do work for the Duomo. The statue of St Peter of the Butchers' Guild on Or San Michele in Florence is now believed to be the work of Ciuffagni rather than of Donatello. He left Florence in 1417 probably for Venice and returned in the 1420s. In the 1420s and 1430s he received some commissions for statuary for the Duomo. He was not active after 1440 to our knowledge. Suppositions that he worked on the sculpture of the Tempio Malatestiano seem groundless.

SCHOTTMÜLLER, F., in *Thieme–Becker*, VII (1912), 17–19.

LÁNYI, J., in 'Le Statue quattrocentesche dei profeti nel campanile e nell' antica facciata di Santa Maria del Fiore', *Rivista d'Arte*, XVII (1935), 128–32.
 The classic article for Lányi's method.

WUNDRAM, M. 'Donatello und Ciuffagni', *Zeitschrift für Kunstgeschichte*, XXII (1959), 85–101.
 Excellent up-to-date view both of documentary and visual evidence.

CIVITALE, MATTEO (1436–1501)

He was born at Lucca, but must have been trained by Antonio Rossellino in his studio in Florence. Matteo worked mostly at Lucca, where Domenico Bertini was his special patron, and where the best of his work in marble may be seen in the Duomo. Late in his career Matteo was active in Genoa on statuary for the baptistery in the cathedral; the series begun by him was finished by Andrea Sansovino.

SCHOTTMÜLLER, F., in *Thieme–Becker*, VII (1912), 23–8.

RIDOLFI, E. *L'Arte in Lucca studiata nella sua cattedrale*. Lucca, 1882.
 Elaborate appendix on Civitale.

COZZARELLI, GIACOMO (1453–1515)

Born at Siena in 1453, Cozzarelli was a pupil of Francesco di Giorgio. He was an architect and a sculptor working in bronze, wood, terracotta, and marble, and was active at Urbino and Montepulciano as well as at Siena.

NICOLA, G. DE, in *Thieme–Becker*, VIII (1913), 37–8.

BACCI, P. 'Commentarii dell'arte senese. 1. Il Pittore, scultore e architetto Iacopo Cozzarelli e la sua permanenza in Urbino con Francesco di Giorgio Martini del 1478 al 1488', *Bollettino Senese di Storia Patria*, XXXIX (1932), 97 ff.

BERSANO, L. 'L'Arte di Giacomo Cozzarelli', *Bollettino Senese di Storia Patria*, LXIV (1957), 109–42.

KINGSLEY PORTER, A. 'Giacomo Cozzarelli and the Winthrop Statuette', *Art in America*, IX (1921), 95–101.

SCHUBRING, P. *Die Plastik Sienas im Quattrocento*, 202–22. Berlin, 1907.

DALMATA, GIOVANNI (1440–1509)

Ivan Duknovic, known as Giovanni da Traù, was born at Traù, Dalmatia (now Trogir, Yugoslavia). He was almost certainly first influenced by Giorgio da Sebenico. He went to Rome about 1460, where he may have worked under Paolo Romano. From c. 1465 to 1480 his major work was in Rome. There he was associated with Andrea Bregno and Mino da Fiesole. He went to Hungary in the service of Matthias Corvinus in 1481, and later can be traced in Venice, at Ancona, and at Traù.

SCHOTTMÜLLER, F., in *Thieme–Becker*, VIII (1913) 303–4.

DONATI, L. 'L'Attività in Roma di Giovanni Dalmata di Traù', *Archivio storico per la Dalmazia*, X (1931), 522–34; XI (1932), 54–66.

PRIJATELJ, K. *Ivan Duknovic*. Zagreb, 1957.

PRIJATELJ, K. 'Profilo di Giovanni Dalmata', *Arte Antica e Moderna*, VII (1959), 283–97.

DELLI, DELLO DI NICCOLÒ (c. 1404–66/7)

Dello was born in Florence, where he was active during the first and last parts of his career, with a sojourn in Spain between. He was a painter, but also made sculpture in terracotta. His major commissions were for statues for the interior and exterior of S. Egidio in Florence (before 1424).

WEISBACH, W., in *Thieme–Becker*, IX (1913), 27–8.

MIDDELDORF, U. 'Dello Delli and The Man of Sorrows in the Victoria and Albert Museum', *B.M.*, LXXVIII (1941), 71–8.

DESIDERIO DA SETTIGNANO (c. 1430–64)

Born between 1428 and 1431, Desiderio was trained in Florence probably by Bernardo Rossellino, and was an established master by 1453. He was to a certain extent influenced by Donatello and enjoyed great fame during his relatively brief lifetime and

during the entire fifteenth century. He had as first assistant his brother Geri. His *bottega* seems to have been large and was extremely influential. Desiderio's work included marble reliefs, busts, tombs, and altars. The major works are the Marsuppini Monument in S. Croce and the Altar of the Sacrament in S. Lorenzo.

SCHOTTMÜLLER, F., in *Thieme–Becker*, IX (1913), 132–3.

CARDELLINI, I. 'Desiderio da Settignano e il Tabernacolo di San Lorenzo', *Critica d'Arte*, N.S. III (1956), 68–75.

CARDELLINI, I. *Desiderio da Settignano*. Milan, 1962.
> Review by A. Markham, in *A.B.*, XLVI (1964), 239–47. Needed corrective.

KENNEDY, C. 'Documenti inediti su Desiderio da Settignano e la sua famiglia', *Rivista d'Arte*, XII (1930), 248–91.

PLANISCIG, L. *Desiderio da Settignano*. Vienna, 1942.

DOMENICO DI NICCOLÒ DE' CORI
(Domenico di Niccolò Spinelli) (*c.* 1362–1450)

Domenico worked in Siena, where he was born. He was a wood sculptor, intarsia designer, and architect. He received acclaim for the choir stalls he did for the chapel of the Palazzo Pubblico in Siena and from which he took his nickname 'dei Cori'.

BERNATH, M. H., in *Thieme–Becker*, IX (1913), 412–13.

BACCI, P. *Jacopo della Quercia*, 53–9, 71 ff., 121–2, 152. Siena, 1929.

CARLI, E. *Scultura lignea senese*, 41–9, 116–17. Milan–Florence, 1954.

DOMENICO DI PARIS (fl. *c.* 1450–92)

He was born in Padua and trained by Niccolò Baroncelli, whose shop he took over after Baroncelli's death in 1453. They had worked together on the bronze equestrian statue of Niccolò d'Este in Ferrara; most of Domenico's later work was in Ferrara (in particular, St George and St Maurelius (Plate 61A) for the cathedral; ceiling of the Antecamera of the Palazzo Schifanoia).

BALLARDINI, G., in *Thieme–Becker*, IX (1913), 407.

DUSSLER, L. 'An Unknown Sculpture by Domenico di Paris', *B.M.*, XLVIII (1926), 301–2.

SCHUBRING, P. 'Zwei Madonnenreliefs von Giovanni da Pisa e Domenico di Paris', *Der Cicerone*, XVIII (1926), 566–8.

DONATELLO (Donato di Niccolò di Betti Bardi) (1383/6–1466)

Donatello was born and died in Florence. He was active there and in Rome (1432–3), Padua (1443–53), and Siena (1457–9). His overpowering individualism and his unmatched originality obscure the traces of his training (partly with Ghiberti) and first public work. The latter was probably connected with the Porta della Mandorla of Florence Cathedral. After a first period spent largely on big monumental programmes, and a stay in Rome with Michelozzo, he became a favourite artist of Cosimo de' Medici. He then left for Padua and the North (1443–53). His last period in Siena (*c.* 1457–9) and Florence (1459–61) was marked by deeply emotional work in wood and bronze. He left as inheritors of his last commissions Bertoldo and Bellano, but no one could be called his successor, except possibly Michelangelo.

SEMRAU, M., in *Thieme–Becker*, IX (1913), 420–5.

BECHERUCCI, L. 'Donatello', *Encyclopedia of World Art*, IV, 427–42. New York, 1961.

BOCCHI, F. *Eccellenza della statua di S. Giorgio di Donatello*. Florence, 1584.

JANSON, H. W. *The Sculpture of Donatello*. Princeton, 1957, 1962.

KAUFFMANN, H. *Donatello: Eine Einführung in sein Bilden und Denken*. Berlin, 1935.

LÁNYI, J. 'Problemi di critica donatelliana', *Critica d'Arte*, IV (1939), 9 ff.

LÁNYI, J. 'Le statue quattrocentesche dei Profeti nel Campanile e nell'antica facciata di Santa Maria del Fiore', *Rivista d'Arte*, XVII (1935), 121–59, 245–80.

MARTINELLI, V. 'Donatello e Michelozzo a Roma', *Commentari*, VII (1957), 167–94; IX (1958), 3–24.

MIDDELDORF, U. Review of Kauffmann, *Donatello*, 1935, in *A.B.*, XVIII (1936), 570–85.

MORISANI, O. *Studi su Donatello*. Venice, 1952.

PLANISCIG, L. *Donatello*. Florence, 1939.

POPE-HENNESSY, J. *Donatello's Relief of the Ascension and Christ Giving the Keys to St Peter* (Victoria and Albert Museum Monograph). London, 1949.

WUNDRAM, M. 'Donatello und Ciuffagni' (*see* above under Ciuffagni).

The most important specialized studies which have appeared since Janson's monograph are as follows:

JANSON, H. W. 'Giovanni Chellini's *Libro* and Donatello', in W. Lotz and L. L. Möller (eds),

Studien zur Toskanischen Kunst, Festschrift für L. H. Heydenreich (Munich, 1964), 131–8.

LAVIN, I. 'The Sources of Donatello's Pulpits in San Lorenzo', *A.B.*, XLI (1959), 19–38.

LISNER, M. 'Zur frühen Bildhauerarchitektur Donatellos', *Münchner Jahrbuch der bildenden Kunst*, 3rd ser., IX–X (1958/9), 72–127.

LISNER, M. 'Zum Frühwerk Donatello's', *Münchner Jahrbuch der bildenden Kunst*, 3. XIII (1963), 63–8.

PARRONCHI, A. 'Per la riconstruzione dell'altare del Santo', *Arte antica e moderna*, XXII (1963), 109–23.

POPE-HENNESSY, J. 'Some Donatello Problems', *Studies in the History of Art Dedicated to William E. Suida*, 47–61. New York, 1959.

SARTORI, P. A. 'Documenti riguardanti Donatello e il suo altare a Padova', *Il Santo*, I (1961), 37–99.
 May be used instead of earlier publication by Gloria.

SARTORI, P. A. 'Il Donatelliano Monumento equestre a Erasmo Gattamelata', *Il Santo*, I (1961), 326 ff.

FEDERIGHI, ANTONIO (c. 1400–90)

Born in Siena, Antonio Federighi dei Tolomei was presumably a pupil of Pietro del Minella, but was mainly influenced by the late work of Quercia. He was active at both Siena and Orvieto (1455/6), and was an architect as well as a sculptor in wood and marble. First mentioned in the Duomo rolls in 1414 (Carli).

NICOLA, G. DE, in *Thieme–Becker*, I (1907), 587–8.

CARLI, E. *La Scultura lignea senese*, 73–4, 117–18. Milan–Florence, 1954.
 Treats hypotheses for wood sculpture.

FERRUCCI, ANDREA DI PIERO (1465–1526)

Born in Fiesole and trained by Francesco di Simone Ferrucci da Fiesole. As an architect and sculptor in marble, Andrea was active in Florence and elsewhere in Tuscany, and also in Rome, where he did the monument of Pius III (1503–4).

SCHOTTMÜLLER, F., in *Thieme–Becker*, XI (1915), 489–91.
See also Fabriczy, below.

FERRUCCI, FRANCESCO DI SIMONE DA FIESOLE (1437–93)

Francesco was a pupil of his father, Simone di Nanni Ferrucci, and of Desiderio. He was most influenced by Verrocchio and Desiderio, and was active as an architect and sculptor at Fiesole, Florence, and Bologna, where he worked on several tombs and monuments.

SCHOTTMÜLLER, F., in *Thieme–Becker*, XI (1915), 492–3.

FABRICZY, C. VON. 'Die Bildhauerfamilie Ferrucci aus Fiesole', *Berlin Jahrbuch*, XXIX (1908), 1–28.

FIAMBERTI, TOMMASO (fl. 1498–1524)

Born at Campione on Lake Lugano. His training is unknown, but it was probably Venetian and shows the influence of the Lombardi. He was active on the east coast, at Cesena, Forlì, and Ravenna. At one time identified, but without conclusive evidence, with the so-called 'Master of the Marble Madonnas'.

KREPLIN, B. C., in *Thieme–Becker*, XI (1915), 526.

GRIGIONI, C., in *Felix Ravenna*, XII (1913), 497–514.

NICOLA, G. DE. 'Tommaso Fiamberti', *Rassegna d'Arte*, XXII (1922), 80–1.

FILARETE (AVERLINO), ANTONIO DI PIETRO (c. 1400–69)

Filarete (a name he adopted for himself) was born in Florence, but went to Rome in or about 1433 to work on the bronze doors of St Peter's. After the doors were completed in 1445, Filarete went to Florence and Venice and from 1451 to 1465 worked as architect for the Sforza in Milan and on bronze statuettes and reliefs.

SCHUBRING, P., in *Thieme–Becker*, XI (1915), 552–6.

KEUTNER, H. 'Hektor zu Pferde', *Studien zur toskanischen Kunst (Festschrift für L. H. Heydenreich)*, 139–56. Munich, 1964.

LAZZARONI, M., and MUNOZ, A. *Filarete, scultore e architetto del sec. XV*. Rome, 1908.

SPENCER, J. R. 'Two Bronzes by Filarete', *B.M.*, C (1958), 392–5.

FONDULO, AGOSTINO (sometimes called de Fondutis) (fl. c. 1480)

Agostino Fondulo was a Lombard sculptor of unknown training, but seems certainly to have been influenced by Bramante's ideas. He worked in terracotta and was active at Crema, Milan, and Piacenza.

[ANON.], in *Thieme–Becker*, XII (1916), 160.

BANDIRALI, M. 'Scheda per Agostino Fondulo scultore', *Arte Lombarda*, III (1958), 29–44.

FRANCESCO DI GIORGIO (1439–1501/2)

Francesco di Giorgio was born in Siena in 1439 and was a pupil of Vecchietta. He shared a studio with Neroccio until 1475. He went to Urbino in 1477 and returned to Siena in 1485. He was a painter, sculptor, and architect and achieved great distinction also as a military and civil engineer.

SCHUBRING, P., in *Thieme–Becker*, XII (1916), 303–6.

CARLI, E. 'A Recovered Francesco di Giorgio', *B.M.*, XCI (1949), 33–9.

WELLER, A. *Francesco di Giorgio*. Chicago, 1943.

FRANCESCO DI VALDAMBRINO (fl. 1401–35)

Francesco di Domenico Valdambrino: a fair sculptor in wood and marble. He worked in the Late Gothic manner at Siena, where he was born, and was an associate of Quercia. He took part in the competition for the bronze doors of the baptistery in Florence. Polychrome wood statuary is ascribed to him in his later Sienese period. He was associated with Quercia in the Fonte Gaia, according to most authorities.

BACCI, P. *Francesco di Valdambrino, emulo del Ghiberti e collaboratore di Jacopo della Quercia.* Florence, 1936.

CARLI, E. *La Scultura lignea senese*, 52–64, 118–19. Milan–Florence, 1954.

RAGGHIANTI, C. L. 'Su Francesco di Valdambrino', *Critica d'Arte*, III (1938), 136–43.

GAGGINI, ANTONELLO (1478–1536)

Antonello Gaggini was born at Palermo and was the son and pupil of Domenico Gaggini. He was active throughout Sicily and Calabria, produced a vast amount of work, and was considered the most significant Renaissance sculptor of Sicily. Work from his shop was in marble, terracotta, and 'mistura' (plaster and papiermâché mixed).

KREPLIN, B. C., in *Thieme–Becker*, XIII (1920), 53–4.

MARZO, G. DI. *I Gagini e la scultura in Sicilia nei secoli XV e XVI.* Palermo, 1883.
 This is still the only available monograph, though very much dated.

GAGGINI, DOMENICO (fl. 1448–92)

Born at Bissone on Lake Lugano, Domenico was the founder of the Sicilian clan of Gaggini sculptors and the most famous of all the Gaggini. He worked mainly in marble, and was active in Genoa, Naples, and Sicily, where he settled about 1465.

KREPLIN, B. C., in *Thieme–Becker*, XIII (1920), 55–7.

ACCASCINA, M. 'Aggiunte a Domenico Gagini', *Bollettino d'Arte*, XLIV (1959), 19–29.

BOTTARI, S. 'Per Domenico Gagini', *Rivista d'Arte*, XVII (1935), 77–85.

VALENTINER, W. R. 'The Early Development of Domenico Gagini', *B.M.*, LXXVI (1940), 81–2, 85–7.

GAGGINI, PACE (fl. 1493–1522)

Pace Gaggini was born at Bissone, the son of Beltrame Gaggini. He was a marble sculptor active at Genoa, Pavia, and Seville, and came briefly under the influence of Amadeo. His career was largely in the Cinquecento.

KREPLIN, B. C., in *Thieme–Becker*, XIII (1920), 61–2.

GHIBERTI, LORENZO DI CIONE (1378–1455)

A Florentine, he was, according to his own statement, trained first as a painter. After winning the baptistery doors competition in 1403 his place in Florentine art was secure. He was given the commission for the last set of doors for the baptistery in 1424. In his time he was the most influential of all Florentine sculptors. His commissions included important statuary for Or San Michele and for the Duomo. He was a collector of antiquities and a friend of humanist scholars, and the life-long rival of Donatello and Brunelleschi.

KREPLIN, B. C., in *Thieme–Becker*, XIII (1920), 541–6.

DOREN, A. 'Das Aktenbuch für Ghibertis Matthäusstatue an Or San Michele zu Florenz', *Kunsthistorisches Institut in Florenz, Italienische Forschungen*, I. Berlin, 1906.

KRAUTHEIMER, R., with T. Krautheimer-Hess. *Lorenzo Ghiberti*. Princeton, 1956.
 This contains the documents and principal sources.

KRAUTHEIMER-HESS, T. 'More Ghibertiana', *A.B.*, XLVI (1964), 307–21.

PLANISCIG, L. *Lorenzo Ghiberti*. Vienna, 1940.

SCHLOSSER, J. VON. *Leben und Meinungen des Florentinischen Bildners: Lorenzo Ghiberti*. Basel, 1941.

GIAMBERTI *see* SAN GALLO

GIAN CRISTOFORO ROMANO (c. 1470–1512)

The son of Isaia da Pisa, Gian was born in Rome and was trained as a metalworker, though he practised

not only as a medallist but also as an architect and marble sculptor. He was called to the north by Lodovico Sforza in 1491 and was principally engaged in work of the first importance at the Certosa of Pavia to 1501.

FILANGIERI DI CANDIDA, R., in *Thieme–Becker*, XXVIII (1934), 552–3.

HILL, G. F. *Corpus of Italian Medals of the Renaissance before Cellini*, 55–61. London, 1930.

MELLER, S. 'Diva Beatrix', *Zeitschrift für Kunstwissenschaft*, IX (1955), 73–80.

VENTURI, A. 'Gian Cristoforo Romano', *Archivio Storico dell'Arte*, I (1888), 49–59, 107–18, 148–58.

GIORGIO DA SEBENICO (fl. *c.* 1440–d. 1475)

Born at Sebenico (Šibenik, Yugoslavia), Giorgio came under the influence of the Venetian school of Buon and the dalle Masegne. He was active in Dalmatia and in Ancona (in the period 1451–71). He was an architect and marble sculptor. His principal documented work in Ancona comprises the façades with sculpture of the Loggia dei Mercanti, S. Chiara, and S. Agostino, finished only after his death.

FOLNESICS, H., in *Thieme–Becker*, XIV (1921), 84–5.

GIANUIZZI, P. 'Giorgio da Sebenico; architetto e scultore', *Archivio Storico dell'Arte*, VII (1894), 397–454.

PETROVITCH, R. 'Questi schiavoni: III. Giovanni Duknovich e Giorgio da Sebenico', *Gazette des Beaux-Arts*, 6e sér., XXXII (1947), 143–50.

ZAMPETTI, P. 'Una Scultura di Giorgio da Sebenico', in *Atti del XVIII Congresso Internazionale di Storia d'Arte*, 213–14. Venice, 1956.

GIOVANNI DI STEFANO (*c.* 1446–before 1506)

Giovanni di Stefano was born in Siena, the son of Stefano di Giovanni (Sassetta). He was a pupil of Vecchietta and a sculptor in bronze and marble. He was active mainly in Siena.

KREPLIN, B. C., in *Thieme–Becker*, XIV (1921), 144–5.

SCHUBRING, P. *Die Plastik Sienas im Quattrocento*, 128–53. Berlin, 1907.

GIULIANO DA MAJANO (1432–90)

He was born at Majano, near Fiesole, and was the brother of Benedetto and Giovanni da Majano. He was a co-worker with Benedetto as an architect and as a sculptor in wood and in stone. He was active in Fiesole, Florence, and Prato.

SEMRAU, M., in *Thieme–Becker*, XIV (1921), 211–13.

FABRICZY, C. VON. 'Giuliano da Majano', *Berlin Jahrbuch*, XXIV (1903), 137–76.

GUARDI, ANDREA (fl. *c.* 1450)

Born in Florence and influenced by Donatello and Michelozzo. He worked in marble and stucco and at some time was a co-worker with Buggiano. He was active at Pisa and on the west coast.

SCHUBRING, P., in *Thieme–Becker*, I (1907), 456.

MORIONDO, M. 'Ricostruzione di due opera di Andrea Guardi', *Belle Arti*, I (1946–8), 325–37.

SCHUBRING, P. *Urbano da Cortona* (Appendix). Strassburg, 1903.

ISAIA DA PISA (fl. 1447–64)

Isaia da Pisa was the son of a sculptor, Pippo di Giovanni da Pisa. He worked in Rome, Orvieto, and Naples, and from 1462 to 1464 worked with Paolo Romano for Pius II. Porcellio, the poet, refers to Isaia's work, but facts on his career are scanty.

SEMRAU, R., in *Thieme–Becker*, XIX (1926), 240–2.

BÜRGER, F. 'Isaias plastische Werke in Rom', *Berlin Jahrbuch*, XXXVII (1906), 228–44.

CIACCIO, L. 'La Scultura romana del Rinascimento', *L'Arte*, IX (1906), 165–84.

DAVISON, M. *Isaia da Pisa*. M.A. Thesis (typescript), Yale University, 1959.

LAMBERTI, NICCOLÒ DI PIETRO (*c.* 1375–1451)
LAMBERTI, PIERO DI NICCOLÒ (*c.* 1393–1435)

Niccolò di Pietro Lamberti, one of the baptistery contestants, was born in Florence and was trained by Giovanni d'Ambrogio. His first documented work, of 1491, was a *stemma* for the Loggia dei Lanzi. He was part of the team of sculptors who worked on the Porta della Mandorla and the Porta dei Canonici of the Duomo. As an architect and sculptor he did work at Prato and on Or San Michele. After 1410 his popularity in Florence began to wane, and in 1416 he went to Venice, where he had already been invited in 1403 to take charge of the work on the Ducal Palace. He was assisted by his son, Piero di Niccolò, who was probably born in Florence between 1390 and 1395. He moved to Venice with his father after 1418 and thereafter worked mainly in Venice and Padua as a marble sculptor (Fulgioso Monument in the Santo, façade of St Mark, possibly worked on the Ducal Palace).

PLANISCIG, L., in *Thieme–Becker*, XXV (1931), 436–8; XXVII (1933), 24–5.

PLANISCIG, L. 'Die Bildhauer Venedigs in der ersten Hälfe des Quattrocento, II, III', *Jahrbuch der Kunsthistorischen Sammlungen in Wien*, N.F. IV (1930), 50–4, 55–70.

FIOCCO, G. 'I Lamberti a Venezia', *Dedalo*, VIII (1927), 287–313, 343–76, 432–58.

PROCACCI, U. 'Niccolò di Piero Lamberti . . . e Niccolò di Luca Spinello', *Il Vasari*, I (1927–8), 300–16.

SEYMOUR, C., Jr. 'The Younger Masters . . . of the Porta della Mandorla, 1391–1397', *A.B.*, XLI (1959), 8–17.

LAURANA, FRANCESCO DA (c. 1430–1502)

Laurana was born at La Vrana near Zadar (Zara) and may have been the pupil of Giorgio da Sebenico. He worked on the Triumphal Arch of the Castelnuovo in Naples from 1453 to 1458 and then went to France. There, until 1466, he designed medals for René d'Anjou. He was in Sicily until the early seventies, when he returned to Naples. In Provence again, Laurana was busy with work for Count René at Marseille, Tarascon, and Avignon. He may then have gone back to Naples and Sicily. He died at Avignon in 1502.

SCHOTTMÜLLER, F., in *Thieme–Becker*, XXII (1928), 440–2.

BOTTARI, S. 'Un Opera poco nota di Francesco Laurana', *Arte Veneta*, VIII (1954), 142–4.

BRENDEL, O. 'Laurana's Bust of Ippolita Sforza', *Art Quarterly*, VII (1944), 59–62.

CAUSA, R. 'Sagrera, Laurana e l'Arco di Castelnuovo', *Paragone*, V (1954), 3–23.

ELIA, M. D'. 'Ipotesi intorno a un bassorilievo di Santeramo', *Commentari*, X (1959), 108–14.

KENNEDY, C. and R. W. *Four Portrait Busts by Francesco Laurana*. Northampton, Mass., 1962.

TIETZE-CONRAT, E. 'A Relief Portrait by Francesco Laurana', *Bulletin of the Allen Memorial Art Museum*, XII (1955), 87–90.

VALENTINER, W. R. 'Laurana's Portrait Busts of Women', *Art Quarterly*, V (1942), 272–99.

LEONARDO DA VINCI (1452–1519)

Leonardo was born at Vinci near Florence and trained in Verrocchio's shop, where he seems to have had instruction as a sculptor in modelling, stone-carving(?), and bronze-casting. He left Florence for the Milanese court in 1481, where he began the equestrian monument to Francesco Sforza (never finished). After an interlude in Florence, he returned in 1508 to Milan, where he made sketches for the Trivulzio Monument (never actually begun). Vasari states that he helped the young Rustici in Florence in bronze figures for the Florentine baptistery. No documented sculpture by Leonardo survives.

PAULI, in *Thieme–Becker*, XXIII (1929), 76–80.

BRUGNOLI, M. V. 'Documenti, notizie e ipotesi sulla scultura di Leonardo', *Leonardo, Saggi e Ricerche*, 359–89. Rome, 1954.

MACLAGAN, E. 'Leonardo as a Sculptor', *B.M.*, XLIII (1923), 67–9.

MALAGUZZI-VALERI, F. *Leonardo da Vinci e la scultura*. Bologna, 1922.

POPP, A. E. 'Leonardos Reiterdenkmalprojekte', *Zeitschrift für bildende Kunst*, LX (1926/7), 52–62.

STITES, R. S. 'Leonardo da Vinci, Sculptor', *Art Studies*, IV (1926), 103–9; VI (1928), 73–7; IX (1931), 287–300.

VALENTINER, W. R. 'Two Terracotta Reliefs by Leonardo', *Studies of Renaissance Sculpture*, 178–92. London, 1950.

LOMBARDO, ANTONIO (c. 1458–1516)

Antonio Lombardo was the son of Pietro Lombardo. He worked on the Onigo and Zanetti Monuments at Treviso and on the bronze sculpture for the Zen Chapel at St Mark's in Venice; he did one relief (1505) for the Chapel of St Anthony in the Santo at Padua. He was active at Ferrara after 1506 in the service of Alfonso I d'Este, and died there in 1516.

MOSCHETTI, A., in *Thieme–Becker*, XXIII (1929), 341.

For other entries see below under Pietro Lombardo.

LOMBARDO, PIETRO (c. 1435–1515)

Pietro Solari, called in Venice Pietro Lombardo, was born at Carona on Lake Lugano. The date of his birth and details of his training are alike unknown; he was active mainly in Venice as a most influential marble sculptor and chief rival of Antonio Rizzo. He was at Padua in 1464 and probably in Tuscany before setting up his *bottega* in Venice (1470–5?). He designed several monuments carried out with his sons, Tullio and Antonio, at Treviso as well as in Venice. He was architect and chief sculptor of the church of S. Maria dei Miracoli (after 1481).

MOSCHETTI, A., in *Thieme–Becker*, XXIII (1929), 343–4.

MARIACHER, G. 'Pietro Lombardo a Venezia', *Arte Veneta*, IX (1955), 36–53.

MOSCHETTI, A. 'Un Quadriennio di Pietro Lombardo a Padova', *Bollettino del Museo Civico di Padova*, XVI (1913), 1–99; XVII (1914), 1–43.

PLANISCIG, L., in *Venezianische Bildhauer der Renaissance*. Vienna, 1921.

 Pietro, 41–80; Tullio, 226–55; Antonio, 209–25.

PLANISCIG, L. 'Pietro, Tullio und Antonio Lombardo', *Jahrbuch der Kunsthistorischen Sammlungen in Wien*, XI (1937), 87 ff.

LOMBARDO, TULLIO (*c.* 1455–1532)

Tullio was the second son and pupil of Pietro Lombardo. He was active mainly in Venice, from 1475. His first great independent work was the Vendramin Monument, virtually completed in 1493. His startlingly neo-classical, proto-Canovesque style ushered in the High Renaissance in Venetian sculpture. His career extended well into the Cinquecento, with major work at Padua and Ravenna as well as in Venice.

MOSCHETTI, A., in *Thieme–Becker*, XXIII (1929), 344–5.

MARIACHER, G. 'Tullio Lombardi Studies', *B.M.*, XCVI (1954), 366–74.

LORENZO DI GIOVANNI D'AMBROGIO (fl. 1396–1405)

Lorenzo was probably born in Florence (birth-date unknown) and was trained by his father, Giovanni d'Ambrogio. His documented work in Florence was on the Porta della Mandorla and Porta dei Canonici of the Duomo. A distinguished sculptor in marble, his promising career was cut short by early death.

KREPLIN, B. C., in *Thieme–Becker*, XXIII (1929), 390–1.

KAUFFMANN, H. 'Florentiner Domplastik', *Berlin Jahrbuch*, XLVII (1926), 166, 217, 221.

SEYMOUR, C., Jr. 'The Younger Masters of the ... Porta della Mandorla, 1391–1397', *A.B.*, XLI (1959), 8, 14–15.

LORENZO DI PIETRO *see* VECCHIETTA

MANTEGAZZA, CRISTOFORO (fl. 1464–82)
MANTEGAZZA, ANTONIO (fl. 1473–95)

Cristoforo and Antonio were brothers born in Milan. They were goldsmiths and marble sculptors, but little is known of their training. They were active in Milan and especially at Pavia from *c.* 1465. The style of Cristoforo seems to have been the more original and more influential, and was remarkable for its combining of formal and expressive values.

VERGA, E., in *Thieme–Becker*, XXIV (1920), 37–8.

ACQUA, G. A. DELL'. 'Problemi di scultura lombarda: Mantegazza e Amadeo', *Proporzioni* II (1948), 89–107.

ARSLAN, E. 'Sui Mantegazza', *Bollettino d'Arte*, XXXV (1950), 27–34.

MANTEGNA, ANDREA (1431–1506)

Mantegna was born in the Veneto near Padua and died in Mantua. His activity as a sculptor, apparently always quite secondary to his painting, is poorly documented and still a matter of research. In close touch with the art of Pietro Lombardo, he was also a continuator of Donatello's Paduan style. He was a modeller, not a carver.

FIOCCO, G., in *Thieme–Becker*, XXIV (1930), 38–42.

PACCAGNINI, G. 'Mantegna e la plastica d'Italia settentrionale', *Bollettino d'Arte*, XLVI (1961), 65–100.

MARINI, MICHELE (1459–?; fl. *c.* 1485)

Marini was born at Fiesole and was active in Rome in the last decades of the fifteenth century. He was a marble sculptor, but of unknown training. He is chiefly known for a statue of St Sebastian in S. Maria sopra Minerva in Rome, though the attribution is not documented.

[ANON.], in *Thieme–Becker*, XXIV (1930), 106.

STEINMANN, E. 'Michele Marini', *Zeitschrift für bildende Kunst*, XIV (1903), 147–57.

MASEGNE, JACOBELLO DALLE (fl. 1383–d. *c.* 1409)
MASEGNE, PIERPAOLO DALLE (fl. 1383–d. 1403?)

The dalle Masegne were brothers of Venetian origin who worked in marble in Venice, Milan, Modena, and Bologna in a Late Gothic naturalistic style which acted as a catalyst for the International Gothic Style and Tuscan trends. They had a large shop and influenced Brunelleschi and Jacopo della Quercia, who may have worked briefly with the shop in Bologna in 1490–5.

PLANISCIG, L., in *Thieme–Becker*, XXIV (1930), 201–3.

GNUDI, C. 'Jacobello e Pietro Paolo di Venezia', *Critica d'Arte*, II (1937), 26–38.

GNUDI, C. 'Nuovi Appunti sui fratelli dalle Masegne', *Proporzione*, III (1950), 48–55.

KRAUTHEIMER, R. 'Zur Venezianischen Trecento-Plastik', *Marburger Jahrbuch für Kunstwissenschaft*, V (1929), 193–212.

KRAUTHEIMER, R. *Lorenzo Ghiberti*, 56–9. Princeton, 1956.

MASO DI BARTOLOMMEO (fl. 1435–?)

Born about 1405, Maso di Bartolommeo was active mainly in Florence. He was trained probably by Ghiberti and was influenced by Donatello and Michelozzo. He worked on the architectural sculpture of the exterior pulpit of the Duomo at Prato and was in charge of the early phase of the bronze grille of the Cappella della Cintola there.

KREPLIN, B. C., in *Thieme–Becker*, XXIV (1930), 210.

MARCHINI, G. 'Di Maso di Bartolommeo e d'altri', *Commentari*, III (1952), 112–17.

YRIARTE, C. E. *Le Livre de souvenirs de Maso di Bartolomeo*. Paris, 1894.
 Source.

MAZZONI, GUIDO (fl. after 1473–d. 1518)

Mazzoni worked in the Modena area on dramatic Lamentation and Nativity groups in the 1470s. He is first mentioned in charge of a theatrical presentation in honour of Eleanora of Aragon in Modena in 1473. He was active also in Venice and Naples in the last decade of the century. From 1495 to 1516 he was in France, having accompanied Charles VIII there in 1495. He worked on the tomb of Charles VIII in St Denis in 1498 and did an equestrian statue of Louis XII at Blois. He was the first choice of Henry VIII for the monument of Henry VII in Westminster Abbey, which was ultimately commissioned in 1512 from the Florentine Pietro Torrigiano. In 1516 he returned to Modena and died there in 1518. Only references to his pre-1500 activity in Italy are given below.

[ANON.], in *Thieme–Becker*, XXIV (1930), 315.

PETTORELLI, A.-L. *Guido Mazzoni da Modena plasticatore*. Turin, 1925.

PEVSNER, N., in *Buildings of England: Cities London and Westminster*, 400 ff. 2nd ed. London, 1962.

VENTURI, A., in *Storia*, VI (1908), 768–84.

MICHELANGELO BUONARROTI (1475–1564)

He was born at Caprese in the Casentino into an old and tradition-proud Florentine family. Before he was fifteen he had been trained in fresco technique in Domenico Ghirlandaio's shop and already probably had the rudiments of stone-carving. His master in sculpture is not known, though it is quite possible that it was Benedetto da Majano. He entered the household of Lorenzo de' Medici about 1490 and studied the Medici collection of antiquities in the Garden and Casino near S. Marco. Bertoldo's influence, once considered central to Michelangelo's formation as a sculptor, now appears to have been peripheral and in any event brief. In 1494/5 Michelangelo left Florence for North Italy and stayed for some months in Bologna. He returned to Florence in 1495 and worked briefly for Pierfrancesco de' Medici, going soon to Rome (1496–1500) where he did his Bacchus and first Pietà. He returned to Florence in the spring of 1500 and was given the commission for the colossal David in 1501. The bibliography given here concentrates on the pre-1500 period.

TOLNAY, C. DE, in *Thieme–Becker*, XXIV (1930), 515–26.

TOLNAY, C. DE, in *Enciclopedia Universale dell'Arte*, IX (1962), 263–306.
 Summarizes bibliography after 1930.

BAUMGART, F. 'Die Jugendzeichnungen Michelangelos bis 1506', *Marburger Jahrbuch für Kunstwissenschaft*, X (1937), 209 ff.

FORATTI, A. 'Michelangelo a Bologna', *Atti e memorie della R. Deputazione di storia patria per le provincie di Romagna*. Bologna, 1918.

LANCKORONSKA, K. 'Antike Elemente im Bacchus Michelangelos und in seinen Darstellungen des David', *Dauna Sztuka*, I (1938), 183 ff.

LISNER, M. 'Zu Benedetto da Maiano und Michelangelo', *Zeitschrift für Kunstwissenschaft*, XII (1958), 141 ff.

LISNER, M. 'Michelangelo's Kruzifixus aus S. Spirito in Florenz', *Münchner Jahrbuch der bildenden Kunst*, 3. XV (1964), 7–36.
 Illustrations after cleaning.

TOLNAY, C. DE. *The Youth of Michelangelo*. Princeton, 1943.

WILDE, J. 'Eine Studie Michelangelos nach der Antike', *Mitteilungen des Kunsthistorischen Instituts in Florenz*, IV (1932–4), 41–64.

MICHELE DA FIRENZE ('Master of the Pellegrini Chapel') (fl. first half of fifteenth century)

Michele da Firenze was probably born in Florence, though he was active at first at Arezzo. He was a sculptor in terracotta, working alone as far as is known. About 1435 he moved north, where his work is to be found at Verona (S. Anastasia), Modena, and Ferrara.

FIOCCO, G. 'Michele da Firenze', *Dedalo*, XII (1932), 542–63.

MARIACHER, G. 'Contributi su Michele da Firenze', *Proporzione*, III (1950), 68–72.

PETROBELLI, E. 'Michele da Firenze ad Adria', *Rivista d'Arte*, XXIX (1947), 121–32.

MICHELE DI GIOVANNI (Il Greco) (fl. c. 1460)

Birth and death dates are unknown. Michele, generally known as Il Greco, was born at Fiesole and trained in the entourage of Bernardo Rossellino and Michelozzo in Florence. Otherwise the background of this artist is uncertain. He was a sculptor in marble and was active principally at Urbino on the sculpture of the Ducal Palace.

KENNEDY, C. 'Il Greco aus Fiesole', *Mitteilungen des Kunsthistorischen Instituts in Florenz*, IV (1932), 25 ff.

MICHELOZZO DI BARTOLOMMEO (1396–1472)

Michelozzo was born in Florence and first worked for the Florentine mint. He was associated with Ghiberti in the casting of the St Matthew for Or San Michele and on the chasing of the second doors of the baptistery. He worked with Donatello and shared a studio with him from 1425 to about 1438, both going to Rome together in 1431–3. Later, he worked with Luca della Robbia on the bronze door of the north sacristy of the cathedral in Florence, and may have experimented with the Robbia glaze technique in terracotta. As a carver he was a good master. Apart from being a sculptor in marble and bronze, he was also a distinguished architect. In silver he did the main figure for the altar frontal of the Florentine baptistery.

WILLICH, H., in *Thieme–Becker*, XXIV (1930), 530–1.

FABRICZY, C. VON. 'Michelozzo di Bartolommeo', *Berlin Jahrbuch*, XXIV (1904), 34–117.

JANSON, H. W. *The Sculpture of Michelozzo di Bartolommeo*. Ph.D. Dissertation (typescript), Harvard University.

MARTINELLI, V. 'Donatello e Michelozzo a Roma', *Commentari*, VIII (1957), 167–94; IX (1958), 3–24.

MORISANI, O. *Michelozzo architetto*. Florence, 1951.
 Treats sculpture and replaces older monograph (1900) by F. Wolf.

MINO DA FIESOLE (1429–84)

Mino was born in the Casentino, but must very early have moved to Fiesole. In the 1450s he did busts in Florence, Rome, and presumably Naples. In 1464 he was again in Florence, when he did many tombs and tabernacles in marble. He was in Rome again between 1472 and 1480, and then returned to Florence, where he imitated Desiderio's manner in his last phase. He died in 1484. It would seem that the production of the so-called Mino del Reame was actually that of Mino da Fiesole's large shop in Rome before 1480. According to Valentiner, Mino is to be identified with a 'Dominico de Monteminyao' mentioned in Neapolitan documents *c.* 1455 (a theory in need of confirmation).

SCHOTTMÜLLER, F., in *Thieme–Becker*, XXIV (1930), 580–2.

CARRARA, L. 'Nota sulla formazione di Mino da Fiesole', *Critica d'Arte*, III (1956), 76–83.

VALENTINER, W. R. 'Mino da Fiesole', *A.Q.*, VII (1944), 150–80; republished in *Studies of Italian Renaissance Sculpture*, 70–96, London, 1950.

NANNI DI BANCO (Giovanni di Antonio di Banco) (c. 1390–1421)

Born in Florence and beginning with his father, Antonio di Banco, Nanni worked in Florence, especially on the Porta della Mandorla (from 1414 to his death in charge of its decoration). As Donatello's early rival and a convinced enthusiast for a revived classical style, he was given important commissions by the guilds for Or San Michele. His untimely death may have affected more deeply than usually acknowledged the course of style in Florence. Lányi's article (*see below*) reversed the earlier trend of criticism which blindly underestimated him.

LÁNYI, J. 'Il Profeta Isaia di Nanni di Banco', *Rivista d'Arte*, XVIII (1936), 137–78.

PLANISCIG, L. *Nanni di Banco*. Florence, 1946.

VACCARINO, R. *Nanni*. Florence, 1951.

NANNI DI BARTOLO (Giovanni di Bartolo, called Il Rosso) (fl. 1419–51)

Nanni di Bartolo worked with Donatello and also independently on statues for the campanile of Florence Cathedral. He was probably Florentine by birth. He had left for Venice by 1424 and was active there as a marble sculptor on monumental schemes, and elsewhere on the same (Verona and Tolentino).

PLANISCIG, L., in *Thieme–Becker*, XXIX (1935), 58–9.

LÁNYI, J. 'Le Statue quattrocentesche dei profeti nel Campanile e nell'antica facciata di Santa Maria del Fiore', *Rivista d'Arte*, XVII (1935), 120–59, 258–80.

PLANISCIG, L. 'Nanni di Bartolo, Il Rosso', *Miscellanea Supino*, 295–304. Florence, 1933.

NEROCCIO DEI LANDI (1447–1500)

Neroccio was born in Siena and was a pupil of Sassetta and Vecchietta. He was active in Siena and for a time in the 1470s was an associate of Francesco di Giorgio. He was a painter and a sculptor in wood and marble in Siena, and his shop turned out many replicas and variants of his popular Madonna reliefs.

SCHUBRING, P., in *Thieme–Becker*, XXII (1928), 295–6.
COOR, G. *Neroccio de' Landi, 1447–1500*. Princeton, 1961.

NICCOLÒ DELL'ARCA (c. 1435–94)

It is believed that Niccolò was born at Bari in Apulia. Between 1460 and 1470 he settled at Bologna and was commissioned to do the cover of the Shrine (*Arca*) of St Dominic in S. Domenico. He came under the influence of the Burgundian style, either through earlier contacts in Naples, or possibly through a trip to France. He also was influenced by Antonio Rossellino and Verrocchio. Most of his extant work other than the statuary for the Arca is in polychrome terracotta.

FREY, K. (ed.), G. Vasari, *Le Vite de più eccellenti pittori, scultori, e architettori*, I, 711–16, 720–1. Munich, 1911.
　Documents.
GNUDI, C. *Niccolò dell'Arca*. Turin, 1942.
MALAGUZZI-VALERI, F. 'Documenti su Niccolò da Puglia, detto dall'Arca, etc.', *Archivio Storico dell'Arte*, VII (1894), 365–71.
TOESCA, P. 'On Niccolò dell'Arca', *Art Quarterly*, XIX (1956), 271–7.

PAOLO ROMANO (Paolo di Mariano di Tuccio Taccone) (fl. 1445?–1470)

Paolo's training is unknown. He was born, it would seem, at Sezze near Velletri and was active in Rome and Naples, having worked on the Arch of Alfonso in Naples. He played a major role in sculpture of the 1460s in Rome.

[ANON.], in *Thieme–Becker*, XXXII (1938), 392.
See also article by Ciaccio, above, under Rome (II, E).

PASQUINO DA MONTEPULCIANO (fl. 1445–73)

Pasquino was a pupil of Filarete and an assistant on the doors of St Peter's in Rome. He was later active at Urbino and Prato and worked mostly in bronze.

PLANISCIG, L., in *Thieme–Becker*, XXVI (1932), 275.
MARCHINI, G. 'Di Maso di Bartolommeo e altro', *Commentari*, III (1952), 122–5.
NUTI, R. 'Pasquino di Matteo da Montepulciano e le sue sculture nel Duomo di Prato', *Bollettino senese di storia patria*, N.S. X (1939), 338.
TSCHUDI, H. VON. 'Filarete's Mitarbeiter an der Bronzetüren von St Peters', *Repertorium für Kunstwissenschaft*, VII (1884), 291–4.

PASTI, MATTEO DI ANDREA DE' (c. 1420–67/8)

Matteo de' Pasti was born at Verona and may have been a pupil of Pisanello. He was active as an illuminator, architect, and medallist at Verona and Rimini and was medallist for Sigismondo Malatesta. He collaborated with Alberti as architect of the Tempio Malatestiano at Rimini, and perhaps with Agostino di Duccio on the sculpture.

HILL, G. F., in *Thieme–Becker*, XXVI (1932), 287–8.
HILL, G. F. *A Corpus of Italian Renaissance Medals before Cellini*, I, 37–43. Oxford, 1930.
RICCI, C. *Il Tempio Malatestiano, passim*. Rome-Milan, 1925.
SCHUBRING, P. 'Matteo de' Pasti', *Kunstwissenschaftliche Beiträge August Schmarsow gewidmet*, 115–28. Leipzig, 1907.

PIETRO DA BONITATE (fl. 1468–95)

A Lombard marble sculptor who was active in Sicily and a co-worker with Francesco Laurana on the Mastrantonio Chapel in S. Francesco at Palermo. From 1468 to 1495 he was apparently active at both Messina and Palermo, but of this period no authenticated work is on record.

MAUCERI, E., in *Thieme–Becker*, IV (1910), 302.
ACCASCINA, M. 'Scultores habitatores Panormi', *Rivista dell'Istituto Nazionale di Archeologia e Storia dell'Arte*, N.S. VII (1959), 270–86.
MARZO, G. DI. *I Gaggini e la scultura in Sicilia nei secoli XV e XVI*, I (1880), 26–46, 209; II (1883), 4, 7–8.

PISANELLO, ANTONIO (c. 1395–1455/6)

Born probably at Pisa. Little is known about his early artistic training. He may have been trained by Altichiero. He was influenced by the International Style and Gentile da Fabriano. As a painter and medallist he was active in Venice, Verona, Rome, Ferrara, Milan, and Naples, where from 1448 he was employed by Alfonso in connexion with the Castelnuovo Arch. He was the chief medallist of the Quattrocento.

HILL, G. F., in *Thieme–Becker*, XXVII (1933), 92–3.

DEGENHART, B. *Pisanello*. Turin, 1945.

HILL, G. F. *Pisanello*. London, 1903.

KELLER, H. 'Bildhauerzeichnungen Pisanellos', *Festschrift für Kurt Bauch*, 139–52. Munich, 1957.

POLLAIUOLO, ANTONIO DEL (1431/2–98)

Pollaiuolo may have been a pupil of Ghiberti. He was born in Florence and worked as a goldsmith and metal worker before becoming a painter and architect. He was in Rome after 1483 to do the tombs of Popes Sixtus IV and Innocent VIII. He began as a goldsmith; in 1457 he was commissioned to do the silver crucifix for the high altar of the baptistery in Florence. He was frequently assisted by his younger brother, Piero (1443/7–96).

SCHOTTMÜLLER, F., in *Thieme–Becker*, XXVII (1933), 210–14.

COLACICCHI, G. *Antonio del Pollaiuolo*. Florence, 1943.

ETTLINGER, L. D. 'Pollajuolo's Tomb of Pope Sixtus IV', *Journal of the Warburg and Courtauld Institutes*, XVI (1953), 239–71.

MATHER, R. G. 'Documents mostly new relating to Florentine Painters and Sculptors of the Fifteenth Century', *A.B.*, XXX (1948), 32–5.

ORTOLANI, S. *Il Pollaiuolo*. Milan, 1948.

SABATINI, A. *Antonio e Piero del Pollaiuolo*. Florence, 1944.

PYRGOTELES (Giovanni Giorgio Lascaris) (fl. c. 1480–d. 1531)

'Pyrgoteles' was of Greek origin. He was a marble sculptor in the style of the Lombardi and was active in Padua and Venice.

PLANISCIG, L., in *Thieme–Becker*, XXVII (1933), 480–1.

PLANISCIG, L. *Venezianischer Bildhauer der Renaissance*, 198 ff. Vienna, 1921.

QUERCIA, JACOPO DELLA (c. 1374–1438)

The Sienese counterpart of Donatello and Ghiberti. He was born in Siena and was probably trained by his father, Piero di Angelo. He had early contact with the works of the dalle Masegne, and worked in marble and wood at Lucca, Ferrara, Siena, and Bologna. He entered the competition for the bronze doors of the baptistery in Florence, carved the Fonte Gaia in Siena, and from 1425 to 1438 was in charge of the façade and execution of the main portal of S. Petronio at Bologna. For limited periods of time he worked in partnership with Francesco di Valdambrino and Giovanni da Imola. His chief artistic heir in Siena was Antonio Federighi, but his major influence was a generation later on the young Michelangelo.

FORATTI, A., in *Thieme–Becker*, XXVII (1933), 513–16.

NICCO-FASOLA, G., in *Encyclopedia of World Art*, IV, 286–95.

BACCI, P. *Jacopo della Quercia*. Siena, 1929.

BACCI, P. *Francesco di Valdambrino, passim*. Siena, 1936.

BECK, J. H. *Jacopo della Quercia at Bologna: The Portal of San Petronio*. Ph.D. Dissertation (typescript), Columbia University, 1963.

CARLI, E. 'Una Primizia di Jacopo della Quercia', *Critica d'Arte*, VIII–IX (1949–50), 17–24.

HANSON, A. C. *Jacopo della Quercia's Fonte Gaia*. Oxford, 1965.

KRAUTHEIMER, R. 'Terracotta Madonnas, etc.', *Parnassus*, VIII (1936), 210–18.

KRAUTHEIMER, R. 'A Drawing for the Fonte Gaia in Siena', *The Metropolitan Museum of Art Bulletin*, X (1951), 265–74.

MORISANI, O. *Tutta la scultura di Jacopo della Quercia*. Milan, 1962.
 Review by J. H. Beck, in *Arte Antica e Moderna*, XX (1962), 456–7.

SANPAOLESI, P. 'Una figura lignea inedita di Jacopo della Quercia', *Bollettino d'Arte*, XLIII (1958), 112–16.

SEYMOUR, C., Jr, and SWARZENSKI, H. 'A Madonna of Humility and Quercia's Early Style', *Gazette des Beaux-Arts*, XXX (1946), 129–52.

WUNDRAM, M. 'Die sienische Annunziata in Berlin, ein Frühwerk des Jacopo della Quercia', *Jahrbuch der Berliner Museen*, VI (1964), 39–52.

RAVERTI, MATTEO

Birth-date and death-date are unknown. He is first documented as a fully trained and active sculptor in the shops of Milan Cathedral shortly before 1404. He later worked in Venice on the decoration for the Cà d'Oro, and possibly the façade of S. Marco over the period 1418/34 and on the Ducal Palace.

MARIACHER, G. 'Matteo Raverti nell'arte veneziana del primo Quattrocento', *Rivista d'Arte*, XXI (1939), 3–20.

NEBBIA, U. *Scultura del Duomo di Milano*, 61–2, 106–16. Milan, 1898.

VISANI, M. C. 'Proposto per Matteo Raverti', *Arte Veneta*, XVI (1962), 31–41.

IL RICCIO (Andrea Briosco) (c. 1470/5–1532)

Riccio was born in Padua and was a pupil of Bellano. He was trained as a goldsmith and worked at first both in bronze and terracotta. He was mainly active as a master of small bronzes in his native town of Padua, where he did his masterpiece, the Easter Candlestick for the Santo, in 1515. His work before 1500 is still somewhat conjectural, but he is believed to have finished Bellano's Rocca-bonella Monument in S. Francesco at Padua and may have worked in terracotta on the kind of groups made famous by Mazzoni (see the Dead Christ in the Abbey of Carrara outside Padua).

PLANISCIG, L., in *Thieme–Becker*, XXVIII (1934), 259–63.

PLANISCIG, L. *Andrea Riccio*. Vienna, 1927.

MOSCHETTI, A. 'Andrea Briosco', *Bollettino del Museo di Padova* (1927), 118 ff.

PIGNATTI, T. 'Gli inizi di Andrea Riccio', *Arte Veneta*, VII (1953), 25–38.

SEYMOUR, C., Jr. 'An Attribution to Riccio, etc.', *Bulletin of the Yale Art Gallery*, XXVII (1962), 5–16.

RICCOMANNO, LEONARDO (fl. 1431–d. after 1472)
RICCOMANNO, FRANCESCO (fl. 1437–d. before 1490)

Leonardo Riccomanno was the uncle of Francesco, and both were born in Pietrasanta, where Leonardo trained under his father, Riccomanno di Pietrasanta. He was influenced to some extent by Quercia. Francesco was his pupil, and they worked in collaboration at Sarzana and Genoa.

[ANON.], in *Thieme–Becker*, XXVIII (1934), 265.

RIZZO, ANTONIO (fl. after 1465–d. 1499/1500)

Rizzo was born at Verona and was an architect, engineer, and marble sculptor. He worked on the Certosa outside Pavia with Amadeo and the Mantegazza, specifically carving the columns and capitals; but he was most active in Venice (after 1470).

PLANISCIG, L., in *Thieme–Becker*, XXVIII (1934), 408–10.

ARSLAN, E. 'Œuvres de jeunesse d'Antonio Rizzo', *Gazette des Beaux-Arts*, XLII (1953), 104–14.

MARIACHER, G. 'Antonio da Righeggio e Antonio Rizzo', *Le Arti*, II (1941), 193–8.

MARIACHER, G. 'Profile di Antonio Rizzo', *Arte Veneta*, II (1948), 67–84.

MARIACHER, G. 'Due inediti scolture di Antonio Rizzo', *Rivista d'Arte*, XXVII (1951–2), 185–9.

PAOLETTI, P. *L'Architettura e la scultura del Rinascimento in Venezia*, I, 141–63. Venice, 1893.

PLANISCIG, L. *Venezianische Bildhauer der Renaissance*, 56–72. Vienna, 1921.

ROBBIA, ANDREA DELLA (1435–1525)

Andrea della Robbia was born in Florence, a nephew of Luca della Robbia. He was Luca's pupil and took over his shop in 1482. He continued to work in glazed terracotta, popularizing his uncle's style. His works are found all over Tuscany, but he was active mostly in Florence.

SUPINO, I. B., in *Thieme–Becker*, XXVIII (1934), 414.

MARQUAND, A. *Andrea della Robbia and his Atelier*. Princeton, 1922.

ROBBIA, GIOVANNI DELLA (1469–1529)

Son of Andrea della Robbia and grandnephew of the greater Luca, Giovanni was raised as heir-apparent to the control of the Robbia shop. He was more attracted to the shop of Verrocchio than to his father's, yet there is nothing that can be attributed to him personally on the basis of documents before a relatively minor piece, the lavabo of the sacristy of S. Maria Novella in Florence, commissioned in 1497. As an independent artist he belonged far more to the Cinquecento than to the Quattrocento. However, there are a good number of designs that go under Andrea della Robbia's name although more probably they are by Giovanni. On this account, and on the chances of future scholarship establishing them, his name is included here.

SUPINO, I. B., in *Thieme–Becker*, XXVIII (1934), 414–15.

MARQUAND, A. *Giovanni della Robbia*. Princeton–London–Oxford, 1920.

ROBBIA, LUCA DELLA (1399/1400–1482)

Luca di Simone di Marco della Robbia was born in Florence and may well have been trained by Nanni di Banco. His first documented work is his Cantoria in the Duomo in Florence, begun in 1431. This was completed shortly after 1437, when he received a commission to finish five reliefs for the campanile begun by Andrea Pisano. He also worked on an altar in the cathedral. Luca della Robbia worked in bronze and marble, but he is best known for his

enamelled terracotta. He was succeeded in the family *bottega* by his nephew, Andrea (*q.v.*).

SUPINO, I. B., in *Thieme–Becker*, XXVIII (1934), 413–14.

BRUNETTI, G. 'Della Robbia', *Encyclopedia of World Art*, IV (1961), 295–302.

BRUNETTI, G. 'Note su Luca della Robbia', *Scritti in onore di Mario Salmi*, II, 263–72. Rome, 1962.

LISNER, M. *Die Sängerkanzel des Luca della Robbia*. Ph.D. Dissertation. Freiburg, 1958.

MARQUAND, A. *Luca della Robbia*. Princeton, 1914.
 Review: H. Horne, in *B.M.*, XXVIII (1915–16), 3–7.

MATHER, R. 'Nuovi Documenti Robbiani', *L'Arte*, XXI (1918), 190–209.

PLANISCIG, L. *Luca della Robbia*. Florence, 1948.

SEYMOUR, C., Jr. 'The Young Luca della Robbia', *Allen Memorial Art Museum Bulletin, Oberlin*, XX (1963), 92–119.

RODARI, TOMMASO (fl. 1487–1526)

Tommaso Rodari was one of the Rodari family of sculptors from Maroggia on Lake Lugano. He came under the influence of Amadeo and Bramante and was active mainly at Como, where he was architect and sculptor for the cathedral. Also active on the sculpture of Como Cathedral were his brothers Bernardino, Donato, and Giacomo.

VIGEZZI, S., in *Thieme–Becker*, XXVIII (1934), 454–5.

ROSSELLI, DOMENICO DI GIOVANNI (*c.* 1439–1497/8)

Domenico Rosselli was born at Pistoia and worked as a sculptor in marble and stucco. He was active in Florence, but also took the influence of Antonio Rossellino into the Marches and the Romagna. His work was primarily in Madonnas, reliefs, and decorative sculpture.

MIDDELDORF, U., in *Thieme–Becker*, XXIX (1935), 36–7.

MIDDELDORF, U. 'Some New Works by Domenico Rosselli', *B.M.*, LXII (1933), 165–72.

ROSSELLINO, ANTONIO (1427–79)

With his brothers Giovanni, Domenico, and Tommaso, Antonio di Matteo di Domenico Gambarelli, called Rossellino, was trained by his much older brother, Bernardo, in Florence, where he was born. He was perhaps the most promising sculptor of his generation in Florence in the 1450s and 1460s.

He worked for Desiderio da Settignano and later as an independent artist. He was in demand in Naples, and did work for Empoli, Faenza, and Venice.

SCHOTTMÜLLER, F., in *Thieme–Becker*, XXIX (1935), 40–2.

GOTTSCHALK, H. *Antonio Rossellino*. Berlin, 1930.

HARTT, F., CORTI, G., and KENNEDY, C. *The Chapel of the Cardinal of Portugal*. Philadelphia, 1964. Documents pp. 132–61.

MIDDELDORF, U., and WEINBERGER, M. 'Unbeachtete Werke der Brüder Rossellino', *Münchner Jahrbuch der bildenden Kunst*, V (1928), 85–100.

PLANISCIG, L. *Bernardo und Antonio Rossellino*. Vienna, 1942.

ROSSELLINO, BERNARDO (1409–64)

Bernardo Rossellino was born at Settignano and trained his younger brothers, Giovanni, Domenico, Tommaso, and Antonio. He was an architect and marble sculptor working mostly in Florence, though he did work elsewhere in Tuscany and Rome. He was for a time *capomaestro* for the Duomo of Florence.

HEYDENREICH, L. H., and SCHOTTMÜLLER, F., in *Thieme–Becker*, XXIX (1935), 42–5.

HARTT, F. 'New Attributions to Bernardo Rossellino', *B.M.*, CIII (1961), 387–92.
 Also treats aspects of Antonio Rossellino.

MARKHAM, A. 'Desiderio da Settignano and the Workshop of Bernardo Rossellino', *A.B.*, XLV (1963), 35–45.

See also the important article by Middeldorf and Weinberger and Planiscig's small volume under Antonio Rossellino.

SAN GALLO, GIULIANO DA (GIULIANO GIAMBERTI) (1445/52–1516)

Born at Florence, San Gallo was trained according to Vasari as a wood sculptor by a certain Francesco Francione. As an architect and marble sculptor he collaborated with his brother Antonio in Florence, and also in Rome, Loreto, and France.

HEYDENREICH, L. H., in *Thieme–Becker*, XXIX (1935), 406–8.

MARCHINI, G. *Giuliano da Sangallo*. Florence, 1942; *Commentari*, I (1950), 34–8.

MIDDELDORF, U. 'Giuliano da Sangallo and Andrea Sansovino', *A.B.*, XVI (1934), 107–15.

PARRONCHI, A., in *Journal of the Warburg and Courtauld Institutes*, XXVII (1964), 108–36.

SANSOVINO, ANDREA (c. 1460–1529)

Sansovino was born at Monte San Savino and was a pupil of Antonio del Pollaiuolo and later of Bertoldo. He was an architect and sculptor in marble, terracotta, and bronze, and active in Florence, Genoa, Rome, Loreto, and Spain. His style is transitional to the High Renaissance.

HUNTLEY, G. H., in *Thieme–Becker*, XXIX (1935), 418–20.

BATELLI, G. *Andrea Sansovino e l'arte italiana della Rinascenza in Portogallo*. Florence, 1936.
> Requires caution.

HUNTLEY, G. H. *Andrea Sansovino, Sculptor and Architect of the Italian Renaissance*. Cambridge, Mass., 1935.

KUBLER, G., and SORIA, M., in *Art and Architecture in Spain and Portugal and their American Dominions 1500–1800 (Pelican History of Art)*, 125, 373. Harmondsworth, 1959.

SILVESTRO DELL'AQUILA (Silvestro di Giacomo da Sulmona, called Ariscola) (fl. 1471–d. 1504)

Silvestro dell'Aquila came under the influence of Desiderio, Rossellino, and Bregno. He was born at Sulmona (Abruzzi) and was active at Aquila as a painter, architect, and sculptor in marble, wood, and terracotta.

[ANON.], in *Thieme–Becker*, XXXI (1937), 40–1.

BONGIORNO, L. M. 'Notes on the Art of Silvestro dell'Aquila', *A.B.*, XXIV (1942), 232–43.

SOLARI, CRISTOFORO (fl. 1489–1520)

Solari first appears in Venice working on an altar which has since been destroyed. He succeeded the Mantegazza as sculptor to the court of Milan and did most of his work in Milan. He was also an architect at Como and worked at Ferrara and for Isabella d'Este.

[ANON.], in *Thieme–Becker*, XXXI (1937), 227.

MALAGUZZI-VALERI, F. 'I Solari, architetti e scultori lombardi del XV secolo', in *Italienische Forschungen, herausgegeben vom Kunsthistorischen Institut in Florenz*, I, 63–168. Berlin, 1906.
> See pp. 132–56 for the sculpture of Cristoforo Solari.

SPERANDIO, SAVELLI (1431–1504)

Born at Mantua in 1431. Trained by his father as a goldsmith, Sperandio was a goldsmith, medallist, architect, and sculptor in marble and terracotta, and was active at Mantua, Ferrara, Milan, Faenza, Venice, and Bologna, where he did the monument of Pope Alexander V in S. Francesco.

HILL, G. F., in *Thieme–Becker*, XXXI (1937), 359–60.

VENTURI, A. 'Sperandio da Mantova', *Archivio Storico dell'Arte*, II (1888), 385–97; III (1889), 229–34.

WEINBERGER, M. 'Sperandio und die Frage der Franciaskulpturen', *Münchner Jahrbuch der bildenden Kunst*, VII (1930), 292–318.

TURINI, GIOVANNI (c. 1385–1455)

Turini was born in Siena and was the son and pupil of Turino di Sano. He was a goldsmith and sculptor in marble, bronze, and wood, and worked with his father on the Siena font. He also was associated with his brother Lorenzo and was influenced by Ghiberti and Donatello.

[ANON.], in *Thieme–Becker*, XXXIII (1939), 488–9.

BACCI, P. 'La "Colonna" del Campo ... e la "Lupa" di Giovanni e Lorenzo Turini', *La Balzana*, I (1927), 227 ff.

MACHETTI, I. 'Orefici senesi', *La Diana*, IV (1929), 62 ff.

SCHUBRING, P. *Die Plastik Sienas im Quattrocento*, 21–53. Berlin, 1907.

URBANO DI PIETRO DA CORTONA (1426?–1504)

Urbano was a pupil of Donatello. He worked both at Padua and Perugia, but did most of his work in Siena, including a marble seat for the Loggia di S. Paolo (1462).

[ANON.], in *Thieme–Becker*, XXXIII (1939), 591.

POPE-HENNESSY, J. 'Three Stucco Reliefs', *Studies in the History of Art Dedicated to William E. Suida*, 61–5. London, 1959.

SCHUBRING, P. *Urbano da Cortona: ein Beitrag zur Kenntnis der Schule Donatellos und der Seneser Plastik im Quattrocento*. Strassburg, 1903.

VECCHIETTA (Lorenzo di Pietro) (c. 1412–80)

Vecchietta, born at Castiglione d'Orcia, was also a painter. His arrival in Siena is not exactly charted, but it was probably c. 1435 or a little later. During this time he worked in wood. In 1457–9 he fell under the influence of Donatello, when the latter was in Siena. It is at this point that he took up bronze sculpture, a technique in which he proved to be an outstanding master.

PERKINS, F. F. M., in *Thieme–Becker*, XXXIV (1940), 152–6.

CARLI, E. 'Il Vecchietta e Neroccio a Siena e "in quel di Lucca": Nuovi documenti e commenti', *Critica d'Arte*, N.S. I (1954), 336–54.

VIGNI, G. *Lorenzo di Pietro, detto il Vecchietta.* Florence, 1937.

VERROCCHIO, ANDREA DEL (1435–88)

Andrea di Cione, called del Verrocchio, was born in Florence and was first trained as a goldsmith. With the Medici as patrons, he shifted to sculpture in marble, bronze, and terracotta, having given up the goldsmith's trade, as he himself reported, because of lack of opportunities. In 1465 he was confirmed in the commission of the group of Christ and St Thomas for Or San Michele. He completed the tomb of Piero and Giovanni de' Medici in S. Lorenzo in 1472, and at that time had already cast the figure of Christ for the Or San Michele group. In the 1470s he was commissioned to carve the marble sculpture of the Forteguerri Monument at Pistoia. In 1483 he left Florence to complete his Colleoni Monument in Venice. There he died in 1488, before he could cast either horse or rider.

DUSSLER, L., in *Thieme–Becker*, XXXIV (1940), 292–8.

BONGIORNO, L. M. 'A Fifteenth-Century Stucco and the Style of Verrocchio', *Allen Memorial Art Museum Bulletin, Oberlin*, XIX (1962), 115–38.

CRUTWELL, M. *Verrocchio.* London, 1904.
 Documents: pp. 234–55.

KENNEDY, C., and WILDER, E. *The Unfinished Monument by Andrea del Verrocchio to the Cardinal Niccolò Forteguerri at Pistoia.* Northampton, Mass., 1932.

MATHER, R. G. 'Documents mostly new relating to Florentine Painters and Sculptors of the Fifteenth Century', *A.B.*, XXX (1948), 29–31.

PLANISCIG, L. *Andrea del Verrocchio.* Vienna, 1941.

VALENTINER, W. 'Rediscovered Works by Andrea del Verrocchio', 96–112; 'On Leonardo's Relation to Verrocchio', 113–78, *Studies of Renaissance Sculpture.* London, 1950.

IV. PRINCIPAL COLLECTIONS AND EXHIBITIONS

A. PRINCIPAL MUSEUM COLLECTIONS: CATALOGUES AND HANDBOOKS

1. Austria

Vienna

Kunsthistorisches Museum

PLANISCIG, L. *Die Bronzeplastiken, Statuetten, Reliefs, Geräte und Plaketten.* Vienna, 1924.

2. England

London

Victoria and Albert Museum

MACLAGAN, E., and LONGHURST, M. *Catalogue of Italian Sculpture.* 2 vols. London, 1932.

MACLAGAN, E. *Catalogue of Italian Plaquettes.* London, 1924.

POPE-HENNESSY, J., assisted by LIGHTBOWN, R. W. *Catalogue of Italian Sculpture in the Victoria and Albert Museum.* 3 vols. London, 1964.
 Supplants catalogue of 1932 (*see* above).

3. France

Lyon

JULLIAN, R. *Catalogue des sculptures du Musée de Lyon.* Lyon, 1945.

Paris

Musée Jacquemart-André

Catalogue itinéraire. 6th (revised) ed. Paris, n.d.

Musée National du Louvre

Catalogue des sculptures du Moyen Âge, de la Renaissance et des Temps Modernes, I: *Moyen Âge et Renaissance.* Paris, 1922.

BEAULIEU, M. *Les Sculptures: Moyen-Âge, Renaissance, Temps Modernes au Musée du Louvre.* Paris, 1957.

4. Germany

Berlin

Staatliche Museen

BANGE, E. F. *Reliefs und Plaketten.* Berlin, 1930.

BODE, W. VON. *Bronzestatuetten, Büsten und Gebrauchsgegenstände.* Berlin, 1930.

SCHOTTMÜLLER, F. *Die Bildwerke in Stein, Holz, Ton und Wachs.* Berlin, 1933.

 Note: The losses in the Second World War were officially published in *Berliner Museen. Berichte aus den ehemaligen preussische Kunstsammlungen*, III (1953), 10–24. Subject to some caution, as later information has become available.

5. Italy

Florence

ROSSI, F. *Il Bargello*. Florence, 1952.

POGGI, G. *Il Museo del Opera del Duomo*. Florence, 1904.

Milan

AURIA, A. D'. 'Le Sculture della Villa Tittoni di Desio passate al Castello Sforzesco di Milano', *Arte antica e moderna*, XXII (1963), 124–38.

VIGEZZI, S. *La scultura in Milano* (Museo archeologico, Castello Sforzesco). Milan, 1934.

BICCHI, U. *Il Museo del Duomo*. Milan, 1956.

Padua

MOSCHETTI, A. *Il Museo Civico di Padova*. Padua, 1938.

Rome

TOTH, G. B. DE. *Le Grotte Vaticane*. Città del Vaticano, 1955.

SANTANGELO, A. *Catalogo delle Sculture* (Museo di Palazzo Venezia). Rome, 1954.

Siena

CARLI, E. *Il Museo dell'Opera e la Libreria Piccolomini di Siena*. Siena, 1946.

6. United States

Cleveland

Museum of Art. Handbook. Cleveland, 1958.

Detroit

Institute of Art. Paintings and Sculpture. Detroit, n.d.

Los Angeles

VALENTINER, W. R. *Gothic and Renaissance Sculptures in the Collection of the Los Angeles County Museum*. Los Angeles, 1951.

New York

Frick Collection

MACLAGAN, E., with emendations by LEVI D'ANCONA, M., and WAY, D. J.; foreword by SEYMOUR, C., Jr. *Sculpture of the Renaissance and Later Periods*. New York, 1953.

Metropolitan Museum of Art

Guide to the Collections. New York, 1934.

Handbook of the Benjamin Altman Collection. New York, 1928.

Santa Barbara

MIDDELDORF, U., and GOETZ, O. *Medals and Plaquettes from the Sigmund Morgenroth Collection*. Chicago Art Institute, 1944.

Reportedly at Santa Barbara Museum as a recent acquisition.

Washington

The National Gallery of Art

[SEYMOUR, C., Jr.] *Preliminary Catalogue*, 217–38. Washington, 1941.

POPE-HENNESSY, J. *Renaissance Bronzes from the Samuel H. Kress Collection*. London, 1965. Former G. Dreyfus Collection, Paris.

HILL, G. F. *The Gustave Dreyfus Collection: Medals*. Oxford, 1931.

RICCI, S. DE. *The Gustave Dreyfus Collection: Reliefs and Plaquettes*. Oxford, 1931.

SEYMOUR, C., Jr. *Masterpieces of Sculpture in the National Gallery of Art*. New York, 1949.

SWARZENSKI, G. 'Some Aspects of Italian Renaissance Sculpture in the National Gallery', *Gazette des Beaux-Arts*, ser. 6, XXIV (1943), 149–56, 283–304.

Worcester, Mass.

Worcester Art Museum

JANSON, H. W. *Catalogue of Sculpture, Annual*, II (1936–7).

NOTE: For indications of the passage of important pieces of fifteenth-century sculpture from American private collections to public museums in the United States over the past fifty years, see *Duveen Sculpture in Public Collections of America. Italian Renaissance*, New York, 1944; the collections include the Altman, Frick, Goldman, Huntington, Kress, Mellon, Morgan, and Widener.

B. PRINCIPAL EXHIBITIONS SINCE 1900: CATALOGUES

[C. RICCI, Introduction], Siena. *Mostra dell'antica arte senese*. Siena, 1904.

[E. MACLAGAN, Introduction], London, Burlington Fine Arts Club. *Catalogue of a Collection of Italian Sculpture and Other Plastic Art of the Renaissance*. London, 1913.

New York, Metropolitan Museum. *Italian Renaissance Sculpture*. New York, 1933.

Amsterdam, Stedelijk Museum. *Italianische Kunst in Nederlandisch Bezit*. Amsterdam, 1934.

[WASHBURN, G., ed.], Buffalo, Albright Art Gallery. *Master Bronzes Selected from Museums and Collections in America* (containing *An Introduction to Bronze Statuettes of the Renaissance* by J. G. Phillips, Jr). Buffalo, 1937.

Siena. *Mostra di sculture d'arte senese del XV secolo – nel V centenario della morte di Jacopo della Quercia.* Siena, 1938.

[VALENTINER, W. R.], Detroit, Institute of Arts. *Catalogue of an Exhibition of Gothic and Early Renaissance Sculptures.* Detroit, 1938.

New York, Metropolitan Museum. *Italian Bronze Statuettes.* New York, 1941.

[CARLI, E.], Siena. *Mostra della antica scultura lignea senese.* Florence, 1949.

[GRIGAUT, P. L.], Detroit, Institute of Arts. *Decorative Arts of the Italian Renaissance 1400–1600.* Detroit, 1958.

[J. POPE-HENNESSY, Introduction], London, Victoria and Albert Museum. *Italian Bronze Statuettes.* 27 July–1 October 1961.

Amsterdam, Rijksmuseum. *Meesters van het Brons der Italiaanse Renaissance.* 29 October 1961–14 January 1962.

Florence, Palazzo Strozzi. *Bronzetti Italiani del Rinascimento.* February–March 1962.

V. PERIODICAL LITERATURE GUIDE

Preliminary Note

A high percentage of the literature on the subject of Italian fifteenth-century sculpture has appeared, and continues to appear, in periodicals. The following guide to the periodicals most concerned with publication on the topic is printed here as a potentially useful bibliographical aid. Included are year-books and museum bulletins. Non-current periodicals are so noted.

A. YEARBOOKS

BERLIN: *Jahrbuch der Königlich Preussischen Kunstsammlungen,* and (after 1918) *Jahrbuch der Preussischen Kunstsammlungen,* 1880–1940. Followed by *Jahrbuch der Berliner Museen,* 1959–.

MARBURG: *Marburger Jahrbuch für Kunstwissenschaft,* 1924–.

MILAN: *Arte Lombarda,* 1950–.

MUNICH: *Münchner Jahrbuch der bildenden Kunst,* 1908–23; 1924–38/9; 1950–.

ROME: *Kunstgeschichtliches Jahrbuch der Bibliotheca Hertziana,* 1927–.

VENICE: *Arte Veneta,* 1947–.

VIENNA: *Jahrbuch den Künstsammlungen des Allerhöchsten Kaiserhauses zu Wien,* 1883–1918; *Jahrbuch der Kunsthistorischen Sammlungen Wien,* 1919–.

B. PERIODICALS

Archivio Storico Italiano, 8 series, 1842–. Florence.

Archivio Storico dell'Arte, 1888–94; 1895–7, Rome. Non-current (superseded by *L'Arte, q.v.*).

Archivio Storico Lombardo, 8 series, 1874–. Milan.

Archivio Storico per le Provincie Napoletane, 1876–. Naples.

Art Bulletin, 1913–. College Art Association of America.

Art Quarterly, 1938–. Detroit.

L'Arte, 1898–. Milan.

Arte Antica e Moderna, 1954–. Bologna–Florence.

Le Arti, 1938–43. Rome. Non-current (published during interval between vols. XXXII and XXXIII of *Bollettino d'Arte*).

Les Arts, 1902–20. Paris. Non-current.

La Balzana, 1927–33. Siena. Non-current.

Belli Arti, 1946–. Pisa.

Belvedere, 1922–43. Vienna. Non-current.

Berliner Museen. *Berichte aus den ehemaligen Preussischen Kunstsammlungen,* N.S., 1950–. Berlin.

Bollettino Senese di Storia Patria, 1894–1929; N.S., 1930–9. Siena. Non-current.

Bollettino d'Arte, 1907–38; superseded by *Le Arti,* 1938–43; resumed publication with vol. XXXIII, 1943–. Rome.

Boston, Museum of Fine Arts. *Bulletin,* 1903–.

Burlington Magazine, 1902–. London.

Chicago, Art Institute. *Quarterly,* then *Bulletin,* 1907–.

Der Cicerone, 1909–30. Leipzig. Incorporated in *Pantheon (see below)*.

Cleveland, Museum of Art. *Bulletin,* 1940–.

Commentari, 1950–. Florence.

La Critica d'Arte, 1935–; new series, 1954–. Florence.

Dedalo, 1920–33. Rome–Milan. Non-current.

Detroit, Institute of Art. *Bulletin,* 1919–.

La Diana, 1926–34. Siena. Non-current.

Emporium, 1895–. Bergamo.

Florence, Kunsthistorisches Institut. *Mitteilungen*, 1908–14, 1916–17, 1929–41, 1953–.

Gazette des Beaux-arts, 1859–. 6 series. Paris (for a time during the Second World War, New York).

London University, Warburg and Courtauld Institutes. *Journal*, 1937–.

Monatshefte für Kunstwissenschaft, 1908–22. Leipzig. Non-current.

Napoli Nobilissima, 1892–1906; 1920–2; 1961–. Naples.

New York, Metropolitan Museum of Art. *Bulletin*, 1905–.

Pantheon, 1928–44; 1960–. Munich.

Paragone, 1949–. Florence.

Philadelphia, Museum of Art. *Bulletin*, 1903–.

Rassegna d'Arte Antica e Moderna, 1901–22. Milan. Non-current.

Rassegna d'Arte Senese, 1905–26. Siena. Non-current.

Rivista d'Arte, 1903–7; 1912; 1929–. Florence.

Il Santo, 1961–. Padua.

Repertorium für Kunstwissenschaft, 1876–1931. Berlin. Non-current.

Revue de l'Art Ancien et Moderne, 1897–1937. Paris. Non-current.

Revue de l'Art Chrétien, 1857–1914. Paris. Non-current.

Zeitschrift für bildende Kunst, 1866–1932. Leipzig. (Became *Zeitschrift für Kunstgeschichte*, 1932–.) Non-current.

Zeitschrift für Kunstgeschichte, 1932–. Berlin. Publishes valuable annual bibliographies with virtually complete international coverage.

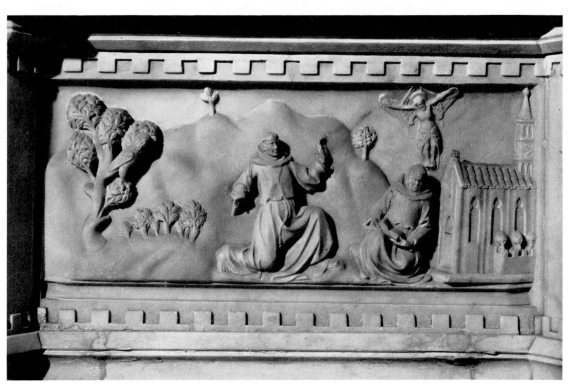

(A) Jacobello dalle Masegne (attrib.): The Miracle of the Stigmata, predella relief, high altar.
Marble. 1388–92. *Bologna, S. Francesco*

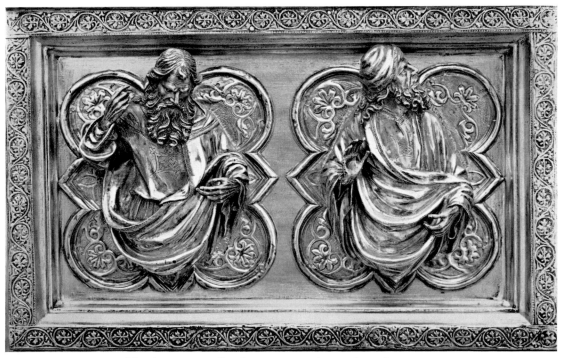

(B) Filippo Brunelleschi: Two Prophets, Altar of St James.
Silver. 1398–1400. *Pistoia, Duomo*

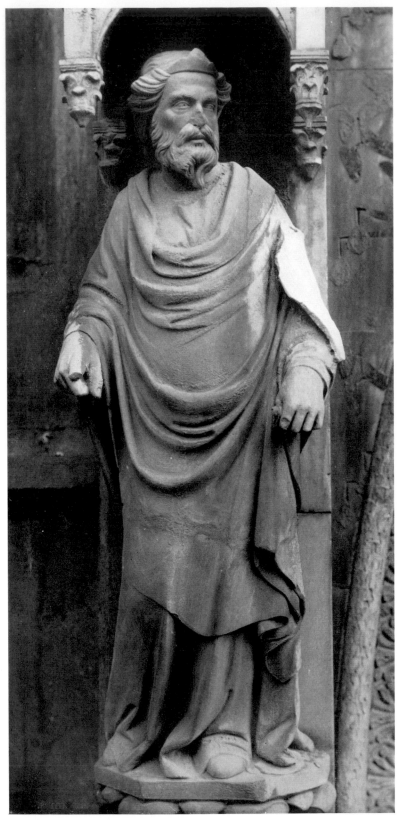

Lorenzo di Giovanni d'Ambrogio: Prophet, Porta della Mandorla.
Marble. 1396–7. *Florence, Duomo*

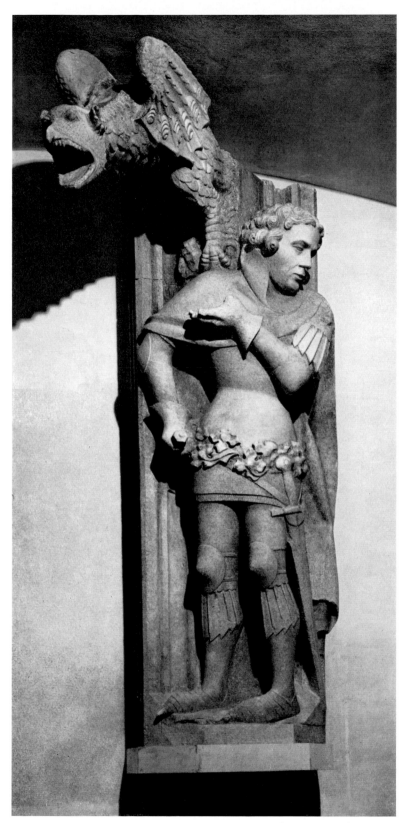

Matteo Raverti: Gargoyle and 'Gigante' for Milan Cathedral (cast).
1404. *Milan, Museo del Duomo*

3

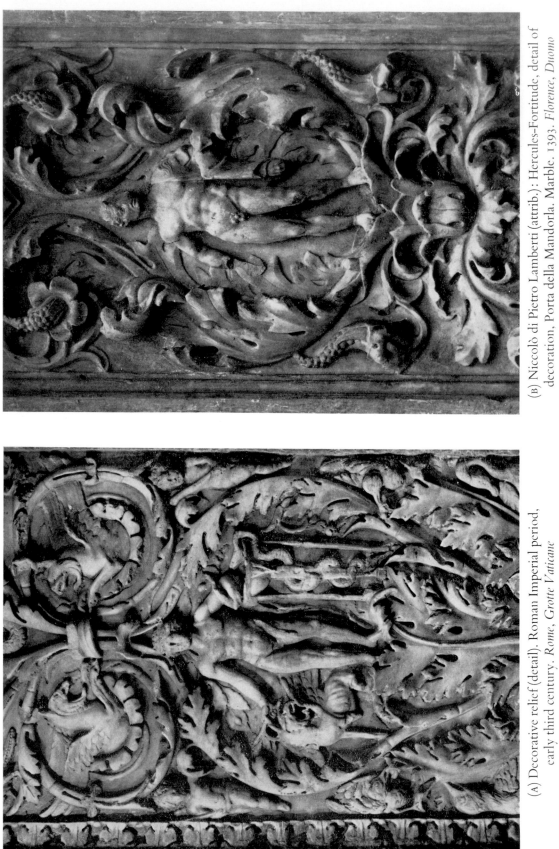

(B) Niccolò di Pietro Lamberti (attrib.): Hercules–Fortitude, detail of decoration, Porta della Mandorla. Marble. 1393. *Florence, Duomo*

(A) Decorative relief (detail). Roman Imperial period, early third century. *Rome, Grotte Vaticane*

4

(B) Jacopo della Quercia (attrib.), with Jacobello dalle Masegne: Angel of the Annunciation (detail), high altar retable. Marble. *c.* 1390–6. *Bologna, S. Francesco*

(A) Nanni di Banco(?): Angel of the Annunciation (detail) from the Porta della Mandorla. Marble. 1406–8(?). *Florence, Museo dell'Opera del Duomo*

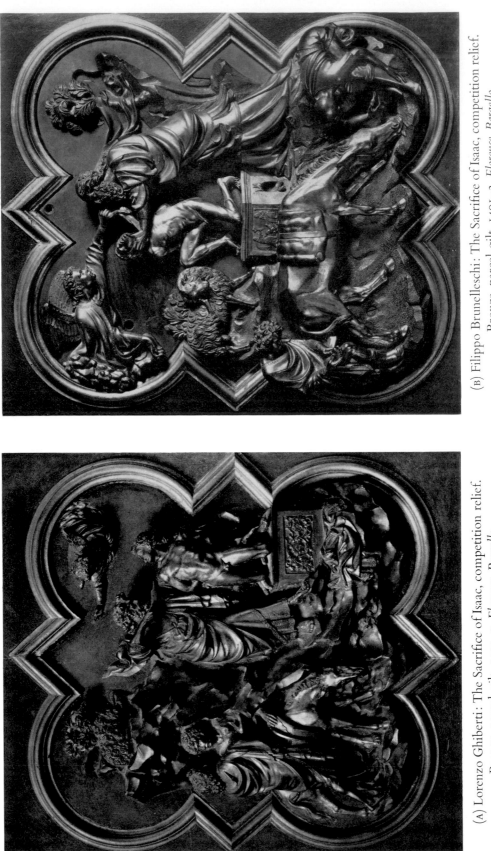

(B) Filippo Brunelleschi: The Sacrifice of Isaac, competition relief. Bronze, parcel-gilt. 1401–2. *Florence, Bargello*

(A) Lorenzo Ghiberti: The Sacrifice of Isaac, competition relief. Bronze, parcel-gilt. 1401–2. *Florence, Bargello*

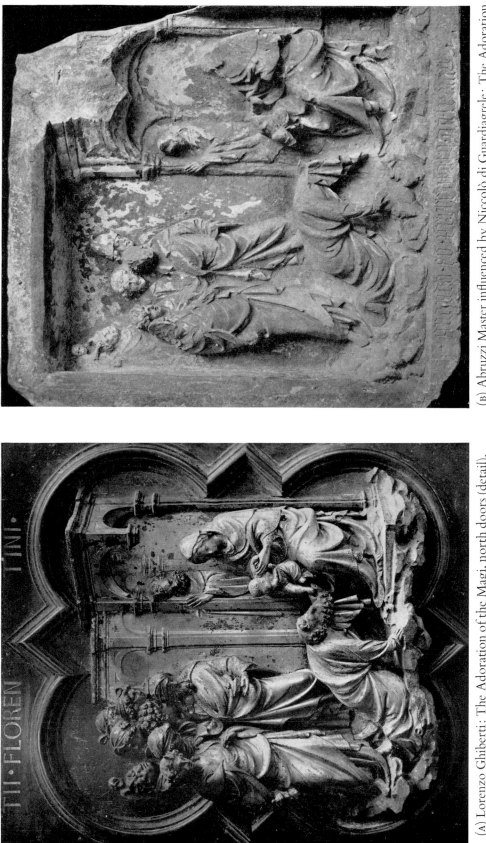

(A) Lorenzo Ghiberti: The Adoration of the Magi, north doors (detail). Bronze, parcel-gilt. 1404–7. *Florence, Baptistery*

(B) Abruzzi Master influenced by Niccolò di Guardiagrele: The Adoration of the Magi, from Castel del Sangro. Stone. *c.* 1425. *Florence, Museo dell'Opera del Duomo*

7

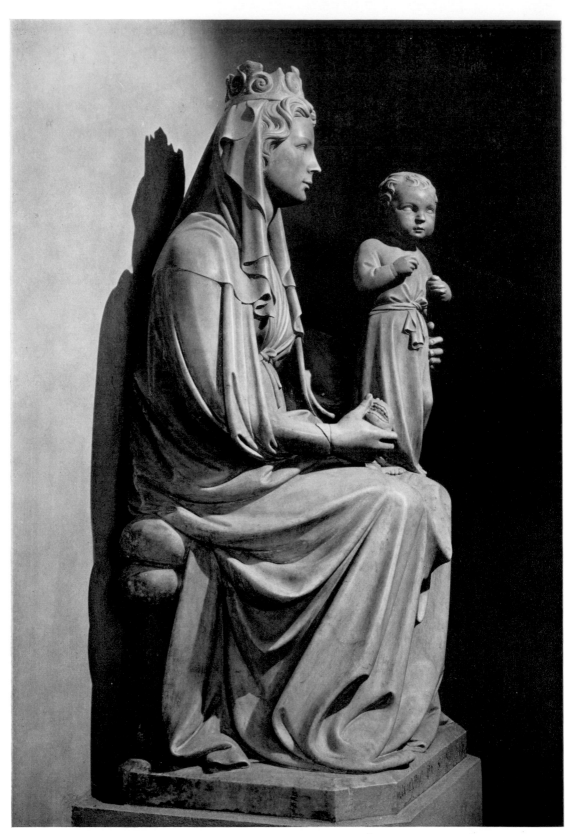

Jacopo della Quercia: Madonna and Child. Marble. 1407/8. *Ferrara, Museo del Duomo*

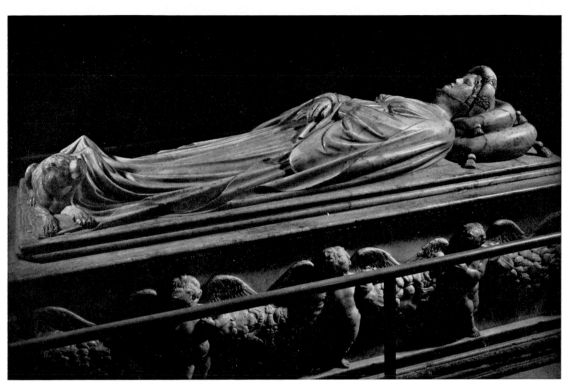

(A) Jacopo della Quercia and Francesco di Valdambrino: Monument of Ilaria del Carretto Guinigi.
Marble. *c.* 1406. *Lucca, Duomo*

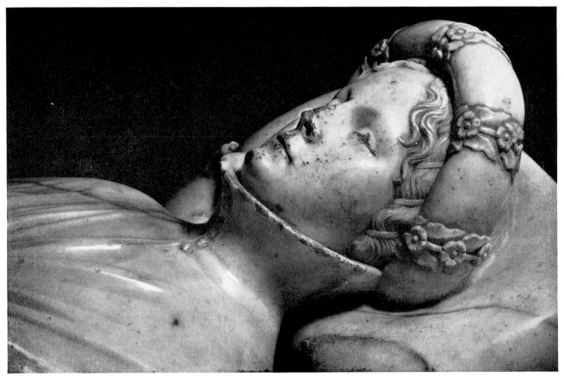

(B) Jacopo della Quercia: Head of effigy, monument of Ilaria del Carretto Guinigi
(cf. Plate 9A). *Lucca, Duomo*

9

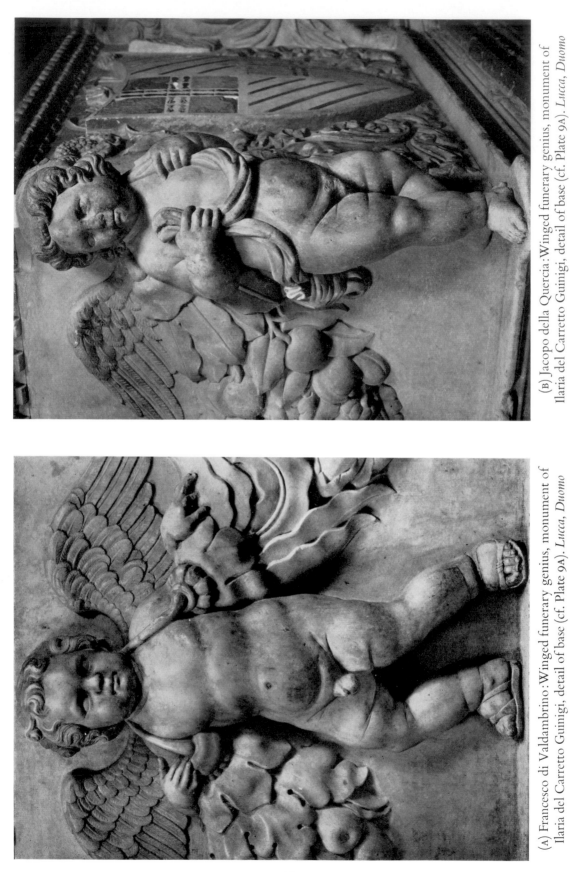

(A) Francesco di Valdambrino: Winged funerary genius, monument of
Ilaria del Carretto Guinigi, detail of base (cf. Plate 9A). *Lucca, Duomo*

(B) Jacopo della Quercia: Winged funerary genius, monument of
Ilaria del Carretto Guinigi, detail of base (cf. Plate 9A). *Lucca, Duomo*

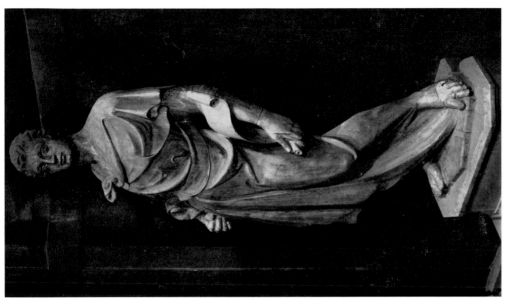

(B) Nanni di Banco: Prophet Isaiah, originally for spur of buttress adjacent to the Porta della Mandorla. Marble. 1408. *Florence, Duomo*

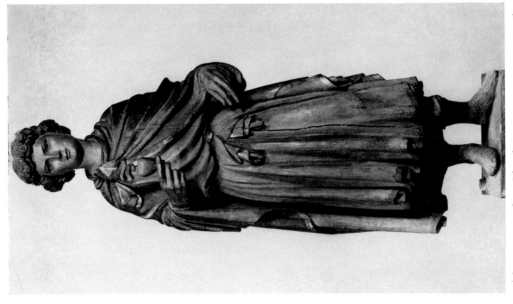

(A) Francesco di Valdambrino: S. Ansano. Painted wood. 1406–7. *Lucca, SS. Simone e Giuda*

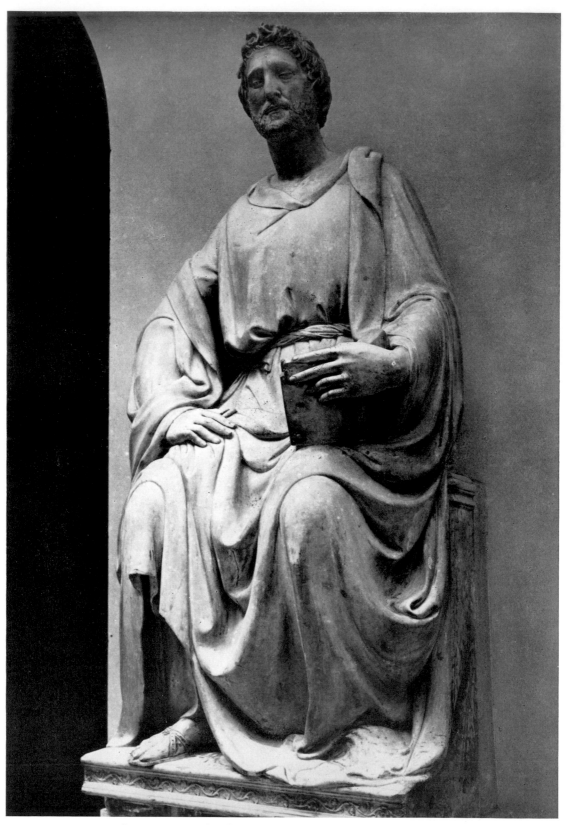

Nanni di Banco: St Luke, for the façade of the Duomo. Marble. 1408–15.
Florence, Museo dell'Opera del Duomo

12

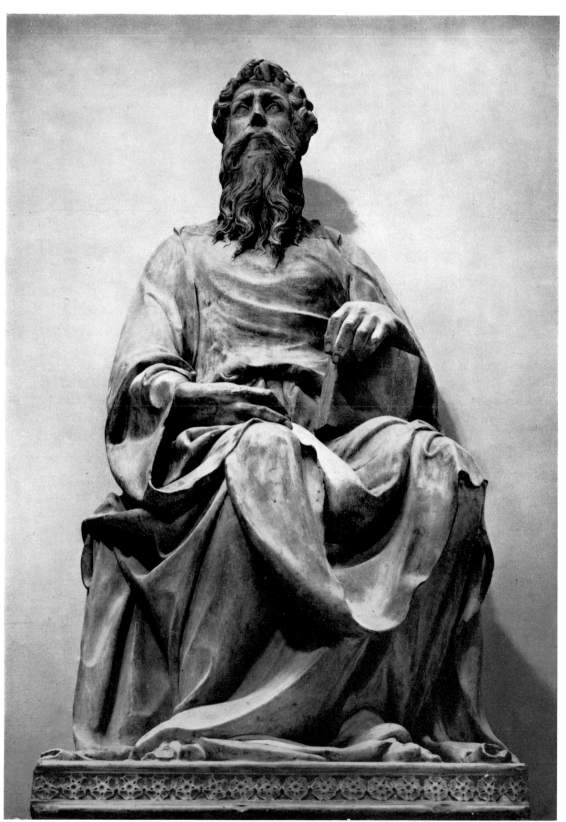

Donatello: St John the Evangelist, for the façade of the Duomo. Marble. 1408–15.
Florence, Museo dell'Opera del Duomo

13

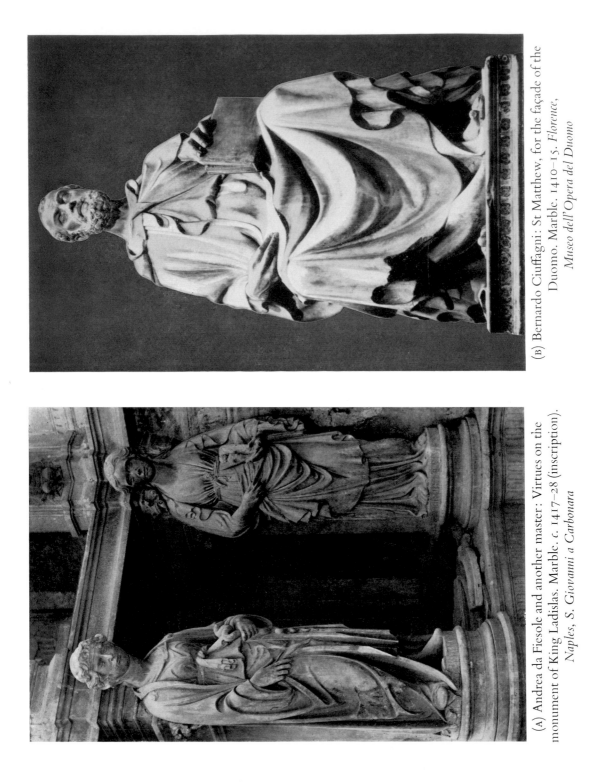

(A) Andrea da Fiesole and another master: Virtues on the monument of King Ladislas. Marble. *c.* 1417–28 (inscription). *Naples, S. Giovanni a Carbonara*

(B) Bernardo Ciuffagni: St Matthew, for the façade of the Duomo. Marble. 1410–15. *Florence, Museo dell'Opera del Duomo*

14

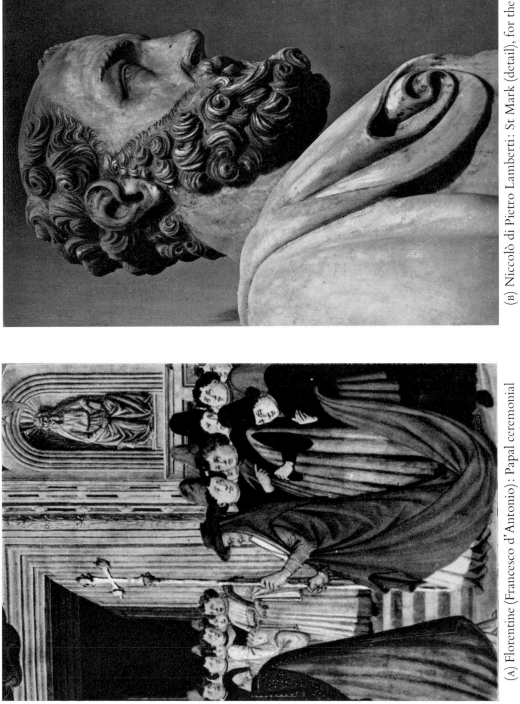

(A) Florentine (Francesco d' Antonio): Papal ceremonial procession at the main portal of S. Maria del Fiore (detail). *c.* 1480. *Florence, Biblioteca Laurenziana*

(B) Niccolò di Pietro Lamberti: St Mark (detail), for the façade of the Duomo, Florence. Marble. 1408–15. *Florence, Museo dell'Opera del Duomo*

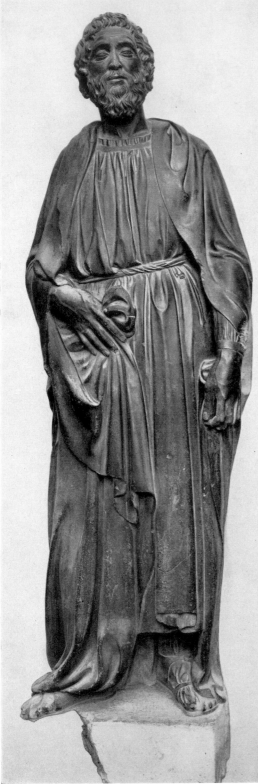

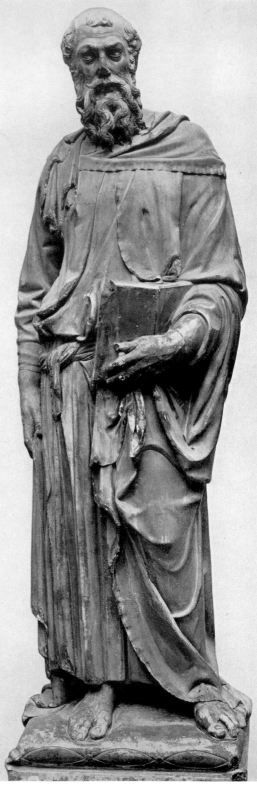

(A) Nanni di Banco: One of the 'Four Crowned Saints'. Marble. *c.* 1410–15.
Florence, Or San Michele

(B) Donatello: St Mark, Niche of the Linen Weavers. Marble. 1411 (commission)–1413.
Florence, Or San Michele

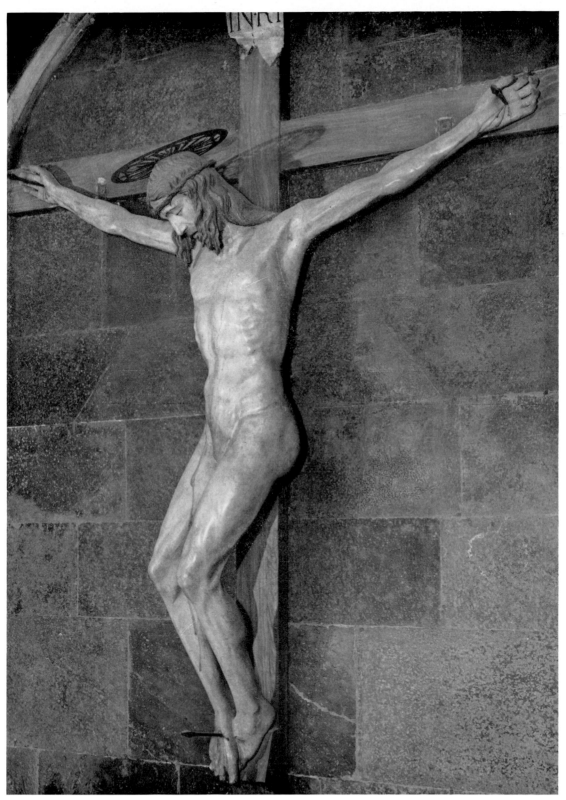

Brunelleschi: Crucifix. Painted wood. *c.* 1410–15. *Florence, S. Maria Novella*

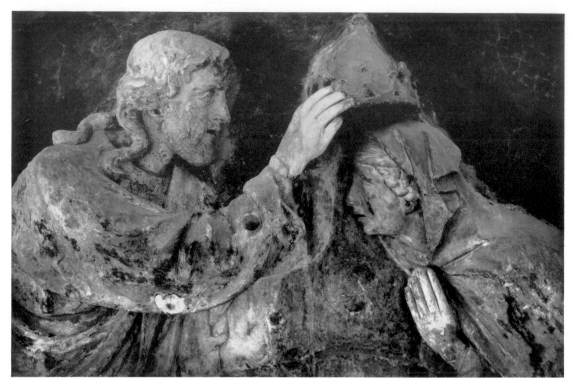

(A) Dello Delli: Coronation of the Virgin (detail). Terracotta originally
painted white. *c.* 1424. *Florence, S. Egidio*

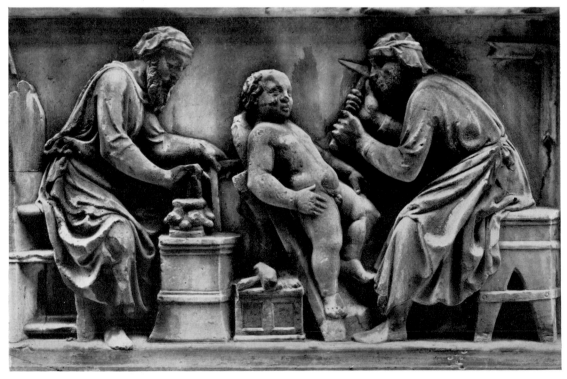

(B) Nanni di Banco: Stone-worker and sculptor, right half of relief under the Niche of
the 'Four Crowned Saints'. Marble. 1411–13(?). *Florence, Or San Michele*

18

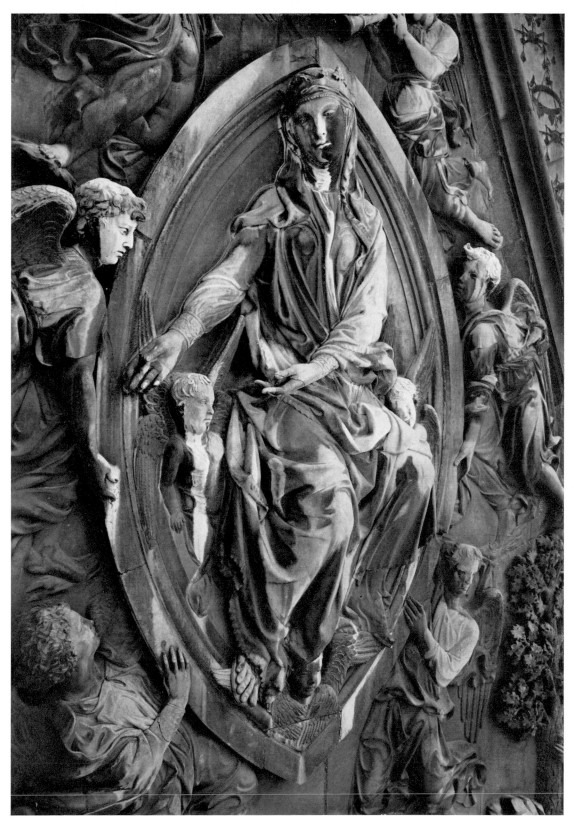

Nanni di Banco: Assumption of the Virgin, central part of tympanum, Porta della
Mandorla. Marble. 1415–22. *Florence, Duomo*

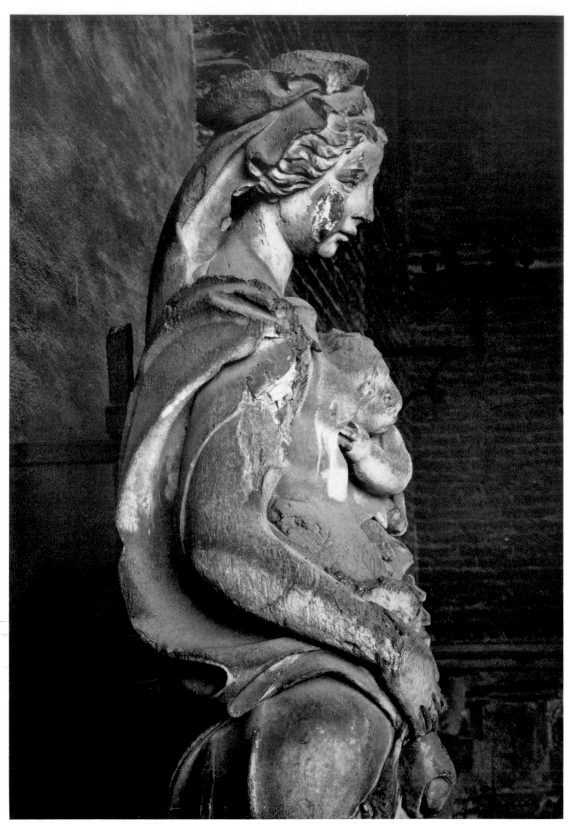

Jacopo della Quercia: 'Acca Laurentia' (detail), from the Fonte Gaia.
Marble. 1416–19. *Siena, Palazzo Pubblico*

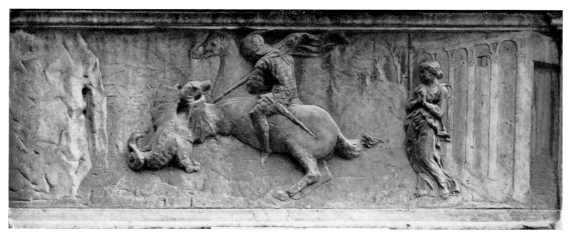

(A) Donatello: St George and the Dragon, relief under the Niche of the Armourers' Guild (cf. Plate 22). Marble. *c.* 1417. *Florence, Or San Michele*

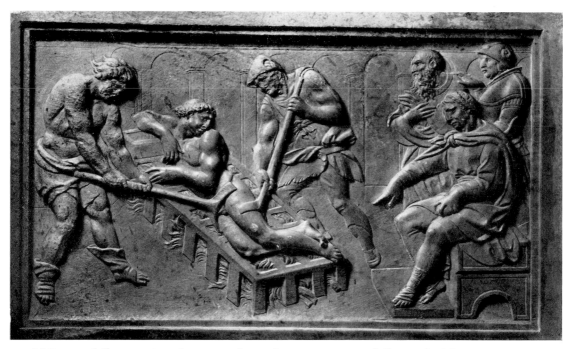

(B) Jacopo della Quercia: The Martyrdom of St Lawrence, predella panel of the Trenta Altar. Marble. 1421–2. *Lucca, S. Frediano*

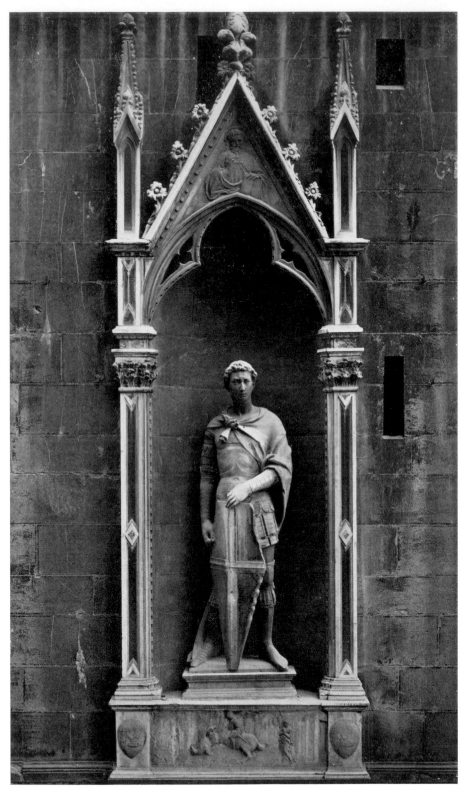

Donatello: St George, Niche of the Armourers' Guild (before removal of the statue to the Bargello). Marble. Begun *c.* 1415 (?). *Florence, Or San Michele*

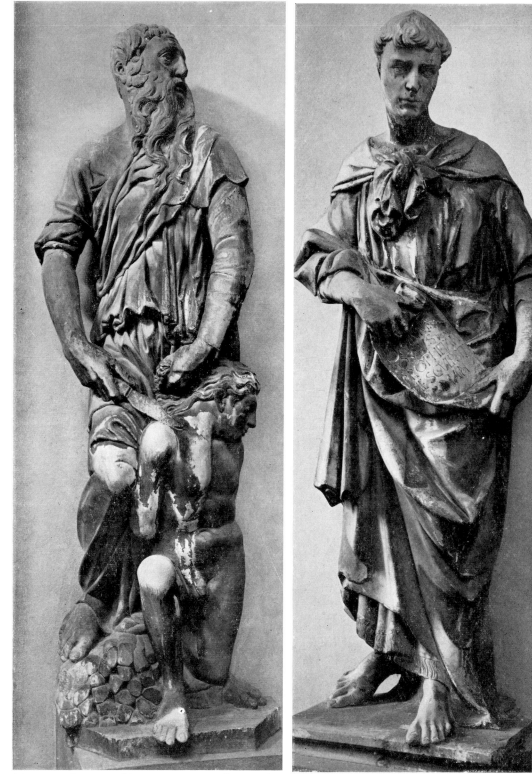

(A) Donatello assisted by Rosso (Nanni di Bartolo):
The Sacrifice of Isaac, for the campanile of the
Duomo. Marble. 1421. *Florence, Museo
dell'Opera del Duomo*

(B) Rosso (Nanni di Bartolo): The Prophet Abdias
(Obadiah), for the campanile of the Duomo.
Marble. 1422. *Florence, Museo
dell'Opera del Duomo*

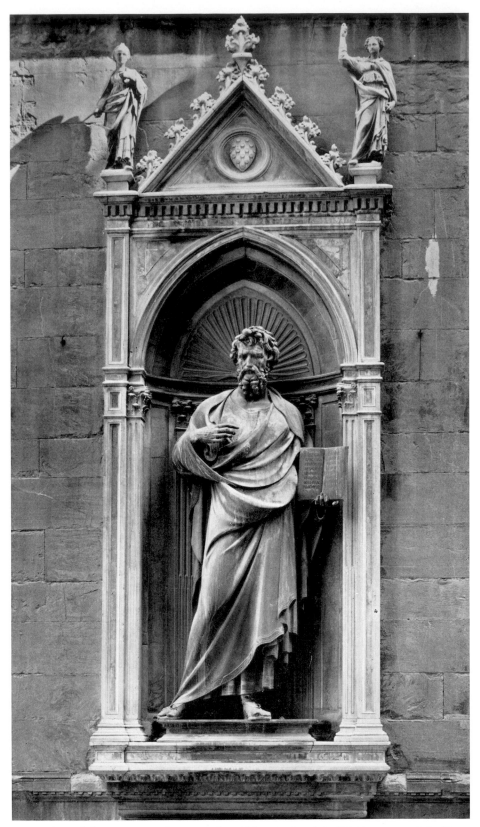

Lorenzo Ghiberti: St Matthew, Niche of the Bankers' Guild. Bronze, originally gilt at least in part. 1419–21. *Florence, Or San Michele*

24

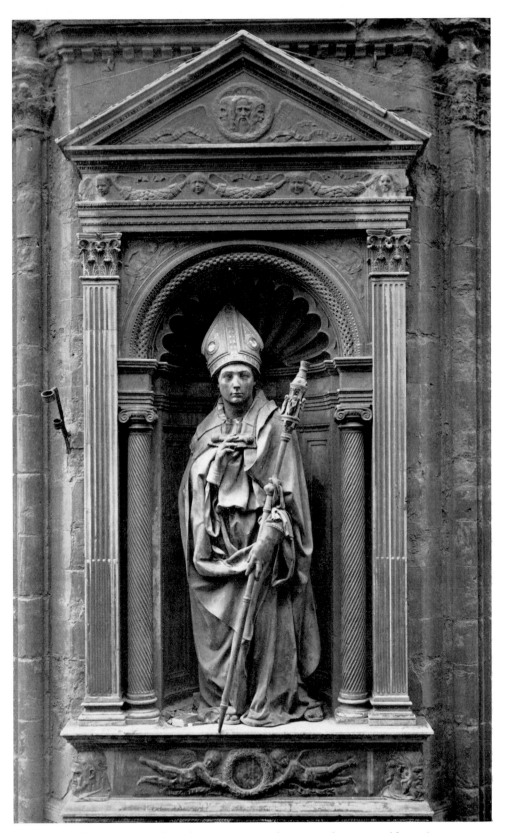

Donatello: St Louis of Toulouse, in original setting of Parte Guelfa Niche, Or San Michele. Bronze gilt. *c.* 1423. *Florence, Museo dell'Opera di S. Croce*

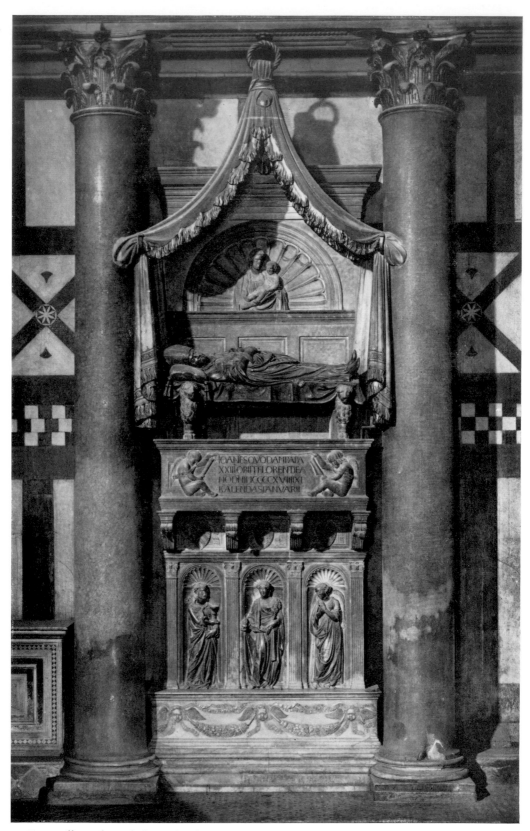

Donatello and Michelozzo (with assistance): Monument of Baldassare Coscia, schismatic
Pope John XXIII. Marble and bronze. *c.* 1424–7. *Florence, Baptistery*

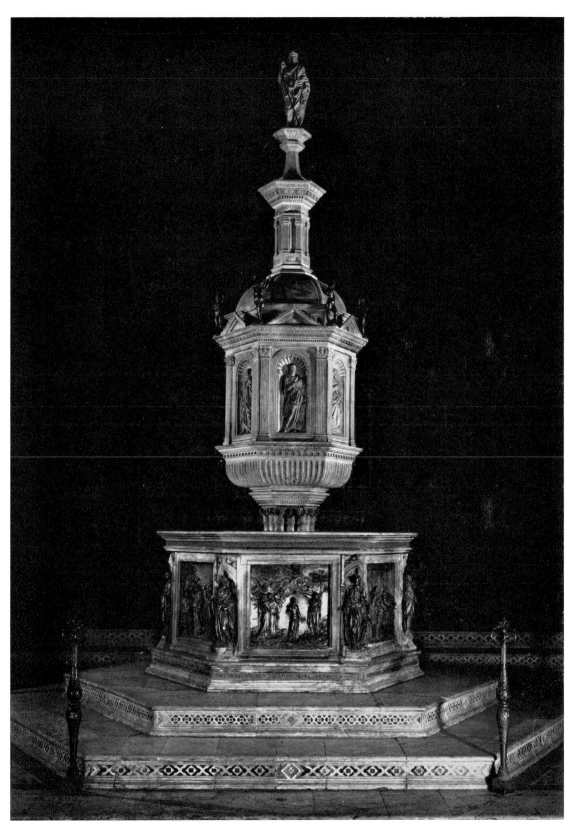

Jacopo della Quercia, Lorenzo Ghiberti, Donatello, and others: Font. Marble, bronze gilt, and enamels. 1417 (commission for reliefs) –1434. *Siena, Baptistery*

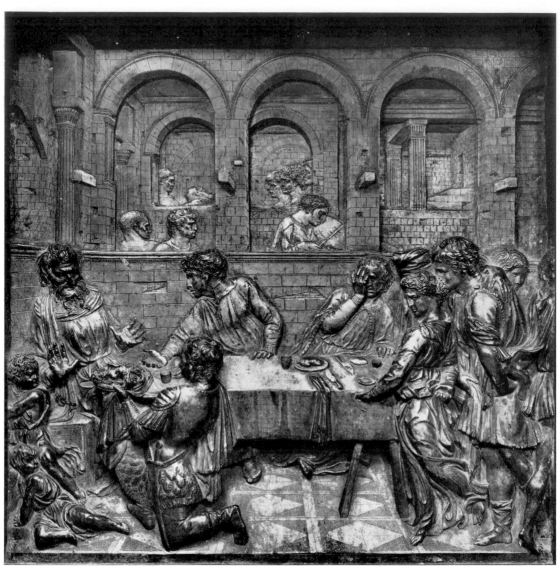

Donatello: Herod's Feast (cf. Plate 27). Bronze gilt. 1423–7. *Siena, Baptistery*

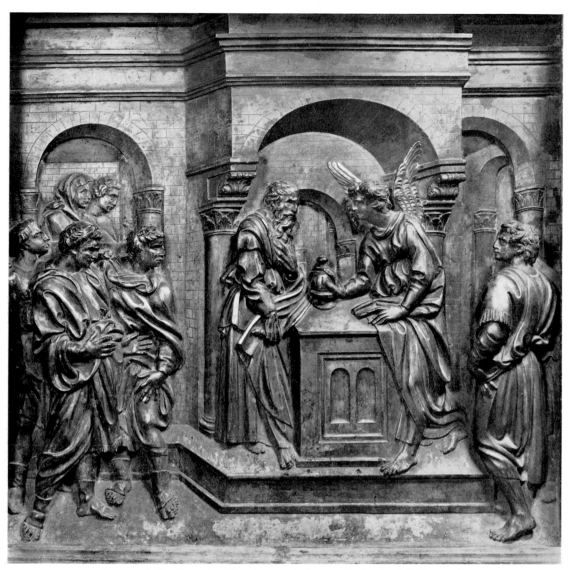

Jacopo della Quercia: The Annunciation to Zacharias (cf. Plate 27).
Bronze gilt. 1427–30. *Siena, Baptistery*

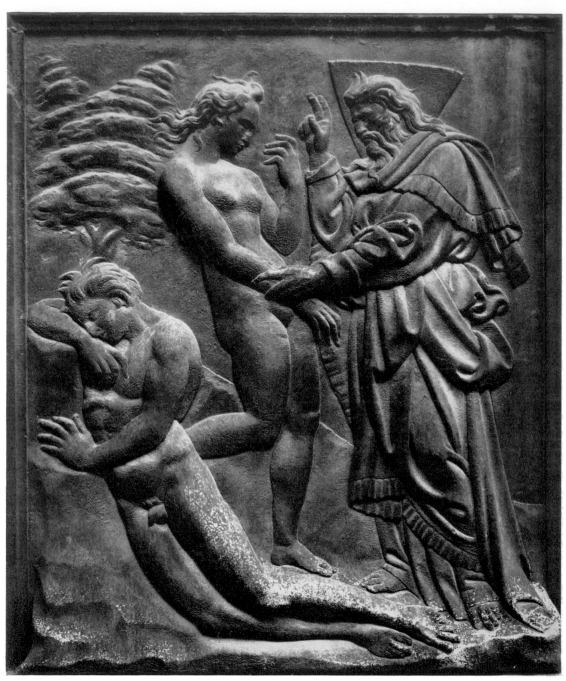

Jacopo della Quercia: The Creation of Eve. Stone. *c.* 1430–5. *Bologna, S. Petronio*

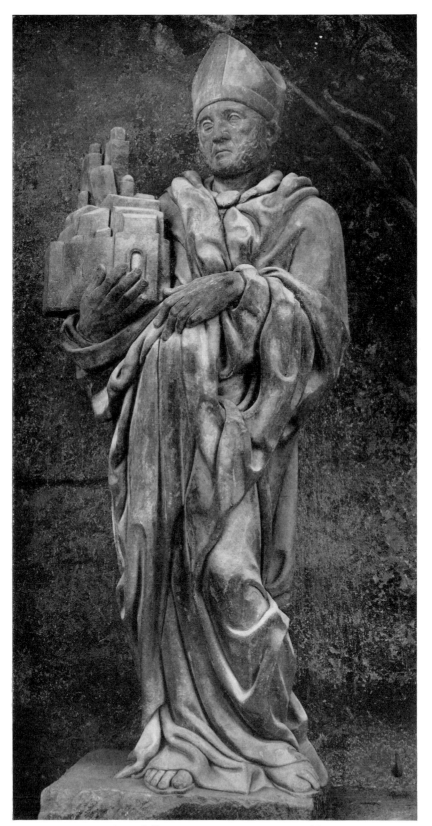

Jacopo della Quercia: S. Petronio. Marble
In place 1434. *Bologna, S. Petronio*

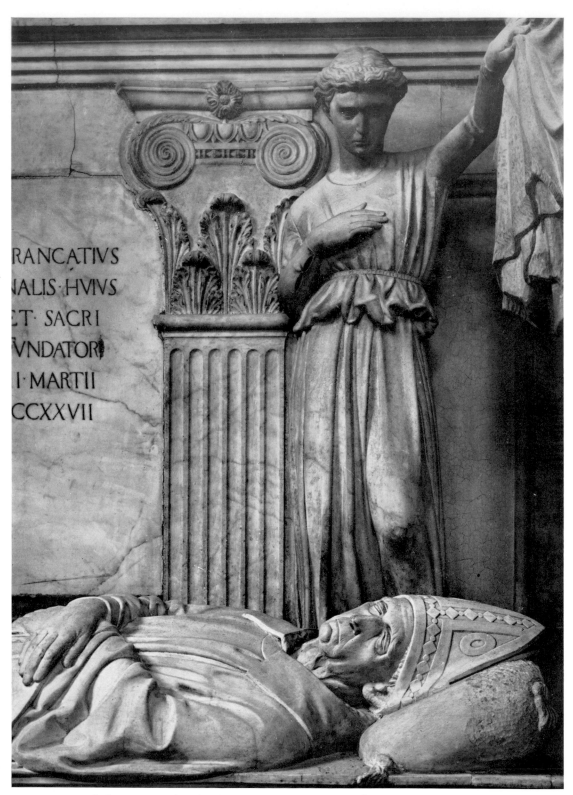

Michelozzo: Angel and effigy, Brancacci Monument (detail). Marble. 1426–30.
Naples, S. Angelo a Nilo

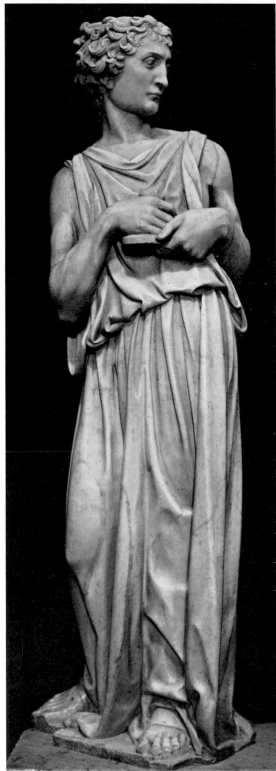

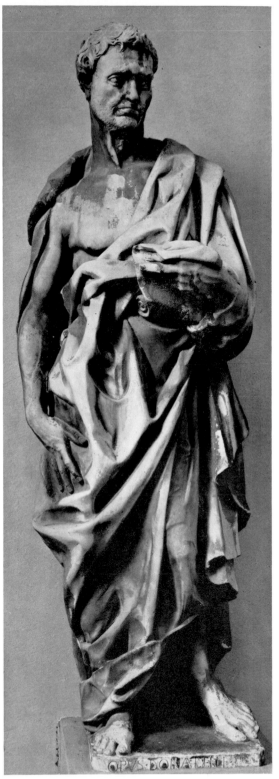

(A) Michelozzo: 'Faith', for the monument of
Bartolommeo Aragazzi. Marble. *c.* 1430.
Montepulciano, Duomo

(B) Donatello: A Prophet (Habbakuk?), 'Il
Popolano', for the campanile of the Duomo.
Marble. 1427–35. *Florence, Museo dell'*
Opera del Duomo

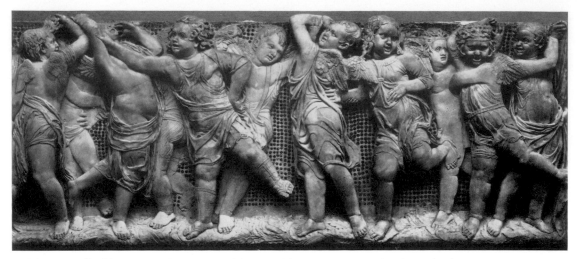

(A) Donatello (design): Left portion of frieze of dancing amorini for the second singing gallery of the Duomo. Marble and mosaic. *c.* 1434–40. *Florence, Museo dell'Opera del Duomo*

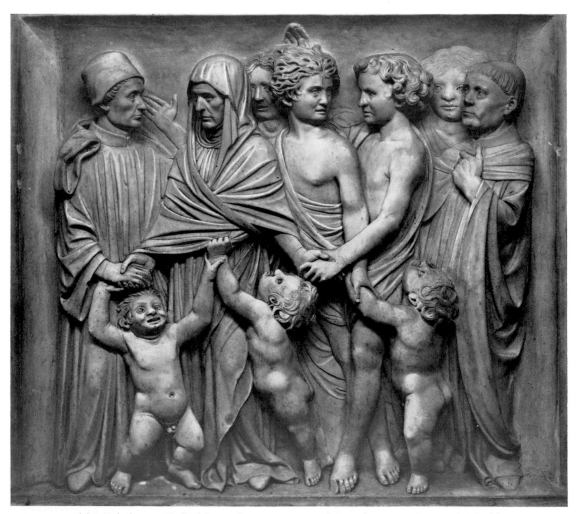

(B) Michelozzo: Relief from the monument of Bartolommeo Aragazzi. Marble. *c.* 1430(?). *Montepulciano, Duomo*

Michelozzo, Donatello, and assistants: Outdoor pulpit. Marble, mosaic, and bronze.
1428 (commission)–1438. *Prato, Duomo*

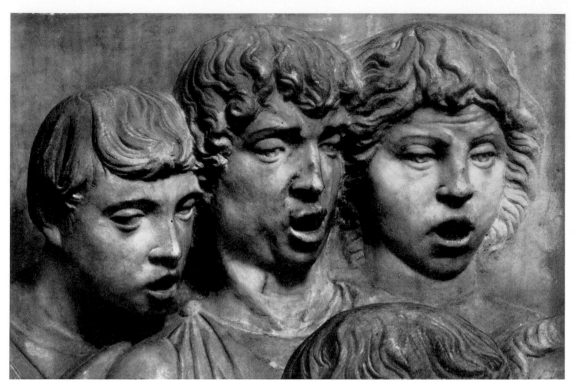

(A) Luca della Robbia: Group of singing boys from the first singing gallery of the Duomo (detail). Marble. *c.* 1435–8. *Florence, Museo dell'Opera del Duomo*

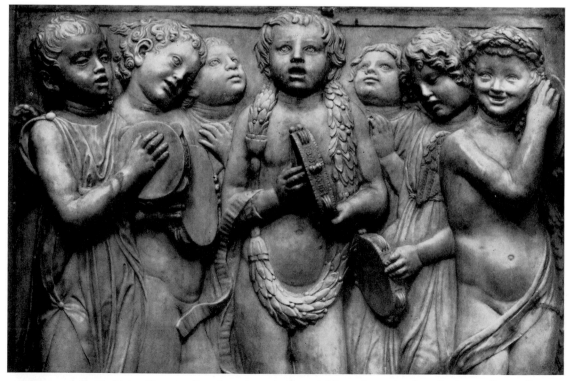

(B) Luca della Robbia: Group of tambourine-playing children from the first singing gallery of the Duomo (detail). Marble. 1432–5. *Florence, Museo dell'Opera del Duomo*

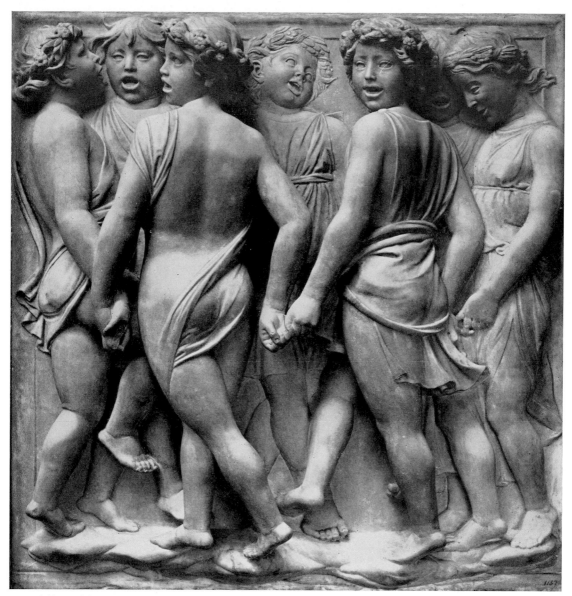

Luca della Robbia: Group of dancing children and fragment of inscription from the first singing gallery of the Duomo. Marble. 1435–8. *Florence, Museo dell'Opera del Duomo*

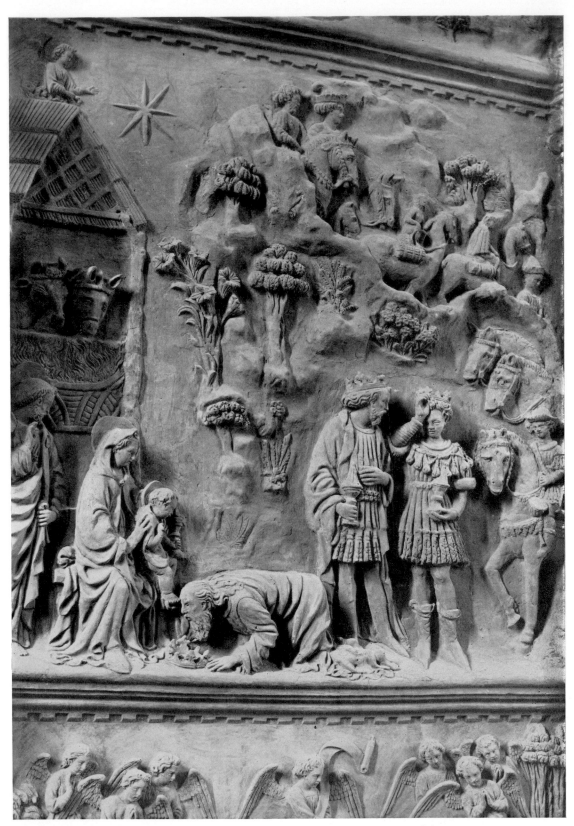

Michele da Firenze (Master of the Pellegrini Chapel): The Adoration of the Magi. Terracotta, probably originally painted. *c.* 1435. *Verona, S. Anastasia, Pellegrini Chapel*

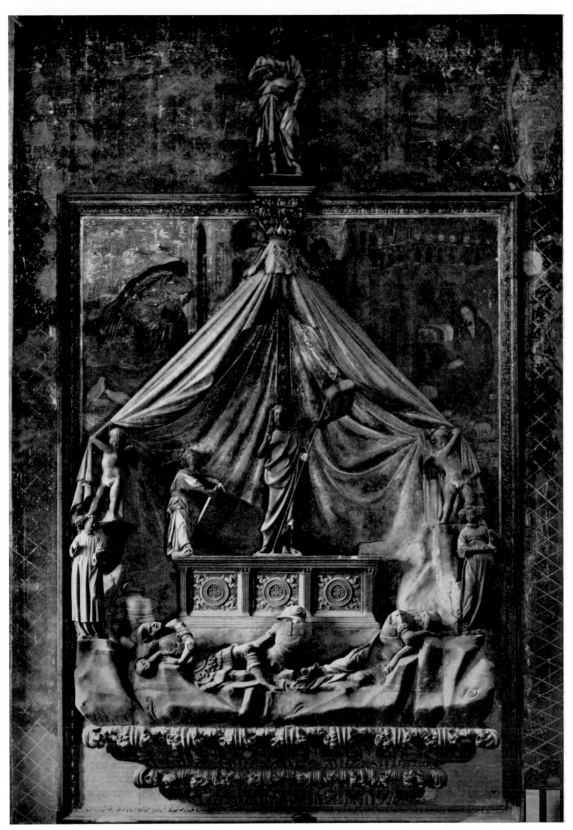

Rosso (Nanni di Bartolo) and others: The Brenzoni Monument. Marble. *c.* 1427–39.
Verona, S. Fermo Maggiore

41

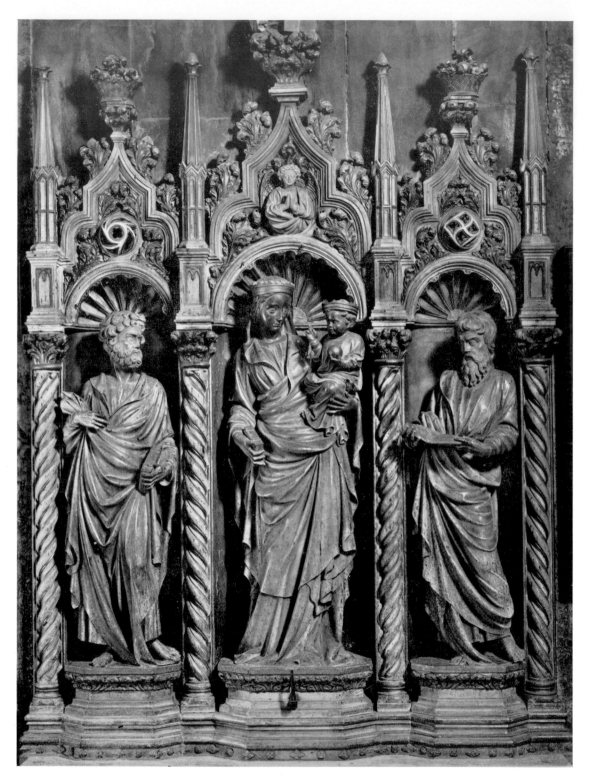

Venetian (the so-called Mascoli Master): Retable. Marble. *c.* 1430 (dedication).
Venice, S. Marco, Mascoli Chapel

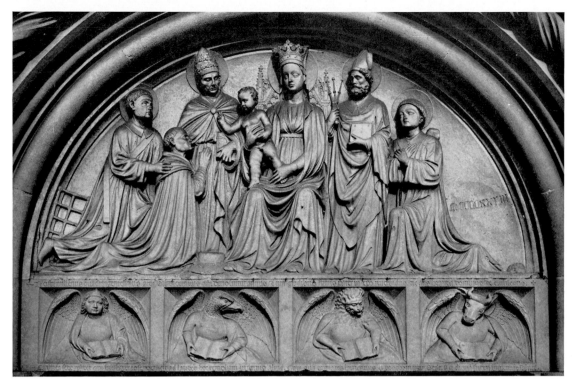

(A) Lombard: Madonna with Saints and Donor (Cardinal Branda). Stone. 1428.
Castiglione d'Olona, Collegiata

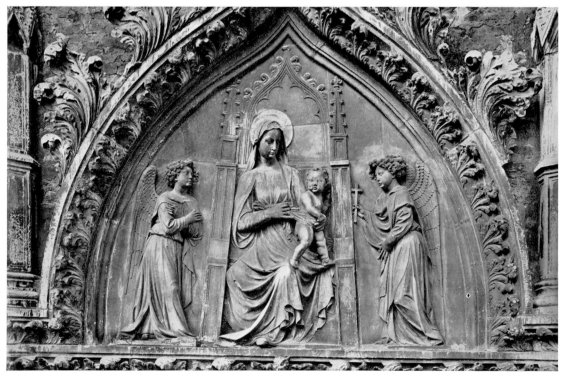

(B) Venetian (Mascoli Master?): Madonna with Angels. Marble. *c.* 1430–5.
Venice, Frari, Corner Chapel

43

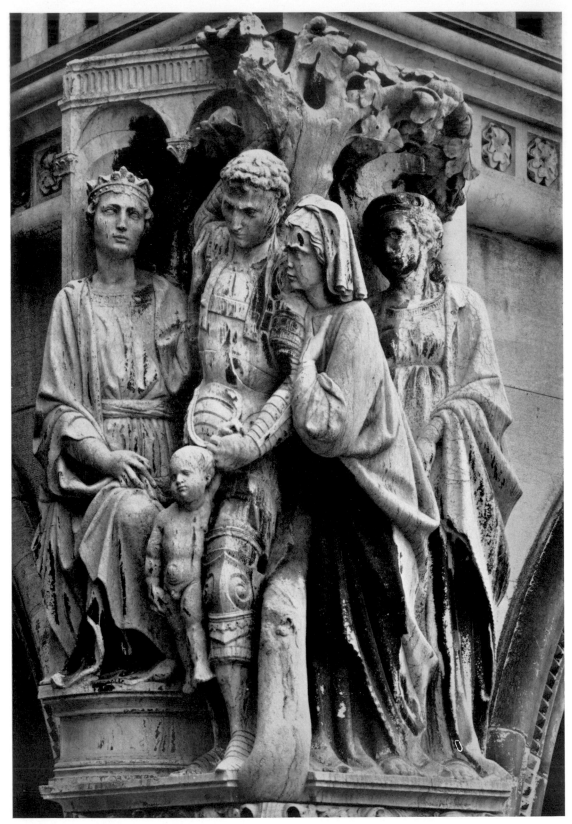

Artist uncertain (Nanni di Bartolo?): The Judgement of Solomon.
Istrian stone. *c.* 1430. *Venice, Palazzo Ducale*

44

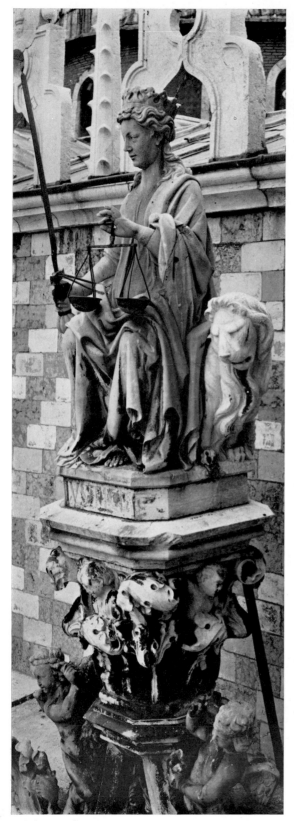

(A) Bartolommeo Buon: Justice. Istrian stone.
c. 1440. *Venice, Porta della Carta*

(B) Bartolommeo Buon (attrib.): Charity.
Istrian stone. c. 1450. *Venice, Scuola di S. Marco*

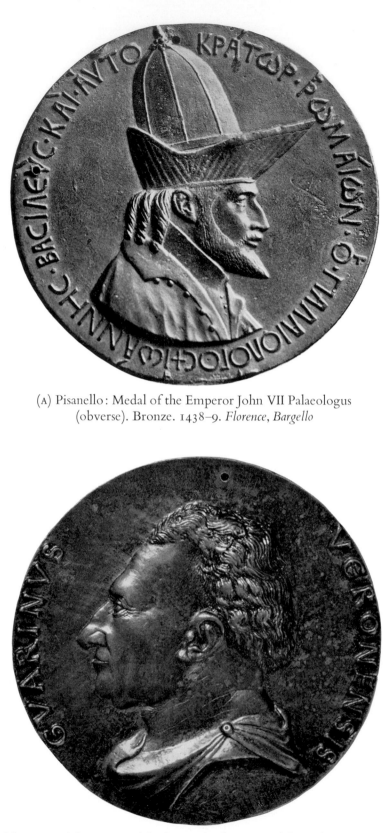

(A) Pisanello: Medal of the Emperor John VII Palaeologus
(obverse). Bronze. 1438–9. *Florence, Bargello*

(B) Matteo de' Pasti: Medal of Guarino da Verona (obverse). Bronze.
c. 1445. *Washington, National Gallery of Art, Kress Collection*

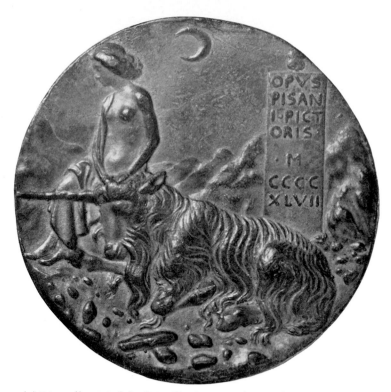

(A) Pisanello: Medal of Cecilia Gonzaga (reverse). Bronze. 1447.
Washington, National Gallery of Art, Kress Collection

(B) Lorenzo Ghiberti: His son, Vittorio, from the 'Gates of Paradise'
(cf. Plate 48). Bronze gilt. *c.* 1448. *Florence, Baptistery*

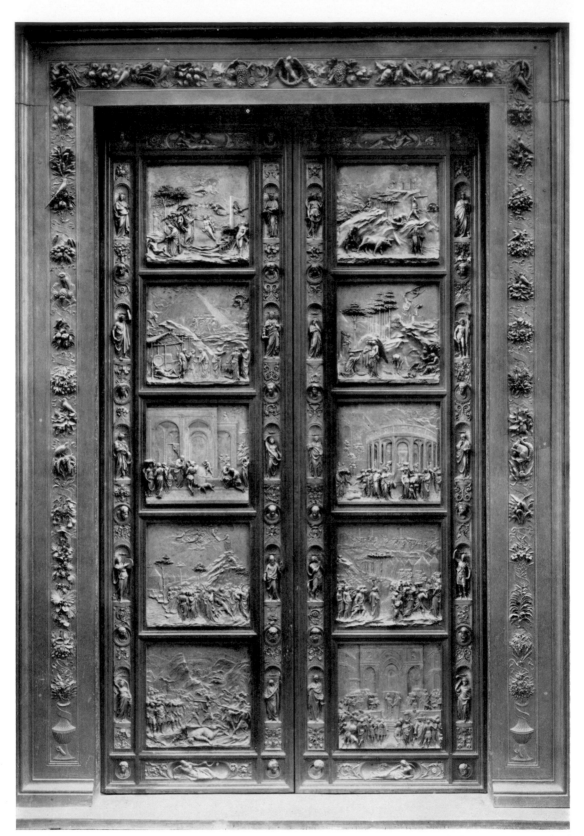

Lorenzo Ghiberti, with assistance of Michelozzo, Vittorio Ghiberti, and others: 'The Gates of Paradise',
east doors. Bronze gilt, bronze, marble. 1424 (commission)–1452 (installation). *Florence, Baptistery*

(A) Lorenzo Ghiberti: Adam, detail of inner frame of east doors (cf. Plate 48). Bronze gilt. Probably before 1448. *Florence, Baptistery*

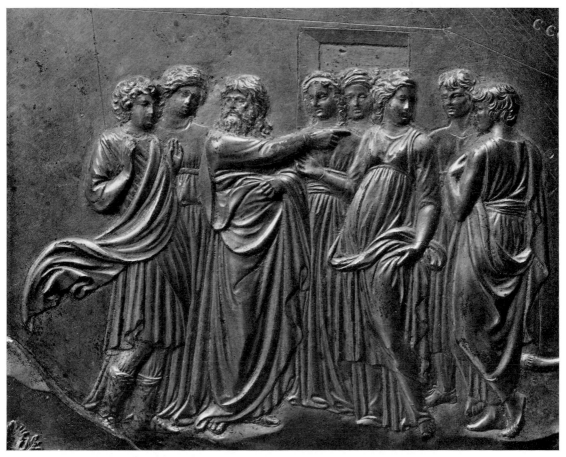

(B) Lorenzo Ghiberti: Detail of the Story of Noah, east doors (detail of Plate 48). Rough-cast by 1436/7; finished by 1443 or 1447. *Florence, Baptistery*

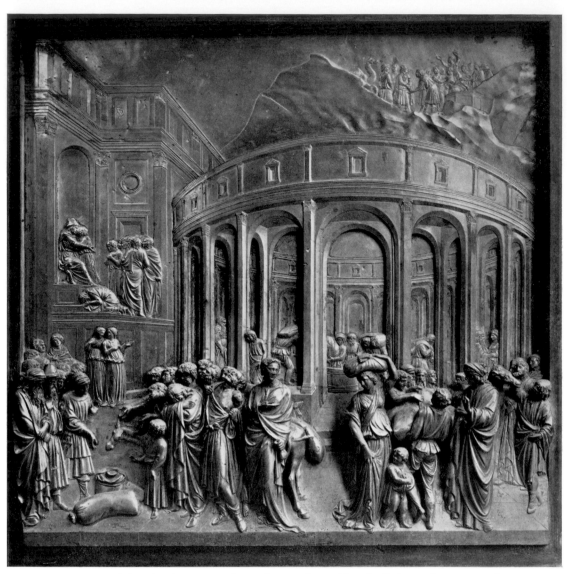

Lorenzo Ghiberti: The Story of Joseph, east doors (detail of Plate 48). Bronze gilt.
Rough-cast by 1436/7; ' half-finished' by 1439. *Florence, Baptistery*

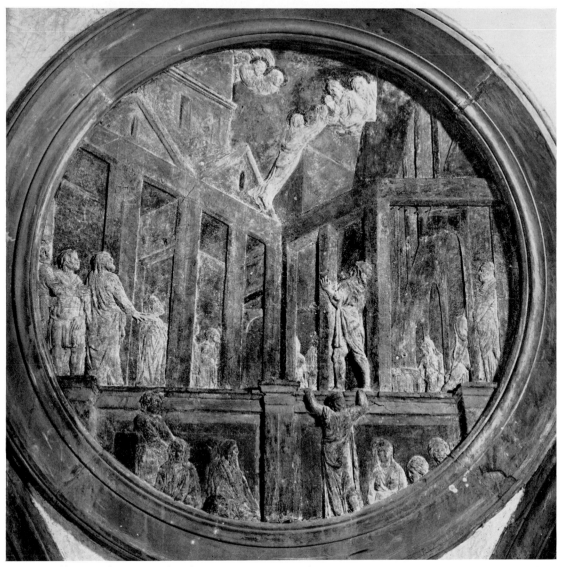

Donatello: St John Evangelist drawn up to Heaven, decoration of a pendentive. Stucco, painted.
c. 1435–40. *Florence, S. Lorenzo, Old Sacristy*

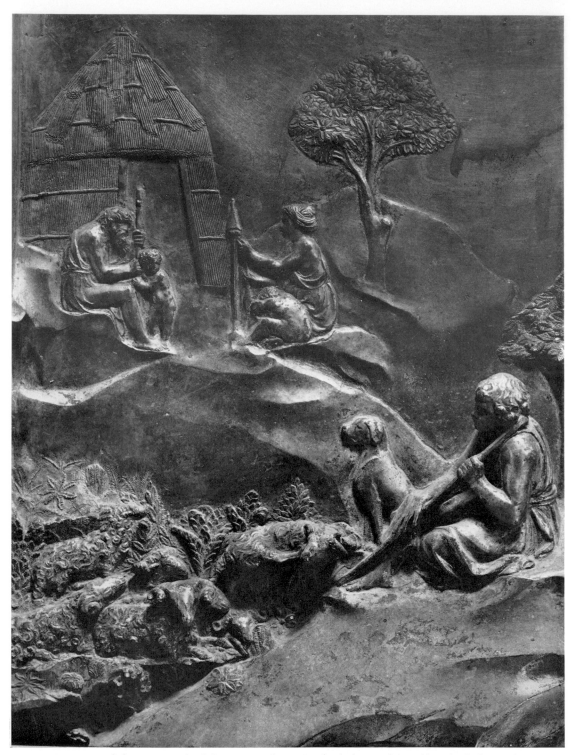

Lorenzo Ghiberti: Detail of the Story of Cain and Abel, east doors (detail of Plate 48).
Bronze gilt. Rough cast by 1436/7; 'really finished' by 1439. *Florence, Baptistery*

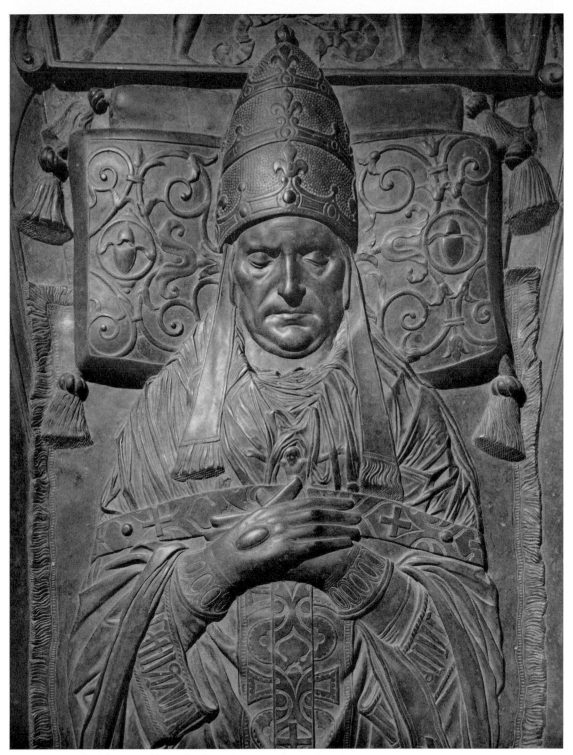

Circle of Donatello and Filarete: Monument of Pope Martin V (detail). *c.* 1432–40.
Rome, S. Giovanni in Laterano

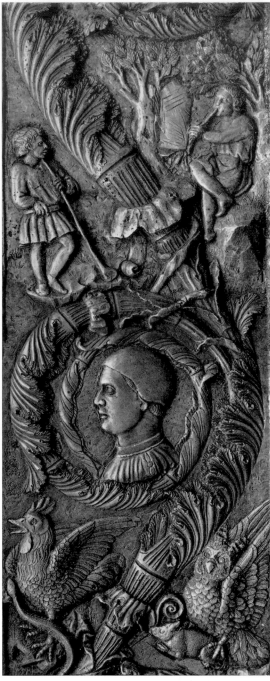

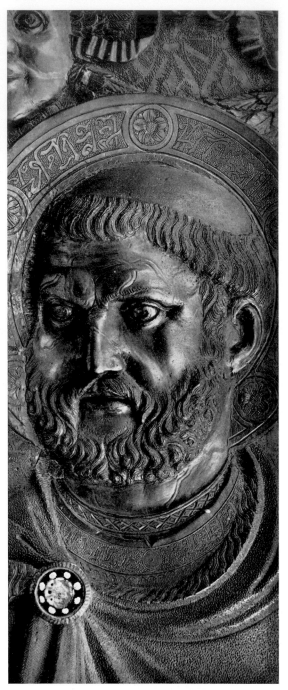

(A) Filarete: Detail of border of doors for
Old St Peter's (after cleaning).
Bronze. *c.* 1440–5. *Rome, St Peter's*

(B) Filarete: St Peter, doors for Old
St Peter's (detail; after cleaning). Bronze (in part
enamelled). *c.* 1435 (probable commission
date)–1445. *Rome, St Peter's*

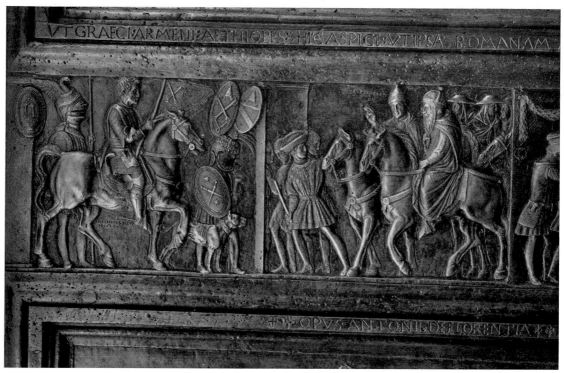

(A) Filarete: The Entry of the Pope and Patriarch into Rome, doors for Old St Peter's (detail; after cleaning). Bronze. *c.* 1440–5. *Rome, St Peter's*

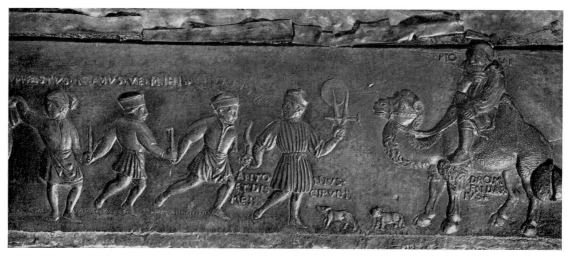

(B) Filarete: Right half of frieze representing the master-sculptor with his assistants, inner side of doors for Old St Peter's (after cleaning). Bronze. *c.* 1440–5. *Rome, St Peter's*

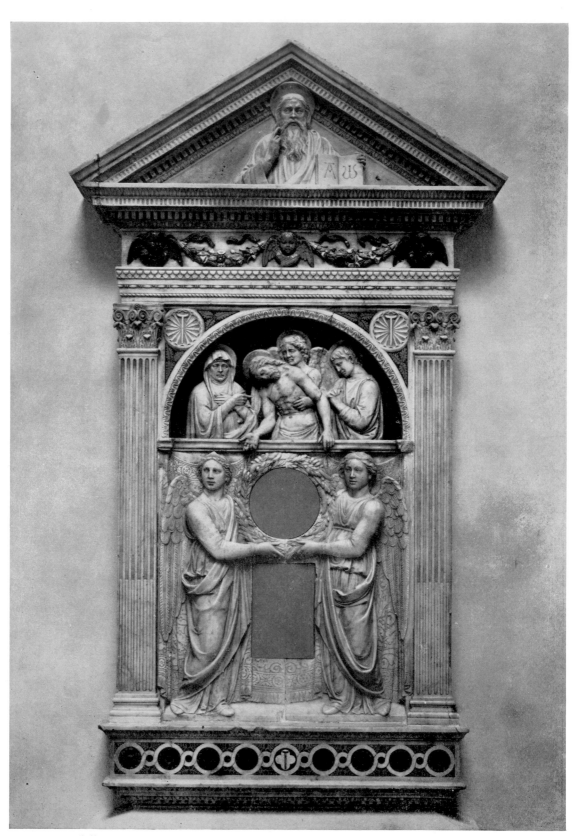

Luca della Robbia: Tabernacle, originally for S. Egidio, Florence. Marble and coloured
glazed terracotta. 1442. *Peretola, parish church*

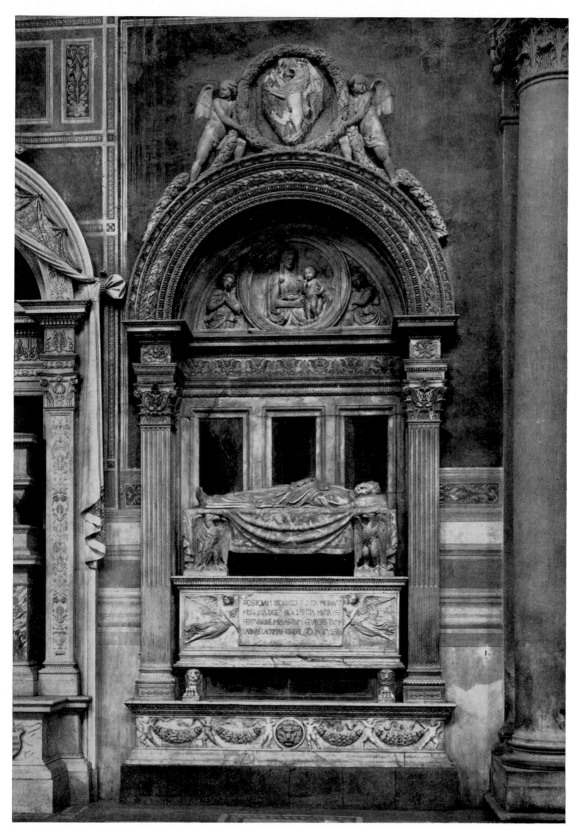

Bernardo Rossellino (with assistance): Monument of Leonardo Bruni. Carrara and coloured marbles, in part originally painted. *c.* 1445/6–*c.* 1449/50. *Florence, S. Croce*

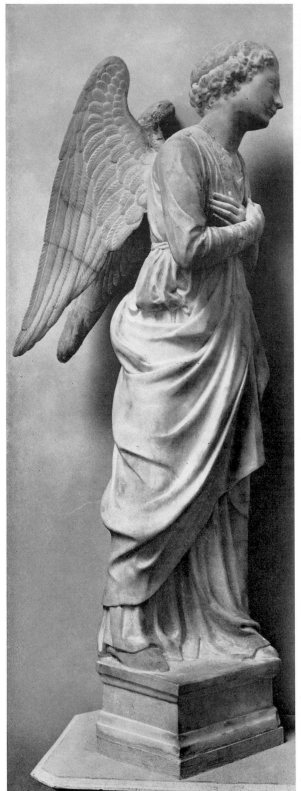 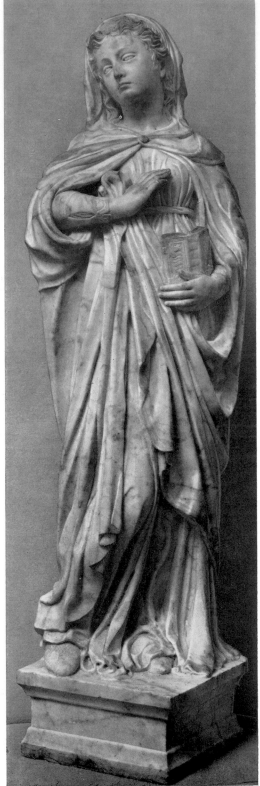

(A) Bernardo Rossellino: Angel of the Annunciation.
Marble. Begun 1444.
Empoli, Collegiata (Museo)

(B) Bernardo Rossellino (and assistant):
Virgin Annunciate. Marble. Begun 1444.
Empoli, Collegiata (Museo)

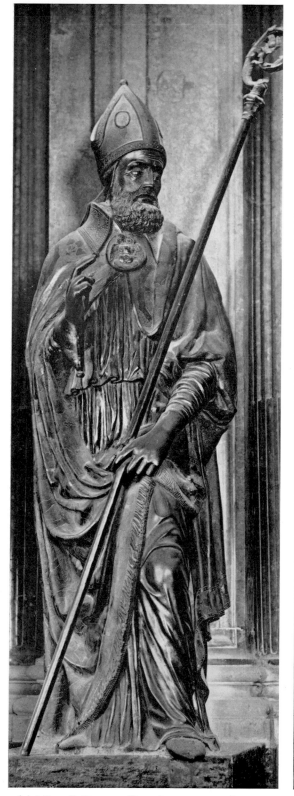

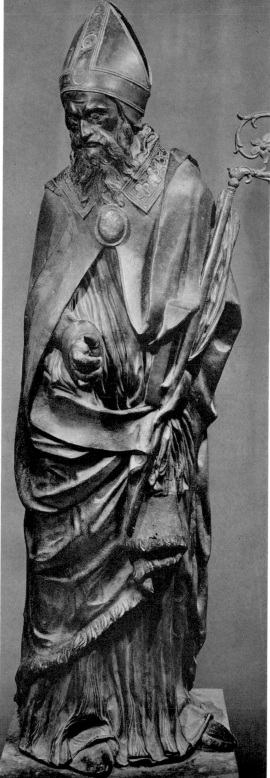

(A) Niccolò Baroncelli and Domenico di Paris:
S. Maurelio. Bronze. *c.* 1450.
Ferrara, Duomo

(B) Donatello: St Prosdocimus, for the high
altar of the Santo. Bronze. 1446–50.
Padua, Santo

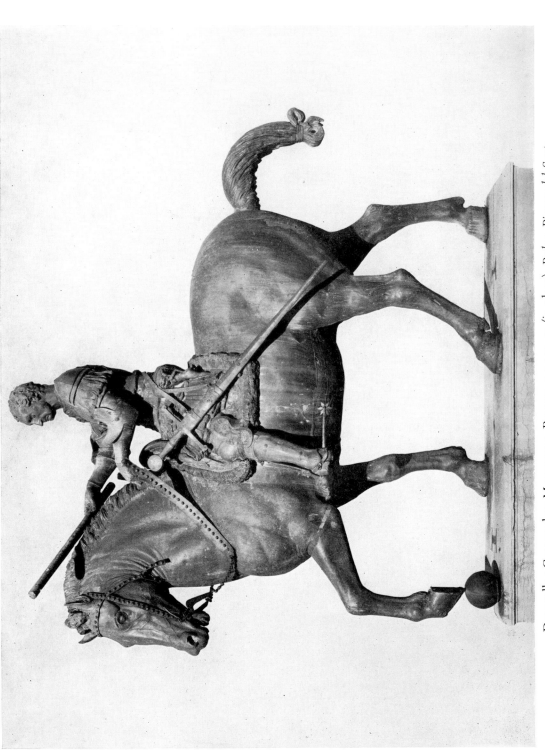

Donatello: Gattamelata Monument. Bronze. c. 1443–53 (in place). *Padua, Piazza del Santo*

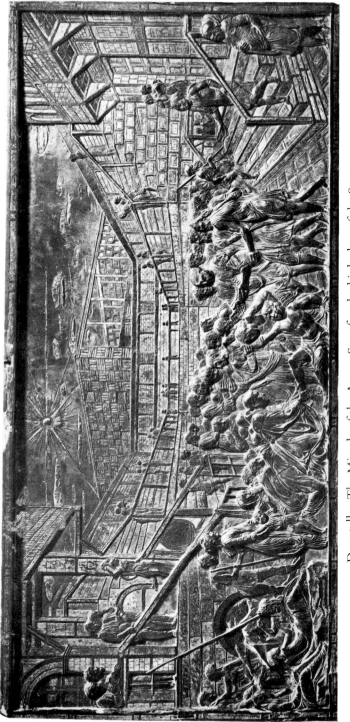

Donatello: The Miracle of the Angry Son, for the high altar of the Santo.
Bronze with inlay of gold and silver. *c.* 1447 (cast). *Padua, Santo*

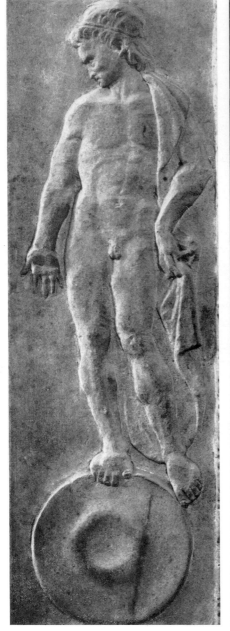

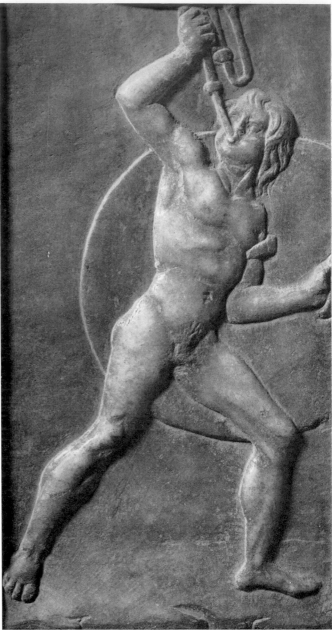

(A) Workshop of Donatello: Decorative
figure from choir screen. Marble.
c. 1450. *Padua, Santo*

(B) Workshop of Agostino di Duccio: Decorative figure,
Chapel of the Virgin. Marble. *c.* 1452.
Rimini, Tempio Malatestiano

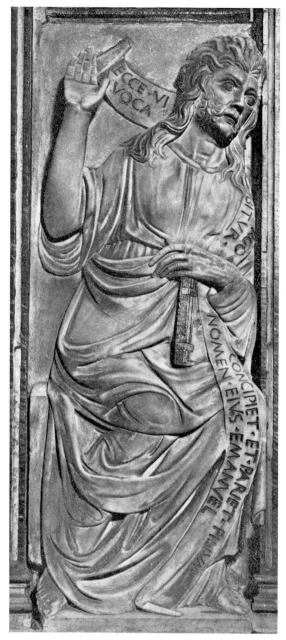

(A) Agostino di Duccio (design only): Isaiah,
Chapel of the Ancestors. Marble. *c.* 1454.
Rimini, Tempio Malatestiano

(B) Agostino di Duccio: 'The Neoplatonic
World', Chapel of the Planets. Marble. *c.* 1456.
Rimini, Tempio Malatestiano

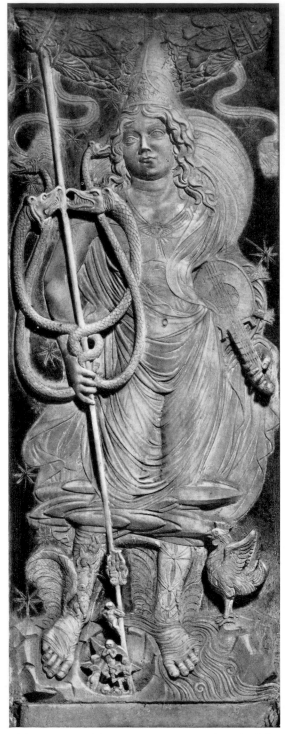

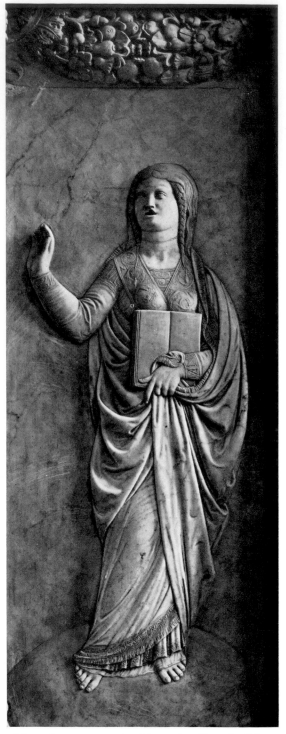

(A) Agostino di Duccio: Mercury, Chapel of the
Planets. Marble. *c.* 1456.
Rimini, Tempio Malatestiano

(B) Sculptor uncertain: Rhetoric, Chapel of the
Arts and Sciences. Marble. After 1457.
Rimini, Tempio Malatestiano

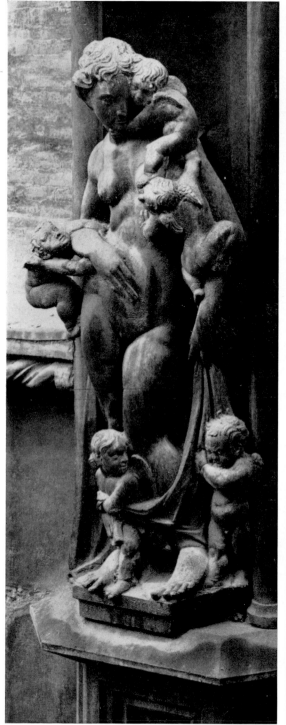

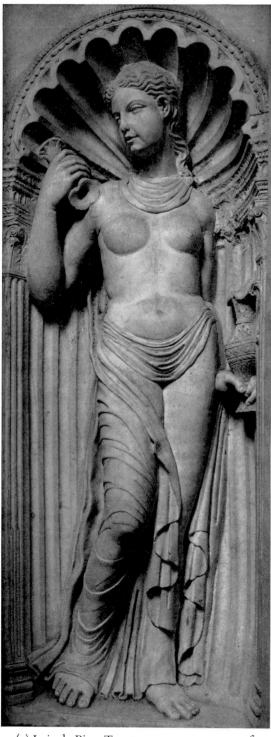

(A) Giorgio Orsini da Sebenico: Charity. Stone.
1455–60. *Ancona, Loggia della Mercanzia*

(B) Isaia da Pisa: Temperance, monument of
Cardinal Martinez de Chavez. Marble. *c.* 1450–5.
Rome, S. Giovanni in Laterano

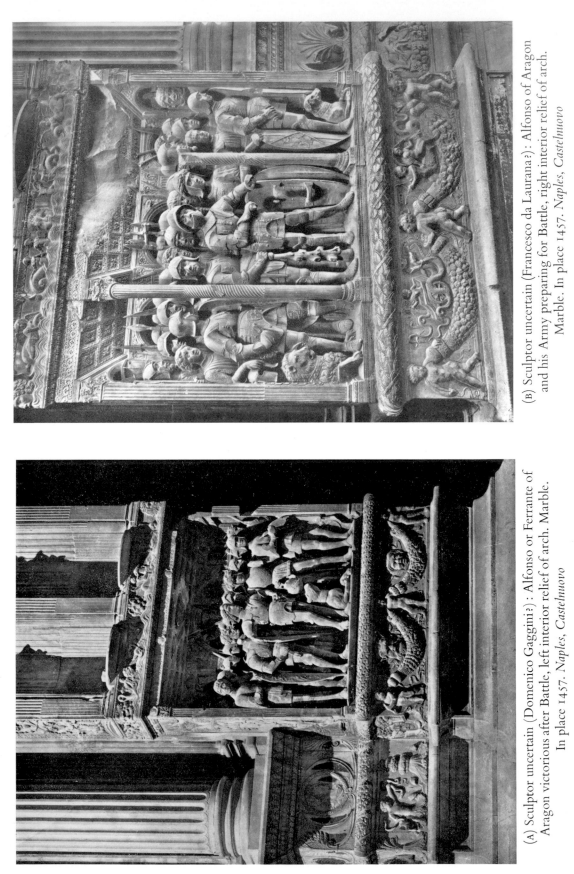

(B) Sculptor uncertain (Francesco da Laurana?): Alfonso of Aragon and his Army preparing for Battle, right interior relief of arch. Marble. In place 1457. *Naples, Castelnuovo*

(A) Sculptor uncertain (Domenico Gaggini?): Alfonso or Ferrante of Aragon victorious after Battle, left interior relief of arch. Marble. In place 1457. *Naples, Castelnuovo*

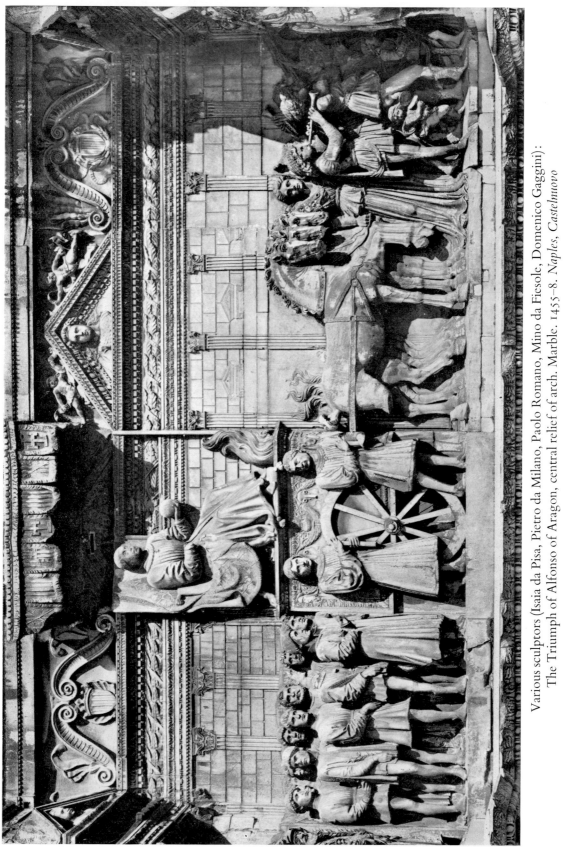

Various sculptors (Isaia da Pisa, Pietro da Milano, Paolo Romano, Mino da Fiesole, Domenico Gaggini):
The Triumph of Alfonso of Aragon, central relief of arch. Marble. 1455–8. *Naples, Castelnuovo*

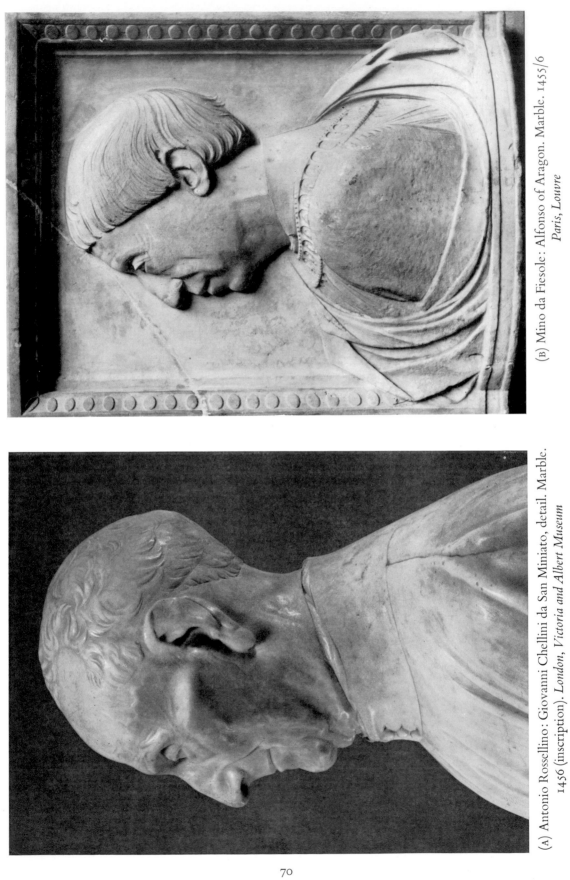

(A) Antonio Rossellino: Giovanni Chellini da San Miniato, detail. Marble. 1456 (inscription). *London, Victoria and Albert Museum*

(B) Mino da Fiesole: Alfonso of Aragon. Marble. 1455/6 *Paris, Louvre*

70

Desiderio da Settignano: St Jerome in the Desert. Marble. *c.* 1455 (?).
Washington, National Gallery of Art, Widener Collection

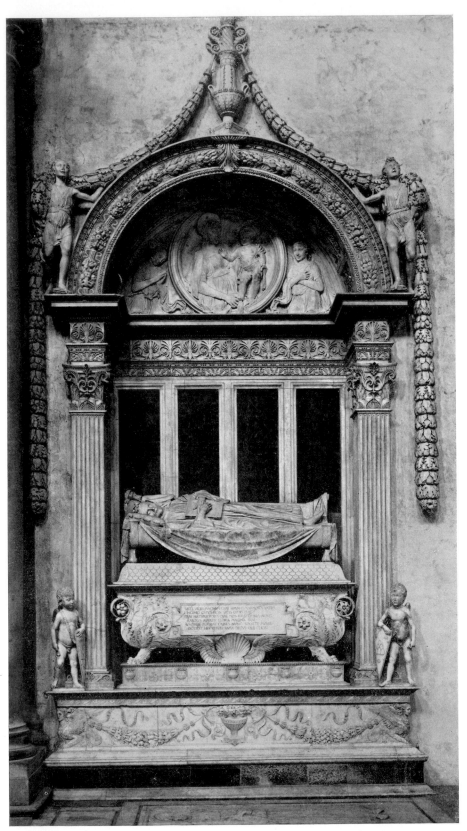

Desiderio da Settignano (with assistance): Monument of Carlo Marsuppini.
Carrara marble, originally in part gilt and painted. *c.* 1455–8. *Florence, S. Croce*

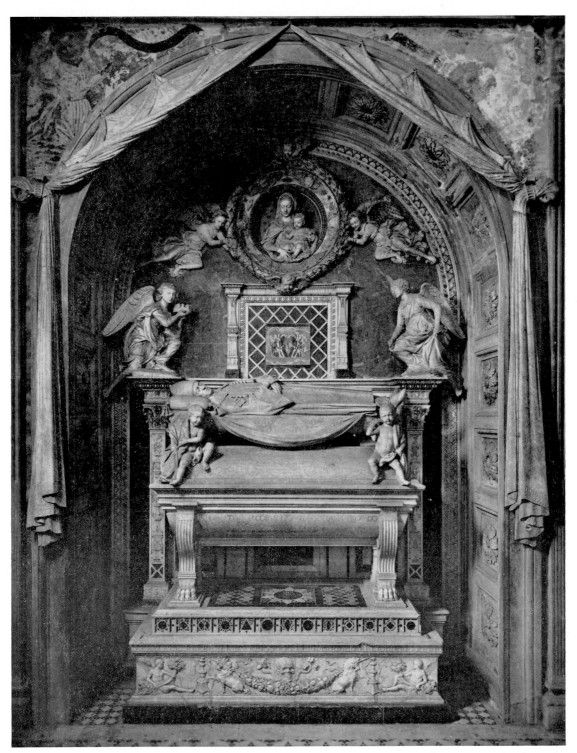

Antonio Rossellino (with assistance): Monument of the Cardinal of Portugal. Carrara and coloured marbles, originally in part gilt and painted. 1461–6. *Florence, S. Miniato al Monte*

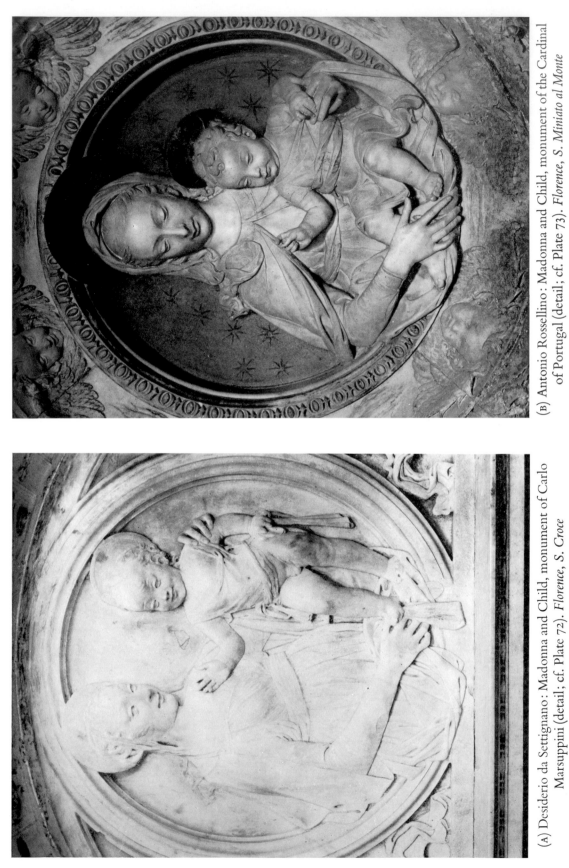

(B) Antonio Rossellino: Madonna and Child, monument of the Cardinal of Portugal (detail; cf. Plate 73). *Florence, S. Miniato al Monte*

(A) Desiderio da Settignano: Madonna and Child, monument of Carlo Marsuppini (detail; cf. Plate 72). *Florence, S. Croce*

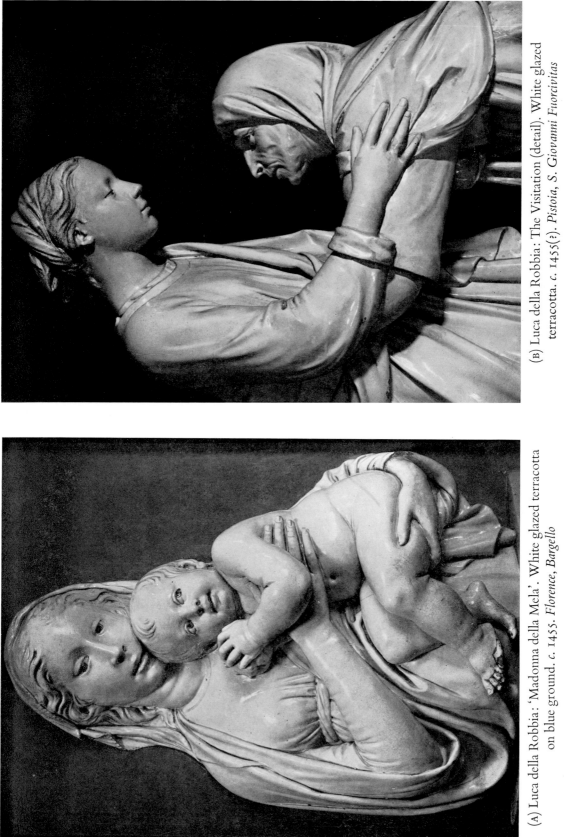

(B) Luca della Robbia: The Visitation (detail). White glazed terracotta. *c.* 1455(?). *Pistoia, S. Giovanni Fuorcivitas*

(A) Luca della Robbia: 'Madonna della Mela'. White glazed terracotta on blue ground. *c.* 1455. *Florence, Bargello*

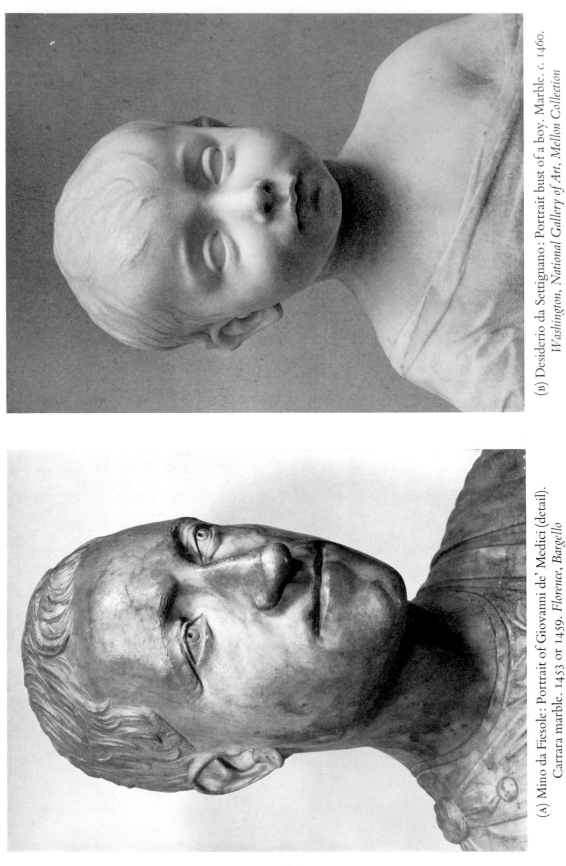

(B) Desiderio da Settignano: Portrait bust of a boy. Marble. *c.* 1460. *Washington, National Gallery of Art, Mellon Collection*

(A) Mino da Fiesole: Portrait of Giovanni de' Medici (detail). Carrara marble. 1453 or 1459. *Florence, Bargello*

76

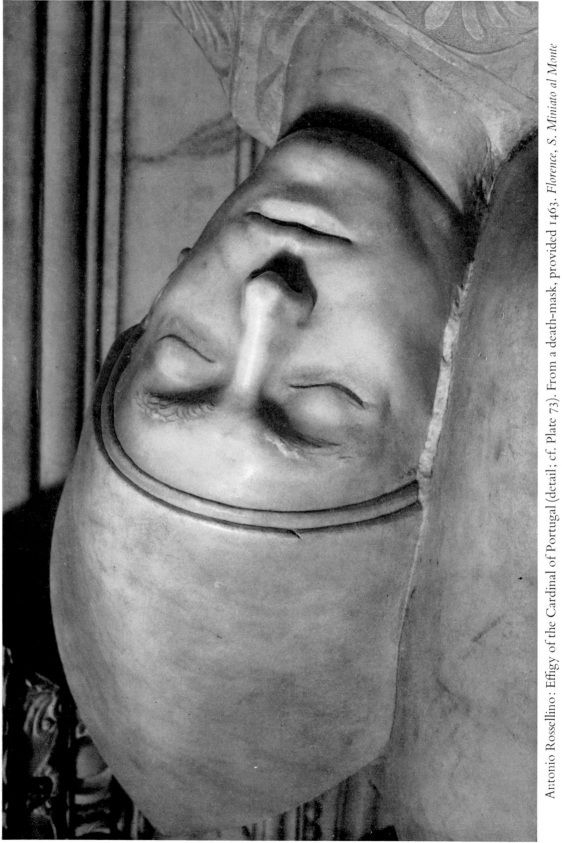

Antonio Rossellino: Effigy of the Cardinal of Portugal (detail; cf. Plate 73). From a death-mask, provided 1463. *Florence, S. Miniato al Monte*

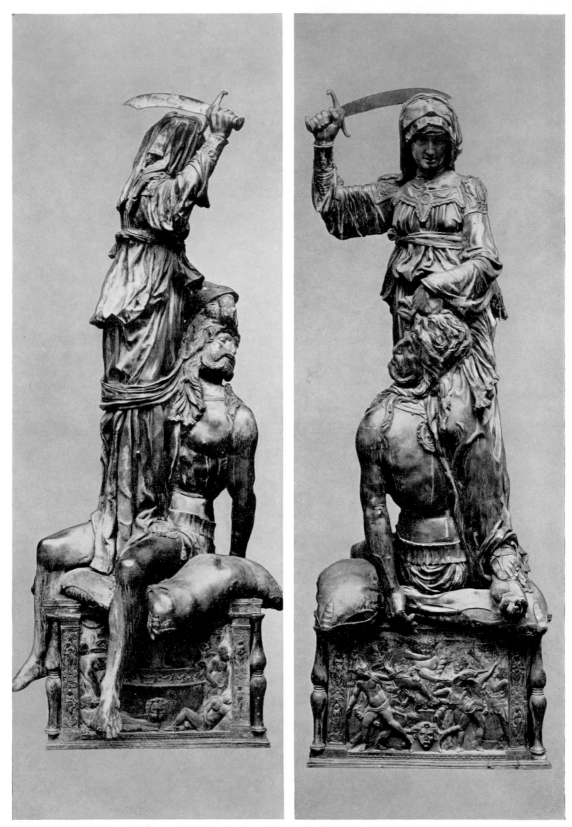

(A) and (B) Donatello: Judith and Holofernes. Bronze. *c.* 1457–60.
Florence, Piazza della Signoria

78

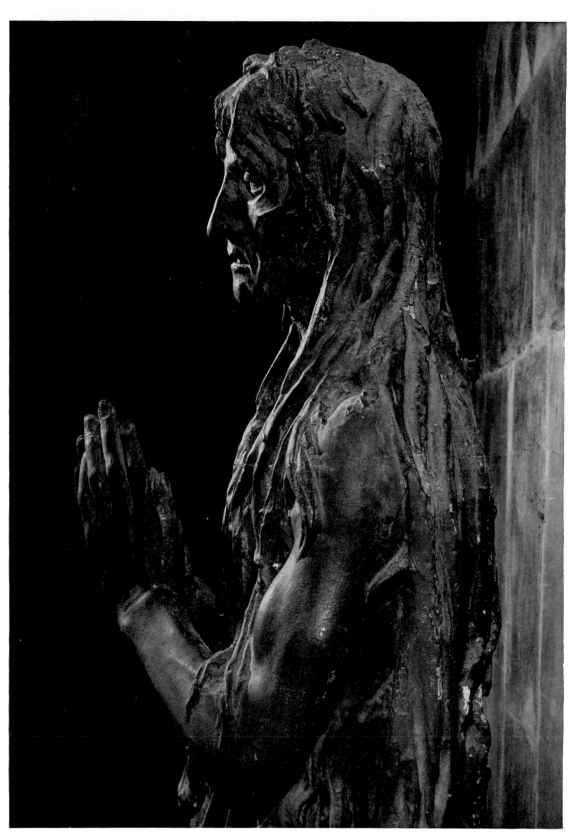

Donatello: The Penitent Magdalen (detail). Painted wood. 1456.
Florence, Baptistery

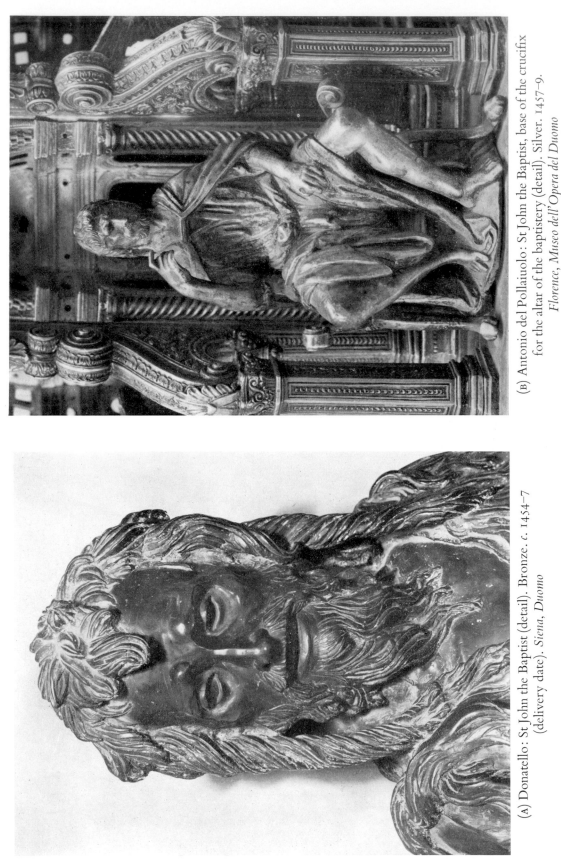

(B) Antonio del Pollaiuolo: St John the Baptist, base of the crucifix for the altar of the baptistery (detail). Silver. 1457–9. *Florence, Museo dell'Opera del Duomo*

(A) Donatello: St John the Baptist (detail). Bronze. c. 1454–7 (delivery date). *Siena, Duomo*

80

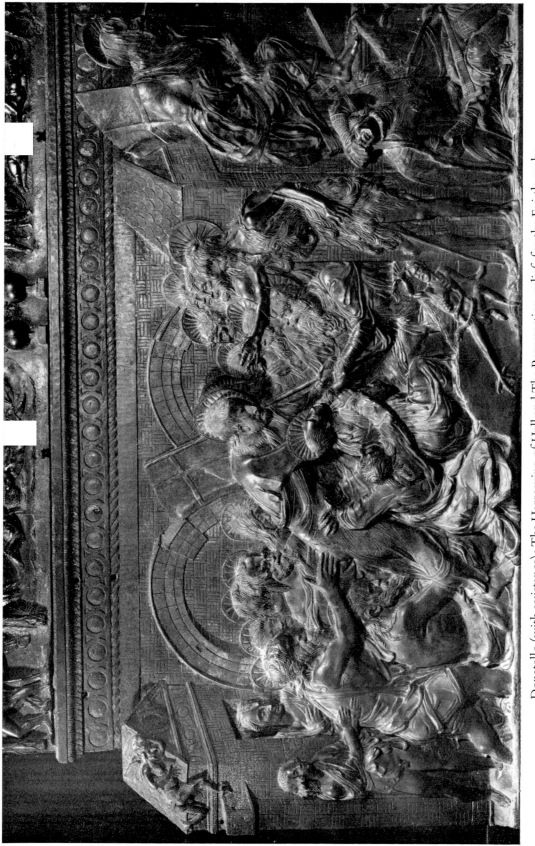

Donatello (with assistance): The Harrowing of Hell and The Resurrection, reliefs for the Epistle ambo.
Bronze. 1460–6. Florence, S. Lorenzo

Donatello assistant (probably Bertoldo): The Entombment, relief for the Gospel ambo (detail).
Bronze. *c.* 1470. *Florence, S. Lorenzo*

Lorenzo di Pietro (Il Vecchietta): The Resurrection. Bronze. 1472
(inscription). *New York, The Frick Collection*

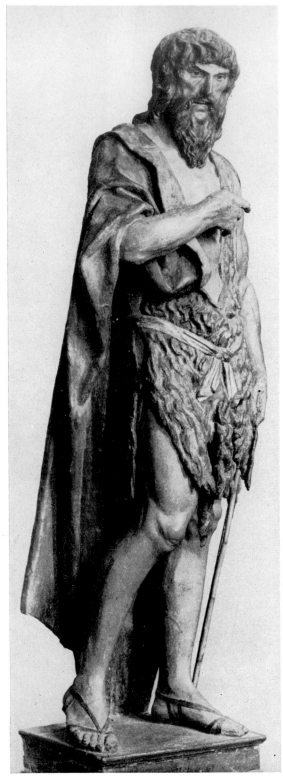

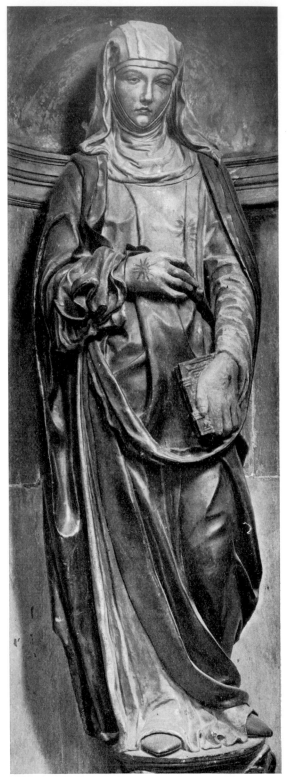

(A) Francesco di Giorgio: St John the Baptist, for
the Oratory of the Compagnia di S. Giovanni
Battista della Morte, Siena. Painted wood.
1464. *Fogliano, parish church*

(B) Neroccio dei Landi: St Catherine.
Painted wood. 1470 (commission).
Siena, Oratory of S. Caterina

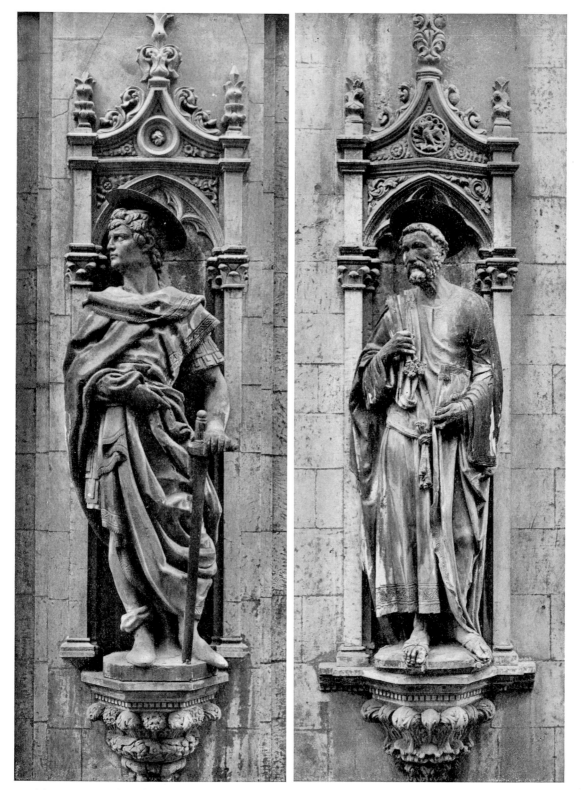

(A) Antonio Federighi: S. Vittorio. Marble. 1456 (commission). *Siena, Loggia di S. Paolo*

(B) Lorenzo di Pietro (Il Vecchietta): St Peter. Marble. 1458 (commission). *Siena, Loggia di S. Paolo*

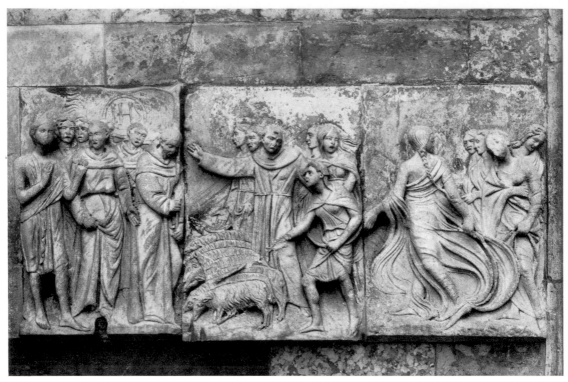

(A) Agostino di Duccio: A Miracle of S. Bernardino. Marble. 1457–61.
Perugia, S. Bernardino

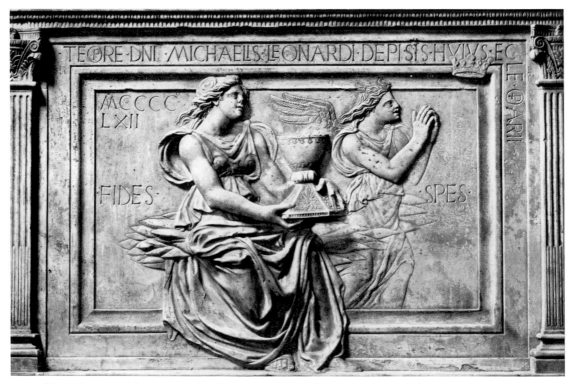

(B) Andrea Guardi: Faith and Hope, altar antependium (detail). Marble. 1462 (inscription).
Pisa, S. Maria della Spina

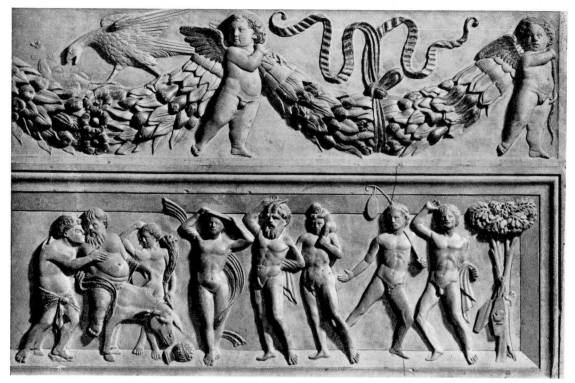

(A) Michele da Fiesole (Il Greco): Frieze, fireplace of Sala di Iole (detail).
Stone. *c.* 1460. *Urbino, Palazzo Ducale*

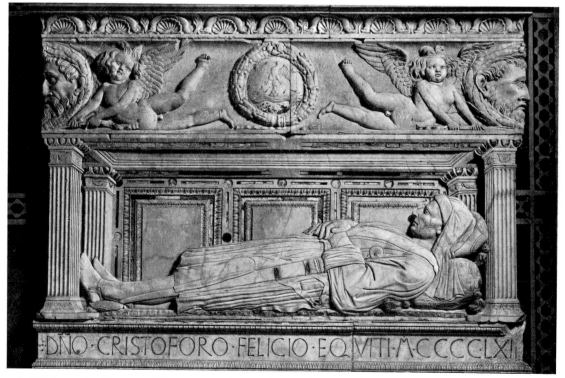

(B) Urbano da Cortona: Monument of Cristoforo Felici. Marble. 1463 (death date). *Siena, Duomo*

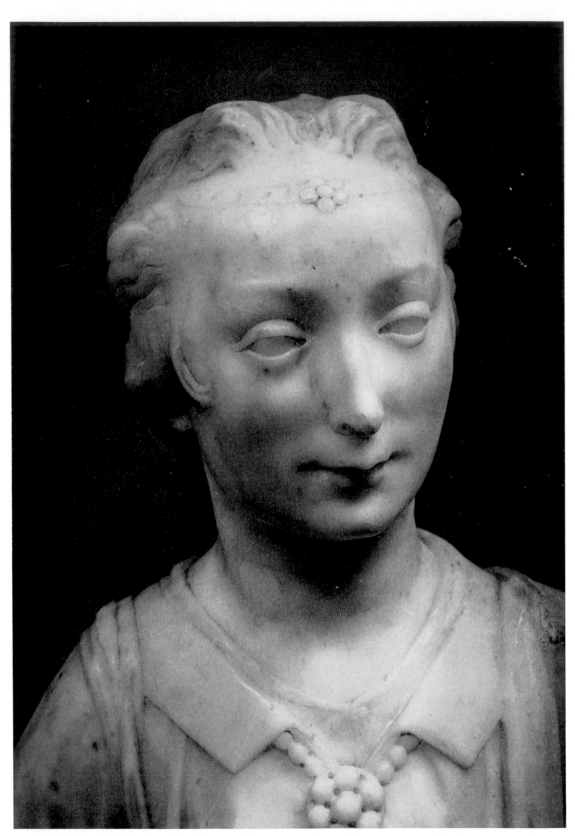

Verrocchio (attrib.): Candle Bearer, Altar of the Sacrament (detail).
Marble. *c.* 1461/2. *Florence, S. Lorenzo*

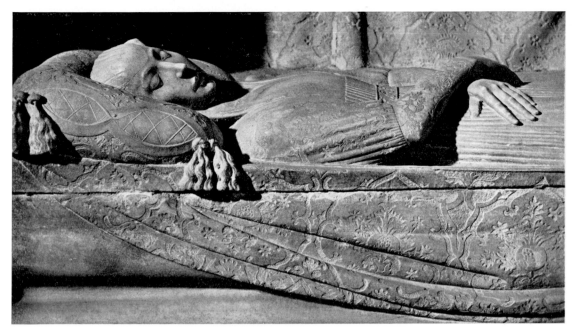

(A) Francesco di Simone Ferrucci: Effigy of Barbara Manfredi (detail). Marble. 1466 (death-date). *Forlì, S. Biagio*

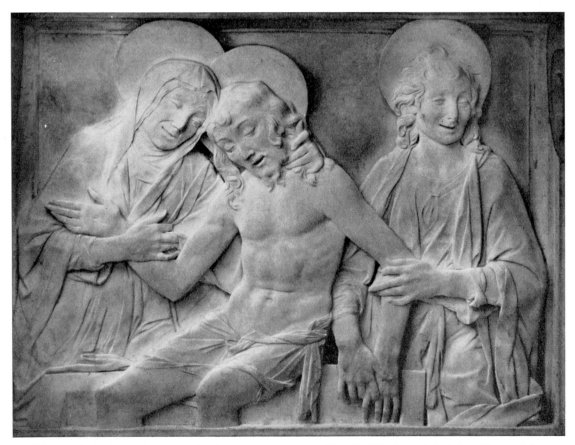

(B) Desiderio da Settignano: The dead Christ mourned by the Virgin and St John, Altar of the Sacrament (detail). Marble. *c.* 1461 (installed). *Florence, S. Lorenzo*

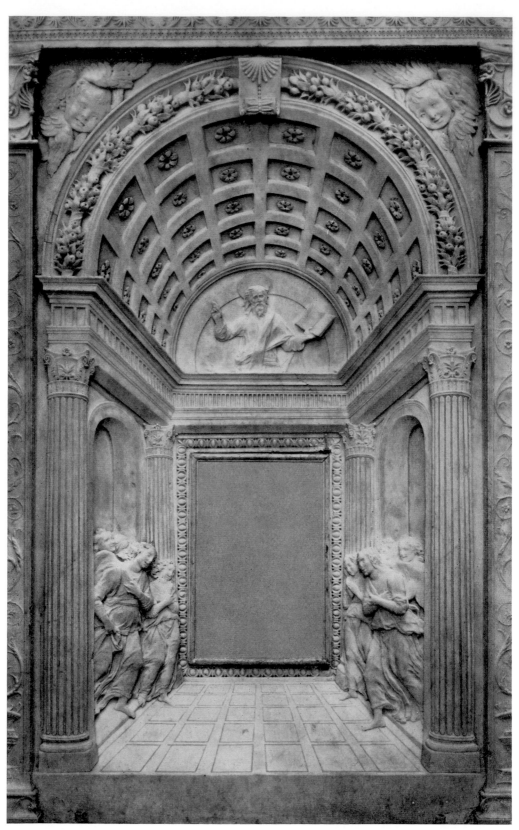

Desiderio da Settignano (with assistance): Central portion of tabernacle. Marble.
c. 1461 (installed). *Florence, S. Lorenzo*

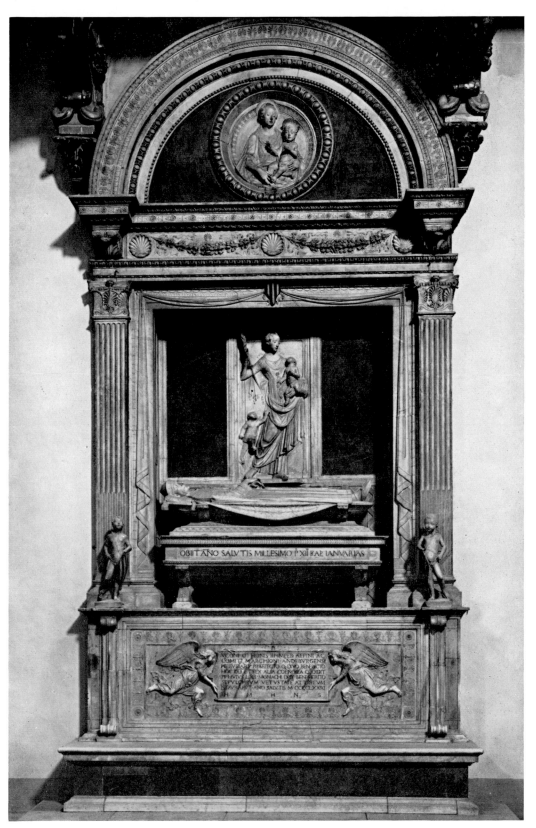

Mino da Fiesole (with assistance): Monument of Count Hugo von Andersburg. Marble.
1469 (commission)–1481 (assembly). *Florence, Badia*

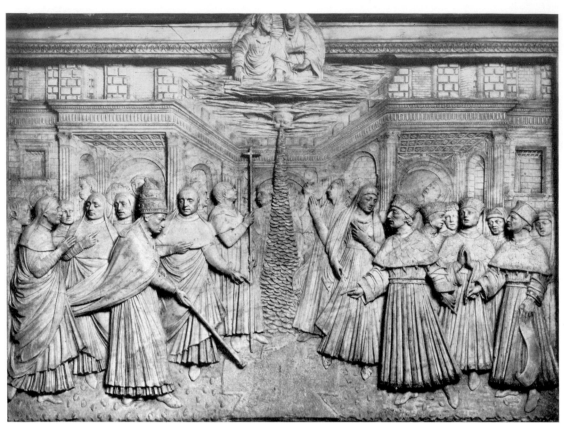

(A) Mino da Fiesole: Miracle of the Snow, relief from the d'Estouteville Ciborium. Marble. *c.* 1461 (recorded inscription). *Rome, S. Maria Maggiore*

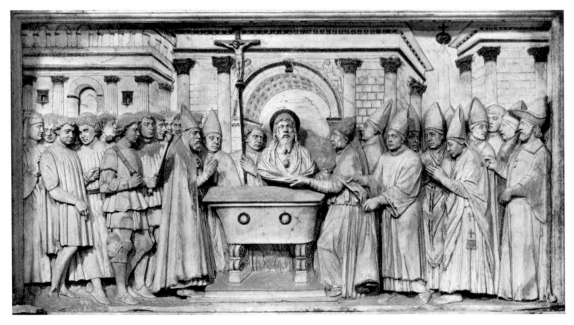

(B) Roman Master, probably Paolo Romano: Reception of the Relic of St Andrew, central relief, tomb of Pius II. *c.* 1464 (death date). *Rome, S. Andrea della Valle*

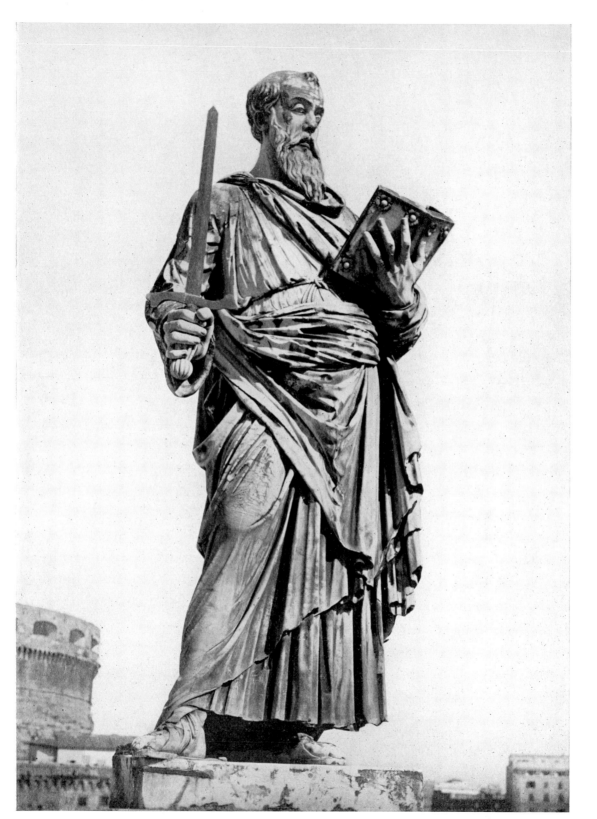

Paolo Romano: St Paul, originally designed for summit of stairs to Old St Peter's (hands and attributes restored). Marble. 1464. *Rome, Ponte S. Angelo*

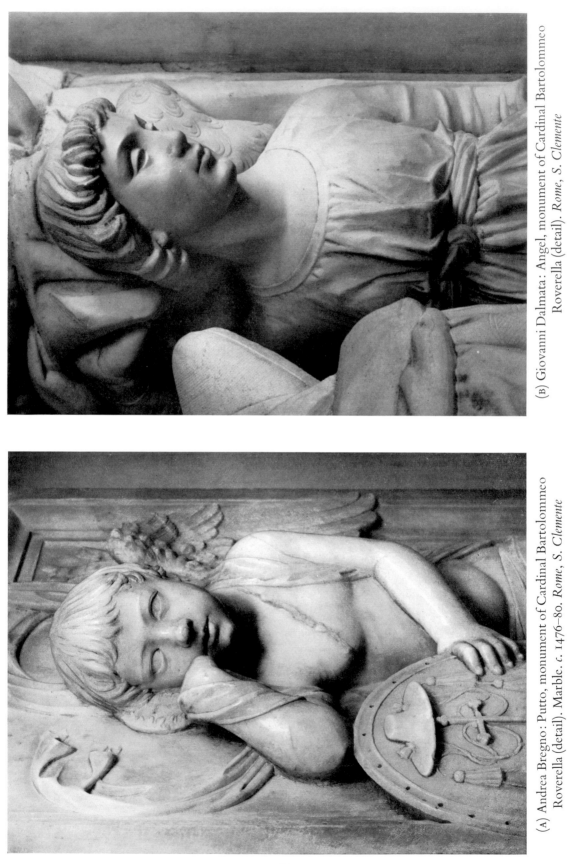

(B) Giovanni Dalmata: Angel, monument of Cardinal Bartolommeo
Roverella (detail). *Rome, S. Clemente*

(A) Andrea Bregno: Putto, monument of Cardinal Bartolommeo
Roverella (detail). Marble. *c.* 1476–80. *Rome, S. Clemente*

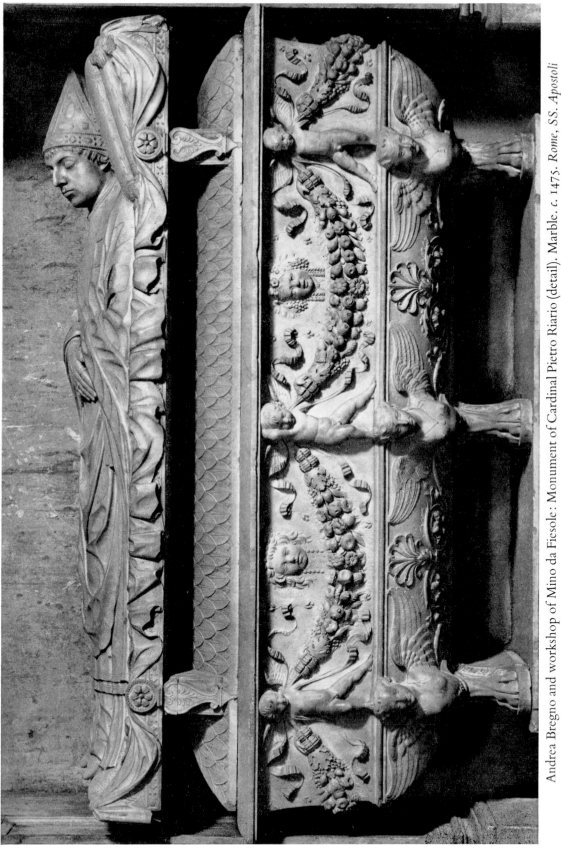

Andrea Bregno and workshop of Mino da Fiesole: Monument of Cardinal Pietro Riario (detail). Marble. c. 1475. *Rome, SS. Apostoli*

95

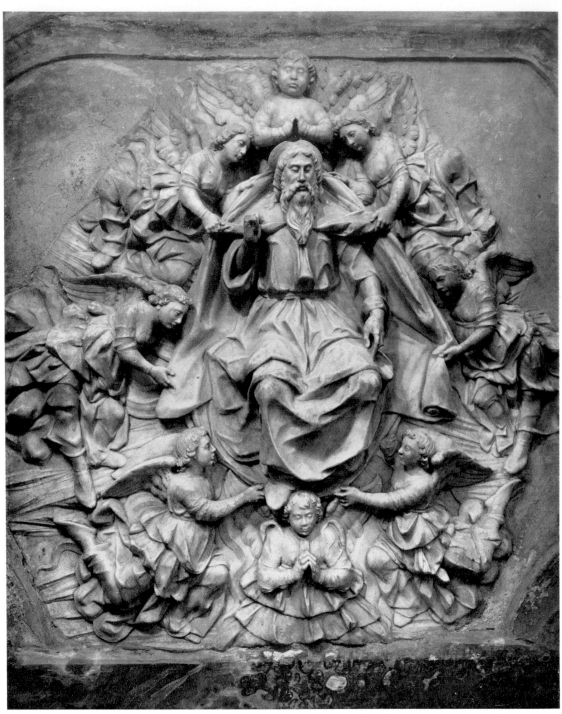

Giovanni Dalmata: God the Father in Glory, from the tomb of Pope Paul II originally in
Old St Peter's. Marble. 1471(?)–7. *Rome, Grotte Vaticane*

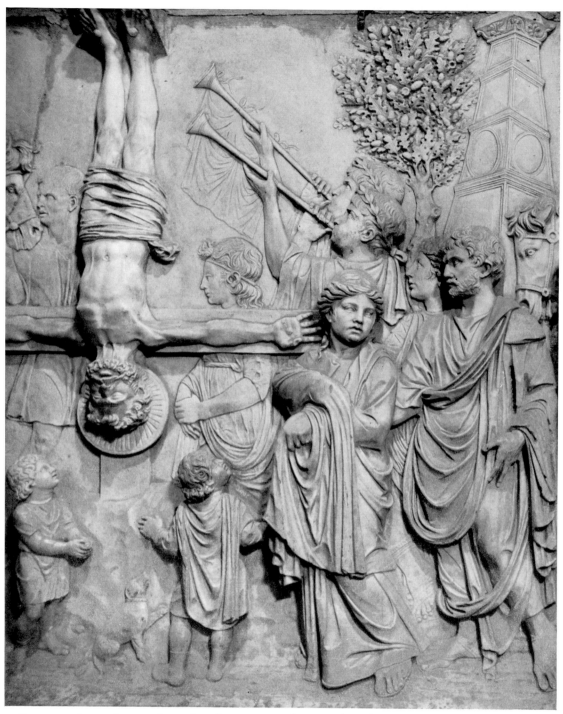

Roman sculptor close to the styles of Giovanni Dalmata and Paolo Romano: The Martyrdom of
St Peter (detail), relief from the ciborium of Sixtus IV for Old St Peter's.
c. 1475–80. *Rome, Grotte Vaticane*

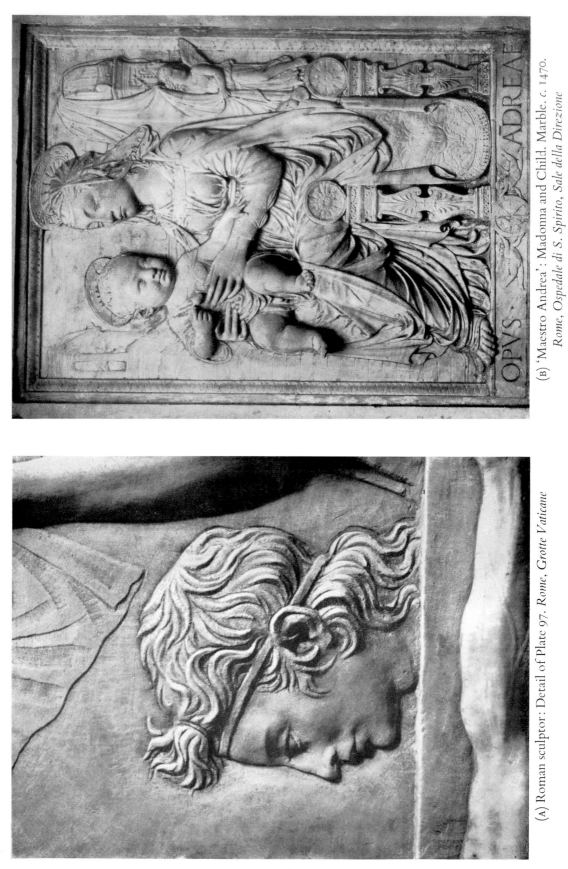

(B) 'Maestro Andrea': Madonna and Child. Marble. c. 1470.
Rome, Ospedale di S. Spirito, Sale della Direzione

(A) Roman sculptor: Detail of Plate 97. Rome, Grotte Vaticane

Silvestro dell'Aquila (with assistance): Monument of Maria Pereira Camponeschi (detail). Marble. *c. 1490–1500. Aquila, S. Bernardino*

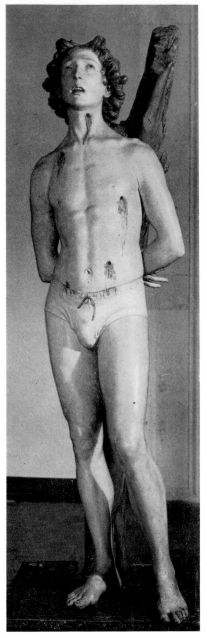

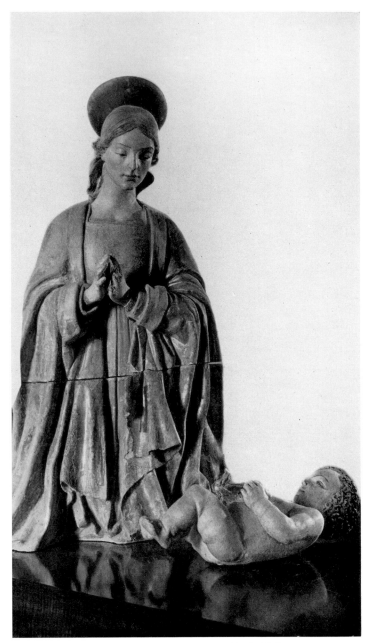

(A) Silvestro dell'Aquila:
St Sebastian. Painted wood.
1478. *Aquila, Museo*

(B) Abruzzi Master: Virgin and Child from a
Nativity Group. Painted terracotta. *c.* 1490.
Aquila, Museo

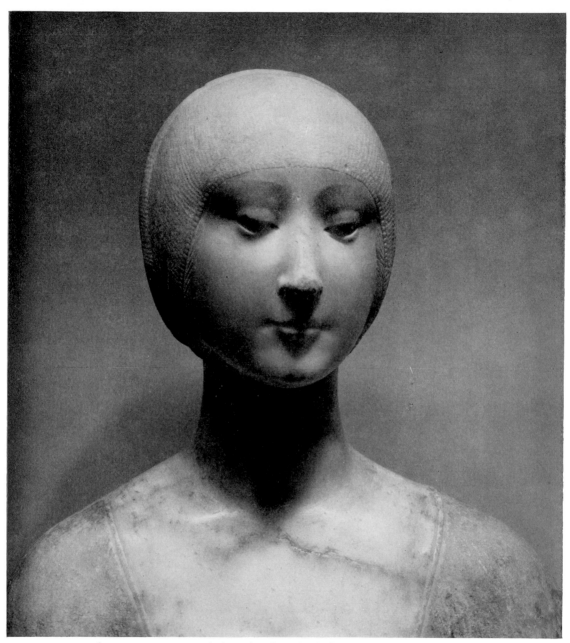

Francesco da Laurana: Portrait believed to be of Isabella of Aragon, wife of Gian Galeazzo Sforza, duke of Milan. Marble. *c.* 1490. *Palermo, Museo Nazionale*

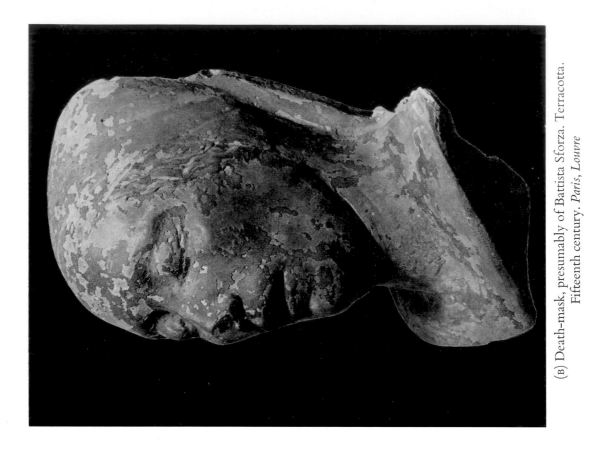

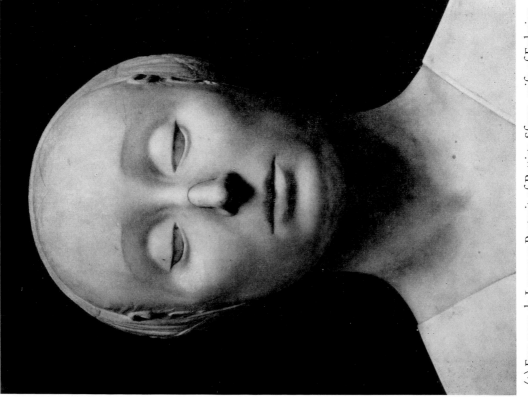

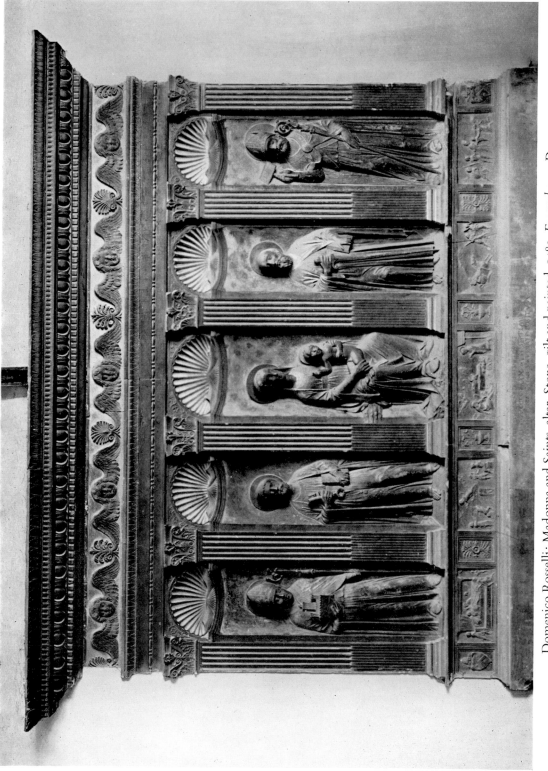

Domenico Rosselli: Madonna and Saints, altar. Stone, gilt and painted. 1480. *Fossombrone, Duomo*

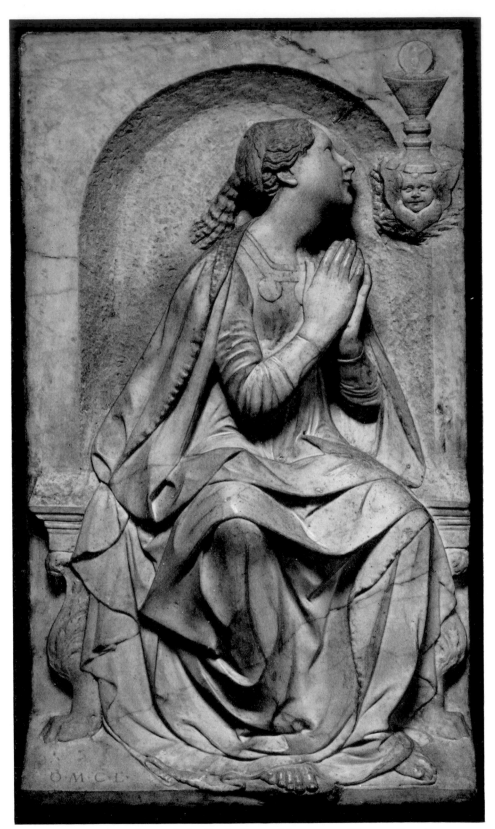

Matteo Civitale: Faith (unfinished). Marble. *c.* 1475. *Florence, Bargello*

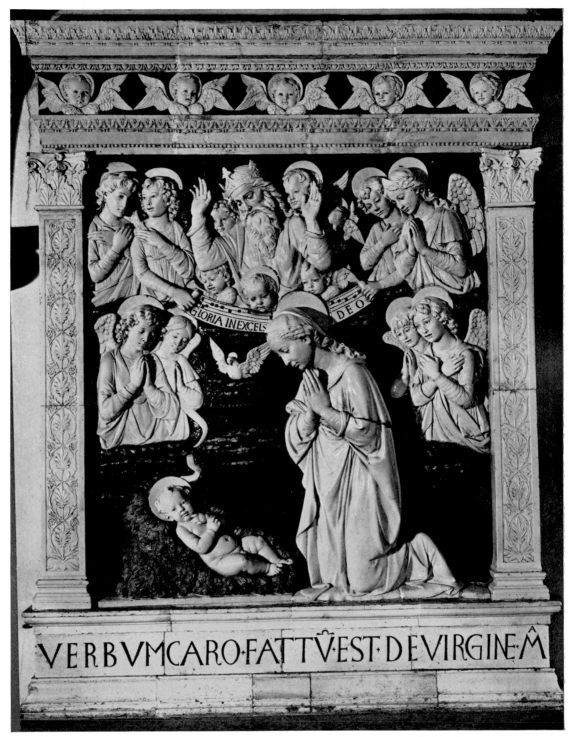

Andrea della Robbia and workshop: The Adoration of the Child. Coloured glazed terracotta. *c.* 1480.
La Verna, Chiesa Maggiore

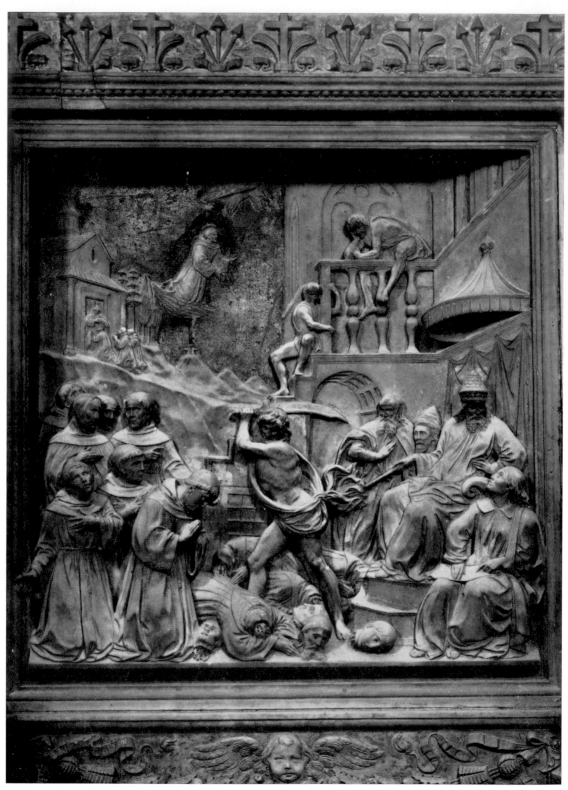

Benedetto da Majano: Martyrdom of the Franciscan Missionaries, panel of pulpit.
Marble, in part gilt. 1472 (commission)–1476. *Florence, S. Croce*

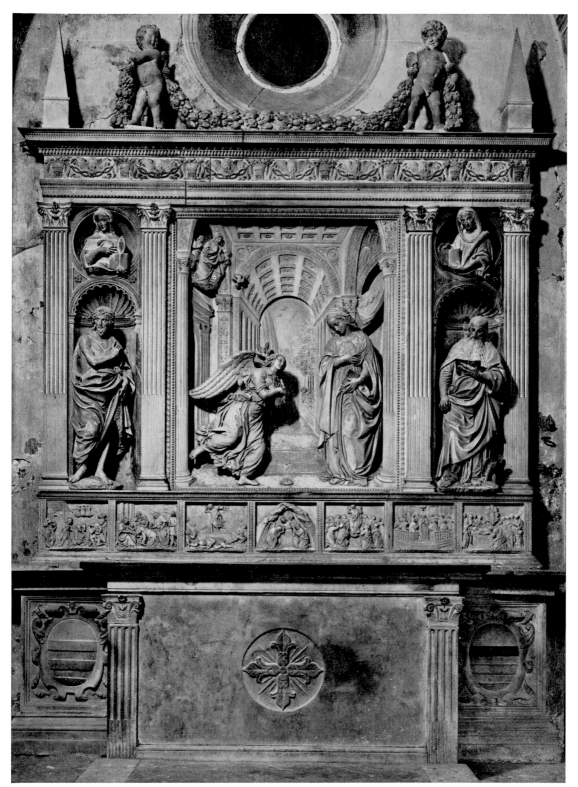

Benedetto da Majano: Mastroguidici Altar. Coloured marbles and originally in part painted.
1489 (delivery). *Naples, S. Anna dei Lombardi (Monte Oliveto)*

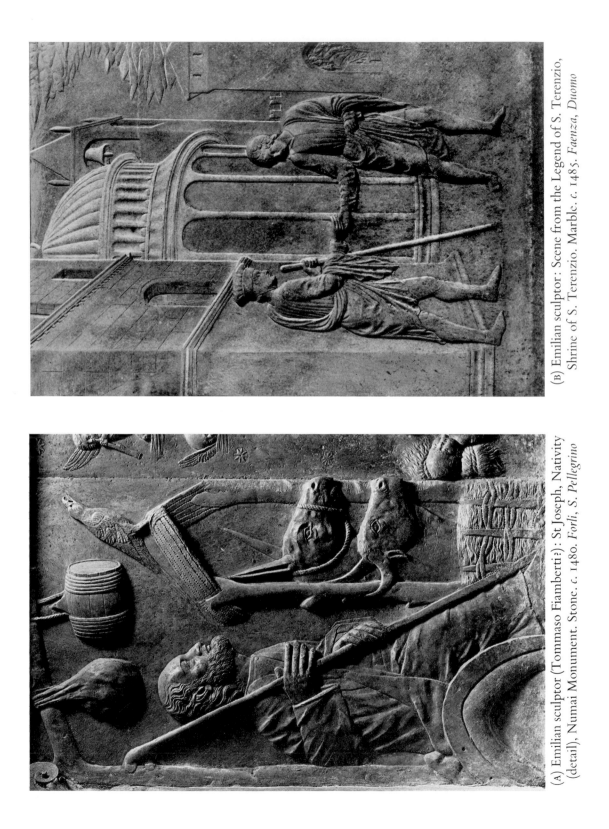

(B) Emilian sculptor: Scene from the Legend of S. Terenzio, Shrine of S. Terenzio. Marble. *c.* 1485. *Faenza, Duomo*

(A) Emilian sculptor (Tommaso Fiamberti?): St Joseph, Nativity (detail), Numai Monument. Stone. *c.* 1480. *Forlì, S. Pellegrino*

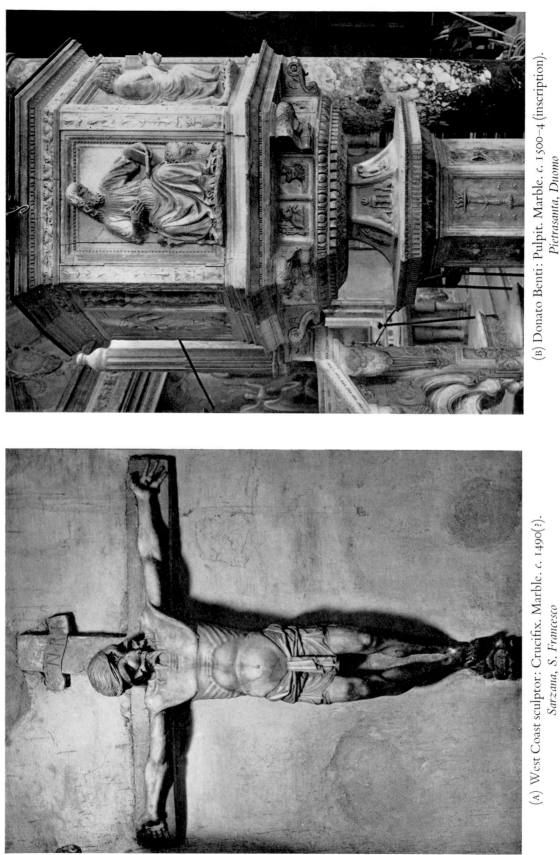

(A) West Coast sculptor: Crucifix. Marble. *c.* 1490(?).
Sarzana, S. Francesco

(B) Donato Benti: Pulpit. Marble. *c.* 1500–4 (inscription).
Pietrasanta, Duomo

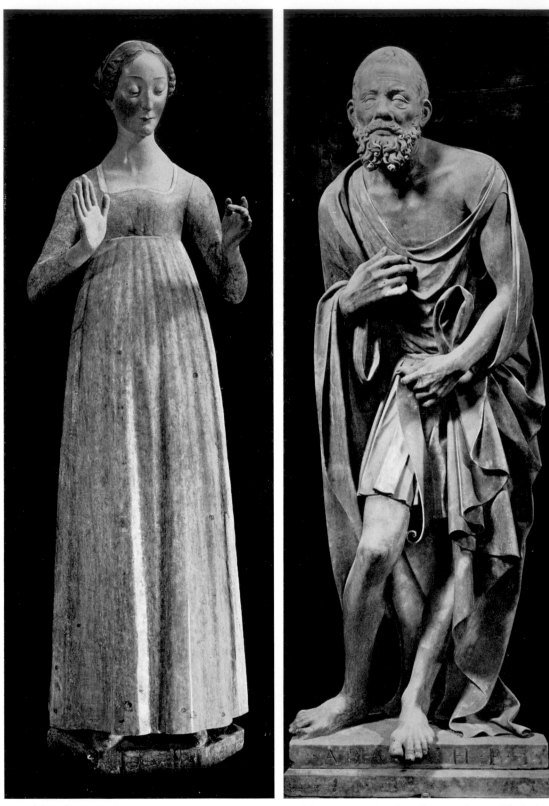

(A) Follower of Matteo Civitale: Virgin
Annunciate. Painted wood. *c.* 1485–90.
Mugnano, S. Michele

(B) Matteo Civitale: The Prophet Habbakuk.
Marble. *c.* 1495. *Genoa, Duomo,
Cappella di S. Giovanni*

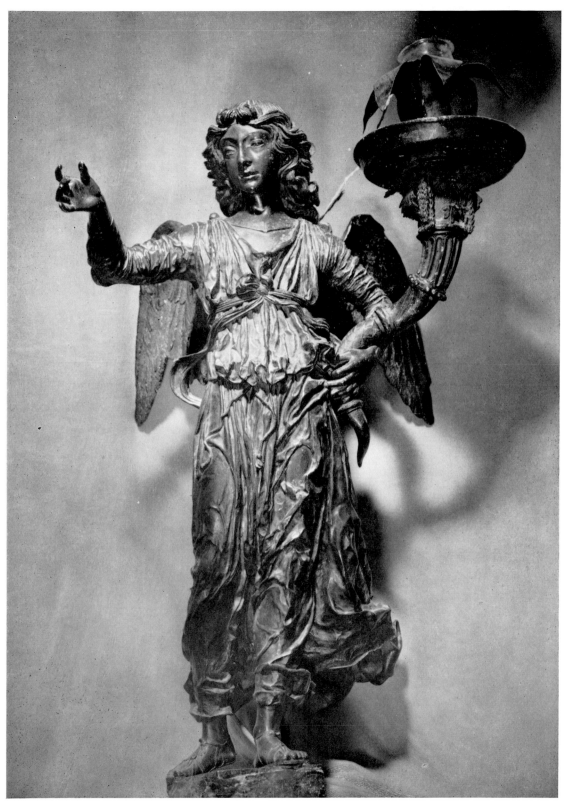

Giovanni di Stefano: Candle-bearing angel for the high altar. Bronze.
Finished 1497. *Siena, Duomo*

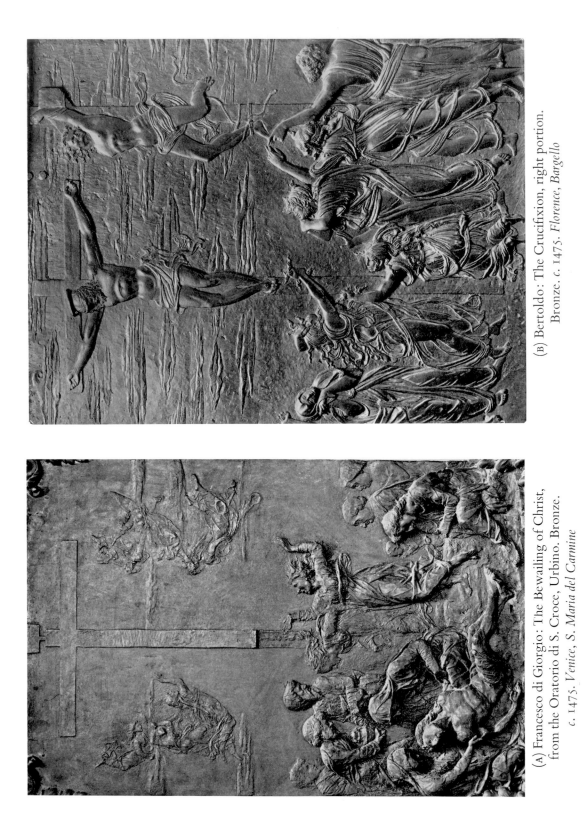

(A) Francesco di Giorgio: The Bewailing of Christ, from the Oratorio di S. Croce, Urbino. Bronze. *c.* 1475. *Venice, S. Maria del Carmine*

(B) Bertoldo: The Crucifixion, right portion. Bronze. *c.* 1475. *Florence, Bargello*

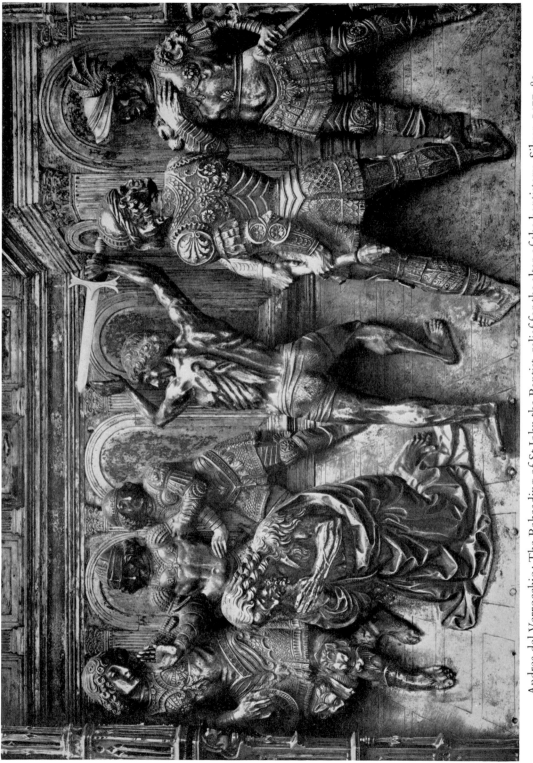

Andrea del Verrocchio: The Beheading of St John the Baptist, relief for the altar of the baptistery. Silver. 1477–80.
Florence, Museo dell'Opera del Duomo

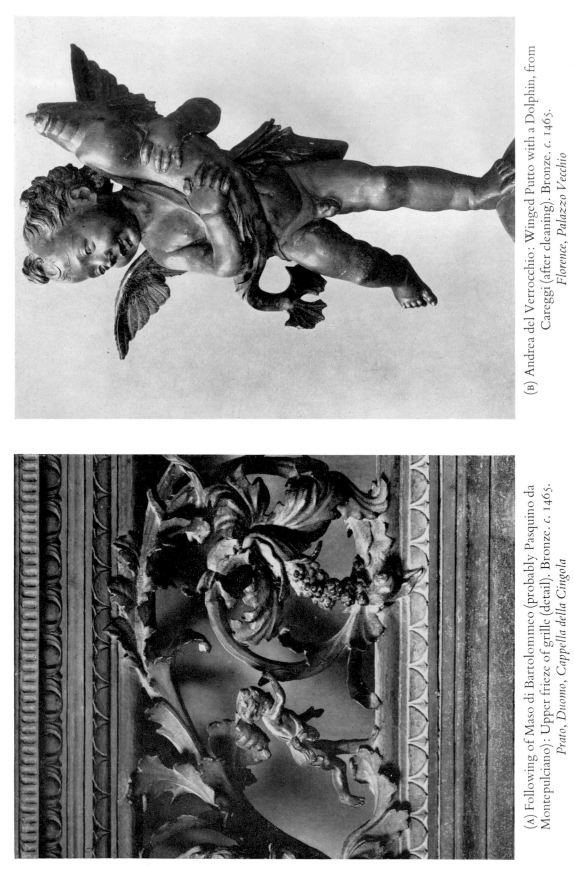

(B) Andrea del Verrocchio: Winged Putto with a Dolphin, from Careggi (after cleaning). Bronze. *c.* 1465.
Florence, Palazzo Vecchio

(A) Following of Maso di Bartolommeo (probably Pasquino da Montepulciano): Upper frieze of grille (detail). Bronze. *c.* 1465.
Prato, Duomo, Cappella della Cingola

114

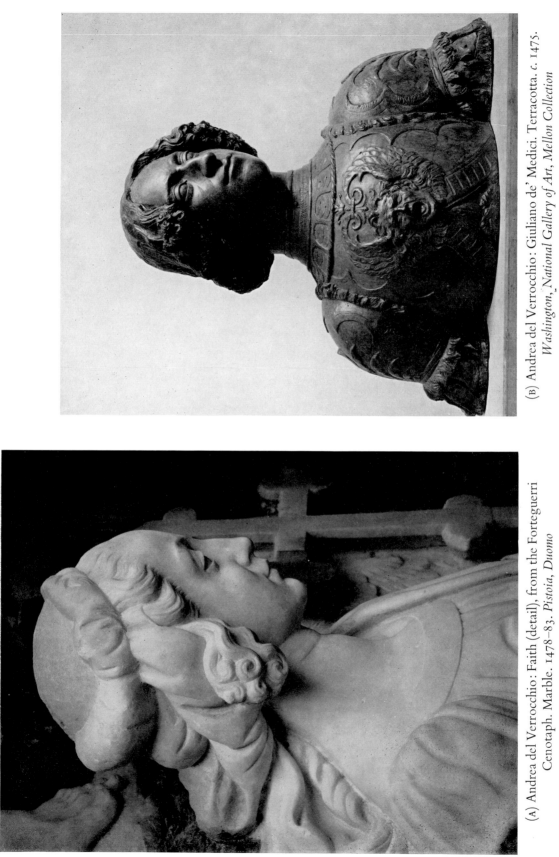

(B) Andrea del Verrocchio: Giuliano de' Medici. Terracotta. *c.* 1475. *Washington, National Gallery of Art, Mellon Collection*

(A) Andrea del Verrocchio: Faith (detail), from the Forteguerri Cenotaph. Marble. 1478–83. *Pistoia, Duomo*

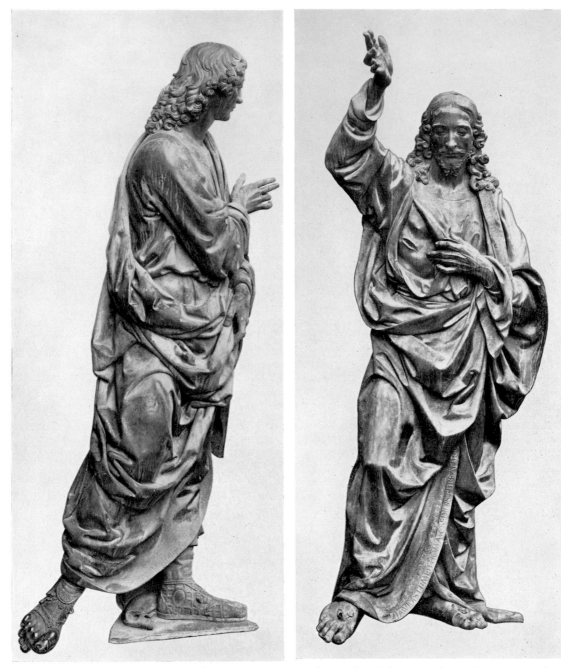

(A) Andrea del Verrocchio: St Thomas, from the group for the Niche of the Mercanzia. Bronze. *c.* 1475–80. *Florence, Or San Michele*

(B) Andrea del Verrocchio: Christ, from the group for the Niche of the Mercanzia. Bronze. *c.* 1465 (decision for commission)– *c.* 1475. *Florence, Or San Michele*

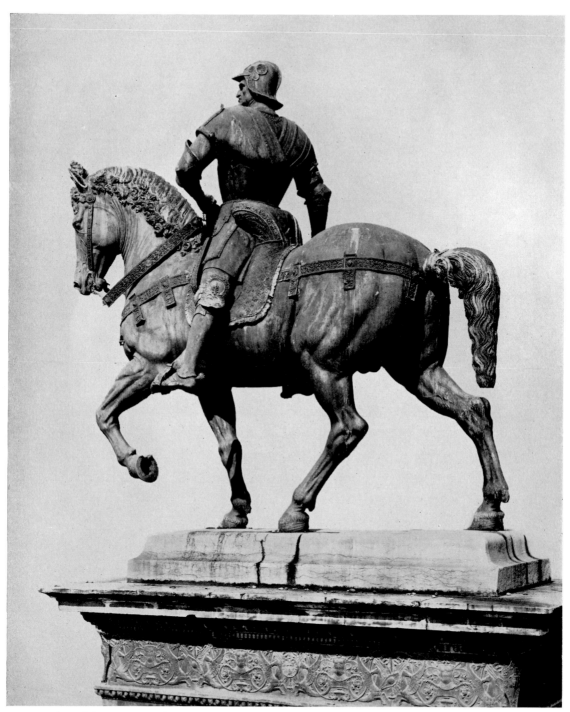

Andrea del Verrocchio (completed by Alessandro Leopardi): Colleoni Monument. Bronze.
1479 (decision for commission)–1496. *Venice, Piazza SS. Giovanni e Paolo*

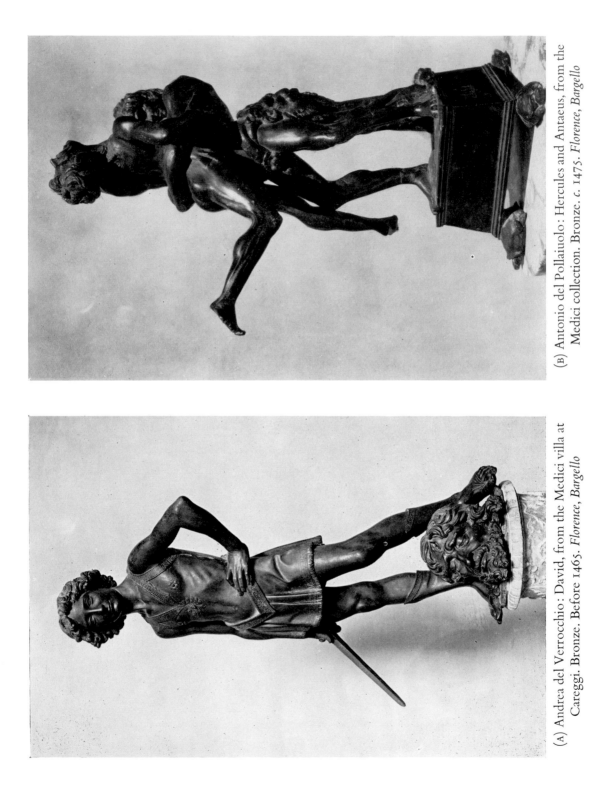

(A) Andrea del Verrocchio: David, from the Medici villa at Careggi. Bronze. Before 1465. *Florence, Bargello*

(B) Antonio del Pollaiuolo: Hercules and Antaeus, from the Medici collection. Bronze. *c.* 1475. *Florence, Bargello*

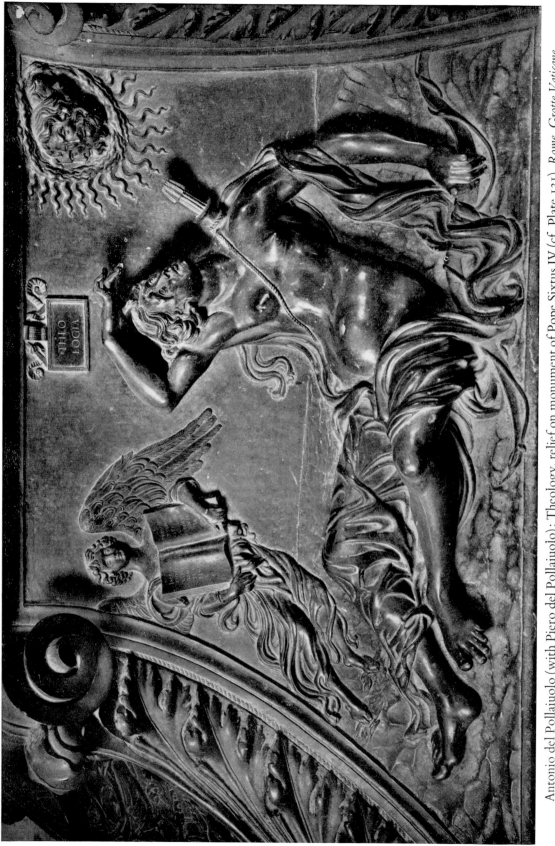

Antonio del Pollaiuolo (with Piero del Pollaiuolo): Theology, relief on monument of Pope Sixtus IV (cf. Plate 121). *Rome, Grotte Vaticane*

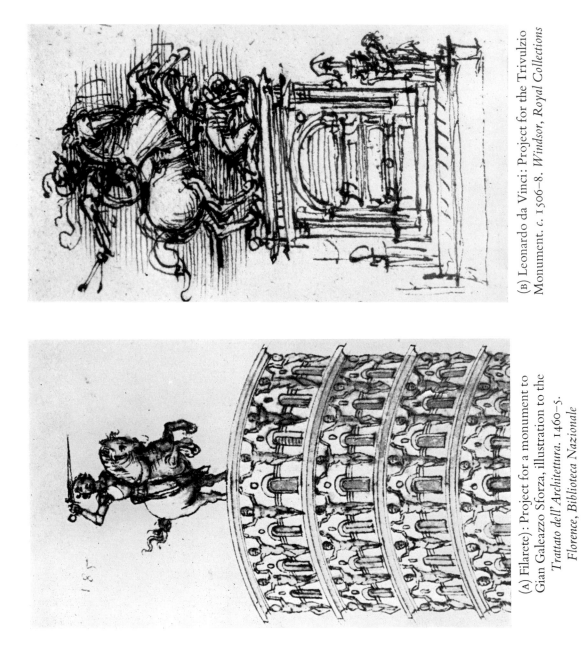

(B) Leonardo da Vinci: Project for the Trivulzio
Monument. c. 1506–8. *Windsor, Royal Collections*

(A) Filarete): Project for a monument to
Gian Galeazzo Sforza, illustration to the
Trattato dell'Architettura. 1460–5.
Florence, Biblioteca Nazionale

Antonio and Piero del Pollaiuolo: Monument of Pope Sixtus IV (detail). Bronze. c. 1484–92/3. *Rome, Grotte Vaticane*

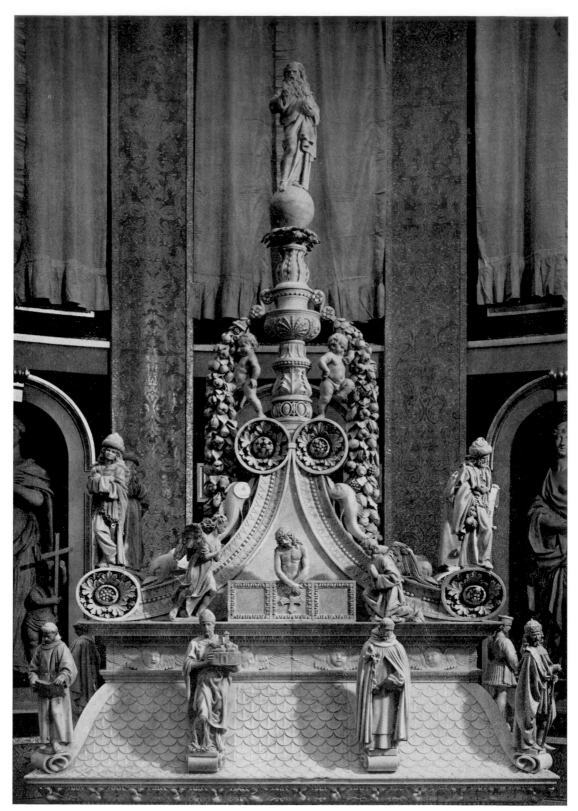

Nicola d'Apulia (called Niccolò dell'Arca) and (in part) Michelangelo: Upper portion of the
Shrine of St Dominic. Marble. 1469 (commission)–1496. *Bologna, S. Domenico*

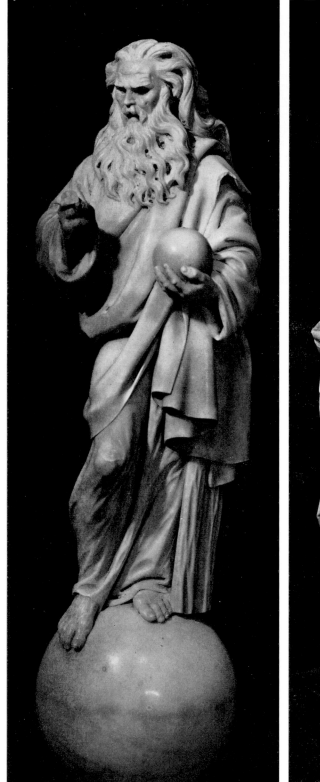

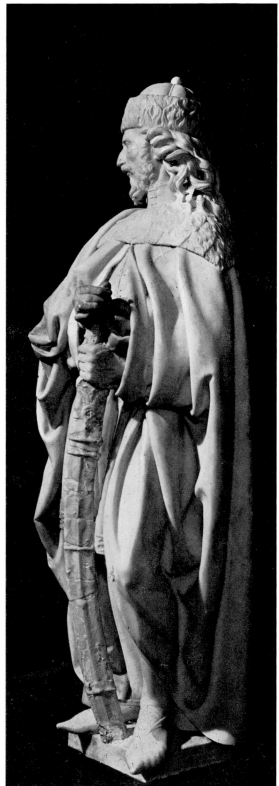

(A) Niccolò dell'Arca: God the Father,
Shrine of St Dominic (detail; cf. Plate 122).
Bologna, S. Domenico

(B) Niccolò dell'Arca: S. Floriano,
Shrine of St Dominic (detail; cf. Plate 122).
Bologna, S. Domenico

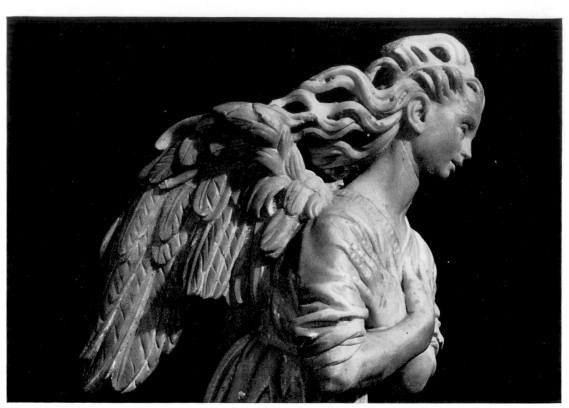

(A) Niccolò dell'Arca: Angel, Shrine of St Dominic (detail; cf. Plate 122). *Bologna, S. Domenico*

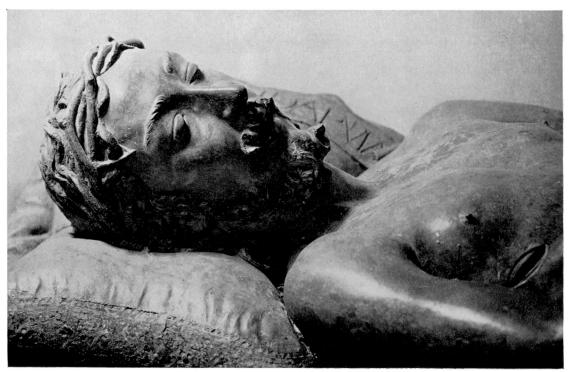

(B) Niccolò dell'Arca: The Dead Christ, Bewailing of Christ (detail; cf. Plate 126).
Bologna, S. Maria della Vita

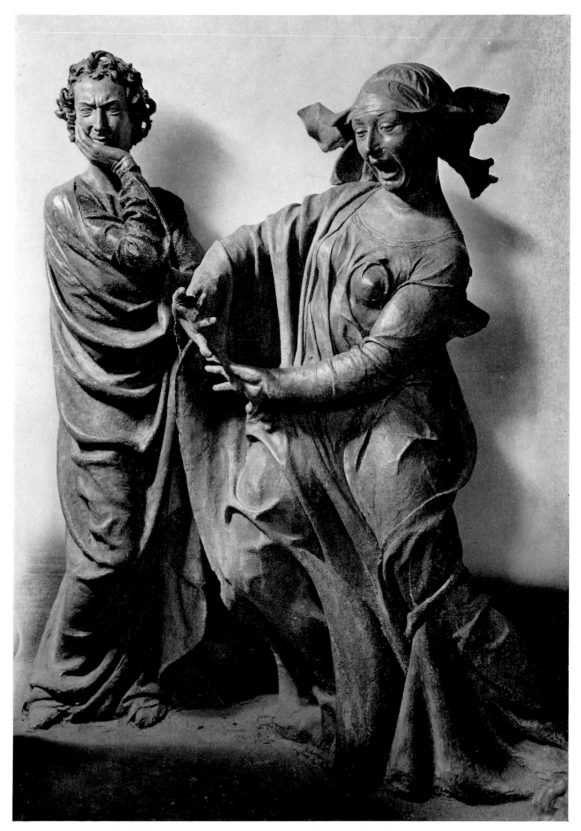

Niccolò dell'Arca: Two Mourners, Bewailing of Christ (detail; cf. Plate 126).
Bologna, S. Maria della Vita

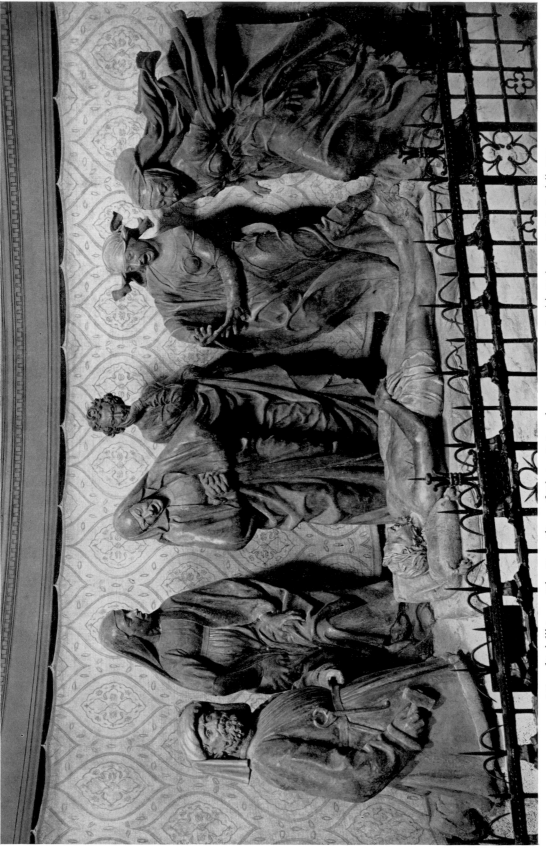

Niccolò dell'Arca: The Bewailing of Christ. Painted terracotta. c. 1485 (?). *Bologna, S. Maria della Vita*

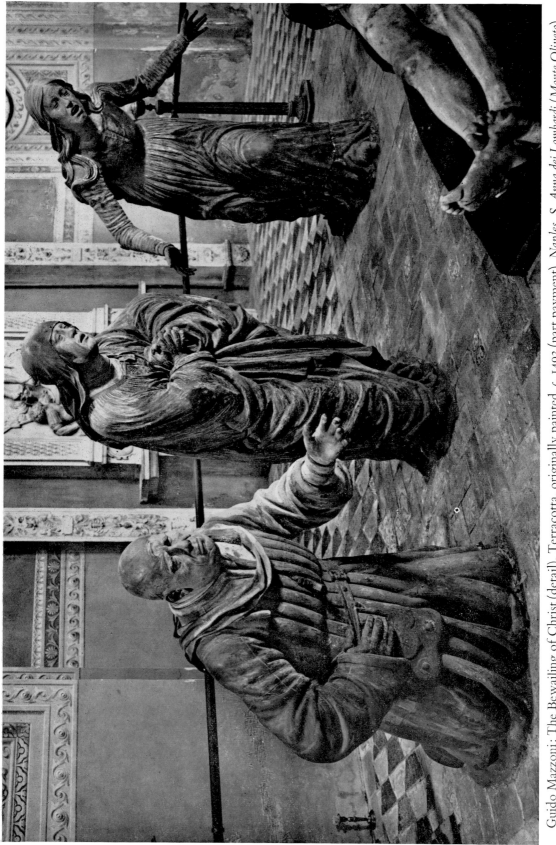

Guido Mazzoni: The Bewailing of Christ (detail). Terracotta, originally painted. *c.* 1492 (part payment). *Naples, S. Anna dei Lombardi (Monte Oliveto)*

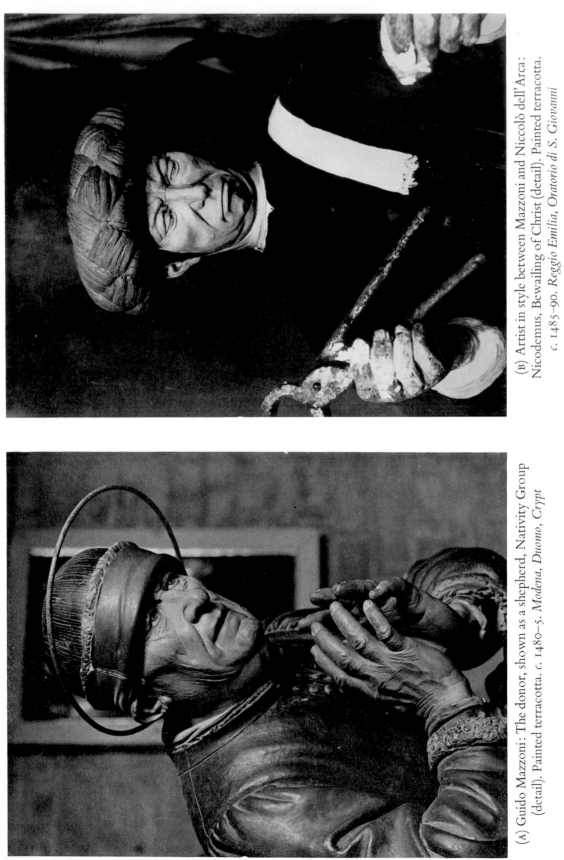

(A) Guido Mazzoni: The donor, shown as a shepherd, Nativity Group (detail). Painted terracotta. c. 1480–5. *Modena, Duomo, Crypt*

(B) Artist in style between Mazzoni and Niccolò dell'Arca: Nicodemus, Bewailing of Christ (detail). Painted terracotta. c. 1485–90. *Reggio Emilia, Oratorio di S. Giovanni*

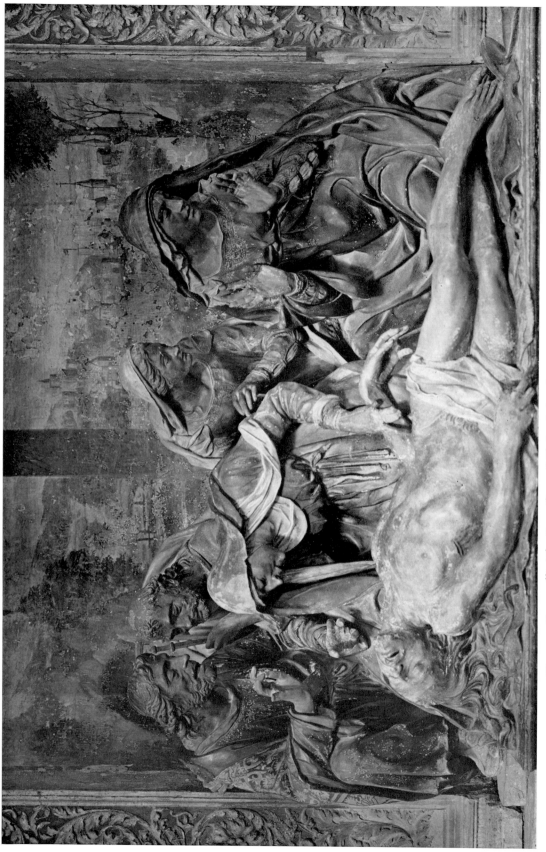

Giacomo Cozzarelli: The Bewailing of Christ. Painted terracotta. *c. 1500. Siena, Osservanza*

Giovanni Antonio Amadeo and others: Lower part of the façade (detail). *c.* 1491–1501. *Pavia, Certosa*

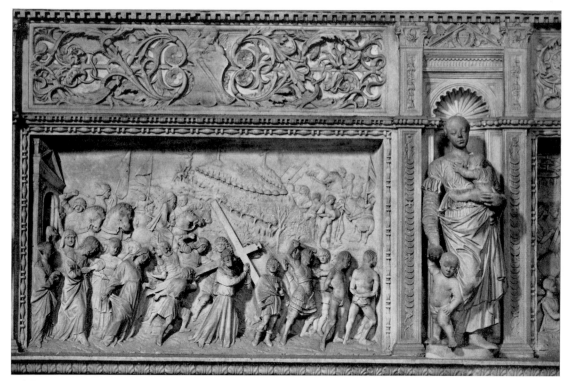

(A) Giovanni Antonio Amadeo and assistants: The Road to Calvary and Charity, Colleoni Tomb (detail). Marble. *c.* 1475. *Bergamo, Cappella Colleoni*

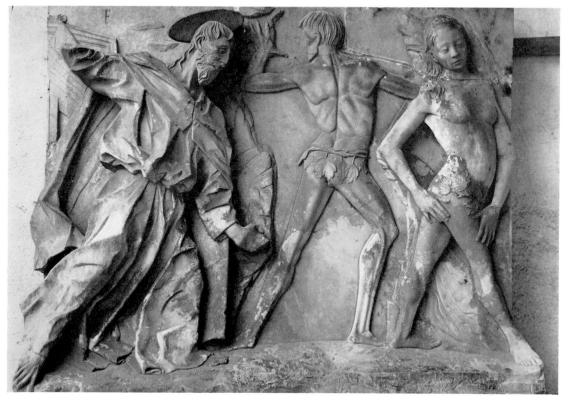

(B) Cristoforo Mantegazza(?): The Expulsion. Marble. *c.* 1480. *Pavia, Certosa (Museo)*

(A) Giovanni Antonio Amadeo and Rinaldo de' Stauris (design and some moulds): Decorated arcade (detail). Terracotta. 1464–80(?). *Pavia, Certosa, Piccolo Chiostro*

(B) Agostino Fondulo: Decorative frieze (detail). Terracotta. *c.* 1485. *Milan, S. Satiro*

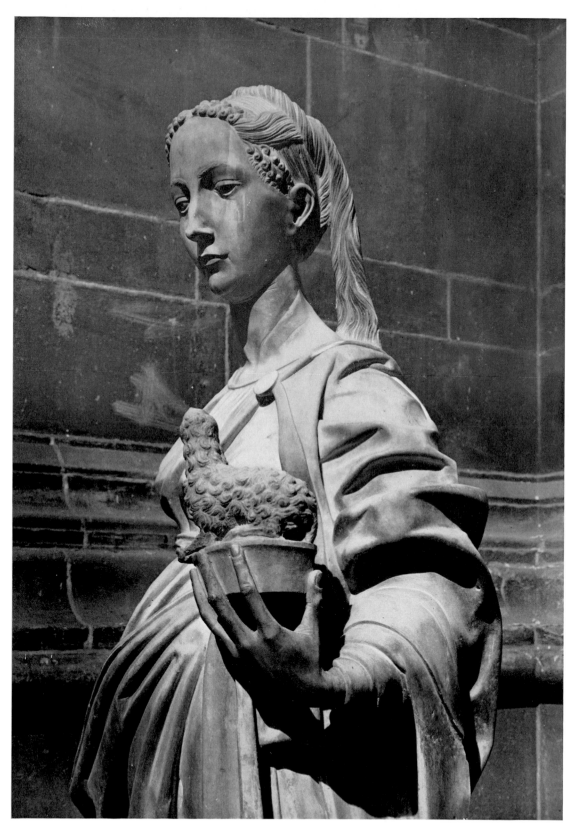

Benedetto Briosco: St Agnes, from the interior of the Duomo.
Marble. 1491. *Milan, Museo del Duomo*

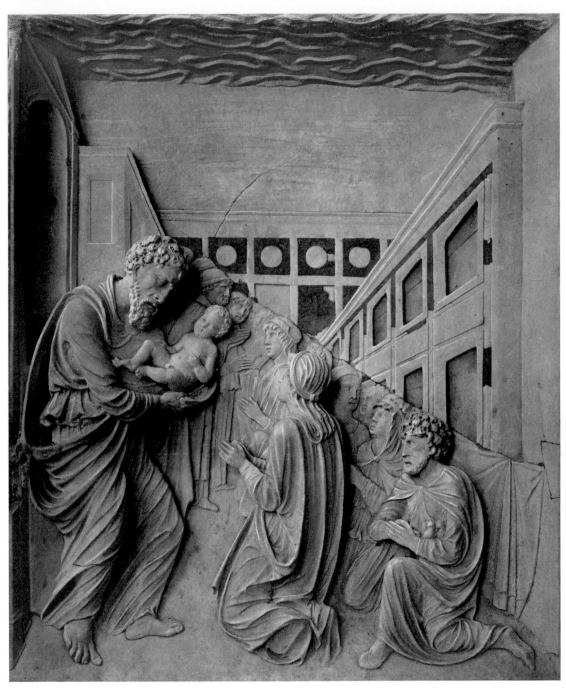

Giovanni Antonio Amadeo workshop: The Presentation in the Temple, relief on the
Arca di S. Lanfranco. Marble. 1498. *Pavia, S. Lanfranco*

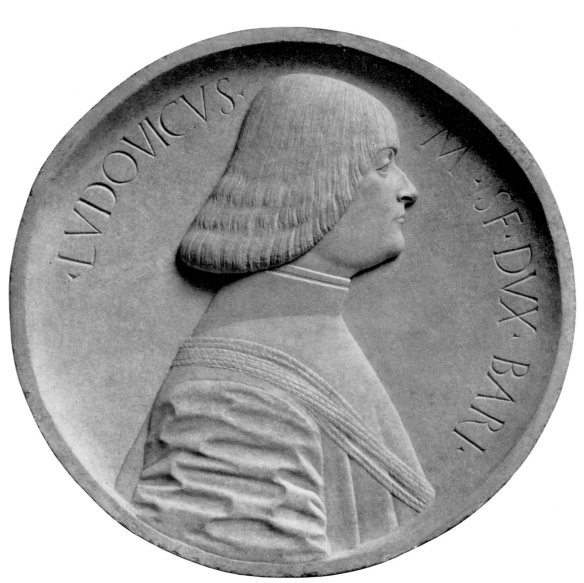

(A) Giovanni Antonio Amadeo or Benedetto Briosco: Portrait of Lodovico Sforza. Marble.
c. 1494. *Washington, National Gallery of Art, Mellon Collection*

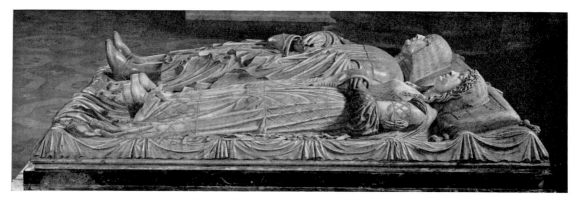

(B) Cristoforo Solari: Effigies of Lodovico Sforza and Beatrice d'Este.
Marble. 1498. *Pavia, Certosa*

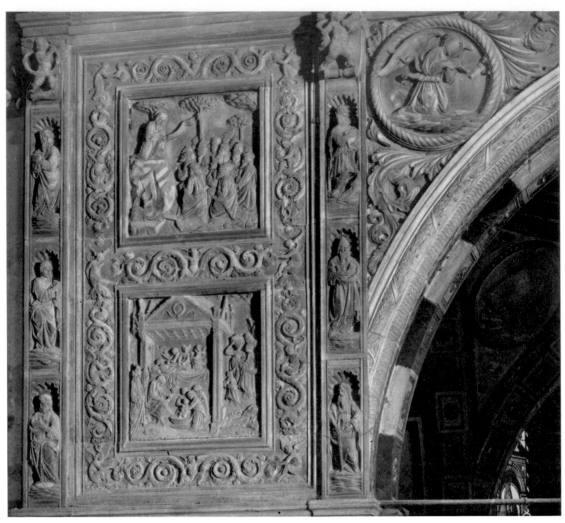

(A) Domenico Gaggini (with assistance): Panels of the Life of St John the Baptist, monumental frontispiece (detail). Marble. 1448–*c*. 1465. *Genoa, Duomo, Cappella S. Giovanni*

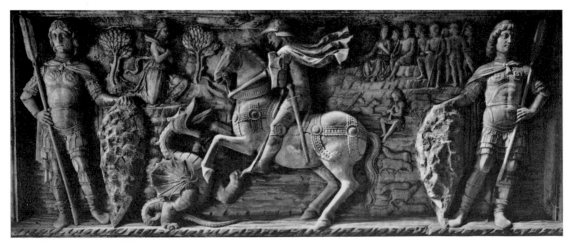

(B) Style of Pace Gaggini: St George and the Dragon, overdoor.
Marble. *c*. 1495. *Genoa, Via degli Indoratori*

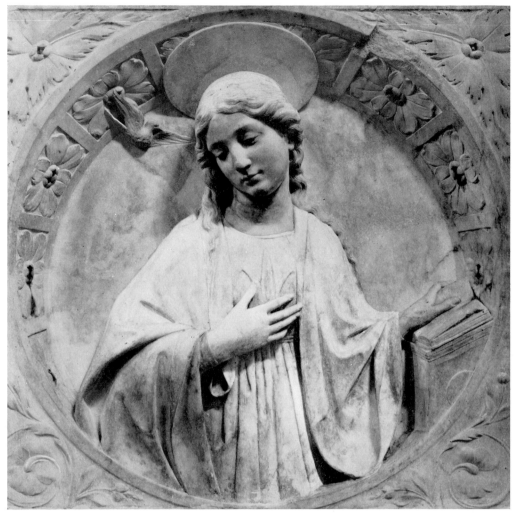

(A) Style of Antonello Gaggini: Virgin of the Annunciation. Marble. *c.* 1500.
Palermo, Convento della Gancia

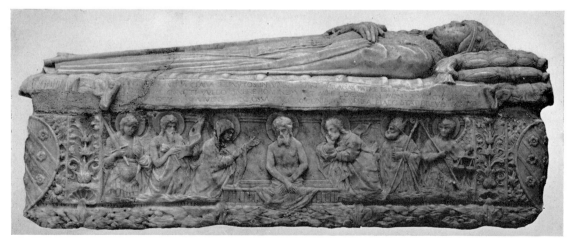

(B) Style of Domenico Gaggini: Monument of Giovanni Montaperto. Marble. 1485
(inscription). *Mazzaro del Vallo, Duomo*

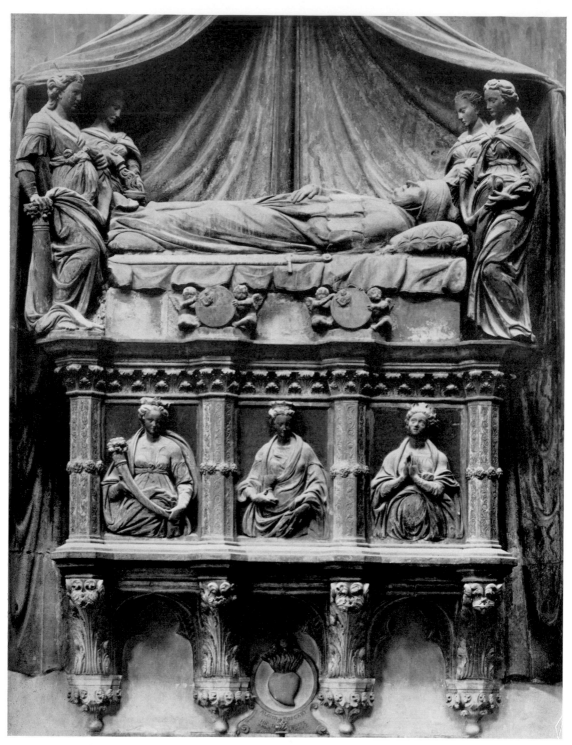

Antonio Bregno: Monument of Doge Francesco Foscari, central portion.
Probably after 1467. Istrian stone(?). *Venice, Frari*

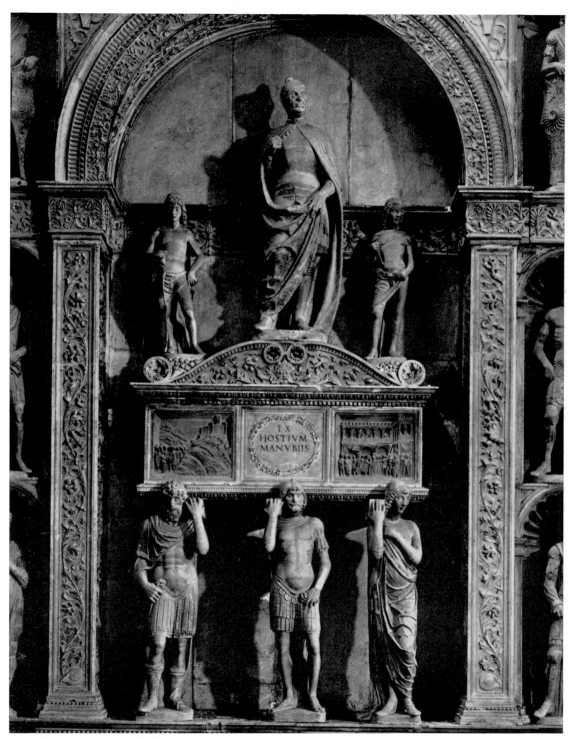

Pietro Lombardo (with assistance): Monument of Doge Pietro Mocenigo, central portion.
Istrian stone and marble. *c.* 1476–81. *Venice, SS. Giovanni e Paolo*

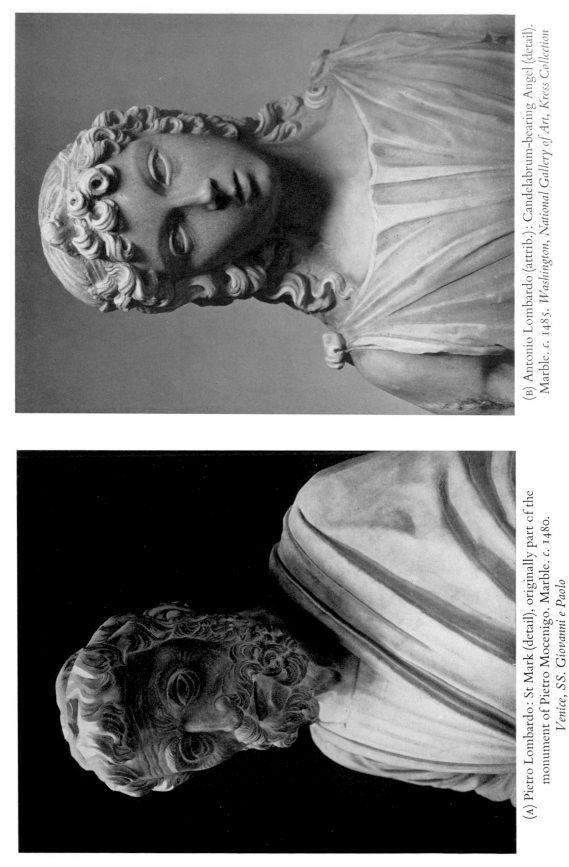

(B) Antonio Lombardo (attrib.): Candelabrum-bearing Angel (detail). Marble. c. 1485. *Washington, National Gallery of Art, Kress Collection*

(A) Pietro Lombardo: St Mark (detail), originally part of the monument of Pietro Mocenigo. Marble. c. 1480. *Venice, SS. Giovanni e Paolo*

140

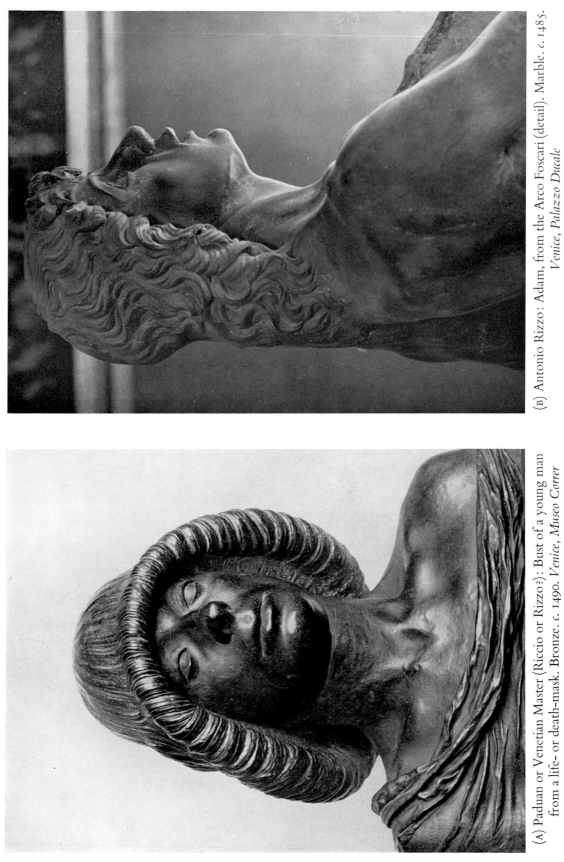

(A) Paduan or Venetian Master (Riccio or Rizzo?): Bust of a young man from a life- or death-mask. Bronze. *c.* 1490. *Venice, Museo Correr*

(B) Antonio Rizzo: Adam, from the Arco Foscari (detail). Marble. *c.* 1485. *Venice, Palazzo Ducale*

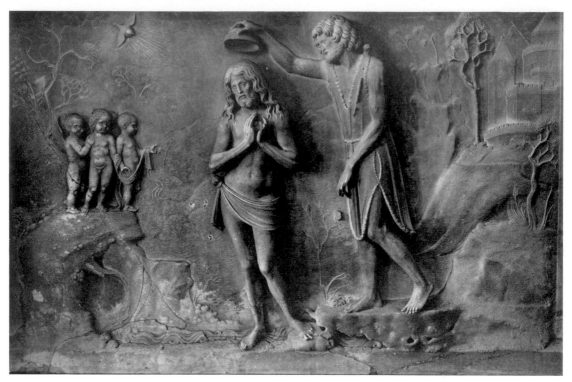

(A) Antonio Lombardo (attrib.): The Baptism of Christ, monument of Doge Giovanni Mocenigo (detail). Marble. *c.* 1500. *Venice, SS. Giovanni e Paolo*

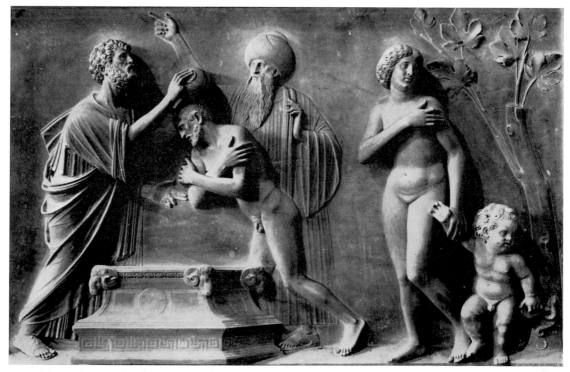

(B) Tullio Lombardo: St Mark baptizing, monument of Doge Giovanni Mocenigo (detail). Marble. *c.* 1500. *Venice, SS. Giovanni e Paolo*

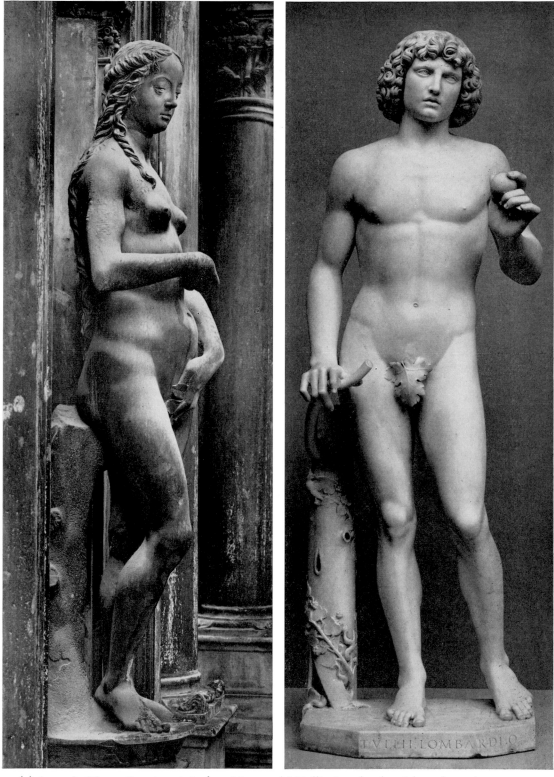

(A) Antonio Rizzo: Eve, in original position
on the Arco Foscari. Marble. *c.* 1485.
Venice, Palazzo Ducale

(B) Tullio Lombardo: Adam, from the monument
to Doge Andrea Vendramin from the Servi
church, Venice. Marble. 1492–5. *New York,
Metropolitan Museum of Art*

143

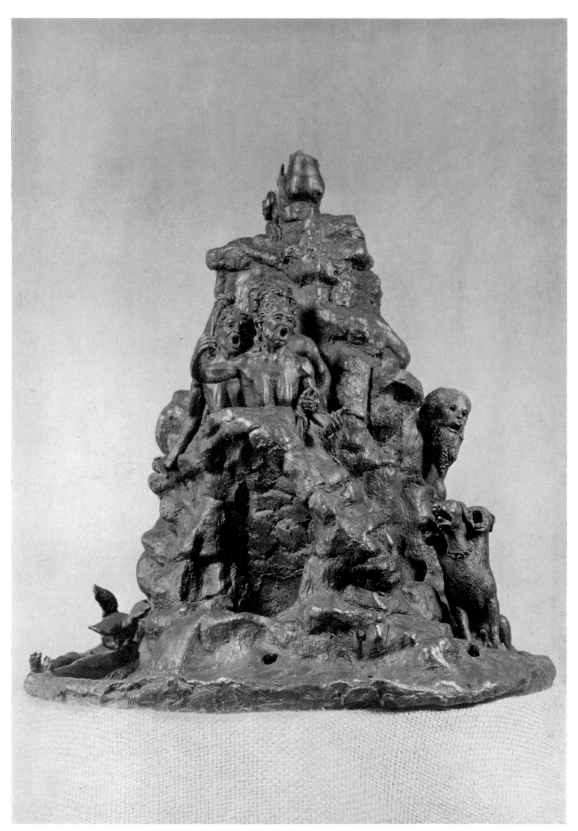

Bartolommeo Bellano: Mountain of Hell, table incense-burner.
Bronze. *c.* 1485. *London, Victoria and Albert Museum*

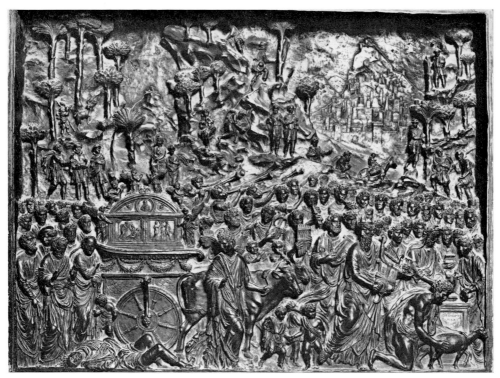

(A) Andrea Briosco Il Riccio): David dancing before the Ark.
Bronze. Finished 1507. *Padua, Santo*

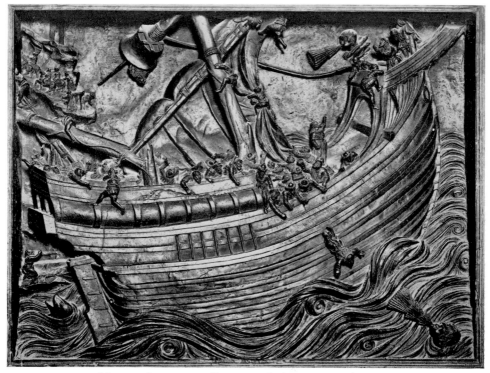

(B) Bartolommeo Bellano: Jonah thrown into the Sea.
Bronze. *c.* 1485. *Padua, Santo*

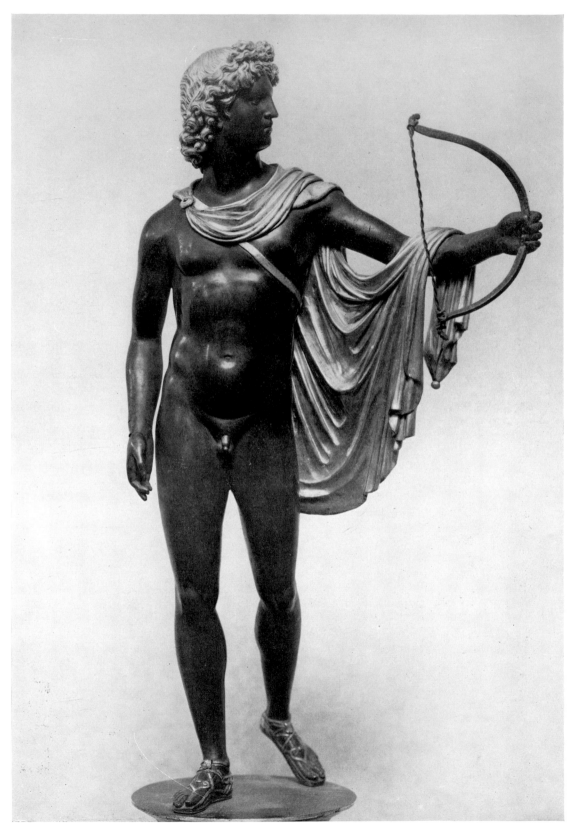

Pier Jacopo Alari Bonacolsi (L'Antico): Apollo, from the Antique. Bronze, in part gilt.
Modello 1497/8. *Venice, Cà d'Oro*

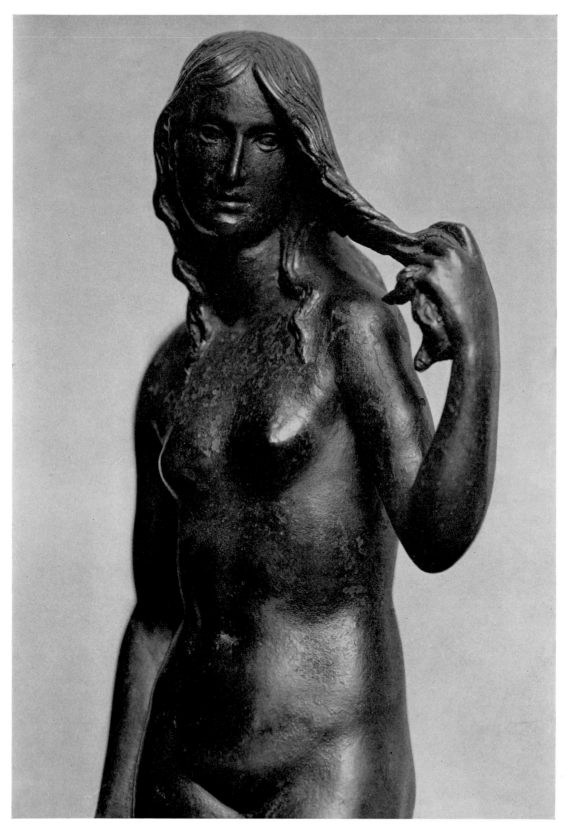

Adriano Fiorentino: Eve or Venus. Bronze. *c.* 1490. *Philadelphia Museum of Art*

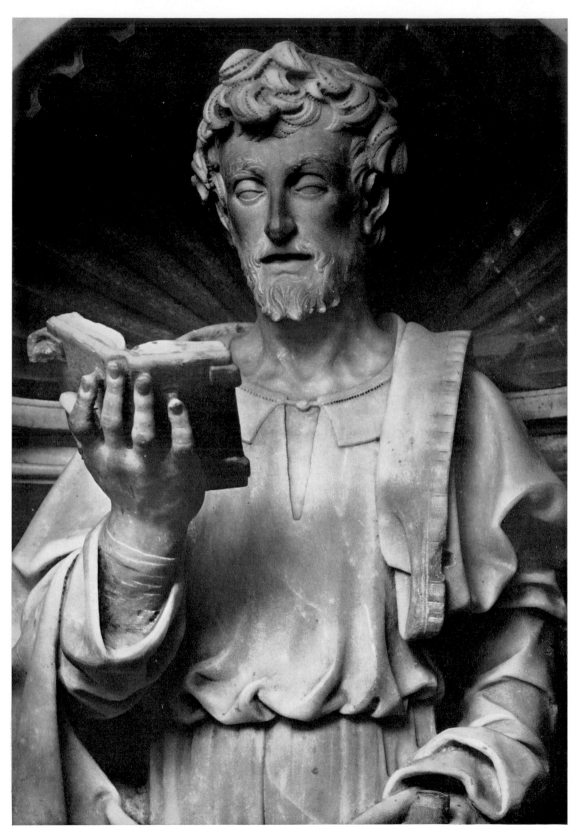

Andrea Sansovino: St James Major (detail), Corbinelli Altar. Marble. 1485–90.
Florence, S. Spirito

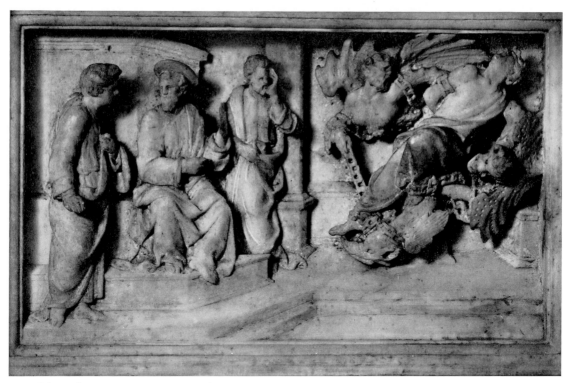

(A) Andrea Sansovino: A Miracle of St James Major, predella scene on the Corbinelli Altar. Marble. 1485–90. *Florence, S. Spirito*

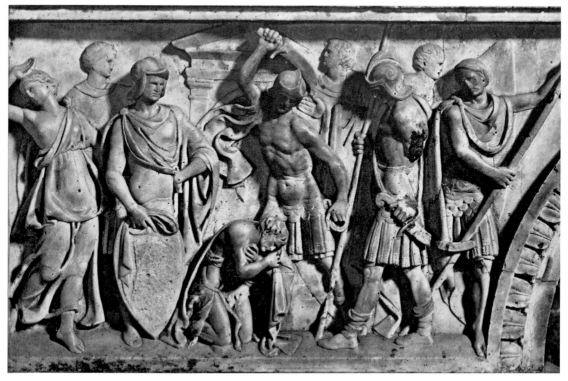

(B) Andrea Ferrucci: Beheading of St John the Baptist, predella scene on the font. Marble. 1494–7. *Pistoia, Duomo*

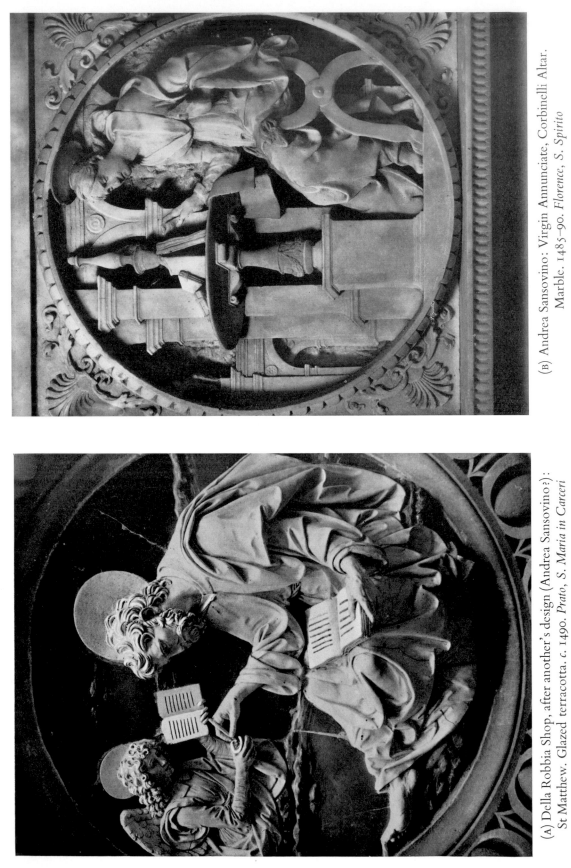

(A) Della Robbia Shop, after another's design (Andrea Sansovino?): St Matthew. Glazed terracotta. *c.* 1490. *Prato, S. Maria in Carceri*

(B) Andrea Sansovino: Virgin Annunciate, Corbinelli Altar. Marble. 1485–90. *Florence, S. Spirito*

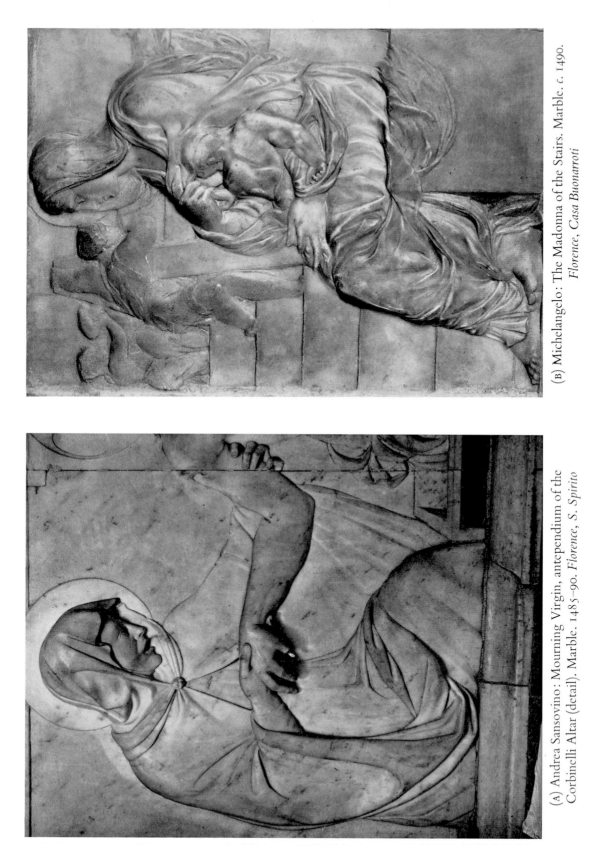

(A) Andrea Sansovino: Mourning Virgin, antependium of the
Corbinelli Altar (detail). Marble. 1485–90. *Florence, S. Spirito*

(B) Michelangelo: The Madonna of the Stairs. Marble. *c.* 1490.
Florence, Casa Buonarroti

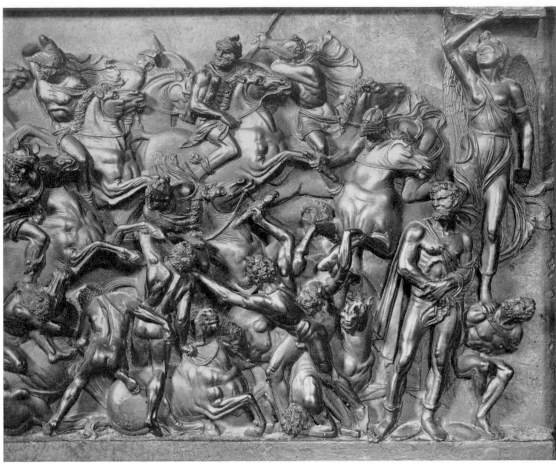

(A) Bertoldo: Battle (detail). Bronze. *c.* 1480–90. *Florence, Bargello*

(B) Design of Andrea Sansovino(?): Frieze (detail). Coloured glazed terracotta. *c.* 1485–90.
Poggio a Caiano, Medici Villa

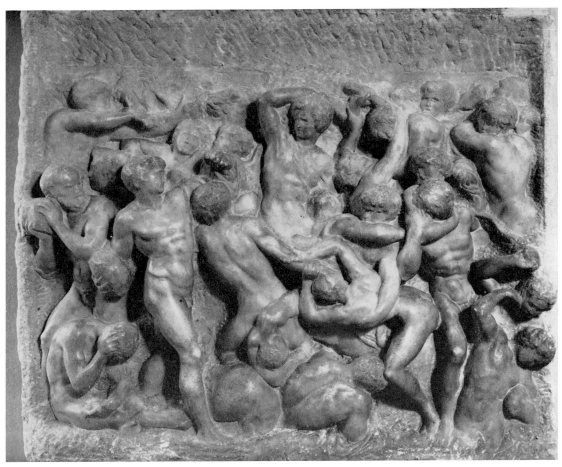

(A) Michelangelo: Battle of Centaurs and Lapiths. Carrara marble. 1490–4.
Florence, Casa Buonarroti

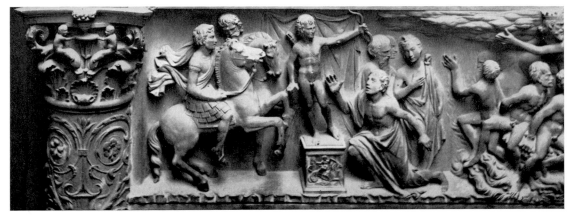

(B) Benedetto da Rovezzano: Frieze on fireplace from the Palazzo Borgherini (detail).
Pietra serena. *c.* 1495. *Florence, Bargello*

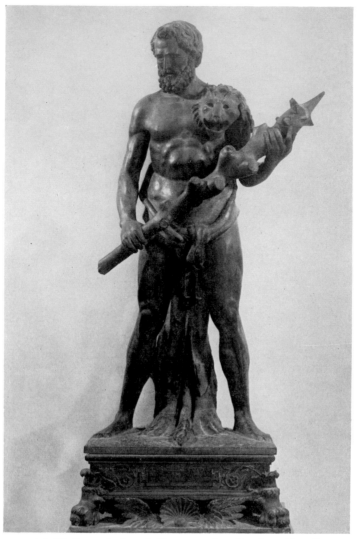

(A) Giuliano da San Gallo: Hercules, fireplace (detail).
Pietra serena. Begun *c.* 1490. *Florence, Palazzo Gondi*

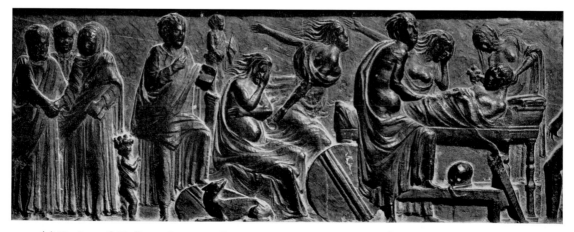

(B) Design of Giuliano da San Gallo: Death scene, monument of Francesco Sassetti (detail).
Polished pietra serena. *c.* 1485. *Florence, S. Trinità, Cappella Sassetti*

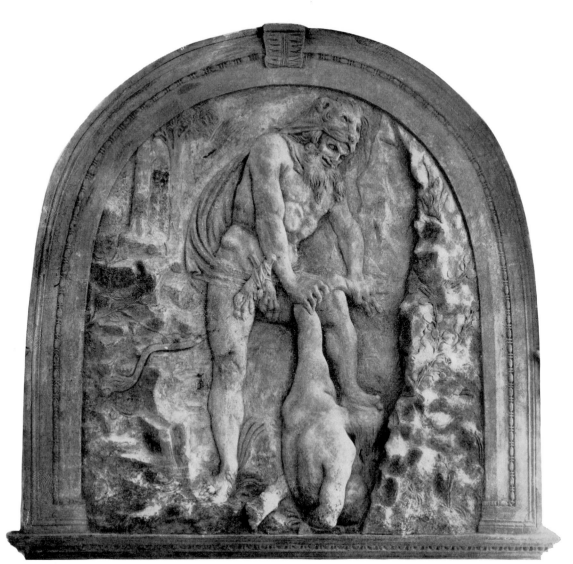

(A) Florentine sculptor (current of Antonio del Pollaiuolo): Hercules and Caecus. Stucco. *c.* 1490. *Florence, Palazzo Guicciardini*

(B) Florentine sculptor (current of Bertoldo): 'Military Glory' (detail). Stucco painted to imitate bronze. *c.* 1480/90. *Florence, Palazzo Gherardesca, Casa Scala Courtyard*

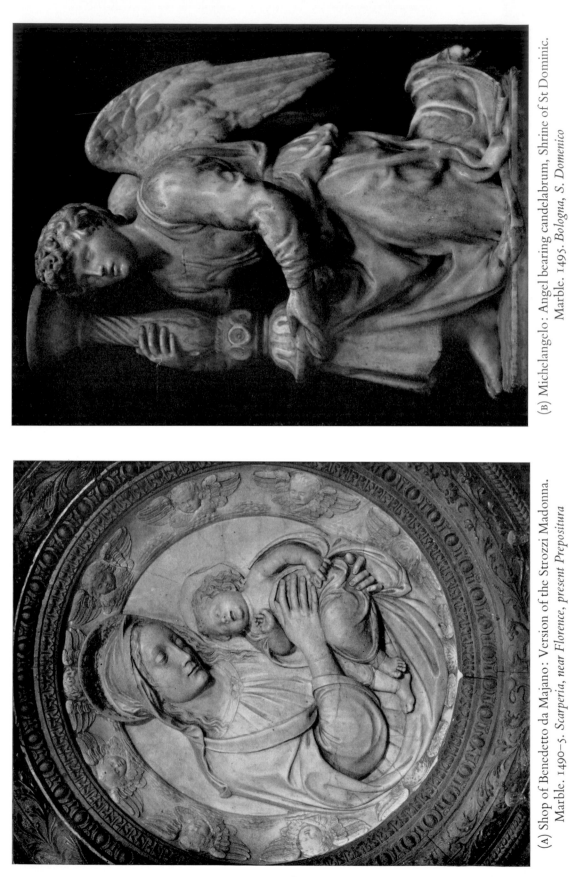

(B) Michelangelo: Angel bearing candelabrum, Shrine of St Dominic.
Marble. 1495. *Bologna, S. Domenico*

(A) Shop of Benedetto da Majano: Version of the Strozzi Madonna.
Marble. 1490–5. *Scarperia, near Florence, present Prepositura*

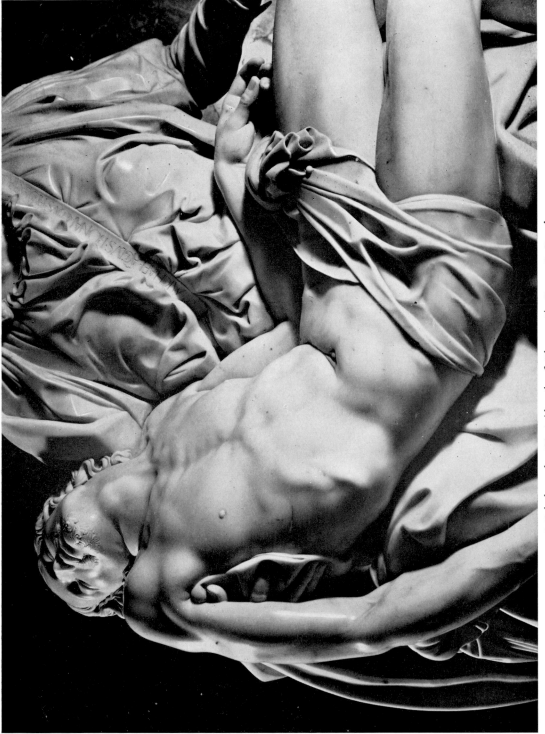

Michelangelo: Pietà (detail; cf. Plate 158). *Rome, St Peter's*

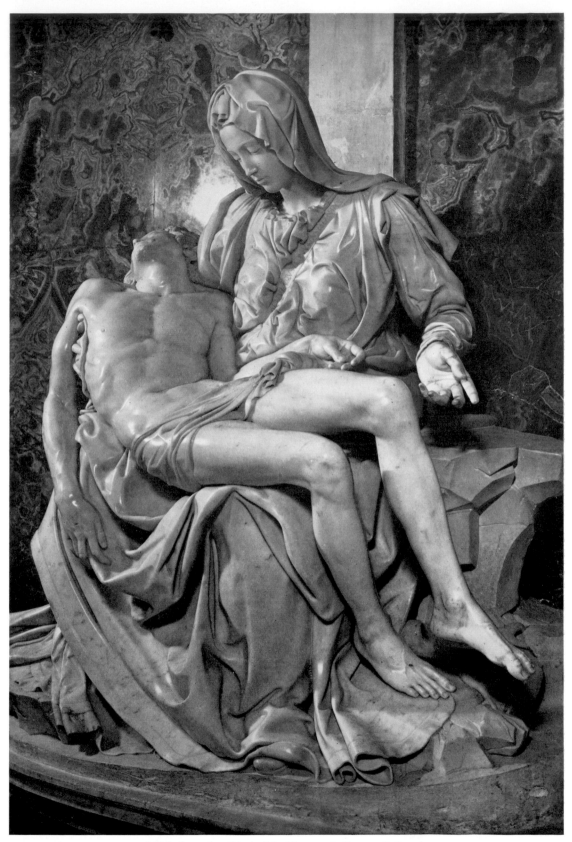

Michelangelo: Pietà. Marble. 1498. *Rome, St Peter's*

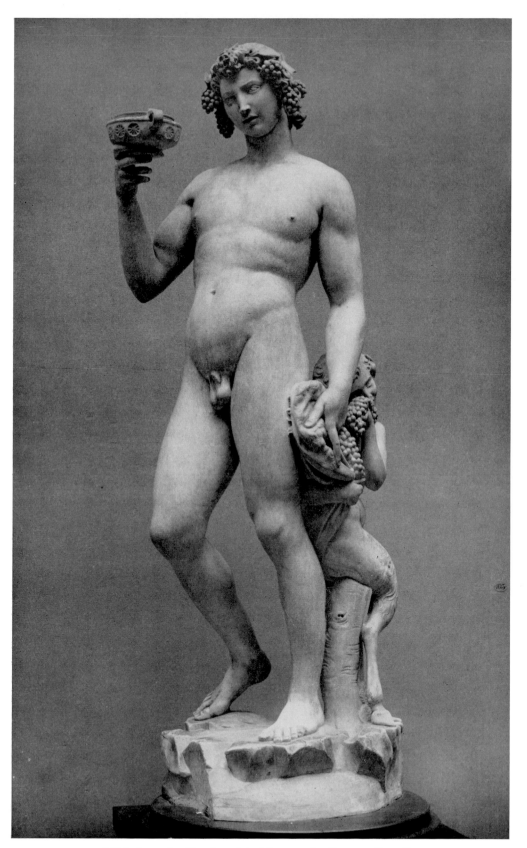

Michelangelo: Bacchus. Marble. 1496/7. *Florence, Bargello*

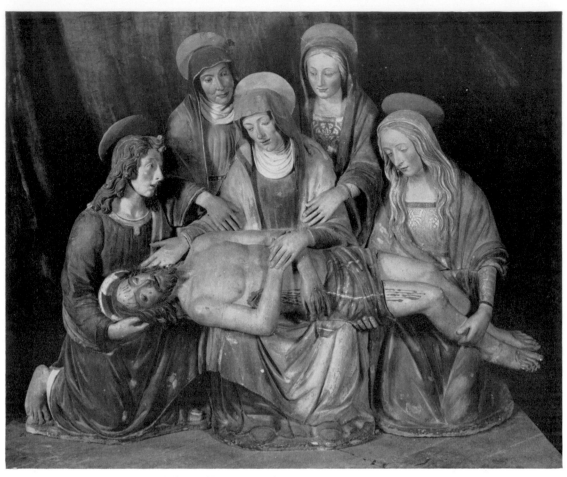

Current of Giovanni della Robbia : Pietà, from the crypt of the Gesù. Painted terracotta.
c. 1500. *Cortona, Museo*

INDEX

Numbers in *italics* refer to plates. References to the Notes are given to the page on which the Note occurs followed by the number of the Note; thus 247³ indicates page 247, Note 3. Notes are indexed only when they contain further concrete information, and not when the further information is purely bibliographical. Portraits, free-standing statues, and some important reliefs have been indexed under their subjects (e.g. *Mark, St* (Donatello), (Lamberti), etc.). If five or more artists worked on programmes localized in one building, they will be found indexed separately under that building. Artists' names follow in general Thieme-Becker, *Künstlerlexikon*. The word 'monument' is abbreviated to 'mon.'.

A

U

W

Y

Z